Visual Effects in a Digital World

Oct 2002

Dear Dan

Thanks for all you invaluable help on HP2.
If you don't make VFX producer by 2005, you owe me an expensive meal.

Good luck for the future, you deserve to do well!

love

Alex (Day)

XXX

Visual Effects in a Digital World

Karen E. Goulekas

**Morgan
Kaufmann**

Morgan Kaufmann is an imprint of Academic Press
A Harcourt Science and Technology Company
San Diego San Francisco New York Boston
London Sydney Tokyo

Cover image:

The final composite featuring six miniature police cars composited over an environment comprised of miniature buildings, CG traffic, and a matte painting. The image was cropped with a 2.35 center extraction for projection. *THE FIFTH ELEMENT* 1997 Copyright © Gaumont. All Rights Reserved. Courtesy of Columbia Pictures.

This book is printed on acid-free paper. ∞

Copyright © 2001 by Academic Press

ACADEMIC PRESS
A Harcourt Science and Technology Company
525 B Street, Suite 1900, San Diego, CA 92101-4495, USA
http://www.academicpress.com

Academic Press
Harcourt Place, 32 Jamestown Road, London NW1 7BY, UK
http://www.academicpress.com

Morgan Kaufmann
A Harcourt Science and Technology Company
340 Pine Street, Sixth Floor, San Francisco, CA 94104-3205
http://www.mkp.com

Library of Congress Catalog Card Number: 00-105908
International Standard Book Number: 0-12-293785-6

Printed in the United States of America
00 01 02 03 04 IP 9 8 7 6 5 4 3 2 1

DEDICATED TO:

(can you guess??)

MOM AND DAD!

Introduction

Although it has become increasingly commonplace to opt for digital solutions in the creation of visual effects for feature films, the terminology surrounding the technology is far from commonplace.

I often find myself in the situation of attempting to define for directors, producers, or studio executives a particular term or technical approach we are using to create the digital visual effects for a project. However, as I struggle for a simple and clear-cut explanation, I find that I unwittingly introduce many new digital terms that also beg interpretation. Before long, not only have I failed to define the original term being discussed, I have also succeeded in confusing my audience even more, in my attempt to make it all perfectly crystal clear!

Even for those of us who have grown up in the digital arena, it is often a challenge to keep up with the ever-changing language and terminology used in everyday conversation among visual effects professionals. Not only does each software and hardware application and technique come equipped with its own unique language, there is also a complete library of slang and abbreviated terms, often varying from facility to facility, that has become part of an entire new language to learn and understand.

Thus, I saw the need for this book. When I set out to compile a list of terms covering film, computer graphics, live action, and special effects photography, I thought I would come up with about 2,500 terms that would more than cover the vocabulary required to enable visual effects professionals from different disciplines to speak the same language. Was I naive! With over 7,000 terms identified during the year I spent writing this book, I feel as though I could continue adding terms forever! Not a day goes by that I don't think of or hear a new term that qualifies for an entry in this book! Well, I guess there's always the second edition....

My hope is that this book will serve as a quick reference of terms for new-comers to the industry, as well as seasoned professionals who barely have enough time to meet their next deadline, let alone study up on the latest digital breakthroughs and terminology!

Enjoy!
KEG

P.S. Please send comments and feedback to kegvfx@mindspring.com.

Contributors

A special thank you to the following group of people who helped me put this book together by proofreading, providing input and feedback for definitions, creating images, and assisting in obtaining the necessary licensing permissions to use the various stills from feature films.

Text Contributors

Alberto Menache
Carolin Quis
Chris Roda
Craig Ring
David Prescott
Debra Wolff
Franklin Londin
Jeff Kalmus
Joe Muxie
Kat Kelly
Matthew Butler
Peter Farson
Remo Balcells
Ron Brinkmann
Sean Dever
Scott Gordon
Simon O'Connor
Steven Blakey
Volker Engel

Aron Pfau
Chris Holsey
Chris Trimble
David Lipman
Derrick Carlin
Fiona Stone
Jeff Baksinski
Jerry Hall
John Hanashiro
Lea Ravage Pfau
Mark Stetson
Raffaella Filipponi
Rocco Passionino
Sean Cunningham
Shawn Neely
Scott Stokdyk
Steffen Wild
Teddy Yang

Image Contributors

Alan Sonneman

Centropolis Effects
- Drew McKeen
- Maura Walls
- Tim Cunningham

Digital Domain
- Bob Hoffman
- Chris Holsey
- Feliciano di Giorgio
- Jeff Kalmus
- Rebecca Brown

Franklin Londin

Gaumont
- Patrice Ledoux
- Rosine Handleman

Jerry Hall

Kodak
- John Pytlak
- Bob Gibbons

Nothing Real
- Lousi Cetorelli
- Ron Brinkmann
- Sid Joyner

Photron USA
- Scott Gross

Teddy Yang

Toho
- Masaharu Ina
- Rosine Handleman

Universal Pictures
- Cindy Chang
- Johnnie Luevanos

Columbia Tristar Pictures
- Gwenn Fitzpatrick
- Margarita Medina
- Monique Diaz

Dreamworks SKG
- Anthony Lanni
- Bill Heiden
- Fumi Kitahara
- Jennifer Scheer
- Melissa Hendricks
- Philip Rowe
- Wendy Backe

Gretag Macbeth
- Joan Smith

Joe Muxie

Lightstorm Entertainment
- Geoff Burdick

Pacific Data Images
- Shawn Neeley
- Jim Derose

Side Effects Software
- Mike Makara
- Peter Bowmar
- Tony Cristiano

20th Century Fox
- Josh Baur
- Rebecca Herrera

A/B cutting See **A/B editing**.

A/B editing An **editing** method for assembling the original **image**s from at least two **roll**s of **film** or **video** by alternating the images from each. See **A/B printing**. *See image below.*

Abby Singer The second-to-last **shot** to be **film**ed for the day. It was named after **Production Manager (PM)** Abby Singer who often announced the last shot of the day only to have the **Director** decide to do another **setup**. See also **martini shot**.

Abekas The brand name for a line of **Digital Disk Recorder**s (**DDR**) owned by **Accom**.

abort To cancel a **computer process** or **command**.

above See **above operation**, *and image on following page.*

above operation A **compositing operation** that layers the **foreground image** over the **background image** but only inside the area covered by the **alpha channel** of the background image. Also called **atop operation**. Opposite of **below operation**. See also **plus above operation**, *image under **layering operation** and image on following page.*

above the line 1. The portion of a **film budget** that covers expenses that have already been incurred or negotiated before **principal photography**

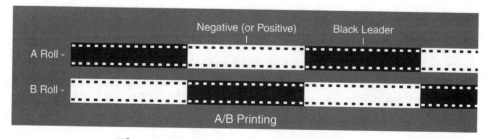

The **A and B rolls** used in **A and B printing**.

1

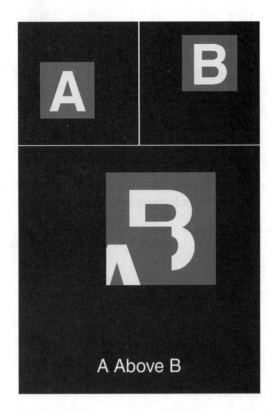

A Above B

begins. Such costs might include the purchase of the **script** or novel and the salaries of the **Director**, **Producer**, and the leading actors. These are typically the most expensive items in the budget. Opposite of **below the line** costs. 2. A term used to describe a credit position that is listed near the top of the credit list hierarchy of a **film**, such as being listed among the principal actors and the Director.

A/B printing A **printing** method that allows multiple rolls of original **film** to be invisibly **splice**d together. **Shot**s from the **negative** or **positive** are alternated between each **roll** with **black leader** so that the shots on one roll correspond with the black leader on the other roll. Every other shot on the **A roll** and **B roll** is then printed in consecutive order. In some cases, a C roll and D roll might be used for additional effects. See also **checkerboard cutting**, invisible splice, **cue mark**, *and image on previous page.*

A/B rolls The **roll**s of **film** or **video** used in **A/B printing**. *See image on previous page.*

absolute address A location in **computer memory** or a **peripheral device** that is not referenced to another **address**. Opposite of **relative address**.

absolute coordinates See **absolute location**.

absolute location The location, expressed as **coordinate**s, of an **object** relative to the **origin** of its **coordinate system**. Also called **absolute coordinates**. See also **relative coordinates**, **absolute value**.

absolute path The location of a **file** relative to the **root directory**. The **path** begins at the **root** of the **file system** and works down the **directory tree** to locate the requested file. When a file is moved to a new location on the **disk**, any **application**s that were referenced to that file will not be able to find it, and as a result, the new absolute path will have to be updated within each application. See also **relative path**.

absolute pathname See **absolute path**.

absolute rotation The **rotation** of an **object** relative to the **origin** of its **coordinate system**. Opposite of **relative rotation**. See also **absolute transformation**, **absolute location**, **absolute translation**, **absolute scale**.

absolute scale To **scale** an **object** relative to the **origin** of its **coordinate system**. Opposite of **relative scale**. See also **absolute transformation**, **absolute location**, **absolute translation**.

absolute transformation A **transformation matrix** that **position**s an **object** to an **absolute location** within the **coordinate system** in terms of **translation**, **rotation**, **scale**, or any other **transformation**s that have been applied. For example, if an **absolute translation** is entered for an object, it will be moved by the specified amount on each **axis** relative to the **origin** of the world. So, if the **world origin** is at (0, 0, 0), and an object whose current position in **3D space** was (4, –15, 12) received an absolute translation value of (30, 57, 100), the object's new position would be (30, 57, 100). Unlike **relative transformation**s, absolute transformations do not take into consideration the current position of the object. See also **absolute rotation**, **absolute scale**.

absolute translation The **translation** of an **object** relative to the **origin** of its **coordinate system**. Opposite of **relative translation**. See also **absolute transformation**, **absolute location**, **absolute rotation**, **absolute scale**.

absolute value 1. See **absolute location**. 2. The absolute value of a negative number is its positive counterpart. For example, the absolute value of negative 8 (–8) would be 8.

absolute vector Any **vector** whose **end point**s are defined in **absolute coordinate**s. See **relative vector**.

A-buffer Abbreviation for **accumulation buffer**. The A-buffer is used to create an **image** by accumulating and merging several images together. It is often used with **hardware rendering** techniques to produce **anti-aliasing**.

A-buffer rendering See **A-buffer**.

A/B wind A/B wind refers to the position of the **film emulsion** relative to the center of the wound-up **film**. The emulsion faces inward toward the center of an A-wind, while the emulsion of a B-wind faces outward away from the center of the **roll**. A-wind film is more commonly used for **release prints**, while B-wind film is generally used for **negative**.

AC Abbreviation for **Assistant Cameraman (AC)**.

Academy 1. See **Academy standards**. 2. See **Academy aperture**. 3. See **Academy of Motion Picture Arts and Sciences (AMPAS)**.

Academy aperture A standard **35mm film format** whose **image** area and its center are positioned to the right of center on the **negative** to allow for the narrow band reserved for the **sound track**. Academy aperture is usually masked on the **release print** or during **projection** to an **aspect ratio** of **1.85**. The aspect ratio of the image area **capture**d is 1.37, and the typical working **image resolution** is 1828 × 1332 before any 1.85 masking occurs. The image area actually captured on **film** is equal to .864″ × .63″. Also called **Full Academy Aperture, standard 35mm**. See also **full aperture, Super 35**, *images under film extraction*, *Vista Vision*.

Academy Award The gold statuette given as the prize to **film** artists and technicians for the highest achievement in the various categories of **film-making** by the **Academy of Motion Picture Arts and Sciences (AMPAS)**. Also called the **Oscar**.

Academy Awards The annual awards given to the **film** artists and technicians by the **Academy of Motion Picture Arts and Sciences (AMPAS)** for recognition of their work in their various areas of specialty. Within the **visual effects (VFX)** industry, the category for the best visual effects is the most coveted award. With the development of new technologies for the creation of visual effects, the technical achievement award has also become highly prized.

Academy leader The standardized length of **film** attached by the **lab** at the **head** and **tail** of **release print**s that meets the standards specified by the **Academy of Motion Picture Arts and Sciences (AMPAS)**. The leader contains a countdown running from 8 to a single **frame** of 2, which is ac-

companied by a pop on the **sound track**, for use by the lab in audio lineup and later to signal the **Projectionist** to the start of the film. Sometimes referred to as **full Academy leader**. See also **Universal leader**.

Academy mask An **overlay** used to **mask** a portion of an **image**, **camera**, or **projector** to **display** the images with the standard **Academy aperture** format. See also **Academy leader**, **Academy standards**.

Academy of Motion Picture Arts and Sciences (AMPAS) The professional organization that includes branches for almost every area of filmmaking and encourages continued artistic and technical research and development in the industry. The Academy, which was organized in 1927, began with only 26 members, and has grown to over 6,000 members, with membership by invitation only.

Academy of Motion Picture Sound (AMPS) An organization that promotes and encourages the continued creative and technical development of all aspects of **sound** recording and reproduction for **film**.

Academy standards The technical requirements established by the **Academy of Motion Picture Arts and Sciences (AMPAS)** in order to enforce global standards across the **film industry**.

accelerated motion See **fast motion**.

accelerator 1. Any combination of keystrokes used as a substitute for the equivalent **mouse command**. 2. See **accelerator board**.

accelerator board A special **circuit board** that replaces the **central processing unit (CPU)** of a **computer** with a faster one.

accelerator card A special **circuit board** that plugs into one of the **expansion slot**s of a **computer** to make it run faster. See also **graphics accelerator card**.

access To use a **computer** resource.

access code See **password**.

access denied A message that sometimes appears when access is denied to a requested **file**. Access might be denied because the file is currently in use or because use of that file is restricted to specific **user**s. See also **permission mask**.

access privileges To have approved access to **log in** to a **computer**. See **login account**, **password**.

accessory See **peripheral device**.

Accom 1. The company that designs, manufactures, sells, and supports a line of **digital** audio and **video** products. 2. A **Digital Disk Recorder (DDR)** used for **image** recording and **real-time playback**.

account See **login account**.

accumulation buffer See **A-buffer**.

ACE Abbreviation for **American Cinema Editors (ACE)**.

acetate base The **film base** on which the light-sensitive photographic **emulsion** is placed. **Acetate-based films** are relatively fire resistant and chemically stable compared to their earlier **nitrate-based** counterparts, which were highly combustible and deteriorated rapidly over time.

acetate-based film Any **film stock** containing an **acetate base**. See **nitrate-based film**.

acetate cel See **animation cel**.

acetate film An **acetate-based film** that is fire resistant. Also called **safety film**.

acetate sheet See **animation cel**.

achromatic An **image** without **color**. Neutral colors that are **desaturated** and have a low **chroma** are achromatic. These colors can be described as dull and muted, and generally are made up of just shades of gray.

ACM Abbreviation for **Association for Computing Machinery (ACM)**.

Acmade The machine that prints **Acmade code** onto **film**. See **edge numbers**.

Acmade code The code printed on a **dailies** roll of **film**, assigned by the **Editorial Department**.

ACM SIGGRAPH See **SIGGRAPH**.

acquisition format A term used to describe the **film format** used to **capture** the **image**s. For example, **Cinemascope** and **Super 35** are often used to capture images when the desired delivery format is **2.35:1**.

Acrobat A **program**, from **Adobe Systems, Inc.**, that reads and converts documents to the **portable document format (PDF)**. PDF files are a **platform independent** means of reading and printing documents.

Acrobat reader See **Acrobat**.

action 1. The command called by the **Director**, after the **camera** reaches **speed**, to indicate to the **Crew** and actors the start of a **take**. Opposite of **cut**. 2. The movement of the actors or **object**s in front of the camera.

action axis The action axis is the imaginary line drawn at a 180-degree angle between the **subject** and their line of travel relative to the position of the **camera**. In order to maintain **directional continuity**, the camera must remain on the same side of the action axis between **shot**s.

action safe See **safe action**.

action still A single **image** taken directly from the **film negative** for use in publicity. See also **production still**.

active An option becomes active when it is **click**ed on. An active option will generally be denoted with a small red check mark or an X, whereas an **inactive** option will not. See also **check box**.

active bodies See **active rigid bodies**.

active region The portion of a **video signal** that is used for actual **image** information, as opposed to the area reserved for **closed-captioning** and **time code**.

active rigid bodies **Rigid body objects** that react to **dynamics**, as opposed to **passive rigid bodies** that act only as **collision object**s for active bodies.

active window The **window** currently in use on a **graphical user interface (GUI)**. A window is made **active** by **click**ing or **point**ing the **cursor** in it with a **mouse** or **stylus**. Once a window is active, it appears in front of any other open windows on the **screen**, and the **user** can type, draw, or perform any function provided by the particular **application** that created that window. Typically, only one window can be active at a time.

actual footage In most cases, this refers to the amount of **footage** that must be hand drawn or digitally **animate**d in a **scene** and will be less than or equal to **screen footage**. However, if the scene is 96 **frame**s or 6 **feet** $(16 \times 6 = 96)$, but the **animation** is 4 repetitions of a 24-frame **cycle**, then the actual footage would be only 24 frames or 1 foot, 8 frames $(16 + 8)$. See also **film footage**, **feet+frames**.

AD Abbreviation for **Assistant Director (AD)**.

adaptive subdivision A sophisticated **polygonal subdivision** technique that takes advantage of the fact that **flat surface**s require far fewer **polygon**s than do **curved surface**s for accurate representation. The number of polygons used in adaptive subdivision is entirely dependent on the curvature of the **surface** being converted for **rendering**.

A/D converter Abbreviation for **analog to digital converter (A/D converter)**.

add 1. For **compositing**, see **addition operation**. 2. A standard **arithmetic operator**. 3. For **Boolean operation**s, see **union operation**.

addition See **addition operation**.

additional camera Any extra **camera** used to **shoot** complex **stunt**s or action **scene**s.

additional photography A term used to describe the **shooting** of additional **scene**s or the reshooting of particular scenes due to a negative reaction from **Filmmakers**, **studio** executives, or **focus group**s to work already **shot**. Also called **pickups**, **reshoots**, or **pickup shots**.

addition operation 1. A **compositing operation** that adds a **constant value** to each **pixel** in a single **image** or adds together the pixels of two images. If working with **normalized value**s, any resulting **RGB values** greater than 1 are **clamp**ed to a **value** of 1. However, many **compositing package**s offer the ability to specify a **clamping value** of greater than or less than 1. Opposite of **difference operation**. 2. For **Boolean operation**s, see **union operation**.

additive color model A **color model** in which adding equal amounts of the **primary colors**—red **(R)**, green **(G)**, and blue **(B)**—creates **white**. Additive color models are used with **CRT monitor**s and **RGB image**s. Opposite of **subtractive color model**. See **RGB color model**, *Color Plate 3.*

additive colors See **additive primary colors**.

additive primaries See **additive primary colors**.

additive primary colors The three additive primary colors are **red (R)**, **green (G)**, and **blue (B)**. Almost all **color**s can be created by adding these colors together. **White** is the result of these colors mixed together in equal amounts. See **additive color model**, **subtractive primary colors**.

addmix A **compositing operation** that **composite**s a **foreground element** over a **background element** based on **curves** from both **element**s that control how the **foreground alpha** is used to multiply the two **image**s before **add**ing them together.

add operation See **addition operation**.

address 1. The location where **data** is stored on a computer **disk**, **peripheral device**, or in **computer memory (RAM)**. Also referred to as the **location**. 2. See **Internet address**. 3. See **electronic mail address (e-mail address)**.

address track A track on a **videotape** specifically reserved for **time code**. See **longitudinal time code (LTC)**.

address track time code See **longitudinal time code (LTC)**.

adjacent polygons **Polygon**s that share common **edges**. **Smooth shading** can then be achieved across **polygonal surface**s by using **averaged normal**s.

Admin See **System Administrator**.

Administrator See **System Administrator**.

ADO Abbreviation for **Ampex Digital Optics (ADO)**.

Adobe Acrobat See **Acrobat**.

Adobe Illustrator A drawing **software** developed by **Adobe Systems, Inc.** for **Macintosh** and **Windows**.

Adobe Systems, Inc. A pioneering company that developed **portable document format (PDF)**, **Acrobat**, **Photoshop**, **After Effects**, and **Illustrator**, to name just a few.

Adobe Systems PostScript Page Description Language A **page description language (PDL)** implemented in its current form by **Adobe Systems, Inc.** in 1982. See also **PostScript**.

ADR Abbreviation for **Automatic Dialogue Replacement (ADR)**.

ADR editing See **Automatic Dialogue Replacement (ADR)**.

ADR Editor See **Automatic Dialogue Replacement Editor (ADR Editor)**.

ADR Mixer See **Automatic Dialogue Replacement Editor (ADR Editor)**.

ADSL Abbreviation for **Asymmetric Digital Subscriber Line (ADSL)**.

advance The distance between the **sound track** and the **image area** on **film** or a **projector**.

advance screening See **preview**—Definition #2.

Advanced Interactive Executive (AIX) A **Unix**-like **operating system (OS)** designed for use on IBM workstations.

advanced television (ATV) One of many systems proposed for the new **digital** television standards. See also **high definition television (HDTV)**, **digital television (DTV)**.

aerial Shorthand for **aerial shot**.

aerial perspective See **atmospheric perspective**.

aerial shot Any extreme **high-angle shot** filmed from a high vantage point, such as a plane or mountain, to depict a vast area from a long distance.

affine Linear **geometric transformation**s including **pan**, **rotate**, **scale**, and **shear**.

After Effects A **compositing package** owned by **Adobe Systems, Inc.** for **Macintosh** and **Windows**.

AGC Abbreviation for **Automatic Gain Control (AGC)**.

age See **particle age**.

aggregate object An **object** made up of multiple **primitive**s.

AI Abbreviation for **artificial intelligence (AI)**.

AIFF Abbreviation for **Audio Interchange File Format (AIFF)**.

aim constraint A type of **constraint** used to orient the **axis** of one **node** in the direction of another node.

aims Shorthand for **lab aims densities (LAD)**.

aims girl See **LAD girl**.

airbrush A type of **digital paintbrush** available in **paint package**s that mimics traditional airbrush techniques.

AIX Abbreviation for **Advanced Interactive Executive (AIX)**.

AL Abbreviation for **artificial life (AL)**.

alert box See **error dialog**.

alert message See **error message**.

algorithm A mathematical **expression** or **procedure** following a precise set of rules that specify how to solve a problem. It frequently involves many repetitions of a particular **operation**. See also **rendering algorithm**, **shading algorithm**.

alias 1. A **user-defined** abbreviation, usually short and easy to remember, of the longer keyboard **command**. These aliases are usually stored in a **dot file** in the **home account** of each **user** and are **source**d into **computer memory** at the time of **login**. Each time the **computer** receives one of these aliased commands, its **command interpreter** expands it out to its full **syntax** without needing to reference any file. For example, a common alias used in **Unix** for the command "history" is simply "h." 2. See **aliasing**.

Alias A **3D software package** that has, for the most part, been replaced by **Maya**. See **Alias/Wavefront**.

aliasing The jagged **artifact**s, sometimes referred to as **jaggies** or **stairstepping**, seen in the diagonal and curved **edge**s of an **image** when displayed on a **digital device** with a limited number of **pixel**s. For example, if viewing a **black and white** image on a **display** that cannot show intermediate levels of gray, then a pixel will be completely **black** if it falls within a black area and completely **white** if it falls within a white area. With **anti-aliasing** applied, the jagged edges can be removed by calculating and inserting an intermediate shade of gray between adjacent pixels to give smoother **transition** of **value**s to the display. The term aliasing is also used in a more global sense to describe any type of **sampling** artifact, such as **wagon wheeling** and **strobing**.

Alias/Wavefront The company responsible for manufacturing a large variety of **2D** and **3D software package**s, such as **Maya** and **Composer**. For years, the two companies, Alias Research Inc. and Wavefront Technologies, were competitors until their merger in 1995.

alignment tone See **reference tone**.

alpha 1. Shorthand for **alpha channel**. 2. Shorthand for **alpha software**.

alpha channel **Digital image**s typically store their information in four **channels—red (R)**, **green (G)**, **blue (B)**, and the alpha, or **matte channel**. The alpha channel is a **grayscale image** that describes the **opacity** of the corresponding **color channel**s with **black** being completely **transparent** and **white** being completely **opaque**. When **compositing** the **foreground** image **over** another image, it is the gray **value**s of the alpha channel that determine what percentage of the color channels appear over the **background** image. *See also Color Plates 12, 19, 23–25, and image under* **erode**.

alpha component See **alpha channel**.

alpha copy 1. An **image operation** in which the **alpha channel** of one **image** is copied into the alpha channel of another. Also called **switch matte**. See also **channel swapping**. 2. See **alpha software**.

alphanumeric See **alphanumeric characters**.

alphanumeric characters Alphanumeric characters consist of only the letters A–Z and digits 0–9.

alpha release The official release of **alpha software**. See also **beta release**.

alpha software A very early prerelease **version** of **software** that precedes the **beta release**. Alpha software is often only **release**d for **in-house** testing, although some **vendor**s will send copies out to their longtime **user**s for testing and feedback.

alpha version See **alpha software**.

alphaware See **alpha software**.

alternating triangles A method of connecting the **point**s that make up a **polygon mesh**, in which each connecting triangle is oriented in the opposite direction of its surrounding **triangles**. See also **rows and columns**, **quadrilateral**s, **polygon detail**.

Amazon Paint A **paint software** developed and sold by Interactive Effects, Inc.

ambient 1. See **ambient color**. 2. See **ambient light source**, *image under diffuse*.

ambient coefficient See **ambient component**.

ambient color The **color** of an **object** in response to **ambient light**. See also **diffuse color**, **specular color**.

ambient component The amount of **ambient light** striking a **surface**. See also **diffuseness**, **specularity**.

ambient light 1. For **computer graphics (CG)**, a directionless **light source** that uniformly distributes **light** in all directions, and all **object**s are equally illuminated regardless of their orientation. Ambient light sources are often used to simulate the indirect illumination of light bounced off of other objects in the **environment** that we see in the real world. The need for ambient light is removed when using **radiosity**, as it computes the actual **light bounce** between objects. See also **directional light**, **spotlight**, **area light**, **point light**, **volume light**. 2. For **film**, the available light completely surrounding the **subject**, such as light already existing in the indoor or outdoor setting that is not created by additional lights.

ambient light source See **ambient light**.

ambient reflection **Reflection**s striking a **surface** that are a result of an **ambient light source**.

ambient value See **ambient component**.

American Cinema Editors (ACE) The professional society for **film** and television **Editor**s. Membership is by invitation only.

American Cinematographer Manual A manual, published by the **American Society of Cinematographers (ASC)**, that is considered to be the industry "Bible" for **Cinematographer**s, as well as anyone involved in the field. It contains information about **camera**s, **lighting**, **filter**s, **film speed** tables, and most other elements of **cinematography**.

American National Standards Institute (ANSI) ANSI is an organization that produces documents defining information standards for **input** and **output** interfaces. For example, this group sets the **ASA rating**s for **film**, and **ASCII** is an **ANSI character set**. ANSI, which was formerly named the **American Standards Association (ASA)**, is the American division of the **International Standards Organization (ISO)**. See also **Deutsche Industrie Norm (DIN)**.

American Society of Cinematographers (ASC) The nonprofit organization dedicated to the continued advancement of the art of **cinematography** through technical and artistic growth. The society publishes the *American Cinematographer Manual* and the monthly magazine *American Cinematographer*. See also **British Society of Cinematographers (BSC)**, **Canadian Society of Cinematographers (CSC)**.

American Standard Code for Information Interchange (ASCII) ASCII is a 7-**bit** code used for information exchange between **computer**s. In general, the term ASCII refers to any **data** that is stored as a **text file** and does not require a **decoder** for reading. See also **ASCII characters**, **ASCII file**, **ASCII Table**.

American Standards Association (ASA) The former name of the committee now known as the **American National Standards Institute (ANSI)**.

American wide-screen Referring to a standard **film format**, common in the United States, that uses an **aspect ratio** of **1.85:1**. See also **European wide-screen**.

Amiga A line of **personal computer**s that uses extra **microprocessor**s for handling **graphics** and **sound** generation.

AMPAS Abbreviation for **Academy of Motion Picture Arts and Sciences (AMPAS)**.

Ampex Corporation The company that manufactures **digital** and electronic **image** storing products such as the **ADO**, **D2 video format**, and **DST** data storage.

Ampex Digital Optics (ADO) A **hardware**-based **video** effects system manufactured and sold by **Ampex**.

amplitude The maximum distance between the waves of a periodic **curve** along the **vertical axis**. See also **frequency**, **phase**.

AMPS Abbreviation for **Academy of Motion Picture Sound (AMPS)**.

anaglyph A **stereo image** that requires the use of **anaglyph glasses**.

anaglyph glasses A type of **3D glasses** that uses two different lens **color**s, usually **red (R)** and **blue (B)**, to control the **image**s that are seen by each eye in a **stereo film**. See also **flicker glasses, polarized glasses**.

analog **Data** that is composed of continually varying electronic **signal**s. Unlike **digital** information, which is either on or off, analog information is represented by continuous change and flow, such as current or voltage. Sometimes spelled **analogue**.

analog computer Any **computer** that **process**es **data** with **analog** methods. An analog computer operates from data that is represented by directly measurable quantities, such as voltage or current. See **digital computer**.

analog data Any **data** represented in an **analog** form. Opposite of **digital data**.

analog monitor A **monitor** that can display **analog signal**s, such as **composite video**.

analog signal The continuously variable electronic **signal**s that make up **analog data**. See **digital signal**s.

analog to digital conversion The process of converting an **analog signal** into a **digital** form. See **analog to digital converter (A/D converter)**.

analog to digital converter (A/D converter) A **device** that converts an **analog signal** into its **digital** representation by taking **sample**s of that **signal** at a fixed time interval, or **sampling rate**. The higher this sampling rate, the better the quality of the signal and, therefore, the more accurate the reconstruction of the original analog signal into its digital form. See also **Digital to Analog Converter (DAC)**.

analog sound A **sound track** that is composed of recorded electronic **signal**s that are converted into **sound** signals. See **digital sound**.

analogue Another spelling for **analog**.

analog video Analog video records visual information as a series of continuous **analog signal**s onto magnetically charged **videotape** that, when played back through proper **video** equipment, appear as moving **image**s. Analog **video** read from **videotape** is subject to **image degradation** due to noise distortion, whereas a **digital video** is represented as unique and well-defined **sample**s. Information stored as analog video can only be accessed using **sequential access**.

anamorphic A **wide-screen** film format that horizontally squeezes the **image area** captured on the **negative** during photography by using an

A **circle** as it will be **project**ed with an **anamorphic lens** and the same circle as it was captured during **filming**.

anamorphic lens. At the time of **projection**, the image is **unsqueezed** by the inverse amount to make it look "normal" again. The actual size of the image area **capture**d on **film** is equal to .838″ × .7″. For 35mm **feature film** work, the standard anamorphic format is most often projected with a 2.35:1 **aspect ratio**. **Cinemascope** is the tradename of an anamorphic technique. See also **Techniscope**, **Superscope**, *Color Plate 28, and image above.*

anamorphic image Any distorted **image** that can be restored to its original, undistorted **format**. See **anamorphic**.

anamorphic lens A special **lens** that squeezes the original **image** by changing its **height**-to-**width** ratio. The most commonly used anamorphic lenses compress the **horizontal** image width by 50 percent. Opposite of **spherical lens**. See also **Cinemascope, normal lens, auxiliary lens, zoom lens, telephoto lens**.

anamorphic lens flare Any **lens flare** that is **film**ed using an **anamorphic lens**. See also **spherical lens flare, CG lens flare**, *Color Plates 27–29*.

anamorphic projection See **anamorphic format**.

anamorphic widescreen format See **anamorphic format**.

ancestor Any **node** in a **hierarchy** that is above another node. See **parent**.

anchor See **root**—Definition #1.

AND See **AND operator**.

AND operator 1. For **compositing**, see **plus operation**. 2. One of the **Boolean operator**s. See **intersection operation**.

angle The **camera**-to-**subject** relationship in a **shot**.

angle of incidence The angle at which a **light ray** intersects the **surface** of an **object**. This is used to calculate the intensity of **light** striking a surface. The larger the angle of incidence, ranging from 0 to 90 degrees, the stronger the **specular component** relative to the **camera view**.

angle of view See **field of view (FOV)**.

angle-plus-angle shot A **shot** in which the **camera** is tilted either upward or downward relative to the **subject**. Angle-plus-angle shots create the strongest dimensional effect and eliminate the **2D** flatness of straight-on shots.

angular units The **units** used to define **rotation**s, such as **degree**s or **radian**s.

animate The process of creating **animation**.

animated Any characteristics, or **attribute**s, that change over time are referred to as "animated."

animated reveal See **reveal matte**.

animated texture A **texture map** that is sequentially replaced with a new **image** for each **frame** that is **render**ed.

animated wipe See **wipe transition**.

animatic A rough **animation** created to give a sense about the timing and **motion** of a **shot** or **sequence**. An animatic can range in complexity from a sequence of edited **storyboard**s to a full **3D** representation of the **scene**s. Animatics often include rough music and sound effects to help get a sense of the work before it goes into **production**. An animatic created in **computer graphics (CG)** is often referred to as **previsualization**. Also called a **leica reel**.

animation Animation is the process of "giving life" to a **sequence** of still **image**s that represent the illusion of **motion** over time. When a sequence of images is played back quickly enough, our eyes perceive them as in continuous motion. See **computer animation**, **stop motion animation**, **cel animation**, *Color Plates 47, 56, 57, 61–63, 67*.

animation camera A **camera** designed for **frame**-by-frame **photography** on an **animation stand**. The animation camera can be moved vertically to change the size of the **image**s or to create the illusion of a **zoom**, while the table can be **translate**d along the **X**- and **Y**-axes and **rotate**d along the **Z**-axis.

animation cel The clear acetate sheets onto which the different **layer**s of a **scene** are hand-drawn to produce **cel animation**. For example, one **cel** might be the **background (BG)**, while another might be a **character** walking across that background. Cel animation is produced by placing the transparent layers on top of each other and photographing them **frame** by frame. However, it should be noted that the background layer used in cel animation might also be created on paper or as a **digital image** over which all the other cels are layered. *See Color Plate 32.*

animation compress See **time warp**.

animation curve The **graphical representation** of the animated **parameter**s of an **object**, **camera**, or **light**.

animation cycle A **sequence** of drawings or **image**s that can be seamlessly played back by placing the first **frame** immediately after the last to suggest continuous action. Also called a **motion cycle**, **cycle**.

animation dailies **Dailies** shown specifically to the **character animation** team to review the latest round of **motion** in the **shot**s. Also called **motion dailies**. However, for a small **show** or **facility**, dailies are often grouped into one global **screening** for all types of artists working on the **project**. See also **lighting dailies**, **effects dailies**, **stage dailies**.

Animation Department See **Character Animation Department**.

Animation Director The Animation Director is responsible for developing and supervising the behavior and **motion** of all **animate**d characters that appear in the **film**. The scope of the **character animation** for the **project** will generally determine whether the Animation Director works for or is placed on the same level within the **show hierarchy** as the **Visual Effects Supervisor (VFX Sup)**. See also **Animation Supervisor**.

animation expand See **time warp**.

animation footage The amount of **footage** in a **scene** that needs to be **animated**. **Cel animated feature**s and, in some cases, **full CG feature**s track the length of a scene in terms of **feet+frames**. Also referred to as **scene footage**. See also **film footage**.

animation hierarchy The arrangement of levels from the **root node** down through the entire **hierarchy** that describes the **animation** controls and relationships for a group of **object**s.

Animation Lead For larger **project**s, a number of Animation Leads might be assigned to oversee the behavior and **motion** of the characters in a particular **sequence** or for an individual **character** across the entire **film**. Depending on the size of the project, the Animation Lead reports to the **Animation Supervisor** and/or the **Animation Director**.

animation module The portion of a **3D software package** used to create and modify **animation**.

animation package 1. Referring to the specific **software package** used for **animation**, such as **Maya**, **Houdini**, **Softimage**, **Lightwave**, or **3D Studio Max**. 2. A term used to describe a complete **station ID** in **broadcast graphics**. It is generally composed of a series of news, sports, and movie opens and **logo IDs** as a means of presenting a distinct and easily identifiable look and feel to the **viewer** for a particular television station.

animation parameter Any **attribute** that can be animated over time, such as **XYZ translation**, **rotation**, **scale**, **color**, **reflectivity**, or **transparency**.

animation replacement A technique in which an **Animator** copies the **animation** from one **character** to another character with the same **hierarchy**. This technique is often used in **crowd simulation** where the same animation can be applied to different but similar **model**s. See also **geometry replacement**.

animation scale See **time warp**.

animation setup See **character setup**.

Animation Setup Supervisor See **Character Setup Supervisor**.

Animation Setup TD Abbreviation for **Animation Setup Technical Director (Animation Setup TD)**. See **Character Setup Technical Director (Character Setup TD)**.

Animation Setup Technical Director (Animation Setup TD) See **Character Setup Technical Director (Character Setup TD)**.

animation software A **software application** specifically designed to allow the **user** to **setup** and **animate** objects in **3D space**. Popular packages used for **animation** include **Maya**, **Houdini**, **Softimage**, **Lightwave**, and **3D Studio Max**. See also **animation package**, **modeling software**, **lighting software**, **compositing software**, **paint software**, **particle software**, **render software**, **tracking software**.

animation stand The **device** designed to hold and control the movement of **flat artwork** for the **camera** that photographs them **frame** by frame. For **cel animation**, each **cel** is held in place by pegs on the table to precisely position them. See also **animation camera**.

animation stretch See **time warp**.

Animation Supervisor Technically, the job of the Animation Supervisor is very similar to that of the **Animation Director**. Like all job descriptions, the role of the Animation Supervisor can change dramatically from **show** to show. If the show has an Animation Director, the Animation Supervisor reports to him or her and will most likely be responsible for supervising the animation of the characters based on the vision of the Animation Director. In the absence of the Animation Director, the Animation Supervisor reports to the **Visual Effects Supervisor (VFX Sup)** and is responsible for all the **Digital Character**s in the show.

Animation TD Abbreviation for **Animation Technical Director (Animation TD)**. See **Character Setup Technical Director (Character Setup TD)**.

Animation Technical Director See **Character Setup Technical Director (Character Setup TD)**.

Animator This is a very broad term with different meanings depending on the **facility**. In general, an Animator is any artist who creates **animation**. An Animator draws individual **frame**s by hand for **cel animation**, manipu-

lates the **model**s in **stop motion animation**, and creates **key frame**s that **interpolate** over **time** in **computer animation**. See also **CG Animator**, **Character Animator**.

animatronic A **puppet** whose **motion** is brought to life through remote control, cable control, **computer** control, or hand puppetry. See also **servo**.

Anime A Japanese **animation** style whose roots originated from Japanese comic books. Anime covers a wide variety of subject matter and is most often characterized outside of Japan as science fiction and fantasy **film**s with adult themes.

Animo A **2D software package**, developed by Cambridge Animation, that is used for **cel animation**.

anisotropic Having properties that differ based on the direction of measurement. Opposite of **isotropic**.

ANN Abbreviation for **artificial neural network (ANN)**. See **neural network (NN)**.

answer print The first **print** from the **lab** containing synchronized **image** and **sound** that has been **color balance**d to accommodate all the **scene**s. More often than not, this first print, also called the **first answer print**, needs further adjustments and is followed by a **second answer print**, **third answer print**, and so on before it is accepted as final and the **release print**s can be made. Also called an **approval print**.

ANSI Abbreviation for **American National Standards Institute (ANSI)**.

ANSI Character Set See **ASCII characters**.

anti-aliasing A **rendering** technique used to make jagged **edge**s, referred to as **jaggies** or **stairstepping**, appear smoother by inserting **pixel**s of an intermediate **color** between adjacent pixels with abrupt edges.

anticipation A classic **character animation** technique used to simulate an anticipation of **motion** in a **character** in which a brief action in the opposite direction precedes and foreshadows the main action.

anti-glare screen A specially designed **screen** that is attached to the front of the **computer** screen to reduce glare.

anti-halation backing The dark gelatin coating used on the back of **unexposed film stock** in order to reduce **halation** by absorbing any **light** that might pass through the **emulsion**.

anti-virus program Any **program** that detects and removes **computer virus**es.

anti-virus software See **anti-virus program**.

aperture The measurement of the opening in a **viewing device**, such as a **camera**, **printer**, or **projector**, that controls the amount of **light** that is allowed to reach the **film**. Aperture size is typically calculated in **f-stop** values where the larger the number, the smaller the aperture opening. See **camera aperture**, **picture aperture**, **printer aperture**, **projector aperture**.

aperture plate The metal plate placed in front of the **film** inside the **camera** that contains an opening defining the size of the **frame**.

API Abbreviation for **Application Program Interface (API)**.

APM Abbreviation for **Assistant Production Manager (APM)**.

apparent motion The natural ability of the eye to perceive **motion** in a series of **image**s that are played back quickly enough. Also called **stroboscopic motion**, **phi phenomenon**. See also **persistence of vision**.

Apple See **Apple Computer, Inc.**

apple box A small wooden box, used on **set**, to raise equipment or for actors or **Crew** members to stand on when they need to get some extra height. There are also **half apple**s and **quarter apple**s that are one-half and one-quarter as thick as a regular apple box.

Apple Computer, Inc. The company founded by Steve Jobs and Steve Wozniak that manufactures the **Macintosh** range of **personal computer**s (**PC**s).

applet A little **application**. Many applets are written in **Java** to produce **HTML document**s for use on the **World Wide Web (WWW)**. See **Java applet**.

application See **software application**.

application program See **software application**.

Application Program Interface (API) An API provides an **interface** between the **operating system (OS)** and **application program**s. It is a set of building blocks, made up of **routine**s, **protocol**s, and various tools that allow **Programmer**s to write consistent **application**s within that particular environment. See also **software developers kit (SDK)**.

Apprentice Editor The individual who works with and assists the **Second Assistant Editor (AE)**.

approval print See **answer print**.

approximating curve See **approximating spline**.

approximating spline A **spline** that calculates a smooth **curve** without necessarily passing directly through any of its **control points**. **B-spline** and

Bézier curves are examples of approximating splines. Unlike an **interpolating spline**, an advantage of this type of spline is that it allows for a wide margin of error in **user** placement of each control point while still producing a smoothly **interpolated** curve.

approximation The process of calculating an inexact result. 1. See **geometric approximation**. 2. See **polygonal approximation**. 3. See **linear approximation**.

architecture The overall design and structure of the **hardware** and **software** that make up a **computer system** or complex **software package**.

archive 1. A copy of **computer data** that is stored separately from the original and used in the event of a failure or loss of the original. Typically, the data from an entire **project** is backed up twice before removing it from on-line **storage device**s for later use if the project should come back for changes or for use as an asset in the **library** of **data** that each **facility** builds up over time. 2. A temporary and periodic backup of data that is stored on **tape**s that will be recycled again for future backups. Many facilities perform automatic daily or weekly backups of all the data on their **computer disk**s. Also referred to as **backup, dump**. See also **incremental backup**.

archival backup See **archive**.

area light See **area light source**.

area light source A **light source** whose **light** is emitted from a rectangular or ellipsoidal area rather than from a single **point**. Fluorescent lights are a good example of an area light. See also **point sight, spotlight, directional light, ambient light**.

arena The total amount of **memory** that has ever been allocated to run a **process**. The arena size will never decrease even though the process might release portions of **random access memory (RAM)** during execution. The arena either remains constant or grows as more memory is allocated to the process.

arg Shorthand for **argument**. See **parameter**.

argument See **parameter**.

argument list The list of **parameter**s fed into a **program**.

arithmetic operator The standard **operator**s used in **programming**, such as **add** (+), **subtract** (−), **multiply** (*), and **divide** (/). See also **Boolean operator**s, **logical operators**.

armature The skeletal framework inside a **stop-motion puppet** used to control various kinds of **motion**. See also **stop-motion animation**.

armature wire Any wire used for support of **armature**s.

A roll See **A/B rolls**.

array A rectangular organization of **data** in **rows and columns**. The **val-ue**s of an array are a convenient means of storing data that a **program** needs to access in an unpredictable order. A **zero-dimensional array** consists of a single **variable** and is called a **scalar**, a **one-dimensional array** is called a **vector**, and a **two-dimensional array**, or greater, is called a **matrix**. The number of **dimension**s in an array may be limited by the **programming language** it is being used with, but it is not dependent on it.

array of dots A **digital image** is represented by **pixel**s, the smallest individual units of an **image** element, and can be defined as an **array** of dots that make up the whole of the image.

Arri 1. Abbreviation for Arnold & Richter. A company based in Munich, Germany, that developed the line of professional **film camera**s. See also **Panavision**. 2. Abbreviation for the **Arriflex Camera**.

Arriflex Camera The trade name for a brand of professional **film camera**s manufactured by **Arri**.

ArriLaser film recorder A **laser film recorder** from **Arri** that uses solid state **diode laser**s to convert **digital image**s onto **film**. Unlike the **gas laser**s used by other recorders, such as the **Lux laser film recorder** and the **Lightning II laser film recorder**, the three **red (R)**, **green (G)**, and **blue (B)** diode lasers used in the Arri recorder offer a lifespan of approximately 50,000 hours each while providing greater beam stability, lower noise levels and power consumption, and most importantly, greater temperature stability. Varying temperature fluctuations during recording can result in **beam convergence** misalignment, causing **image artifact**s such as **color fringing** at the edges of **object**s in the **image**. Also, because the recorder can expose **low-speed film**s, such as a 50 **ASA** film, within seconds, there is no quality loss due to large **film grain**. The ArriLaser recorder is about the size of a large office photocopier.

arrow 1. A **scroll bar** usually contains arrows on either end of the bar that allows the **user** to bring up more information, one line at a time, by **click**ing on one of the arrows. Information in a scroll bar can also be reviewed by using the **thumb** and the **gutter** of the bar. 2. Another name for **cursor**.

Art Department The group of artists responsible for designing and creating the visual reference for the **film**. The department is led by the **Production Designer** or **Art Director**.

Art Director The Art Director oversees the artists in the **Art Department** and is responsible for creating designs and detailed artwork that can be used to communicate the aesthetic vision of the **film** to the **Production Team**.

articulate matte A **matte** that changes **shape** and **position** over time so that it accurately conforms to the contours of the moving **image** for which it was created. These **black and white** images can then be used as the **alpha channel**s to **composite** their accompanying **element**s into a **scene**. Also called a **rotoscope matte**.

artifact 1. See **image artifact**. 2. See **motion artifact**.

artificial intelligence (AI) Artificial intelligence is a method of creating living systems based on a set of **computer** instructions or **algorithm**s designed to simulate the actions of a living being. See **neural network (NN)**.

artificial life (AL) While **artificial intelligence (AI)** attempts to simulate real-world behavior based on a complex set of rules, artificial life starts with a system of very simple rules that allows complex behavior to grow and result from them.

artificial neural network (ANN) The fancy name for **neural network (NN)**.

Artisan An integrated brush interface for "sculpting" **3D model**s and **attribute** painting within **Maya** software.

ASA Abbreviation for **American Standards Association (ASA)**.

ASA rating The standard numerical rating for specifying the speed of a **film** or its sensitivity to **light** as determined by the **American National Standards Institute (ANSI)**. A **film stock** with a low **ASA rating** is referred to as a **slow-speed film**, whereas one with a high **ASA** rating is called a **fast film** or **high-speed film**. Also called **exposure index**. See also **DIN Rating**, **ISO index**.

ASC Abbreviation for **American Society of Cinematographers (ASC)**.

ASC Manual See **American Cinematographer's Manual**.

ASCII Abbreviation for **American Standard Code for Information Interchange (ASCII)**.

ASCII art The creation of designs and patterns on a **computer** using only **ASCII characters**. ASCII art is often included in the **signature file** of a **user**.

ASCII characters A 7-**bit** code representing 128 characters including **alphanumeric character**s, punctuation marks, and **control character**s. An additional group of 128 characters, known as **extended ASCII**, can be added to the original 128 to make an extended set of 256 characters. The extended set of 128 characters is usually foreign language accents, math symbols, graphics symbols, and other special symbols.

ASCII character set See **ASCII characters**.

ASCII control characters **ASCII characters** that indicate specific formatting, such as a carriage return, tab, escape, and backspace.

ASCII file See **ASCII file format**.

ASCII file format Computer **data** containing **ASCII characters** and usually represented as a readable **text file**. Unlike a **binary file**, an ASCII file can be read and edited by a **user** using any number of available **text editors**, such as **JOT**, **VI**, and **ED**.

ASCII Table See **ASCII characters**.

ASCII text See **ASCII file format**.

A side See **A/B rolls**.

ASIFA Abbreviation for Association Internationale du Film d'Animation. See **International Animation Association (ASIFA).**

aspect Shorthand for **aspect ratio**.

aspect ratio The **ratio** of **width** to **height** of a displayed **image**. Typical aspect ratios are 1.37:1 for **Academy aperture**; **1.66:1** for **European wide-screen**; **1.85:1** for **American wide-screen**; **2.35:1** for **anamorphic**; and 2.2:1 for **70mm**. **Monitor**s generally have an aspect ratio of three vertical **unit**s by four horizontal units, or **1.33:1**. See also **pixel aspect ratio**, *images under **film extraction***.

assembler A **program** that converts **code** written in **assembly language** into **machine language**. Opposite of **disassembler**.

assembly code See **assembly language**.

assembly edit A type of **editing** in which any existing **signal**s residing on **tape** are replaced with or appended to a new signal.

assembly language A **low-level programming language** that is a close approximation to **machine language**. Because **programming** in assembly language is not **user friendly**, its **code** is usually created from a **high-level**

programming language, such as **C** or **Fortran**, that uses a clearer **syntax**. However, there are instances when the only way to make the necessary tweaks to a **program** is within the assembly **code**.

assembly program See **assembler**.

Assistant Art Director An individual who works with and assists the **Art Director**.

Assistant Cameraman (AC) The individual on the **Film Crew** who works closely with the **Cameraman** and the **Director of Photography (DP)** during **shooting**. He is responsible for maintenance of the **camera**, changing **lens**es and **magazine**s, **focus**ing and **zoom**ing during the **shot**, clapping the **slate**, and keeping **camera report**s. Also called **First Assistant Cameraman (1st AC)**, **Camera Assistant**. See also **Second Assistant Cameraman (2nd AC)**.

Assistant Camera Operator See **Assistant Cameraman (AC)**.

Assistant Chief Lighting Technician See **Best Boy**.

Assistant Director (AD) The AD is the right-hand man of the **Director** and handles many aspects of the **production**, including the scheduling and budgeting of the **shoot**, preparing the **call sheet**s, and maintaining order and management of the **Film Crew**. On larger **show**s, a Second and even a Third AD might also be employed to work with the Assistant Director. Also called the **First Assistant Director (1st AD)**.

Assistant Editor (AE) The member of the **Production Team** who is responsible for editing equipment maintenance, maintaining records of all the **film**, performing any necessary **film splice**s, and assisting the **Editor** in synchronizing **image** and **sound**. Also called **Assistant Film Editor**, **Assistant Picture Editor**, **Assistant Sound Editor**, **First Assistant Editor (1st AE)**. See also **Second Assistant Editor (2nd AE)**, **Apprentice Editor**.

Assistant Film Editor See **Assistant Editor (AE)**.

Assistant Picture Editor See **Assistant Editor (AE)**.

Assistant Production Manager (APM) The individual who works for and assists the **Production Manager (PM)**.

Assistant Sound Editor See **Assistant Editor (AE)**.

Associate Producer An individual who assists the **Producer** and **Director** in overseeing a subset of the overall **production**. For example, for a large **project**, there might be an Associate Producer who is responsible for all

budgetary and scheduling issues involved in the **visual effects work**, while another Associate Producer might be responsible for all the **location shoot**s. See also **Co-producer**, **Line Producer**, **Executive Producer (EP)**.

Associate Visual Effects Supervisor (Assoc VFX Sup) A relatively new position in which the individual is hired to assist the **Visual Effects Supervisor (VFX Sup)** with his tasks. The role has been used increasingly as a means of providing a stepping stone for the **Digital Effects Supervisor (DFX Sup)** who desires to gain enough experience to become a Visual Effects Supervisor.

Association for Computing Machinery (ACM) An organization, founded in 1947, that is the world's first educational and scientific computing society. **SIGGRAPH** is one of the many special interest groups within the ACM.

Association of Film Commissioners International An organization that assists the needs of **Filmmaker**s with **location shoot**s for **film** and television **production**.

Association of Film, Television, and Radio Artists An organization that has jurisdiction over works that can be recorded by **sound** or **picture**.

Association of Motion Picture and Television Producers A guild for **film** and television **Producer**s.

asymmetrical model A **CG Model** created asymmetrically. See **asymmetrical modeling**.

asymmetrical modeling A **modeling** technique in which an artist **model**s the entire **surface** of an **object**, as opposed to **symmetrical modeling** in which the **Modeler** creates only half of the object and then **mirror**s it around an **axis** to create the other half. Asymmetrical modeling is particularly important in the creation of believable and photoreal **facial animation**, since real creatures do not have perfectly symmetrical faces.

asymmetric digital subscriber line (ADSL) An **ANSI** standard that defines a high-speed **modem** that can **transmit** more than 6 **megabytes per second (MBPS)** of **data** over **twisted pair cable**s.

asynchronous transfer mode (ATM) A high-**bandwidth** method used to **transmit** information at very high speeds. ATM can be used on both **local area network**s **(LAN)** and **wide area network**s **(WAN)**.

AT&T Abbreviation for American Telephone and Telegraph, Inc. See **AT&T/Bell Laboratories**.

AT&T/Bell Laboratories AT&T is one of the largest telecommunications carriers in the United States, and its research and development center, Bell Laboratories, is credited with many technology breakthroughs, including the **Unix operating system (Unix OS)** and the **C** and **C++ programming language**s.

ATM Abbreviation for **asynchronous transfer mode (ATM)**.

atmosphere Any number of **depth cue**s, such as **fog**, dust, and smoke, that cause the **object**s they surround to decrease in **contrast** as they move farther away from the **camera**.

atmospheric effects **Effects**, such as smoke, fog, and dust, that are used to simulate the influence of **atmosphere** on the **object**s in the **environment**.

atmosphere perspective The natural, gradual brightening and/or softening of **object**s as they diminish into the distance due to atmospheric factors. See also **perspective**, **linear perspective**.

atop See **above operation**.

attenuation A diminishment of the strength of **light** or a **signal** over distance.

at the screen For **3D film**s, an **object** is said to be located at the **screen** if it is **position**ed at the same **depth** as the **screen plane**.

attitude The **orientation** of **geometry** relative to its **origin**.

atop operation See **above operation**.

attribute Any factors or properties that can be attached to any type of **computer graphics (CG)** element, such as an **object**, **particle**s, or **curve**s. For example, the attributes that describe the visual characteristics of a **render**ed object might include **color**, **specularity**, **reflectivity**, **transparency**, **texture**, and **roughness**, whereas the attributes attached to a **particle system** might include its **lifetime**, **emission rate**, **randomness**, and color. When the attributes of a piece of **geometry** are set, it is "stamped" with those values each time it is passed through the **renderer**. Attributes are not associated with an **image** as a whole but with the individual **element**s making up the image. Also referred to as **value**, **parameter**, **properties**.

attribute block A **block** of statements relating to the **attribute**s of an **object** in a **RenderMan** rib file.

attribute editor The **window** in which a **user** can adjust the **attribute**s of an **object**, such as its **color**, **size**, or **shape**.

ATV Abbreviation for **Advanced Television (ATV)**.

audience point of view Another name for an **objective camera angle**.

audience POV Abbreviation for **audience point of view**.

audio See **sound track**.

audio board See **audio card**.

audio card A **circuit board** inserted into a **computer** that allows the **playback** and recording of **audio**. Also referred to as an **audio board**, **sound board**, **sound card**.

audio clip A **clip** of a **sound track**.

Audio Interchange File Format (AIFF) AIFF is a standard **file format** for storing audio **data**. Typically, these files have .aiff as their **filename extension**.

audio layback See **layback**.

audio sweetening The process of adding music, narration, and **Foley** effects, as well as fixing minor problems in the **sound track**.

audio track See **sound track**.

audio video interleaved (AVI) A **file format**, similar to **MPEG** and **QuickTime**, developed by **Microsoft Corp.** for **Windows**. AVI files are typically **platform independent**.

auto assembly See **auto assembly edit**.

auto assembly edit An **editing** process in which the assembly of **image**s on **videotape** are controlled by an **edit list** on a computerized **editing system**.

Autocad A **CAD** software developed by **Autodesk, Inc.**, used for mechanical engineering and design.

Autodesk One of the largest **personal computer (PC)** software companies in the world, which manufactures a wide range of products, such as **Autocad** software for **CAD** applications and **3D Studio Max**.

autofocus A mechanical **device** in a **camera** that automatically maintains **focus** at a predefined **focal plane**.

auto login The **user** who is automatically **logged in** to the **computer** each time it is powered up.

auto login user See **auto login**.

Automatic Dialogue Replacement (ADR) ADR is the rerecording of an actor's dialogue in a **recording studio** during **post production** in order to replace poor-quality sound. ADR is usually performed to a **playback** of the original **image** so the actor can match to his or her original lip movements, but it can also be used to insert new dialog. Also called **dialogue looping**, **looping**, **ADR editing**, **dubbing**, **electronic post-sync (EPS)**.

Automatic Dialogue Replacement Editor (ADR Editor) The individual responsible for performing the **Automatic Dialogue Replacement (ADR)** sessions. Also called the **Automatic Dialogue Replacement Mixer (ADR Mixer)**.

Automatic Dialogue Replacement Mixer (ADR Mixer) See **Automatic Dialogue Replacement Editor (ADR Editor)**.

Automatic Gain Control (AGC) A circuit that can automatically adjust the input levels for **audio** and **video**.

autosave A function of some **software application**s to automatically save **data** to **disk** periodically.

auxiliary disk space Additional **disk space** used to store **data** beyond the capacity of the **computer**.

auxiliary lens Any supplementary **lens extender** used to modify the **focal length** of **prime lens**es or **zoom lens**es. Sometimes referred to as **diopter lens**. See also **normal lens**, **telephoto lens**, **anamorphic lens**.

available memory The **memory** that is available to a **process**. If a process runs short of available memory, it has to use **swap space**.

average 1. The middle value of a group of figures that is calculated by adding the numbers in the group together and dividing the total by the number of figures in the group. Also called the **mean**, **median**. 2. See **frame averaging**. 3. See **grain averaging**.

averaged grain See **grain averaging**.

averaged normal A **surface normal** that can display **smooth shading** on a **polygonal object** by sharing the same normal across a group of **adjacent polygons**. Also called **shared normal**s.

averaging 1. See **filtering algorithm**. 2. See **frame averaging**.

AVI Abbreviation for **Audio Video Interleaved (AVI)**.

Avid The trade name for a **nonlinear editing** system developed by **Avid Technology, Inc.**

Avid Technology, Inc. The maker of a **nonlinear editing** system that has become an industry standard. Avid has also acquired **Elastic Reality (ER)**, **Matador**, and **Softimage**.

award To hire a **facility** to create the **visual effects work** for a **film** or **commercial**.

A-wind See **A/B wind**.

awk An **interpretive language**, written in a **C-like syntax**, used to **parse** and modify **text file**s. It was named after its developers' initials: Alfred Aho, Peter Weinberger, and Brian Kernighan, in 1978. **Nawk** and **gawk** are variants of **awk**. See also **Perl**, **sed**.

axes The plural form of **axis**.

axis The line along which we measure a distance, such as **north** or **south**, is called the axis. Generally, the **horizontal axis** represents the **X-axis**, the **vertical axis** is the **Y-axis**, and the **Z-axis** is used to define **depth**. By using two **axes**, a **2D plane** can be determined. For example, the **XY plane** can be defined by the **intersection** of the X-axis and Y-axis at the **origin**. Three dimensions can be defined by using three axes, X, Y, and Z. See **coordinate system**.

axis of measurement The line or **axis** along which a distance is measured. For example, if a distance is measured along a tape measure, then the measuring tape is the axis of measurement.

axis of revolution See **axis of rotation**.

axis of rotation The line or **axis** around which an **object** may **revolve**.

axis of symmetry The imaginary line on which an **object** is said to be symmetrical, such as the diagonal of a **square**.

B Abbreviation for **blue (B)**.

baby legs See **baby tripod**.

baby light See **baby spot**.

baby spot A small **spotlight** used for **close-up**s and as a **kick light**.

baby tripod A **tripod** with short legs used for **low-angle shot**s. Also called **baby legs**.

back and forth shots A series of **shot**s that cut back and forth from opposite angles but use a similar **camera distance** and **camera angle** to maintain a uniform appearance.

backbone The top level in a **network**. The backbone serves as the major access point to which smaller networks can connect.

back buffer The **buffer**, used in **double buffering**, to update the next **image** in a **sequence** to be shown on the **display device**. Because the **viewer** cannot see the update of the back buffer, there is no visible **flicker** between images that is seen when double buffering is turned off. Also called the **off screen buffer**.

back clipping plane See **far clipping plane**.

back door A deliberately designed means of disabling the security of a **system** used to allow **access** to a **computer** by **System Administrator**s. Also called **trap door**.

backdrop An artificial **background (BG)**, such as a **Cyclorama**, used during **filming**.

back end 1. A **computer** that does the main **processing** and uses a smaller and more **user friendly** computer, called the front end, for the **user** to interact with. 2. A **program** that performs tasks behind the scenes that are not directly controlled by the user. 3. Monies payable to an individual or

entity involved in the production of a film (such as actor, **Director**, or **production company**), which are usually based on the income or performance of the film, either as a percentage of the gross income or after the deduction of costs, expenses, and **distribution** fees. Also referred to as **back end participation**. 4. A term sometimes used to describe the **post production** portion of a **film** project. See also **front end**.

back end participation See **back end**—Definition #3.

backface The backface of a **polygon** is attached to a **surface normal** that faces away from the **camera** and is completely occluded by the polygons that are facing the camera. **Backface culling** can be turned on to speed up calculation times. Opposite of **frontface**. See also **double-sided**.

backface culling The process of removing the **surface**s that face away from the **camera view**. When **backface** culling is turned on, the **user** can select and modify only the surfaces of a **3D object** that face toward the **camera**. Backface culling can greatly decrease the **rendering** time of a **scene** since there is less **data** for the **renderer** to calculate. Backface culling is one of the techniques used in **hidden surface removal**.

backfacing Referring to **geometry** that contains **backface**s.

background (BG) 1. The portion of the **scene** that is farthest away from the **camera view** in front of which the action takes place. 2. For **compositing**, the **image** that serves as the primary backdrop or **environment** on top of which all **element**s are **composite**d. The **background plate** can come from a variety of sources, such as **live action plate**s, **full size set**s, **matte painting**s, and **CG** environments. 3. The pattern or **colors** displayed on a **computer screen** behind the **window**s. *See Color Plates 17–26.*

background alpha The **alpha channel** of the **background element** in **compositing**. Opposite of **foreground alpha**.

Background Artist See **Scenic Artist**.

background element Referring to the **image** or **sequence** of images that serves as the primary **plate** over which all **foreground element**s are **composite**d.

background image See **background element**.

background layer See **background element**.

background noise Any **sound** that creates a mood or gives the illusion of **off-camera** action taking place in a **scene**.

background plate Another term for **background element**.

background process Any **process** that can **run** on its own while allowing the **user** to interact with the **computer** using a **foreground process**.

background task See **background process**.

backing 1. Shorthand for **backing color**. 2. See **anti-halation backing**. 3. See **noncurl backing**. 4. Another name for **cyclorama**.

backing color The **color** of the **background (BG)** that is used when **shooting** an **element** for a **matte extraction**.

back light **Lighting** that strikes a **subject** from behind relative to the subject's position to the **camera**. Back lighting is used to make a subject stand out against the **background (BG)**. Also called **kick light**, **rim light**. See also **front light**, **side light**.

back lighting See **back light**.

backlit See **back light**.

backlot An area located on **studio** property where large **set**s can be constructed for **filming**.

back plane See **background (BG)**.

back projection See **rear projection photography**.

backup To **archive** data on **disk** to a **storage device**. Opposite of **retrieval**.

backup copy An extra copy of a **file**. See **archive**.

backup tape Any **tape** format, such as **magnetic tape**, containing a **copy** of the **data** created during a **backup**.

backward compatible Any **version** of **software** that is able to recognize **file**s that may have been created by an earlier version of software that was installed on that **computer**. Also called **downward compatible**. See also **forward compatible**.

backwind To rewind the **film** in the **camera** to **shoot** a **double exposure**.

bad block The portion of a **storage device** that loses its ability to store **data**.

bad disk Any **disk** that can no longer store or retrieve **data**.

bad key A **composite** is said to have a "bad key" when there are noticeable **image artifact**s such as **fringing**, **halo**s, **chatter**. See **chroma key**, **luminance key**, **color difference key**.

bad sector A pie-sliced division on a **disk** that is damaged and cannot store or retrieve **data** from that **sector**.

BAFTA Abbreviation for the **British Academy of Film and Television Arts (BAFTA)**.

BAFTA award See **British Academy award (BAFTA award)**.

bake-off A slang term used to describe the evening in which the nominees representing the top seven movies chosen as candidates for the best **visual effects (VFX)** of the year present their work at the **Academy of Motion Picture Arts and Sciences (AMPAS)**. After each group makes their presentation and shows a 15-minute clip of their work, the members of the **Academy** vote and nominate the three movies that will be up for an **Academy Award** the night of the **Oscar**s. Also referred to as the **long list**.

balance 1. Referring to the overall **composition** of a **shot**. See also **image balance**, **color balance**. 2. See **white balance**.

ball joint A rotational **joint** that can move across three **axes** when used with a **skeleton** structure.

ball pass See **lighting spheres**.

ball and socket joint See **ball joint**.

banding An **image artifact**, also known as **contouring**, **quantizing**, **mach bands**, or **posterization**, which appears in areas with insufficient **color resolution** or **bits per channel**. This causes noticeable bands of color rather than a smooth transition between colors.

bandwidth The total amount of **data** that can be **transmit**ted through a **network** over a given amount of time. All transmitted **signal**s, either **analog** or **digital**, have a defined bandwidth. For digital, bandwidth data speed is most commonly measured in **bits per second (BPS)**, whereas analog systems tend to measure bandwidth as the difference between the highest- and lowest-frequency signal components. The greater the bandwidth, the greater the capacity.

bang A slang name for an exclamation point (!), represented as **ASCII character** 33. In **Unix**, the (!) can be used as a shortcut to repeat a previously typed **user command**.

bank To **roll** and **translate** the **camera** in the same direction to "bank" into a turn.

barn doors The hinged panels attached to **stage light**s that can be adjusted to restrict or direct the amount of **light** it is **emit**ting.

barrel distortion Distortion of a **lens** that produces straight lines to bend away from the center of the **image**. See also **pinhole distortion**, **lens distortion**.

bars See **color bars**.

bars and tone The combination of **color bars** and an **alignment tone** that appears at the head of a **videotape** and is used to set the proper **video** and **sound** levels during **playback**.

barycentric coordinates A technique used to blend the **value**s assigned to the **vertices** of a triangle. For any given **point** inside the triangle, the triangle can be **subdivide**d into three smaller triangles. The **weight** of each **vertex** of the original triangle can then be calculated by the area formed by one of these smaller triangles.

base See **film base**.

base 2 See **binary**.

base 8 Base 8 numbers use only the digits 0, 1, 2, 3, 4, 5, 6, and 7. The second column to the left is the 8's place. For example, the number 43 in base 8 is 3 ones and 5 eights which equals $(5 \times 8) + 3 = 43$. Also called **octal numbering system**.

base 10 A numbering system in which each place to the left or right of the decimal point represents a power of 10. Also referred to as the **decimal** numbering system.

base 16 Base 16 numbers are **hexadecimal** numbers used to represent **binary number**s using the digits 0–9 and the letters A–F, which represent numbers 10 to 15. Each place to the left is 16 times greater than the number to its right.

base address The **memory address** used as the reference for **relative address**es.

Basic See **Basic Programming Language**.

Basic Language See **Basic Programming Language**.

Basic Programming Language Abbreviation for "Beginner's All-Purpose Symbolic Instruction Code," which is a simplified **programming language**. Basic was designed as a language to write simple **program**s that could be learned quickly.

basis matrix A **matrix** that interprets a **geometry matrix** of **control point**s to create a **bicubic patch**.

basis spline See **B-spline**.

basis vector A **vector** that defines one **axis** within a **coordinate system**. For a **3D** coordinate system, the three basis vectors needed are the **XYZ axes**.

batch See **batch processing**.

batch compositing To **execute** a **composite script** as a means of creating a **sequence** of **image**s during **batch processing**. Opposite of **online compositing**.

batch file The **file**, such as a **shell script**, containing the **command**s that will **execute** a series of **process**es, such as a **render**, during **batch processing**.

batch mode See **batch processing**.

batch processing The ability to **process** data without a **graphical user interface (GUI)** or **user input** across any number of **central processing unit**s (**CPU**s) simultaneously without **user** supervision. Also referred to as **batch mode, background process**. See also **interactive processing**.

batch system Any **software package** that requires that you **execute** a series of **command**s or **operation**s in order to produce the updated result. See also **online system**.

bath 1. Any of the various chemicals used during **film processing**. 2. The tanks that hold these chemicals.

battery belt The belt containing battery cells worn by the **Cameraman** or **Assistant Cameraman (AC)** during **handheld shot**s.

baud See **baud rate**.

baud rate The speed, calculated as **bits per second (BPS)**, that a **computer** transmits **data** to a **peripheral device**, such as a **modem** or **printer**.

beam convergence For **laser film recorder**s, the fine **focus**ing of the **red (R)**, **green (G)**, and **blue (B)** laser beams that are used to convert **digital image**s onto **film**. If the **laser beam**s become misaligned during **record**ing, the resulting **image**s can contain **color fringing** along the **edge**s of the **object**s in each **frame**.

beauty pass 1. In **multiple pass photography**, the **pass** of the **object** that contains the most **color** and detail, as compared with the **matte pass**, re-

flection pass, or **shadow pass**. Also called the **color pass**. 2. In **multiple pass rendering**, the **CG element** that contains the most color and detail information. See also **shadow pass**, **reflection pass**, **matte pass**, **light pass**.

behind the scenes A term used to describe any work associated with **film-making** that does not take place in front of a **camera**.

behind the screen In **3D film**s, an **object** is considered to be "behind the screen" if it is positioned farther back in **depth** relative to the **screen plane**. See also **at the screen**, **breaking the frame**.

bell curve See **bell-shaped curve**.

Bell Laboratories See **AT&T Bell Laboratories**.

bell shape See **bell-shaped curve**.

bell-shaped curve The symmetrical **curve** representing **normal distribution**. Also called **Gaussian curve**, **Gaussian shape**, **bell curve**, **bell shape**.

below the line The portion of a **film budget** that covers expenses incurred during **production**, such as the salaries of the **Film Crew** and the members of the cast not covered in the **above the line** costs, travel and location expenses, and the cost of creating the **visual effects work** at various facilities.

below operation A **compositing operation** that layers the **foreground image** under the **background image** but only inside the area covered by the **alpha channel** of the foreground image. Opposite of **above operation**. See also **plus below operation**, *image under **layering operation**, and image on the following page.*

bench See **editing bench**.

benchmark A reproducible measurement of a particular **computer process**. Benchmarks are often used to determine how much time and how many **central processing unit**s (**CPU**s) will be required to **render** all the **scene**s in a **project** based on the tested renderings of a few sample **frame**s.

benchmark tests See **benchmark**.

bend A **deformation** technique used to curve or **warp** a **surface** around its **local origin** or specified **pivot point**, using any combination of **lattice box**es, **point group**s, and **dynamic**s. See also **twist**, **taper**.

bendy box Slang for **lattice box**.

A Below B

bendy box animation Slang for **lattice box animation**.

benign virus A **computer virus** that is intended primarily for a prank and does not destroy or **delete** any **data** on the **computer**.

Best Boy The main assistant to the **Gaffer**. Also called **Assistant Chief Lighting Technician**, **Best Boy Electric**, **Best Boy Grip**.

Best Boy Electric See **Best Boy**.

Best Boy Grip See **Best Boy**.

beta 1. A half-inch **magnetic tape** format used for **video**. 2. For **software**, see **beta software**.

Beta Abbreviation for **Betacam**.

Betacam The trade name for a **camera**/recorder **component video** system, developed by Sony, that uses a **half-inch tape** format.

Betacam SP A superior version of **Betacam** developed by Sony. Betacam SP uses a wider **bandwidth** for recording and more **audio** channels than Betacam.

beta copy See **beta software**.

beta release The official release of **beta software**. See also **alpha release**.

beta software A prerelease **version** of **software** that is sent out to a small group of users to test for their feedback. Beta software comes after **alpha software** and before the official **release** of the new version. The testing of beta software is the last stage where **bug**s can be fixed and **user** requests can, in some cases, be accommodated.

beta test The final testing phase of a **beta version** of a **software** before its commercial release in which **user**s are asked to test and report **bug**s.

beta version See **beta software**.

betaware See **beta software**.

bevel See **bevelling**.

bevelling Bevelling is an extension of **extrusion** used to add small geometric detail to **polygonal object**s. This detail is accomplished by creating a smaller but similarly shaped **polygon** that is inset and raised above the polygon being bevelled. The two polygons are then connected together with a new **group** of polygons used to define the **shape** of the bevelled **edge**s.

Bézier See **Bézier spline**.

Bézier curve See **Bézier spline**.

Bézier patch A type of **bicubic patch** defined by **Bézier spline**s.

Bézier spline A type of **approximating spline** defined by a minimum of two **control point**s, in which the **curve** passes through all its control points to create an **interpolate**d curve **segment**. A Bézier spline uses **tangent vector**s, which, based on their direction and length, determine the curvature of the **spline**. Bézier curves allow the creation of complex curves with few control points due to the ability to manipulate these **handle**s.

BG Abbreviation for **background (BG)**.

bias 1. To skew the result of a **program** or **process** in favor of a defined **value**. 2. The current from a **sound recorder** sent to **magnetic tape** to raise the **audio** to a level that can eliminate noise and distortion while still recording low **signal**s.

bicubic *Bi* means "two," and *cubic* refers to mathematics involving the powers of three. See **bicubic patch**.

bicubic interpolation An **image interpolation** technique that is based on the averaging of the 16 nearest **pixel**s in a **digital image**. See also **linear interpolation**, **bilinear interpolation**.

bicubic patch Any four-sided **curved surface** generated from two **cubic spline**s that are joined at one corner and are positioned at 90-degree angles from one another. The direction of the first **curve** is generally called the **U direction**, and the direction of the second curve is referred to as the **V direction**. By replicating the **U curve** along the **V curve**, a curved **surface** can be defined. The type of **patch** created is dependent on the type of **spline** used by the original curves. For example, a **B-spline patch** is created by **B-spline** curves, and a **Bézier patch** is defined by **Bézier curve**s. The resulting patch also contains its own **hull**.

bid To **breakdown** a **project** into the individual components and dollar amount required to create the **film**. The first bidding phase of every movie begins with the **Production Team** assessing what it will cost the **studio** or **production company** to make the movie. The outcome of this process determines whether the movie will be **greenlit** or added to the long list of films that never made it into **production**. If the movie gets a **greenlight**, then various **Crew**s and facilities will be asked to bid for the work on certain portions of the **show**. Bidding can be a long and painful process!

bilinear filtering See **bilinear interpolation**.

bilinear interpolation An **image interpolation** technique that is based on the averaging of the four nearest **pixel**s in a **digital image**. See also **linear interpolation**, **MIP mapping**, **trilinear interpolation**.

bilinear patch A **quadrilateral** with straight **edge**s defined by four **vertices**.

binary See **binary number**.

binary code **Code** that is represented with **binary number**s as either one of two states, such as 1 or 0, true or false, on or off.

binary digit See **bit**—*B*inary dig*IT*.

binary file A **file** that is represented by 0's and 1's. While a **binary** file uses less **disk space** than an **ASCII file**, it cannot be **read** and modified with a **text editor** as an ASCII file can. For example, you would not store a file that you wanted to **parse** and **edit** as a binary file.

binary number A numbering system that uses 2 as its base and represents **data** as a sequence of 0's and 1's. Also referred to as **base 2**.

binary numbering system See **binary**.

binary space partition trees (BSP trees) A method of subdividing a **volume** in **3D space**. The volume is originally represented as a single rectangular **bounding box**, and if more detail is needed, it is split into two volumes. This process continues until each sub-box contains the desired **level of detail (LOD)**. See also **octrees**, **quadtrees**.

bi-phase Electrical pulses from a **Telecine** device used to update the next **frame** of **film** to be transferred.

bit Abbreviation for *B*inary dig*IT*, a bit is the smallest unit of information a **computer** can recognize. One mathematical bit is defined by only two levels, or states, of information that can be obtained by asking a yes or no question. For example, the answer to the question can be only one of two **value**s, such as true or false, 0 or 1, black or white. Two bits can define four levels of information, three bits can define eight, and so on. Eight bits are equal to one **byte**.

bit depth Each **pixel component** in a **digital image** is represented by a number of **bit**s, and the number of **bits per channel** is known as the bit **depth** of that **image**. A commonly used bit depth is **8 bits per channel**, which is also referred to as a **24-bit image** (8 bits × 3 **channel**s = 24 bits). If you have 8 bits per channel (also called **8 bits per component**), it means that each channel can have 2^8 or 256 different possible **color value**s from 0 to 255. Also referred to as **color depth**.

bitmap A **3D array** of **bit**s used to represent a **2D array** of **pixel**s that make up a **digital image**. A bitmap is defined by the number of **color**s or shades of gray it can represent, and its size is determined by the **width** and **height** of the pixels in the image. A bitmap representing a color image is called a **pixel map**. Also called a **raster image**, **bitmapped image**, **pixel map**. See **bits per pixel**.

bitmap display A **display device**, such as a television or **computer screen**, onto which each **pixel** displayed on the **screen** is **map**ped to one or more **bit**s in **memory**. The **image** is formed by **scanning** horizontally from top to bottom, line by line, with an **electron beam**. Also called a **raster display**, **graphics display**.

bitmapped graphics The **display** of an **image** as an **array** of **pixel**s, arranged in **rows and columns**, on a **computer screen**. Unlike **vector**

graphics, the **element**s contained within the **image** cannot be independently changed without re**rendering** the entire image. Also called **raster graphics**, **pixel graphics**.

bitmapped image See **bitmap**.

bitmapping The process of creating a **bitmap display** in terms of the **brightness** values of **pixel**s.

bitpad A 2D **input device** that consists of a **pad** or sensing surface and a **pointing device**, such as a **pen**, **mouse**, **stylus**, or **puck**.

bitplane A rectangular **2D array** of **bit**s mapped one to one with **pixel**s. The **frame buffer** is an example of a bitplane.

bits per channel The number of bits per **channel** in an **image**, also referred to as its **bit depth** or **bits per component**, determines the total number of possible **color value**s that can be represented within each channel of that image. See also **16 bits per channel, 8 bits per channel, 4 bits per channel**.

bits per color channel Synonymous with **bits per channel**.

bits per component See **bits per channel**.

bits per inch (BPI) The **unit** of measurement used to determine **magnetic tape** storage capacity.

bits per pixel (BPP) See **pixel depth**.

bits per second (BPS) The rate that **data** is **transmit**ted over a **communication line**.

bitwise To work with **bit**s rather than **byte**s or larger **unit**s.

bitwise operators **Program** operators that work with **bit**s.

black 1. As a **color**, to produce or **reflect** no **light** and be devoid of **hue**. 2. For **digital**, black is typically thought of as the **normalized value**s in an **image** whose **RGB channels** are equal to (0,0,0). Also referred to as **pure black, normalized black**. 3. For **display device**s, black is only as dark as the display can represent it. See also **white**.

black a tape See **blacking**.

black and white (B/W) 1. For a **digital image**, an **image** with no **color**. See also **grayscale image**. 2. For **film**, see **black and white film**.

black and white film **Film stock** that contains an **emulsion** that transforms **color** into various shades of gray during **processing**. In some cases, **color**

film is used, and the color is removed during the **develop**ing and **print**ing process.

black bag See **changing bag**.

black body An ideal **surface** that completely absorbs all the **light** falling on it with no **reflection**. Such a surface is used to determine the **color temperature** in **Kelvin degree**s of a light based on the temperature that the black body has to be heated in order to **emit** a particular color of light.

black burst A **composite video** signal that is typically used as a reference **signal** to lock the entire **facility** to a common signal. Also called **house sync**, **house black**, **house reference**, **reference black**.

blacked tape A **videotape** with **control track** already recorded onto it but no **picture** or **sound**. Also called a **preblacked tape**, **striped tape**.

black emulsion leader See **black leader**.

blacking To record a **black burst** signal across the length of a **tape** before recording to ensure there are no **image**s already on the tape and that there is a clean and continuous **video signal**. Also called **striping**.

black leader Black and opaque **film** used by the **Negative Cutter** when preparing **A/B rolls**. Also called **black emulsion leader**.

black level 1. In **video**, the blackest part of the **video image**. Also called the **setup level**. 2. In **digital compositing**, the blackest part of the **image**. All **element**s must have their black levels properly matched in order to create a realistic looking **composite**. Mismatched black levels are one of the most common problems found in poorly composited shots. When compositing a **shot**, it is a good idea to occasionally boost the **gamma** on the **monitor** you are working on to get a true sense of how the black levels across the different elements are relating to one another. This can avoid the embarrassing video transfer version that contains elevated **brightness** levels and shows all the mismatched black levels that seemed acceptable on **film** in the theatre.

black light Invisible **ultraviolet** radiation. Black light causes fluorescent materials to **emit** a visible **light**. See **black light photography**.

black light pass An **element**, shot with **multiple pass photography**, that is lit by **black light** against a fluorescent **orange screen**. Also called a **UV pass**. See **black light photography**.

black light photography A technique in which **physical model**s are lit with **black light** and photographed against a fluorescent **orange screen**.

When certain **object**s are **subject**ed to invisible **ultraviolet (UV light)**, they give off a visible radiation called fluorescence, which can be photographed with conventional **film**. For materials that don't fluoresce, fluorescent paints can be applied to the objects before photography. Like **greenscreen** and **bluescreen photography**, black light photography is done as a means of separating the subject from its **backing color** to allow for a **matte extraction** to be accomplished during **compositing**. It can also be used to **shoot** effects elements such as molten lava or metal so they appear to self-illuminate. For **multiple-pass photography**, an **element** shot with black light is often referred to as the **UV pass** or **black light pass**.

blackness The amount of **black** mixed with **hue** in the **HWB color space**. See also **whiteness**.

black point 1. For **film**, the measurement of **density** in the portion of the **frame** with the greatest **opacity**. 2. For **digital**, the numerical **value** corresponding to the darkest area that will be **display**ed in its final **viewing format**. For example, black in an **image** might be considered as 0.1. By treating the **pixel**s in this range as if they were the limit of the darkness range, a bit of extra room is created at the bottom end of the image. When this image is sent to a **display device**, any pixel containing a value below or equal to the specified black point will appear to be pure **black**. See also **white point**, **lookup table (LUT)**.

blanking The period when a **monitor**'s **electron beam** is positioning to begin a new **scan line** or **field**. See **blanking interval**.

blanking interval The horizontal **blanking** interval is the period of time in a **video signal** between the end of **scanning** one **scan line** and the beginning of the next. The **vertical blanking interval** is the time between the end of one **field** of **video** and the beginning of the next.

blanking level The level of the **video signal** during the **blanking interval**.

bleach bypass A general term used to describe a number of **film processing** techniques offered by various **lab**s, in which the bleaching function done during normal **processing** is partially or completely skipped as a means of increasing **contrast** and reducing **saturation**. This results in an **image** in which the **silver halide crystals**, which are normally removed by bleaching, are retained. The retained silver increases the contrast of the image and decreases the **color** saturation by adding gray or **black** to the image colors. Also called **skip bleach**, **ENR**.

blend 1. An **image process** that combines two **source image**s, based on their **alpha channel**, into a new resulting **image**. 2. See **blended surface**. 3. For **metaball**s, see **fusion**.

blended surface A **modeling** technique used to connect a new **surface** in between and attached to the **edge**s of two other surfaces without any visible seams. The resulting object appears to be a single and continuous object. Many **software package**s will automatically recalculate the blending across the surfaces if either of the two **source object**s are modified or **reposition**ed. A blended surface allows for the seamless connection between more irregular surfaces than does the **fillet** technique, which tends to expect surfaces whose edges are roughly circular. More advanced versions of the blended surface technique, such as **socking**, are capable of blending more than two surfaces at a time, which is essential for most complex **character models**.

blending groups See **fusion groups**.

Blinn, James The man responsible for developing the **Blinn shading model** for the **rendering** of **3D surface**s and **blobbies**.

Blinn lighting model See **Blinn shading model**.

Blinn shading See **Blinn shading model**.

Blinn shading model A **shading model**, developed by James Blinn, to calculate the **shading** and **rendering** of **3D surface**s based on **diffusion**, **eccentricity**, **refractive index**, and **specularity**. It has greater accuracy and controls for **specular roll-off** and **eccentricity** than does the **Phong shading model**. See also **Gouraud shading model**, **Lambert shading model**, **Cook/Torrence shading model**. *See also image on following page and image under* **shading model**.

blobbies See **metaball**.

blobby's Another spelling of **blobbies**. See **metaball**.

blobby modeling To **model** a **surface** with **metaball**s.

blobby molecules See **metaball**.

block 1. A section of **code** or a block of statements that are treated as single entities in most **programming language**s. For example, an **if/then/else loop** in a piece of code is a series of **conditional statement**s relating to one specific purpose and can be considered as one block or statement. 2. A **unit** of **memory** or **data** on a **computer disk** or **tape device**. See also **track**, **sector**. 3. Shorthand for **blocking a scene**.

Blinn Shading

blocking Referring to **blocking a scene**. See **scene blocking**, *Color Plates 42, 46.*

blocking a scene Another term for **scene blocking**. *See Color Plates 42, 43, 46.*

block size The minimum amount of **memory** that a **tape** or **disk** will **read** or **write** at a time.

bloom Glare caused by an **object** reflecting too much **light**. See also **flare**.

bloop light An electronic means of marking a **take** with a **flash frame**. Bloop **light**s are essential in order to synchronize multiple **element**s shot with **motion control (MOCO)** during **compositing**. The bloop light is triggered by the same **computer** that controls the **motion** of the **camera** in order to ensure that the flash **frame** appears on the same frame of each **pass**.

blow away Slang for the removal of **file**s from a **storage medium**, such as a **hard disk**. See also **delete**.

blue (B) 1. One of the three **primary color**s. 2. For **digital**, see **blue channel**. 3. For **film**, see **blue record**.

blue backing See **bluescreen (BS)**, **color backing**.

blue channel The **channel** that contains all the **blue (B)** information represented in an **image**. Also called **blue component**, **blue record**. See also **green channel**, **red channel**, *Color Plate 14.*

blue component See **blue channel**.

blue contamination Shorthand for **bluescreen contamination**.

blue key Abbreviation for **bluescreen key**. See also **chroma key**, **color difference key**.

Blue Moon Rendering Tools (BMRT) A public domain **renderer**, written by Larry Gritz, that adheres to the **RenderMan (RMAN)** standards as set forth by Pixar. BMRT supports features such as **radiosity**, **ray tracing**, and **area light**s, but in general it uses much slower **render** calculations.

blue record 1. In **digital**, synonymous with the **blue channel**. 2. In **film**, the **blue (B)** color-sensitive **layer** on a piece of film.

bluescreen (BS) A primary blue **backing** that is placed behind the **subject** to be photographed so that a **matte** can be extracted. Ideally, the bluescreen is uniformly lit and contains no **color contamination** in order to **expose** only the **blue (B)** layer of the **film**. Same concept as **greenscreen (GS)** and **redscreen (RS)**. See also **bluescreen key**.

bluescreen contamination 1. A **blue backing** that is contaminated with **green (G)** or **red (R)**. See **color contamination**. 2. Another term for **bluescreen spill**. See also **color spill**.

bluescreen element See **bluescreen plate**.

bluescreen key A **matte extraction** technique that separates a **subject** from its **background (BG)** based on a blue **color backing** in front of which the subject has been photographed. Also called a **color difference key**, the best results are obtained from a **bluescreen (BS)** that contains strong **chroma** or purity of **color**. Same concept as a **greenscreen key**, **redscreen key**. *See Color Plates 17–20.*

bluescreen photography The process of **filming** a **subject** in front of a **bluescreen (BS)** for use in **matte extraction** during **compositing**. Same concept as **greenscreen photography**, **redscreen photography**.

bluescreen plate Any **element** photographed that uses **blue (B)** for its **backing color**. See **redscreen plate**, **greenscreen plate**, *Color Plate 18.*

bluescreen spill The blue **color** that falls onto a **subject** during **bluescreen photography** as a result of the **blue light** reflecting off the **blue backing** behind it. Same as **greenscreen spill**, **redscreen spill**. See **color spill**.

bluescreen shot Any **shot** that uses **bluescreen photography**.

bluescreen stage Any **stage** that can be used for **bluescreen photography**.

blue signal The **blue component** of a **video signal**.

blue spill Shorthand for **bluescreen spill**. See also **color spill**.

blur See **blur filter**.

blur algorithm The mathematical **function**s that define the way an **image** is **blur**red. **Color**s from neighboring **pixel**s are partially **average**d with the current pixel to produce a new image that appears to have a decrease in **sharpness**. Most blurring algorithms use **convolution filter**s. A larger **convolution kernel** averages an area and results in more blurring. Opposite of **sharpen algorithm**.

blur filter An **image process** that uses many varieties of **blur algorithm**s to blur the **pixel**s of an **image**. Commonly used blur algorithms include **Gaussian filter**, **Mitchell filter**, **Median filter**, **impulse filter**, and **box filter**. Opposite of **sharpen filter**. Also called an **image filter**. *See also image under* **image processing**.

blur operation See **blur filter**.

BMRT Abbreviation for **Blue Moon Rendering Tools (BMRT)**.

boat anchor Slang term for a really slow **computer**.

body double See **stand-in**.

boilerplate See **template**.

bomb 1. To **crash**. Typically used in reference to a **software** failure. 2. **Code** written into a **program** or a **system**, either as a prank or maliciously, that is intended to cause some effect at a later time on the **computer**. 3. A **box office** flop!

bookmark A **user** reference to a particular document on a **Web browser** that allows quick access to document **link**s you want to refer to again.

bone The individual sections that make up the **skeleton** used to **animate** with **inverse kinematics (IK)** or **forward kinematics (FK)**. Bones define the **translation**s and **rotation**s that occur in the **limb**s of a **character**. Also referred to as a **link**, **chain**. See also **joint**, **effector**, **root**, *and image on following page.*

Boolean To have two possible **value**s, such as 0 or 1, true or false, on or off. See **Boolean operation**. *See image on page 50.*

Boolean algebra A mathematics system, developed by George Boole in the 1850s, that uses the **logical operator**s **AND**, **OR**, **NOT**, and **XOR** to determine

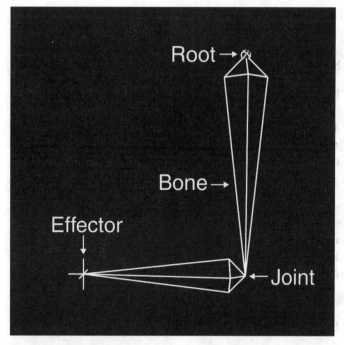

The components of a **skeleton chain**.
IMAGE CREATED USING HOUDINI AND COURTESY OF SIDE EFFECTS SOFTWARE.

a solution with only one of two possible **value**s, such as 0 or 1, on or off, true or false. Boolean algebra is commonly used in **3D modeling** and is referred to as **Boolean operation**s.

Boolean data Any **data** that can have a **value** of 1 or 0, which can be represented as one of two values, such as true or false, yes or no, on or off. See **Boolean operation**.

Boolean difference operation See **difference operation**—Definition #2.

Boolean intersection operation See **intersection operation**.

Boolean logic See **Boolean algebra**.

Boolean modeling See **Boolean operation**.

Boolean operation A **modeling** technique, developed by George Boole, in which a series of rules govern the various ways to combine two sets of **source object**s into a new resulting **object**. The main types of **Boolean operator**s are the **union operation (OR)**, **difference operation (NOT)**, and **intersection operation (AND)**. *See image on following page.*

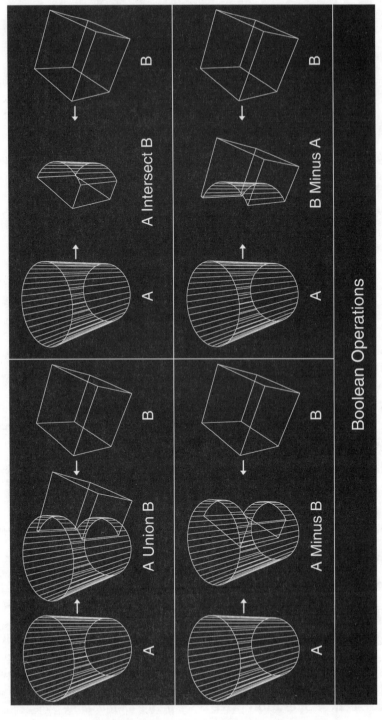

The results of **union**, intersection, and **difference operations** using **Boolean algebra** with a **cylinder** and a **cube**.

Boolean operator The **operators AND**, **OR**, **NOT**, and **XOR** used in **Boolean algebra**. Also referred to as **logical operator**s.

Boolean union operation See **union operation**—Definition #2.

Boole, George The self-educated British mathematician who developed **Boolean algebra**. In 1847, he published *The Mathematical Analysis of Logic,* which established the basis of modern mathematical logic. See **Boolean operation**.

boom 1. A long mechanical arm that supports a **camera** or a **microphone**. See **camera boom**, **boom microphone**. 2. To move the camera up or down. Synonymous with **crane**.

boom down To physically move the **camera** down along the **Y-axis** during **filming**. Opposite of **boom up**.

boom microphone A telescoping arm used to support a **microphone** and used by the **Sound Man** to position the microphone just outside the **camera view** while recording **sound** for the **scene**.

Boom Operator The member of the **Sound Crew** who operates the **boom microphone**. Also called the **Sound Man**.

boom shot Any **shot** in which the **camera** moves up or down during **filming**. See **boom up**, **boom down**.

boom/swing A type of **motion control rig (MOCO rig)** that can travel in an arc for both up-and-down and side-to-side motion. See also **Cartesian robot system**, **mechanical concepts system**, **gantry system**.

boom up To physically move the **camera** up along the **Y-axis** during **filming**. Opposite of **boom down**.

boot The process of loading and initializing the **operating system (OS)** on a **computer**. Also called **reboot**, **cold boot**, **warm boot**, **soft boot**, **hard boot**, **startup**.

boot CD A **compact disc (CD)** that can be used to **boot** a **computer**.

boot disk The **disk** used to start a **computer**.

boot drive The **drive** that stores the **operating system (OS)** used to **boot up** a **computer**.

bootleg software Any **software** that has been illegally copied for use.

boot up See **boot**.

boot virus A **computer virus** that infects a **computer** when it is **boot**ed. A boot virus can also prevent a computer from starting up.

border See **window border**.

borderless window A **window** containing no **title bar** or **border**s.

bounce card A card used to bounce off **light** for soft indirect lighting of the **subject**.

bounced See **bounced e-mail**.

bounced e-mail Any **electronic mail (e-mail)** message that did not make it to the intended recipient and as a result was sent back to the original sender. Bounced e-mail can occur due to a failed connection or an incorrect **e-mail address**.

bounce light Any **light** that is **reflect**ed or "bounced off" other **object**s in a **scene** before reaching the **subject**. A bounce light is used to simulate the way light is reflected in the "real world."

bouncing ball A commonly used **animation** exercise used to demonstrate timing and **squash and stretch**.

boundary The outer extent of an **object** as defined by its **vertices**.

boundary box See **bounding box**.

boundary curve The **curve**s used to define the boundaries of a **boundary patch**.

boundary patch A **modeling** technique in which a set of **curve**s is used to specify the **edge**s or boundaries of a **surface**. Boundary patches created by only two **boundary curve**s result in a surface that is straight along two of the four edges. However, more complicated surfaces can be created if four boundary curves are used.

boundary representation To describe an **object** by its **edge**s, **face**s, and **vertices**, unlike **solid modeling**, which describes an object by its **volume**.

boundary wall See **clipping plane**.

bounding box A box whose dimensions define the most extreme **edge**s of a specific **object** or **image**. Often used in **collision detection** as a means of speeding up calculations. Also called a **boundary box**.

bounding sphere A **sphere** whose dimensions define the most extreme **edge**s of a specific **object**. Bounding spheres are sometimes used in **collision**

detection and **collision avoidance** operations as a means of reducing calculation times that can be quite long when using detailed **geometry**.

Bourne Shell (SH) The original **shell** and **scripting language** written for **Unix**. See **C Shell (CSH)**, **Korn Shell (KSH)**, **command interpreter**.

box See **bounding box**.

box blur See **box filter**.

box filter A fast but low-quality **filtering algorithm** used to **resample** an **image**. When used in conjunction with scaling up an image, the resulting image can appear "boxy." See also **impulse filter**, **Gaussian filter**, **Mitchell filter**, **triangle filter**, **sinc filter**.

box office The measure of the total amount of money paid by the general public to view a **film**.

box select Selecting **element**s by enclosing them within a **2D** rectangle to make them **current**. The box is created by positioning the **cursor** on the upper left-hand corner of the desired area and **drag**ging the **mouse** to the lower right-hand corner to enclose the selected area. Also called **marquee select**.

box zoom The boundaries of a box used to fill the entire **view** with the contents surrounded by that box. Like **box select**, the box is defined by **drag**ging the **cursor** from the upper left-hand corner of the desired area to the lower right-hand corner of the selected area.

BPI Abbreviation for **bits per inch (BPI)**.

BPP Abbreviation for **bits per pixel (BPP)**. See **pixel depth**.

BPS Abbreviation for **bits per second (BPS)**.

bracketing See **wedge**.

branch 1. All the **node**s contained in a **path** from the **parent** to a **child** within a **hierarchy**. 2. The subdirectories that are attached to the **root directory** in a **hierarchical file system**.

branches See **branch**.

break Generally, referring to "breaking" a pair of **tangent vector**s on a **spline** to create discontinuity in the **curve**. See **cusp**.

break down The separation of a **camera original negative** into its individual **scene**s.

breakdown 1. The written analysis outlining the needs and elements of a **script**. The **Assistant Director (AD)** and/or the **Unit Production Manager (UPM)** then create the most efficient **shooting schedule** for the **film**. 2. A detailed timing analysis of the **script** prepared by the **Script Supervisor**. 3. For **visual effects work**, a detailed description and methodology on the approaches to be used for the creation of the **shot**s. Generally, the script is broken down in terms of **sequence**s, shots, and the method in which each **element** needed in the shot will be created, such as **computer graphics (CG)**, **miniature photography**, **live action photography**.

breakdown drawings See **in between**s.

breakdown script A detailed list of all the people, **prop**s, and equipment required for each **shoot** day. See **call sheet**.

breaking the frame For **stereo film**s, an **object** is said to be "breaking the **frame**" when it is at the point of extending beyond the **screen plane**. This is considered taboo in stereo films because an object that breaks the frame of the screen on the top, bottom, or sides results in a partially cut-off image that completely ruins the stereo effect. However, if objects are kept entirely within the frames, they can be floated far out in positive virtual space without breaking the stereo illusion. Also called **breaking the screen**.

breaking the screen See **breaking the frame**.

breakup 1. A disturbance or loss of the **image** or **sound signal**s due to a loss of **sync** or a damaged **videotape**. 2. See **noise function**.

b-rep See **boundary representation**.

brightness 1. The perception of how **light** or dark an **image** appears. For example, the **color** light **blue (B)** contains a high value of brightness, or **lightness**, whereas dark blue contains a low value of brightness, or **darkness**. 2. A **compositing operation** that multiplies the **RGB channels** in a single image by an equal amount. 3. In **video**, brightness is often referred to as the **black level**.

British Academy award (BAFTA Award) The British version of the American "**Academy Award**."

British Academy of Film and Television Arts (BAFTA) The British version of the American **Academy of Motion Picture Arts and Sciences (AMPAS)**.

British Society of Cinematographers (BSC) The British version of the **American Society of Cinematographers (ASC)**. See also **Canadian Society of Cinematographers (CSC)**.

broadband A method of **transmit**ting **data** between **network**s across **coaxial cable**s and **fiber optic cable**s by establishing different **bandwidth**s.

broadcast The **transmission** to multiple, unspecified **computer**s using **packet**s, in which all recipients are always open to receive **data**.

broadcast graphics Generally, referring to the **animations package**s created for broadcast television, such as news and sports opens, **station ID**s, and movie opens. They are heavily composed of **flying logo**s.

broadcast storm A **broadcast** across a **network** that causes multiple **computer**s to respond by broadcasting information back, which can lead a "storm" across the network that continues to grow exponentially and can lead to an **overload** or **network meltdown**.

B roll See **A/B rolls**.

browser See **Web browser**.

brute force Slang for a solution to a **program** or other problem that is not necessarily the most elegant approach but gets the job done by the **deadline**! Also called a **hack**, **kluge**.

BS Abbreviation for **bluescreen (BS)**.

BSC Abbreviation for **British Society of Cinematographers (BSC)**.

B side See **A/B rolls**.

B-spline A class of **approximating spline**s in which a **curve** is calculated without necessarily crossing directly through any of its **control point**s. Like the **Cardinal spline**, the B-spline does not extend out to its first and last control points unless there are additional points grouped at those locations. Many **3D software package**s have built in extra **point**s that are hidden by default so that any B-spline curves drawn by the **user** will automatically extend out to its **end point**s. See also **Bézier spline**, **Hermite spline**, **NURBS**.

B-spline curve See **B-spline**.

B-spline patch A type of **bicubic patch** defined by **B-spline curve**s.

BSP trees Abbreviation for **binary space partition trees (BSP trees)**.

bucket A **rendering** technique in which an **image** is **subdivide**d into smaller **block**s for calculation purposes. When rendering on **multiprocessor**s, each **processor** can be assigned a separate bucket to calculate.

budget The amount of money required to create a **film** or television **production** that includes all projected expenses for salaries, equipment, locations, travel, and all other **above the line** and **below the line** costs.

buffer Temporary **memory** storage in a **computer** used to modify or **display** an **image**.

bug An error in a **computer program** that causes the **computer** to perform incorrectly or erratically, stop completely, or **crash**. See also **glitch**.

bullet hits Thin packets of fake blood that are worn on the body and detonated by small **squib**s to simulate an actor being struck by a bullet.

bullet time A variation on the original **Timetrack** technique, developed in 1994 by Dayton Taylor, that was used by Manex Entertainment for their **visual effects work** on *The Matrix*. See **Flo-Mo**.

bump map The **grayscale image** that is **map**ped onto a **surface** for use in **bump mapping**. The brighter the **value**s in the **image**, the greater the alteration to the **surface normal**s to simulate a bumpy surface. *See also image under **displacement mapping***.

bump mapping A **texture mapping** technique in which the **intensity** of the gray **value**s contained in an **image**, called a **bump map**, is used to simulate a bumpy **surface** on an otherwise flat **3D object**. Because a **flat surface** contains **surface normal**s that point straight up and a bumpy surface contains **normal**s pointing out in different directions, bump mapping is achieved by tricking the **renderer** into believing the surface is bumpy by artificially tilting or **perturbing** its normals in many different directions. If a bump map **pixel** is bright, the surface normal is perturbed in one direction, and if the bump map pixel is dark, the surface normal is perturbed in the opposite direction. Unlike **displacement mapping**, one drawback to bump mapping is that the **edge**s of the **object** remain straight, as they are unaffected by the perturbed surface normals. For example, if a golf ball is rendered with bump mapping, the center of the image will appear to have dimples, but the edges of the ball will be perfectly smooth. Conversely, the same golf ball rendered with displacement mapping will have true geometry dimples across the entire ball, center and edges alike. See also **color mapping**, **transparency mapping**, **environment mapping**. *See image under **displacement mapping***.

bump texture See **bump map**.

bump texture map See **bump map**.

bump texture mapping See **bump mapping**.

bump up To transfer the **image**s recorded on a lower-quality **videotape** to a higher-quality videotape, such as copying the images from a **VHS** tape to a **beta** tape.

bundled software Any additional **software** that comes free with the purchase of new **hardware** or a particular **software package**.

bundling 1. See **bundled software**. 2. Combining two or more different **function**s into one **peripheral device** or **expansion board**.

burn To record **data** onto a medium, such as a recordable **CD-ROM**, that can be written to only one time.

burn a CD The process of recording **digital** information onto a recordable **compact disc (CD)**, called a **compact disc recordable (CD-R)**, with a **compact disc burner (CD burner)**.

burner See **compact disc burner (CD burner)**.

burn-in 1. For **film** effects, see **double exposure**. 2. For **timecode**, see **burn-in timecode**. 3. When viewing **video resolution** shots in **dailies**, it is common practice to "burn in" or overlay information about the **shot** in text form, such as shot name, date, **version number**, frame counter.

burn-in timecode **Timecode** that is overlaid, or "burned in," to the **image area** of a **videotape**. Also called **visual timecode**, **window code**, **burn-in**, **window burn-in**.

burn-in window The area on the **videotape** where the **burn-in timecode** is overlaid.

burst See **black burst**, **color burst**.

bus An internal pathway in the **computer** that sends **digital signal**s from one part of the **system** to another. The size of a bus is determined by the number of **bit**s of **data** it can carry. For example, many **microprocessor**s have 32-bit busses both internally and externally. Also called the **main bus**. See also **local bus**.

bus error An error in the **bus** of a **computer**.

button 1. The rectangular region or box that performs a specific action when activated with a **mouse click**. Examples of types of buttons include **check box**es, **push button**s, and **radio button**s. 2. On a **mouse**, the button a

user presses on with his or her finger to activate a response within the **computer application**.

B/W Abbreviation for **black and white (B/W)**.

B-wind See **A/B wind**.

byte A group of **8 bit**s is equal to one byte of information, which is the amount of **computer memory** required to represent one **character** of **alphanumeric** data. For example, the number 0 is represented by an **array** of 8 bits, 00000000, and the number 255 is represented as 11111111. See also **ASCII**, **kilobyte**, **megabyte**, **gigabyte**.

C See **C programming language**.

C++ See **C++ programming language**.

cable Strands of various materials, such as metal or glass, encased in a housing and used to **transmit** information from one location to another. See **fiber optic cable**, **twisted pair cable**, **coaxial cable**.

cache See **cache memory**.

cache memory Pronounced "cash," a fast storage **buffer** in a **computer** that is used to hold recently accessed **data**. When data is **read** or written from **main memory**, a copy is also saved in the cache. The cache stores the **address** of the data and monitors the **address**es of subsequent reads to see if the required **memory** for that data has already been allocated in the cache. The two main types of cache memory are **memory cache** and **disk cache**.

CAD Abbreviation for **Computer Aided Design (CAD)**.

CAID Abbreviation for **Computer Aided Industrial Design (CAID)**.

calibrate See **calibration**.

calibration The adjustment of a **display device** to **display** colors as closely as possible to the way they will appear in their final **viewing format**. For example, a **monitor calibration** is done to make the **color**s represented in **digital image**s look the way they will appear on **film** or **videotape**, and a **light box calibration** is done to make a **workprint** or **match clip** look the way the same piece of film will appear when **project**ed on a **projection screen**. Also called **color calibration**. See also **lookup table (LUT)**.

call 1. To reference a **parameter** or **function** in a **program**. 2. See **call time**.

call lights To request specific **printing lights** during **film processing** to achieve a desired look or effect as opposed to receiving a **one light** print.

call sheet The list handed out at the end of each **shoot** day that displays the **Cast and Crew** members' **call time**s for the next day, the **scene**s to

be **shot** and the order in which they will be shot, as well as noting any extra equipment needed such as **crane**s or dollies. Call sheets are typically created by the **Assistant Director (AD)** or **Second Assistant Director (2nd AD)**.

call time 1. For **filming**, the time and **location** of the next day's **shoot**. 2. For **Digital Artist**s, the time they are expected to arrive at work.

camcorder A **device** that combines a **camera** and **videotape** recorder into one.

camera Regardless of whether a **physical camera** or a **digital camera** is used, the camera determines the **point of view (POV)** in which a **scene** is viewed based on a combination of **position, rotation, field of view (FOV), lens, aperture, shutter**, and its general **viewing direction**.

camera angle The position of the **camera** relative to the setting and action of the **scene**. The camera angle can be described by a combination of **position, rotation, field of view (FOV), lens**, and **aperture**, and can be described as the camera's **point of view (POV)**. Also called **camera position, camera location, eye location**.

camera angle projection A technique of portraying the blueprints of a **set** into a **perspective** drawing as it will appear through a particular **camera position, lens**, and **aspect ratio**.

camera aperture The opening of the **aperture** that defines the area of the **film** that will be **expose**d. It can be measured as the **width** and **height** of the **film back** in inches. The camera aperture is relative to the **focal length** in that different apertures require different **lens**es in order to create a "normal" **perspective**. For instance, a larger camera aperture requires a longer focal length, whereas a smaller aperture requires a shorter focal length. The aperture setting is described by **f-stop**s. The smaller the f-stop, the larger the opening of the aperture and thus the greater amount of **light** that is allowed to pass through.

Camera Assistant See **Assistant Cameraman (AC)**.

camera blocking The rehearsal of the **camera motion** required to **film** the action of the **scene**. See **scene blocking**.

camera body The main part of a **physical camera** through which the **film** passes and is **expose**d to **light** through the **aperture** during **filming**. Attachable parts, such as the **film magazine** and **lens**, are not considered part of the body.

camera boom A mechanical arm used to counterweight and support a **camera** that is attached to a **dolly** in order to create an increased range of **motion**. Also called a **jib arm**.

camera car A car or truck designed to carry one or more **camera**s and operators for the purpose of **shooting** fast-moving **photography**.

camera coordinate system A **coordinate system** whose **origin** is located at the **camera viewpoint**. The camera coordinate system is defined as either a **right-handed coordinate system** or as a **left-handed coordinate system**. Also called **camera space**.

Camera Crew The individuals responsible for the operation of the **camera** during **shooting**. The Camera Crew generally consists of the **Director of Photography (DP)**, **Cameraman**, **Assistant Cameraman (AC)**, **Second Assistant Cameraman (2nd AC)**, and **Grip**s.

camera direction See **camera angle**.

camera distance The distance of the **camera** relative to the **subject** that is being **film**ed. The distance of the camera is generally measured from the subject to the **film plane** and is also referred to as the **subject distance**.

camera dolly See **dolly**.

camera filter See **filter**—Definition #2.

camera gate See **film gate**.

camera height The height of the **camera** relative to the **ground plane** and the **subject** that is being **film**ed. The height of the camera is generally measured from the ground plane to the middle of the **camera lens** and is also referred to as the **lens height**.

camera interest The location in space where the **camera** is looking.

camera jam A malfunction occurring in a physical **camera** when the **film** backs up and gets caught inside the **camera movement**.

camera left The left side of the **camera** from the viewpoint of the **Camera Operator** and, therefore, the left side of the **screen** from the audience perspective. For the actor facing the camera, camera left is to the actor's right. Opposite of **camera right**.

camera lens The **lens** that **focus**es the **image** seen by the **camera**. See **lens**.

Camera Loader See **Clapper/Loader**.

camera location See **camera angle**.

camera log A record detailing the **scene**s that were **film**ed on a particular **roll** of **original negative**.

camera lookat See **camera interest**.

Cameraman The **Crew Member** who operates the **camera** during **filming** based on the specifications given by the **Director of Photography (DP)**. The cameraman is also responsible for maintaining the desired **composition** of the **shot** and for creating smooth **camera move**s. In some cases, the **Director** or DP might assume this role.

camera mapping A **projection mapping** technique in which an **image** is projected from the **camera** onto the **3D object** that is being **texture map**ped. This technique is useful for reproducing imagery from **plate photography** on **3D surface**s. Also called **camera projection mapping**. See also **spherical mapping**, **orthographic mapping**.

camera motion See **camera move**, *and image below.*

camera mount Any **device** on which the **camera** can be mounted for support, such as a **tripod**, **high hat**, **low hat**, **dolly**, **camera car**.

camera move A camera move refers to any combination of **motion** using **pan**, **tilt**, **roll**, **dolly**, **truck**, **boom**, and **zoom**. A shot in which the **camera** performs a move is called a **moving shot**. Also called **camera motion**.

camera movement 1. The area within a **physical camera** where **film** is moved into position for **exposure**. 2. See **camera move**.

Camera Operator See **Cameraman**.

Camera tilt, pan, and roll.

camera orientation The angle at which a **camera** is **position**ed, in terms of **pan**, **tilt**, and **roll**. *See image on previous page.*

camera origin The center of the **camera**.

camera original Another name for **negative**.

camera original negative Another name for **negative**.

camera pan See **pan**.

camera path A term used to describe the **curve**s representing the **camera move** of the **digital camera** within a **3D software package**. See also **camera path animation**, *image under* ***path animation***.

camera path animation A **path animation** technique in which the **digital camera** is assigned to move along a specified **curve** in **3D space**. By modifying the **shape** of the curve, or **motion path**, the **motion** of the **camera** can be modified. *See image under path animation.*

camera point See **eye point**.

camera position See **camera angle**.

camera projection See **camera mapping**.

camera projection mapping See **camera mapping**.

camera rental house Any company that maintains and rents professional **camera** equipment.

camera report A detailed information page that documents the events occurring during the **filming** of each **take**. Generally, the information includes the **production** name, key **Crew member**s, the **camera settings**, **light position**s and types, a description of each take, the **film roll** number, the **location**, and the date and time. Camera reports can also be used to specify special **timing** request to the **lab** as well. Sometimes also referred to as a **dope sheet**.

camera right The right side of the **camera** from the viewpoint of the **Camera Operator** and, therefore, the right side of the **screen** from the audience perspective. For the actor facing the camera, camera right is to the actor's left. Opposite of **camera left**.

camera roll 1. See **roll**—Definition #1. 2. The specific roll of **film** used during **shooting** various **scene**s throughout the day.

camera settings A general term describing all the factors that contribute to the **setup** of the **camera**, such as its **position** and angle relative to the **scene**, **lens**, **stop**, and **focus**.

camera shake 1. The unwanted **jitter** of **captured** **image**s as a result of an **unsteady** camera, wind, or an unstable **camera mount**. 2. An **image process** technique that applies **noise function**s to the **animation curve**s of a series of images to mimic the physical effects that can cause a camera to shake. For example, camera shake was added to the **composite**s in *Apollo 13* during the launch **sequence** to simulate the effect that a rocket launch would have on its surrounding environment.

camera shutter The rotating disk in the **camera** used to prevent **light** from entering the camera while each **frame** of **film** is pulled into the **film gate** for **exposure**. See also **variable shutter**, **fixed shutter**.

camera space See **camera coordinate system**.

camera speed The rate the **film** moves through the **camera** during **filming**. Also called **speed**. See also **frames per second (FPS)**.

camera stabilization The **steadiness** of the **image**s **captured** by a **camera**. When a camera is not properly **stabilize**d, the **unsteadiness** of the images can be smoothed out with **image stabilization** techniques.

camera tape The cloth tape used by the **Film Crew** to make labels and seal **film can**s.

camera tilt See **tilt**.

camera track 1. For a type of **camera move**, see **track**. 2. To extract a camera move from a **plate**, see **2D tracking**, **3D tracking**.

camera truck 1. Another name for **dolly**. 2. A large truck used to store and transport all the **camera** equipment required for **location shooting**.

camera viewfinder See **viewfinder**.

camera viewpoint The location of the **camera**.

camera window See **viewing windows**.

can See **film can**.

Canadian Society of Cinematographers (CSC) The British version of the **American Society of Cinematographers (ASC)**. See also **British Society of Cinematographers (BSC)**.

candela See **footcandle**.

candle power See **footcandle**.

canted angle Another name for **dutch angle**.

canted shot A **shot** that contains a **dutch angle**.

CAPS Abbreviation for **Computer Animation Production System (CAPS)**.

capture 1. To record an **image** on a **camera** or **scanner**. 2. See **screen grab**. 3. To record **data**.

capture buffer An area of **computer memory** that stores incoming **data** until it can be **process**ed. See **buffer**.

Cardinal See **Cardinal spline**.

Cardinal curve See **Cardinal spline**.

Cardinal patch A **patch** defined by **Cardinal curve**s.

Cardinal spline A specific type of **interpolating spline** in which the **curve segment** crosses directly through all but its first and last **control point**s. **Cardinal curve**s do not use true **end point interpolation**, but many **3D software package**s will automatically insert extra **point**s so the curve will extend out to its **end point**s. See also **B-spline**, **Bézier spline**, **NURBS**.

Carpal Tunnel Syndrome (CTS) A type of **repetitive strain injury (RSI)** that causes the soft tissues around the hand and wrist areas, such as the nerves and tendons, to swell due to overuse, injury, friction, or fracture. However, unlike most areas of the body where swelling can simply protrude, the swelling in this area has no place to expand, because it is encircled by bones and ligaments. Because the swelling is contained, pressure builds around the area and crushes the main nerve to the hand, causing it to function improperly. The symptoms of Carpal Tunnel include fatigue, pain, numbness, stiffness, and swelling in the hands and wrists. It is often caused by long hours of typing on a **keyboard** and operating a **mouse**.

Cartesian coordinates The location of **data**, represented by **coordinate**s, as defined by the **Cartesian coordinate system**.

Cartesian coordinate system A **coordinate system** in which a **point** can be located in either **2D** or **3D space** in terms of its distance from any two or three **axes** that are at right angles to each other. Since any two axes in a coordinate system can be defined by a **plane**, the three basic planes used in the Cartesian Coordinate System are the **XY plane**, **XZ plane**, and **YZ plane**. See also **right-handed coordinate system**, **left-handed coordinate system**. *See image on following page.*

Cartesian robot system A type of **motion control rig (MOCO rig)** that only allows for **translation**s along straight lines, as opposed to the

The precise location of **points** defining a **cube** in the **Cartesian coordinate system**.

boom/swing system that can travel in arcs. See also **gantry system**, **mechanical concept system**.

cascading menu A type of **pulldown menu** in which additional **menu** choices are indicated with an arrow and appear to the right of the main menu.

case sensitive A **computer program** that can distinguish between upper- and lower-case letters.

cassette The case that surrounds and protects **magnetic tape**.

Cast and Crew A global term used to describe all personnel working on a **film**, from actors to **production** personnel.

cast shadow 1. An **object** whose **light source** is occluded by another object is said to have a cast shadow. Two methods used to cast shadows in **computer graphics (CG)** are **ray tracing** and **shadow depth map**s. 2. A **compositing operation** used to simulate true **3D** cast shadows by applying a **reposition**, **blur**, and **color correction** to the **alpha channel** of an **image** and compositing it under the original image to create a shadow effect.

cat Abbreviation for **concatenation**.

catalog A **directory** of **file**s on a **computer**.

Caterer The people responsible for supplying the meals for the **Cast and Crew** during **location** and **set** shoots. See also **Craft Service**.

Cathode Ray Tube (CRT) The picture tube found in most television and **computer display**s. A thin beam of electrons is swept from side to side and from top to bottom to hit every point on the **screen** and form an **image**. See also **liquid crystal display (LCD)**.

Catmull, Ed Dr. Ed Catmull is one of the most significant contributors to the **computer graphics (CG)** industry. His many achievements include the development of **texture mapping**, **hidden surface removal** with a **Z-buffer**, **Catmull-Rom spline**s, and the **subdivision** of **surface**s.

Catmull-Rom patch A **bicubic patch** defined by **Catmull-Rom spline**s.

Catmull-Rom spline A **curve type** that **interpolate**s all its inner **control point**s but not its **end point**s.

caustic lighting A filtering of **light** intended to simulate the effects of light passing through water.

CBB See **could be better (CBB)**.

CBD See **could be different (CBD)**.

CC Abbreviation for **color correction (CC)**.

CCD Abbreviation for **charged coupled device (CCD)**.

CCD array The **2D array** of **CCD** chips used for **image capture** in **video camera**s and **scanner**s.

CC filter Abbreviation for **color correction filter (CC filter)**.

CCIR The regulatory body of the United Nations that sets standards and makes recommendations for all forms of communications.

CCIR 601 See **4:2:2**, **D1**.

CD Abbreviation for **compact disc (CD)**.

CD burner Abbreviation for **compact disc burner (CD burner)**.

CD-I Abbreviation for **compact disc interactive (CD-I)**.

CD-R Abbreviation for **compact disc recordable (CD-R)**.

CD-ROM Abbreviation for **compact disc read only memory (CD-ROM)**.

CD ROM drive The **device** that can read a **CD-ROM**.

cel Abbreviation for **cellulose**. See **animation cel**.

cel animated feature A **feature film** whose imagery was created entirely or partially with **cel animation**. See also **live action feature**, **CG animated feature**, *Color Plate 32*.

cel animation The process of photographing a **sequence** of **image**s drawn on individual **cel**s that are stacked to create continuous **motion** when played back quickly. See also **animation cel**s, *Color Plate 32*.

Celco Abbreviation for Constantine Engineering Laboratories, Co. A company that manufactures a line of **CRT film recorder**s. See **Celco film recorder**.

Celco film recorder The trade name for a **CRT film recorder** from **Celco**.

cell See **menu field**.

cel level The individual **animation cel**s that are combined together to make up a complete cel.

cell noise An alternative to **fractal noise** as a **procedural texture** generation method.

cell side The **base** or **cellulose** surface of a strip of **film**.

cellulose See **cellulose acetate**, **cellulose nitrate**.

cellulose acetate The material attached to an **acetate-based film**.

cellulose nitrate The highly unstable material attached to **nitrate-based film**s that has been replaced by **acetate-based film**s.

center extraction A term used to describe any process, such as **masking** or **crop**ping, used to extract a centered portion of the original **image** for its final **viewing format**. See also **common topline**.

center matte Referring to the center portion of a **matte**. Also called **fill matte**. See also **edge matte**.

center of interest 1. The portion of the **scene** that attracts the greatest viewer attention and dominates the action. 2. Synonymous with **camera interest**.

central computer See **mainframe computer**.

central processing unit (CPU) The portion of the **computer** that interprets and **execute**s sets of instructions. CPUs are used during **batch processing** and **rendering** to calculate their **data**. Also called a **processor**, **proc**.

centroid The center of **mass** in an **object**.

CG Abbreviation for **computer graphics (CG)**.

CG animated Any **element** that was created and **animate**d on a **computer**.

CG animated feature See **CG feature**.

CG Animator Any artist who uses a **computer** to animate **Digital Character**s or other **object**s. Also called a **Digital Animator**. See **Character Animator**.

CG Artist Another term for **Digital Artist (DA)**.

CG camera The **camera view** that is used by a **software package** for **rendering**. See **digital camera**.

CG character See **Digital Character**.

CG element Any **image** that has been created entirely on the **computer**. *See Color Plates 22, 38–40, 42–49, 61–63.*

CG facility See **digital effects facility**.

CG feature Any **feature film** created entirely with **computer graphics (CG)**, such as *Toy Story* or *Antz*. Also called a **full CG feature**, **CG animated feature**. See also **cel animated feature**, **live action film**.

CG generated Referring to any **image** or **data** that was created on the **computer**.

CG house See **digital effects facility**.

CGI Abbreviation for **computer generated imagery (CGI)**. Also referred to as **computer graphics (CG)**.

CG image See **CG element**.

CG Lead A global term referring to any artist who holds a lead or supervisory position in a particular area, such as **animation**, **lighting**, **effects**, or, **compositing** or who is responsible for an entire **sequence**. See also **Sequence Supervisor**, **Animation Lead**, **Effects Lead**, **Lighting Lead**, **Compositing Lead**.

CG lens flare Any **lens flare** that is created with a **computer** using a particular **software package** or **program**. See also **spherical lens flare**, **anamorphic lens flare**, *Color Plates 27–29*.

CG lighting The process of **position**ing and **color**ing **light**s for a **CG scene**.

CG model Referring to any **geometry** created with a **3D modeling package**.

CG Producer Abbreviation for **Computer Graphics Producer**. See **Digital Effects Producer (DFX Producer)**.

CG shot 1. A **shot** whose **element**s are created entirely in the **computer**. 2. A shot that requires the creation of **CG element**s to be **composite**d with **live action plate**s.

CG studio See **digital effects facility**.

CG Sup Abbreviation for **Computer Graphics Supervisor (CG Sup)**.

CG Supervisor Abbreviation for **Computer Graphics Supervisor (CG Sup)**.

CG work Abbreviation for **computer graphics work**.

chain See **skeleton chain**.

Chainer A term often used synonymously with a **Character Setup Technical Director (Character Setup TD)**, although a Chainer describes an artist who focuses completely on the creation of the **IK skeleton**, whereas a Character Setup TD focuses on all aspects of **character setup**.

chaining See **character setup**.

Chalice A **compositing software** developed by Silicon Grail.

change-over 1. The process of changing from one **projector** to another, preferably without interruption of continuous **projection**. 2. See **change-over cue**.

change-over cue The small marks placed in the corner of a **frame** on the **release print** to alert the **Projectionist** to the approaching end of the **reel** and to turn on the second **projector** in preparation for the upcoming **change-over** of projectors and **film roll**s. The first mark, called the **motor cue**, indicates that the second projector should be turned on, and the second mark indicates that the actual change-over should take place. Also called **change-over mark**, **reel change mark**.

change-over mark See **change-over cue**.

change pages When there are changes made to a **script** during **production**, the new pages are distributed on different color pages. The new pages typically include the date of the changes and an asterisk in the margin next to the lines that have been modified.

changing bag The lightproof cloth bag used for loading and unloading **film** in the absence of a darkroom. Also called a **black bag**. See also **changing tent**.

changing tent Same concept as a **changing bag**, except that the changing tent forms a dome shape over the **film** during loading and unloading.

channel 1. In **computer graphics (CG)**, the mathematical **data** or **curve** representation that describes the **transformation**s and **attribute**s of an **object** or **element**. 2. A **digital image** is, generally, broken down into 4 distinct **color channel**s, representing the **red (R)**, **green (G)**, **blue (B)**, and **alpha channel**s. 3. In **channel animation**, the link between the **input device** and the **animation parameter** that it controls. 4. In **motion control (MOCO)**, the stored **motion** information. 5. For **sound track**s, one of the individual frequencies carrying sound.

channel animation A **motion capture (MOCAP)** technique in which an **animation** is created in **real time** through the manipulation of one or more **input device**s. For example, a **mouse** can be used to generate **X** and **Y** locations in space based on the **position** of the mouse. Any **horizontal** motion can generate the **X translation**s, and any **vertical** motion can generate **Y translation**s. The link defined between the input device, in this case the mouse, and the **animation parameter**s, X and Y translation, is called a **channel**. The mouse in this example is the **device driver** through which motion **data** is input and output.

channel array A set of **value**s containing one number for each **frame** of **animation**.

channel swapping An **image operation** that can **swap** the **channel** order of an **image** or move specific channels between two different images. Also called **reorder**, **shuffle**.

channel values The **color value**s contained in the four **channel**s of an **RGBA image**.

character 1. Referring to any actor, regardless of whether he is human, hand-drawn, or **computer generated**. See **Digital Character**. 2. The combination of qualities and features that distinguishes one **subject** from another. See **character animation**. 3. See **ASCII characters**.

character animation To **animate** an **object**, using any number of **animation** techniques, in order to give it personality and to appear alive and fluid in **motion**. *See also Color Plates 47, 56–57, 61–63, 67.*

Character Animation Department The group of **artist**s who primarily focus on **character animation** at a **facility**.

character animation setup See **character setup**.

Character Animation Supervisor See **Animation Supervisor**, **Animation Director**.

Character Animator An artist who specializes in creating motion for **Digital Character**s. Many Character Animators come from **traditional animation** and are trained to work with a specific piece of **3D software**. Depending on the size and scope of the **project**, a Character Animator might report to an **Animation Lead**, **Animation Supervisor**, or an **Animation Director**. Also referred to as **CG Animator**, **Digital Animator**, **Animator**.

characteristic curve A **curve** that plots the change in **density** of a **negative** as the amount of **light** falling on the **film**, or the **exposure**, is increased. This curve is used to predict how different **film stock**s will respond to different lighting conditions.

character design **2D** and **3D** renderings used to establish the **character**s of a **film**. Character designs are typically created by **Character Designer**s and **Character Animator**s.

Character Designer Any individual whose specialty lies in the design of **character**s for a **film**. Character Designers work in a wide variety of media, including pencil, paint, clay, and **computer graphics (CG)**.

character generator A **device** that electronically generates **text**, called **super**s. Used most often to **superimpose** text over a **video image**.

Character Lead See **Animation Lead**.

character models 1. The drawings, paintings, and **render**ings used to establish the look and feel of the characters of a **film**. For **cel animation**, once a **character** model is approved, Xeroxed copies, called **model sheet**s, are sent to each department to ensure drawing and **color** consistency between all the artists working on the **project**. See **character design**, **concept art**. 2. The **3D model**s used to create **character animation** in the **computer**.

character set See **ASCII character set**.

character setup This is the process in which a **3D model**, the **geometry**, is prepared so that a **CG animator** can begin the process of **animation**. It includes the creation of **IK structure**s, **shape targets**, **enveloping**, **point weighting**, **lattice box**es, **point clusters**, **procedural effects**, and mathematical **expression**s, to name a few. The animation setup is a very iterative process throughout the **development** stage and well into the **production** phase because as **Animator**s push the **model** to create the range of **motion** required, they discover features that need to be added, fixed, altered, or removed. A 3D model that is not properly set up during this phase will con-

tinually **break** during production when it cannot handle the requirements needed to achieve the goals of the **shot**. Also referred to as **animation setup**, **character animation setup**, **physiquing**, **rigging**, **chaining**. See also **muscle system**, *Color Plate 38, 39.*

Character Setup Supervisor The individual responsible for the **setup** for all **Digital Character**s and **model**s. His team of **Character Setup TD**s are responsible for the **skeleton**, **deformation**, and **skinning** requirements for each model based on the **motion** requirements defined by the **Director** and **Animation Director**. Also called **Animation Setup Supervisor**, **Motion Setup Supervisor**, **Character Supervisor**.

Character Setup TD See **Character Setup Technical Director (Character Setup TD)**.

Character Setup Technical Director (Character Setup TD) An artist who creates the **character setup** for **digital character**s so they can be **animate**d by a **Character Animator**. Also called **Motion Technical Director (Motion TD)**, **Animation Technical Director (Animation TD)**, **Rigger**, **Chainer**, **Technical Animator**.

Character Supervisor See **Character Setup Supervisor**.

Character TD See **Character Setup Technical Director (Character Setup TD)**.

Character Technical Director (Character TD) See **Character Setup Technical Director (Character Setup TD)**.

charge-coupled device (CCD) A **light**-sensitive semiconductor chip used in **scanner**s and **video camera**s for temporary **image capture**. When the CCD is struck by light, the **color** and **brightness** information is converted into **binary number**s that can be interpreted by the **computer**. CCD chips store **data** in a **linear** format and as a result **capture** a narrower range of **contrast** information than **film**, which stores data **logarithmic**ally and can more accurately represent **highlight**s a thousand times brighter than the lowest recorded **shadow** tones.

chatter An **image artifact** in which the **edge**s of an **element** do not remain stable over time. This is most often due to misaligned **articulated matte**s or **tracking curve**s or **image**s **capture**d with an **unsteady** camera. Also referred to as **chewing**, **crawling**.

cheat 1. For **digital**, see **workaround**. 2. During **filming**, the slight adjustment of the positions of the **subject**s and/or **prop**s in a **scene**, when shooting a second **shot** from a different **camera angle**, in order to improve the new **shot composition**. In most cases, the difference in the **perspective**

and angle of the two shots hides the fact that everything is not exactly in the same place as in the previous shot.

check box A group of options presented in a list that allows the **user** to check off which options to make **active** or to **disable**. Most check boxes offer only two states, such as on or off, so rather than requiring the user to input a specific **value**, the check box is simply put into its "on state" or "off state" via a **software specific** indicator, such as a check mark, **highlight, color**, or **shape** change. See also **button, push buttons, radial button**s.

checkerboard assembly See **checkerboard cutting**.

checkerboard cutting An **editing** method used to assemble alternate **scene**s of **negative** on **A/B roll**s that allows **print**s to be made with **invisible splice**s. See **A/B printing**.

checkerboarding See **checkerboard cutting**.

Chernobyl packet A **packet** that can induce a **broadcast storm** and/or **network meltdown** on a **system**. Named after the 1986 Chernobyl nuclear accident.

chewing See **chatter**.

Chief Lighting Technician See **Gaffer**.

child An **object**, **node**, or **element** whose **attribute**s and/or **transformation**s are controlled by a **parent** in a **hierarchy**. A child can be a parent to other **children**. See also **parenting**.

child process A **process**, created by a **parent process**, that can create multiple child processes but will have only one parent process. A child process in **Unix** is created by using **fork** as a **copy** of the **parent**. See also **process identifier**.

child program Any **program**s that are loaded into **memory** by the **parent program**.

children A group of **object**s, **node**s or **element**s whose **attribute**s and/or **transformation**s controlled by a **parent** are said to be the "children" of the parent object. For example, in a **3D model** of a car, the tires are children of the car body. When the car body moves forward, the tires move with it. However, the tires are free to have their own unique transformations to spin around.

chinese angle Another name for **dutch angle**.

chip See **computer chip**.

chip chart See **color chart**.

choker close-up Shorthand for **choker close-up shot**.

choker close-up shot Another name for **tight close-up shot**.

choose See **select**—Definition #1.

chroma The intensity of **color** in an **image**. See **saturation**.

chroma key A **matte extraction** technique that separates a **subject** from its **background (BG)** based on a **color** that is unique to either the **foreground image** or background **image**. In a **bluescreen key** or **greenscreen key**, the best results are obtained with a **key** color that contains strong **chroma**, or purity of color. Some **software package**s allow the **user** to define not only a specific **hue** range but also a specific **saturation** and **luminance** range as a means of increased control over the resulting **matte**. However, chroma keying should not be confused with a **color difference key**. See also **luminance key**, *Color Plates 17–20, 54–55*.

chroma signal The **signal** that carries **color** in television.

chromatic aberration Referring to the shifting of **light** across the curvature of a **camera lens**. Most noticeable in **wide-angle lens**es, the **artifact** appears as a slight shifting of the **RGB components** along sharp **edge**s of the **scene**.

chromatic color Refers to the spectrum of **color**s in a rainbow.

chromatic purity The absence of **white** in a **color**, which creates a vivid **hue**.

chromatic resolution Another name for **color resolution**.

chrominance The **color** portion of a **video signal** carrying **hue** and **saturation** information. **Luminance** information is required to make it visible. **black**, gray, and **white** have no chrominance, but all color signals contain both chrominance and luminance.

chrominance signal The portion of the **video signal** that contains **color**.

CIE Abbreviation for the **Commission Internationale de L'Eclairage (CIE)** or, in English, the International Commission on Illumination. This group is an international standards committee that develops color matching systems.

cinch marks The small scratches running parallel to the length of a strip of **film** that are caused when a loose **roll** of film is tightened and the two film surfaces slide against each other.

Cinemascope A **35mm film** format that uses an **anamorphic lens** to squeeze its captured **image**s by 50 percent horizontally in order to **capture** a wider **field of view (FOV)**. Another special **lens** is then placed on the **projector**

that unsqueezes the image projected back onto the **screen** to carry an **aspect ratio** of **2.35:1**. The actual **image area** captured on **film** is equal to .864″ × .732″. Also referred to as **C-scope**. See also **Superscope, Techniscope**.

Cinematographer An individual who is experienced in the art of capturing **image**s on **camera**. The main Cinematographer for a **film** is the **Director of Photography (DP)**.

cinematography The art and science of capturing **image**s on **film**.

Cineon 1. See **Cineon file format**. 2. See **Cineon FX**.

Cineon file format The most common **image format**, developed by **Kodak**, used to store and represent **image**s **scan**ned from original **film** for **visual effects work**. **Cineon** images are stored in a **nonlinear color space** and, most commonly, contain **10 bits per channel** for the three **channel**s of **red (R)**, **green (G)**, and **blue (B)** that are represented as a **32-bit image**. This particular **color space**, sometimes referred to as **density space**, was designed to reproduce as closely as possible the manner by which **film negative** responds to the amount of **light** hitting it in terms of **density**.

Cineon format See **Cineon file format**.

Cineon FX A **compositing software** developed by **Kodak**.

Cineon Genesis film scanner A high-resolution **film scanner**, formerly manufactured by **Eastman Kodak Company**, that offers pin registered **step scanning** for various **film format**s using a three-**color array** of **CCD** image sensors. The Genesis offers Oxberry shutter-style movements for **film** transport, in which two metal plates lift the film on and off the register pins to allow the **pulldown claw** to pull the film into its next position. See also **Imagica film scanner, Oxberry film scanner**.

Cinespeed A **program** offered in the **Cineon** compositing **software** that offers a way of modifying the length of a **sequence** of **frame**s by subtracting or adding frames. Unlike most systems that use **frame averaging** that often results in soft images and **ghosting** artifacts, Cinespeed uses a complex **algorithm** that analyzes the **edge**s of the **object**s in the **scene** and then builds new frames accordingly. This method creates **sharp**er images than the traditional frame averaging approach.

cinex strip Another name for an **exposure wedge**.

circle A **planar** object that is equidistant from a given **point of origin**. See **geometric primitive**.

circle of confusion The size of the circle formed by the **camera lens** on the **image** where rays of **light** will **converge**. The smaller the **circle**, the less confusion of **blur** and the **sharp**er the image.

circled takes See **printed takes**.

circuit board The thin panels that hold electronic components and circuits that are located in a **computer**.

circular polarizer 1. For **filming**, a type of **filter** used to reduce glare and **reflection**. 2. For **stereo films**, the filters used in **polarized glasses** to transform **light rays** passing through them into a series of ovals. Unlike **linear polarizers**, the **viewer** can rotate their head more without a significant increase in **ghosting**. However, because the **light** cancellation is not as effective, circular polarizers introduce more overall ghosting than do **linear** polarizers.

circumference The length of the **line** that encloses a curved **plane**, such as a **circle** or **sphere**.

clamp 1. An **image process** that limits **pixel value**s within a specific range. **Value**s above or below this range will be forced to fit within the new values. See also **expand**. 2. To restrict an **attribute** within a defined limit. See also **constraint**.

clamping value The range of numbers to which the resulting **pixel value**s of a **compositing operation** are restricted or **clamp**ed.

C-language syntax See **C-like syntax**.

clapboard A special type of **slate** with a pair of hinged boards that are photographed while being "clapped" together at the start of each **take** as a record of **image** and **sound** synchronization. Also called **clapsticks**.

Clapper 1. See **clapboard**. 2. See **Clapper/Loader**.

Clapper/Loader The member of the **Camera Crew**, typically the **Assistant Cameraman (AC)** or **Second Assistant Cameraman (2nd AC)**, who handles the **clapboard** for each **shot** and loads **film** into the **film magazine**s. Also called **Camera Loader**.

clapper board See **clapboard**.

clapsticks See **clapboard**.

clay animation A **stop-motion animation** technique in which clay models are physically sculpted, **position**ed, and **photograph**ed for each **frame** of **animation**.

Claymation The trademarked name, owned by Will Vinton Productions, for their **clay animation** technique.

clean boot To start the **computer** and **load** only the main portion of its **operating system (OS)**.

clean plate 1. A **plate**, usually using **bluescreen** or **greenscreen photography**, that differs from the **background plate** only in that it does not contain the **subject** in the **frame**. Clean plates are used to extract **difference matte**s. 2. A plate shot on **location** that requires **rig removal**, **wire removal**, or other **paint**-fixing techniques to remove and replace some unwanted portion of the frame. This application works only if the **camera** is **locked off** or if **motion control (MOCO)** is used to ensure repeatable **motion** across different **pass**es.

cleanup For **cel animation**, the step in which the **rough animation** is refined and drawn with more detail. These sketches are the final stage of **animation** before going to **color model**.

click The action of pressing and releasing a **button** on a **pointing device**, such as a **mouse**, in order to select or activate an item **display**ed by the **graphical user interface (GUI)**. See also **point**, **drag**, **right click**, **middle click**, **left click**.

click and drag The action of grabbing an item on the **computer screen** and moving it to another location on the **screen** with a **pointing device**.

client A **computer process** that makes requests of another **computer**, known as a **server**. See **client-server**, **protocol**.

client-server A system in which a **software application** is split between its **server** and **client** tasks. The client sends its requests to the server, based on a **protocol**, and asks for information or a specific **action**, and the server responds.

C-like See **C-like syntax**.

C-like syntax Referring to any **programming language** that is similar in form to the **C programming language**. Also referred to as **C-like**, **C-language syntax**, **C-syntax**.

clip 1. A continuous **sequence** of **frame**s. See **film clip**, **video clip**, **audio clip**. 2. See **clipping**.

clipboard A temporary storage area to hold information for **copy**, **cut**, and **paste** operations. Also called **copy buffer**, **cut buffer**, **paste buffer**.

clipping 1. In **digital image**s, any **data** that is removed or lost when it is above or below a defined **threshold**. This technique is often used to increase or decrease the **contrast** of an **image**, by "clipping" its **black** and **white** levels. 2. In **geometry**, the portion of the **object** that is removed from view if it falls outside a defined **clipping plane** or **pyramid of vision**. See **far clipping plane**, **near clipping plane**. 3. For **video**, to electronically cut off the peaks of either the white or black portions of the **video signal**.

clipping plane A **plane** that is parallel to the **digital camera** and is used to define the boundaries within a **3D environment** that should be used for **view**ing and **rendering** calculations. The **parameter**s commonly used to define the area of the clipping plane are **hither** (**near**) and **yon** (**far**).

clobber To **overwrite** a **file**, usually unintentionally.

clone 1. To make a **duplicate** of a particular **node**, **object**, or **element**. 2. In **digital paint**, **to copy**, **offset**, and paint with a portion of the **image** to repair **artifact**s such as dust and scratches. 3. A **computer** designed to imitate a brand name computer and sold at a lower price. See **PC clone**. 4. In **digital compositing**, to **cut and paste** portions of images together to enhance a **shot**. **Crowd duplication** is a good example of using cloning techniques. 5. To make a duplicate of a **tape**.

close 1. See **closed curve**. 2. A **window** is **stow**ed or closed by temporarily shrinking the window and **display**ing it as a small **icon**. It can be **open**ed again by **click**ing on the icon. Closed **application**s continue to **run**. Also called **minimize**. 3. To write a **file** to **disk**. 4. To exit a sessions with a **software application**. See also **open**.

closed-captioning A **device** that **display**s the dialog of a **film** or television **show** on the **screen** for deaf or hearing-impaired **viewer**s.

closed curve A **curve** whose starting and ending **point**s are at the same location, such as in a **circle**. Opposite of **open curve**.

closed object An **object** whose **surface**s can be seen from only one side, generally, the "inside" or "outside" of that object.

closed polygon A **polygon** whose start and **end point**s are at the same location. Opposite of **open polygon**. *See image on following page.*

closed set A **set** on **location** or in a **studio** that is not open to any visitors or to **Cast and Crew member**s not directly involved in the **filming** of that **scene**. See also **hot set**.

closed surface See **closed object**.

Open Polygon Closed Polygon

closed window A **window** on the **computer screen** that is **iconified** and cannot be worked within. Opposite of **open window**.

close-up (CU) Shorthand for close-up shot. A **shot** that **film**s the **subject** within the ranges from midway between the waist and shoulders to above the head (**medium close-up shot**), from just below the shoulders to above the head (**head and shoulder close-up**), the head only (**head close-up**), or from just below the lips to just above the eyes (**choker close-up**). See also **extreme close-up (ECU)**.

close-up lens A supplementary **lens extender** that is placed in front of the **normal lens** in order to achieve **extreme close-up (ECU)** shots. Also called a **diopter lens**.

closing down the lens Turning the adjustment ring on the **lens** to a higher **f-stop** number to create a smaller opening and as a result allow less **light** to strike the **film**. Opposite of **opening up the lens**.

cloth simulation A **computer graphics (CG)** technique used to simulate the realistic **motion** of cloth.

cloud tank A large glass-enclosed tank of water used to **film** clouds, atmospheric effects, and underwater **miniature**s. The "clouds" are created by injecting a white, opaque liquid into the water in a controlled manner.

cluster 1. See **point cluster**. 2. See **block**—Definition #2.

cluster animation See **point cluster animation**.

cluster deformation See **point cluster deformation**.

cluster fk** A term used to describe what some **project**s can become when they are not properly planned!

CLUT Abbreviation for **color lookup table (CLUT)**.

CMY Abbreviation for **cyan**, **magenta**, and **yellow**. See **CMY color model**.

CMY color model A **subtractive color model** that mixes the three **complementary colors** of **cyan**, **magenta**, and **yellow** to represent the **color** properties of **reflected light**. Mixed equally, **green (G)** and **blue (B)** make cyan, **red (R)** and blue make magenta, and red and green make yellow. See also **CMYK color model**.

CMYK Abbreviation for **cyan**, **magenta**, **yellow**, and **black**. See **CMYK color model**.

CMYK color model Essentially the same model as the **CMY color model** except that it introduces **black** into the mix. This model is commonly used for printwork because black ink is cheaper to use to create dark colors instead of mixing the more expensive **CMY** colors.

coaxial cable A **cable** used in high-frequency **data** transmission such as an **ethernet** connection.

code 1. The language the **computer** can **read**. See **machine code**. 2. The set of instructions that make up a **computer program**. See **source code**.

code numbers See **edge code**.

coding The process of writing **code** for a **program**.

coding machine A machine, such as the **Acmade**, that inks **edge numbers** onto the edge of **film**. Also called a **numbering block**.

cold boot Synonymous with **hard boot**. Also called a **cold start**.

cold fault An **error** that occurs immediately after starting a **computer**.

cold start Synonymous with **hard boot**. Also called a **cold boot**.

cold swap To remove or replace a component of a **computer** while the power is off. Opposite of **hot swap**.

collision 1. See **collision avoidance**. 2. See **collision detection**.

collision avoidance A technique used to prevent the **object**s in a **scene** from colliding into one another by automatically calculating a **path** for each object that avoids **collision**s with all other objects. See also **collision detection**, **flocking**.

collision detection A technique that calculates when different **object**s in a **scene** occupy the same space and, as a result, alters their **position** or behavior so that they no longer collide with one another. For example, a **sphere** can be used as the **collision object** used to prevent an eyelid from crashing into an eye. For **animation** purposes, collision detection is often used in conjunction with **motion dynamics** to control the way an object behaves when it collides with another. For instance, if the **ground plane** is the collision object for a ball, then the ball will bounce back up in the air when it contacts the floor. *See also Color Plate 63.*

collision object Any **object** that is used in **collision avoidance** and **collision detection** techniques to control the behavior of other objects that come into contact with it. In some cases, a **bounding box** or **bounding sphere** can be used as the collision object as a means of reducing high calculation times resulting from **high-resolution** collision objects.

color 1. The visual perception of the quality of a **surface** caused by **reflected light** and generally expressed in terms of **hue**, **saturation**, and **brightness**. 2. For **digital**, color can be defined by the **component**s of **ambient**, **diffuse**, **specular**, **transmit**, and **emit**. 3. See **primary colors** 4. See **subtractive primary colors**. *See also Color Plate 3.*

color balance 1. To balance all the **element**s in a **digital composite** together so the combined **image** looks natural and believable and intercuts seamlessly with **surrounding shot**s. See also **color correction (CC)**. 2. A **film** in which all **scene**s have been properly balanced for **color continuity**. See **color timing**. 3. The way in which a color **film stock** is able to reproduce the colors of a scene. Color films are designed to be **expose**d by **light**s of certain color qualities, such as **daylight** or **Tungsten**. 4. For a **video signal**, the process of matching the **amplitude**s of the **RGB** signals so their combined mixture makes an accurate **white**.

color banding See **banding**.

color bars Standard **test pattern**s used in **video** to determine the quality of a **video signal**. Color bars consist of equal-width bars representing **black**, **white**, **red**, **green**, **blue**, **yellow**, **cyan**, and **magenta**. These colors are

generally represented at 75 percent of their pure **value**. Colors bars are often accompanied by a matching length of **alignment tone**, and when combined, they are referred to as **bars and tone**. The most common color bar standards used include **100% color bars**, **75% color bars**, and **SMPTE color bars**. *See Color Plates 8–10*.

color bits The **bit**s mapped to each **pixel** in a **raster display** that define the **pixel color**.

color bracketing See **color wedge**.

color burst A **color** reference inserted during the **blanking interval** of a **video signal** to **decode** color information in the active **image**.

color calibration The adjustment of a **display device** to display **color**s as closely as possible to the way they will appear in their final **viewing format**. Also called **monitor calibration**.

color channel A **digital image** is generally broken down into four distinct color **channel**s, representing the **red (R)**, **green (G)**, **blue (B)**, and **alpha channel**s. In a **32-bit image**, each of the four channels can be represented by **8 bit**s or 256 color levels, thus making it an **image** with 8 bits per color channel.

color chart A chart containing various standard **hue**s and/or **gray value**s that is filmed at the **head** of each **roll** as color reference for the **lab** to develop and process the **film**. Also called a **color scale**, **chip chart**. See also **Macbeth chart**, **18% gray card**.

color checker See **Macbeth chart**.

color chooser See **color picker**.

color circle Synonym for **color wheel**.

color compensation filter See **color correction filter**.

color contamination A term used to describe a **backing color**, such as **bluescreen (BS)** or **greenscreen (GS)**, that is not pure and is contaminated with one of the other **primary colors**. Color contamination can make the job of **matte extraction** much more difficult. See also **color spill**.

color continuity **Color** continuity refers to the portrayal of color and look across a **motion picture** that transitions smoothly from **scene** to scene.

color conversion filter See **color correction filter**.

color correct See **color correction (CC)**.

color correction (CC) A global term referring to any technique used to adjust the **color** of **video**, **film**, or **digital image**s. Sometimes used synonymously with **color timing**, **color grading**.

color correction curve Any curve used to adjust the **color** of the individual **element**s that make up a **composite** or an entire **image** as a whole. Also called a **timing curve**.

color correction filter A **filter** of one of the **primary** or **complementary colors** used to adjust the **color temperature** of the **camera** or **light**s on the **set**. Also called a **CC filter**, **color conversion filter**.

color curve See **color correction curve**.

color cycle An **image operation** in which a range of **color**s are continuously changed and repeated across a series of **image**. An example for such a technique would be for the creation of a neon sign that continuously **animate**s.

color depth Synonymous with **bit depth**.

color difference key A **matte extraction** technique used to separate a **subject** from its **background (BG)** by using **color** differences that exist within the **color channel**s. This process, like **bluescreen (BS)** and **greenscreen (GS)** extraction, relies on the **foreground (FG)** subject to contain minimal amounts of the **background (BG)** color against which they are photographed. For example, if we are working with a **bluescreen plate**, the first step in color difference keying is to **suppress** the blue **backing** to **black** by selectively replacing the **green channel** for the **blue channel** in every **pixel** where the **blue (B)** component is higher in **intensity** than the **green (G)** component. Because the green channel should contain a **value** of zero in any areas of the **image** containing pure blue, the result should be that those blue areas have been changed to black. Then by subtracting the maximum of the **red (R)** or **green component** from the **blue component**, we are left with an **inverted matte**. Also called **color difference method**. See also **luminance key**, **chroma key**, **color spill suppression**.

color difference method See **color difference key**.

color difference signal The **signal**s used in color television to convey **color** information.

color film Any **film stock** that photographs a **scene** in **color**, as opposed to **black and white film** that transforms color into various shades of gray during **processing**.

color fringing See **fringing**—Definition #2.

color grade See **color correct**.

Color Grader The artist responsible for creating the **color correction**s of the **scanned image**s to get the best possible **color** match to the **workprint** or **match clip** and, if necessary, to convert the **image**s from **log space** to **linear space**.

color grading 1. The process of **color** correcting a **digital image** to get the desired look or match to a **reference clip**. 2. The process of converting a digital image from one **color space** to another, such as converting from **log to linear**. The **grading** process is generally done by a **Color Grader** who has a good eye for color and has a thorough knowledge of color space and **film** imaging. Also referred to as **color correction**, **color timing**.

Color Grading Supervisor The individual responsible for ensuring that all the **scanned image**s are **color correct**ed to meet the technical and aesthetic requirements of the **show** and to maintain **color continuity** of all the **plate**s used. The Grading Supervisor manages a small team of **Color Grader**s and, depending on the **show hierarchy**, reports to either the **Compositing Supervisor** or **Digital Effects Supervisor (DFX Sup)**.

color image An **image** whose **RGB values** are not limited to only shades of gray. Opposite of **grayscale image**.

colorimetry A scientific method for describing **color** in terms of electromagnetic energy.

color index value A single **value** that represents a **color** rather than by its **red (R)**, **green (G)**, **blue (B)**, and **alpha component**s. When an **image** is **display**ed on a **monitor**, each color index is first read from the color **buffer** and then converted to **RGB value**s. See also **color map**, **8-bit image**.

Colorist See **Color Timer**.

colorization Any process in which **black and white film** or **image**s are **digitally** altered to include **color**.

color lookup table (CLUT) Pronounced "see-lut." A **hardware** or **software** implementation that uses a table of **value**s to **map** the **pixel value**s of the **input image** to create a new **output image**. Rather than using more traditional **color correction** techniques, a table of values is created so that every possible **input** value will have a corresponding **output** value defined. For example, various types of **monitor lookup table**s, such as a **gamma correction**, can be used to modify the **color** of the **image**s being **display**ed. See also **lookup table (LUT)**, **indexed color**.

color management A global term used to describe the process of producing consistent **color** and providing standards for **lookup table**s (**LUT**s), **color space**, **image format**s, **calibration**, and **conversion** methods used to **display** images on various **display device**s, **hardware**, and **software** within a **facility**.

color map 1. A **texture map** used to vary the **color** information across a **surface**. 2. The process of converting a **color index** value into three **RGB values** before **display**ing an **image** on a **monitor**.

color mapping 1. A **texture mapping** technique in which the **pixel values** of the texture map are interpreted as **color**s and are used to map those colors onto a **3D surface**. See also **transparency mapping**, **bump mapping**, **displacement mapping**, **reflection mapping**. 2. See **color map**—Definition #2.

color model 1. Another term for **color space**. 2. For **cel animation**, the process of adding **color** to the final drawn **animation** frames.

color palette The range of available **color**s for use on a **computer platform**. For example, a system that supports **8 bits per channel** will contain a palette with over 16 million colors.

color pass See **beauty pass**.

color phase The correct relationship of **color** within a **display device**. A color is said to be "in phase" when its **hue** is accurately reproduced when **display**ed.

color picker A **software tool** that allows a **user** to select a specific **color** from either a **palette** or from an **image**. Also called a **color chooser**. See also **pixel analyzer**.

color purity 1. The degree to which one of the three **primary colors** can be represented on a **display device** without displaying any portion of the other two **color**s. 2. A term used to describe the purity of the **greenscreen** or **bluescreen (BS)** in **photography** based on the absence of any other color.

color range The total number of **color**s that can be reproduced in an **image** or **viewing device**.

color reproduction The ability of **film stock** to reproduce the **color**s in the **scene**.

color resolution The number of **bits per channel** allocated for specifying the individual **color value**s within a **digital image**.

color reversal intermediate (CRI) A duplicate color **negative** produced by **reversal processing**.

color scale See **color chart**.

color separation Any process used in **digital**, **film**, or printwork that splits an **image** into its individual **components** of **red (R)**, **green (G)**, and **blue (B)**.

color space The method of representing the **color** of an **image**, such as **RGB** used in **digital**, **CMYK** used in printing, or **NTSC** for **video**. **HSV** and **HLS** are also examples of alternate ways to represent and modify the color of an image. Also referred to as **color model**. See also **nonlinear color space**, **linear color space**.

color space conversion The conversion of **image**s between various **color space**s, such as **HSV**, **RGB**, **HLS**, and custom color spaces such as **Cineon**.

color spill Any **light** in a **scene** that unintentionally illuminates the **subject**. For example, **bluescreen (BS)** or **greenscreen (GS)** spill on a subject will result in holes in the **matte** created during **compositing**. **Garbage matte**s and **rotoscope** techniques will usually need to be used to get a clean matte. Also referred to as **blue spill**, **green spill**. Color spill can be reduced by keeping the **foreground (FG)** subject as far away from the **backing** as possible. See also **color suppression**.

color spill suppression See **color suppression**.

color suppression An **image process** that involves selectively substituting the **value**s contained in one **color channel** into the values of another color **channel**. One popular method used is called the **color difference method** in which the **color** of the **spill** on the **foreground subject** is substituted by comparing it with one of the other color **channel**s and substituting the spill color wherever that color channel contains a higher **intensity** than the color channel against which it is being compared. The disadvantage of this technique is that color suppression will also affect all other areas of the **image** that are the same color as the **color spill** that must be suppressed. However, this can be addressed with specific **matte**s to isolate the areas that need to be affected.

color system Another term for **color model**.

color table See **color lookup table (CLUT)**.

color temperature The measurement of the **color** of **light** in **Kelvin**. The color temperature is equal to the temperature that a pure **black body** needs to be heated in order to **emit** that particular color of light. Higher

color temperatures lean more toward **blue (B)**, whereas lower color temperatures tend toward **red (R)**. The color temperature of lights used during **photography** is very important because different **film emulsion**s are designed to produce accurate colors when exposed to different lighting scenarios. See **3200 Kelvin**, **5400 Kelvin**, **6500 Kelvin**.

color texture map See **color map**.

color texture mapping See **color mapping**.

Color Timer The person responsible for adjusting the **color timing** across all **scene**s in the final print of the film. See also **Color Grader**.

color timing Any process used to **color balance** an **element**, **composite**, **sequence** of **shot**s or entire **film** so that **scene**-to-scene color continuity is maintained in the final print of the film. Often used synonymously with **color correction**, **color grading**.

color triangle A triangle of **color** used to represent the relationship between **additive primary colors** and **subtractive primary colors**. The additive colors are placed on the three points of the triangle, whereas the subtractive colors are placed along its three sides. Each subtractive color is created from the combination of the two adjacent additive colors.

color value Referring to the lightness or darkness of a **color**.

color wedge A series of **image**s that contain incremental steps in **color** of an **element** or a **composite** as a means of selecting the final **color value**. Also called **color bracketing**, **wedge**. See also **exposure wedge**.

color wheel A circular **display** of the **color** spectrum. **Complementary colors** can be found on opposite sides of a **circle**. **Hue** varies based on the angle within the circle, and **saturation** increases from the center outward. Also called **color circle**, **hue circle**, **hue wheel**. *See Color Plate 1.*

column The equally spaced vertical **line**s that make up a **surface**. Opposite of **row**. See **rows and columns**.

coming attractions See **trailer**.

command The explicit set of instructions **input** by a **user** into the **computer** to perform a task or **function**. Most commands take **argument**s from **user input** or from a **command interpreter**.

command.com The file **source**d by the **MS-DOS command interpreter** when an **IBM PC** is **boot**ed. The commands recognized by **command.com**, such as "copy" and "dir," are called internal commands.

command interpreter A **program** that **read**s and **execute**s text **command**s from a **user** or **source file**. For **Unix**, the command interpreters are known as **shells**, whereas the **MS-DOS** command interpreter is brought into **memory** from a **file** called **command.com**, which is sorted on the **hard drive** or **floppy disk**.

command language A language designed to give specific instructions to a **computer** to perform certain tasks. A command language is not as powerful as a **programming language**.

command line A mode in which an explicit set of instructions can be **input** by a **user** to **execute** a particular task or **process**.

command line argument See **command line**.

command line interface An **application** that is able to interpret **command**s. See **command interpreter**.

command line interpreter See **command interpreter**.

command line mode The mode in a **software package** that takes only text input from the **user**, as opposed to a **graphical user interface (GUI)**.

command shell See **C shell**.

command syntax The specific text **format** required to give **argument**s to a particular **program**.

Commission Internationale de L'Eclairage (CIE) The international standards committee that develops **color** matching systems. In English, it is referred to as the International Commission on Illumination. See **L*A*B color model**.

common marker The **Second Assistant Camera (2nd AC)** calls this out when using only one **slate** for slating two or more **camera**s.

common slate See **common marker**.

common topline Common topline refers to the multiple **film format**s that are used with **Super 35**, and all share the same top line of the **image area**. The idea behind the common topline is that the **Filmmaker** can shoot the **film** in a generic format and later have the option of releasing the film in any **aspect ratio** desired. The use of the common topline is intended to lessen the effect of changing aspect ratios by maintaining consistent headroom and raising or lowering the bottom portion of the **frame**. See also **center extraction**. *See images under film extraction*.

Commotion A **2D software package**, developed by Puffin Designs, Inc., for the **Macintosh** and **Windows NT**.

communication line Any **device** used to transmit **data**, such as a **modem** or **T1 line**.

comp Abbreviation for **composite**.

compact disc (CD) An **optical disk** format for storing **digital data**. Some common CD formats include **compact disc interactive (CD-I)**, **compact disc recordable (CD-R)**, **compact disc read-only memory (CD-ROM)**.

compact disc burner (CD burner) A **program** that enables **data** to be written to a **compact disc (CD)**.

compact disc interactive (CD-I) A **compact disc (CD)** player that can connect to a television and **read** photo **CD** images.

compact disc read-only memory (CD-ROM) A type of **compact disc (CD)** that typically contains information that can be viewed or copied onto a **hard disk** but cannot be modified.

compact disc recordable (CD-R) A **compact disc (CD)** that can **write** data that can then be **read** by a **CD-ROM drive**.

compand Abbreviation for *comp*ress and exp*and*. This is a weighted **function** that applies more influence to **data** in some areas than to others.

Compaq Corporation A leading manufacturer of high quality **personal computer**s (**PC**s). In 1998, Compaq acquired **Digital Equipment Corporation (DEC)**.

compatible Any configurations of **hardware** and **software** that can work together. Opposite of **incompatible**.

compilation cutting A method of **editing** in which the portrayal of the story is dependent on the narration, and the **scene**s are **cut** together to serve as visual representation to illustrate what is being described. Opposite of **continuity cutting**.

compile To convert **code** into an **executable program** with a **compiler**.

compiled code **Source code** that has been **run** through a **compiler**.

compiler A **program** that converts **code** written in a **high-level language** into **machine code** in order to create an **executable program**. Typically, a compiler will first convert the high-level language into **assembly language** and then translate the assembly language into **machine language**. Opposite of **decompiler**. See **source code**, **interpreter**.

complementary See **complementary colors**.

complementary colors The **color** resulting from subtracting a **primary color** from **white** is its **complementary color**. **Cyan**, **magenta**, and **yellow** are complementary colors for **red (R)**, **green (G)**, and **blue (B)**, respectively. Any two colors on opposite sides of a **color wheel** are complementary colors. *See Color Plates 1, 3.*

complementary mattes Any pair of **matte**s that are the complement, or inverse, of one another. Also referred to as a **male matte** and **female matte**. *See image below.*

component 1. A single **value** representing an **intensity** or quantity. For example, each **red (R)**, **green (G)**, and **blue (B) channel** representing a **pixel** is called a component, and the **signal**s representing **luminance** and **chrominance** in **component video** are also referred to as its components. 2. A **hardware** or **software** element contained within a **system**.

component video A **video signal** that carries the **luminance** and **chrominance** values of an **image** as separate **signal**s. Unlike **composite video**, the **red (R)**, **green (G)**, and **blue (B)** signals of a component video are split into separate **channel**s. See also **YUV**, **YIQ**, **Super Video**.

component video signal The **video signal**, used in **component video**, in which **luminance** and **chrominance** are sent as separate **signal**s. Separating these **component**s results in a signal with a higher **bandwidth** for **color** than is found in **composite video**.

Female Matte Male Matte

Composer The **compositing software** developed by **Alias/Wavefront**. Also called **Wavefront Composer**.

composite 1. The combination and/or manipulation of at least two source **image**s to create an integrated resulting image or **sequence** of images. A **digital composite** can involve hundreds of **element**s including **live action plate**s, **CG element**s, **roto matte**s, **matte painting**s, and **stage** and **miniature** elements. See also **optical composite**, *Color Plates 17–26, 36, 41, 45, 49–53, 55–57, 60–62, 68, and images under **layering operation**.* 2. See **composite video**.

composite module The portion of a **3D software package** used to perform **compositing operation**s.

composite print A **print** of **film** containing both **picture** and **sound**. Also called a **married print**. See **release print**.

composite script 1. The **scene file** that is created by most **compositing software**s when the **user** writes the **file** to **disk**. 2. For compositing packages with a **command line interface**, the file that is created by the user for the purpose of running the composite in **batch mode** or to view individual **frame**s.

composite track The final **sound track** of a **film** created by the **Sound Mixer**.

composite video A **video signal** that **encode**s the **luminance** and **chrominance** values of an **image** into one **signal**, as opposed to **component video**, which carries the **red (R)**, **green (G)**, and **blue (B)** signals as separate **channel**s.

composite video signal The special **video signal** used in **composite video**.

compositing The process of creating a **composite**. 1. See **digital compositing**. 2. See **optical compositing**.

Compositing Artist See **Compositor**.

Compositing Crew For **computer graphics (CG)**, the team of artists responsible for **compositing** the **plate**s and **CG element**s.

compositing function See **compositing operation**.

Compositing Lead For larger **project**s, a number of compositing leads will be assigned to oversee the **compositing** across individual **sequence**s. In this case, a Compositing Lead will manage a small team of **Compositing Artist**s and report to the **Compositing Supervisor**. They are responsible for delivering their **shot**s based on the technical and aesthetic requirements of the **show**. For smaller **project**s, the Compositing Lead can be synonymous with the Compositing Supervisor.

composition See **image composition**.

compositing operation Any **image process** that enables an artist to manipulate and/or combine multiple **image**s into a new and integrated result.

compositing package See **compositing software**.

compositing software A **software application** specifically designed to allow the **user** to create and modify **image**s to create a **composite**. See also **lighting software**, **rendering software**, **tracking software**, **paint software**, **particle software**, **modeling software**.

Compositing Supervisor The individual responsible for the aesthetic and technical supervision of all the **digital composite**s created for a **project**. The Compositing Supervisor leads a team of **Compositor**s and is responsible for **color continuity** and the overall quality of the composites. This role requires thorough knowledge of **color**, **color space**, **image formats**, and **film**. Depending on the **show hierarchy**, the compositing supervisor reports to the **Digital Effects Supervisor (DFX Sup)**, **Associate Visual Effects Supervisor (Assoc VFX Sup)**, and/or the **Visual Effects Supervisor (VFX Sup)**.

compositing tools The **software tools** used to create a **digital composite**. Examples include **color correction** tools, **paint package**s, **warp**ing and **morph**ing utilities, **key**ing functions, **roto** tools, and **proprietary** and **3rd party** general **compositing package**s.

Compositor An artist who combines the many **element**s of a particular **shot** into an integrated final shot. A Compositor needs to be able to **pull a matte**, work with various **image format**s and **color space**s, and have a thorough understanding of **color** and **composition**. The Compositor reports to the **Compositing Lead** and/or **Compositing Supervisor** of a **project**. Also called a **Digital Compositor**.

compress 1. A **compositing operation** similar to **clamp**. 2. To reduce the amount of **disk space** used to represent **data** with a **compression** algorithm. Opposite of **uncompress**.

compressed air Canned air used on **set** to blow dust out of the **camera**, **magazine**s, and **lens**es.

compressed animation See **time warp**.

compression A method of saving **disk space** by compressing the information used to represent **digital data**. A good compression scheme is said to be **lossless** if it completely reverses the compressed **data** back to its original state, as opposed to **lossy compression**, which loses information dur-

ing compression and can never be restored to an identical version of the original. Opposite of **decompression**. See also **image compression**.

compression ratio The amount and type of **image compression** used to reduce the amount of **disk space** used by **digital image**s. See **4:1:1**, **4:2:2**, **4:4:4**.

compute 1. To use a **computer**. 2. To calculate.

computer An electronic **device** designed to perform calculations and **process**es, as well as retrieve and store large amounts of **data**. See **hardware**, **software**, **central processing unit (CPU)**.

Computer Aided Design (CAD) CAD is widely used **software** for the creation of **computer graphics (CG)** in the electric and engineering fields. See also **Autocad**.

Computer Aided Industrial Design (CAID) Synonymous with **CAD**.

computer animation **Animation** created and manipulated on a **computer**. An **Animator** sets the **key frame**s of the **object**s to be animated, and the computer **interpolate**s the **in between** frames.

Computer Animation Production System (CAPS) CAPS is a **software package** that computerizes the traditional **ink and paint** techniques used in **cel animation**.

computer chip A thin rectangular **device** made up of tiny electronic components that store and transmit **data** and provide circuitry for **microprocessor**s. Also called a **chip**, **microchip**, **integrated circuit**, **microelectronic**.

computer code See **machine code**.

computer display The **screen** on which a **computer** can **display** its **output** to the **user**. Also called the **computer screen**. See also **Cathode Ray Tube (CRT)**, **liquid crystal display (LCD)**.

computer error A **hardware**, **software**, or **programming** mistake.

computer geek Anyone who is fanatically addicted to using **computer**s.

computer generated Any **data** created on a **computer**.

computer generated imagery (CGI) Any **image** created by or manipulated on a **computer**.

computer graphics (CG) A global term referring to the creation or manipulation of **image**s on a **computer**. The two main methods of representing images with computer graphics are with **vector graphics** and **raster graphics**.

computer graphics program Any **program** designed to help in the creation of **digital image**s.

Computer Graphics Producer See **Digital Effects Producer (DFX Producer)**.

Computer Graphics Supervisor (CG Sup) The CG Sup is responsible for determining the aesthetic and technical solutions, **software** selections, and overall **pipeline** for the **3D** work on a **project**. The CG Sup works closely with and is on the same level in the **show hierarchy** as the **Compositing Supervisor**. Together, they determine what portion of **2D** and **3D** work each **shot** requires. The CG Sup leads a team of **3D artist**s and is responsible for ensuring the quality and continuity of the **3D element**s his team creates. Depending on the **show hierarchy**, the CG Supervisor can report to either the **Digital Effects Supervisor (DFX Sup)**, **Associate Visual Effects Supervisor (Associate VFX Sup)**, and/or the **Visual Effects Supervisor (VFX Sup)**. See also **Sequence Supervisor**.

computer graphics work A global term referring to any **image**s created or modified in the **computer**.

computer hardware See **hardware**.

computer interface See **user interface**.

computer mainframe See **mainframe computer**.

computer memory See **memory**, **random access memory (RAM)**.

computer monitor See **computer display**.

computer operating system See **operating system (OS)**.

computer paint program See **paint software**.

computer platform The specific **hardware** and **operating system (OS)** that defines how a **computer** will operate and what type of **software** it can **run**. See **platform independent**.

computer process To calculate **data** or **execute** a **program** on a **computer**. Also called a **process**.

computer program A set of instructions and rules that a **computer** can interpret and **execute** for solving a problem or **data processing**. There are many **programming language**s such as **C**, **C++**, **Fortran**, **Java**, **LISP**, **Perl**.

Computer Programmer Anyone who writes **computer program**s. See also **Software Developer**.

computer process A global term referring to any series of calculations performed by a **computer**. See **central processing unit (CPU)**.

computer programming language See **programming language**.

computer screen The surface on which an electronically created **image** is formed. Also called **CRT screen**. See also **computer display**.

computer software See **software**.

computer system Referring to the entire range of **hardware, software, operating system (OS)**, and **peripheral device**s that are able to communicate with one another. A system can be a **standalone workstation** or a **computer** connected to a **network**.

computer virus A **program** that infects a **computer** by attaching itself to another program residing on that computer and propagating itself each time that program is **execute**d. A computer can become infected when **file**s containing the virus are **download**ed over a **network** or **read** in from a **disk** when installing new **software**. While many viruses are harmless pranks, known as **benign virus**es, some can delete files or wipe out an entire **hard disk**. See also **boot virus**.

compy A slang term used to describe a **composite** that doesn't look natural, so the **viewer** can easily tell that it is the result of a lot of different **element**s layered together rather than an **image** that was **shot** in one **pass** with the **camera**. The goal, of course, is for the viewer not to be able to distinguish between a composited shot and one **film**ed completely **in camera**. A "compy" looking shot is often the result of poorly integrated **color correction**s, **bad key**s, and **matte edge**s.

concatenation 1. To connect a series of **input file**s together into one resulting **output file**. 2. See **transformation concatenation**.

concatenation of transformations See **transformation concatenation**.

concave An **object** that turns inward on itself. Opposite of **convex**.

concave polygon A **polygon** that turns in on itself is called a concave polygon. For instance, if a **bounding box** were placed around the polygon, it would not be able to touch all sides of the polygon. A concave polygon is considered an **illegal polygon** and must be **triangulated** before **rendering** in order to ensure the expected results. Stars and crescent moons are examples of concave polygons. *See image on following page.*

concept art Sketches or paintings used to inspire and establish the mood and style of a **film**. See **production artwork**, **visual development**.

Convex Polygons

Concave Polygons

Concept Artist Any artist who creates **concept art** for a **film**, typically during the **visual development** phase.

conditional statement A statement in **programming** that defines the conditions under which an event can take place. See **if/then/else loop**, **while loop**, **for loop**.

cone A **quadric surface** defined by a 360-degree **sweep** of a **line segment**, with one **end point** located at the **axis of rotation**. The **parameter**s required to define a cone as a **geometric primitive** are its **origin**, **height**, and the **radius** of its base. *See also image under geometric primitive.*

cone of vision The **field of view (FOV)** seen by the human eye as represented by a cone-shaped area for each eye. **Object**s within the cone of vision are visible, while objects outside the cone of vision are not visible. See also **pyramid of vision**.

confidence test A test that is run to ensure that individual **peripheral**s, such as the **mouse**, **drive**, or **monitor** are set up and properly working.

configuration The customized settings that define the way a **system** behaves and includes the type of **hardware**, **software**, and **peripheral device**s. Also called **system configuration**.

configuration file The **file** containing the customized settings of your **system configuration**. Also called **customization file**s.

confirmation box The **window** or **box** that appears and requires a **user** to make a choice or to acknowledge that an **error** or other condition has been recognized. The confirmation box generally contains a brief explanation and the option for one or more selections, such as "continue," "yes," or "no." The user must **click** on one of the **option**s in order to dismiss the window. See also **dialog box**, **error dialog**.

confirmation dialog See **confirmation box**.

confirmation window See **confirmation box**.

conform The process of matching the **original** film to the **workprint** by matching the **edge numbers** on both pieces of **film**.

connections The lines that define the connections and **dependencies** between a series of **node**s.

console window The **window** in which all status and **error message**s are reported.

constant color A **color** in which each **pixel** carries the identical **RGB values** across the **image**.

constant shading See **flat shading model**.

constant shading model See **flat shading model**.

constant value A numerical **parameter** that does not change over time.

constant variable A constant **variable** is one that does not change over time.

constrained model Any **model** whose **motion** is restricted by **constraints**.

constrained object See **constrained model**.

constraint A technique used to restrict the range of **motion** for **object**s or the **joint**s of a **skeleton chain** in **animation**. Constraints can be defined for any of the three basic **transformation**s, **translation**, **rotation**, and **scale**. For **inverse kinematics (IK)**, many **3D package**s default to a 180-degree constraint for the joints but also allow for **user defined** constraints for each joint. For a **model constraint**, each of the model's transformations are associated with another model in order to limit its

range of **motion**. The three most common ways to constrain a model are with **translation constraint**s, **rotation constraint**s, and **direction constraint**s. Also referred to as **limits**. See also **up vector constraint**, **point constraint**.

construction history A **text file** or series of **node**s that contain all the **modeling** operations used to create a completed **model**. Also known as **dependencies**.

Construction Crew The group of individuals responsible for the building of the physical **set**s used in **filming**.

construction plane The invisible **plane** in **3D space** used to construct **geometry** relative to when **modeling**.

constructive solid geometry (CSG) A **modeling** technique in which complex **shape**s can be created with combinations of simple shapes, such as the shapes that can be created with **Boolean operator**s. See **solid modeling**.

contact printer The **device** used for **contact printing**.

contact printing The process of making a **print** by sandwiching the **original negative** and the **unexposed film stock** together, **emulsion** to emulsion, and running them together past a uniformly lit slit of **light** that shines through the original negative and **expose**s the **print stock** to the same **image**. All **workprint**s, **answer print**s, and **release print**s are contact prints.

contact shadow A **shadow** from an **object** that is connected to that object, as opposed to being a shadow cast on a distant **surface**.

contamination 1. See **color contamination**. 2. Any unwanted **exposure** of the **film** to **light** that can cause **flashed** images.

contiguous To connect without a break, such as a **surface** that shares an **edge** with another surface or an arrangement of **file**s stored on **disk** so that each file is represented as a physically continuous segment. See **defragmentation**, **fragmentation**.

continuity The smooth **transition** of actions and events from **scene** to scene without revealing the fact that each **shot** may have been photographed and/or **process**ed at different times. Continuity issues include **color continuity**, **time continuity**, **space continuity**, and **directional continuity**. Also referred to as **shot continuity**.

continuity cutting A method of **editing** in which the portrayal of the story is dependent on **cutting** together consecutive matching **scene**s. The opposite of **compilation cutting**. Also called **matched cutting**.

continuity report A detailed list of events describing the **filming** of a **scene**. The information typically recorded includes the **Crew member**s present, **camera** settings, a description of each **take**, the takes the **Director** wants to see **print**ed, and the date and time.

continuity style The style of **shooting** and **editing** a **sequence** so that the **shot**s appear to portray the events as they occurred. See **continuity cutting**.

contour curve A term used to describe the **curve**s that define the **edge**s or **shape** of a **surface**. See also **laser scanner**, **lofting**, **surface of revolution**.

contouring See **banding**.

contrast 1. For **digital**, the ratio of the bright to dark **value**s in an **image**. See **D-max** and **D-min**. 2. For **film**, the ratio of the **density** of the **opacity** to the **transparency** on a piece of film. 3. For **compositing**, see **contrast operation**.

contrasting shots Pairs of **shot**s that are comprised of opposing sizes of **image**s, such as cutting between a **long shot (LS)** and a **close-up (CU)** or a **high-angle shot** and a **low-angle shot**. Each pair of **contrast**ing shots must have a large enough difference in **image size** to create sufficient contrast. Opposite of **repetitious shots**.

contrast operation An **image operation** that modifies the ratio of bright to dark **value**s in an **image**. An increase in **contrast** makes dark areas darker and bright areas brighter.

contrast range A range of **contrast** that a **film emulsion** can reproduce. A **film stock** that produces the extremes of dark to light, with few intermediate steps, is called **high-contrast film**, whereas a film stock that produces a wide range of intermediate steps of gray is called a **low-contrast film**.

contrast ratio See **dynamic range**.

contrasty A term used to describe a higher than normal amount of **contrast** in an **image**.

control character See **ASCII control characters**.

control hull See **hull**.

controlled action The **filming** of an event that can be directed and regulated. Such **sequence**s can be rehearsed and filmed from many angles and take as much time as required to get a good **take**. Opposite of **uncontrolled action**.

control point The set of **point**s that defines the **shape** of the **curve segment**s that make up a single continuous **curve** or **patch**. Depending on their **curve type**, control points may lie on or off the curve. The shape of a curve can be altered by moving the **position** of its control points. Control points contain **3D** positional **data** and **tension** information, as well as other **spline** attributes. Also called a **control vertex**.

control strip A strip of **film** exposed by a **sensitometer** to create a range of **exposure**s from light to dark as a means of evaluating the **contrast range** of a particular **film stock**.

control track The electronic version of **sprocket hole**s that are recorded onto a **videotape** to help guide **tape** transport during **playback** and recording.

control vertex See **control point**.

control vertices Plural of **control vertex**. See **control point**.

converge To approach an intersection point.

convergence 1. For **stereo film**s, the point at which two imaginary lines drawn out from the center of two **camera lens**es intersect in space. The convergence point can be thought of as the equivalent to the **screen plane** that the **3D film** will be **project**ed on. Any **object**s in front of the convergence point in space appear to be floating in front of it, while objects behind this point appear to be **behind the screen**. See also **at the screen, breaking the frame**. 2. The point at which the **RGB** signals converge into one **pixel** on a **CRT monitor**. If the pixels are misconverged, the pixels can appear blurry due to **color fringing**. 3. See **convergence chart**.

convergence chart A **black and white** grid **image** used to make adjustments to a **monitor** or **projector** so that **color fringing** is eliminated. *See image on following page.*

conversion 1. The process of converting a **sequence** of **image**s from one **frame rate** to another. See **3:2 pulldown, 3:2 pullup**. 2. The process of converting a series of images from one **image format** or **color space** to another.

conversion filter A **filter** used on **set** to convert a **light** or **camera** from one **color temperature** to another.

convex An **object** that does not turn inward on itself. Opposite of **concave**. *See image under **concave polygon**.*

convex hull The smallest region that can enclose a defined **group** of **point**s.

Convergence chart.

convex polygon A **polygon** that does not turn in on itself. For instance, if a **bounding box** were placed around the polygon, it would be able to touch all the sides of the polygon. Unlike a **concave polygon**, a convex polygon is considered a **legal polygon** and requires no additional processing before **rendering**. A **triangle** or **rectangle** are examples of convex polygons. *See image under concave polygon.*

convolution The weighted averaging of **data**. See **convolution filter**.

convolution filter A **spatial filter** that uses weighted averaging to modify each input **pixel** based on a small group of surrounding pixels. The group of pixels used for calculations is called the **convolution kernel** and is typically a square **array** of pixels made up of an odd number of **rows and columns**, such as a 3×3 or 5×5 **kernel**. Convolution filters are widely used to **blur**, **sharp**en, and **anti-alias** images. Also called **spatial convolution**, **convolve operation**, **convolution mask**.

convolution kernel The **array** of **pixel**s used in a **convolution filter**.

convolution mask Another name for **convolution filter**.

convolve See **convolution filter**.

convolve operation An **image operation** that calculates the averaging of a group of **pixel**s using a **convolution filter**.

cook Another term for **processing**.

Cook See **Cook/Torrence shading model**.

cookie 1. Another name for **cukaloris**. 2. A **program** that is sent to a **computer** across the **internet** to record the actions of a **user** on a specific **Web site**. When a user returns to that Web site, the site will load according to the information saved in the cookie. For example, it might remember information such as **user name** and **password**. Some cookies also allow for the customization of the **display** on the **Web page**.

cooking Another term for **processing**.

Cook/Torrence lighting model See **Cook/Torrence shading model**.

Cook/Torrence shading See **Cook/Torrence shading model**.

Cook/Torrence shading model A **shading model** that is similar to the **Blinn shading model** but calculates the **highlight**s a little differently. **Color** is calculated by computing the **shared normal** at each **vertex** of each **polygon** on the **object** and then interpolating those normals across the **face** of each polygon. The result is an object that appears smooth. This model is good for glass and metals. See also **Phong shading model**, **Gouraud shading model**, **Lambert shading model**. *See image on following page and under shading model.*

cool 1. A **color** or **image** that is biased toward **blue (B)** or **green (G)** is referred to as "cool." Opposite of **warm**. 2. This book!

cool colors See **cool**.

coons patch A **patch** that defines a **surface** based on the boundaries of four **curves**.

coordinate 1. Two or three numbers, expressed as (X, Y) or (X, Y, Z), that define the **position** of a **point** in space relative to an **origin** or **axis**. See **coordinate system**, **Cartesian coordinates**, **polar coordinates**. 2. See **texture coordinates**.

coordinate space See **coordinate system**.

coordinate system The alignment of a combination of **axes** used to describe the **position** of a **point** in space. The location of any point can be defined by its **coordinate**s relative to the **origin**. Most often, the **Y-up coordinate system** is used, in which the **X-axis** represents the **horizontal**

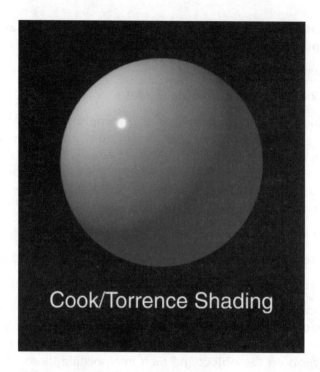

Cook/Torrence Shading

axis, the **Y-axis** represents the **vertical axis**, and the **Z-axis** is represented by the **depth axis**. See also **Cartesian coordinates**, **polar coordinates**, **world coordinate system**, **local coordinate system**, **Z-up coordinate system**, **right-handed coordinate system**, **left-handed coordinate system**. *See images under right-handed coordinate system, Y-up coordinate system,* **quadrant,** *and* **Cartesian Coordinate System**.

coordinate system handedness See **handedness**.

coordinate system orientation See **orientation**.

Coordinator See **Production Coordinator**.

coplanar **Lines** or **points** that lie in the same **2D plane** in **3D space**.

Co-producer A **Producer** who shares in the responsibility with another producer or other producers for the **budget**ing, planning, and completion of a **project** and offers creative input. See also **Executive Producer (EP)**, **Associate Producer, Line Producer**.

copy 1. To copy **text** into the **clipboard** that had been previously **cut** from a page. See also **paste**. 2. See **duplicate**. 3. See **clone**.

copy buffer Another name for **clipboard**.

core 1. Synonymous with **main memory**, **random access memory (RAM)**. 2. The plastic disks around which **film** is wound. See also **spool**.

core dump A **copy** of the contents of the **core** created when a **computer process** is aborted due to an internal **error**.

corner pinning An **image processing** technique that **warp**s an **image** based on **user-define**d corners of a rectangular region. The portion of the image contained within the corner pin remains inside those borders while freely warping and stretching the image contained within the interior region. This technique is often used to attempt to match two **elements** containing different **perspective**s. See also **four-point track**. *See image below.*

correct See **color correction**.

corrected print See **timed print**.

corrupted file A **file** containing so much damage that the **computer** can no longer **read** it.

Costume Designer The individual responsible for designing the costumes worn by the actors in a **film**. The Costume Designer works closely with the **Production Designer** and **Director of Photography (DP)** to coordinate the color scheme and mood of the film.

could be better (CBB) When a **shot** has a few minor technical or aesthetic adjustments to be made, but the delivery date is close at hand, this term is used to **final** a shot with the caveat that it will be improved at a later date if time and **budget** permit. Due to tight **deadline** and budget constraints, most of these CBBs never make it back into **production** and do end up in the **final cut** of the **movie**.

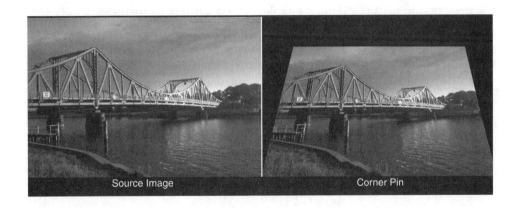

Source Image Corner Pin

could be different (CBD) What a **shot** is called when an indecisive **Director** would like to make changes to a shot but can't decide what those changes should be. So, the shot gets finaled. (This isn't much of a compliment, but a **final** is a final.)

countering Referring to **camera motion** that moves in the opposite direction of the moving **subject**.

cover set An interior **set** that can be used during **filming** if inclement weather prevents **shooting** outside. This can either be an alternate **location** for the **scene** planned or a different scene altogether.

cover shot 1. An extra **scene** filmed as backup to cover any unforeseen **editing** problems such as bad timing and/or mismatched **take**s. 2. See **establishing shot**.

coverage 1. Referring to the area of the **image** that is covered by an **alpha channel**. 2. The process of **filming** enough **shot**s in a **scene** that can be **cut** together smoothly and make the scene work as a whole.

C programming language (C) A **high-level programming language** that was developed to enable **Unix** to run on a variety of **computer**s. C is a popular language that can be **compile**d into **machine language** on most computers. See also **C++ programming language (C++)**.

C++ programming language (C++) An **object-oriented programming language** that is an extension of the **C programming language (C)**. C++ is the basis of **Java**.

CPS Abbreviation for **cycles per second (CPS)**.

CPU Abbreviation for **central processing unit (CPU)**.

CPU cache The chunk of **memory** between **main memory** and a **central processing unit (CPU)** that enables the **computer** to **process** data faster.

CPU hog See **CPU intensive**.

CPU intensive A **process** or **program** that requires a large number of **CPU**s to calculate its **process**es. Also called a **CPU hog**. See also **memory intensive**.

crab To move a **camera** side to side or diagonally relative to the **scene**.

Craft Service The people responsible for supplying snacks, drinks, and light meals for the **Cast and Crew** throughout the duration of the **shoot** day. See also **Caterer**.

crane 1. The piece of equipment used to mount the **camera** and **Cameraman** to during the **film**ing of a **crane shot**. 2. To physically move the camera up and down. Also called **boom**.

crane shot A **shot** in which a **camera** is mounted onto a **crane** in order to achieve a specific range of **camera motion** that could not otherwise be achieved.

crash A term used to describe a sudden failure of **hardware**, **software**, a **disk drive**, a **program**, or the **operating system (OS)** of a **computer**. A loss of **data** can result if the crash is a serious one. Also called **system crash**, **network crash**.

crawl A type of **credit** listing in which the names roll up through the **frame**.

crawling See **chatter**.

Creature Developer 1. For **computer graphics (CG)**, often used synonymously with a **Character Setup TD**, although the term Creature Developer is also used to describe an artist who has anything to do with the construction of a **digital character**, including **modeling**, **chaining**, **skinning**, and **surfacing**. 2. For **practical effects**, the individuals who create **animatronic**s and **puppet**s for use in the **film**.

creature development The development and creation of **digital character**s, **animatronic**s, and **puppet**s.

Creature Shop Any **facility** that creates **prosthetic**s, **animatronic**s, **puppet**s, robotics, and creatures for use in a **film**.

Creature Supervisor The individual who supervises all aspects of the development and creation of **digital character**s, **animatronic**s, and **puppet**s. For **computer graphics (CG)**, this includes the supervision of **modeling**, **surfacing**, and **character setup**.

credit card A **credit** that remains stationary on **screen**. See **single card**, **shared card**.

credits The list of various personnel that work on a **film** that is presented at the start (**main titles**) and conclusion (**end titles**) of a film. See also **subtitles**, **insert titles**.

Crew A global term referring to anyone involved in the **production** of a **film** and who does not appear in the film itself. Each individual on the Crew is referred to as a **Crew member**. The term most often refers to the individuals who work for the **production team** and the **Filmmaker**s.

Crew member Each individual that is part of the **Crew**.

CRI Abbreviation for **color reversal intermediate (CRI)**.

critical error A **computer error** that cannot continue to **process** currently **run**ning **program**s.

crop 1. An **image operation** that removes the portion of the **image** that falls outside a **user-defined** rectangular boundary. 2. To **print** only a portion of the image **capture**d on a **negative** or **slide**.

crop window The rectangular boundary that defines the portion of the **image** to be **crop**ped.

cross-cut A **cut-away** to a **scene** of separate but parallel action. See **cross-cutting**.

cross-cutting A method of **editing** in which two or more events are **cut** in parallel in an alternating pattern. Used to portray separate actions that will come together in conflict. See also **continuity cutting**, **compilation cutting**.

cross dissolve See **dissolve**.

cross-eyed method See **cross-eyed viewing method**.

cross-eyed pair The pair of **stereo image**s used for the **cross-eyed viewing method**. See also **parallel pair**.

cross-eyed viewing method A **free viewing method** for viewing **stereo images** without the use of **3D glasses**. In the cross-eyed viewing method, the images are brought into alignment by crossing your eyes, which creates a sense of **depth** when they come together. When you cross-view, the muscles that control the focusing **lens** inside your eyes strongly contract and shorten. With cross-eyed viewing, the left image is on the right side and the right image is on the left side, so when your eyes are crossed, the images come together. Also referred to as the **cross-eyed method**. See also **parallel viewing method**. *See Color Plates 30, 31 and images under free viewing method.*

cross fade See **cross dissolve**.

cross hair The cross-shaped wire strands that are located on the **ground glass** of a physical **camera** or on a **computer screen**.

crossing the line To move the **camera** to a position on the opposite side of the **action axis** which can create confusion for the **viewer**s.

cross platform See **platform independent**.

cross-plug A term used to describe a **trailer** that is shown at other theatres belonging to the same exhibition chain.

crossover sheet The information sheet, prepared by **Editorial**, that lets the **Compositor** know the various **frame**s at which various **element**s "cross over" or need to be **composite**d over the others. Also called a **lineup sheet**.

cross product The cross product of two **vector**s produces a third vector that is always at right angles to the first two.

cross section Any **generating curve** used to define a **surface** created by a number of modeling techniques, such as **extrude, sweep, surface of revolution, lofting, skin**. *See also image under lofting.*

cross sectional slice 1. See **cross section**. 2. A technique used to **digitize** a **physical model** is actually cut into slices that reveal both the interior and exterior contours of the **model**. By tracing around the **shape** of each slice with a **digitizing pen** and then offsetting the resulting **curve**s in the **computer** a **lofted surface** can be created.

crosstalk Any interference between two **audio** or **video signal**s caused by stray **signal**s.

crowd duplication Any **2D** or **3D** methods used to replicate small groups of actors or extras in a **scene**. Also called **crowd replication**.

crowd replication Synonym for **crowd duplication**.

crowd shot 1. Any **shot** that is photographed with a large number of actors. 2. Any shot in which a large number of **digital character**s are **animate**d and **render**ed. See also **crowd duplication**.

crowd simulation For **computer graphics (CG)**, a term used to describe any **animation** technique used to animate large groups of similar **character**s. Often, this is achieved with various techniques, such as **flocking, particle system**s, and **motion dynamics**. *See also Color Plates 38–39, 43–45, 67.*

CRT 1. Abbreviation for **cathode ray tube (CRT)**. 2. See **CRT film recorder**.

CRT display See **computer display**.

CRT film recorder An **output device** that uses a **cathode ray tube (CRT)** to convert **digital image**s onto **film**, one line at a time, requiring the **exposure** of each **color** separately. This is achieved in three passes or suc-

cessive exposures on each frame to build up a complete **image**. Compared with **laser film recorder**s, the lower **dynamic range** from CRT film recorders tends to produce **grain**ier images with a more restricted **contrast range**, resulting in insufficient **color** fidelity, higher image **flare**, and much longer exposure times. The three exposures required also consume considerable time to execute. These qualitative differences are based in part on the lower **light** output produced by CRTs. As a means of compensation, a narrower **density** range is chosen and higher-speed **film stock**s are used, which in turn produce a grainier image. The two most common CRT film recorders used are the **Celco film recorder** and **Solitaire film recorder**.

CRT monitor　A **monitor** that uses **cathode ray tube**s (**CRT**s) to display **color**s.

CRT screen　See **computer screen**.

crunch　1. To **process** data on the **computer**. 2. See **crunch time.**

crunch time　A slang term used to describe the period when a **project** deadline is rapidly approaching and the entire **Crew** must work *very* long hours.

crush　An **image** whose darkest areas have been dropped down to **pure black** is said to be a "crushed image." See also **clipping**.

C-scope　Abbreviation for **Cinemascope (C-scope)**.

CSG　Abbreviation for **constructive solid geometry (CSG)**.

CSH　Abbreviation for **C shell (CSH)**.

CSHRC　Abbreviation for **C shell run commands (CSHRC)**.

C shell (CSH)　Abbreviation for **command shell**, this is a **shell** and **scripting language** that allows the **user** to interact with the **Unix** file system. See also **Bourne shell (SH), Korn shell (KSH), command interpreter**.

C shell run commands (CSHRC)　The .cshrc file is stored in the **home directory** of each **user** on a **Unix-based system** and defines **environment variable**s, **alias**es, and any initialization that needs to occur.

C shell script　A series of **C shell** commands with some similarity to the **C-language syntax**, that allows the **user** to run a series of commands and processes.

C-syntax　See **C-like syntax**.

CU　Abbreviation for **close-up (CU)**.

cube 1. An **object** defined by six equal square sides. 2. A number that is raised to a power of 3, or multiplied by itself three times. *See also image under* ***geometric primitive***.

cubic An equation containing a sequence of terms in which no terms are equal to a power greater than three. Also referred to as a **polynomial of the third degree**.

cubic environment map A cubic environment map is comprised of six **images** mapped to the **face**s of a virtual **cube**, representing the **3D environment** it surrounds, for use in **cubic environment mapping**. Most **3D software package**s will automatically create the six images by placing the **camera** in the center of the **environment** and **rendering** an image from the six orientations needed: top, bottom, front, back, right, and left. The **field of view (FOV)** of the camera is set to 90 degrees in order to ensure that the **render**ed panels accurately match up at the **edge**s. Also called **cubic reflection map**. See also **spherical environment map**. Also called a **six-pack**.

cubic environment mapping An **environment mapping** technique in which six **images map**ped to the interior faces of a virtual **cube** are used to simulate the **reflect**ions of the **environment** being cast onto the **object**s in the **scene**. Cubic mapping works by drawing a perpendicular **vector** from each **point** on the objects intended to receive **reflection**s out to a point on one of the six cubic images. The **pixel value** of that point on the image is then reflected back onto the base point of the vector on the **surface**.

cubic map See **cubic environment map**.

cubic mapping See **cubic environment mapping**.

cubic NURBS A **NURBS curve** that requires a minimum of four **control point**s. See also **linear NURBS**, **quadratic NURBS**.

cubic reflection map See **cubic environment map**.

cubic reflection mapping See **cubic environment mapping**.

cubic spline Any **spline** mathematically defined by **variable**s raised to the third or **cubic** power.

cubic texture map See **cubic environment map**.

cubic texture mapping See **cubic environment mapping**.

cue A predefined signal, such as an action, a line of dialogue, or a marking on the **set** that alerts an actor to perform a specific line or action or for **Crew member**s to activate various equipment.

cue card Large panels of cardboard on which dialogue is printed to help actors remember their lines. Also called **idiot card**s. Cue cards have, for the most part, been replaced by **teleprompter**s.

cue mark 1. A small mark placed on the **set** to identify the position where an actor needs to stand or to indicate his eyeline, particularly when a **digital character** will later be added to the **scene**. Also called a **tape mark**. 2. A mark placed on the **workprint** by the **Editor** to indicate the point where music, narration, or **effects** are to begin. 3. See **change-over cue**.

cukaloris A panel cut with irregular shapes placed in front of a **light source** to **project** patterned **shadow**s onto a **subject**. Also called a **cookie, gobo, cuke**.

cuke Abbreviation for **cukaloris**.

culling 1. See **backface culling**. 2. The process of selectively throwing away a portion of the **data** representing an **object** in order to make the remaining object more manageable. Also called **thinning**.

culled surface A **surface** that is **display**ed with **backface culling** turned on.

curl See **film curl**.

current The **object**, **node**, or **image** whose **parameter**s are **active** and can be modified. Also referred to as **selected**.

current directory See **current working directory (CWD)**.

current frame The **frame** that is currently being **display**ed in a **software package**.

current node The **node** that is currently being **display**ed or modified in a **software package**.

current window The **window** that is currently being interacted with.

current working directory (CWD) The directory on **disk** in which a **user** is currently located when working in a **shell window**.

cursor The graphical shape, such as an **arrow** or **cross hair**, **display**ed on the **computer screen** that is moved by a **mouse**, **stylus**, or other **pointing device**. The cursor is used to move to a specific location on the **screen** and to **select** items, such as **menu**s, **object**s, and **node**s. Also called **pointer, mouse pointer, mouse cursor**.

curve Curves are defined by two or more **point**s, which make up a series of attached **curve segment**s to create a single continuous **line**. Curves are used to define the form of a **surface** or as the **path** for an **object** to follow in **path animation**. A curve can be **open** or **closed**. Some curves pass directly

through their **control point**s, whereas other types do not. Common **curve type**s include **linear**, **Bézier**, **B-spline**, **Cardinal**, **Hermite**, and **NURBS**. *See also images under* ***ease***, ***ease in***, ***ease out***.

curve deformation See **spline deformation**.

curve deformation animation See **spline deformation**.

curved surface Any **bicubic patch** generated from two **cubic spline**s running along the **U** and **V direction**s.

curve editing A method for viewing, creating, and modifying the **attribute**s of a given **object**, **image**, or **node** in a **graphical representation**. Any changes made to the graph of any **parameter** results in a corresponding change to the **animation**. Depending on the type of **spline interpolation** used, it might also be possible to adjust the **slope** of the **curve**s with its **tangent vector**s. Most **software package**s allow the **user** to select the type of **interpolation** to be used between any two **point**s along the curve.

curve editor Any **graphical user interface (GUI)** in which the **user** can create and modify **curve**s. Typically, the **X-axis** represents time as measured in **frame**s, and the **Y-axis** represents the **value** of the curve **parameter** being viewed. See **curve editing**.

curve of intersection The point of **intersection**, when **trimming** a **patch**, between the patch to be trimmed and the **curve** or **object** used to do the actual trimming.

curve segment The individual **line** that connects two **control point**s together on a **curve**. Depending on the type of curve, the curve segments may or may not cross directly through its control point.

curve type Referring to the type of **curve**, such as **Bézier**, **B-spline**, **Cardinal**, **linear**, **NURBS**. Various curve types respond differently to their **control point**s. For example, Bézier, Cardinal, and linear curves all pass directly through their control points, whereas B-splines and NURBS, having a **degree** other than **linear**, do not. The type of curve will also affect the **interpolation** across control points.

cusp 1. To intentionally create a visible **edge** in a **surface** where two adjacent **polygon**s meet. See also **normal**. 2. To intentionally **break** a pair of **tangent vector**s on a **curve** so they can be separately manipulated to create a kink in the curve. Also called **discontinuity**.

customer support **Technical support** supplied by **vendor**s who manufacture and sell **3rd-party software**.

customization file See **configuration file**.

cut 1. A continuous view of an action or series of events from a single **camera** without interruption. The term derives from the portion of a **shot**, which was "cut out" and used separately as a "cut away." 2. The visual transition point from one **scene** to another. 3. Referring to the **Editor**'s cut of the entire movie or a particular **sequence**. 4. The command called by the **Director** during the **filming** of a scene, as an indication to stop the **action** and stop rolling **film**. This signifies the end of that particular **take**. 5. To break a **patch** into two separate patches along a **span**. See also **trim**. 6. To remove **text** from the page and place it in a **clipboard**. See also **copy**, **paste**.

cut and paste To **move** a chunk of information on the **computer screen** from one place and move it to another location.

cut-away Shorthand for **cut-away shot**.

cut-away close-up shot A cut-away shot that frames the actor in a **close-up (CU)**.

cut-away shot A **shot** that depicts a secondary event occurring in a different location from the previous **scene**. See also **insert shot**.

cut buffer See **clipboard**.

cut-in Shorthand for **cut-in shot**.

cut-in close-up shot A **shot** that is a magnified portion of the previous **scene**.

cut-in shot A **shot** that **cut**s directly into a portion of the previous **scene**, such as a **close-up (CU)** of a person or **object**. See **cut-in close-up shot**.

cut length The length of a **shot** excluding **handles**. See also **shot length**.

cutting The process of **editing** the photographed **scene**s to portray the story while maintaining **continuity**. The **Editor** actually **cut**s away portions of each scene to create the best and most coherent portrayal of the action across the **sequence**. Common methods of cutting include **cross-cutting**, **continuity cutting**, **compilation cutting**.

cutting in the camera Another term for **triple-take**.

cutting on action A method of **editing** in which the **scene**s are **cut** on movements, rather than between two static **frame**s, in order to split the action between two **shot**s.

cutting room floor Slang phrase for where unused portions of **film** end up when they don't make it into the **final cut**.

CV Abbreviation for **control vertex (CV)**.

CWD Abbreviation for **current working directory (CWD)**.

cyan One of the **complementary colors** used in the **CMY/CMYK color models**. Equal amounts of **green (G)** and **blue (B)** combined together or the subtraction of **red (R)** from **white** creates cyan. Adding cyan to a shot is the equivalent of subtracting red.

cyan, magenta, and yellow (CMY) The **color**s used in the **CMY color model**.

cyber glove See **data glove**.

cyberscan See **laser scanner**—Definition #2.

cyberspace Synonym for the **Internet**.

CYC Abbreviation for **cyclorama (CYC)**. Pronounced "sike."

cycle 1. See **animation cycle**. 2. A sequence of **operation**s that are repeated. The time it takes to repeat the cycle is called the **cycle time**.

cycles per second (CPS) See **hertz (HZ)**.

cycle time The period of time it takes to complete a **cycle**.

cyclorama (CYC) A seamless material used as a **background (BG)** during the **filming** of a **scene**. Cycs can range from very simple sky backgrounds to elaborate painted landscapes. Also referred to as a **backing**, **backdrop**.

cylinder A **quadric surface**, defined by a 360-degree **sweep** of a **line segment**, whose **end point**s are **parallel** to the **axis of rotation**. The **parameter**s required to define a cylinder as a **geometric primitive** are its **origin**, **radius**, and **height**. *See also image under geometric primitive.*

cylindrical mapping A **texture mapping** method in which a **2D image** is bent around an imaginary **cylinder** before any **projection mapping** of the **3D object** occurs. Cylindrical mapping is most effective when the **surface** to be **map**ped is approximately shaped like a cylinder; otherwise undesirable stretching of the **texture** across the surface can occur. Also called **cylindrical projection**, **cylindrical projection mapping**. See also **orthographic mapping**, **spherical mapping**, **camera mapping**.

cylindrical projection See **cylindrical mapping**.

cylindrical projection mapping See **cylindrical mapping**.

cyphertext **Text** that has been converted by an **encryption** system. Opposite of **plain text**.

D1 A **digital recording** technique used for **component video**. D1 is said to be almost completely **lossless** and is therefore the best choice for high-end work in which many **generation**s of **video** are required. D1 can be an **8-bit** or **10-bit** signal and uses a 19mm **digital cassette** format. The resolution of D1 is, typically, 720 × 486. Sometimes referred to as **4:2:2** D1, **CCIR 601**. See also **D2**, **D3**, **D5**.

D1 video format See **D1**.

D2 A **digital recording** technique used for **composite video**. D2 is less expensive than **D1**, and although it can make multiple **generation**s without noticeable quality loss, D1 still maintains a higher quality. D2 uses a 19mm **digital cassette** format but is not compatible with D1.

D2 video format See **D2**.

D3 A **VHS** tape version of **D2**. Sometimes called **DX**.

D3 video format See **D3**.

D5 A digital **component video** format that holds the same level of quality as **D1** and can also store **HDTV** images. It uses a half-inch **digital cassette** format.

D5 video format See **D5**.

DA 1. Abbreviation for **Digital Artist (DA)**.

D/A Abbreviation for **Digital to Analog Converter (DAC)**.

DAC Abbreviation for **Digital to Analog Converter (DAC)**.

daemon Abbreviation for *d*isk *a*nd *e*xecution *mon*itor. A daemon is a **program** that lies dormant until a specific set of conditions occur. Most **system**s run many daemons to handle requests from other **host**s on a **network**.

DAG node Abbreviation for *d*irected *a*cyclic *g*raph node. A synonym for a **hierarchy** made up of a **parent** and **children**.

119

dailies 1. The first **workprint** of the the **negative** that was shot the previous day. Also called **rushes**. 2. The daily **screening** of the previous day's work by the Film Crew. Also called **Production Dailies**. 3. The regular meeting of the **Visual Effects Crew** to review both the **video** and **film** of the **visual effects work** from the previous day. On larger **project**s, dailies are often broken up into smaller categories, such as **animation dailies, effects dailies, film dailies, video dailies**.

daisy chain A **configuration** in which **device**s are connected together in a sequence, such that "device 1" is connected to "device 2," "device 2" is connected to "device 3," and so on, and therefore, the devices are connected like a "chain of daisies."

darkness Referring to the apparent lack of **brightness** in a **color**. The color dark blue contains a low value of brightness, whereas light **blue (B)** contains a high value of brightness or **lightness**.

darkroom A lightproof room used to load and unload **film**. See also **changing bag**.

DAT Abbreviation for **digital audiotape (DAT)**.

data 1. Information that can be **read**, created, manipulated, or stored in a **computer**. Known as **digital data**, the smallest piece of data that a computer can interpret is a **bit**. 2. Information represented in an **analog** form. Opposite of digital data.

database A formally structured collection of **data** on a **computer** that is organized for fast search and retrieval.

data communication The **transmission** of **data** between **computer**s.

data compression To **compress** data so it uses less **storage space**.

Data Donkey A slang term for a **Digital Artist (DA)** who creates **geometry** containing an unnecessary amount of **high-resolution** detail, referred to as **heavy geometry**.

data entry The process of **input**ting **data** into a **computer**.

data file **Text** or **binary** files that contain information about features such as **animation, modeling, rendering, compositing, lighting, code, painting**.

data file format Referring to the standard **format** in which **data** is stored on the **computer**, such as **ASCII** or **binary**, as well as the specific method used to store it, which is typically indicated by its **filename extension**.

data-flow diagram interface A fancy term for a **hierarchy** represented with **node**s.

data format See **data file format**.

data glove An **input device** used in **virtual reality (VR)** to allow the **user** to interact with a **simulation** and in **motion capture (MOCAP)** to **capture** the **motion** of the hands and fingers. Also called a **cyber glove**.

data loss 1. Any loss of **image** information due to **image processing** or **image encoding**. 2. The loss of information during **transmission** or when transferring the **data** to a new **address** on a **computer disk** or **peripheral device**.

data packet A format used for the **transmission** of **data** across a **network**. Packets contain the content of the data and any other information required to ensure that the data reaches its intended destination.

data portability The ability for **data** to be accessed and manipulated on different **operating system**s **(OS)**.

data processing The interpretation of **data** by a **computer**.

data recovery The process of recovering **file**s lost in a **computer** failure, such as damaged **disk**s, a **computer virus**, power surges, or any other problems that can result in lost **data**. **Norton Utilities** is a popular data recovery **program**.

data storage technology (DST) A **data** storage **tape** format, developed by **Ampex Corporation**. See also **digital linear tape (DLT)**.

data structure The organization and storage allocations of **data** in a **computer**.

data transfer rate The rate at which **data** can be **transmit**ted between **computer**s and **peripheral**s. The data transfer speed for a **modem** is typically measured in **kilobytes per second (KBPS)**, whereas **hard disk**s and **memory** are measured in **megabytes per second (MBPS)**.

Data Wrangler Slang for **Job TD**.

DAT drive The **peripheral device** that can **read** and **write** to a **DAT tape**.

daughter board A **circuit board** that can be plugged into the **mother board** of a **computer**.

day for night A photographic technique used to simulate nighttime **lighting** conditions that are **shot** in daytime lighting conditions. This can be achieved with a combination of **underexposure**, special **filter**s, and any

number of **color correction**s performed during **compositing**. See also **dusk for night**, **night for night**.

daylight 1. See **daylight balanced film**. 2. See **daylight light source**. 3. To send a **roll** of **film** to the **lab** early in the day and pay extra money to get it back that same day. This is also referred to as a **daylight run**.

daylight balanced film Chemically balanced color **film stock** used to reproduce accurate **color**s when used in daylight **lighting** conditions. See also **color temperature**.

daylight light source The **light source**s used when **shooting** with **daylight balanced film** that don't require any additional adjustments for **filter**s to the **camera** to correct for the **color temperature**. Daylight light sources are approximately **5400 Kelvin**. Also called **HMI lights**. See also **Tungsten light source**.

daylight run See **daylight**—Definition #3.

dB Abbreviation for **decibel (dB)**.

DDR Abbreviation for **digital disk recorder (DDR)**.

deadline The delivery date for a **project**. See also **drop dead deadline**.

deadlock Two or more **process**es that cannot continue to **run** because each is waiting for a resource that is held by the other.

dead start See **hard boot**.

dead time See **Timetrack**.

deal See **skip print**.

deal memo A short written document outlining the terms and conditions of employment.

debug To search for and fix **error**s in **hardware**, **software**, or a **program**.

DEC Abbreviation for **Digital Equipment Corporation (DEC)** and pronounced "deck."

DEC Alpha The name of a popular **computer system** from **Digital Equipment Corporation**. The Alpha **processor** has more advanced **architecture** than **DEC**'s earlier products, and it offers either DEC's **Unix operating system (Unix OS)** or **Windows NT**.

decal See **texture map**.

decay See **falloff**.

decibel (dB) The **unit**s used to measure the loudness and electrical **signal**s on a logarithmic scale.

decimal The **base 10** numbering system in which the number to the right or left of the decimal point represents a power of 10. Any number less than 1 that is expressed numerically with values written after the decimal point. For example, 1.2 or 100.728 are decimal numbers.

decimation A method of reducing an **image size** by removing unnecessary or redundant information. See also **lossless compression, lossy compression**.

decode To separate a **composite video** signal into a **component video** signal. Opposite of **encode**.

decoder 1. The **video** device used to separate a **composite video** signal into a **component video signal**. The opposite of an **encoder**. 2. **Hardware** or **software** used to convert a coded **signal** back into its original form.

decompiler A **program** that converts **machine code** back into **source code**. Opposite of **compiler**.

decompress To restore a **compress**ed **file** to its original state. Also called **uncompress, expand**. See **lossless compression, lossy compression**.

decompression A method of restoring **data** that has been reduced in size with a **compression** algorithm. See also **lossless compression, lossy compression**.

decrypt To **decode** data that has been **encrypt**ed.

dedicated line A **communication line** that creates a direct and permanent connection between a **computer** and the **Internet**. Opposite of **dialup connection**.

deep focus A **shot** that uses a **wide-angle lens** and a small **camera aperture** to achieve a large **depth of field (DOF)** in which all **object**s ranging from the extreme **foreground (FG)** to the **background (BG)** remain in sharp **focus**. Opposite of **shallow focus**.

default scene The **3D environment** that appears when a **software application** is launched. This can be the original settings created by the **vendor**, or, more often, it refers to the specific **setup** created during the **development** phase of a **project** to ensure that every artist is working from the same set of tools and **parameter**s. For example, if the final **viewing format** for a particular project is **1.85**, the default scene file might include a **wireframe** or **image** of a **hard mask** representing the **image area** that will be included when viewed with the 1.85 **aspect ratio**.

default settings The preset values for an **application** in a **computer** that are presented when the settings are not predefined by the **user**.

default transformation See **identity matrix**.

default values **Parameter**s that are used for calculations unless they are changed by the **user**.

definition 1. The detail available on a **computer screen**. 2. The **sharpness** and detail in an **image**. 3. For **geometry**, see **level of detail (LOD)**.

defocus To change the current **plane** of **focus** to be out of focus by focusing on another plane in the **scene**. See **rack focus, follow focus**.

deform See **deformation**.

deformation To change the shape of an **object**, using techniques outside of basic **modeling** options. Deformations can be created by using techniques such as **motion dynamics, lattice box deformation**s, **point cluster deformation**s, **spline deformation**s, **patch deformation**s, and **path deformation**s to **bend, twist, taper,** or otherwise modify a **surface**. For example, some deformation techniques involve the creation of **keyshape**s for each shape desired, and then, like any **animation** technique, the **computer** calculates the **interpolation** across those keyshapes to create new **in-between** shapes for the object. In some cases, the only way to get the desired shapes is by moving **point**s on the object by hand. As a result, **shape animation** using a **polygonal model** can involve the manual positioning of many more points than when using a **spline model**. Also called **3D morph**.

deformation map Another name for **displacement map**.

deformed model See **deformed object**.

deformed object Any **object** whose **shape** has been manipulated by any number of **deformation** techniques.

deformed surface See **deformed object**.

deformer An **object type** that is used to reshape another **object**. Deformer objects, such as **lattice**s and **sculpt object**s, can be used to interactively **squash** and **stretch** a group of objects. See **deformation**.

deformer object See **deformer**.

defragmentation The defragment of a **hard drive** is accomplished by using a **software** utility to arrange the order of the **file**s on **disk** so that each file is represented in a physically continuous segment. Defragmentation can im-

prove the performance of a hard drive because it can **read** files in a continuous stream as opposed to jumping around the hard drive to locate each individual **fragment**. See also **fragmentation**.

degauss 1. To erase information from **magnetic tape** or **film**. 2. For **monitor**s, magnetic fields can build up over time and cause a loss of **color** accuracy. Degaussing a monitor resets the magnetic fields in the monitor. Many monitors automatically degauss themselves. Also called **demagnetize**.

degausser The **device** used to **degauss** a **magnetic tape** or **film**.

degenerate polygon See **illegal polygon**.

degenerate primitive A **primitive** that cannot exist due to errors in the **geometry**, such as a **circle** with a **radius** of 0 or a **closed polygon** with less than three **points**.

degradation The loss of quality of an **image** due to **duplication**, **image processing**, or a conversion to an insufficient **bit depth**.

degree 1. A common **unit** of measurement to define the angle of **rotation**. See also **radian**. 2. The degree of a **NURBS surface** is defined by the minimum number of **control point**s that are required to define it. For instance, a **linear NURBS** surface requires at least two control points, a **quadratic NURBS** surface requires three, and a **cubic NURBS** surface requires four.

degrees of freedom (DOF) 1. The range of **motion** that a **skeleton** or **model** can achieve. See **constraint**. 2. The number of **value**s that an **input device** provides. For example, in **channel animation**, a **mouse** has two degrees of freedom: movement in **X** and movement in **Y**.

deinterlace An **image operation** that creates two new **video image**s made up of either the even or odd **scan line**s from the **source image**. Opposite of **interlace**. Also called **noninterlace**d.

delete The removal of unwanted **data** from a **storage device** or within a **software application**. Opposite of **save**. Also referred to as **blow away**.

delivery format The **resolution**, **aspect ratio**, and **image file format** that the final **image**s for a **project** are delivered to the client. See also **viewing format**.

delta Referring to the difference between two pieces of **input data**.

demagnetize See **degauss**.

demo Abbreviation for **demonstration**.

Demo Jock An individual who gives **3rd-party software** demonstrations to potential clients.

demonstration A free sample of the capabilities of a **program**, **software**, or **hardware**.

densitometer A **device** designed to measure the **density** of a piece of **negative**, called **status M density**, or a **print**, called **status A density**. The scale that is used runs from 0.00 to 4.00 and represents the **lightness**, or **value** of **color**, on the **film**. The densitometer is able to read densities as either separate **RGB value**s or as an overall density of the film. See also **lab aim densities (LAD)**.

densitometry The process of measuring the **density** of a **film** with a **densitometer**.

density 1. The **opacity** of a piece of **film**. A film **image** that can **transmit** no **light** has maximum density, whereas a transparent image contains no density. The blackness of a portion of a **negative** or **print** is what determines the amount of light that can pass through or reflect from it. Sometimes used synonymously with **contrast**. See also **D-min**, **D-max**. 2. For **motion dynamics**, the **volume** of an **object** is based on its size and the density of the materials from which it is made. For example, a small iron ball is much denser than a large, air-filled rubber ball. See also **weight**, **mass**, **friction**, **volume**. 3. For **metaball**s, see **density field**.

density distribution The redistribution of the **density field** within a **metaball** in order to create a **surface** that is not perfectly spherical. Density distribution can be used to create metaballs that are **ellipsoid**al and irregularly shaped, which can greatly aid in **modeling**. See also **negative density**.

density field The **surface** of a **metaball** is defined to "exist" wherever the density of the metaball reaches a predefined **threshold** value. When the density fields of neighboring metaballs overlap, the resulting surface is a **fusion** of the two density **value**s. The density field can also be adjusted to create a **negative density** in a surface by subtracting the densities of overlapping fields rather than adding them together.

density point The numbers produced from measuring the **density** of a piece of **negative** with a **densitometer**. See also **D-max**, **D-min**.

density space A **nonlinear color space** that represents an **image** based on the **density** of **processed film** relative to the percentage of **light** that reached it. See **Cineon file format**.

density value 1. See **density**. 2. For **metaball**s, see **density field**.

dependencies The connections between a series of **node**s.

dependency graph A **node view** of a **hierarchy**.

depth Generally, referring to the distance from the front to back of an **object** or **scene** along the **Z-axis**. See **Z-depth**.

depth axis See **Z-axis**.

depth buffer See **Z-buffer**.

depth channel Another name for **Z depth channel**.

depth cue Visual information, such as **atmosphere** and **fog**, that enables the **viewer** to determine the distance of **object**s relative to the **camera position**.

depth map See **Z depth map**.

depth of field (DOF) The area in front of and behind the **focus plane** that remains in relatively sharp **focus** through the **camera lens**. The depth of field is determined by a combination of the **lens** and **aperture** settings used, as well as the distance of the lens from the **primary focal plane**. A large aperture creates a narrow depth of field, whereas a small aperture will widen it. Depth of field is proportional to the square of the distance of the **subject**. So, if the subject distance is doubled, the depth of field is quadrupled.

depth of focus The range of distance over which the **film** can be shifted at the **film plane** in the **camera** and still maintain proper **focus** of the **subject**. If the film moves either forward or backward away from the precise position required to maintain **sharpness** during **exposure**, the resulting images will be **out of focus**. The term depth of focus is often improperly used to mean **depth of field (DOF)**.

depth perception The way a person can gauge **depth**. For **stereo film**s, the apparent depth of the **image**s are dependent on the creation of a second image that is offset by a small amount to the side of the first, which results in a slightly different **perspective** on the **object**s in the **scene**. Each eye receives either the right or left image during **projection**.

desaturated Referring to **color**s that are dull and muted and contain a high degree of gray. A completely desaturated **image** contains only shades of gray and is referred to as a **grayscale image**. Opposite of **saturated**.

desaturation The removal of **saturation** or **chroma** from **color**.

descendant Another name for a **child** in a **hierarchy**.

deselect See **unselect**.

desktop 1. See **desktop computer**. 2. The **icon**s and **window**s that appear on the **computer screen** as a part of the **graphical user interface (GUI)**.

desktop computer A **computer** small enough to sit on a desk.

destination See **destination address**.

destination address The location to which a **file** is moved or copied to from its **source address**. See **routing**.

destination file See **output file**.

destination image See **output image**.

detail See **definition**.

detail generator A **video camera** adjustment that increases **sharpness** on the recorded **image**.

detail shot An **extreme close-up (ECU)** used to show a magnified portion of a **subject** or a full **frame** of a very small **object**. See also **insert shot**.

Deutsche Industrie Norm (DIN) The group that sets the **DIN rating**s for **film**. Also referred to as the **German Industry Standard**. See also **ASA rating**.

develop See **film developing**.

developer's kit See **software developer's kit (SDK)**.

development 1. See **film developing**. 2. For **computer graphics (CG)**, one of the most crucial stages in the **production pipeline** for **visual effects (VFX)**. This is the stage during which the methods that will be used to cre-ate the required visual effects are discovered and defined. If the develop-ment stage of a **show** has been properly managed, the execution of the **shot**s themselves can become what is known as **plug and play**.

device 1. Referring to the **viewing device** used to display **image**s. 2. Referring to **peripheral device**s.

device coordinate system See **screen space**.

device driver **Software** that provides an interface between the **operating sys-tem (OS)** and **peripheral device**s, such as a **disk**, **tape drive**, or **mouse**.

device independent color (DIC) A **color space** that can transfer **image**s across different **platform**s without the use of special **CLUT**s or other con-

versions. For example, the **L*A*B* color model** can simultaneously represent both the **RGB** and **CMY** color spaces.

device space See **screen space**.

DFT Abbreviation for **discrete Fourier transform (DFT)**.

DFX Abbreviation for **digital effects (DFX)**.

DFX Sup Abbreviation for **Digital Effects Supervisor (DFX Sup)**.

DFX Producer Abbreviation for **Digital Effects Producer (DFX Producer)**.

DGA Abbreviation for **Directors Guild of America (DGA)**.

diagnostics A series of tests used to check the **hardware** of your **system**.

dialog box A **menu** or **window** that accepts **user** input, such as **attribute**s, **value**s, or **command**s. No other action can be taken by the **software** until this window is **close**d. See also **confirmation window**, **error window**.

dialog looping See **automatic dialog replacement (ADR)**.

dialogue track The separate **sound track** channel onto which dialogue is recorded. See also **effects track**, **music track**.

dialup Any temporary connection between **computer**s requiring a telephone number to be dialed using a **modem**.

dialup account Any type of **internet** account that can be accessed with a **modem**. Unlike a **dedicated line**, this is a temporary connection.

dialup connection See **dialup**.

dialup password The extra **password** required by **user**s who are accessing a **workstation** through a **modem**. This password is required before the **login password** is requested and is used to provide an additional level of security against **hacker**s. Also called **system password**.

diaphragm See **iris**.

DIC Abbreviation for **device independent color (DIC)**.

DID Abbreviation for **digital input device (DID)**.

difference 1. See **difference operation**. 2. A standard **arithmetic operator**.

difference matte A **matte extraction** technique used to separate a **subject** from its **background (BG)** by subtracting another identically framed **image**

that does not contain the subject from the image that does. The result of such a process consists of the portion of the **frame** where only the subject was present. Because the creation of a difference **matte** requires two separate images with an identical **camera position** and **lighting**, it can only be used for **lock off**s or shots using **motion control (MOCO)**.

difference operation 1. A **compositing operation** that subtracts a constant **value** from each **pixel** in a single **image** or subtracts the pixels of image A from the corresponding pixels in image B. If working with **normalized value**s, any resulting **RGB values** greater than 1 are, generally, **clamp**ed to a value of 1. However, a **clamping value** of greater or less than one can also be specified. Opposite of **addition operation**. Also

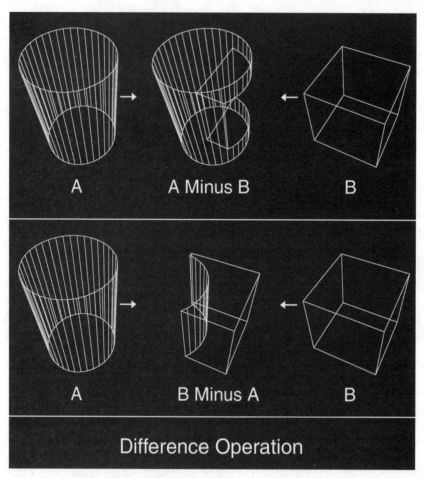

Boolean difference operation.

called **subtraction operation, minus operation**. 2. A **Boolean operation** that creates a new **object** based on the subtraction of one **source object** from another. Also referred to as a subtraction operation, **NOT operator**. See also **union operation, intersection operation, exclusive operation**. *See image on previous page and image under **Boolean operation**.*

difference set The set containing all the **element**s that are not contained in the other set. See **Boolean operation**.

diffuse The **color** of an **object** when it is hit by direct **light**. A **surface** with a small **diffuse component** will be darker because it **reflect**s less light, whereas a surface with a high diffuse component will be brighter because it reflects more light. See also **ambient, specular**. *See image below.*

diffuse coefficient See **diffuse component**.

diffuse color The primary **color** of an **object** that is revealed when the object is placed under **white light**. See **diffuse light**.

diffuse component The amount of **diffuseness** found on a **surface**.

diffuse light The primary **light** that is reflected by a **surface** and is equally scattered in all directions regardless of the **viewing angle**. Also called **Lambertian reflection**. Diffuse lighting is low to moderate in **contrast**.

diffuse light source See **diffuse light**.

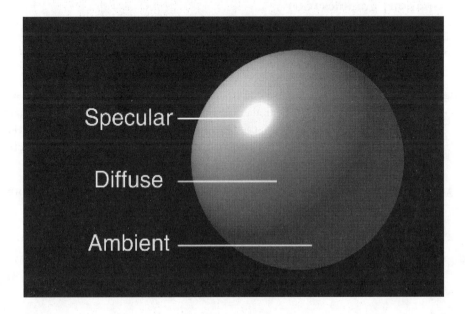

diffuse reflection See **diffuse light**.

diffuse value See **diffuse component**.

diffusion The amount of **light** reflected from a **surface**. The effect of diffusion is caused by **atmosphere** or special **filter**s placed on the **lens** to scatter the light across the surface, which creates an overall softer appearance. See also **diffuse color**.

diffusion filter 1. For **filming**, a **filter** placed over the **camera lens** that is designed to decrease the **sharpness** of the **scene**. Diffusion filters are available in various densities. 2. For **digital**, an **image process** that softens an **image** by averaging each **pixel** with a specified number of surrounding pixels to create a new resulting pixel.

Digibeta Abbreviation for **digital Beta (Digibeta)**.

digit Within the **decimal** number system, any number from 0 to 9.

digital **Data** represented as unique and well-defined **sample**s, as opposed to the continuously variable information found in **analog** data. A digital-to-digital duplication of data is, theoretically, an exact duplication of the original and thus eliminates **generation loss**. **Digital signal**s are said to be virtually free of interference due to noise and **crosstalk**, and digital based equipment generally offers high-speed data **transmission** and a low **error** rate.

digital animation Any **animation** that is created within the **computer**. See **computer graphics (CG)**.

Digital Animator A term used to describe a **Digital Artist (DA)** who does all types of **animation** ranging from **character animation** to **particle animation**.

Digital Artist (DA) Any artist who creates and manipulates **image**s on a **computer platform**. The term Digital Artist encompasses both **2D** and **3D Artist**s and can be synonymous with the various titles used, such as **CG Artist**, **Technical Director (TD)**, **Compositor**, **Matte Painter**, **Character Animator**, **Character Setup Technical Director (Character Setup TD)**.

digital audio tape (DAT) A **magnetic tape** format, developed by Sony, from which **audio** and **digital** information can be read and copied.

digital Beta (Digibeta) A **4:2:2** digital **tape format** developed by Sony.

digital camera 1. Any **camera** used within a **computer**, as opposed to a **physical camera**. The digital camera determines the portion of the **3D**

scene that will be **project**ed onto a **2D image** based on a combination of **position**, **rotation**, **field of view (FOV)**, **lens**, **aperture**, **shutter**, and **center of interest**. Also called **CG camera**, **3D camera**, **virtual camera**. 2. A camera that can capture **image**s in a **digital format** without the use of **film**. A digital camera stores the images in its **memory** until they can be transferred to a computer.

digital cassette The **tape format** used in **digital recording**.

digital character Any **character** whose **motion** is controlled by a **skeleton** or **muscle system** and is **animated** by a **Character Animator**. Human characters created digitally are called **synthespian** or **virtual celebrities**. Also referred to as **3D character**, **CG character**.

digital composite See **digital compositing**.

digital compositing The **digital** combination and/or manipulation of at least two **source image**s to create an integrated resulting image or **sequence** of images. *See also Color Plates 17–26, 36, 41, 45, 49–53, 55–57, 60–62, 68, and image under **layering operation**.*

digital compositing function See **compositing operation**.

digital compositing operation See **compositing operation**.

digital compositing package See **compositing software**.

digital compositing software See **compositing software**.

Digital Compositing Supervisor See **Compositing Supervisor**.

digital compositing tools See **compositing tools**.

Digital Compositor See **Compositor**.

digital computer Any **computer** that operates from **data** represented with **binary number**s. Unlike an **analog computer**, a digital computer uses **signal**s, represented as either 0 or 1, that can be translated into one of two states, such as on or off, true or false, yes or no.

digital data Any **data** created, manipulated, or stored in a **computer**. Digital data is stored in a **binary** format that can be interpreted by the computer. Opposite of **analog data**.

digital disk recorder (DDR) A **device** used for **real-time playback**, **random access**, and single-**frame** recording and **retrieval** over a **network** using **video resolution image**s. Most commonly, **digital image**s are recorded from **disk** to a DDR, and then, while playing back in **real-time**,

are recorded to **tape** for storage. In **post production** work, disk recorders are generally used as a kind of "way station" for routing **image**s to and from **tape** storage and the **computer** disks. See also **personal video recorder (PVR)**.

digital double exposure To mathematically **average** two distinct **image**s together into a new **mix**ed result. See also **optical double exposure**.

digital duplication Any duplication of **digital image**s that does not result in **generation loss**.

digital editing The use of **nonlinear editing** systems to edit **film** or **video**.

digital effects (DFX) Any **2D** and/or **3D** work performed on a **computer** falls under the category of digital effects. See **digital effects work**.

Digital Effects Crew Referring to the individuals involved in creating **visual effects (VFX)** using a **computer**.

digital effects facility Any company that creates or offers services for **digital effects work**. Also called a **digital effects house, digital effects studio, CG house, CG facility, CG studio**. See **facility**.

digital effects house See **digital effects facility**.

digital effects pipeline See **digital pipeline**.

Digital Effects Producer (DFX Producer) The individual responsible for the **budget** and scheduling of resources involved in creating the **digital effects work** for a **project**. The Digital Effects Producer works for the **Visual Effects Producer (VFX Producer)** and works with the **Digital Effects Supervisor (DFX Sup)** and **Visual Effects Supervisor (VFX Sup)** in determining the best approach, based on the available budget and time, for each **shot**. For **feature animation**, this role is often referred to as the **Production Manager (PM)**. Also called a **CG Producer, Computer Graphics Producer, Digital Producer**.

digital effects shot Any **visual effects shot** that requires some work to be done on a **computer**.

digital effects studio See **digital effects facility**.

Digital Effects Supervisor (DFX Sup) The individual responsible for the creation of all the **digital effects work** required for a **production**. The DFX Sup supervises the work of the **CG Supervisor** and the **Compositing Supervisor** and is responsible for determining the best split of **2D** and **3D** **work** and ensuring that each **shot** meets the technical, aesthetic, and **conti-**

nuity needs for the **show**. The DFX Sup reports directly to the **Visual Effects Supervisor (VFX Sup)** and often accompanies him to **shoot**s to help ensure that the necessary data is gathered, such as **camera report**s, **survey data**, **encoded data**, **motion control data**, and photo reference, as well as the placement of any **tracking marker**s on the **set**. Larger projects might find the need to have both a DFX Sup and an **Associate Visual Effects Supervisor (Associate VFX Sup)** to handle the workload.

digital effects work The portion of the **visual effects work** that is created or modified on a **computer**, which includes all digital **development, modeling, animation, character, character setup, particle system**s, **lighting, shader** writing, **previs, layout, matte painting**, and other **paint work** and **compositing**, to name just a few. Also referred to as **digital work**.

digital enhancement A global term used to describe a **shot** that needs a little help from the **digital** world. For example, adding a **glow** or simple **color correction** to a **live action element** would fall into the category of a digital enhancement.

Digital Equipment Corporation (DEC) One of the leading producers of **workstation**s, **server**s, and **personal computer**s (**PC**s). DEC also developed one of the most popular **search engine**s for the **Internet** called Alta Vista. **Compaq Corporation** purchased DEC in 1998.

digital facility See **digital effects facility**.

digital filter See **filtering algorithm**.

digital frame See **digital image**.

digital image Digital images are composed of a **2D array** of **pixel**s and can be defined by **height** and **width** but not **depth**. The greater the number of pixels, the larger the **image resolution**. Each pixel is comprised of three or four **component**s that represent the **red (R), green (G), blue (B)**, and **alpha channel**s, also known as **RGBA channel**s. Also called a **bitmapped image, bitmap, raster image**.

digital image processing See **image processing**.

digital image storage While there are a multitude of ways to digitally store an image, all methods store image information as an **array of dots** or **pixel**s. The greater the number of pixels used, the higher the **image resolution**.

digital information See **digital data**.

digital input device (DID) An **armature** that records the poses of **stop motion animation** into a **computer** so they can later be applied to a **CG character** of the same or similar proportions.

Digital Lead See **CG lead**.

digital linear tape (DLT) A widely used 1/2-inch **magnetic tape** format. See also **data storage technology (DST)**.

digital manipulation The process of applying **image processing** techniques to an **image** in a **computer**.

digital paintbrush A global term referring to any number of paintbrush options that are available within a **paint package**.

digital pipeline A term used to describe the step-by-step process used to create **computer generated imagery (CGI)**. There is no **industry standard** for the setup of a digital pipeline, as not only does each **facility** have its own unique standards, but the requirements of each **project** can also dictate the need for slightly differing pipelines within the same facility. See **2D pipeline**, **3D pipeline**.

digital plate restoration See **plate restoration**.

digital printer A **device** used to convert **digital image**s into **film image**s. See **laser printer**, **solitaire**.

Digital Producer See **Digital Effects Producer (DFX Producer)**.

Digital Production Manager (DPM) See **Production Manager (PM)**.

digital recording To record **image**s on a **digital tape** format. See **D1**, **D2**, **D3**, **D5**.

digital shot Any **shot** that contains **element**s that were created or manipulated on a **computer**.

digital signal The unique and well-defined data **samples** that make up **digital** information, as opposed to the continuously variable information found in **analog signal**s. Digital signals are virtually immune to interference from noise and **crosstalk**, and digitally based equipment tends to offer higher **transmission** speeds and a lower **error** rate than is found in **analog** technology.

digital sound A **soundtrack**, such as **Digital Theatre Systems (DTS)**, that records **computer** digits and converts them into **sound** signals. See **analog sound**.

digital studio See **facility**.

Digital Supervisor See **Digital Effects Supervisor (DFX Sup)**.

digital technology A global term used to describe any and all techniques that are solved with a digital solution.

digital television (DTV) One of many systems proposed for the new digital television standards. See also **high definition television (HDTV)**, **advanced television (ATV)**.

digital theatre systems (DTS) A **digital sound** format that stores the **sound track** on a **CD-ROM** rather than **printing** it directly onto the **film**. See also **Dolby**, **Sony Dynamic Digital Sound (SDDS)**, **THX**.

digital to analog converter (DAC) A **device** that converts **analog data** into **digital data**. Opposite of **analog to digital converter (A/D converter)**.

digital versatile disc (DVD) An **optical disk**, with greater capacity than a **compact disc (CD)**, that is used to store large amounts of **digital data**. A DVD can hold a full-length **film** of high-quality **video** up to 133 minutes long. DVD originally stood for **digital video disc** but was changed to Digital Versatile Disc when applications beyond video came into place. Some common **DVD** formats include **DVD-audio**, **DVD-R**, **DVD-RAM**, and **DVD-video**.

digital video A **video signal** that is represented **digital**ly with **binary number**s. Rather than representing visual information as a series of **analog sig-nal**s, as is the case with **analog video**, digital video represents information as collections of digital **bit**s of information that can be stored on **disk**s or **tape**s. Examples of **video** include **D1** and **D2**, and the main advantage is that multiple copies can be made without **generation loss**.

digital video disc (DVD) The original abbreviation for DVDs. See **digital versatile disc (DVD)**.

digital video disc-read only memory (DVD-ROM) A **DVD** format that holds **computer** data and is read by a DVD-ROM drive hooked up to a computer. DVDs have more **storage capacity** than a **CD-ROM** and can write **data** but cannot modify it. DVD-ROMs are commonly used for video games.

digital video effects (DVE) 1. Typically refers to any number of **2D** and **3D** animated **effects**, such as **rotate**, **pan**, **flip**s, **wipe**s, and **page turn**s, that can be performed in **real-time**. Examples of DVEs include **Harry** and **ADO**. 2. The trade name for a digital video effects system manufactured by NEC.

digital work See **digital effects work**.

digitize 1. To convert **analog data** to **digital data**. See **analog to digital con-verter (A/D converter)**. 2. The process of **scanning** images created by

nondigital methods, such as film, into the **computer**. See **film scanner**, **flatbed scanner**, **slide scanner**, **2D digitize**. 3. See **Telecine**. 4. The process of scanning **physical model**s with three dimensions into the **computer**. Referred to as **3D digitize**.

digitization See **digitize**.

digitizer 1. A **device** used to convert **analog signal**s into **digital signal**s. 2. The **device** used to **digitize** a **physical model**, such as a **maquette**, into a **digital model**. 3. See **Digitizer**. 4. See **Telecine**.

Digitizer The individual who **digitize**s a **physical model** for use on a **computer**.

digitizing pen A digitizing pen is used to **digitize** a **physical model** into a **computer**. When the the tip of the digitizing pen touches the **surface** of the **object** to be digitized, a corresponding **XYZ coordinate** is created in the computer. The physical **model** is generally prepared with evenly spaced **grid** lines across its surface as a visual aid to produce evenly spaced **data**. Also called a **pressure sensitive pen**.

digitizing tablet A digitizing tablet is used in conjunction with a **digitizing pen** to **digitize** 2D artwork into the **computer**. The artwork is laid flat across the digitizing tablet, and where the digitizing pen touches the artwork, **X** and **Y** coordinates are created in the computer.

dihedral angle The angle formed by two intersecting **plane**s. This angle can be used to calculate the minimum angle allowed between two **adjacent polygon**s when using **polygon reduction**.

dilate A **compositing operation** in which the darkest areas of an **image** decrease in size and the brightest areas increase in size. Opposite of **erode**. *See also image under erode.*

dimension A measurement of the size of an **object**, usually determined by **coordinate**s along the **XYZ axes** and described in terms of **width**, **height**, and **depth**. See **zero-dimensional**, **one-dimensional**, **two-dimensional**, **three-dimensional**.

DIN Abbreviation for **Deutsche Industrie Norme (DIN)**.

DIN rating The standard numerical rating for specifying the speed of a **film** or its sensitivity to **light**, as determined by the **German Industry Standard**. See also **ASA rating**, **ISO index**.

diode A semiconductor **device** that sends electric current in one direction only.

diode laser A solid state **laser** built from semiconductor materials that is used to create **red (R)**, **green (G)**, and **blue (B)** in some **laser film recorder**s, such as the **ArriLaser film recorder**. Diode lasers consume less power than **gas laser**s, which reduces problems resulting from the production of high or unstable heat levels. Diode lasers have low noise, a very stable energy output, and a life expectancy nearly four times that of gas lasers. Also called a **semiconductor laser**, **solid state laser**.

diopter lens See **close-up lens**.

dirac filter See **impulse filter**.

direct access See **random access**.

direct color See **true color**.

Directing Animator See **Animation Director, Animation Supervisor**.

directional continuity The established **screen direction** in which a person or **object** moves across a series of **shot**s within a **sequence**. An unexplained change in screen direction can cause a jarring mismatch. See **action axis**.

directional light A **light source** that is located infinitely far away and throws equal amounts of **light** in all directions. The sun is a good example of a directional light. The light comes from a specific point but is equally emitted in all directions. See also **area light, ambient light, point light, spotlight, volume light**.

directional light source See **directional light**.

directional limits See **direction constraint**s.

direction constraint The **constraint** that forces one **object** to orient itself toward the object to which it is constrained. The constrained object will always adjust its **rotation**s to point toward its constraining object. See also **translation constraint, rotation constraint**.

direct light **Light** that directly hits the **subject** and **surface**s in a **scene**. Contrast with **indirect lighting**. See also **incident light**.

Director The person responsible for overseeing the creative aspects of a **production** and for creating the final realization of the **film**. The Director guides the actors, defines the mood and **lighting**, determines the type of **camera move**s, and controls all aspects of the look and feel of the final **film**. In many cases, the Director also writes the **screenplay**.

Director of Photography (DP) The Director of Photography is responsible for **lighting** and photographing a **film** based on the vision of the **Director**. The DP is responsible for maintaining an overall **continuity** of style across the film and, for each **shot**, must determine the choice of **camera**s, **film stock**, **lens**es, **filter**s, the **camera move**, and the integration of any **special effects (SFX)**. The DP is also involved in the final **color timing** of the film. Sometimes referred to as the **Cinematographer**, **Cameraman**, **First Cameraman**, **Lighting Cameraman**. See also **Visual Effects Director of Photography (VFX DP)**.

Director's cut A first **cut** of the **film** created by the **Director** and his **Editor** as a step in developing the Director's vision of the final version of the film. The director's cut typically will contain a synchronized **sound track** but will not have the final **color timing**, **music track**, or **effects track**. Also called **first cut**.

Directors Guild of America (DGA) The professional organization and negotiating body for **Director**s, **Assistant Director**s, and some **production** personnel for **film** and television.

directory A grouping of files stored under one common name. In **Unix** and **DOS** environments, a directory can be easily identified because it is listed with a trailing slash (/) as in "image/" or "usr/." See also **folder**.

directory structure 1. The formal organization of all directories or **folder**s on a **hard drive**. The top **directory** from which all other subdirectories are attached is called the **root directory**. 2. The formally defined layout of the directories created within a **project**. While every **facility** has a different directory structure, it is imperative that the rules outlining the structure within that project are strictly adhered to by all **user**s in order to maintain control and continuity. See also **naming convention**s.

directory tree See **directory structure**.

direct to video A **feature film** made immediately available on **video** formats without a formal theatrical release in movie theatres.

dirt removal Synonym for **dust busting**.

disable A function available in most **software package**s to turn off or ignore a particular **node** or **function**. Opposite of **enable**.

disassembler A **program** that converts **machine code** back into **assembly language**. Opposite of **assembler**.

discontinuity See **cusp**.

Discreet Logic The Montreal-based developers of widely used **2D software package**s, such as **Flame**, **Inferno**, **Flint**, **Smoke**, **Harry**.

Discrete Fourier Transform (DFT) See **Fourier transform**.

disk A **storage device**.

disk allocation A global term referring to the amount of **disk space** that is set aside for a particular **file** or **project**. See also **job system**.

disk cache The portion of **memory** between the **disk** and the **central processing unit (CPU)** that enables the **computer** to retrieve **data** from disk faster. Recently accessed data is placed in the disk cache so that each time it is needed it can be instantly accessed without the need to search for it each time on the **hard disk**. Also called **external cache**. See also **memory cache**.

disk drive See **hard disk drive**.

disk formatting The preparation of a **disk** so that a **computer** can read and write **data** to it. Also called **format**, **initialize**.

diskette Synonymous with **floppy disk**.

disk hog See **disk intensive**.

disk intensive **Program**s or **process**es that require large amounts of **data** to be **read** and written from **disk** are said to be disk intensive. Also called a **disk hog**.

disk operating system (DOS) An **operating system (OS)** that resides on a **disk** and is most commonly used on **personal computer**s (**PC**s). See also **MS-DOS**, **PC-DOS**.

Disk Police Slang for the individuals responsible for managing the available **disk space** on a **network**.

disk space The amount of storage space available on a storage device.

disk storage To store **data** on a storage device.

disk usage The percentage of space on a **disk** that is storing **data**.

displaced geometry **Geometry** that has been displaced by a **displacement map** or an **expression** to create a new resulting **object** with a perturbed **surface**.

displacement 1. For **compositing**, see **displacement operation**. 2. To physically perturb or displace an **object** in **3D space**. See **displacement mapping**.

Displacement mapping actually displaces the height of the **surface** across a **3D object,** whereas **bump mapping** only perturbs the **surface normals.**
IMAGE CREATED USING MAYA AND COURTESY OF TEDDY YANG.

displacement map A **grayscale image** used to calculate the amount of **displacement** across the **surface** of an **object**. Also called a **displacement texture, deformation map, height map, displacement texture map**. See also **displacement mapping, displaced geometry**.

displacement mapping A **texture mapping** technique in which the **intensity** of the **gray value**s contained in a **displacement map** or **procedural shader** control the amount of **displacement** in **height** across the **surface** of a **3D object**. Generally, darker **pixel**s will move the surface down or inward, whereas brighter pixels move the surface up or outward. Unlike **bump mapping**, displacement mapping physically displaces the **geometry** of the object in **3D space**. See also **color mapping, environment mapping, procedural mapping,** *and image above.*

displacement operation A **compositing operation** that **warp**s an **image** by using another image to control the amount and location of the warp. See also **emboss**.

displacement shader A **procedural shader** that accomplishes **displacement** with mathematical **expression**s rather than with a **displacement map**. See also **surface shader, volume shader, light shader**.

displacement texture See **displacement map**.

displacement texture map See **displacement map**.

display 1. To **show** an **object** or an **image** within a **software package**. 2. The **device** on which an image is being viewed. Also called a **viewing device**. 3. Any visual representation of **data**.

display adapter See **graphics board**.

display board See **graphics board**.

display buffer The memory **buffer** that is used to **read** and display **image**s on a **viewing device**.

display card See **graphics board**.

display device Any **device** on which **image**s are displayed. Also called the **display**, **viewing device**.

display mode The type of **image display** seen in the **viewport**. Examples of common display modes include **wireframe**, **hidden line**, **flat** or **faceted** (**Lambert**), and **smooth shading** (**Gouraud**, **Phong**).

display monitor The **monitor** used to **display** and view **image**s.

dissolve An **image transition** that blends one **image** into another. Technically, a dissolve maintains image **density** by balancing the **gain** of **brightness** in the first image with the loss of brightness in the second image. Common types of dissolves include **matched dissolve**s, **distorted dissolve**s, and **frozen dissolve**s. Also called a **cross dissolve**.

distant light See **directional light**.

distant shot See **long shot (LS)**.

distort To **twist** or **warp** away from the natural or regular **shape** of an **object** or **image**. In some cases, **image processing** techniques are used to warp **CG element**s so they mimic the effects of the **lens distortion** seen in **live action plate**s. See **undistort**, **pincushion distortion**.

distorted dissolve A type of **dissolve** in which the **transition** between the two sets of **image**s includes an additional **distortion** effect such as a ripple, **warp**, **defocus**.

distortion 1. See **distort**. 2. In **video**, changes in the **luminance** or **chrominance** portions of the **signal** that can cause improper **contrast** or **color**.

distribution 1. A term used to describe the process of updating all **computer**s on a **network** with the same version of the **operating system (OS)** or **software release**. 2. The coordination of the marketing of the finished **film**

through licensing and sales. 3. The way in which a set of **data** is distributed, such as **linear**, **nonlinear**, or random fashion.

distributor See **film distributor**.

dither An **image process** that attempts to portray more **color**s than are available in the **palette** by displaying groups of different colored **pixel**s together to approximate the needed color. Dithering relies on the premise that the human eye will attempt to average the colors together and perceive them to be new intermediate colors. See **dither patterns**, **quantization**.

dither patterns The tightly grouped patterns of alternating shades of **color** used in **dither**ing to approximate the needed color. Dither patterns add **noise** to an **image** as a means of hiding undesirable **artifact**s, such as **banding**. However, too much dither can cause too coarse an image.

diverge To extend from a common point in different directions.

divergence method See **parallel viewing**.

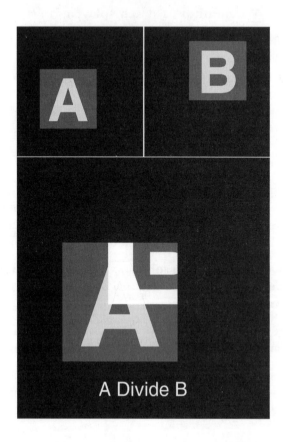

A Divide B

divide 1. See **divide operation**. 2. A standard **arithmetic operator**.

divide operation A **compositing operation** that divides each **pixel** in a single **image** by a **constant value** or divides the values of the pixels in image A by the corresponding pixels in image B. If working with **normalized value**s, any resulting **RGB value**s greater than one are **clamp**ed to a value of one. However, many **compositing package**s offer the ability to specify a **clamping value** of greater than or less than one. Opposite of **multiply operation**. *See also image under **layering operation**, and image on previous page.*

DLT Abbreviation for **digital linear tape (DLT)**.

D-max Also called **maximum density**, D-max refers to the actual maximum **density** on a given piece of **film**. D-max is expressed in terms of **density point**s and represents the top end of this scale, which reflects the **opacity** of the film. Opposite of **D-min**. See also **status A density**, **status M density**.

D-min Also called **minimum density**, D-min refers to the actual minimum **density** on a given piece of **film**. D-min is expressed in terms of **density point**s and represents the bottom end of this scale, which reflects the **transparency** of the film. Opposite of **D-max**. See also **status A density**, **status M density**.

DNS Abbreviation for **domain name system (DNS)**.

documentation Any instructions that accompany **hardware** or **software**. See also **readme**, **man page**s, **online documentation**.

DOD Abbreviation for **domain of definition (DOD)**.

DOF 1. Abbreviation for **depth of field (DOF)**. 2. Abbreviation for **degrees of freedom (DOF)**.

Dolby The trade name for a noise reduction **system** used in **sound** recording and reproduction.

dolly 1. To move the **camera** along the **Z-axis** either forward, **dolly in**, or backward, **dolly out**, relative to the **scene**. Unlike a **zoom**, a dolly involves changing **camera location**. Also called **camera dolly**. 2. A platform on wheels that is used to mount the camera for moving **shot**s. See also **dolly track**, **pan**, **tilt**, **roll**.

Dolly Grip The individual that moves the **dolly** on **set**.

dolly in To move the **camera forward** in space or toward the **subject** is to dolly in.

dolly out To move the **camera** backwards in space or away from the **subject** is to dolly out.

dolly shot A **shot** in which the **camera** dollies during the **filming** of the **action**. This move is often achieved with the aid of a **dolly track**. Also called a **tracking shot**, **follow shot**. See also **dolly**.

dolly track A length of track on which the **dolly**, **camera**, and **Cameraman** can be mounted that enables the camera to perform smooth **motion** during **filming**. *See also Color Plate 58.*

domain A group of **host**s on a **network** whose **hostname**s share a common suffix. See **domain name**.

domain name The **address** of a **network** address in the form of server.organization.type, such as www.sitename.com. See **domain name system (DNS)**.

domain name system (DNS) A **protocol** used on the **Internet** for translating **hostname**s into **Internet address**es. When an **electronic mail (e-mail)** message is sent or a **Web browser** locates a specific **Web page** on the Internet, the domain name system translates an **address**, such as www.nameofsite.com, into a series of numbers in the form of 111.222.33.4. DNS refers to both the conventions for naming **host**s and the way those names are handled by the Internet.

domain of definition (DOD) The region defining the maximum boundaries of useful **image** information. A DOD is calculated automatically, and the **channel values** outside its boundaries are generally equal to zero. See also **region of interest (ROI)**.

domestic release The first major **release** of a **film** in the United States and in English-speaking countries, as opposed to the **foreign release** that contains a new **sound track** and **subtitle**s for release in non-English-speaking countries.

domestic version See **domestic release**.

Domino A **compositing package** developed by **Quantel**.

dongle A security **device** sometimes used for **3rd-party software** as a means of **copy** protection. The dongle is plugged into a **port** on a **computer** to ensure that only authorized **user**s can copy or use the **software**. The use of dongles has become increasingly rare.

donut A circular piece of rubber that is placed in front of the **lens** to prevent any **light** from passing through the **matte box**.

dope sheet 1. See **timeline**. 2. See **camera report**.

DOS Abbreviation for **disk operating system (DOS)**.

DOS-based See **DOS-based system**.

DOS-based system A general term describing a **computer** that runs under **DOS**. See also **Unix-based system** and **Mac-based system**.

DOS Shell A **command interpreter** used by the **DOS operating system**, such as **command.com** and **DOS**. See also **Unix shell**.

dot file A **configuration file** used on **Unix-based system**s. Dot files, such as .login, .cshrc, and .profile, are used to define the startup **configuration** for each **user** at the time of login. Dot files get their name because the first **character** in their name is always a "dot" or period. If a dot file is updated while the user is logged into the **system**, the file must be **source**d in order to make the **computer** aware of the changes.

dot matrix A dense pattern of dots used to reproduce **alphanumeric** characters on a **dot matrix printer**.

dot matrix line printer See **dot matrix printer**.

dot matrix printer A **printer** that prints one line at a time and uses patterns of dots from an ink ribbon to represent each **character**. Also called a **line printer**, **dot matrix line printer**.

dot product A **scalar** that is the product of two **vector**s. Also called **scalar product**.

dots per inch (DPI) A standard of defining the **spatial resolution** of a **digital image** in the print industry. DPI represents the number of individual dots reproduced both horizontally and vertically in any inch of the **image**. See also **lines per inch (LPI)**.

dot size The unit of measurement used to describe the diameter of the dots left by the impressions of a **printer**.

double buffering Double buffering increases the quality of **image**s viewed on a **24-bit display** by using two **display buffer**s to alternate between displaying an image and receiving a new image. Because the image update is never made directly to the **screen**, the **viewer** does not see the **flicker** that occurs when double buffering is turned off and only one display buffer is used. See **single buffering**.

double click A common **menu** activator in which the **user** is required to **click** twice with their **mouse button** in order to make a menu **open** and **active** for their **input**.

double-density disk A **disk** that has twice as much **storage space** per **unit** as a **single-density disk**. See also **high-density disk**.

double exposure (DX) 1. To **expose** at least two different **images** onto one **negative** to create a **mix**ed result of the images. Also called an **optical double exposure**, **multiple exposure**, **burn-in**. See **backwind**. 2. For **digital**, to mathematically **average** two distinct images together into a new mixed result.

double float Synonymous with **double precision number**.

double frame Another term for **double print**.

double precision See **double precision number**.

double precision number A **floating point number** that uses more **precision**, or more numbers to the right of the decimal point, than a **single precision number**. A double precision number does not necessarily contain twice as many digits as the single precision number but twice as many **bits**. For example, if a single precision number requires **32 bit**s to represent it, it will take **64 bit**s to represent it in double precision.

double print 1. A method to decrease the speed of a series of **images** by half by duplicating and repeating every **frame** in the **sequence**. The **viewer** can often perceive the individual steps that break up the original smooth action. The opposite of **skip print**. Also known as **double frame**. 2. To make two identical sets of **dailies** to have an extra **print** available for **editing** or the **client**.

double reel Before **distribution** of a **film**, the 1000-**foot** editing **reel**s are combined into 2000-foot reels for theatres.

double-sided 1. See **double-sided geometry**. 2. See **double-sided disk**.

double-sided disk A **floppy disk** that can be written to on both sides.

double-sided geometry Double-sided **geometry** refers to an **object** containing **surface**s with both **backface**s and **front face**s. The **normal**s attached to the frontfacing geometry face the **camera**, and the backfacing normals face away from the camera. Generally, only one side of the surface needs to be **render**ed. See also **single-sided geometry**.

double system A **projection** system that locks together during projection two separate pieces of **film**, one containing **picture** and the other containing **sound**. **Sync** is maintained as though viewing a **composite print**.

down A **computer** or **disk** that is not operational due to either an intentional **shutdown** for maintenance or an unexpected **crash**.

download To transfer **data** from a **central computer** or **storage device** to another computer or **peripheral device**. Opposite of **upload**.

downloadable Any **data** that can be transferred from the **Internet** or another **network**.

downtime 1. The time during which a **computer** cannot be used due to **system** problems or scheduled maintenance. 2. The period of time that a **Digital Artist (DA)** cannot work due to a **computer** or **network** that is not operational.

downward compatible See **backward compatible**.

DP Abbreviation for **Director of Photography (DP)**.

DPI Abbreviation for **dots per inch (DPI)**.

DPM Abbreviation for **Digital Production Manager (DPM)**. See **Production Manager (PM)**.

drag 1. To hold down the **mouse button** to **select** a **window**, **icon**, or **menu** tab and then without releasing the mouse button, move the **cursor** to another location on the **screen**. 2. For **particle system**s, a **parameter** that controls the **friction** due to air resistance for an **object**.

DRAM Abbreviation for **dynamic random access memory (DRAM)**.

drawing exchange file (DXF) This is a common **file format** for exchanging **geometry** and drawing information between **CAD** systems.

draw order The back-to-front order that **polygonal object**s are drawn on top of one another in a **3D scene**. See **Z-buffer**.

draw rate See **frames per second (FPS)**.

drive A **hardware device** that allows access to information on other media, such as a **CD-ROM**, **hard disk**, **floppy disk**, or **magnetic tape**.

drive-bys Slang for fast **walkthroughs**. See also **fly-bys**.

driver See **device driver**.

drive on Permission left by an employee with the guard at the main gate of a **studio**, allowing entrance onto the **lot** for expected visitors. Also called a **gate pass**.

drop dead deadline The absolutely final **deadline**—no fooling!

drop frame See **drop frame timecode**.

drop frame timecode A method used for **video** playback to compensate for the fact that **timecode** runs at exactly 30 **frames per second (FPS)**, whereas **NTSC** runs at 29.97 FPS. Technically, this is achieved by dropping two **frame**s every minute except on the tenth minute.

dropoff The **parameter**, usually used for a **spotlight**, that controls the way the **light intensity** fades based on its distance from the center of the **light cone**. Also referred to as **attenuation**. See also **spread**, **falloff**.

dropout The momentary loss of a portion of information on a **magnetic tape** characterized by **horizontal** black or white streaks running through the **frame**.

drum scanner A **scanner** driven by a spinning **cylinder** capable of capturing **high-resolution image**s, transparencies, and **flat artwork**.

DST Abbreviation for **data storage technology (DST)**.

DTS Abbreviation for **digital theatre systems (DTS)**.

DTV Abbreviation for **digital television (DTV)**.

dual boot A configuration that enables a **computer** to start with one of two possible **operating system**s **(OS)**.

dual input operator An **image operator** that takes two **sequences** of **image**s as its **input**. Also referred to as **multiple image operator**.

dual processor A **computer** that has two **central processing unit**s **(CPUs)**.

dub 1. A **copy** of a **videotape**. 2. The process of creating a copy of a videotape. 3. See **automatic dialogue replacement (ADR)**.

dumb terminal A **keyboard** or **screen** that is connected to a main **computer** for simple **data entry** and **retrieval**.

dummy node See **null node**.

dummy object See **null node**.

dump 1. Synonymous with **backup**, **archive**. 2. Shorthand for **dump core**. See **core dump**.

dump core See **core dump**.

dump ribs The **process** of calculating and writing to **disk** the **RIB file**s that make up the **scene**.

dumpster The **icon** to which you **drag** any **file**s that you wish to **delete**.

dupe 1. Short for **duplicate**. 2. Short for **duplicate negative**. See **internegative**.

dupe neg Abbreviation for **duplicate negative**. See **internegative (IN)**.

dupe negative Abbreviation for **duplicate negative**. See **internegative**.

duplicate 1. Referring to a **copy** made of a **film** at any stage. See also **duplicate negative**. 2. Another copy of any piece of **data**. 3. See **clone**.

duplicate negative Another name for an **internegative (IN)**.

dusk for night A term used to describe **plate**s that are **shot** at dusk with the the intent of **color correct**ing them to appear to have been shot at night. The advantage of shooting such plates at dusk is that there is still sufficient detail in the buildings to allow for **digital** manipulation and there are lights on in the buildings that can be intensified for a night look. See also **day for night**.

dust busting The term used to describe the process of painting out dirt and scratches on **scanned images**. Also referred to as **dirt removal**, **digital plate restoration**.

dutch See **roll**.

dutch angle To **frame** a **shot** so that the **camera** is **rotate**d along the **Z-axis** and the **image** appears diagonally within the frame. Also called **canted angle**, **chinese angle**.

dutch shot See **dutch angle shot**.

dutch angle shot A **shot** in which the **camera** rotates around the **Z-axis**.

dutch tilt See **dutch angle**.

DVD Abbreviation for **digital versatile disc (DVD)**.

DVD-audio A **DVD** format used for audio recording.

DVD-R A recordable **DVD** format. See also **DVD-RAM**.

DVD-RAM A recordable **DVD** format. See also **DVD-R**.

DVD-ROM Abbreviation for **digital video disc-read only memory (DVD-ROM)**.

DVD-video The **DVD** format used to hold **video** programs that is played back on a DVD player hooked up to a television.

DVE Abbreviation for **digital video effects (DVE)**.

DX 1. Abbreviation for **double exposure (DX)**. 2. Another name for **D3**.

DXF Abbreviation for **drawing exchange file (DXF)**.

dye sublimation printer A **printer** that uses heat transfer to produce continuous tone.

Dykstraflex The **motion control (MOCO)** system designed by John Dykstra and others at Industrial Light and Magic for the making of *Star Wars*.

dynamic random access memory (DRAM) A type of **random access memory (RAM)** that is cheaper than, but not as fast as, other types of RAM. See also **extended data-out random access memory (EDO RAM)**.

Dynamation 1. The **particle system** developed by **Alias/Wavefront**. It was widely used as a **standalone** product but has since been integrated into **Maya**. 2. A technique, first developed in 1958 by Ray Harryhausen for *The Seventh Voyage of Sinbad*, that enables **live action** matte and **stop-motion animation** to be combined as an **in camera effect**.

dynamics See **motion dynamics**.

dynamic range 1. The ratio of bright-to-dark **value**s in an **image** or **display device**. **Film** contains a greater dynamic range than **video**. Also called **contrast ratio**. 2. The total number of different **color**s represented in an image. 3. For **audio**, the range between the softest and loudest sound levels a source can reproduce without distortion.

dynamic resolution Another term for **color resolution** that refers to the greater **dynamic range** available from using more **bits per component**.

dynamic simulation An **animation** that is based on the use of **motion dynamics** to calculate its **motion**.

ease The **interpolation** of a **curve** in which the rate of change is slowly increased, **ease in**, or slowly decreased, **ease out**. For some **animation package**s, ease can automatically imply both an ease in and ease out. *See image below and images on following page.*

ease in A **curve** in which the rate of change begins very slowly and then speeds up to a faster change rate. Opposite of **ease out**. Also called **slow in**. *See image below and images on following page.*

ease out A **curve** in which the rate of change is slowly decreased at the end of a move. Opposite of **ease-in**. Also called **slow out**. *See image below and images on following page.*

ease in/ease out A **curve** that contains both an **ease in** and an **ease out**. Also called a **slow in/slow out**. *See image below.*

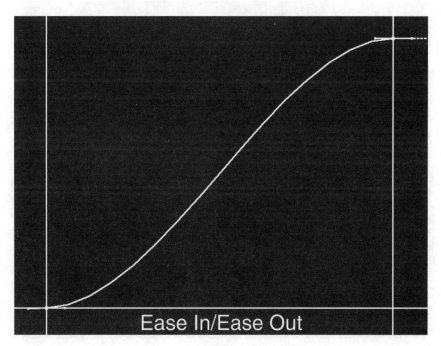

Ease In/Ease Out

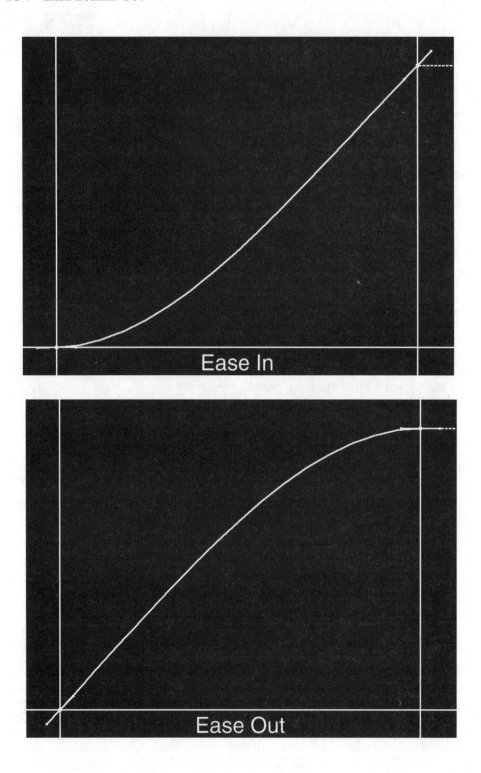

Ease In

Ease Out

east Compass terminology used to refer to the positive portion of the **X-axis**, of a **frame** or **image**.

Eastman Kodak Company The company started in 1880 by George Eastman that provides a wide range of **film** and **digital** products including **camera**s, **printer**s, **film recorder**s, **scanner**s, **projector**s, and their accessories.

east/west axis Another name for the **X-axis**.

EBR Abbreviation for **electronic beam recorder (EBR)**.

eccentricity The **attribute** in the **Blinn shading model** used to control the size of the **specular highlight**.

ECU See **extreme close-up (ECU)**.

ed A **text editor** that has been, for the most part, replaced by **visual interface**.

edge 1. The straight lines connected between the **point**s of a **polygon**. 2. The point where two **surface**s meet or one surface ends. 3. The areas in an **image** where **color** changes abruptly and creates the illusion of a contour. 4. See **matte edge**. 5. The boundaries of an image or **frame**. See **domain of definition (DOD)**.

edge blending A **compositing** technique in which a subtle **blur** is applied to the **edge** of an **element** to help better integrate it into the **background plate**.

edge characteristics See **edge quality**.

edge code The sequential numbers printed on the edges of a piece of **film** by **Editorial** after **processing** as a means of maintaining **sync** between **picture** and **sound** after the film has been edited into shorter **cut**s. Also called **code numbers**. See **edge numbers**.

edge detection An **image process** using an **algorithm** to isolate or enhance the **edge**s, or areas of **transition**, in an **image**.

edge matte A **matte** that defines only the **edge**s or outlines of an **object**. See also **center matte**, *image under **image processing***.

edge numbers The sequential numbers printed along one edge of a strip of **film** outside the **perforation**s that are used for identifying **footage** or specific **frame**s. Edge numbers, represented by four digits, are printed during manufacture of the film, whereas **edge code** numbers, represented by three digits, are added after **processing** by the **Editorial** staff. Also called **key numbers, footage numbers, negative numbers, keycode numbers, keykode, latent edge numbers**.

edge quality A term used to describe the characteristics of the **edge**s of an **element** that have been **matte**d into a **scene**. Edge quality characteristics might include the **sharp**ness or **soft**ness of the matted edge or whether the edge **chatter**s due to a poorly **rotoscope**d matte.

edit 1. To make changes to a **file**. See also **text editor**, **curve editor**. 2. See **editing**.

edit bay The room used for **editing**.

edit decision list (EDL) The complete list of **time code**, **cut**s and **transition**s, and **sound** that is prepared during **offline editing** for use during **online editing**.

edit field The **box**, usually rectangular, used for inputting **text command**s and **value**s.

editing 1. The process of **cutting** together a series of **scene**s in order to best portray the story being told while maintaining **continuity**. Also referred to as **cutting**. See **film editing**, **video editing**. 2. The process of creating and modifying **geometry** or **curve**s.

editing bench The work table on which most **film editing** equipment sits. Also called the **bench**.

edit list See **edit decision list (EDL)**.

Editor The individual who assembles the **shot**s into the final **cut** of a **film** or **videotape**.

Editorial The department responsible for all the **editing** tasks of a **film**.

edit point 1. In **computer graphics (CG)**, a **point** directly placed on a **spline** that controls the **shape** of a **curve**. Also called a **knot**. 2. In **editing**, the location on the **tape** or **film** where a **transition**, such as a **cut**, **dissolve**, or **wipe**, occurs from one **scene** to the next.

edit session The time during which an **Editor** works on a **cut** of the **film** or **videotape**.

EDL Abbreviation for **edit decision list (EDL)**.

EDO RAM Abbreviation for **extended data-out random access memory (EDO RAM)**.

effector The **end point**, or last **bone**, of a **skeleton chain** that is used to **position** and **pose** the rest of the **chain** with **inverse kinematics (IK)**. Also called **end effector**, **end joint**. *See also image under bones.*

effects Referring to all kinds of effects work, including **special effects (SFX)**, **visual effects (VFX)**, **digital effects (DFX)**, and **cel animation effects**.

effects animation Generally referring to **cel animation** or **digital animation** techniques that are not **character** related, such as smoke, sparks, water, snow, fire.

Effects Artist An artist who creates **effects animation**.

effects dailies A **dailies** dedicated to reviewing the latest round of **effects** in the **shot**s with the **Effects Team**. See also **animation dailies**, **effects dailies**, **lighting dailies**, **stage dailies**.

effects facility A term describing a company or **studio** that specializes in the creation of **visual effects (VFX)**. Also called an **effects house**, **effects studio**, **facility**.

effects film Generally, referring to a **film** that contains a lot of **visual effects (VFX)**.

effects filter Any **filter**s added to the **camera lens** to create **diffusion**, **flare**s, and **glow**s.

effects house See **effects facility**.

effects module The portion of a **3D software package** use to create **effects**, such as **dynamic simulation**s and **particle animation**.

effects shot A **shot** that requires the use of **special effects (SFX)** and/or **visual effects (VFX)** techniques.

effects studio See **effects facility**.

Effects Supervisor 1. Abbreviation for **Visual Effects Supervisor (VFX Sup)**, **Digital Effects Supervisor (DFX Sup)** or **Special Effects Supervisor (SFX Sup)**. 2. The artist responsible for the creation of **digital effects (DFX)**, such as **particle animation** and **dynamic simulation**s. The Effects Supervisor manages a small team of **Effects Artist**s and is responsible for delivering effects that maintain the technical and aesthetic needs of the **project**.

effects track The separate **sound track** channel onto which **sound effects** are recorded. See also **music track**, **dialogue track**.

effects work See **effects**.

EFX Abbreviation for **effects**. **FX** is also used.

EI Abbreviation for **exposure index (EI)**.

eight bit 1. See **8 bits per channel**. 2. See **8-bit image**. 3. See **8-bit display**.

eight-bit color 1. See **8 bits per channel**. 2. See **8-bit image**. 3. See **8-bit display**.

eight-bit computer See **8-bit computer**.

eight-bit display See **8-bit display**.

eight bits per channel See **8 bits per channel**.

eight bits per color channel See **8 bits per color channel**.

eight bits per component See **8 bits per component**.

eighteen-percent gray card See **gray card**.

eight-millimeter film See **8mm film**.

eight-perf See **8-perf**.

eight's See **on eight's**.

elasticity The amount of energy lost when an **object** makes contact with another object. For example, a ball that is very elastic will lose little energy when it hits another **surface**, and it will bounce a lot. Conversely, a ball with little elasticity will barely bounce at all, as it will lose a great deal of energy when it makes contact with another surface. Elasticity is a common **physical property** used to create **simulation**s with **motion dynamics**.

Elastic Reality (ER) The trade name for a **2D software package** designed for **morphing**, **warping**, and the creation of **articulated matte**s.

Electric Image A **PC**-based, **3D software package** owned by Play Incorporated.

electron beam A stream of electrons produced by an **electron gun**. See **cathode ray tube (CRT)**.

electron gun The electrodes in a **cathode ray tube (CRT)** that **emit** an **electron beam**.

electronic beam recorder (EBR) An electronic beam that can directly **expose** an **image**. Opposite of a **CRT recorder**.

electronic clapper See **electronic slate**.

electronic mail (e-mail) A global term used to describe messages that are sent and received electronically between **computer**s with a variety of avail-

able **program**s. See **electronic mail address (e-mail address)**, **electronic mail server (e-mail server)**.

electronic mail address (e-mail address) The **string** used to specify the **source** and/or **destination** of an **electronic mail message (e-mail message)**.

electronic mail alias (e-mail alias) A list of **e-mail address**es that are grouped into one name to make sending an **e-mail message** to a large group of people easier. When the **e-mail server** sees the e-mail alias, it expands it to include all the e-mail addresses included on the list. E-mail aliases are often used for the various **show**s at each **facility** as a means of identifying smaller groups of people that need to receive particular mailings.

electronic mail list (e-mail list) See **electronic mail alias**.

electronic mail message (e-mail message) A message sent or received electronically between **computer**s.

electronic mail server (e-mail server) A **program** that manages and distributes the message sent with **electronic mail (e-mail)**. Also referred to as **mail server**.

electronic pin register (EPR) The **device** that stabilizes and reduces the **ride** and **weave** of **film** as it is transported through a **Telecine** machine. Also called a **steady gate**.

electronic postsync (EPS) See **automatic dialogue replacement (ADR)**.

electronic press kit (EPK) The behind-the-scenes **video** that shows how a **film** was made. Generally, it includes interviews with the **Director**, **Producer**, and main actors, and often covers points that were particularly unusual, challenging, or even dangerous about the making of the film.

electronic slate A type of **slate** that contains a running **time code** display on its frontface. When the **clapsticks** are struck together, the time code freezes. Also called an **electronic clapper**. See also **bloop light**.

electronic stylus See **stylus**.

element The individual **layer**s of **image**s used to create a **digital composite** are referred to as elements. While there is a wide range of element types, they can most simplistically be broken down in terms of **scanned images**, **hand-painted element**s, and **computer-generated images (CGI)**.

ellipsoid A **surface** composed of **cross section**s that are either ellipses or circles.

ELS Abbreviation for **extreme long shot (ELS)**.

EMACS Abbreviation for Editing MACroS or Extensible MACroSystem. A pro-grammable **text editor** that contains the entire **LISP** system inside of it and **run**s under most **operating system**s (**OS**). See also **visual interface (VI)**, **jot**.

e-mail Abbreviation for **electronic mail (e-mail)**.

e-mail address Abbreviation for **electronic mail address (e-mail address)**.

e-mail alias Abbreviation for **electronic mail alias (e-mail alias)**.

e-mail list Abbreviation for **electronic mail list (e-mail list)**. See **electronic mail alias (e-mail alias)**.

e-mail message Abbreviation for **electronic mail message (e-mail message)**.

e-mail server Abbreviation for **electronic mail server (e-mail server)**.

emboss An **image operation** that increases the apparent **depth** of an **image** based on its **luminance** values. See also **displacement operation**, *and image below.*

emission rate See **particle emission rate**.

emit 1. The **color** or **light** that an **object** appears to give off from itself. See also **ambient**, **diffuse**, **specular**, **transmit**. 2. For **particle animation**, to birth or give off **particle**s. See **particle emitter**.

Embossing can create an apparent **depth** to a **image**.

emitter See **particle emitter**.

emulator **Hardware** or **software** that performs like other hardware or software.

emulsion See **film emulsion**.

emulsion side The side of the **film** coated with the **film emulsion**.

enable A function available in most **software package**s to turn on or include a particular **node** or **function**. Opposite of **disable**.

encode 1. To combine **component video** signals into a **composite video** signal. Opposite of **decode**. 2. See **encryption**. 3. To **convert** electronic **data** into a standard format.

encoded data **Data** that has been **encode**d or run through an **encryption** process.

encoder 1. The **video** device used to combine a **component video** signal into a **composite video** signal. The opposite of a **decoder**. 2. A **device** used with **motion control (MOCO)** equipment to measure **rotation** of the motor shaft or in the absence of motion control to measure the rotation of the **camera** itself. See also **nodal point**—Definition #2.

encrypt See **encryption**.

encryption 1. The conversion of **plain text** into scrambled **text**, known as **cyphertext**, in order to prevent unintended access by other **user**s. 2. The scrambling of **signal**s.

end curve See **boundary curve**.

end effector See **effector**.

end joint See **effector**.

end point The start and end **control point**s used to define a **curve** or **vector**.

end point interpolation The way that **curve segment**s attach to their start and end **control point**s. Some curves will lie directly on their end points, whereas others, such as **B-spline**s and **Cardinal**s, do not. In the case of the latter two **curve type**s, additional control points must be added to force the curve to cross through these points. Some **3D package**s will do this automatically by adding **phantom control points**.

end slate See **tail slate**.

end titles The list of **credits** that appear at the end of a **film** and typically include all the **Cast and Crew** members that did not appear in the **main titles** at the start of the film. See also **insert titles**, **subtitles**.

end user The **user**s who will use a piece of **software** or **hardware** after the people responsible for creating it have **release**d it.

enhancement 1. Any change that adds features to or makes a previous **version** of **hardware** or **software** perform better. 2. See **digital enhancement**.

ENR See **bleach bypass**.

envelope See **skin**.

Enveloper Another term for a **Character Setup Technical Director (Character Setup TD)**.

enveloping See **skinning**.

environment 1. Referring to the **3D environment** surrounding the **object**s in a **scene**. 2. All the settings, preferences, and commonly used **application**s in a **system** make up its environment. See **environment variable**s. 3. The **hardware and software** configuration of a **computer**.

environment map The **image** used to simulate a **reflective** appearance of the **3D environment** it surrounds without the use of **ray tracing**. Also called a **reflection map**. See **environment mapping**.

environment mapping A **texture mapping** technique in which **image**s are used to simulate a **reflective** appearance of the **3D object**s they surround without the use of **ray tracing**. The two most common methods of environment mapping are **cubic mapping**, which uses six images mapped to the faces of a **cube**, and **spherical mapping**, which maps one image to the interior of a **sphere**. Environment mapping is a lot less **render intensive** than ray tracing but also less accurate. Also referred to as **reflection mapping**.

environment procedures Some **3D software package**s offer **tool**s to **procedural**ly create **element**s of a **3D environment**, such as clouds, **atmosphere**, terrain, and the sun. More advanced packages even include the ability to specify the year, month, time of day, and even the location of the elements in terms of their latitude and longitude.

environment reflection mapping See **environment mapping**.

environment texture See **environment map**.

environment texture map See **environment map**.

environment texture mapping See **environment mapping**.

environment variable A **parameter** that is bound to the current **environment** and is used in the evaluation and calculation of an **expression** referring to that parameter.

EP Abbreviation for **Executive Producer (EP)**.

EPK Abbreviation for **electronic press kit (EPK)**.

EPR Abbreviation for **electronic pin register (EPR)**.

EPS Abbreviation for **electronic postsync (EPS)**. See **automatic dialogue replacement (ADR)**.

EQ Abbreviation for **equalization (EQ)**.

equalization (EQ) The process of adjusting the volume level of individual **channel**s of **audio**.

equalizer A **device** that can increase or decrease specific **signal**s during **transmission**.

ER Abbreviation for **Elastic Reality (ER)**.

erase See **delete**.

erode A **compositing operation** in which the darkest areas of an **image** increase in size and the brightest areas decrease in size. Opposite of **dilate**. *See image on following page.*

error 1. See **computer error**. 2. See **operator error**.

error dialog The box that pops up on the **computer screen** to alert the **user** to a warning or **error message**. Typically, the user must **click** on the box to acknowledge receipt of the message before continuing. Also called **alert box**. See also **dialog box, confirmation box**.

error message The message **display**ed in an **error dialog** or into the **current window** to let the **user** know the **computer** cannot carry out the current set of **command**s due to an error with the **hardware** or **software**, or an **operator error**. Also called an **alert message**.

error window Synonymous with **error dialog**.

e-split Abbreviation for **exposure split**.

establishing shot A **shot**, usually a **wide shot**, used at the beginning of a **sequence** to orient the viewers to the location in which the action will take place and to the relative placement of the **subject**s within it. See also **master shot**.

ethernet A type of **local area network (LAN)** that **transmit**s information between **computer**s across **coaxial cable**s or **twisted pair cable**s at speeds ranging between 10 and 1,000 **megabytes per second (MBPS)**.

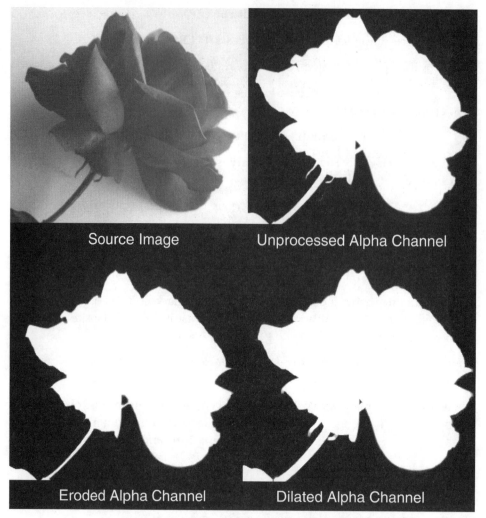

Source Image Unprocessed Alpha Channel

Eroded Alpha Channel Dilated Alpha Channel

A **matte** before and after an **erode** and **dilate** process.

Each computer first checks if another computer is transmitting and, if so, waits its turn to transmit the **data**. In the event that two computers accidentally transmit at the same time, resulting in their messages colliding, they will wait again in turn before resending. **Fast ethernet** works at 100 MBPS, whereas the newer **gigabit ethernet** will support **data** transfer at 1,000 MBPS! See also **10Base-T**, **100Base-T**.

ethernet address The physical address that identifies an individual **ethernet** board and is usually written as six **hexadecimal** numbers.

ethernet card The **circuit board** that enables the connection between a **computer** and an **ethernet**.

ethernet meltdown A **network meltdown** occurring on the **ethernet**.

ethernet network Any **network** that uses **ethernet**.

Ethertalk **Software** from **Apple** that enables a **Macintosh** to talk to an **ethernet network**.

Euler's Formula The **formula** used to describe the conditional relationship between the **vertices**, **edge**s, and **face**s of a **polyhedron**. In simple terms, it is a formula used to compute **rotation**s.

European wide-screen Referring to a standard **film format** common in Europe that uses an **aspect ratio** of **1:66.1**. See also **American wide-screen**.

eval Shorthand for **evaluation**.

evaluation A term used to describe the temporary licensing of a **software package** from a **vendor** in order for an individual or **facility** to "evaluate" it as a product they might want to purchase.

even field The half of a **video** frame that is made up of the even-numbered **scan line**s. Opposite of **odd field**. See **field**.

even lines See **even field**.

even scan lines See **even field**.

event In **editing**, a change in **picture** or **sound**, such as a **cut** or **transition**.

evolutionary art An **animation** technique based on **artificial intelligence (AI)** and living **simulation**s.

ex The root of a family of display-based **text editor**s, including **ed** and **vi**.

exabyte An 8mm **electronic tape** for storing **digital data**.

exclusive light A **light source** that can cast **light** only onto user-defined **object**s in a **scene**. Also called a **selective light**. See **light linking**.

exclusive operation A **Boolean operation** that creates a new **object** that exists only where each **input** object existed without intersecting with one another. Also called the **XOR operator**.

executable Shorthand for **executable program**.

executable program A **program** that has been **compile**d and is ready to **run**.

execute The act of running a **program** or a **batch process**. Also referred to as **run**.

execute mask The portion of the **permissions** on a **file** that determines who can **execute** that file. See also **read**.

execute only A **file** whose **permissions** allow it only to be **run**. No **user**s can **read** or **write** to that file. See also **write only, execute only**.

Executive Producer (EP) The individual who is in charge of the entire **budget** of a **film** or who supervises the work of individual **Producer**s on their specific films at a large **facility** or **studio**. The Executive Producer is not involved in the technical aspects of **filmmaking** but is still responsible for the overall production. In some cases, the title of Executive Producer is also awarded to the individual who initially acquired the rights to a **project** or arranged the deal to get the project made. See also **Head of Production**.

executive program A **program** that controls the execution of other programs. Also called the **supervisory program**.

exit To leave a mode in which the **computer** currently resides.

expand 1. An **image process** that takes a specific range of **pixel value**s and remaps them to fall within a range between 0 and 1. **Value**s that were originally above or below this range will now be included within 0 and 1 as well. See also **clamp**. 2. See **uncompress**.

expansion board Any board that can be plugged into the **expansion slot**s of a **computer** to increase some feature, such as **memory**, **display**, or **sound**. Also called an **expansion card**.

expansion card See **expansion board**.

expansion slot The narrow openings in a **computer** that allow additional **disk**s and **expansion board**s to be inserted. Also called a **slot**.

exponential curve Another name for **gamma correction curve**.

export The ability to **write** out a **file** created in one **application** to a file that can be **read** by another application. See **import**.

expose To allow **light** to strike the **emulsion** layer of **unexposed film stock** in order to create an **image**.

exposed film Referring to a **film** after **exposure** but before **processing**. See **unexposed film**.

exposed negative See **exposed film**.

exposure 1. The process of exposing **film** to **light** in a **camera** or **printer** so that a **latent image** is formed in the **emulsion**. The quality of the exposure is dependent on the **scene** lighting, the period of time that the film is exposed to the light, and the size of the opening in the **camera lens**. **Overexposure** creates a very light and washed-out image, whereas **underexposure** creates a dark image. 2. The amount of light allowed to strike the film. 3. The length of time that the film is exposed to light. 4. The portion of the film that is exposed to light.

exposure bracketing Another term for an **exposure wedge**.

exposure index The numerical rating used to indicate the speed of a **film stock** and its sensitivity to **light**. See **ASA rating**, **DIN rating**, **ISO index**.

exposure latitude The range of **overexposure** and **underexposure** a particular **film stock** can tolerate and still produce an acceptable result.

exposure meter See **light meter**.

exposure sheet 1. For **computer graphics (CG)**, see **timeline**. 2. The list of **scene**s from the **script** that have already been **film**ed. 3. The list of contents on an **expose**d reel of **film stock**. Also referred to as a **dope sheet** for all three definitions.

exposure split A method of combining multiple **exposure**s of a **scene** as a **split-screen** in order to maintain a wide range of **contrast** within the same **shot**.

exposure test strip See **sensitometric strip**.

exposure time The length of time each **frame** of **film** is **expose**d to **light**.

exposure value The number indicating the amount of **light** reflecting off the **subject**. An exposure value is obtained using a **reflected light meter**.

exposure wedge A series of **image**s that contain incremental steps in **exposure**, or **brightness**, of an **element** or **composite** as a means of selecting the final **value**. Also called **exposure bracketing**, **wedge**. See also **color wedge**.

expression A mathematical function specified by a **text string**. Also called **mathematical expression**.

expression language A language available in most **software package**s that allow the **attribute**s of **object**s and **image**s to be modified based on **mathematical expression**s.

expression operation An **image operator** that accepts a **user-defined** set of **expression**s to adjust the **color channel**s.

EXT Abbreviation for **exterior (EXT)**. See **exterior shot**.

extended ASCII An additional set of **ASCII characters** than may include foreign characters, math symbols, graphics symbols, and other special symbols.

extended data-out random access memory (EDO RAM) A type of **dynamic random access memory (DRAM)** that increases the access speed of **memory** locations by making an assumption that each **address** accessed will exist in a **contiguous** location of **disk**. See also **static random access memory (SRAM)**, **random access memory (RAM)**.

extensibility The ability to add functionality to a **software package** via custom **macro**s and **plug ins**. Also called **open architecture**.

extents Another name for **bounding box**.

exterior (EXT) See **exterior shot**.

exterior shot A **shot** in which the **action** is **film**ed outdoors or from the exterior of a **set**. Opposite of **interior shot**.

external cache See **disk cache**.

external device See **peripheral device**.

external drive A **drive** that is attached to a **computer** with a **cable**. Opposite of **internal drive**. See **peripheral device**.

external modem A **modem** that is attached to a **computer** with a **cable**. Opposite of **internal modem**. See **peripheral device**.

external storage Additional **storage device**s that are attached outside the **computer**. See **peripheral device**.

external unit Any **peripheral device** that is connected to the **computer** but is not internal to the computer itself.

Extra An Actor hired to appear as a background person, such as for crowd **scene**s, that do not speak any lines of dialogue. Extras are represented by the **Screen Extras Guild (SEG)**.

extraction area The actual portion of the **captured** **image area** that is used in the final **viewing format**. See also **masking**, **crop**, **padding**.

extranet A **network** that allows a corporation to share information with other businesses and customers. An extranet **transmit**s information over

the **Internet** and usually requires the use of a **password** to access internal company **data**.

extreme close-up (ECU) The **filming** of small **object**s or areas, or small portions of large objects or areas, so that they appear greatly magnified on **screen**.

extreme long shot (ELS) A **shot** generally **film**ed from a high vantage point that depicts a vast area from a far distance. It is used to establish setting and to show the huge scope of that setting and events. An example of a type of extreme long shot is an **aerial shot**. See also **long shot**.

extrude See **extrusion**.

extrusion A **model**ing technique in which a **generating curve** is duplicated and **offset** in **3D space** to create a **surface** with **depth**. The resulting **object** contains sides but no **frontface** or **backface**. However, this can be achieved by extruding a **face** in the same **shape** as the original generating curve to create the front and back boundaries surrounding the newly created sides of the new object. See also **surface of revolution**, **sweep**, **lofting**, **bevelling**, and *image below*.

eye line An imaginary line drawn between the **subject** and what he or she is looking at. See also **action axis**.

eye location A term used to describe the **camera angle** of a **digital camera**.

eyepiece The **camera** attachment that allows the **Camera Operator** to view the **scene** during **filming**.

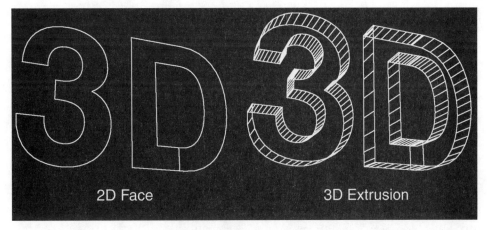

2D Face 3D Extrusion

Extrusion is a common **modeling** technique used to create **depth** in an **object**.

eye point The **point** a **scene** is being **view**ed from. Also called **camera point**.

eye scan The scanning movement of the viewer's eyes as he or she searches for the **center of interest** in a **scene**.

face A closed, flat **curve** defining a **surface**. A face can have a hole in it, such as the letter *A*. When using a face as a **cross section**, you can **extrude** it to make a **3D object**. A face is a **planar object** and contains no **depth**. *See also image under* ***extrusion***.

faceted 1. See **flat shading**. 2. A term used to describe a **polygonal model** in which the **level of detail (LOD)** is insufficient to create the illusion of **smooth shading** and, as a result, the flat **surface**s of the individual **polygon**s can be seen.

faceted shading See **flat shading**.

faceted surface See **flat shading**.

faceting See **faceted**.

facial animation A term used to describe any **animation** and **deformation** techniques used to **animate** the face of a **digital character**. Common techniques include **shape animation**, **key frame**, and **motion capture (MOCAP)**.

facial capture Any **motion capture (MOCAP)** technique used to **capture** only the facial movement of the **subject**.

facial system A type of **character setup** used specifically for the face of a **character**, in which the underlying **skeletal structure** is based on the positioning of the **bone**s and muscles found in the face of a real life character. Many facilities are also building complete **muscle system**s into their character setups as a means of achieving even more control and realism of **motion**.

facility A global term describing a company or **studio** that is hired to create **visual effects (VFX)** for a **film** or commercial. Also called **visual effects facility**, **effects house**, **digital studio**, **digital effects house**, **digital effects facility**, **post house**, **post production facility**, **vendor**.

facility side A term used to describe the **Production Team** that works for a specific **visual effects facility**. Opposite of **production side**.

Facility Visual Effects Producer The **Visual Effects Producer (VFX Producer)** that is responsible for the budgeting and scheduling of the portion of the **visual effects work** that is **award**ed to the **facility** they work for. See also **Production Visual Effects Producer**.

Facility Visual Effects Supervisor The **Visual Effects Supervisor (VFX Supervisor)** that supervises the portion of work that is **award**ed to the **facility** that they are employed by. See also **Production Visual Effects Supervisor**.

factor The **value**s related to scaling.

fade An **image transition** in which a **frame** is gradually replaced by a **black** screen or vice versa. See **fade in**, **fade out**.

fade in An **image transition** in which a **black** screen is gradually brightened to reveal an **image**. Opposite of **fade out**.

fade out An **image transition** in which an **image** gradually darkens to a **black** screen. Opposite of **fade in**.

fade to black See **fade out**.

falloff The diminishment, or **attenuation**, in the **intensity** of a **light source** as the distance from its **source** is increased. Also called **decay**. See also **spread**, **dropoff**, **spotlight**.

false contours Areas of an **image** containing abrupt changes in **pixel values** due to **quantization**.

fan See **fan force**.

fan force A **physical force** used in **motion dynamics** to push **object**s in a particular direction during a **simulation**. Unlike a **wind force**, a fan force can be limited in the distance its force will travel and the **radius** of the area that it will affect. See also **gravity**.

far See **far clipping plane**.

far clipping plane The portion of the **clipping plane** that is farthest from **camera** and beyond which **object**s will not be **render**ed. Opposite of **near clipping plane**. Also called **yon clipping plane**, **Z clipping plane**, **back clipping plane**.

faro arm A **device** used to measure **physical model**s used on **set** for reference in building **CG model**s and to acquire the **absolute location** of the model relative to the **motion control data (MOCO data)**.

fast ethernet A type of **ethernet** that supports **data** transfer at 100 **megabits per second (MBPS)**. Also called **100Base-T**. See also **gigabit ethernet**.

fast film See **high-speed film**.

fast-film stock See **high-speed film**.

Fast Fourier Transform (FFT) A common implementation of the **Fourier Transform** used to convert an **image** into a representation in terms of its frequencies of magnitude and **phase**.

fast lens A fast lens is one that allows for a small **f-stop** number, and thus, a large opening of the **lens aperture**. As a result, fast lenses can successfully **film** in very low **light**. Opposite of **slow lens**. See also **lens speed**.

fast motion Any technique used to speed up the **motion** of moving people or **objects** in a **scene**. Also called **accelerated motion**. Opposite of **slow motion**. See also **slow-speed photography**, **skip frame**, **undercrank**.

fast-speed film See **high-speed film**.

FC Abbreviation for **fiber channel (FC)**.

fcurve Abbreviation for **function curve (fcurve)**.

feather To softly blend the **edges** of bordering **colors** or the edges of a **matte** by increasing the **interpolation** between neighboring **pixels**. See also **blur**, **erode**, **dilate**.

feature A particular **function** or behavior of **software** or **hardware**.

feature animation Generally, referring to **films** that are created using **cel animation**, **full CG**, or a combination of both, such as *Toy Story* and *Prince of Egypt*. See **live action film**.

feature film A term used to describe any full-length **film** distributed for exhibition in public theatres.

feed The **transmission** of a **video signal** from one point to another.

feedback 1. The comments given by the **Director** or supervisors regarding the work the **Digital Artists** (**DA**s) have done for their **shots**. Usually, feedback is given during **dailies** or **walkthroughs**. 2. The loop caused by a portion of an **audio** or **video** signal being fed back into itself. For audio signals, this can cause an echo or high squeal sound.

feed reel The **film reel** that feeds the **film** to the **projector**. Opposite of **take-up reel**. Also called **supply reel**.

feed side The side of the **magazine** that holds the **unexposed film**. Opposite of **take-up side**.

feet 16 **frame**s equal one foot of **film**. **Cel animated feature**s generally express **shot length**s in terms of **feet + frames**. See also **film footage**.

feet + frames As there are 16 **frames** per one foot of **film**, a 120-frame **shot** would be expressed as "seven feet, 8 frames" and noted as "7 + 08." This notation can be calculated back to frames with the following equation: 7 feet × 16 frames = 112 frames + 8 frames = 120 frames.

female matte A "normal" **matte** in which the area that we wish to maintain is **white** and the area that we want to remove is **black**. Opposite of **male matte**. Together, the male and female mattes are referred to as **complementary matte**s. *See image under complementary mattes.*

fettle The slang version of **tweaking** used in the United Kingdom.

FFT Abbreviation for **Fast Fourier Transform (FFT)**.

FG Abbreviation for **foreground (FG)**.

fiber channel (FC) Fiber channel connections are capable of quickly transferring **data** between **workstation**s, **mainframe**s, **storage device**s, and other **peripheral**s. A fiber channel is typically **hardware** intensive and can transport data at high speeds with low overhead.

fiber optic cables A **cable** made up of thin filaments of glass, thinner than a human hair, that are used to **transmit** data in **fiber optics**. Because fiber optic cables are so thin and fragile and are typically placed underground, they can be very expensive to install. If the cables break too many times, they need to be completely replaced, as breaks in such delicate cables can be fixed only a few times.

fiber optics A technology in which **data** is transmitted with the use of **light**-generating transmitters and light-detecting receivers across **fiber optic cables**. The receiving end of the transmission converts the light **signal**s into frequencies that can be read by a **computer**. Because fiber optics are based on beams of light, they can **transmit** data at high speeds over long distances with very little signal interference.

fibre channel (FC) Another spelling for **fiber channel (FC)**.

field 1. A unit of measure on a standard **field chart**. 2. Half of a **video frame** made up of either all **even scan line**s or **odd scan line**s. The first field contains the odd-numbered lines, and the second field contains the even-

numbered lines. This is done as a means of reducing the amount of **flicker** that can be perceived during **frame** transitions. Each field is **display**ed for half the **frame rate** being used, so for **NTSC video** playback at 30 FPS each field is displayed for 1/60th of a second. **Format**s using two fields to define a single frame are referred to as **interlace**d formats. 3. The force field within a **metaball**. 4. For **menu**s, see **menu field**. 5. For certain **text editor**s, such as **awk**, a field represents a **string** of **text** that is separated by a space or **tab**. See **parse**.

field averaging The process of using a **filter** to average **pixel values** across **field**s as a means of reducing **flicker**.

field blanking See **blanking**.

field chart A standard reference **grid** used to specify an **image** in terms of **grid coordinates**. Also called a **field guide, 12-field chart**.

field dominance The order in which the **field**s of a **video image**, either the **odd field** or **even field**, are displayed. For **NTSC**, the even-numbered **scan line**s are **display**ed first, whereas for **PAL**, the odd-numbered scan lines are displayed first.

field guide Another name for **field chart**.

fielding The area of an **image** that falls within the sight of the **camera** or **display device**.

field of view (FOV) The number of **degree**s representing the area that can be viewed with the **camera lens**. The field of view narrows or expands relative to the **focal length**. A longer focal length causes the field of view to narrow, whereas a shorter focal length produces a wider field of view. A **wide-angle lens** gives a **wide angle of view** and a great deal of **perspective** distortion. A **telephoto lens** creates a **narrow angle of view** and very little perspective **distortion**. Generally, the **FOV** is represented by the number of **horizontal** degrees, although a **vertical field of view** is also valid. Also called **angle of view**. See also **cone of vision, pyramid of vision**.

field of view angle See **field of view (FOV)**.

field rate For **video**, the rate at which **field**s are **display**ed. The field rate is always double the **frame rate** as there are two fields in every **frame**.

field size The size of an **image** relative to a **field chart**.

fifteen-bit color See **15-bit color**.

fifty-four hundred Kelvin See **5400 Kelvin**.

file Information stored on **disk** under a particular name is a file. A file includes any form of **data** stored in **text** or **binary** format such as **source code**, **shell script**s, **image**s, **model**s, **shader**s, **scene file**s, **composite script**s, **executable program**s. A file is represented as a **block** of **byte**s on the **computer** or **storage device** it resides on.

file compression See **compression**.

file conversion To change the **format** of one **file** to another. While most **software package**s use their own **native format**, they will almost always accept other **file format**s as well.

file extension See **filename extension**.

file format 1. A term used to describe the specific method used to store **image**s or **data** on **disk**, such as **TIFF**, **JPEG**, **Cineon**, **OBJ**. Generally, a three- or four-letter **filename extension** is tagged onto the end of a **filename** to indicate the type of file format under which it has been stored. 2. Used in a broader sense, file format can refer to the method used to **capture** or **display** a series of **image**s or data, such as **35mm film**, **Vista Vision**, **video**, **laser scanner**, **digitizing**. See also **image file format**, **data file format**, **naming conventions**.

file format independence The ability within a **compositing package** to **read** and **write** images from a variety of **image format**s.

file header A **block** of information that identifies information about a particular file, such as how, when, where, and by whom it was created. This comment block is ignored when the **file** is **display**ed for viewing. However, **Programmer**s can use this to troubleshoot and **debug** any problems that might arise with that particular file. Also called a **header**. See also **magic number**.

file hierarchy See **file system**.

file in The **source file** used as **input** to a **program** or **software application**.

file locking To make a **file** currently in use by one **user** unavailable to other users.

Filemaker Pro A **Macintosh** program widely used for tracking the progress of **visual effects work**.

file name See **filename**.

filename The name given to an **image** or **database** so it can be stored on **disk**. A filename is typically composed of a **root name** (the element de-

scription), a **frame number** (if it is one of a series), and a **filename extension** (to denote the **file format** in which it is stored). See **naming conventions**.

filename extension The portion of a **filename** after the final decimal point that indicates the **format** of the **data** stored in the **file**. Typically, they are three-letter abbreviations. For example, ".cin" indicates an **image** stored as **Cineon**, and ".obj" indicates a **polygonal object**.

filenaming conventions See **naming conventions**.

file out The **output file** created by a **program** or **software application**.

file recovery program A **program** used to **restore** any **file**s that have been damaged or accidentally **delete**d. See **data recovery**.

file server A **computer** that serves as the central location for shared resources used by other computers on the **network**. Storing **file**s on a file server eliminates the need for multiple copies of **data** stored on individual **workstation**s.

file size The size of a **file** on a **storage device**, such as a **disk**, usually represented in terms of **megabyte**s (**MB**), **kilobyte**s (**KB**), or **gigabyte**s (**GB**).

file system The hierarchical system that stores and organizes **file**s in a **directory structure**. The **root directory** is the **directory** at the top of the **hierarchy**, whereas the individual **node**s of the hierarchy are called directories and the **leaves** are the individual files. Also called **hierarchical file system**.

file transfer To copy a **file** from one **computer** to another.

file transfer program Any **program** that allows the **user** to copy a **file** from one **computer** to another.

file transfer protocol (FTP) A **client-server** protocol that transfers **file**s from one **computer** to another over a **network**. Most **FTP site**s require a **password** to allow a **user** to **log in**.

file type A description of the structure, type, and **format** of a particular **file**. Usually indicated by its **filename extension**.

file update To modify **data** in a **file**.

fill See **fill light**.

fillet A subset of the **blended surface** technique used to create new **geometry** between one **surface** and another surface that is typically **perpendicular** to the **planar** portion of the first surface. For example, a fillet could

be used to create the illusion that a pipe is actually attached to the floor by creating a **curved surface** that rises up and connects the pipe at some distance above the floor. The term *fillet* originated from a technique used to create a smooth, rounded connection between two machining joints. See also **socking**.

fill light A secondary **light source** positioned to "fill in" the areas of an **object** that the **key light** is not **illuminating**. Also called **bounce light** if the object is a **reflect**ive surface.

fill matte See **center matte**.

film 1. A form of storytelling, whether fictional, educational, documentary, biographical, or **animate**d, that **project**s a **sequence** of **image**s giving the illusion of continuous movement. Also called a **motion picture**, **flick**, **feature film**, **movie**. 2. A thin and flexible strip containing a layer of **emulsion** on which an image is formed from brief **exposure** to **light** through a **camera lens**. As each **frame** of film is exposed to light, **silver halide crystals** undergo a chemical change, forming a bottom-side-up **latent image**. 3. The act of photographing an **action** or **scene** and **record**ing it on film, as in "shoot a scene" or "film a screenplay."

film back The actual **image area** captured on a particular **film format**, usually measured in millimeters. The film back, also referred to as the **camera aperture**, is located at the back of a camera where the **film gate** holds the film in place during **exposure** or **projection**.

film base The **transparent** and flexible material on which **film emulsion** is placed. A highly flammable **nitrate base** was originally used but has since been replaced by an **acetate base** that is flame resistant.

film budget The complete cost to create a **film** that includes both the **above the line** and **below the line** costs.

film camera Any **camera** that photographs with professional **film stock**.

film can The metal or plastic container used to hold **raw stock** or to store **exposed film** and **short end**s created during **filming**.

film clip A short piece of **film** that has been "clipped" from a **scene** for reference purposes. See also **reference clip**.

Film Crew All individuals working on a **film** but not appearing in the film itself.

film curl A defect occurring during **film processing** that causes the **film** to curl along its **width** due to improper drying conditions.

film dailies 1. The **workprint** of the work **shot** the prevoius day by the **Film Crew**. Also called **Production dailies**. 2. The **screening** of the latest rounds of **filmout**s or **workprint** that has come back from the **lab**. See also **video dailies**.

film developing The process of making visible the **latent image**s **capture**d on **exposed film**. The term *developing* is sometimes used to describe all the steps involved in the **processing** of film, but developing really refers to an early step in the entire process. During development of **color film**, chemicals are used to convert the **silver halide crystals** into black, metallic silver grains that are used to form the **negative image**.

film distributor The organization responsible for the coordination and **distribution** of a **film**.

film editing The process of **cutting** together a **film** from the photographed **scene**s to tell the best story while maintaining **continuity** throughout. See **Film Editor, continuity cutting, compilation cutting**.

Film Editor The individual responsible for **cut**ting the **film** together into its final form. This job involves careful **shot** selection, arrangement, and timing to maintain **continuity** and portray the screen story in its best light.

film emulsion The thin light-sensitive strip that contains **silver halide crystals** and is applied to the **base** of the **film**. **Color film** emulsions are composed of three separate layers of emulsion that are each sensitive to one of the three **primary colors, red (R), green (G)**, or **blue (B)**. When the emulsion is **expose**d and **develop**ed, an **image** is created. **Bluescreen (BS)** and **greenscreen photography** relies on the fact that each of the three layers of emulsion will be exposed by a different primary **color** of **light**.

film extraction The size and **aspect ratio** of the **image area** that is actually used in the final **viewing format** of a series of **image**s, such as **2.35, 1.85, 1.66**. See also **masking, letterbox, Super 35mm film, Academy aperture**, *images on the following three pages, and image under* **Vista Vision, anamorphic**.

film footage There are 16 **frames per foot** on a **film roll**. While **live action feature**s generally define the length of a **shot** in terms of the number of **frames, cel animated feature**s generally express their **shot length** as **feet + frames**. For example, the film footage of a shot that is 120 frames in length would be expressed as "seven feet, 8 frames" and noted as "7 + 08."

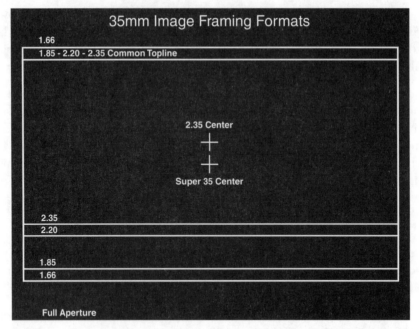

Common **image extraction** areas for **35mm film**.

Due to the continual growth of **digital technology**, many **project**s are us-ing a combination of **cel animation** and **digital effects** to achieve their shot needs. As such combined efforts are bringing together artists from very different disciplines, it has become more commonplace to express shot lengths in both formats, frames, and feet + frames in order to minimize confusion between departments.

film format A broad term used to describe both the **gauge** of the **film** used to **capture** the **image**s, such as **35mm** or **65mm**, and the **aspect ratio** in which the film was shot, such as **1.85** or **2.35**. See also **film ex-traction**, **Super 35mm film**, **Academy aperture**. See also **film extrac-tion**, *images on the following six pages, and image under **Vista Vision**, anamorphic*.

film gate 1. The opening in the **aperture plate** on a **camera** or **projector** that holds the **film** in place during **exposure** or **projection**. See also **pressure gate**, **pulldown claw**, and **registration pins**. 2. The entire **aperture** on a **camera** or **projector**.

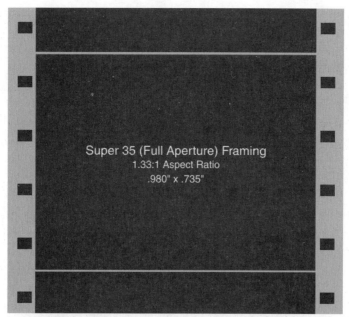

The full **image** area **captured** with **Super 35mm film**.

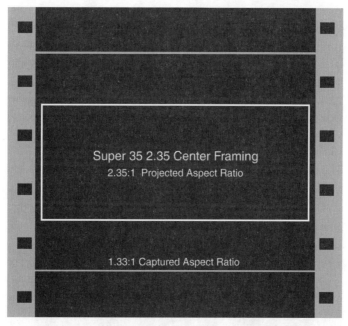

A centered **2.35:1** image extraction from **Super 35**.

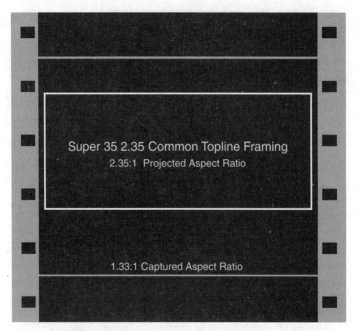

A 2.35:1 **common topline** image extraction from **Super 35**.

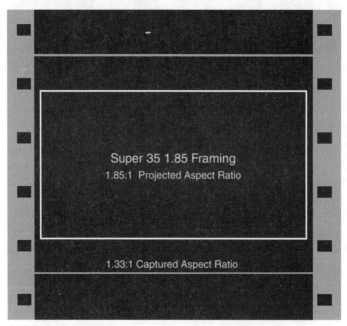

A **1.85:1** image extraction from **Super 35**.

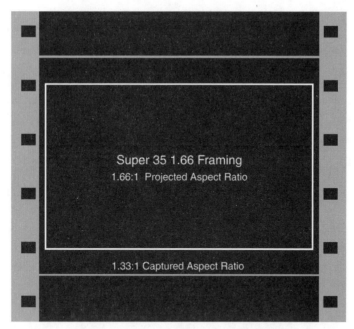

A **1.66:1** image extraction from **Super 35**.

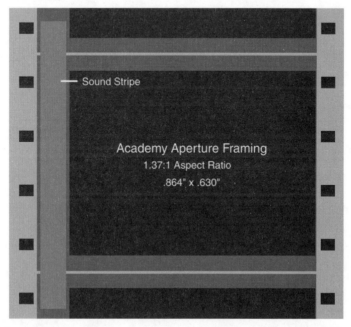

The full **image area captured** with **Academy aperture** framing.

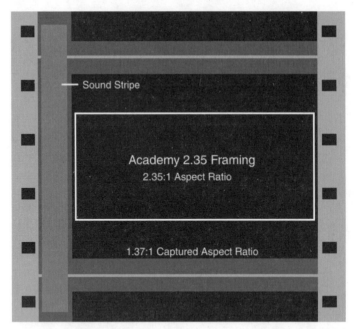

A centered **2.35:1** image extraction from **Academy aperture**.

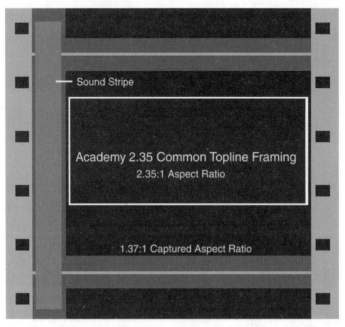

A **2.35:1 common topline** image extraction from **Academy aperture**.

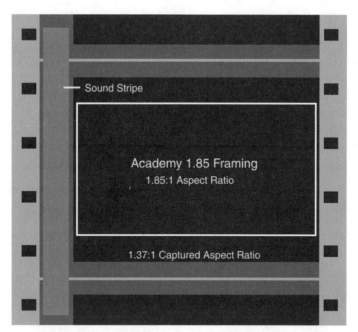

A **1.85:1** image extraction from **Academy aperture**.

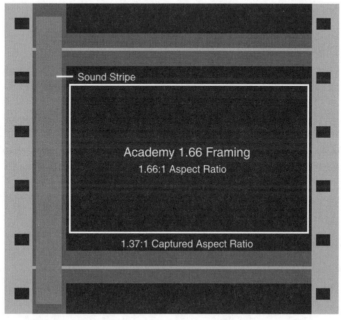

A **1.66:1** image extraction from **Academy aperture**.

film gauge The width of a particular **film stock**, such as **16mm film, 35mm film, 65mm film**, etc.

film grain The **silver halide crystals** found on **film** that **capture** the **image** when it is **exposed** to **light**. Because these particles are not uniform from **frame** to frame, the viewer can perceive their **motion** during **projection**. Each **film stock** has a different **grain structure**. When the grain is very large and noticeable, the film is said to be very **grainy**. The **blue record** of an image typically contains the most noisy and noticeable grain, whereas the **green record** contains the least noise and finest grain. See also **T grain**.

film image **Image**s that are recorded, modified, and **display**ed with a **resolution** that can be presented on a **film**. See also **video image**.

film industry A global term used to describe the creation of **motion pictures** worldwide.

filming The act of photographing a series of **image**s for the purpose of making a **motion picture**.

film lab See **film laboratory**.

film laboratory The facility where **film** is sent to be **process**ed, **develop**ed, and **print**ed.

film loop A single strip of **film** that has been joined together at both ends so that it can be continually repeated when **project**ed with a **loop tree**. This is particularly helpful when viewing a **shot** in **dailies**, as it can often take several viewings to determine what needs to be done to bring a shot to completion.

film loupe A specially designed viewing glass used to look at a single **frame** of **film** on a **light box**. This is particularly useful when viewing the results of a **film wedge** to determine the settings to use for the next **filmout**. Also spelled **film lupe**.

film lupe Another spelling for **film loupe**.

film mag Abbreviation for **film magazine**. See **magazine**.

film magazine See **magazine**.

Filmmaker A global term referring to individuals who have a significant amount of control over the creation of a **film**, such as the **Director, Producer, Editor, Screenwriter**.

film movement See **camera movement**—Definition #1.

film negative See **negative**.

filmout The process of recording digital **image**s onto **film**. See **film recorder**.

film pitch See **pitch**.

film plane The area behind the **lens** where the **film** is held in place during **exposure**. It is also the point from which **camera**-to-**subject** distances should be measured. See also **focal plane**.

film positive See **positive**.

film printing The process of transferring **image**s on a **negative print** to a **positive print**.

film processing To make visible the **latent images captured** on **exposed film** and wash the **film** of all chemicals so that the **image** is permanently fixed. The film is first put into a lightfree **magazine** that is attached to processing machines. From there, the film is passed through various tanks of chemicals, referred to as the **bath**, that must wash away the **anti-halation backing** before developing the image. During **development**, the chemicals convert the **silver halide crystals** into black metallic silver crystals that are used to form the **negative image**. The time needed for development depends on the film **stock** and the temperature of the chemicals. After development, the film is washed, and the image is made permanent in a process called **fixing** by washing away the unexposed grains of silver halide. See also **reversal film**.

film production A term used to describe the three main activities that go into making a **film**: **preproduction**, **principal photography**, and **post production**.

film recorder The device used to transfer **digital image**s onto a **film negative**. See **laser film recorder**, **CRT film recorder**.

film recording 1. The process of transferring **digital image**s onto a **film negative** via a **film recorder**. 2. To record a **video image** onto film using a **Kinescope**.

film reel 1. The plastic or metal spool on which **print**ed **film** is wound. 2. A strip of **film** wound on a metal spool.

film ride The undesirable and irregular **vertical** movement on a **film** as it moves through the **camera** or **projector**. See also **film weave**.

film roll 1. **Film** that is wound on a **spool** or **core**. 2. The specific roll of film used for each **take** of a **scene**. This film roll number is usually included on the **camera report**.

film room Referring to the area where the **film** is **scan**ned, **cut**, **splice**d, and **edit**ed.

film scanner 1. A **device** used to convert **film** into **digital image**s. The process of **scanning** is accomplished by positioning a **light source** on one side of the **film** and an **array** of mounted sensors on the opposite side that **capture**s the **transmitted color**. Typically, the array is one **pixel** tall and one **scan line** wide, so the **image** is created one scan line at a time as this array moves across the film. See also **Imagica film scanner**, **Cineon Genesis Film Scanner**, **Oxberry film scanner**, **flatbed scanner**, **slide scanner**. 2. To convert **film** to **video image**s, see **Telecine**.

film scanning The process of transferring **film** into **digital image**s via a **film scanner**.

film speed 1. The number of **frames per second (FPS)** that move through the **camera** or **projector**. 2. A **film stock**'s sensitivity to **light** as indicated by its **ISO index** or **DIN Rating**. See **exposure index**.

film splice Any method of attaching two separate strips of **film** end to end to form a single strip of film.

film stock A term used to describe a particular **film** in terms of its **exposure index**, or sensitivity to **light**. Every film stock is balanced to accurately re-produce **color**s when illuminated with specific types of lights, such as **day-light** or **Tungsten light source**s. Different speed films can also vary in their **color reproduction** even if they are balanced for the same lighting conditions. For example, **high-speed** film tends to produce lower **contrast** and grainier images, whereas **slow-speed** film tends to produce higher con-trast images with finer **grain**.

film-to-tape transfer The process of converting **film image**s to **video im-age**s. See **Telecine**.

film weave The undesirable and irregular **horizontal** movement on a **film** as it moves though the **camera** or **projector**. See also **film ride**.

film wedge See **color wedge**.

filter 1. For **digital**, any **image process** that **samples** an **image** during **trans-formation**s to determine the resulting **image sharpness**. Each **pixel** is modified based on information from neighboring pixels in the image. See **fil-tering algorithm**. 2. To **process** any type of **data**. For example, **motion capture data (MOCO data)** data and **tracking curve**s are often **sample**d and smoothed to reduce any unwanted high-**frequency** noise appearing in

the **curve**s. 3. For **filming**, a piece of translucent glass or **gel** that is placed in front of a **light** or **camera lens** to modify the **color** or **density** of the **scene**. Filters can affect **contrast**, **sharpness**, **color**, **highlight**s, and light **intensity**. See also **neutral density filter (ND filter)**, **diffusion filter**, **polarizing filter**, **fog filter**, **star filter**, **color correction filter (CC filter)**.

filtering algorithm The mathematical **function**s used each time a **geometric transformation** is performed on an **image** that **sample**s the **pixel**s of the **input image** as a means of calculating the resulting **output image**. A good **filter**ing algorithm will take into account all the pixels of the original image and then selectively **average** these pixels together to create the best representation in the new image. There are a wide range of filtering algorithms used, such as the **impulse filter**, **box filter**, **Mitchell filter**, **Triangle filter**, **Sinc filter**, and **Gaussian filter**.

filtering See **filtering algorithm**.

filter kernel See **convolution filter**.

filter layer The thin, uniformly colored layer that is applied above or below the **emulsion** layer to control and **filter** the **light** that is reaching the emulsion.

final A **digital shot** that has either been **film**ed out or transferred to **videotape** and has been approved as complete by the **Director** or other appropriate personnel.

final cut 1. The last **edit**ed **cut** of the **film** that is ready to be combined with the **sound track**. 2. The last edited sound track of the film that is ready to be combined with **image**s. 3. The final mix of sound and images that make up the **answer print**. Also called a **composite print**. See also **release print**.

final edit See **final cut**.

finder See **viewfinder**.

finger 1. See **flag**. 2. A **Unix program** that **display**s information about a particular **user** such as their full name, **login ID**, and **login** time. It may also display a **plan file**.

fire in the hole The phrase that is yelled out to alert the Crew that some sort of **pyrotechnics** will be used in the next **take**. Ear plugs and eye protection are often handed out to the Crew for protection while **film**ing these **special effects (SFX)**.

firewall A **hardware** and **software** combination that separates a **local area network (LAN)** into two or more sections for increased security against

unauthorized **user**s. A firewall allows only certain information from the **Internet** to travel in and out of and internal **network**.

firewire A thin **cable** used to connect various **peripheral device**s to a **computer** that offers a high-speed rate of **data** transfer.

First AC (1st AC) Abbreviation for **First Assistant Cameraman (1st AC)**. See **Assistant Cameraman (AC)**.

First AD (1st AD) Abbreviation for **First Assistant Director (1st AD)**. See **Assistant Director (AD)**.

First AE (1st AE) Abbreviation for **First Assistant Editor (1st AE)**. See **Assistant Editor (AE)**.

first answer print See **answer print**.

First Assistant Cameraman (1st AC) See **Assistant Cameraman (AC)**.

First Assistant Director (1st AD) See **Assistant Director (AD)**.

First Assistant Editor (1st AE) See **Assistant Editor (AE)**.

First Camera Assistant See **Assistant Cameraman (AC)**.

First Cameraman See **Director of Photography (DP)**.

first cut See **director's cut**.

first generation The first and original **copy** of a series of **film** or **video images**. Also called the **master copy**. Subsequent copies made from this first-generation copy are called **second-generation** copies. See also **generation**, **generation loss, intermediate positive, intermediate negative**.

first quadrant See **quadrant one**.

first run The first public showing of a **film** in single theatres in major cities, often at a higher price, as opposed to a **multiple first run** in which the film is **release**d in multiple theatres in each major city. Also called a **premium run**. See **first-run theatre**.

first-run theatre A theatre in a major city that exhibits a **feature film** during its initial **release** and may be the only theatre to screen the **film** in that area.

First Unit The primary **Film Crew** used during **principal photography**. Also called **Main Unit**. See also **Second Unit**.

fish eye lens An extreme **wide-angle lens** capable of viewing a **field of view (FOV)** of almost 180 degrees. Such a large **angle of view** creates a

distorted **image** with a pronounced rounding of the image along the sides.

fit A **compositing operation** that **scale**s an **image** to a specific **resolution**. Generally, the option to maintain the **aspect ratio** of the **source image** is available.

five-perf See **5-perf**.

fixed definition An **object** whose **surface resolution** cannot be easily increased or decreased.

fixed disk A **hard disk** that cannot be easily removed from the **computer**.

fixed focal length lens See **prime lens**.

fixed focus lens A **lens** whose **focus** is fixed and cannot be adjusted by the **Cameraman**.

fixed lens See **prime lens**.

fixed matte Another name for **static matte**. Opposite of **traveling matte**. See **articulate matte**.

fixed shutter A **camera shutter** that cannot adjust the **exposure time** of each **frame**. Also called **nonvariable shutter**. Opposite of **variable shutter**.

fixing The removal of unexposed **silver halide crystals** from the **film** during **processing**.

fixing bath The solution used in **fixing** to remove any remaining **silver halide crystal**s that were not **expose**d during **develop**ment.

fix it in post A phrase commonly used when time and/or conditions prohibit the ability to **shoot** a **scene** with less than "ideal" circumstances for the required **visual effects work**. Instead, rather than holding up the actors and/or **Film Crew**, a decision is made to shoot as quickly as possible and make the necessary adjustments and fixes during **post production**. For example, while the **subject** might not be completely surrounded by **greenscreen**, it might be determined that it will cost less to do more **roto** on the **element** than to take the time to **light** for more greenscreen coverage.

FK Abbreviation for **forward kinematics (FK)**.

flag 1. A general term for any **object** placed in front of a **light source** to block **light** or cast **shadow**s. Also called a **card, finger, gobo, scrim**. 2. A **variable** that can take on one of two **value**s. Flags are often used as **argument**s to **program**s and **software application**s to indicate one of

two outcomes or options when the program is **run**. See also **argument**, **parameter**, **usage statement**.

Flame An industry standard **compositing package** developed and sold by **Discreet Logic**, who also manufacture **Inferno**, **Flint**, **Smoke**.

flange A flat metal disk used with a **core** to wind **film**.

flaps Another word for **barn doors**.

flare Any bright flash of **light** caused by the **light source**s shining directly into the **camera lens**. See also **lens flare**, **bloom**.

flash 1. To decrease **saturation** and **contrast** of an **image** by exposing additional **light** on the **film** or by manipulating the image with **digital compositing** techniques. 2. A brief and intense burst of light from a flashbulb or electronic flash.

flashback A **scene** that portrays what took place before the present story began. Opposite of **flashforward**.

flash cut An extremely fast **cut**, often as short as one **frame**, used to create a subliminal effect on the **viewer**.

flashed 1. Referring to an **image** on **film** that appears low in **contrast** as a result of the **negative** being **expose**d to too much **light**. 2. A **digital image** that appears **flat** or lacking in contrast. Also referred to as **washed out**.

flashforward A **scene** that describes an event in the future that will or could happen. Opposite of **flashback**.

flash frame 1. Another name for **flash cut**. 2. A single **frame** that has been **overexpose**d or blown out with **compositing** techniques. 3. The frame containing the **bloop light**.

flashing 1. An **optical** process that **expose**s the **unprocessed negative** to a small amount of **light** in order to decrease the **contrast** and/or **saturation** of the **scene**. 2. What a **still photographer** yells out before taking a flash picture on **set**. This is done so the **Stage Crew** will not think that one of the lights has blown out.

flashing green See **flashing greenlight**.

flashing greenlight A **film** that will be greenlit as soon as a few last details are taken care of. Often, it involves the final signing of contracts by all involved parties. See also **greenlight**.

flat A term used to describe an **image** that is **flashed** or lacking in **contrast**.

flat artwork A term used to describe **2D** artwork displayed on a flat surface, such as canvas, paper, or glass. Used most often to describe **image**s to be **scan**ned into the **computer**.

flatbed 1. See **flatbed editor**. 2. See **flatbed scanner**.

flatbed editor A type of **editing** machine laid out on a table with a **screen** in the middle on which **film** can be threaded and run horizontally through for viewing. See also **Moviola**.

flatbed scanner A **scanner** that places a piece of **flat artwork** on a piece of glass and **digitize**s it into the **computer** to produce a **digital image**. See also **film scanner**, **slide scanner**.

flat lens Another term for **spherical lens**.

flat lighting **Lighting** that produces low **contrast** and minimum **shadow**s.

flat projection See **orthographic projection**.

flat shading See **flat shading model**. *See images under **shading model** and **smooth shading**.*

flat shading model A **shading model** that calculates the **color** and **intensity** for each **polygon** from a single **point** on that polygon that is then applied to the entire polygon. This type of **rendering** produces a blocky or **faceted** look to the **surface**. The **lightness** and **darkness** of each flat surface are dependent on the orientation of its **surface normal**s to the **light source vector**s in the **scene**. Also called **faceted shading**, **constant shading**. See **smooth shading** and *images under **shading model**.*

flat surface Any **surface** that is parallel to only one **axis**. A flat surface contains no **depth**. A **polygon** is an example of a flat surface.

flexor **Sculpt object**s and **lattice**s that are set up to work with **skeleton joint chain**s to perform surface deformations. Because in many cases the **skinning** of a **character** does not create realistic **deformation**s across the **joint** areas, the addition of flexors can perform secondary deformations to control any undesirable bulging or **intersection**s that may occur.

flick Slang for **movie, motion picture, film, picture show**.

flicker 1. The alternation of **light** and dark periods when **project**ing a **film**, due to factors such as, too few **frames per second (fps)** to allow for a **persistence of vision**, a **camera** malfunction, or defective **film stock**. 2. The effect caused by viewing the alternating **field**s that make up a **frame**. See also **field averaging**. 3. The flickering of **image**s seen in a **computer display** re-

Basic **image processing** techniques used to alter the orientation of an **image**. Bridge image photographed courtesy of Alan Sonneman.

sulting from a slow **refresh rate**. 4. The alternation of light and dark periods when viewing a **shot** through the **eyepiece** of a camera during **filming**.

flicker glasses A type of **3D glasses** that uses an electronic **shutter** to open and close each eye independently. By syncing the shutter openings on the projection shutter for each eye, the **image**s sent to each eye can be controlled. When one eye of the shutter in the glasses is open, the other eye is closed. Each **projector** must be a half **frame** out of **sync** with each other, or in the case of a **monitor** system the **scan rate** must be equal to the **shutter speed**. See also **polarized glasses**, **anaglyph glasses**.

Flint A **compositing package** developed and sold by **Discreet Logic**, who are also the makers of **Inferno**, **Flame**, and **Smoke**.

flip To **scale** an **object** or **image** by negative 1 in the **X-axis**. Also called **mirror**. *See image above.*

flipbook A **program** that is capable of playing back a **sequence** of **image**s on a **computer**. If the computer has enough **memory**, the flipbook will be able to play the **frame**s back in **real-time**. Most flipbook programs of-

fer options to reduce the size and/or **bit depth** of the images when they are displayed as a means of getting **real-time playback**. See also **movie file**.

float A number defined with **float precision**.

floating point A term used to describe a number in which no fixed number of digits must be used before or after a decimal point to describe a number, meaning that the decimal point can "float." See **floating point number**.

floating point number A floating point number represents the fractional portion of a number. The greater the **precision**, the more exact the fractional quantity. For example, 2.0, −78.49, and 3/4 are all floating point numbers. See also **single precision**, **double precision**, **precision**.

float precision See **precision**.

flocking An **animation** technique that simulates the **motion** of large numbers of creatures in herding or schooling patterns. Using **collision avoidance**, each member of the flock can move in a natural way while avoiding any collisions with its fellow flockers.

Flo-Mo A term coined by Manex Entertainment to describe their variation on the original **Timetrack** technique. Unlike Timetrack, Flo-Mo is not restricted to static moments in time but can create varying moments in time for different **element**s within the same **scene**. Also referred to as **bullet time**, "**dead time**" for its use in *The Matrix*.

flop To **scale** an **object** or **image** by negative 1 in the **X-axis**. Also called **mirror**. *See also image above.*

floppy Abbreviation for **floppy disk**.

floppy disk A flexible **magnetic disk**, covered by a protective plastic jacket, that is used to store **data**. Examples of floppy disks include **Zip** and **Jaz**. See also **hard disk**.

floppy disk drive The **disk drive** in which **floppy disk**s are inserted.

floppy drive See **floppy disk drive**.

fluid head A fluid-filled **camera mount** that enables the **Camera Operator** to perform smooth **pan** and **tilt** moves during **filming**. See also **geared head**.

flutter The variation of sound **frequency** caused by an unsteady **tape drive** or strip of **film**.

fly-bys Slang for really fast **walkthroughs**.

flying logo A general term used to describe **broadcast graphics**, such as station IDs and news, sports, and movie opens. It is most often character-ized by **extrud**ed and **bevel**ed numbers and letters that are **animate**d across the **screen**. Flying logos made up the bulk of work being done in **3D graphics** in the 1980s.

f-number See **f-stop**.

foamcore A common material used in making **physical model**s that is made from a Styrofoam core with a cardboard covering.

foam latex A widely used chemical combination used to create molds for **makeup effects (makeup fx)**. See also **silicone**.

focal distance The distance from the **camera** at which an **object** contains the sharpest **focus**.

focal length The distance, generally expressed in millimeters, from the **lens** to the **film plane**. The shorter the focal length, the closer the **focal plane** is to the back of the lens, whereas a longer focal length produces a focal plane that is farther away. Focal length is directly proportional to the size of the **subject** in the **frame**. For example, if the focal length is doubled and the distance from the **camera** to the subject remains constant, the subject will appear to be twice as large in the frame. A **wide-angle lens** contains a smaller focal length that will increase the apparent **depth** of a **scene**, while a **telephoto lens** will have a larger focal length, which will decrease the apparent depth. Lenses are expressed by their focal length.

focal plane The area behind the **lens** where the **film** is located and where the **image** comes into **focus**. Sometimes referred to as the **film plane**.

focal plane shutter The rotating **shutter** at the **focal plane** that alternates be-tween blocking **light** from the **film** and allowing the light to strike the film.

focal point The point behind a **lens** where rays of **light** converge.

focus 1. The point in the **scene** that appears **sharp** when viewed through the **camera**. 2. The physical adjustment of the **lens** to make the **subject** appear sharp and within the **depth of field (DOF)**. 3. The physical adjustment of the **projector** to make the projected **film** appear sharp. See also **in focus**, **out of focus**, **rack focus**.

focus chart A **chart** designed to test the **focus** of a **camera lens**.

focus group A group of individuals not involved in the **film industry** who are invited to attend a **sneak preview** so the **Filmmaker**s can get an early sense of what audience reaction will be to their **film**. In cases where the re-

sponses are negative, the Filmmakers might decide to shoot **additional photography**.

focus in A **transition effect** in which the **subject** is brought into **focus**.

focus out A **transition effect** in which the **subject** is brought out of **focus**.

focus plane The area in the **camera view** that contains the sharpest **focus**. Also called the **primary focal plane**.

focus pull See **rack focus**.

Focus Puller A member of the **Camera Crew** responsible for adjusting the **focus** of the **camera** during **filming**. This task is often handled by the **Assistant Cameraman (AC)**.

focus range The range at which a **camera** is able to **focus** on a **scene**.

focus setting The **lens** adjustment that produces the sharpest **focus** on the **subject**.

focus shift See **rack focus**.

fog 1. The undesirable darkening or discoloring of a **negative** caused by too much handling during **development**, **overdevelopment**, poor **emulsion**, or improper development. 2. A **rendering** technique used to simulate atmospheric effects by blending **object**s into the **background (BG)** based on their distance from **camera**. See **Z depth**.

fog filter An **optical filter** that is placed in front of a **light** or **camera** to simulate the effects of **fog** in the environment. See **filter**.

foggy Another term for a **flashed** or **washed**-out image.

folder The equivalent of a **directory** for **Macintosh** and **Windows '95** screens. **File**s can be organized by storing them in different folders.

folding The consolidation of a series of math **operation**s into a single operation.

foley Background sounds added during **audio sweetening** to increase realism, such as footsteps, door creaks, thunder.

Foley Artist An individual who creates **foley** sound effects.

Foley Editor An individual who **edit**s the sound effects created by a **Foley Artist**.

follow focus The adjustment of **focus** during the **filming** of a **shot** to keep a moving **subject** within the **depth of field (DOF)**. Also called **pull focus**, **shift focus**. See also **rack focus**.

follow shot Another name for **tracking shot**.

font A complete set of type, such as letters, numbers, and symbols, that belong to a specific typeface defined by its weight, style, and size.

font generator Any **software** that can generate and modify **font**s in a **computer**.

foo See **foo-bar**.

foo-bar Universally understood nonsense words often used in **computer graphics (CG)** as generic placeholders or examples. For example, a discussion about different **filename extension**s might use "foobar.tif" or "foobar.obj" to describe the different **format**s. The use of foo-bar originally evolved from **fubar**.

foot There are 16 **frame**s per one foot of **film**. **Cel animated feature**s generally express their **shot** lengths in terms of **feet + frames**. See also **film footage**.

footage The number of **feet** of **film** in a particular **scene**.

footage counter A dial on the **camera** showing the amount of **film** that has been run through the camera.

footage encoder An electronic **video** device that reads **keycode numbers** and converts them into **footage** count, which can be displayed as a **window burn-in**.

footage numbers See **edge numbers**.

foot candle A standard unit used to measure the **intensity** of **light** that illuminates a **scene**. One foot candle is equal to the light of one candle that is one foot away. Also called **candle power**, **candela**. See also **lux**.

forces See **physical forces**.

forced development See **overdevelopment**.

forced processing See **overdevelopment**.

forced perspective A photographic technique used to create the illusion of increased **depth**. The **foreground (FG)** set pieces are built full size or a little larger, whereas **background (BG)** set pieces are built smaller than normal so they will seem farther away.

foreground (FG) 1. Referring to a **foreground element** in a **composite**. *See also Color Plates 17–20*. 2. Referring to the foreground **subject** in a **scene**.

foreground alpha The **alpha channel** of the **foreground element** in compositing. Opposite of **background alpha**.

foreground element Generally, referring to an **element** that will be **composite**d over the **background plate**. Depending on the complexity of the composite, there can be multiple foreground elements.

foreground image See **foreground element**.

foreground layer See **foreground element**.

foreground process Any **process** that requires the **user** to interact with the **computer**. Opposite of **background process**.

foreground task See **foreground process**.

foreground subject Referring to the primary **foreground element** in a **scene**.

foreign release The release of a **film** that contains a new **sound track** and **subtitles** for **release** in non-English-speaking countries. Also called **foreign version**. See **domestic release**.

foreign version See **foreign release**.

foreshortening The exaggerated decrease of **depth** in a **scene** resulting from using a **long lens** or **telephoto lens**. Because these lenses greatly increase the appearance of spatial distance, any **motion** of an **object** toward or away from the **camera** appears to move faster than normal.

fork A **Unix system** call used by the **parent process** to make a copy or **child process** of itself. The child process is identical to the parent process except that it has a different **process identifier (PID)**.

for loop A **conditional statement** that is a variation on a **while loop** in **programming**. "For every instance of this, do this." See also **if/then/else loop**.

format 1. The size or **aspect ratio** of a **frame** of film. 2. Referring to the **file format** of a **digital image** or **data file**. 3. The **input** and **output** medium used to **display** an **image**, such as film, **video**, **high definition**. 4. A term used to describe the setup and layout of a **template**.

formatted disk See **disk formatting**.

formula A standard procedure defining a set of rules or principles for solving problems.

formula translation programming language (Fortran) A widely used **high-level programming language** for mathematical and scientific **application**s, developed by **IBM**.

Fortran See **formula translation programming language (Fortran)**.

forty-eight-bit image See **48-bit image**.

forward compatible **Software** that is compatible with later **version**s of the same software.

forward kinematics animation (FK animation) Any **animation** created with the use of forward kinematics (FK). Opposite of **inverse kinematics animation (IK animation)**. Also called **hierarchical animation**.

forward kinematics chain (FK chain) The **skeleton** used to **animate** a **character** with **forward kinematics (FK)**. See also **inverse kinematics chain (IK chain)**.

forward kinematics skeleton (FK skeleton) See **forward kinematics chain (FK chain)**.

four bit 1. See **4 bits per channel**. 2. See **4-bit display**.

four-bit color See **4-bit color**.

four bits per channel See **4 bits per channel**.

four bits per color channel See **4 bits per channel**.

four bits per component See **4 bits per component**.

four by four matrix See 4×4 **matrix**.

four-channel image See **RGBA image**.

four-corner grad See **four-corner gradation**.

four-corner gradation A type of **gradient** in which **color**s defined at each of the four corners of the **frame** are smoothly **interpolate**d across. Also called a **ramp**, **gradient**, **four-corner ramp**. See also **horizontal gradation**, **vertical gradation**, **radial gradation**, *Color Plate 2*.

four-corner ramp See **four-corner gradation**.

four-k See **4K resolution**.

four-k resolution See **4K resolution**.

four:one:one See **4:1:1**.

four:one:one compression See **4:1:1 compression**.

four-perf See **4 perf**.

four-point track A type of **2D tracking** in which four **point**s are selected from a **sequence** of **image**s to extract the **camera move** based on the **motion** of those points over time. With four points, the information extracted is **X translation**, **Y translation**, **rotatio**nal changes occurring between the

four points, changes in **scale** based on changes in distance between the points, and enough information to reproduce simple **perspective** shifts and **warp**s. Sometimes referred to as **corner pinning**. See also **one-point track**, **two-point track**, **stabilization**, **region of interest (ROI)**, **3D tracking**.

four's See **on four's**.

fourth quadrant See **quadrant four**.

four:two:two See **4:2:2**.

four:two:two compression See **4:2:2 compression**.

four:four:four See **4:4:4**.

four:four:four compression See **4:4:4 compression**.

Fourier Transform An **algorithm** used to analyze **signal**s, such as the **compression** of **image** and **sound** information, as a weighted sum of sines and cosines. A commonly used implementation of the Fourier Transform is known as the **Fast Fourier Transform (FFT)**. Also referred to as the **Discrete Fourier Transform (DFT)**.

FOV Abbreviation for **field of view (FOV)**.

FP Abbreviation for **front projection (FP)**.

FPS Abbreviation for **frames per second (FPS)**.

fractal A geometric pattern using **recursive subdivision** to create infinite detail. Each **subdivision** produces smaller copies of similar shape, that are uniquely created with a random **variable**. Fractals contain a characteristic, called **self-similarity**, in which each **shape** looks like the whole and is independent of **scale**. Thus, they look the same regardless of how close you **zoom in**. A fractal curve can contain an unlimited number of **generation**s and detail. See also **Mandelbrot Set**, **Koch island**, **recursion**, *and image on the following page*.

fractal compression An **image compression** technique that is based on the repetition of **scale**d and **rotate**d patterns of **pixel**s. This method results in a **lossy image**.

fractal image Any **image** created with the use of **fractal noise** functions.

fractal model See **fractal surface**.

fractal noise Mathematical **function**s used to create **shader**s and **procedural texture**s, such as clouds, rock surfaces, terrain, smoke.

Source Object

Subdivisions = 1

Subdivisions = 2

Subdivisions = 3

Fractal Geometry

Fractal patterns can be infinitely created using **recursive subdivision**.

fractal surface Any **surface** created by the use of **fractal** mathematics.

fragment 1. A fragment represents the **color**, **depth**, and **texture coordinates** of a single **pixel** in a **rasterized** **image**. 2. A piece of a **file**. When a file is written to a **hard drive**, it will sometimes be written in multiple fragments due to a lack of contiguous disk space that is large enough to store the entire file. See also **fragmentation**.

fragmentation The state that occurs when the **hard drive** has to write a **file** in multiple segments, or **fragment**s, due to the absence of **contiguous** disk space that can store the entire file. **Defragmentation** is a process that puts the files back into continuous segments.

frame 1. A single **image** that is generally a part of a **sequence** of **moving** images. 2. For **video**, a complete image made up of two **field**s. 3. For **film**, a single image on a strip of film. 4. A global term referring to the **image**

area that will be displayed in the final viewing form. Also called **frame line**. 5. To "frame a shot" is to determine its composition. 6. A complete **snapshot** of the **computer screen**.

frame aspect ratio See **image aspect ratio**.

frame averaging 1. An **image process** used to adjust the length of a **sequence** of **image**s by averaging and mixing the **input** images to create a series of new **output** images representing either a shorter or longer span of time. For example, rather than dropping every other **frame**, as in **skip print**ing, a 50/50 **mix** between each pair of frames can be combined to produce a new intermediate frame. However, this type of mixing of images can create soft images and double **edge**s, or **ghosting**, on some frames. See also **Cinespeed**. 2. See **grain averaging**.

frame buffer The **digital** memory used to store and **display** a single **image**. The size of the frame buffer needed is defined by the **bit depth** and **width** and **height** in **pixel**s.

frame capture See **frame grab**.

frame effect A term used to describe the **filming** of actors frozen in time while the **camera** still continues to move around them. See **Timetrack**.

frame grab 1. To **capture** a **frame** of **video** or **film** and store it as a **digital image**. 2. Synonymous with **screen grab**.

frame grabber A **device** that can **capture** a **frame** of **video** or **film**.

frame handles The additional **frame**s that are tagged onto the **length** of a **shot** in order to give the **Director** and **Editor** some flexibility in **cutting** the **final edit**. **Handles**, also referred to as **padding**, are, in most cases, an additional four frames at the **head** and **tail** of each shot. This would be referred to as "4-frame handles" and would include a total of 8 additional frames of action over the actual **cut length**.

frame interval The amount of time that a **display device** has to prepare to **display** the next **frame**.

frame line 1. The rectangular boundary of an **image**. 2. The small space between two **frame**s on a strip of **film**. This is the point where two images can be cut apart and joined.

frame number The unique number that indicates the location of a particular **frame** on **video**, **film**, or in a **sequence** of **digital image**s.

frame rate The speed at which a series of **images** are **captured** or **displayed**. The frame rate is measured in **frames per second (FPS)** such as 24 FPS for **film** and 30 FPS for **video**. See also **fast motion, slow motion**.

frame range The total number of **frames** to be **captured, displayed**, or created for viewing. Also called **scope, range**.

Framestore A **digital** device capable of storing and **display**ing a single **video frame** as a **freeze frame**.

frames per foot There are 16 **frames** per foot of **film**. **Cel animated features** generally express their **shot length** in terms of **feet + frames**, whereas **live action features** express shot length by the total number of frames. See also **film footage**.

frames per second (FPS) The number of **frames** that are **captured** or **display**ed per second. **Video** plays back at 30 FPS, whereas **film** is **project**ed at 24 FPS. Also called **frame rate**.

free form deformation See **deformation**.

free software Any **software** that can freely be copied, **distribute**d and modified without any licensing fees or restrictions. See **open source**.

free viewing method Any method used to view **stereo images** without the use of **3D glasses**, such as the **parallel viewing method** and the **cross-eyed viewing method**. *See also Color Plate 30, 31, and image on following page.*

freeware **Software** that can be **download**ed and used free of charge. The **Developer** holds a copyright and retains the right to control its **distribution** and to sell it in the future. See also **free software, shareware**.

freeze 1. To put a stop to the **action**. A **freeze frame** is often used to achieve this. 2. See **lockup**.

freeze frame A **static image** that is duplicated and repeated for a period of time. Also called a **held frame**.

freeze frame effect See **Timetrack**.

frequency The number of repetitions of a complete cycle of a periodic process occurring per **unit** of time. For example, for **audio**, frequency is represented by the number of cycles, represented in **hertz (HZ)**, that a **signal** completes per second. See also **amplitude, phase**.

fresnel A standard studio **light source** that allows for maximum **light** control. It is an enclosed light source that gives off a large soft-edged beam.

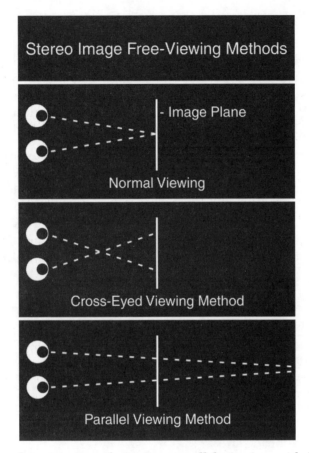

The differences between normal viewing, **parallel viewing**, and the **cross-eyed viewing method**.

friction A **physical property** used in **motion dynamics** to describe how smooth or rough a **surface** is. The two main types of friction are **static friction**, which prevents stationary **object**s from sliding down inclined surfaces, and **kinetic friction**, which causes moving objects to come to a stop. Sometimes called **roughness**.

fringing 1. An **image artifact** that can be seen when the **foreground element** contains a visible outline when **composite**d over the **background element**. Generally, this artifact is the result of an improper or **bad key**. 2. An image artifact that occurs when the **RGB component**s of a **video signal** are slightly offset from one another, causing **color** fringes and blurriness around the **pixel**s. Also called **color fringing**.

front clipping plane See **near clipping plane**.

front end 1. Referring to a small, **user-friendly** computer that interacts with the **user**, while a larger **computer**, known as the **back end**, **process**es the bulk of the **data**. 2. A **program** providing a user-friendly **interface** while another back end program addresses tasks that are not directly controlled by the user. 3. A term used to describe the **preproduction** and **principal photography** portion of a **film** project. See also **back end**.

front face The front face of a **polygon** is attached to a **surface normal** that faces toward the **camera** and is the **geometry** that shows up in the **image** when **render**ed. Opposite of **backface**. See also **double-sided**.

front facing Referring to **geometry** that contains **frontface**s.

front light **Lighting** that strikes the **subject** from the same side from where the subject faces the **camera**. See also **side light**, **back light**.

front lit See **front light**.

front projection (FP) An **in-camera** compositing technique, in which the **subject**s are **film**ed in front of an **image**, or **sequence** of images, that are **project**ed onto a **screen** behind them to produce a single combined image on the **exposed film**. While **rear projection (RP)** projects the **background (BG)** from behind the screen, front projection projects the background from in front of the screen.

front projection photography See **front projection (FP)**.

front slate See **head slate**.

front view An **orthographic view** of the front of the **scene**. See also **top view**, **side view**, *image under **viewing windows***.

frozen Synonymous with **lockup**.

frozen dissolve A type of **dissolve** in which the last **frame** of the first set of **image**s and the first frame of the second set of images are frozen during the dissolve.

frozen time See **Timetrack**.

frustrum See **viewing frustrum**.

frustrum of vision See **viewing frustrum**.

fry To send too much electricity through a **computer** that results in damage.

f-stop The setting on the **lens** that defines the size of the **aperture**. The f-stop can be calculated by dividing the **focal length** by the aperture. The smaller

the f-stop number, the larger the aperture opening. Unlike a **t-stop**, the f-stop can indicate the amount of **light** entering the lens but cannot account for light loss due to absorption. Standard f-stop numbers include 1, 1.4, 2, 2.8, 4, 5.6, 8, 11, 16, 22, 32. An f-stop of 3.5 would be written as f/3.5. Also referred to as **f-number**s.

FTP Abbreviation for **file transfer protocol (FTP)**.

FTP site An **Internet site** that allows **user**s to **download** and **upload** data.

fubar Abbreviation for "f****d up beyond all repair!"

Fuji The trade name of a professional motion picture **film stock**.

full Academy aperture See **Academy aperture**.

full ap Abbreviation for **full aperture**.

full aperture A standard 35mm **film format** that extends beyond the area reserved for the **sound track** to use the entire film **frame** and produce an **image** with a 1.33 **aspect ratio** and, typically, a working **image resolution** of 2048 × 1556 for **visual effects work**. The dimensions of the image actually **capture**d on the **film** are equal to .980″ × .735″. Using this extra area results in a frame that is approximately 30 percent larger than using the standard **Academy aperture**. Because of this, it is quite common to use full aperture framing for **visual effects (VFX)**. Also referred to as **Super 35**. See also **35mm film**.

full CG Referring to **image**s that are completely created with **computer graphics (CG)**, using no **live action element**s. *See also Color Plates 42–49, 61–63.*

full CG feature See **CG feature**.

full featured **Software** or **hardware** that comes with all the latest, greatest features.

full path See **absolute path**.

full scale A term used to describe a **model** that is built to the actual size of the **subject**. See **miniature**, **model scale**.

fullscreen A term used to describe an **image** that contains a 4:3 **aspect ratio** and is designed to fit a regular television screen when **display**ed. See also **widescreen**.

full shot See **long shot (LS)**.

full size See **full scale**.

full size set A **set** or **model** that is built to its actual size. Opposite of **miniature set**.

full size set piece A portion of a **set** or **model** that is built to its actual size. Opposite of **miniature set piece**.

function A **variable** that is related to another variable so that the **value** assigned to one is the same value assigned to the other. See also **procedure**.

function curve (fcurve) A **graphical representation** of a **function** or **expression**, such as a **curve**, that an artist can **view** and modify. Also called an **fcurve**.

fuse See **fusion**.

fusion Whenever two **metaball**s overlap, the **value**s of the **density field**s add up, and if the new density value is equal to or greater than the visibility **threshold**, the overlapped area between the two metaballs will be visible. Also called **blend**. *See image under metaball.*

fusion groups The use of separate groups of **metaball system**s to define which groups of metaballs will be allowed to **fuse** together. Also called **blending groups**.

fx Abbreviation for **effects, special effects (special FX), visual effects (VFX)**.

G Abbreviation for **green (G)**.

gadget A term used for an **interface element**.

Gaffer The individual who heads up the electrical department and is in charge of the **lighting** for a **film**. Also called **Chief Lighting Technician**.

gaffer tape Cloth tape commonly used on **set** by the **Film Crew**.

gain 1. The amplification of **audio**. 2. Referring to the **highlight**s in an **image**. 3. For some **compositing package**s, gain is used to refer to **operation**s involving a modification to the highlights or **brightness** values of an image.

gamma 1. For **film**, a measurement of the **contrast** or **emulsion** of an **image** based on the slope of the **characteristic curve**. 2. For **video**, the accuracy of the **intensity** of **light** that is transferred through a **monitor display**. The gamma factor typically applied to **video image**s when they are acquired is 2.2. Because properly stored video images contain this built-in gamma of 2.2, a **monitor lookup table** must be used when transferring them to a **display device** so they don't appear to be too bright. 3. For **digital**, a **color curve** applied to an image to adjust its **brightness** for the **display device** on which it is being displayed. 4. A **compositing operation** that modifies the perceived brightness of an image by increasing or decreasing the midrange **value**s.

gamma correction 1. The **nonlinear conversion** of a **video image** is referred to as a gamma correction. Since video images are generally stored with a **gamma** of 2.2, a conversion back to **linear space** is achieved by applying the inverse of gamma 2.2, or gamma 0.45, to the image. 2. The **color lookup table (CLUT)** applied to an **image** in the **frame buffer** before it is **display**ed for viewing on a **monitor**. 3. For **compositing**, see **gamma operation**.

gamma correction curve The resulting **curve**, also referred to as an **exponential curve**, that is the result of applying a **gamma correction** to a **digital image**.

gamma curve Shorthand for **gamma correction curve**.

gamma operation An **image operator** that can apply **color correction**s to the **midtones** of an **image** without altering the **black point** and **white point** of the image. Gamma works by raising the **value** of each **pixel** to the power of 1 divided by the input gamma value. For example, if an input pixel value is equal to .5, and the gamma value applied is 1.5, the resulting pixel gamma value is equal to .629 (.5 raised to the power of 1/1.5). So, when working with **normalized value**s, input pixel values of 0 (**black**) and 1 (**white**) will remain the same because 0 and 1 raised to any power are still 0 and 1.

gamut The complete **color range** that can be **display**ed in an **image** or **viewing device**. Also called **spectrum**.

gantry system A type of **motion control rig (MOCO rig)** that can travel in an arc for both up-and-down and side-to-side motion. See also **Cartesian robot system**, **mechanical concepts system**, **gantry system**.

garbage in, garbage out (GIGO) A term used to describe the frustrating process of trying to make high-quality **composite**s from mediocre (or worse) **input element**s. Also used to describe the process of trying to **debug** a **program** only to find that the input **data** was inaccurate.

garbage matte A very rough **matte**, as opposed to an **articulate matte**, that isolates the **subject** from any unwanted **background element**s. **Bluescreen (BS)** and **greenscreen photography** often needs garbage mattes to **hold out** the areas of the **set** that are not contained in the **backing**.

gas laser A type of **laser**, whose active lasing medium is gas, used to create **red (R)**, **green (G)**, and **blue (B)** in some **laser film recorder**s, such as the **Lightning II film recorder** and the **Lux laser film recorder**. Disadvantages resulting from using gas lasers over **diode laser**s include a vastly shorter lifespan, greatly increased service requirements, and an extremely high power consumption, producing significant heat that can lead to **beam convergence** misalignment that causes **color fringing** in the **output image**s.

gate See **film gate**.

gate pass See **drive on**.

gateway See **router**.

gauge See **film gauge**.

Gaussian blur See **Gaussian filter**.

Gaussian curve See **bell-shaped curve**.

Gaussian distribution See **normal distribution**.

Gaussian filter A **filtering algorithm** used to **resample** a **digital image**. The Gaussian filter is relatively free of **aliasing** or **ringing** artifacts but tends to noticeably soften the image. See also **box filter**, **impulse filter**, **Mitchell filter**, **Sinc filter**, **triangle filter**.

Gaussian shape See **bell-shaped curve**.

gawk Abbreviation for "gnu awk." A pattern-searching **text editor** that is an enhanced version of **awk**. See also **Perl**, **sed**.

GB Abbreviation for **gigabyte (GB)**.

G-byte Abbreviation for **gigabyte (GB)**.

geared head A **camera** mount controlled by gears that enables the **Camera Operator** to perform smooth **pan** and **tilt** moves during **filming**. See also **fluid head**.

gel See **gelatin filter**.

gelatin See **gelatin filter**.

gelatine The material widely used for **makeup effects (makeup fx)** before **silicone** came into common use. Gelatine was typically used for fleshlike effects. The biggest problem with the use of gelatine was that it tended to soften and melt under the hot **set lights**.

gelatin filter An **optical filter** placed in front of the **camera** or **light**s to adjust the viewing **color** of the **scene**.

generated object The **object** created by a **generator** in **procedural modeling**.

generating curve The **curve** used as the **source object** or **generator** to create a resulting **object**, such as an **extrusion** or **surface of revolution**.

generation 1. Each **duplication** of **film** and **video** images performed between the original recording and subsequent copies of that recording. For example, the **first-generation** copy of an **original negative** is the **interpositive (IP)**. The first-generation copy is the cleanest representation of the **image**s, the **second generation** is a copy of the first generation, the **third generation** is a copy of the second generation, and so on. Unless the copies have been done with **digital duplication**, each generation will have an increased loss of quality, referred to as **generation loss**. 2. For **L-System**s, generations refer to the number of **recursion**s used to define an **object** in terms of itself. See also **generator**, **initiator**, **Koch island**.

generation loss The loss of **image quality** caused by repeated **duplication**. For **optical compositing**, **film printing**, and **tape duplication**, **image**s lose **sharpness** each time they are run through another **process**. **Digital**-to-digital duplications, however, do not suffer generation loss. See **generation**, **internegative (IN)**, **interpositive (IP)**.

generator 1. The **object** that controls the **output** of another object. A generator can be a **curve**, a **surface**, or a **face**. Each time the generator is modified, the **generated object** will automatically reflect the changes. This type of **modeling** is called **procedural modeling**. 2. For **L-System**s, the generator is the pattern that is used to **subdivide** the **initiator** into generator patterns over and over again. See also **Koch island**.

genesis film scanner See **Cineon Genesis film scanner**.

genlock A **device** capable of synchronizing itself with the incoming **video signal**. Also called **sync generator**.

geodesic dome See **geodesic sphere**.

geodesic sphere A **sphere** constructed of interlocking **polygon**s.

geometric normal See **surface normal**.

geometric primitive A group of basic geometric **shape**s that are used so frequently in **computer graphics (CG)** that most **3D software package**s include them as pre-defined **topology**. They include the familiar shapes of a **sphere**, **torus**, **cylinder**, **cube**, **cone**, **grid**, **circle**, and **truncated cone**. Geometric primitives are **quadratic surface**s that can be defined by a set of **quadratic equation**s. *See image on following page.*

geometric transformation See **transformation matrix**.

geometric vector See **surface normal**.

geometry The **vertices** and **parameter**s that describe an **object** in **3D space**.

geometry attributes The **node** or **window** that contains the characteristics that contribute to the **surface** of an **object**.

geometry matrix The 4×4 **matrix** of **control point**s that define a **bicubic patch**.

geometry replacement A technique in which the **low-resolution geometry** is swapped out with the **high-resolution geometry** for **lighting** and **rendering**, or the high-resolution **geometry** is replaced with the low-resolution geometry so the **animator** can get faster feedback while working. See also **animation replacement**.

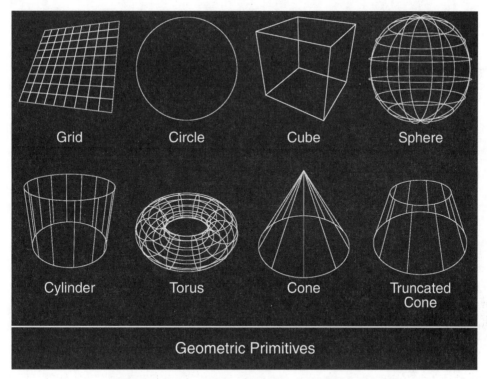

Geometric Primitives

Grid Circle Cube Sphere

Cylinder Torus Cone Truncated Cone

Some common types of **geometric primitives**.

German Industry Standard See **Deutsche Industrie Norm (DIN)**.

ghosting The dim secondary **image** usually **offset** or delayed from the primary image seen in **video**, **film**, and **stereo film**s. 1. For video, ghosting can be caused by **signal** interference. 2. For film, ghosting is typically due to internal **lens** reflections or is intentionally created using **double exposure** techniques. 3. For stereo films, the effect occurs when **light** from the opposite eye leaks through the **polarized glasses** or when the viewer rotates his head too much. 4. For **digital**, ghosting can result from **frame averaging** a **sequence** of images to be a shorter or longer duration. See also **Cinespeed**.

GIF Abbreviation for **graphics interchange format (GIF)**.

gig Abbreviation for **gigabyte (GB)**.

giga Prefix for one billion. See **gigabit**, **gigabyte**.

gigabit One billion, or more specifically, 2^{30} or 1,073,741,824 **bit**s. See also **gigabyte (GB)**, **megabit**, **kilobit**.

gigabit ethernet A type of **ethernet** that supports **data** transfer at 1,000 **megabit**s per second. Also called **1000Base-T**. See also **fast ethernet**.

gigabyte (GB) One billion, or more specifically, 2^30 or 1,073,741,824 **byte**s. Also 1,024 **megabytes (MB)**. See also **kilobyte (KB)**, **gigabit**, **terabyte (TB)**.

GIGO Abbreviation for **garbage in, garbage out (GIGO)**.

gimbal See **gimbal lock**.

gimbal lock Gimbal lock is the loss of a degree of **rotation**al freedom due to the alignment of two **axes**, which results in the loss of the ability to **rotate** about one of the axes. The visual cue of a gimbal lock occurrence is the sudden jump of rotational data from one **frame** to the next. Rotations applied with **quaternion**s eliminate this problem. Also referred to as **parametric singularity**.

gimble See **motion base**.

girl head See **LAD girl**.

glare filter See **glare screen**.

glare guard See **glare screen**.

glare screen A special **screen** placed in front of the **computer display** to reduce glare. Also called a **glare filter**, **glare guard**.

glitch A temporary malfunction in a **computer**, as opposed to a **bug**, which is a recurring malfunction.

global Something that affects the entire **file**, **program**, **computer**, or **network**.

global coordinates See **world coordinates**.

global coordinate system See **world coordinate system**.

global envelope A term used to describe the use of a single continuous **surface** as the **skin** or **envelope** to be attached to a **skeleton chain**.

global illumination A general term used to describe the **reflect**ed and **transmitted light** that originates from every **surface** in a **scene**. See **radiosity**, **ray tracing**, **local illumination**.

global positioning system (GPS) A system of satellites that continually **transmit** signals to determine positions on the earth's surface. GPSs are sometimes used to **survey** a **set** for use in **3D tracking**.

global space See **world coordinate system**.

global variable A **variable** that affects the entire **database**, **object**, or **image** when modified. The opposite of a **local variable**.

glow See **glow operation**.

glow operation A **compositing** technique that adds the appearance of light **emit**ting from a particular **element** in a **scene** by using a combination of **blur** and **color correction**s.

GM Abbreviation for **General Manager (GM)**.

gobo See **cukaloris**.

Gofer See **Production Assistant (PA)**.

go motion An **animation** technique, similar to **stop-motion animation**, that is capable of incorporating **motion blur**. Robotic models moved during the **exposure** of each **frame** can produce the motion blur that cannot be achieved with stop-motion techniques.

good 1. Any **take**s of a **scene** that the **Director** likes and wants to see in **dailies**. 2. Any **filmout** that was successfully sent to the **recorder** without any glitches. 3. Any **film roll** that comes back from the **lab** that meets **aims**. See also **no good (NG)**.

Gouraud lighting model See **Gouraud shading model**.

Gouraud shading See **Gouraud shading model**.

Gouraud shading model A **shading model**, developed by Henri Gouraud, used to make **surface**s made up of connected **polygon**s appear to be smooth. **Color**s at the shared corners of the polygons are calculated using **averaged normal**s, and then this color is linearly **interpolate**d across the interior of each polygon. One of the drawbacks of Gouraud shading is that the **interpolated shading** technique can sometimes make seams between **adjacent polygon**s visible, particularly around bright **highlight**s. Sometimes referred to as **smooth shading** or **linear shading** because the color interpolation is a **linear** calculation. See also **Phong shading model**, **Blinn shading model**, **Cook/Torrence shading model**, **Lambert shading model**, *and image on following page*.

GPS Abbreviation for **Global Positioning System (GPS)**.

grab See **frame grab**.

grad Abbreviation for **gradient**.

grade See **color grade**.

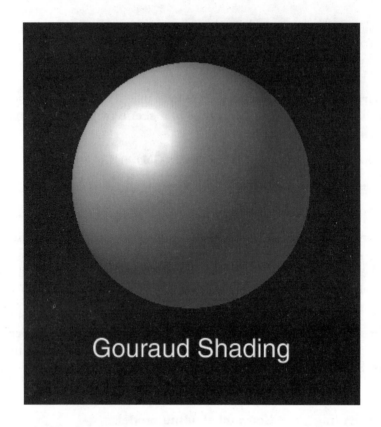

Gouraud Shading

Grader See **Color Grader**.

gradient An **image operation** that creates an **image** by smoothly blending between the **colors** defined at the **edges** of the image. A **horizontal gradation** blends colors from left to right of the **frame**, a **vertical gradation** blends colors from top to bottom, a **four-corner gradation** blends across the colors from each corner and a **radial gradation** interpolates colors from the center of the frame out to its edges in the shape of a **circle**. *See Color Plate 2, images under horizontal gradation, vertical gradation, radial gradation.*

grading See **color grading**.

Grading Supervisor See **Color Grading Supervisor**.

grain See **film grain**.

grain averaging An **image process** in which a series of still **image**s containing **film grain** are **add**ed together and then divided by the total number of images used to produce a resulting image without film grain. This technique is often used for **matte painting** to eliminate **static grain**. After av-

eraging, and after the paint work is completed, moving film grain is added back on to the image once again. Also referred to as **frame averaging**, **image averaging**.

grain characteristics See **grain structure**.

graininess Referring to the size and **density** of **film grain** that can be seen on a particular **film stock** when **project**ed.

grain structure The characteristics that define a **film grain** on a particular **film stock**, such as its size and **density**. When grain is very large and noticeable when **project**ed, it is said to be very **grainy**.

grainy A term used to describe a **film stock** that contains very large and heavy **film grain** when **project**ed.

granularity The **density** of a **viewing surface**, such as the number of **pixel**s in an **image** or the amount of **film grain** on a piece of **film**.

graph A visual **display** of a collection of **data**. Graphs displaying the various **curve**s that represent the **value**s over **time** for **object**s and **image**s are widely used in most **software package**s.

graphical elements See **interface elements**.

graphical representation Any **graphical user interface (GUI)** representation of **function**s, **attribute**s, or **curve**s that allow the artist to **view**, create, or modify the information **interactive**ly.

graphical user interface (GUI) A **computer interface** based on **graphical element**s, such as **icon**s, **menu**s, and **window**s, that allow the **user** to interact with the **computer**.

graphic paintbox See **paintbox**.

graphics 1. Referring to **flat artwork**. 2. Shorthand for **computer graphics (CG)**.

graphics accelerator See **graphics board**.

graphics accelerator card See **graphics board**.

graphics adaptor See **graphics board**.

graphics board A **circuit board** that is inserted into a **computer** to allow it to display **image**s on the **screen**. The **refresh rate**, **resolution**, and the **bit depth** of the images that can be **display**ed on a **monitor** are determined by the type of graphics board used and is also tied to the limits

of the monitor. Also called **graphics adapter**, **graphics card**, **video adapter**, **video board**, **video card**, **display adapter**, **display board**, **display card**.

graphics card See **graphics board**.

graphics display See **bitmap display**.

graphics environment The current state of **variable**s and **value**s defining **color**, **light**, and **surface** appearance that an **object** added to the **scene** will inherit.

Graphics Interchange Format (GIF) A standard **image file format** that uses **LZW compression** and a total of **8 bit**s of **color** information per **pixel**. The **filename extension** typically used is .gif.

graphics state See **graphics environment**.

gravity Gravity is the natural force of attraction between any two **object**s based on their **mass** and the distance between them. A ball falls to earth because the mass of the earth is greater than the ball. Gravity is the force that pulls objects downward. In **motion dynamics**, gravity is one of the most widely used **physical forces** used to control the speed at which objects in the **simulation** are pulled downward. See also **wind force**, **fan force**.

gray card An even, midtone gray card, representing 18 percent reflectance, that is used to evaluate proper **exposure**. A gray card is often placed at the **head** of a **film roll** for use by the **lab** when **processing** the **film**. Also called an **18% gray card**.

grayscale 1. See **grayscale chart**. 2. See **grayscale image**. 3. A term used to describe the **render**ing of a **3D scene** with a basic gray **material** on the **objects** and no special **lighting**. Used most often for **motion preview**s. Also referred to as a **quick shade**. *See also Color Plate 63.*

grayscale chart A chart or **image** composed of uniformly spaced **vertical** bars made up of gray incremental steps of shades of gray ranging from **black** to **white**. Like a **gray card**, a grayscale is used to determine how to properly **expose** or **print** a **scene** or is used as reference during a **monitor calibration**. *See image on following page.*

grayscale image An **image** composed only of **gray values**, as opposed to a **color image**. Also called a **black and white image**, **monochromatic image**. *See on following page, Color Plate 15.*

gray values The **pixel values** that make up a **grayscale image**.

A typical **grayscale chart.**
IMAGE PROVIDED COURTESY OF PACIFIC DATA IMAGES.

green (G) 1. One of the three **primary colors**. 2. For **digital**, see **green channel** 3. For **film**, see **green record**.

green backing See **greenscreen, color backing**.

green channel The **channel** that contains all the **green (G)** information represented in an **image**. Also called **green component, green record**. See also **blue channel, red channel**. *See Color Plate 14.*

green component See **green channel**.

green contamination Shorthand for **greenscreen contamination**.

green key Abbreviation for **greenscreen key**.

greenlight A film gets the greenlight when the **studio** has approved its **budget** and has committed to creating the **film**. See also **flashing greenlight**.

greenlit See **greenlight**.

green record 1. In **digital**, synonymous with the **green channel**. 2. In **film**, the green **color-sensitive** layer in a piece of film.

greenscreen (GS) A primary green **backing** that is placed behind the **subject** to be photographed so that a **matte** can be extracted. Ideally, the greenscreen is uniformly lit and contains no **color contamination** in order to **expose** only the green layer of the **film**. Greenscreens usually require less **light** than **bluescreen (BS)** because film and **video** are more sensitive to the color green than to blue. See also **greenscreen key**, **bluescreen**, **redscreen**.

greenscreen contamination 1. A **green backing** that is contaminated with **blue (B)** or **red (R)**. See **color contamination**. 2. See **greenscreen spill**.

greenscreen element See **greenscreen plate**.

greenscreen key A **matte extraction** technique that separates a **subject** from its **background (BG)** based on a green **color backing** that the subject has been photographed in front of. Also called **color difference keying**, the best results are obtained from a greenscreen that contains strong **chroma** or purity of **color**. Same concept as a **bluescreen key**, **redscreen key**.

greenscreen photography The process of **filming** a **subject** in front of a **greenscreen (GS)** for use in **matte extraction** during **compositing**. Same concept as **bluescreen photography**, **redscreen photography**. *See also Color Plates 54, 64, 65.*

greenscreen plate Any **element** photographed that uses **green (G)** for its **backing color**. See also **bluescreen plate**, **redscreen plate**. *See Color Plates 54, 64, 65.*

greenscreen shot Any **shot** that uses **greenscreen photography**.

greenscreen spill The green **color** that falls onto a **subject** during **greenscreen photography** as a result of the green **light** reflecting off of the **green backing** placed behind it. Same as **bluescreen spill**, **redscreen spill**. See **color spill**.

green signal The **green component** of a **video signal**.

green spill Shorthand for **greenscreen spill**. See **color spill**.

greenscreen stage Any **stage** that can be used for **greenscreen photography**.

grid A **2D plane** that is made up of uniformly spaced, interconnecting **rows and columns** to define its **surface**. Commonly used as reference in **3D modeling**.

grid coordinates The **coordinate**s for the X- and Y-**axes** along a **grid**.

grid snap See **snap to grid**.

Grip The members of the **Film Crew** that are responsible for a wide assortment of jobs on the **set**, such as transporting equipment and sets and laying **dolly track**. See also **Key Grip**.

ground glass A flat piece of etched glass placed in the **viewfinder** that focuses a portion of the **light** from the **lens** so the **Cameraman** can see the **scene** as the lens sees it. Most ground glasses also contain lines indicating the **edge** of **frame** to assist in **shot composition**.

ground plane The plane on which the **subject** is standing.

group 1. A collection of **user**s who share relaxed **permissions** on **file**s owned and shared by one another. 2. Another name for **point group**. See **point cluster**. 3. A series of **object**s, **element**s, or **node**s that are grouped together within a **hierarchy**. Also called a **unit**.

group shot As the name implies, a **shot** with all the actors included in the **camera** view.

GS Abbreviation for **greenscreen (GS)**.

GUI Abbreviation for **graphical user interface (GUI)**.

gutter In a **graphical user interface (GUI)**, the bar, usually rectangular, that is the length of the **scroll bar**. A **user** can **click** anywhere along this bar to reveal another portion of information contained in the **window**, as opposed to using the **arrow**s or **thumb** of the scroll bar.

hack A **workaround** used to solve a problem in a piece of **software** or a **program**.

hacked in A **Hacker** who has been successful in gaining illegal entry into another **computer** is said to have "hacked in" to that **system**.

Hacker 1. A person who enjoys and is good at **programming**. 2. A person who illegally gains access to another **computer**. 3. A person who is an unconventional **Programmer** and is not formally trained.

Hal A self-contained **digital compositing** package for **video**. Developed by **Quantel**.

halation A **film** defect caused by scattered **light** passing through the **emulsion** layer and causing a localized **fog** around **light source**s and areas of sharply defined **highlight**s.

half apple An **apple box** that is one-half as thick as a regular apple box. See also **quarter apple**.

half-inch tape **Magnetic tape** that is 1/2 inch across in width, such as **VHS** and **Beta**.

halftone A **printing** technique used to create the illusion of intermediate shades of gray based on the size and spacing of dot patterns that do not themselves vary in **value**. Large dots placed close together are used for dark areas, and small dots placed farther apart are used for **light** areas. Our eyes blend the dots together, and we see a perceived **interpolation** of varying shades of gray.

halo A bright or dark glow around an **object** that has in most cases been improperly **composite**d.

handedness A term used to define the **coordinate system** being used, as in either the **right-handed coordinate system** or the **left-handed coordinate system**. *See also images under right-handed coordinate system,* ***Y-up coordinate system****.*

handheld shot A **camera move** created by the **Cameraman** holding the camera during **filming**, as opposed to placing the camera on a **camera mount** such as a **tripod** or **dolly**.

handles 1. See **frame handles**. 2. See **tangent vector**. 3. See **IK handle**.

hand-painted elements **Image**s created by hand with traditional painting methods or **computer paint programs**, such as **matte painting**s and **articulated matte**s.

handshake 1. The **protocol** controlling information flow between a **workstation** and a **printer**. 2. The high-pitched sound heard when two **modem**s try to establish contact with each other.

hanging miniature A **miniature** suspended in front of the **taking camera**.

hard 1. For **film**, having high **contrast**. 2. The placement of **set lights**, causing sharp **shadow**s and glaring **highlight**s. 3. For **digital**, a **key** that contains very sharp **edge**s when **composite**d instead of a feathered **falloff** in **transparency**. 4. In general, referring to an **image** that is very **sharp** or in **focus**.

hard boot To restart a **computer** when its power is off. Also called a **cold boot**, **dead start**. Opposite of **soft boot**.

hard-coded Information written in multiple locations inside **source code**, **shell script**s, or **scene file**s, as opposed to using **global variable**s, that results in **data** that cannot be easily modified. Good **programming** practice encourages the use of the global variables defined at the top of the **file** as a way to quickly modify the information and avoid unnecessary errors. Also called **hard-wired**.

hard copy A printed copy of the **output** of a **computer**. Opposite of **soft copy**.

hard disk A rigid **magnetic disk** that resides within a **computer** for storing **data**. Hard disks generally offer greater storage and faster access to data than **floppy disk**s. Most hard disks are permanently fixed in the computer, but removable hard disks are also available. Also called a **rigid disk**, **fixed disk**.

hard disk drive An internal or external **storage device** that stores **data** that can be accessed by the **computer** and **user**s.

hard drive See **hard disk drive**.

hard-edged matte A **matte** with sharp or hard **edge**s. Opposite of **soft-edged matte**.

hard lighting **Lighting** that casts sharp-edged **shadow**s and creates high **contrast**. Opposite of **soft lighting**.

hard mask See **masking**.

hardware A **computer** and the associated physical equipment that is directly involved in its **performance** and **data processing**. Unlike **software**, hardware refers to the material parts of a computer that can be touched. Computer hardware generally consists of a **central processing unit (CPU)**, **memory**, and **display device**.

hardware device The **peripheral device**s attached to **hardware**.

hardware handshake The **signal**s that establish communication between two **computer**s.

hardware platform See **computer platform**.

hardware rendering The ability to see **rendered image**s within a **software package** for previewing **animation**s and **composite**s. See **flat shading model**, **smooth shading model**.

hardware texture A **hardware rendering** of a **texture map** that is applied to an **object**.

hard-wired 1. See **hard-coded**. 2. A physical connection with a wire or **cable**.

Harriet A **digital effects (DFX)** device that is a variation on the **Harry**. Developed by **Quantel**.

Harry A **digital video effects (DVE)** device capable of complex **composite**s for **video** that is manufactured and sold by **Quantel**.

hazeltine The **color timing** machine that **projects** a **positive image** onto a **screen** from the **negative** to allow the **Color Timer** to make the appropriate adjustments for **density** and **color** during **printing**.

HD camera See **High Definition camera (HD camera)**.

HD monitor See **High Definition monitor (HD monitor)**.

HD video See **High Definition video (HD video)**.

HDTV See **High Definition television (HDTV)**.

head 1. The first **frame** of a **shot**, usually frame 1. 2. The beginning of a **roll** of **film**. 3. A platform used for mounting a **camera**. The two most common types of heads are **fluid head**s and **geared head**s. 4. The magnetic device in a **videotape recorder** used to record, erase, and **playback** video and audio **signal**s.

head and shoulder close-up shot A **shot** that **film**s an actor from just below the shoulders to above the head. See **close-up (CU)**.

head and shoulder shot Shorthand for **head and shoulder close-up shot**.

head beep See **head pop**.

head close-up Shorthand for **head close-up shot**.

head close-up shot A **shot** that **film**s only the head of an actor. See **close-up (CU)**.

header See **file header**.

head-mounted display A specially designed helmet used in **virtual reality (VR)** simulations that consists of two **video monitor**s mounted in front of each eye.

Head of Production The individual who supervises the work of various **Producer**s and **Supervisor**s at a **studio** or large **facility**, as opposed to working on a specific **project**. This individual is also responsible for overseeing budgets, schedules, overages, and ultimate delivery of the product to the client. The Production Head interfaces with the Producers and **Production Manager (PM)** on the individual productions and usually reports to the president or vice president. See also **Executive Producer (EP)**.

Head of Story The individual who leads and manages the **Story Team** and works closely with the **Director** of the **film** to bring the story together. Also called **Story Lead**, **Story Head**.

Head of Software The individual who manages the team of **Software Developer**s at a **facility** or company and sets priorities and deadlines for the various **project**s that the team is handling. The Head of Software works very closely with the **Head of Technology** and the **Digital** and **Visual Effects Supervisor**s at a facility to determine the best way to meet the needs of **production**.

Head of Technology The individual at a **studio** or **facility** who is responsible for the purchasing of **hardware** and **3rd party software** as well as the management of any **proprietary software** that is written within the company. The Head of Technology works very closely with the **Head of Software**, **Head of Production**, and various supervisors within the facility to determine the priorities for purchases and the writing of custom tools.

head-on shot A **shot** in which an actor moves directly toward the **camera**. The opposite of a **tail-away shot**. Also referred to as a **neutral shot** because such a move is nondirectional.

head pop The sound tone at the **head** of a **reel** used to mark a specific location on a **sound track**. Also called **head beep**. See also **tail pop**.

head room 1. An **image** that has been **color grade**d so that there is room to brighten the image without immediately **clipping** the **white**s. See **open**—Definition #3. 2. The area of the **frame** between the actor's head and the top of frame.

head slate A **slate** that is recorded at the head of a **shot**, as opposed to a **tail slate**, which is recorded at the end of the shot. Also called a **front slate**.

heavy geometry Generally, referring to **3D object**s that contain a very high **level of detail (LOD)** and as a result, take a long time to calculate **render**s. See **data donkey**.

height How tall an **object** or **image** is along the **Y-axis**. See **width**.

height field A technique used to define a simple **surface** by specifying only height information for each **point** on a **plane**.

height map See **displacement map**.

held frame See **freeze frame**.

help Any **documentation** available on the **computer screen** about the **computer** or a particular piece of **software**.

Hermite curve See **Hermite spline**.

Hermite patch A **bicubic patch** defined by **Hermite spline**s.

Hermite spline A **curve type** that **interpolate**s across its first and third **control point**s and allows for explicit **tangent** control. See also **Cardinal spline**, **Bézier spline**, **B-spline**, **NURBS**.

hertz (HZ) The measurement of **cycles per second (CPS)** in **frequency**. The **refresh rate** of a **monitor** is expressed in hertz. One HZ is equal to one cycle per second. See also **megahertz (MHZ)**.

hex Shorthand for **hexadecimal**.

hexadecimal Hexa (six) and decimal (ten) is a method used to represent **binary number**s. The digits used are 0–9 and A–F, which stand for the numbers 10 to 15. The digit furthest to the right represents the ones place, the next place to its left is 16^1, the next 16^2, and so on. Each place to the left is 16 times greater than the number to its right. For example, the hexadecimal representation of the number 20 would be 14 (4 in the ones place plus 16 in the 1^16 place – 4 + 16 = 20). Also called **base 16**.

hexadecimal number See **hexadecimal**.

hexadecimal numbering system See **hexadecimal**.

hexadecimal value See **hexadecimal**.

hiatus A planned interruption in a **production schedule**, often to reassess the **budget**, **script**, or **shooting schedule**. See also **turnaround**.

hicon 1. Abbreviation for **high-contrast film**. 2. A black and white **matte** image. See **alpha channel**.

hidden line See **hidden line removal**.

hidden line removal A **wireframe** representation of an **object** in which only the portion of the object that faces the **camera** is **display**ed. Also called **visible line determination**, **visible surface determination**. *See image under **shading model** and image below.*

hidden line rendering A **rendering** of an **object** as though it were composed only of a series of **line**s to define its **edge**s. Hidden line rendering differs from a **wireframe rendering** in that some of the lines are hidden by the **surface**s in front of them. *See also **surface rendering**, image under **shading model**, and image below.*

hidden line shading See **hidden line rendering**.

hidden surface See **hidden surface removal**.

hidden surface removal The process of determining which **surface**s are visible or occluded within the **camera view** and will be included in the **render** time calculations. The **Warnock recursive subdivision algorithm** is one method used for this type of calculation. Also called **visible surface determination**. See also **backface culling**.

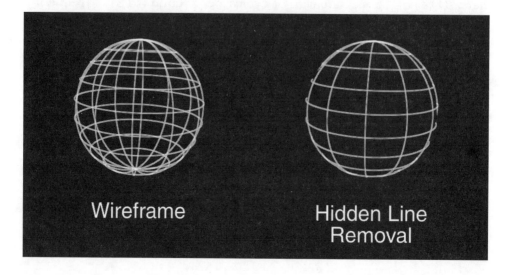

hide An **interface** option used to "turn off" or not **display** certain items on the **computer screen**. Opposite of **show**.

Hi-8 An 8mm **video** recording format that accepts **signals** for **composite** and **S-Video**.

hidline Abbreviation for **hidden line removal**.

hierarchical animation A technique in which an **animation** is created using a **hierarchical model** to organize the **objects**. A **key frame** is set for each **node** in the hierarchy and then, as with any other animation technique, the **software** calculates the **interpolated frames** for each node. The hierarchy typically should be structured so you can either **transform** the entire hierarchy or individually transform the lower-level nodes. Also called **forward kinematics animation (FK animation)**. See also **inverse kinematics animation (IK animation)**.

hierarchical file system See **file system**.

hierarchical model Any **model** whose separate **elements** are organized into a **hierarchy** with a **parent** at the top and all the **children** comprising the elements below. The benefit of **hierarchical modeling** is that the model can be modified as a whole from the top level while still allowing for modifications of individual elements contained in the lower levels. Under this scenario, each element still maintains its own **local coordinate system** while also inheriting the **coordinate system** of its parent. See also **null node**, **inverse kinematics (IK)**, **forward kinematics (FK)**.

hierarchical modeling See **hierarchical model**.

hierarchical structure A global term referring to the layout of any **hierarchy** within a **software package**.

hierarchy 1. An arrangement of connected **nodes** that make up all the **objects**, **elements**, and **attributes** for a particular **scene** or **object**. A **scene file** can be composed of many different **trees** or hierarchies. For instance, if there are two **3D characters** in a scene file, then each character has its own distinct hierarchy nodes or **components**. Also called **scene hierarchy**. See also **parent**, **child**, **group**ing. 2. Shorthand for **hierarchical file system**. See **file system**.

high-angle shot A **shot** in which the **camera** is angled downward toward the **subject**. Opposite of **low-angle shot**.

high contrast A **negative**, **print**, or **digital image** containing a wide range of **density** or **contrast**.

high-contrast film A **film stock** containing an **emulsion** capable of capturing the extreme **light** and dark **value**s of a **scene** with minimal steps of gray in between. Opposite of **low-contrast film**. See also **contrast range**.

high def Shorthand for **high definition television (HDTV)**.

high definition Shorthand for **high definition television (HDTV)**.

high definition camera (HD camera) Any **camera** capable of capturing and playing back **high definition video (HD video)**.

high definition monitor (HD monitor) A **video monitor** capable of **displaying** **image**s greater than the standard 525 **scan line**s.

high definition television (HDTV) A proposed **component video** broadcast standard that offers much greater **spatial resolution** than its counterparts, **NTSC**, **PAL**, and **SECAM**. **HDTV** has provisions for **interlaced images**, 8 or 10 **bit**s of **color**, and allows for both **analog** and **digital** versions and its typical **resolution** is 1920 × 1080 **pixel**s. See also **advance television (ATV)**, **digital television (DTV)**.

high definition video (HD video) High definition **video** refers to the highest-quality version of **digital video** currently available. See **high definition television (HDTV)**.

high density Having high **storage capacity**. Opposite of **low density**.

high-density disk A **disk** that can store more information than a **double-density disk**. See also **single-density disk**.

high end A general term referring to **visual effects work** that requires the delivery of high-quality and **high-resolution** imagery. High-budget **feature film** work is an example of high-end work. The opposite of **low end**.

high hat A low **camera mount** used to film **low-angle shot**s. Not quite as low as a **low hat**.

high-level code See **high-level source code**.

high-level language See **high-level programming language**.

high-level programming language A **programming language** that is written by a **Programmer**. Unlike a **low-level programming language**, it contains readable **syntax**. Examples of high-level languages include **C**, **C++**, **Fortran**, **Java**, **Lisp**, **Pascal**. High-level languages do not have to be written for a particular **computer**, but they do need to be **compile**d on the **system** on which they will **run**.

high-level source code Any **source code** written in a **high-level programming language**. See also **low-level source code**.

highlight 1. The hot spots caused by **light** hitting a **surface** and creating the perception of a shiny surface. See **specular, shadow, midtone**s. 2. For selecting and modifying items on a **computer screen**, see **select**. 3. The brightest part of an **image**.

highlight color The **parameter** that controls the **color** of the **specular highlight** on a **surface**. See also **highlight size**.

highlight size The **parameter** that controls the size of the **specular highlight** on a **surface**. See also **highlight color**.

high-pass filter A **spatial filter** used to increase high-frequency detail or **sharpness** in an **image**. Opposite of **low-pass filter**.

high performance parallel interface (HIPPI) HIPPI is a high speed **ANSI** standard for **network**ing and is often used to connect a **mainframe computer** to other **computer**s on the network.

high res Abbreviation for **high resolution**.

high resolution In general, high resolution is relative to the **resolution** of the final **delivery format**. 1. The high number of **dots per inch (DPI)** required to produce a **high-resolution image** on a **computer display**. 2. An **object** containing a high **level of detail (LOD)**, and as a result, a high amount of **geometry**. Opposite of **low resolution**. See **high-resolution object**.

high-resolution data See **high-resolution geometry**.

high-resolution geometry A **3D object** that contains a high degree of detail that is typically the **object** that will be sent to the **renderer**. However, **low-resolution geometry** is often used by the **user** as a means of getting faster interaction with the **computer**. The low-resolution object is then replaced by the high-resolution object before sending the **scene** to be **render**ed. See also **geometry replacement**.

high-resolution image Generally referring to a **digital image** whose **resolution** is high enough to be output to **film** and maintain a high level of quality. However, most **digital work** begins with **low-resolution image**s because they are much faster to compute, and, as a result, more iterations can be accomplished before beginning work with the high-resolution images.

high-resolution object See **high-resolution geometry**.

high-resolution monitor See **High Definition monitor (HD monitor)**.

high-resolution television See **High Definition television (HDTV)**.

high shot Shorthand for **high-angle shot**.

high speed 1. See **high-speed photography**. 2. See **high-speed film**.

high-speed camera Any **camera** capable of **filming** at a rate greater than the normal speed of 24 **frames per second (FPS)**. See **low-speed camera**.

high-speed film A **film stock** with a high **ASA rating** that is more sensitive to **light** than a **slow-speed film**. Also called **fast film**, **fast-speed film**.

high-speed photography Any technique used to **film** a **scene** at a **frame rate** higher than 24 **frames per second (FPS)** so that the action will appear to be in **slow motion** when **project**ed at 24 FPS. For example, a scene shot as 48 FPS and projected at 24 FPS will appear to move at half its original speed as each **frame** is **display**ed for twice the length of its original **exposure**. Also referred to as **overcrank**. Opposite of **slow-speed photography**.

high tech See **high technology**.

high technology Referring to the latest greatest developments in technology.

hinge A **joint** that can **rotate** along only two **axes**.

HIPPI Abbreviation for **high performance parallel interface (HIPPI)**.

HIPPI network See **high performance parallel interface (HIPPI)**.

hirez Slang abbreviation for **high resolution**.

hiss Background noise interference during **sound track** recording.

histogram 1. A **graphical representation** used to **display** the **distribution** and **frequency** of particular characteristics in the **pixel**s of an **image**. Histograms are a valuable way to determine if an image has been artificially modified or if some of its original **data** has been lost. For example, many **color correction** operators will create an image with a reduced distribution of **color**s, which will produce noticeable gaps of information in an otherwise normally distributed histogram. Also, if the histogram of an image is sharply cut off at the top of the **frame**, this would indicate that some data has been lost. *See also Color Plate 16*. 2. An **image operation** that stretches the range of **value**s in an image to make the best possible fit between 0 and 1.

histogram sliding An **image process** in which a **value** is added or subtracted to every **pixel** in an **image**.

histogram stretching An **image process** in which every **pixel** in an **image** is multiplied by a **value**.

history The list of **command**s recently **execute**d by each **user**. Many **software package**s automatically save a record of all the **operation**s called to perform a particular task. A history file is simply a **text file** that can be used as a reference in writing **shell script**s and **batch file**s for **procedural modeling** and **procedural animation**.

history file See **history**.

hither See **near clipping plane**.

hither clipping plane See **near clipping plane**.

HLS See **HLS color space**.

HLS correction A **compositing operation** that modifies an **image** based on **hue**, **luminance**, and **saturation**.

HLS color space Abbreviation for the **color space** of **hue**, **luminance**, and **saturation**. More commonly referred to as **HSL**.

HMI See **HMI lights**.

HMI lights **Light**s that are balanced to produce a **color temperature** that is equivalent to natural daylight. The letters HMI stand for both Halogen Metal Incandescence or Hydragyrum (mercury), medium arc length, and iodide. Also called **daylight light source**s.

hold Another term for **freeze**.

hold frame See **freeze frame**.

hold out See **hold out matte**.

hold out matte A **matte** used to prevent the **foreground element** from obscuring an **element** in the **background plate** that it should be behind.

home See **home directory**.

home account See **home directory**.

home computer A **personal computer (PC)** configured for use in the home rather than in an office as part of a **network**.

home directory The **directory** in which a **user** is placed after each **login** and where all the users **dot file**s and personal **data** are stored.

home page The **HTML** document intended as the welcome page to visitors accessing a particular **Web site**. See also **Web page**, **Web browser**.

hookup See **loop** — definition #4.

horizontal 1. Referring to the **width** of an **image**. 2. Referring to the **X-axis**.

horizontal angle The angle from a particular **point of view (POV)** to the **object** it is oriented toward along the **horizontal axis**. For example, in **set surveying**, the horizontal angle needs to be calculated from the position of the **Total Station** to the **point** that is being surveyed. See also **vertical angle**.

horizontal axis Another name for the **X-axis**.

horizontal blanking See **horizontal blanking interval**.

horizontal blanking interval The period of time in a **video signal** between the completion of **scanning** one **scan line** and the start of the next. See also **vertical blanking interval**.

horizontal field of view The number of **degrees** representing the **horizontal** area that can be viewed through the **camera lens**. Opposite of **vertical field of view**.

horizontal grad Abbreviation for **horizontal gradation**.

horizontal gradation A type of **gradient** that **interpolates colors** from the left to right **edges** of the **frame**. Also called a **ramp, horizontal ramp**. See also **vertical gradation, four-corner gradation, radial gradation**, *and image below*.

horizontal interval See **horizontal blanking**.

horizontal plane A **plane** that is parallel with the **horizontal axis**. Opposite of **vertical plane**.

A horizontal gradation.

horizontal ramp See **horizontal gradation**.

horizontal refresh rate (H-rate) The rate at which **scan line**s are drawn when the **image** being **display**ed on a **CRT monitor** is redrawn. See also **vertical refresh rate**, **refresh rate**.

horizontal resolution 1. The number of **pixel**s making up the **width** of an **image**. Also referred to as **X resolution**. See also **vertical resolution**. 2. The number of **scan line**s in a television **screen**.

horizontal scan rate The number of **scan line**s that can be **display**ed per second on a **computer display**.

host See **host computer**.

host computer A **computer** connected to a **network** that provides **data** and services to other computers.

hostname 1. The unique name given to a **computer** for identification on a **network**. 2. See **Internet address**.

hostname alias An optional alternate **hostname** for a **host** on the **network**.

hot A term used to describe an **image** that is too bright. See also **cool** and **warm**.

hot key A **keyboard** shortcut to a **command** or **tool** without accessing it through a **menu**. For example, the **menu selection**s required to switch the **camera view** to an **orthographic camera** of a particular **object** could simply be assigned to the "F1" key. Also called **keyboard shortcut**, **accelerator**.

hot set A **set** on which a **scene** is still in the process of being **film**ed. The term *hot set* is used to indicate that nothing on the set should be changed or moved in between **take**s.

hot splice A method of attaching two separate strips of **film** end to end with cement to form a single strip of film. The cement is rapidly dried with the use of a **hot splicer**.

hot splicer The **film splice** device that uses metal plates heated by electricity to quickly dry cement used two **splice** to pieces of **film** together.

hot spot See **specular**.

hot swap To remove or replace a component of a **computer** while the power is on and the **system** is still operating. Opposite of **cold swap**.

Houdini A **3D animation package**, developed by Side Effects Software, that makes use of a variety of **procedural animation** techniques. It is the next generation of **Prisms** software.

house See **facility**.

house black See **black burst**.

house lights 1. The standard **printing lights** used by a **lab** to **print** your film without any **color correction**. Synonymous with **one light**. 2. On a **stage**, the overhead **lights** used during **set** construction and **scene** setup.

house reference See **black burst**.

house sync See **black burst**.

H-rate See **horizontal refresh rate**.

HSB See **HSB color space**.

HSB correction A **color correction** that modifies an **image** in the **HSB color space** based on the **values** of **hue**, **saturation**, and **brightness**.

HSB color space Abbreviation for the **color space** of **hue**, **saturation**, and **brightness**. HSB is similar to **HSV** except that brightness describes the overall lightness or darkness of the **color** instead of **value**.

HSI See **HSI color space**.

HSI color space Abbreviation for the **color space** of **hue**, **saturation**, and **intensity**.

HSL See **HSL color space**.

HSL correction A **color correction** that modifies an **image** in the **HSL color space** based on the **values** of **hue**, **saturation**, and **luminance**.

HSL color space Abbreviation for the **color space** of **hue**, **saturation**, and **luminance**. HSL is similar to **HSV** except that luminance describes the overall lightness or darkness of the **color** instead of **value**. Sometimes called **HLS**.

H-spline See **Hermite spline**.

HSV Abbreviation for the **color space** of **hue**, **saturation**, and **value**.

HSV color space The **color space** representing **hue**, **saturation**, and **value**. Hue describes the specific **color** (**red (R)**, **green (G)**, **blue (B)**); saturation describes the amount of **white** mixed with the color (red vs pink); and value describes the overall lightness or darkness of the color (dark blue vs light blue). Generally, the HSV color space is not used to store **images** but rather for **color correction** within a **composite**. For example, adjusting the saturation of a color by modifying the **RBG channels** can be

very awkward, but with the HSV color space, the saturation value can be directly adjusted. See also **HSL color space**.

HSV correction A **color correction** that modifies an **image** in the **HSV color space** based on the **value**s of **hue**, **saturation**, and **value**.

HTTP Abbreviation for **hypertext transfer protocol (HTTP)**.

HTML Abbreviation for **hypertext markup language (HTML)**.

HTML document Any document written in **hypertext markup language (HTML)**.

hub **Hardware** that is used to **network** a group of **computer**s together, generally across an **ethernet** connection. A hub serves as the central location where information can flow from one computer to another.

hue Hue is the attribute used to class such **color**s as **red (R)**, **blue (B)**, **green (G)**, **yellow**, and so on. However, the term *hue* should not be confused with color. The distinction is that variations within a particular hue can create a wide range of colors. For example, a blue hue can be composed of such colors as light blue, dark blue, dull blue, and hot blue. The six basic hues are composed of the **primary hues**, red, green, and blue, and the **secondary hues**, orange, green, and purple. See also **saturation**, **luminance**, **color wheel**.

hue circle See **color wheel**.

hue correction A **color correction** that modifies the **color** of an **image** by modifying its **hue**.

hue shift See **hue correct**.

hue wheel See **color wheel**.

Huffman coding A **lossless image compression** technique. See also **image compression**, **LZW compression**.

hull The dotted straight **line**s that connect the **control point**s defining a **spline curve**.

hung See **lockup**.

HWB See **HWB color space**.

HWB color space The **color space** representing **hue**, **whiteness**, and **blackness**. Hue describes the specific **color (red (R)**, **green (G)**, **blue (B))**; whiteness is used to brighten the hue by adding **white**; and blackness is used to darken the hue by adding **black**.

hybrid The combination of two different technologies or **system**s.

hyperboloid A **quadric surface** defined by a 360-degree **sweep** of a **line segment** around the **axis of rotation**. See also **primitive object**.

hyperfocal distance The hyperfocal distance of a **lens** is a type of **depth of field (DOF)** in which the closest **object**s and objects at infinity both can be photographed with an acceptable **sharpness**. This distance is determined by the **focal length** and **f-stop** of the lens. If the **focus** of the lens is set to the hyperfocal distance, then objects from one-half the distance to infinity will be in focus.

hyperlink See **hypertext link**.

hypertext Any **text** in an **HTML document** that contains **hypertext link**s.

hypertext link A link in an **HTML document** that leads to another **Web site** or to another page within the same document. Also referred to as a **link**, **pointer**, or **hyperlink**. The displayed text **color** of hypertext links is usually a different color than the rest of the text on the page, such as blue or purple, and is used to indicate to the **user** viewing the page that **click**ing on this text will lead them to another Web page.

hypertext markup language (HTML) The standard language used to format **document**s for use on the **World Wide Web (WWW)**. **Hypertext** documents use **tags** that are imbedded into the text.

hypertext transfer protocol (HTTP) The **protocol** written by Tim Berners-Lee that allows communication between different **Web browser**s and **server**s to take place.

HZ See **hertz (HZ)**.

IAP Abbreviation for **Internet Access Provider (IAP)**. See **Internet Service Provider (ISP)**.

IATSE Abbreviation for **International Alliance of Theatrical and Stage Employees (IATSE)**.

IBM clone See **PC clone**.

IBM compatible See **PC clone**.

IBM, Corp. Abbreviation for **International Business Machines Corporation**, the world's largest computer company.

IBM PC Abbreviation for **IBM Personal Computer**.

IBM Personal Computer (IBM PC) A widely used family of **personal computer**s (**PC**s) developed by **IBM, Corp.** Most **PC clone**s conform to the standards defined by the IBM PC.

ICC Abbreviation for **International Color Consortium (ICC)**.

Ice The **compositing** program contained with **Houdini** software.

icon A small **image** that is used to represent a specific **file**, **window**, **command**, or **program**. When a window is **stowe**d, the icon is used for easy identification when the **user** wants to **open** it again.

iconified An **image** or **window** on the **computer screen** that is not **open** and cannot be worked within.

iconify To **stow** an **image** or **window** into an **icon** until it is reopened again.

icon catalog A **window** that shows the various **application**s and **tool**s, represented by **icon**s, that are available on a **computer**.

identity matrix The **transformation matrix** that is automatically applied to an **object** when it is created and before it has been **transform**ed. Most often, this value consists of the following **transformation**s: **translate**

(0, 0, 0), **rotate** (0, 0, 0), and **scale** (1, 1, 1). If you remove all the transformations applied to a given object, it will return to the original values contained in its identity matrix.

idiot card See **cue card**.

idle time The period of time during which a **computer** is operational but not in use.

IFD Abbreviation for **instantaneous frame description (IFD)**.

if/then/else loop A **conditional statement** used in **programming** that defines the conditions under which certain events can take place. "If something is true, then do this, but if it is not true, then do this instead." See also **while loop**, **for loop**.

IGES Abbreviation for **initial graphics exchange specification (IGES)**.

IK Abbreviation for **inverse kinematics (IK)**.

IK chain Abbreviation for **inverse kinematics chain (IK chain)**. See **inverse kinematics skeleton (IK skeleton)**.

IK handle In **inverse kinematics (IK)**, the **handle** that solves the **joint rotation**s up the **chain**, based on the position of the **end joint**.

IK skeleton Abbreviation for **inverse kinematics skeleton (IK skeleton)**.

IK structure Abbreviation for **inverse kinematics structure (IK structure)**. See **inverse kinematics skeleton (IK skeleton)**.

illegal polygon A **polygon** that cannot **render** correctly due to errors such as multiple **point**s in the same location in **3D space**, a polygon made up of only one or two points, and polygons that cross over or turn in on themselves. Also called a **degenerate polygon**. Opposite of **legal polygon**. See also **concave polygon**, **convex polygon**. *See image under concave polygon.*

Illustrator See **Adobe Illustrator**.

image 1. In the computer, see **digital image**. 2. The area **capture**d by the **camera** on **film**. 3. A single **frame** from a strip of film. Also referred to as **picture**.

image area Referring to the area of the **action** that was **capture**d by the **camera**.

image artifact An undesirable side effect in an **image** usually caused by an **image process** used to create or modify that image. See also **motion artifact**.

image aspect ratio The **ratio** of **width** to **height** of an **image**. See **aspect ratio**.

image averaging See **grain averaging**.

image balance See **scene balance**.

image based modeling and rendering (IMBR) A loose term referring to techniques used to generate **image**s from **source image**s rather than from **geometric primitive**s. Because it is extremely difficult to produce photoreal images from **3D model**s, IMBR attempts to address this problem by rearranging the **pixel**s of real-world photographs to produce new images from different **camera viewpoint**s. See also **photogrammetry**.

image capture To record an **image**. See **snapshot**, **frame grab**.

image channels The individual **component**s of an **image** defined by its **red (R)**, **green (G)**, **blue (B)**, and **alpha channel**s. See **channel** and *Color Plate 14*.

image composition Good image composition is the arrangement of all the forms that make up a **scene** to convey the desired mood, character and atmosphere as a unified whole. Also referred to as **scene composition**, **shot composition**. See also **image balance**.

image compression The type of **filter**ing used to **compress** an **image** by throwing away redundant or unwanted **data**. **Lossless image compression** maintains the quality and detail of the original image, whereas **lossy image compression** results in **image degradation**.

image conversion The process of converting an **image** from one **image format** and/or **color space** to another.

image crop See **crop**.

image degradation A global term describing any loss of **image** quality due to its **bit depth**, **image processing**, or **generation loss** due to excessive **dub**s.

image distortion A term used to describe the streaking and stretching effects that can appear in an **image** applied to a **surface** resulting from various **texture mapping** techniques.

image encoding Any **image process** that applies a **color correction** to the **source image** that reproduces a resulting image that can be stored in a different **color space**. Also called **image remapping**. See **linear encoding, nonlinear encoding, linear color space, nonlinear color space**, *and images on following page.*

Linear mapping of 16 colors to 8 colors.

IMAGE PROVIDED COURTESY OF RON BRINKMANN AND *THE ART AND SCIENCE OF DIGITAL COMPOSITING.*

Nonlinear mapping of 16 colors to 8 colors.

IMAGE PROVIDED COURTESY OF RON BRINKMANN AND *THE ART AND SCIENCE OF DIGITAL COMPOSITING.*

image enhancement A global term used to describe any technique used to improve the visual quality of an **image**, such as its **sharpness**, **contrast**, or **color**.

image extraction Referring to the actual size and **aspect ratio** of the **image area** used in the final **viewing format** for a series of **image**s. See also **film extraction**.

image file format See **image format**.

image filename extension See **filename extension**.

image filter Any **image processing** technique, such as **blur**, **sharpen**, or **transformation**s, that **sample**s the **pixel**s of an **image** to determine the new resulting image. For example, during a **resize**, each pixel is modified based on information about its neighboring pixels to determine the **sharpness** of the resized image.

image format The specific standard **format** that a series of **digital image**s are stored in, such as **TIFF**, **GIF**, **JPEG**, **RBG**, **SGI**, **Cineon**, and **RLA**. Each of these formats is associated with a standard **filename extension** that is typically three letters long and is appended following the final decimal point of the **filename**. There are many **image conversion** tools that can convert images from one **file format** to another.

image input device A **device** that can **scan** or **digitize image**s that were created by **nondigital** methods. **Video image**s from a **video camera** can be passed through an **encoder** to create digital images, whereas inputting images originating from **film** require a **film scanner** to bring the data **online**. Some companies use **3rd-party**, **off-the-shelf** scanners, whereas others still opt to write their own custom **proprietary** systems.

image interpolation An **image process** that derives new **image data** based on the existing **data**. Common image **interpolation**s include **linear interpolation**, **bilinear interpolation**, and **bicubic interpolation**. See also **frame averaging**, **Cinespeed**.

image mapping See **texture mapping**.

image morph See **2D morph**.

image operation See **image process**.

image operator See **image process**.

image plane 1. In **3D package**s, an **image** that is placed as a backdrop onto the **camera** so that as the camera moves, the **plane** will stay aligned. 2. See **bitplane**.

Some common **image processing** techniques.

image process Any process or tool that manipulates the **input image** to create a resulting **output image**. Also called **image operator**, **image operation**.

image processing The manipulation of **element**s using a **computer**. It includes, but is not limited to, **color correction**, **image warp**ing, **morph**ing, **painting**, and so forth. Simply, it refers to any technique used to process an **image** in order to isolate, remove, alter, enhance, or add to an image. *See also image under **emboss**, and image above.*

image processing software Another term for **compositing software**.

image proxy A **low-resolution image** that is used as a **stand-in** for the original **high-resolution image**. The idea is to increase speed and interactivity while working on the **composite**. Most **compositing package**s will automatically **scale up** or **scale down** all the **curve**s and **function**s relative to the **proxy scale** set for each particular **element**.

image quality Referring to the **resolution, sharpness**, and **generation** of a series of **image**s.

image quantization See **quantizing**.

image remapping See **image encoding**.

image resolution The number of **pixel**s making up the **horizontal** and **vertical** dimensions of a **digital image**. Also referred to as **spatial resolution**. Image resolution can also refer to its **bit depth**.

image restoration The process of restoring **film**s with the use of **digital** methods ranging from hand work to automated **image processing** techniques. While **analog** methods can make good copies of existing **element**s, digital tools can remove dirt, scratches, and grain while still retaining the original **image sharpness**.

image rotation The **orientation** of an **image** around its center along the **XYZ axes**.

image safe See **safe action**.

image scale To change the size of an **image** along the **X-** and **Y-axes** to modify its **height** and **width**.

image sharpness Referring to the **focus** and clarity of detail in an **image**.

image size 1. The size of the area filmed by the **camera**. 2. The size of a **digital image** stored on **disk**, in terms of **height** and **width** or its total number of **megabyte**s (**MB**).

image stabilization A **2D tracking** technique in which the unwanted **jitter** in a series of **image**s is removed. The stabilization process works by **tracking** a feature in the images that is believed to be **stable** and unmoving. By tracking this stable point, a **curve** can be derived that shows the amount of actual **plate** motion for each **frame** in the **sequence**. By inverting this curve and applying it back to the **unstable** plate that was just tracked, the plate is moved in the opposite direction of the original **motion** it contained in each frame. This technique subtracts the plate's unstable motion from itself and produces a plate that no longer moves relative to itself. See also **3D tracking**.

image storage See **digital image storage**.

image transformation Referring to adding a **camera move** to a **plate** via any number of **compositing** techniques, such as **translate**, **rotate**, and **scale**. Often referred to as a **post-move**.

image transition Any effect used to transition one **image** into another. Common techniques include a **cross dissolve**, **fade in**, **fade out**, **morph**, and **swish pan**.

image translation To move an **image** to a new location along the **XYZ axes**.

image toolkit The set of **image processing** tools that come with most **software package**s that are designed to manipulate and process **image**s.

image warp An **image process** that bends or **distort**s an **image** based on the positioning of **point**s in a series of **spline-based** grids. In many cases, warping is used to **transform** one image into another. See also **2D morph**.

Imagica film scanner A high-resolution **film scanner**, manufactured by Imagica, Corp., that offers high-speed multiple **resolution** and pin registered **step scanning** for various **film format**s using a trilinear (a three-**color**, single **exposure** per **frame**) line **array** of **CCD** image sensors. The Imagica scanner also features interchangeable, custom-built, digitally controlled **16mm** and **35mm** sprocket style movements. This type of film handling permits gentle **film** transport at high speed when seeking a specific position on the **roll** being **scan**ned. See also **Cineon Genesis film scanner**, **Oxberry film scanner**.

IMAX A **widescreen** system that uses **65mm film** running horizontally through the **camera** to **capture** an area spanning across 15 **perforation**s. The **image** area captured is more than ten times greater than a **standard** **35mm** frame and three times larger than a standard 65mm frame. Unlike, **Omnimax**, IMAX is projected onto a large, curved **screen**. Imax images are **project**ed on **70mm film**.

IMBR Abbreviation for **Image-Based Modeling and Rendering (IMBR)**.

implicit surface Another name for **blobbies** or **metaball**.

import The ability to **read** a **file** into an **application** that was written out by another application. See **export**.

impulse blur See **impulse filter**.

impulse filter A low-quality, high-speed **filtering algorithm** used to **resample** an **image**. The impulse filter samples only a single **pixel** in the **input image** to determine the **value** of the corresponding pixel in the **output image**. Also called **dirac filter**, **nearest-neighbor filter**. See also **box filter**, **Gaussian filter**, **Mitchell filter**, **Sinc filter**, **triangle filter**.

IN 1. For **compositing**, see **inside operation**. 2. Abbreviation for **intermediate negative (IN)**. See **internegative (IN)**.

inactive See **disable**d.

in between The **frame**s that are created either by hand drawing for **cel animation** or by **interpolation**s for **computer animation** that make up the frames "in between" the **key frame**s set for that **animation**.

In-Betweener In **cel animation**, the artist that hand draws the **frame**s that fall **in between** the **key frame**s drawn by the **Animator**.

in betweening 1. For **computer graphics (CG)**, the **interpolate**d calculations that create **value**s between the **key frame**s of an **animate**d sequence. 2. For **traditional animation**, the process of drawing the **frame**s in between the key frames drawn by the **Animator**.

inbox The area where received **electronic mail message**s (**e-mail message**s) are stored for a **user** to **read**.

in camera See **in camera effect**.

in camera compositing Another term for **in camera effect**.

in camera effect Any **special effects (SFX)** achieved using single or **multiple pass**es through a **camera** without needing any additional **post production** work to complete the **shot**. See **Dynamation, front projection (FP), rear projection (RP)**.

in camera matte shot A **compositing** technique combining two or more **image** components into a single integrated image by placing glass, painted black in the appropriate areas, in front of the **camera lens** to block **light** to that part of the **frame**. An advantage of this technique over the **second-generation** negative resulting from **optical compositing** is that it creates a **first-generation** negative composite. See also **digital compositing**.

incandescence The generation of **light** created by high temperatures. See also **luminescence, color temperature**.

incident cone The area within a cone in which a **light source** can contribute to a **reflection**.

incident light The **light** falling on a **subject** from all **light source**s in the **scene**, as opposed to the light reflected off the subject, which is known as the **reflected light**. See **incident light meter**.

incident light meter A **device** used to measure the amount of **light** falling on a **subject** from all **light source**s in a **scene**. Contrast with **reflected light meter**. Also called **incident meter**.

incident meter See **incident light meter**.

incident vector The **vector** representing the direction from the **viewpoint** to a **point** on a **surface**.

incompatible Any configurations of **hardware** and **software** that cannot work together. Opposite of **compatible**.

increment See **step**.

incremental backup To **backup** only the **file**s that have changed since the last **backup**, rather than backing up every file.

index See **color index**.

indexed color An **image**-storing scheme in which the **pixel value**s refer to a table of available **color**s instead of a unique numerical representation of the individual color. See also **lookup table (LUT)**.

index of refraction See **refractive index**.

indirect lighting **Light** that is **reflect**ed or bounced off **object**s in a **scene**. Contrast with **direct lighting**. See also **reflected light**.

industry standard A widely accepted and commonly used **procedure, operating system (OS)**, **software**, **hardware**, **file format**, and so forth that is used throughout the **visual effects (VFX)** industry. **Photoshop** is an example of a **paint package** that is considered an industry standard.

Inferno A powerful **2D software package** developed and sold by **Discreet Logic**. Inferno is the top of the line product offered by Discreet. It contains all the functionality of the **Flame** and can also handle 4K **image**s and 8 or **12 bits per channel**. See also **Flame, Flint, Smoke**.

infile Abbreviation for **input file**.

infinite light See **directional light**.

infinity The farthest distance from the **lens** that appears in **focus**.

influence See **weight** — Definition #3.

in focus Any **image** that appears **sharp** and well defined during viewing. Opposite of **out of focus**.

Information Technology (IT) 1. The technology utilized in the **process**ing and management of **data**. 2. The department in a **facility** that manages the **data** that resides on the **system**.

infrared A type of red light that is immediately adjacent to the **visible spectrum** and is not invisible to the human eye. See also **ultraviolet (UV)**, **visible spectrum, black light**.

initial graphics exchange specification (IGES) A standard **spline-based** format used to define **geometry**.

initialize See **disk formatting**.

initial velocity A **variable**, often used in **particle animation**, that controls the starting speed of an **object**. See also **velocity**, **particle emitter**, **particle life**, **particle age**.

initiator For **L-system**s, the initiator is the **source object** in which each of its straight **line**s are broken in a pattern, called the **generator**, over and over again in a process known as **recursion**. See also **Koch island**.

ink and paint A stage in **cel animation** when the hand-drawn outlines of the **scene** are filled in with the proper **color**s.

in operation See **inside operation**.

in point The starting point of an **edit**. Opposite of **out point**.

input Information put into a **computer** or **peripheral device** for **transmission** or **processing**. Opposite of **output**. When the **data** is input via a **keyboard**, it is also referred to as **key in**.

input address The **location** of **data** that is being **read** from **disk**. See **output address**.

input connector The connecting line that feeds the **output** from a **source node** into the **input** of the **current node**. Opposite of **output connector**.

input device 1. Any **peripheral device** used to enter information into a **computer**, such as a **mouse**, **modem**, **scanner**, or **keyboard**. 2. For **image**s, see **image input device**. 3. For **physical model**s, see **digitizer**—Definition #2. See **output device**.

input directory The **directory** to which **data** is **read** from. Opposite of **output directory**.

input element See **input image**.

input field See **menu field**.

input file The **file** fed into a **program** or **software application**. Opposite of **output file**. Also called **source file**.

input image The **source image** read into a **software package** for reference or, more often, to perform **image processing** techniques on it. See **output image**.

input node A **node** that serves as the **source node** to drive the results of an **output node**.

input/output (I/O) Abbreviation for **input/output**. A general term used to describe the **upload**ing and **download**ing of **data** and **image**s between **computer**s and **peripheral device**s.

input/output address (I/O address) The unique **address** assigned to a **peripheral device** for **input** and **output**.

input/output device (I/O device) Any **peripheral device** used to transfer **data** into or out of a **computer**.

input pixel values The **pixel values** used as the **input** to an **image process** that then modifies them to create new **output pixel values**. See **blur filter, sharpen filter, convolution filter, resize**.

input resolution The **image resolution** of the **source image**s fed into a **software application**. See **output resolution**.

insert 1. See **insert shot**. 2. See **insert edit**.

insert edit An **editing** process in which **shot**s that are inserted into material already recorded on **videotape** do not alter the existing **control track**.

insert shot Full screen **close-up**s (**CU**s) of any important details in a **scene** are referred to as insert shots. These are generally filmed by the **Second Unit**.

insert stage A location where **insert shot**s are **film**ed.

insert titles **Titles** that are intercut with a **scene**. Also called **intertitle**s.

inside operation A **compositing operation** that retains only the portion of the **foreground image** that fits inside the **alpha channel** of the **background image**. Opposite of **outside operation**. *See also image under **layering operation**, and image on following page.*

install The process of configuring new **hardware** and/or **software** to work on a **computer**. This job is generally performed by the **System Administrator**s. Opposite of **uninstall**.

instance To create a new **transformation matrix** relative to an original **source object**. See **instancing**.

instanced object An **object** that has been **instance**d from a **retained model**. See **instancing**.

instancing A method of handling large numbers of the same **source object** within a **scene** without actually duplicating any **geometry**. When a source object is used to create instances of itself, a **transformation matrix** is cre-

A Inside B

ated for each new **instanced object** that positions them in space relative to the **position** of the original source **object** they are pointing back to. Because each instanced object points back to the original source object, any changes made to that source object are automatically reflected onto all of its instances. This allows for faster **model** changes and reduced **storage space**. For example, to model a spiral staircase, you would need to model only one step that could then be instanced to create all the other steps, each with a **Y** offset and **Y rotation** in its transformation matrix, to create the desired spiral.

instantaneous frame description (IFD) An **ASCII** description of a **scene** for a particular **frame** that contains all the **geometry** and **object attributes** needed to send to the **renderer**. See also **Renderman interface bytestream (RIB)**.

instantiation See **instancing**.

in sync Referring to two **image**s or an image and a **sound track** that are placed in the same **temporal** relationship on a **release print**, **videotape**, or **movie file**. Opposite of **out of sync**.

INT Abbreviation for **interior (INT)**. See **interior shot**.

integer Synonymous with **whole number**.

integrated circuit Fancy name for a **computer chip**.

integrated matte channel Referring to an **image** whose **alpha channel** is included with the **RGB channels**. Such an image is called a **4-channel image** or an **RBGA image**.

Intel 1. See **Intel, Corp.** 2. See **Intel microprocessor**.

Intel, Corp. A company widely known for its development of **microprocessor**s, such as **Intel** and **Pentium**.

Intel microprocessor A widely used **microprocessor** used in **PC**s.

intensity 1. The magnitude of energy with which a distributed force operates or acts, as estimated by the results produced. For example, the effect that **light**s placed in a **scene** have on the surrounding **environment** is dependent on the strength of the light that they produce. 2. The **chromatic purity** of a **color**, particularly to the degree that it lacks **white**. See also **saturation**, **chrominance**. 3. The strength or volume of **sound**.

interactive Work done on a **computer** using a **graphical user interface (GUI)** that allows the **user** to quickly get visual feedback resulting from their **input**.

interactive lighting **Lighting** in a **scene** that changes over time and responds to the activity within the **environment**.

interactive mode The mode in a **software package** that gives fast visual feedback to the explicit instructions and **command**s input by the **user**. Opposite of **command line mode**.

interactive processing The ability of the **computer** to **process** instructions at the same time the **user** is **input**ting instructions. Opposite of **batch processing**.

interactive session The period of time in which the **user** communicates with the **computer**.

inter-cut Another name for **cross-cut**.

inter-cutting Another name for **cross-cutting**.

interdupe Abbreviation for **intermediate duplicate**. See **internegative (IN)**.

interduplicate Abbreviation for **intermediate duplicate**. See **internegative (IN)**.

interface 1. See **user interface**. 2. See **interface elements**. 3. The process of making various **computer** components and/or **peripheral**s work together.

interface elements A generalized term referring to all the various controls available in a **graphical user interface (GUI)**, such as **button**s, **pop-up menu**s, **pulldown menu**s, **slider bar**s, **edit field**s, **icon**s, **window**s. Also called **gadget**s, **widget**s, **graphical element**s.

interframe coding The technique used in **MPEG** encoding, in which intermediate **image**s in a **sequence** are defined by their offset from specific **key frame**s.

interior (INT) See **interior shot**.

interior shot A **shot** in which the **action** is filmed indoors. Opposite of **exterior shot**.

interlace 1. An **image operation** that creates a new **image** by using alternating even and odd **scan line**s from two **source image**s. Opposite of **deinterlace**. 2. A complete **frame** of **video** composed by two **field**s made up of alternating even and odd lines. An alternate line is **scan**ned approximately every 1/60 of a second in **NTSC**.

intermediate General term used for **film**, other than the **original negative (o-neg)**, that is used as the source for **duplicate** copies. Intermediate **film stock**s have very fine **grain structure**s in order to not add **grain** during the **duplication** process. Examples of intermediates include an **interpositive (IP)** (also called a **master positive**), an **internegative (IN)** made from an interpositive (also called a **dupe negative** or **interdupe**), or an internegative printed directly from the original negative using **reversal processing**.

intermediate duplicate Synonymous with **internegative (IN)**.

intermediate negative (IN) A fancy way of saying **internegative (IN)**.

intermediate positive (IP) A fancy way of saying **interpositive (IP)**.

Intern An unpaid **Production Assistant (PA)** that is in most cases receiving college credit toward his/her degree.

internal accuracy The ability of a **software package** to create and process **image**s of different **bit depth**s. For example, some packages might support both **8** and **16 bits per channel** as well as **floating point** values in **pixel**s falling outside the range of 0 to 1.

internal bus A **bus** that connects **component**s in the **computer** that are very close to each other, such as its **main memory** and the **central processing unit (CPU)**.

internal cache See **memory cache**.

internal drive A **drive** located inside the **computer**. Opposite of **external drive**.

internal modem A **modem** located inside the **computer**. Opposite of **external modem**.

International Alliance of Theatrical and Stage Employees (IATSE) The parent organization representing the local unions for various **production** branches across North America.

International Animation Association (ASIFA) An organization founded in 1960 in France that encourages the dissemination of **animation** in **film** as an art form. The abbreviation ASIFA comes from its French name "Association Internationale du Film D'Animation."

International Color Consortium (ICC) The organization established for the purpose of standardizing **color management** across different **platform**s.

International Standards Organization (ISO) An organization responsible for creating international standards in many areas, including **computer**s and communications. ISO is also responsible for setting the standards of the **ISO index** for **film**. **ANSI** is the American division.

interneg (IN) Abbreviation for **intermediate negative (IN)**. See **internegative (IN)**.

internegative (IN) Short for **intermediate negative**, a copy made from the **interpositive (IP)** through **printing** and **developing** or from the **original negative (o-neg)** by printing using the **reversal process**. There are many synonyms for internegative, including **intermediate duplicate**, **duplicate negative**, **dupe**, **dupe neg**, **dupe negative**, **interneg**, **duplicate**, **interdupe**, **IN**.

internet A **network** of **computer**s that enables the transmission and exchange of **data** between **user**s around the world. Also called **cyberspace**.

Internet The Internet is the world's largest **internet** that originated in 1969 as a US Department of Defense research test bed.

Internet access To be able to access the **Internet** through a **dialup account** or a direct connection.

Internet Access Provider (IAP) See **Internet Service Provider (ISP)**.

Internet account An account with an **Internet Service Provider (ISP)** that allows **Internet access**.

Internet address 1. A unique **address** used to identify an individual or organization on the **sitename** and "com" is the **domain name**. 2. See **Internet Protocol address (IP address)**.

Internet Protocol (IP) The method used to route **data** between **computer**s on the **Internet**. See **Internet Protocol address (IP address)**, **TCP/IP**.

Internet Protocol address (IP address) The **address** used by the **domain name system** to translate into a **domain name**.

Internet Service Provider (ISP) A company that provides **user**s with a connection to the **Internet**. An ISP usually charges a monthly fee that gives users **Internet access** and the ability to send and receive **e-mail**. Widely used Internet service providers include America Online and CompuServe. Also called **Internet Access Provider (IAP)**.

Internet site See **Web site**.

interocular 1. The distance between the eyes. In humans, the **interocular distance** between the eyes is an average of 2 to 2.5 inches. 2. The distance between the two **camera lens**es in a **stereo film**.

interocular distance The distance between two **stereo image**s or between the two **camera lens**es used to **capture** the **image**s in a **stereo film**. An **interocular** distance above 2.5 inches will increase the perceived **depth** or dimension of an **object**, whereas a decrease in the interocular will have the effect of lessening the dimension of an object. An increased interocular will also tend to shrink the apparent size of an object, and a decreased interocular will make the object appear larger.

interpolate See **interpolation**.

interpolate shading A **shading** technique in which a **surface** made up of **polygon**s is **render**ed to appear smooth. **Color**s calculated at the shared corners of the polygons are **interpolate**d across the interior of each polygon. See **Gouraud shading**.

interpolating spline A **spline** that passes through each of its **control point**s. A **Cardinal spline** is an example of an interpolating spline. An advantage of this type of spline is that the resulting **curve** bears a direct relationship to the **position** of each of its control points. However, a disadvantage also results from the fact that any misplaced control points can result in an imperfectly smoothed curve as the curve is required to pass directly through each of its control points. See **approximating spline**.

interpolation 1. A method of creating new **in-between** data, based on calculating intermediate **value**s with a series of surrounding **key frame**s or **control point**s. See **linear interpolation, bilinear interpolation, bicubic interpolation**. 2. The process of averaging **pixel** information when performing an **image process**. For example, when the size of an **image** is increased, additional pixels must be created by averaging the pixels of the original image, and when reducing the size of an image, the pixels need to be **average**d to create new pixels to represent the smaller **image size**.

interpos Abbreviation for **intermediate positive (IP)**. See **interpositive (IP)**.

interpositive (IP) Short for **intermediate positive (IP)**, a **positive print** made from the **original negative (o-neg)** for use in making **internegative**s **(IN)** that, in turn, are used as the source of **release print**s. Also called a **master positive, interpos**.

interpreter A **program** that **translate**s other programs into **machine language** for execution. It takes longer to **run** a program using an interpreter than to run **compiled code** because the interpreter must analyze each **line code** before performing the desired **action**, whereas the **compile**d code just performs the action.

interpretive language Any **programming language** that needs to be interpreted by the **computer**, such as **awk** and **sed**. **Program**s written in interpretive languages can only be **run** on computers where the required **interpreter** resides.

interpretive overhead The **code** analysis time used by an **interpreter** before executing the desired action.

intersection 1. To cross at a point. 2. See **intersection operation**.

intersection operation A **Boolean operation** that creates a new **object** based on the areas where two the **source object**s overlap. Also called the **AND operator**. See also **union operation, difference operation, exclusive operation**, *image under Boolean operations, and image on the following page.*

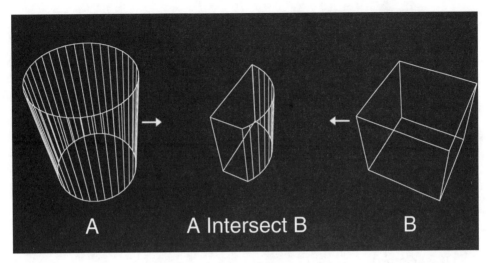

Boolean intersection operation.

intertitles See **insert titles**.

intranet A **local area network (LAN)** of **computer**s within an organization that may not be connected to the **Internet** but that provides some similar functions. Some companies set up **World Wide Web (WWW)** access on their own internal networks to allow employees access to the organization's internal **Web page**s. The biggest difference between an Intranet and the Internet is that an Intranet is private and accessible only to individuals within the company. See also **extranet**.

in the can 1. Referring to the **film** that was photographed and packaged up in a **film can** for delivery to the **lab** for **processing**. 2. The completion of a **project**. 3. The completion of a **scene** or **shot**. 4. When a **sequence** of **digital image**s have been sent to the **recorder** and are in a film can to go to the lab.

Inventor See **Open Inventor**.

inverse kinematics (IK) Inverse kinematics is an **animation** technique that calculates the flow of **transformation**s within a **hierarchical model** in an upward flow through the **hierarchy** rather than downward through the hierarchy. *Kinematics* refers to the mechanical study of **motion**, whereas *inverse* refers to the fact that the flow of transformations within the hierarchy are calculated in the opposite direction of the more "normal" calculations used in **forward kinematics (FK)**. Animation created with inverse kinematics behaves in a **chain**like manner, where each **joint** follows

the motion of the joint below it, and the entire hierarchy is referred to as the **skeleton chain** of the **model**. The individual **node**s that make up the structure of the hierarchy are referred to as the **link**s or **bone**s. Unlike forward kinematics, **inverse kinematics animation (IK animation)** makes it much easier to plant a **character**'s feet on the ground or to make the hand control the arm with the use of **end effector**s that allow you to position the chains. The first link in the chain is called the **root**, and each node in the chain has its own **pivot point** or **local origin** about which all its transformations occur. See also **constraints**, *Color Plate 38.*

inverse kinematics animation (IK animation) Any **animation** created with the use of **inverse kinematics (IK)**. Opposite of **forward kinematics animation (FK animation)**.

inverse kinematics chain (IK chain) See **inverse kinematics skeleton (IK skeleton)**.

inverse kinematics skeleton (IK skeleton) The **skeleton chain** used to **animate** a **character** with **inverse kinematics (IK)**. See also **forward kinematics skeleton (FK skeleton)**.

inverse kinematics structure (IK structure) See **inverse kinematics skeleton (IK skeleton)**.

invert 1. For **compositing**, see **invert operation**. 2. To **scale** an **image** or **object** by negative 1 along one of its **axes**. Also called **mirror**.

inverted matte Generally, referring to a **matte** in which the **foreground (FG)** area, or the area that we wish to **key**, is **black** (**female matte**), and the **background (BG)** area, or the area that we wish to remove, is **white** (**male matte**). It is the exact opposite of a "normal" matte in which the foreground portion is white and the background portion is black.

invert operation A **compositing operation** that inverts the **value** of each **pixel** in an **image** to produce the **negative** of that image. Every pixel is replaced by the value of that pixel when it is subtracted from one. **Color**s become their **complementary color**s, bright areas become dark, and dark areas become bright. Also called **negative operation**.

I/O Abbreviation for **input/output (I/O)**.

I/O address Abbreviation for **input/output address (I/O address)**.

I/O device Abbreviation for **input/output device (I/O device)**.

IP 1. Abbreviation for **intermediate positive (IP)**. See **interpositive (IP)**. 2. Abbreviation for **Internet Protocol (IP)**.

IP address The **address** used by the **domain name system (DNS)** to translate into a **domain name**. See **Internet Protocol address (IP Address)**.

iris The adjustable metal plates inside a **lens** that regulate the amount of **light** that is allowed to pass through. The size of the iris can be modified by adjusting the **f-stop** or **t-stop** setting on the **camera**. Also called a **diaphragm**.

IRIX The version of the **Unix Operating System (Unix OS)** developed by **Silicon Graphics, Inc.**

ISO Abbreviation for **International Standards Organization (ISO)**.

ISO index A standard numerical rating for specifying a film's **exposure index** or sensitivity to **light**, as determined by the **International Standards Organization (ISO)**. The ISO index incorporates both the American **ASA rating** and German **DIN rating**. Also called the **ISO rating**, **ISO speed**.

isometric Equality of measure.

isometric view See **orthographic view**.

isoparametric curve A **line** or **curve** containing constant **U** or **V** values across a **surface**. See **U curve**, **V curve**.

isoparm Abbreviation for **isoparametric curve**.

ISO rating See **ISO index**.

ISO speed See **ISO index**.

isosurface 1. A **surface** containing constant **U** or **V** values. 2. A **metaball** whose **density field** is equal to its **threshold** value.

isotropic Having properties that are the same regardless of the direction of measurement. Opposite of **anisotropic**.

ISP Abbreviation for **Internet Service Provider (ISP)**.

IT Abbreviation for **information technology (IT)**.

jaggies Slang for **aliasing**.

jam sync The process of synchronizing a secondary **time code generator**, such as the audio **time code**, to the **master time code**.

jargon The technical language used in a particular field, such as **visual effects (VFX)**! Also referred to as **technobabble**.

Java The trade name of a **programming language** designed to develop **applications** for use on the **Internet**. Java applications are usually **portable** between different **operating system**s **(OS)**. Java uses a **C-like syntax**.

Java applet A little **application** written in **Java**. Java applets are commonly used for documents on the **World Wide Web (WWW)**.

Jaz See **Jaz drive**.

Jaz drive A **tape drive**, developed by Iomega Corp., that takes removable **disk** cartridges. See also **zip drive**.

jib arm Another name for **camera boom**.

jitter Referring to any small and rapid jerkiness in **motion**. Examples include the shaky **images captured** from an **unsteady** camera or from **3D tracking** data that contains a lot of high-frequency noise and needs to be smoothed out.

job 1. A **project** or work done on a **computer**. 2. A term used to describe the scope of **digital** work attached to a particular **film** or commercial. 3. One of the list of tasks sitting in the **job queue** on a computer.

job name See **project name**.

job queue The lineup of jobs to be **run** on a **computer**.

Jobs, Steve Cofounder of **Apple Computer, Inc.** with Steve Wozniak in 1975.

job scheduling To set up and prioritize the list of **job**s to be run on the **job queue** on a **computer**.

job system A generic term used at many facilities involved in **CG work** to describe the manner in which **project**s are organized and maintained on the **network**. **Naming conventions**, **directory structure**, and **disk allocation** are just a few of the issues that a job system will handle.

Job TD See **Job Technical Director (Job TD)**.

Job Technical Director (Job TD) The individual responsible for allocating and managing the **directory structure**, **naming conventions**, and **disk space** requirements for a **project**. Sometimes also called a **Technical Director (TD)**.

joint The **point** where two or more **bone**s are joined together in a **skeleton hierarchy**. *See also image under bone.*

joint chain See **skeleton chain**.

joint hierarchy See **skeleton chain**.

joint structure See **skeleton chain**.

Joint Photographic Experts Group (JPEG) 1. JPEG is a widely used **image file format** that uses **lossy compression**. The typical **filename extension** used for **image**s stored in this **format** is, typically, .jpg or .jpeg. JPEG and **GIF** are two widely used formats for transferring images across the **World Wide Web (WWW)**. See also **JPEG compression**. 2. The group that established a standardized method for the **compression** and **decompression** of **digital image**s.

jog To step **frame** by frame through a series of **image**s, such as on a **videotape**, a **laser disc**, or a **flipbook**, either forward or backward. Also called **shuttle**, **scrub**.

jot A **mouse**-based **text editor** for **IRIX** that uses a **cut and paste** style of editing **ASCII** files. Jot was originally called **zip**.

joystick An **input device** that pivots around one end and **transmit**s its **position**s to a **computer**. Joysticks are commonly used to control games and **motion control (MOCO)** computers.

JPEG Abbreviation for **Joint Photographic Experts Group (JPEG)**.

JPEG compression A **lossy compression** method of **image compression** in which the RGB **pixel**s are converted to **YUV**, where Y encodes the **luminance** and **UV** encodes the **chroma**. Because the human eye is less sensitive to changes in chroma than changes in luminance, some **compression** can be achieved by simply removing every second chroma **sample**.

Julia Set The Julia Set originates from a **fractal** equation developed by Gaston Julia in 1918. See **Mandlebrot Set**.

jump cut When an action is **film**ed using the same **camera angle** and **lens** from the previous **scene**, a jarring jump cut occurs due to changes in the actor's positions. A jump cut is created when the flow of continuous events appears to have been interrupted by an omission of the action. See also **action axis**.

KB Abbreviation for **kilobyte (KB)**.

KBPS Abbreviation for **kilobytes per second (KBPS)**.

Kelvin The **unit**s used to measure the **color temperature** of a **light source**. Normal daylight measures about **5400 Kelvin**, a **Tungsten light source** in the **studio** measures about **3200 Kelvin**, and a professionally **calibrated monitor** displays **white** at approximately **6500 Kelvin**. See also **foot candle**.

KEM The trade name for a **flatbed editor**.

kept takes See **circled takes**.

kernel 1. The essential part of the **operating system (OS)** that is responsible for resource allocation and **data storage** within the **computer**. 2. For **image processing**, see **convolution kernel**.

key 1. Another name for a **matte**. 2. The process of extracting a **subject** from its **background (BG)** by isolating it with its own matte and **compositing** it over a new background. See **chroma key**, **color difference key**, **luminance key**, *Color Plates 13, 17–20, 54–55*. 3. Each button on a **keyboard**. 4. For **software**, see **license key**.

Key Animator See **Lead Animator**.

keyboard An **input device** containing a complete set of **ASCII character** keys attached to the **computer terminal** that allows the **user** to interact with the **computer**.

keyboard buffer The **memory** used to store keystrokes when the **user** is typing faster than the **program** can **process** the information.

keyboard command The combination of keystrokes input on a **keyboard** that instructs a **computer** or **application** to take a particular action. See **mouse command**, **accelerator**.

keyboard shortcut See **hot key**.

keycode numbers See **edge numbers**.

keycode numbers reader The **device** that reads **keycode numbers** from **film** and converts them into electronic output.

keyer Any **device** or **image operator** used for **matte extraction** is sometimes referred to as a keyer.

key frame 1. In **computer graphics (CG)**, the **value**s such as **translation**, **rotation**, **scale**, and any number of **deformation** parameters used to define the position of an **object** or **image** at specific **frame**s in time and space. **In-between** frames can then be calculated by **interpolation** techniques across these key frames and can be controlled by adjusting the **slope** and **tangency** of the resulting **curve**s or by modifying the original key frames. See also **keyshape**s. 2. In **cel animation**, a specific frame that has been hand drawn by the **Animation Lead** to define the position in time and space of the **subject**. An **In-Betweener** then draws the frames needed in between the key frames in order to create continuous **motion** when played back.

key frame animation The creation of **motion** by **interpolation** across **key frame**s.

keyframing The process of creating **key frame**s to create **key frame animation**.

Key Grip The individual responsible for leading and supervising the team of **Grip**s on a **set**. The Key Grip works closely with the **Gaffer**.

key in To enter **data** into the **computer** via the **keyboard**. Also referred to as **input**.

key light The primary **light source** illuminating a **scene**. It is used in conjunction with **fill light**, **back light**, and **bounce light** to **light** an **environment**. For outdoor **shot**s, the sun is generally the key light.

Keylight The trade name of a **color difference key**er, similar to **Primatte** and **Ultimatte**, developed by Computer Film Company (CFC).

keykode See **edge numbers**.

key numbers See **edge numbers**.

key pose One of the extreme poses of a **character** used to define an emotion or action.

keyshape The individual **object** shapes that are stored as the **key frame**s for the **computer** to **interpolate** across to make the new **in-between**s. See

lattice box animation, point cluster animation image, *image under shape morph*.

keystoning A distortion of an **image** resulting when a rectangular **plane** is not perpendicular to the **axis** of the **lens** in the **camera** or **projector**. For example, the image appears wide at the top and narrow at the bottom.

keyword 1. A specific word that is understood by a particular **programming language**. 2. A word or phrase used to search the **Internet** for articles and **Web site**s containing that particular text pattern.

kicker See **back light**.

kick light See **back light**.

kickoff A term used to describe the start of **production** or **principal photography**.

kill To terminate a **computer process**.

kilo Prefix for one thousand. See **kilobit**, **kilobyte (KB)**.

kilobit One thousand, or more specifically 2^{10} or 1,024 **bit**s. See also **kilobyte (KB)**.

kilobyte (KB) One thousand, or more specifically 2^{10} or 1,024 **byte**s. Kilobytes are a standard **unit** used to measure the storage capacity of **disk**s and **memory**. See also **megabyte**, **gigabyte**, **terabyte**.

kilobytes per second (KBPS) The number of **kilobyte**s, or thousands of **bits**, of **data** that can be transferred per second. **Modem** speed is typically measured in KBPS.

Kine Abbreviation for **Kinescope (Kine)**. Pronounced "kinny."

kinematic chain See **skeleton chain**.

kinematics The mechanical study of motion. See **inverse kinematics (IK)** and **forward kinematics (FK)**.

kinetic friction In **motion dynamics**, the kinetic friction of an **object** is the **physical property** that causes the object to come to a stop. An object with high kinetic friction will stop very quickly, whereas an object with low kinetic friction will continue to slide for a longer distance. See also **static friction**.

Kinescope (Kine) A **film recording** of **video image**, originally appearing on television. Usually of poor quality, this technique was originally used for

Source Object

Generations = 1

Generations = 2

Generations = 3

Quadratic Koch Island

A **Koch island** can be infinitely created using the principles of **recursion** and **self-similarity**.

recording television programs or permanent record or delayed **transmission** before it was replaced by **videotape**.

kluge Pronounce "clooj." A not so elegant **workaround** to a problem in a **system** or **software**.

knot Synonym for **edit point**.

Koch curve See **Koch island**.

Koch island A **fractal** pattern, named after Herge Von Koch, that uses the principles of **self-similarity** and **recursion**. A Koch island, also referred to as a **Koch curve**, is created by breaking a straight **line**—the **initiator**—into a pattern—the **generator**—and then **subdividing** each straight line of that pattern into the generator pattern over and over again. See also **L-system**, *and image on the previous page.*

Kodak See **Eastman Kodak Company**.

Kodak film stock Widely used **film stock** used for **visual effects work**.

Kodak girl See **LAD girl**.

Kodak head See **LAD girl**.

Kodak standard perforation The standard **perforation** shape and size used on all **print stock** in the United States.

Kodak standards The wide range of standards recommended by **Kodak** for the areas of **film**, **image conversion**, and **digital** imaging.

Korn shell (KSH) A **command interpreter** for **Unix**. See also **C shell (CSH)**, **Bourne shell (SH)**.

KSH Abbreviation for **Korn shell (KSH)**.

kuk Shorthand for **kukaloris**. See **cukaloris**.

kukaloris Another spelling for **cukaloris**.

Kuper data The **motion curve**s created by **Kuper software**. This **data** is often used in **computer graphics (CG)** to line up **CG element**s with **motion control (MOCO)** plates. See **motion control data (MOCO data)**.

Kuper software A widely used **motion control software** used to create and modify **motion curve**s for **motion control photography (MOCO photography)**.

lab 1. Shorthand for **film laboratory**. 2. See **L*A*B color model (LAB)**.

L*A*B color model A **3D color model**, developed by the **Commission Internationale de L'eclairage (CIE)**, that was designed to accurately convert **color**s between the **RGB** and **CMYK color model**s.

lab aim densities (LAD) The **Kodak standards**, used by the **lab**, to adjust a **print** to hit specific densities on a properly lit and **exposed 18% gray card**. Commonly, the **density point**s on a **print** will read 1.09, 1.06, 1.03 in **red (R)**, **green (G)**, and **blue (B)**, and is referred to as **status A density**. This will produce a **neutral print** at the correct **density**. The LAD for the same 18% gray card on a **camera negative** film stock is 0.80, 1.20, 1.60 and is called **status M density**.

lab cut-off The time after which the **film lab** will no longer guarantee that **film** received will be **process**ed and returned for next day's **dailies**. See also **daylight run**.

lab report The report sent from the **film laboratory** with the **dailies** rolls listing all the printed **take**s and their **timing lights**.

lab roll The large **roll**s of **film** created at the **lab** from smaller rolls of client **negative** in order to reduce the amount of negative handling during **film processing**.

LAD Abbreviation for **lab aim densities (LAD)**.

LAD girl One of many terms used to describe the **image** of a woman placed at the head of a **lab roll**. The image is used to check flesh tones and usually contains a patch of an **18% gray card** used to reach **lab aim densities (LAD)** during the **printing** process. The "real" LAD girl is a brunette, but sometimes another image of a blond girl—often referred to as **Marcie**—is used. Also called **girl head**, **Kodak girl**, **Marcie head**, **Marcie**, **aims girl**. See also *Color Plates 4–6*.

Lambertian reflection See **diffuse reflection**.

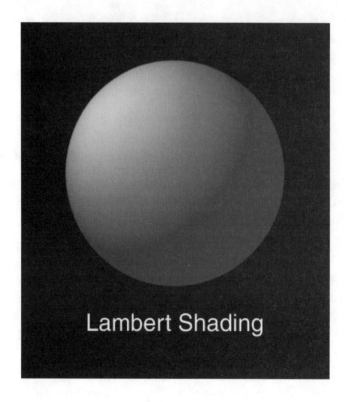

Lambert Shading

Lambert See **Lambert shading model**.

Lambert lighting model See **Lambert shading model**.

Lambert reflection See **diffuse reflection model**.

Lambert shading model A **shading model** that **reflect**s and scatters **light** equally in all directions and, as a result, is best used for **object**s with a matte finish. See also **Gouraud shading model**, **Blinn shading model**, **Gouraud shading model**, **Phong shading model**, **Cook/Torrence shading model**, *see image above and image under shading model.*

LAN Abbreviation for **local area network (LAN)**.

language A specific **syntax** used for communication with and between **computer**s. See **programming language**, **shell**, **machine code**.

laptop See **laptop computer**.

laptop computer A **microcomputer** small enough to use on your lap.

large format See **large format film**.

large format camera Any **camera** designed to use wide-**gauge** films, such as **65mm film**. See also **70mm film**, **Showscan**, **IMAX**.

large format film Generally, referring to any **film** larger than the **standard 35mm film format**.

laser Abbreviation for "Light Amplification by the Stimulated Emission of Radiation." Lasers use the natural oscillations found in atoms to generate narrow, focused beams of **light**. Laser beams are commonly used in medicine, **fiber optic** telecommunications, measurement systems requiring very high precision, and in imaging systems such as **laser scanner**s and **laser recorder**s.

laser beam The narrow, finely focused beam of **light** produced by a **laser**.

laser contour scanner See **laser scanner**—Definition #2.

laser disc A plastic coated **optical disk** capable of storing **digital data**, such as music and movies that can be **read** by a **laser beam**.

laser film recorder An **output device** that uses a **laser** beam, typically either a **gas laser** or a **diode laser**, to convert **digital image**s onto **film**. The advantages of using lasers as a **light source**, rather than a **CRT film recorder**, include faster imaging times per **frame**; **sharp**er, less **grainy** images; low image **flare**; and a greater **dynamic range**. Each of the three laser beams—**red (R)**, **green (G)**, and **blue (B)**—are guided through a system of **lens**es, mirrors, prisms, and pinholes where a single **white** laser beam is formed and then directed onto the **scanner** to **expose** an **image**, line by line, onto film. See **ArriLaser film recorder**, **LUX laser film recorder**, **Lightning II laser film recorder**.

laser pointer A small penlike **device** capable of emitting a small, high-intensity, and typically red **laser beam** of **light**. Laser pointers are ideal for pointing out specific areas on the **screen** and are used by **Director**s and various supervisors in the **screening room** as they comment on the **project**ed **image**s.

laser printer A **printer** that uses a **laser beam**, **focus**ed on a **digital image** placed on a rotating drum, to produce the **image** on paper.

laser recorder See **laser film recorder**.

laser scanner 1. An **input device** that uses a **laser beam** to convert **film image**s into **digital image**s. 2. A digitizing technique that uses a laser beam attached to a rotating platform to **scan** around the **surface** of a **physical model** to produce **contour curve**s representing the **3D model**

in the **computer**. Each time the laser beam completes a 360-degree **rotation** of the **object** to create one contour **curve**, the laser is lowered or raised by a small amount and then continues on for another complete rotation and resulting contour curve. This process continues until all the curves needed to accurately represent the model have been created. Larger scanners are capable of scanning a complete human. Also called **3D scanner**, **3D laser scanner**, **Cyberscan**.

laser scanning The process of using a **laser scanner** to convert **film** images into **digital image**s or **digitize** a **physical model** into a **3D model**.

latent edge numbers See **edge numbers**.

latent image The invisible **image** caused by **light** hitting the **emulsion** in a **camera** or **printer** that has been **expose**d onto a piece of **negative** but has not yet been **develop**ed.

latent image matte shot See **in-camera matte shot**.

latent negative Synonymous with **exposed negative**.

lathed surface See **surface of revolution**.

lathing See **surface of revolution**.

lattice See **lattice box**.

lattice animation See **lattice box animation**.

lattice box A **deformer object** that is used to reshape and **deform** the **object** it surrounds. A lattice box often takes the form of a **bounding box** that completely surrounds the **3D object** to be deformed, but it can also be used to surround only the portion of the object that you wish to deform. Each **point** of the lattice box is associated with a series of points defining the **surface** of the object to be deformed. By **reposition**ing the points along the lattice box to create **keyshape**s, the surface points can **animate** and change the **shape** of the surface. Also called a **squishy box**, **deformer**, **bendy box**.

lattice box animation The process of animating an **object** by creating **keyshape**s with a **lattice box** and calculating the **interpolation** across those shapes to create new **in-between**s. A great advantage of lattice box animation is the reduced number of **point**s that need to be dealt with to get a complex **surface** to **animate**. Also called **squishy box animation**, **bendy box animation**. See also **point cluster animation**.

lattice box deformation The process of **deforming** an **object** based on the **lattice box** that surrounds it. See also **lattice box animation**.

lattice deformation See **lattice box deformation**.

latitude The range of **exposure** in which a correct reproduction can be made on a particular **film stock**.

launch To start up an **application** or **program**.

lavaliere A small **microphone** that can be clipped to clothing or hung around the neck.

layback The transfer of the final **audio track** onto the **master videotape**. Also called **audio layback**.

layer 1. For **computer graphics (CG)**, another name for **element**. 2. For **film**, another name for **record**.

layering See **layering operation**.

layering operation A global term referring to any **compositing operation** that integrates one **element** with another element based on their **alpha channel**s or **RGB values**. See **over operation**, **under operation**, **inside operation**, **outside operation**, **above operation**, **below operation**, **min operation**, **max operation**, **plus operation**, **minus operation**, **plus above operation**, **plus below operation**, **plus in operation**, **plus out operation**, **multiply operation**, **divide operation**, **mix operation**, **screen operation**, **XOR operation**, and *image on following page*.

layout 1. For **computer graphics (CG)**, layout refers to the process of **blocking** out the **camera move** for a **shot**. Typically, **stand-in object**s are used for minimal **animation** and rough timing purposes. In many cases, the **key light** is also positioned during the layout stage as an aid in placing the **character**s in positions that will complement the lighting direction of the **scene**. The term *layout* is typically used for **full CG feature**s, while **previs** is the term used for the similar task for **live action film**s. Also called **3D layout**. 2. For **cel animation**, drawings that represent the main features of each **scene** as a visual tool for planning the animation and **effects** for the shot. Also called **2D layout**. 3. For **filming**, see **scene blocking**, *Color Plates 37, 42, 46.*

Layout Artist 1. For **computer graphics (CG)**, the artist who creates the **camera move**s for **full CG feature**s. This same task is, generally, referred to as **previs** for **live action film**s. 2. For **cel animation**, the **2D artist** that creates the detailed **layout drawing**s.

layout drawing For **cel animation**, a detailed drawing to indicate **frame** composition, **camera** motion, and the action of the **character**s. It is essentially the **2D** versions of the **3D layout** and **previs** steps that are used in **computer graphics (CG)** for **live action** and **full CG** films.

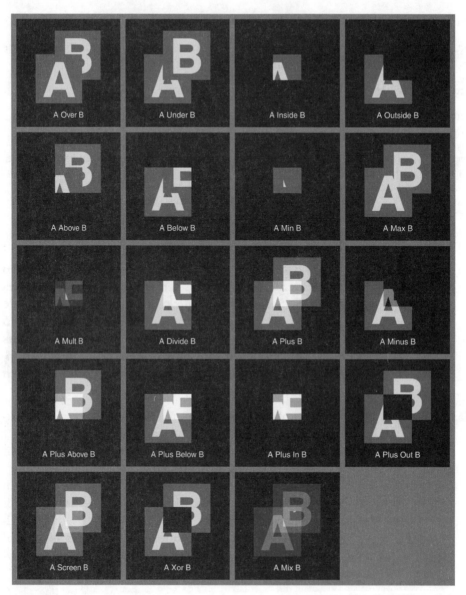

Just a few of the possible types of **layering operation**s available with **digital compositing** operations.

Layout Supervisor The individual responsible for the creation of all the **camera move**s and/or **layout drawing**s for shots involving **computer graphics (CG)** and/or **cel animation** techniques. The Layout Supervisor manages a small team of **Layout Artist**s and is responsible for maintaining a consistent

style of framing and **camera motion** across the **film** based on the vision of the **Director**.

LCD Abbreviation for **liquid crystal display (LCD)**.

L-cut An **edit** in which the **audio** and **video** are cut at different places instead of a **straight cut**, where they are cut at the same place.

Lead Synonymous with **CG Lead**.

Lead Animator See **Animation Lead**.

Lead Compositor See **Compositing Lead**.

leader 1. The short **strip**s of **film** that are attached to the ends of a **print** to protect them from damage when **thread**ing through the **projector**, or machine used to **process** the film. See also **Academy leader**. 2. A strip of blank **tape** used for threading the tape up to the point where it will begin playing or recording.

leading zeros See **padded numbers**.

Lead Lighter See **Lighting Lead**.

Lead Technical Director (Lead TD) The individual responsible for supervising and managing all the other **Technical Director**s **(TD**s) on a **project**.

leaf 1. A **node** or **object** that is a **child** in a **hierarchy** with no **children** of its own. **Leaves** can be thought of as the children's children. 2. The lowest-level node in a **file system**.

Lead TD See **Lead Technical Director (Lead TD)**.

leaves See **leaf**.

LED Abbreviation for **light-emitting diode (LED)**.

left click To depress, or **click**, the leftmost **button** on the **mouse**. See **right click**, **middle click**.

left eye Referring to the **image**s **capture**d or **display**ed for the left eye on a **stereo viewing system**. Opposite of **right eye**.

left-handed coordinate system A standard **coordinate system** used in **computer graphics (CG)** in which the **X-axis** runs from **east** (positive) to **west** (negative), the **Y-axis** runs from **north** (positive) to **south** (negative), and the **Z-axis** runs away (positive) and toward (negative) rela-

tive to **screen space**. According to the **left-hand rule**, if the thumb of the left hand points in the direction of the positive X-axis and the index finger points in the direction of the positive Y-axis, then the middle finger points in the direction of the positive Z-axis. The only difference between the left-handed coordinate system and a **right-handed coordinate system** is that the positive/negative values along the Z-axis are reversed. See also **left-handed rotation**, *image under right-handed coordinate system.*

left-handed rotation To **rotate** an **object** around an **axis** so that if the thumb of your left hand was pointed toward the positive direction of the **axis of rotation**, the remaining four fingers of your hand would curl in the positive direction of the rotation. Positive left-handed rotations occur in the opposite directions in **right-handed rotation**s.

left-hand rule A way of remembering the direction of the **XYZ-axes** in a **left-handed coordinate system**. Hold up your left hand so that your palm is facing away from you. Extend your thumb to the right, your index finger up, and your middle finger away from you. With your hand in this position, your thumb is pointed toward positive **X**, your index finger toward positive **Y**, and your middle finger toward positive **Z**. The opposite direction of your fingers represents negative X, Y, and Z, respectively. See also **right hand rule**, **left-handed rotation**.

legal polygon A **polygon** that is **planar** and not **concave** and is able to **render**. Opposite of **illegal polygon**. *See image under **concave polygon**.*

legs Slang for **tripod**.

leica reel Synonymous with **animatic**.

Lempel-Ziv-Welch compression (LZW compression) A **lossless compression** technique used to find repeated patterns in **blocks** of **pixels** in an **image** as a means of reducing their **file size**. See also **run length encoding (RLE)**.

lens The **transparent** and **curve**d pieces of glass that receive and refract **light rays** to form a sharp **image** on **film** or a **projector** screen. Lenses are commonly referred to by their **focal length**. Types of lenses include a **normal lens**, **zoom lens**, **telephoto lens**, **anamorphic lens**, **spherical lens**, and **auxiliary lens**.

lens aperture Synonymous with **camera aperture**.

lens artifact An **artifact**, such as a **lens flare**, that appears on the **film** as a result of the **lens assembly**.

lens assembly Referring to the set of specially matched **lens**es that are assembled to form a single lens component in a standard **cameral lens**. Each lens element contains a slightly different shape and position that can result in **lens artifact**s. Also called **lens elements**.

lens attachment Synonymous with **lens extender**.

lens distortion A term used to describe any **distortion** of a photographed **image** due to the type of **lens** used. The most common type of lens error is **barrel distortion**, which occurs in many **wide-angle lens**es and causes straight lines to bend away from the center of the image. This type of lens distortion results in a rectangular shape looking more like a barrel shape. **Plate**s containing a high degree of lens distortion can pose problems for calculating **3D tracking** curves for **CG element**s as the **CG camera**s used in most **3D package**s do not produce lens distortion. In these cases, either a special **shader** needs to be written that can **render** with a similar lens distortion as seen in the original **plate**, or **image processing** techniques need to be used to calculate the amount of distortion needed to be applied to use the CG elements during **compositing**. See also **wide-angle distortion**, **telephoto distortion**.

lens elements See **lens assembly**.

lens extender An attachment mounted onto the **lens** and **camera** that increases the **focal length** of the lens being used.

lens flare A colorful flaring effect resulting from a bright **light** shining directly into the **lens assembly** of a **camera** and **reflect**ing off its individual **lens** elements. A lens flare is actually made up of multiple **lens artifact**s due to the slightly different shapes and positions of each lens component. There are a variety of **software package**s on the market that attempt to mimic this effect **digital**ly, but they often tend to feel too regular and not as amorphous as the real thing. *See also Color Plates 27–29.*

lens height See **camera height**.

lens length Another term for **focal length**.

lens shade The hood attached to the front of a **lens** to keep unwanted **light** from striking the lens and causing a **flare**.

lens speed The largest lens opening, or smallest **f-stop** number, at which a lens can be set. A **fast lens** transmits more **light** and has a larger opening than a **slow lens**.

lenticular For the printing of **stereoscopic image**s, lenticulars are thin plastic cards containing **lens** material over multiple **image**s to restrict view to a

particular portion of the images as a means of conveying a sense of **depth** and/or **motion**.

letterbox The technique of shrinking an **image** so that its entire width can fit within the **1.33:1** aspect ratio of the television screen. Typically, this requires the need to **mask** the top and bottom areas of the image with **black** to maintain the proper **aspect ratio**. *See images under film extraction*.

level 1. Synonym for **layer** or **element**. 2. The **amplitude** of a **signal**. 3. The **position** of a particular **node** or element within a **hierarchy**.

level of detail (LOD) The amount of **resolution** required in a **3D surface** as necessitated by its proximity and size in the **display device** relative to the **viewer**. A **low-resolution** version of the **model** is used when it is far from the **camera**, and the **high-resolution** model is used when it gets close to the camera. See also **polygonal approximation**.

L-grammar The **programming language** used in **L-System**s.

library A **database** of standard or frequently used **file**s or **application**s.

license See **software license**.

license key The string of unique numbers that a **computer** reads when **3rd-party software** is **launch**ed as a means of verifying that the **software** is licensed to **run** on that particular **system**.

license manager A **program** that manages all the various **software application**s used across a **network**.

license server The **computer** that stores and manages the allocation of **software license**s to **user**s across a **network**.

Lidar An optical **device** that uses **laser**s to **capture** a **point cloud** representing the **position** of **object**s on a physical **set** or **location** in **3D space**. See **3D tracking**.

life See **particle life**.

life span See **particle life**.

lifetime See **particle life**.

light 1. Any source of illumination, such as from the sun, an electric lighting fixture, or a **laser beam**. 2. The particular quality and quantity produced from a source of illumination, such as **soft lighting** or **hard lighting**. 3. The sensation of perceiving **brightness**. 4. To illuminate a **set** or **location** for **filming** or a **CG element** or **environment** for **rendering**.

light association See **light linking**.

light balance 1. The relationship of illuminated areas and **shadow**s in a **scene** that results a good **composition**al effect. 2. A scene with sufficient **lighting** for **exposure** of the **subject** is said to have good light balance.

light bounce See **reflected color**.

light box A box or table lit from inside and fitted with a white Plexiglas top. Light boxes are used to view **clip**s of **film** while doing **color grading** and to view the results of the **film** that comes back from the **lab**. See also **light table**.

light box calibration A **light box** is **calibrate**d by matching its perceived **brightness** and **color** to the brightness and color of **film** when it is **project**ed in a **screening room**. This adjustment is made by comparing the **workprint** being projected to a **clip** of the same workprint on a lightbox and adding the necessary **ND filter**s and/or color **filter**s inside the lightbox until its **color** and **brightness** match to the levels seen on the projection **screen**.

light change points See **printer points**.

light color The **color** of a **light**. For **computer graphics (CG)**, this is typically represented by a triplet of **RGB value**s.

light cone The cone-shaped area of **light** cast by a **spotlight**.

light direction The direction in which a **light source** throws **light**.

light-emitting diode (LED) A type of semiconductor **diode** that **emit**s either visible or **infrared** light when current travels through it. Visible LEDs are used to indicate status or **error** conditions on a piece of **hardware**, such as a **computer** or **camera**. LEDs have also been successfully used as **tracking marker**s when shooting **live action plate**s that must be **3D track**ed during **post production** in order to add **CG element**s that track properly with the plates.

light flare See **flare**.

light intensity The **brightness** of a **light source**.

lighting The process of illuminating actors, **set**s, **location**, **model**s, **miniature**s, and **CG element**s to create the desired mood and quality of a **scene**. The lighting of a scene is determined by the factors of direction, **intensity**, **color**, and quality of the **light**s. 1. For **computer graphics (CG)**, before **rendering** a **scene** must be lit to create the look and **atmosphere** desired. Any number of lights and **lighting model**s can be used, such as a **spotlight**, **point light**, **directional light**, **area light**. 2. For **film**, the positioning of lights, both **on location** or on a **set**, that creates the appropriate look and feel

of the **scene**. Typically, lighting is designed by the **Director of Photography (DP) Gaffer**, and the **Director**. See also *Color Plates 35, 44, 48.*

Lighting Artist An **artist** who focuses primarily on **CG lighting**.

Lighting Cameraman See **Director of Photography (DP)**.

Lighting Crew 1. The group of **Crew Member**s who position, operate, and maintain the **lighting** of a **set** or **location**. 2. For **computer graphics (CG)**, the team of artists responsible for lighting **CG element**s and **environment**s.

lighting dailies A **dailies** dedicated to reviewing the latest round of **lighting** in the **shot**s with the **Lighting Crew** and **Compositing Crew**. See also **animation dailies**, **effects dailies**, **film dailies**, **stage dailies**, **video dailies**.

Lighting Department For **computer graphics (CG)** or **film**, the group of individuals responsible for **lighting** a **scene**.

Lighting Director 1. For **computer graphics (CG)**, see **Lighting Supervisor**. 2. For **live action**, see **Director of Photography (DP)**.

Lighting Lead For larger **project**s, a number of Lighting Leads might be assigned to oversee the **lighting** across individual **sequence**s. In this case, Lighting Leads manage a small team of **Lighting Artist**s and report to the **Lighting Supervisor**. They are responsible for delivering their **shot**s based on the technical and aesthetic requirements of the **show**. For smaller projects, a Lighting Lead is synonymous with the Lighting Supervisor.

lighting model See **shading model**.

lighting module The portion of a **3D software package** use to create and modify **lighting**.

lighting package See **lighting software**.

lighting reference A **stand-in object** put into a **scene** and photographed in order to provide useful **lighting** information for the addition of **digital effects (DFX)**.

lighting setup Referring to the placement, **color**, **intensity**, and type of **light**s used in a **scene**.

lighting software A **software application** specifically designed to allow the **user** to create and position **light**s for **3D geometry**. Also called a **lighting package**. See also **animation software**, **modeling software**, **render**

software, **paint software**, **particle software**, **compositing software**, **tracking software**.

lighting spheres For **visual effects work**, specially designed spheres that are **film**ed for each **scene** in which **computer graphics (CG)** will be added. These **sphere**s are used as **lighting** reference for adding **CG element**s into **live action plate**s and are, typically, comprised of a highly reflective sphere, an 18% gray sphere and a white **matte** sphere. The combination of these spheres can indicate the **position** and **color** of the various practical **light**s used during "filming." The actual **take** of these spheres is often referred to as the **ball pass** or **sphere pass**.

Lighting Supervisor 1. The individual responsible for the **lighting** of all the **CG element**s required for a **project**. The Lighting Supervisor manages a team of **Lighting Artist**s and is responsible for delivering **shot**s that maintain the technical, aesthetic, and **continuity** requirements of the **show**. Sometimes called the **Lighting Director**. 2. For **film**, see **Gaffer**.

light linking An artificial situation used in **computer graphics (CG)** in which a particular **light source** might be allowed to affect one **object** in a **scene** but not another. Also called **light association**. See also **exclusive light**.

light location The physical **position** of a **light source**. For **computer graphics (CG)**, this is represented with **XYZ coordinates**.

light mask A light mask is used in **3D lighting** to indicate which **object**s in a **scene** will be affected by specific **light**s. See also **shadow mask, reflection mask**.

light meter An instrument with **light**-sensitive cells capable of measuring the light reflected from (**reflected light**) or falling on (**incident light**) a **subject**. See **reflected light meter, incident light meter**.

lightness Referring to the **brightness** of an **color**. The color light blue contains a high value of brightness, whereas dark blue contains a low value of brightness. See **darkness**.

Lightning II laser film recorder A second-generation **laser film recorder** from **Kodak** that uses both **gas laser**s and a **diode laser** to write **digital image**s back onto **film**. See also **LUX Laser film recorder, ArriLaser film recorder**.

light pass 1. In **multiple-pass photography**, the **pass** of individual lights striking the **subject**, such as the **key** or **fill**, for later use in **compositing**. 2. In **multiple-pass rendering**, the **CG element** that represents the effects of a particular **light** striking the **object**. In many cases, a set of three lights

will be assigned to **render** as one of the three **primary colors — red (R)**, **green (G)**, and **blue (B)** — as a means of **rendering** three light passes into one **element**. During compositing, these lights can be separately controlled based on the **RGB channels** that they represent in the **image**. See also **shadow pass, reflection pass, matte pass, beauty pass**.

light pen See **stylus**.

light position See **light location**.

light rays The beams of **light** that are **emit**ted from a **light source**.

light shader A **shader** that defines the properties of a particular **light source**, such as its **color**, direction, **intensity**, and quality of **light**. See also **surface shader, displacement shader, volume shader**.

light source Referring to any source of visible **light**. A light source can be defined in terms of its location, **color intensity**, quality and direction.

light source vector The direction in which a **light** shines on a **scene**.

light stylus See **stylus**.

light table A specially designed table that contains a recessed **light box**.

light type Referring to the specific type of **light** used to illuminate a **scene**. For **computer graphics (CG)**, common types of light include **area light, ambient light, infinite light, directional light, point light, spotlight, volume light**.

Lightwave A **3D software package** developed by **Newtek, Inc.**

Lightworks The trade name for a **digital editing** machine.

limb The series of **bone**s that define the appendages, of a **character** in a **skeleton**, such as an arm or a leg.

limits See **constraint**s.

Lindenmayer System (L-System) An L-System is a **string** rewriting mechanism, developed in the late 1960s by mathematician and botanist Astrid Lindenmayer, to mathematically define the growth of plant-like structures. The central concept of L-Systems is **self-similarity**, in which the whole of a **shape** is made up of parts that are geometrically similar to the whole. L-Systems use self-similarity to define **object**s by successively replacing parts of the initial **source object** rewriting various sets of rules. See also **Koch island**, and *image on following page*.

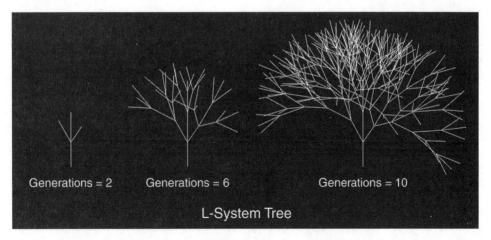

Generations = 2 Generations = 6 Generations = 10

L-System Tree

L-Systems use a specially designed **L-grammar** to mathematically define the growth of plant-life structures based on the principles of **recursion** and **self-similarity**.

line 1. A **line segment** defined by connecting two **end point**s to create a **one-dimensional** trajectory. Also called a **vector**. 2. A single even or odd **scan line** in a **video image**.

linear 1. Evenly spaced increments. Opposite of **nonlinear**. See **linear units**. 2. Relating to or resembling a **line**. See **linear curve**. 3. Having only **one dimension**.

linear approximation See **linear interpolation** — Definition #2.

linear color encoding See **linear encoding**.

linear color remapping See **linear encoding**.

linear color space An **image** stored in a **linear color space** contains evenly distributed **linear** steps of **color value**s across all ranges — low, medium, and high. Unlike a **nonlinear color space**, images stored in a linear color space do not take into account the fact that the human eye is much more sensitive to the low to middle ranges of **intensity** than it is to the high or brighter ranges. It is most common to work with images stored in a linear color space for **visual effects work**, although some facilities have opted to **composite** their work in **logarithmic space**.

linear color space encoding See **linear encoding**.

linear conversion See **linear encoding**.

linear curve A **curve type** in which the **curve segment**s pass directly through their **control point**s and uses true **end point interpolation**. The curve segments in a linear curve connect between the shortest distance of the two control points, which makes sharp **segment**s. See **linear approximation**.

linear editing An **analog** editing method that requires the **Editor** to work in **sequence** by inserting **frame**s, which is referred to as **sequential access**, rather than allowing for the **random access** methods available with **nonlinear editing**.

linear encoding A method of **image encoding** that unlike **nonlinear encoding** converts the **color**s from the **input image** to the **output image** in an evenly distributed, **linear** way. Also referred to as **linear mapping**. See **linear color space**, **nonlinear color space**. *See also images under image encoding.*

linear format Any **image** stored in a **linear color space** is said to be in a **linear** format.

linear interpolation 1. An **image interpolation** technique that is based on the averaging of the two nearest **pixel**s in a **digital image**. See **bicubic interpolation**, **bilinear interpolation**. 2. A technique in which the **value**s calculated between **key frame**s or **control point**s are created with a series of straight **line segment**s. A perfectly smooth defined **curve** can never be created with linear interpolation because regardless of the number of **points** used the curve will always be a series of straight lines. Also called **linear approximation**. See also **polygonal approximation**, **spline interpolation**.

linear mapping See **linear encoding**.

linear NURBS A **NURBS curve** that requires a minimum of three **control point**s. See also **cubic NURBS**, **quadratic NURBS**.

linear perspective Referring to the **convergence** of parallel **line**s on a **plane** at an angle to the **viewer**. See also **perspective**, **aerial perspective**.

linear polarizer 1. For **filming**, a type of **filter** used to reduce **glare** and **reflection**. 2. For **stereo film**s, the filters used in **polarized glasses** to transform **light ray**s passing through them into a series of straight **line**s. A disadvantage of this type of filter is that the **viewer** cannot **rotate** his or her head much without losing the **3D** effect. See also **circular polarizers**.

linear shading See **Gouraud shading**.

linear space See **linear color space**.

linear to log Shorthand for **linear to logarithmic**.

linear to logarithmic An **image conversion** that applies a **color correction** to **image**s stored in a **linear color space** to convert them into a **logarithmic color space**. Opposite of **logarithmic to linear**. See also **nonlinear encoding**, **linear encoding**, and *images under **image encoding***.

linear units Evenly spaced increments of measure, such as inches or centimeters.

linear video **Image**s on **tape** that are viewed or **edit**ed in a **linear** sequence. Tapes using linear video, such as **VHS** or **Beta**, require the **user** to rewind or forward the tape to get to the desired location, which is referred to **sequential access**. Opposite of **nonlinear video**.

linear video editing See **linear editing**.

line blanking See **horizontal blanking**.

lined script A **shooting script** that is prepared by the **Script Supervisor** during **production** to indicate which **scene**s have already been **shot**. The **script** actually contains vertical lines drawn directly onto its pages and indicates if the specific dialogue was performed **on screen** or **off screen**. Different colored lines are typically used to indicate different types of shots, such as **close-up (CU)** or **long shot (LS)**, and notations are made to indicate the **slate**, **shot name**, and **shot description**.

line printer See **dot matrix printer**.

Line Producer A **Producer** who is responsible for managing the entire **Film Crew** during the **filming** of a movie. See also **Unit Production Manager (UPM)**, **Associate Producer**, **Coproducer**, **Executive Producer (EP)**.

line segment A **straight line** that connects two **point**s on a **curve**.

lines of code A measurement of the size of a piece of **source code** based on the number of lines of text it took to create it.

lines of resolution The number of **scan line**s that make up a **video image**. The **NTSC image format** contains 525 scan lines, whereas a **PAL** image is 576 scan lines high. A good portion of these scan lines are used for purposes other than **image** information, such as **time code** and **closed-captioning**. The actual portion used for image information is known as the **active region**.

lines per inch (LPI) A less frequently used standard for defining the **spatial resolution** of an **image** in the print industry. LPI represents the number of individual dots used to reproduce one line in an image. See **dots per inch (DPI)**.

lines per minute A measurement of the speed of a **printer** or **scanner**.

lineup The process of preparing and organizing the various film **select**s that will make up the final **composite**.

lineup sheet See **crossover sheet**.

link 1. A method for connecting one or more pieces of **data** to other data. 2. Another name for a **bone** or **chain** in a **skeleton chain**. 3. For **Web page**s, see **hypertext link**. 4. A line used for the **transmission** of data. 5. To connect various **computer**s and **peripheral**s together.

lin to log Shorthand for **linear to logarithmic**.

Linus Unix See **Linux**.

Linux Abbreviation for **Linus Unix**. An implementation of **Unix**, written from scratch beginning in 1991 by Linus Torvalds and his friends, that **run**s on many different **computer platform**s and is distributed for free over the **Internet**. Linux has gained popularity because it is very customizable and is a free substitute for Unix.

lipstick camera A tiny **camera** used to photograph **scene**s in small and awkward **set**s, such as a **miniature**, where a standard camera cannot fit.

lip sync The process of synchronizing the recorded dialogue of voice actors with the **image**s produced from **character animation**.

lip-sync-sound The **sound track** that drives the story and requires the **audio** to be anchored to the **picture**. Lip-sync-sound gives the **Editor** very little flexibility with his **cut** as his only choice is to either use or discard the **shot** in question. See also **narrated sound**.

liquid crystal display (LCD) A type of **display** used in **laptop computer**s and other **digital device**s. LCDs use much less power than a **CRT monitor**.

liquid gate See **wet-gate printing**.

Lisp Abbreviation for **List Processing Language (LISP)**.

List Processing Language (Lisp) Lisp is a **programming language** designed to **process** lists of **data**.

live action A global term referring to any imagery that was photographed on **location** or on a **set**, as opposed to being created in a **computer** or hand painted by an artist.

live action element See **live action plate**.

live action feature See **live action film**.

live action film A **film** that contains imagery **shot** on **location** or on a **set** with real actors. Many of today's live action films also include some portion of **visual effects work**. The opposite of **feature animation**. *See also Color Plates 54–55.*

live action photography See **live action shoot**.

live action plate Any **image**s that were **photograph**ed on **location** or on a **set**. Simply put, any imagery that was not created in the **computer** or hand painted by an artist. Also called a **live action element**. *See Color Plates 50–51, 54, 58–59, 64–66.*

live action shoot The portion of **filmmaking** during which the **live action element**s of a **film** are photographed.

live area The area seen through a **viewfinder** that represents the actual **image area** that will appear in the final **viewing format**. Markings etched on the viewfinder, called the **ground glass**, indicate to the **Cameraman** the area that will actually be viewable.

LO Abbreviation for **lock off (LO)**.

load 1. The amount of traffic on a **computer**. 2. To put a **disk** or **tape** into a **drive** so its contents can be viewed or modified. 3. To put **data** onto a disk so it can be accessed. 4. The process of placing **raw stock** into the **magazine** of the **camera**. 5. To open a **program**, or **application** into **memory**.

Loader The member of the **Camera Crew** responsible for loading and unloading the **film** into the **magazine**s. Also called **Camera Loader**. See **Clapper/Loader**.

local 1. **Hardware**, **software**, **peripheral device**s, or **data** that resides on a **workstation** and can be readily accessed without needing to go across a **network** connection. Opposite of **remote**. 2. A term used to describe modifications that affect only a defined portion of an **object**, **image**, or **database**. Opposite of **globally**. See **local variable**.

local area network (LAN) A small and isolated **computer network** set up within a limited area, such as within an office building. See also **wide-area network (WAN)**.

local axis The **axis** that represents the **origin** of the **active** object in all **window view**s.

local bus An extra **bus** added to the **main bus** in a **computer** that provides a fast path for connecting the **central processing unit (CPU)** with **memory** and **peripheral**s.

local computer The physical **workstation** that a **user** interacts with, which can be either a **standalone computer** or one that is connected to a **network**. See also **remote computer**.

local coordinates The **coordinate**s that are relative to and represent each **object**. The **origin** of a **local coordinate system** is the center of the object. Also called **model coordinates**, **object coordinates**.

local coordinate system The **coordinate system** that is local to a specific **object**, **node**, or **element**. Also called **local space**, **modeling space**, **object space**.

local data Any **data** that resides on a **user**'s **local computer**. See **remote data**.

local disk The **disk** or **tape drive** connected to a **local computer**. Also called **local drive**. See **remote disk**.

local drive See **local disk**.

local illumination A term used to describe the **color** or **light** that a **surface** appears to **emit**, **transmit**, and **reflect** from itself. See also **global illumination**.

local memory 1. The **memory** allocated to a specific **central processing unit (CPU)** on a **computer**. 2. The memory allocated to a specific **program** or **application**.

local origin The **point of origin** of an **object**. Most often, this is located at (0, 0, 0).

local resource Any **peripheral device** that is connected directly to a **local computer**. See **remote resource**.

local software Any **software** that resides on a **user**'s **local computer**. See **remote software**.

local space See **local coordinate system**.

local storage **Disk space** that resides in a **local computer**. See **remote storage**.

local system The **local computer** that a **user** is working on. See **remote system**.

local variable A **variable** that affects only a defined portion of a **database**, **object**, or **image** when modified. The opposite of a **global variable**.

local workstation See **local computer**.

location 1. Any place other than a **studio** where the **film** is **shot**. 2. For **computer**s, see **address**. 3. See **position**.

Location Manager See **Location Scout**.

Location Scout The individual who is responsible for all aspects involved in a **location shoot**, such as making arrangements with the proper authorities for permission to **shoot** in specific areas.

location scout The process of searching for and visiting a variety of **location**s, selected by the **Location Scout**, as possible sites for **shooting** specific **scene**s of a **film**. The **Director** and his **Production Team** then walk the sites and **block** the scenes to determine if a particular location will work for the intended mood and action that needs to be portrayed.

location shoot Any **filming** done at an actual physical **location** as opposed to filming on a **stage**.

location shot A **shot** in which the action is filmed at a physical location. Opposite of a **stage shot**. See **location shoot**.

locked The point in a **film** when the picture **edit**ing is completed.

locked off See **locked-off camera**.

locked-off camera A **camera** that is on a stable support, such as a **tripod**, and whose mechanisms controlling its movement and **lens** settings have been locked in position for the duration of the **shot**. Such a shot is called a **locked-off camera shot**.

locked-off camera shot A **scene** in which the **camera** remains stationary for the duration of the **action**. Also called a **static camera shot**. Opposite of a **moving shot**.

locked-off shot Shorthand for **locked-off camera shot**.

lock off Shorthand for **locked-off camera shot**.

lockup The condition in which the **computer** is running, but everything on the **screen** and all attached **peripheral device**s, such as the **mouse** and **keyboard**, become frozen in place and unresponsive to **command**s. Also called **frozen**, **hung**. See also **crash**.

LOD Abbreviation for **level of detail (LOD)**.

lofted surface Any **surface** whose **skin** was created by connecting together a series of **contour curve**s. See **lofting**.

Contour
Curves

Lofted
Surface

A **lofted surface** is created by **skinning** a series of **contour curve**s.

lofting A **modeling** technique in which a series of **contour curve**s, also re-
ferred to as **cross section**s, are created and **position**ed at some **offset** in
depth from the previous **curve**. Once the curves are positioned in **3D**
space, the order in which they should be connected together is identified,
and then the **software** will produce a **lofted surface** that has connected all
the curves together with a **skin**. Lofting is a very powerful modeling tech-
nique because the curves can be tweaked and the skin regenerated as many
times as needed until the desired result is achieved. See also **surface of**
revolution, **extrusion**, **sweep**, *and image above.*

log 1. Abbreviation for **log sheet**. See **camera report**. 2. See **log file**.
3. Abbreviation for **logarithmic**.

logarithmic Pertaining to the use of or relating to **nonlinear** computations.

logarithmic color space A specialized **color space** in which an **image** is re-
duced into a lower **bit depth** than it was originally stored as a means of us-
ing less **disk** space. To ensure that the most important image information is
retained, a special **color correction** is applied to reduce the **data loss**.

Because the human eye is far more sensitive to **intensity** changes in the low to middle ranges than to the high ranges, values in the high ranges are consolidated in order to preserve more steps in the lower ranges. **Video** files using **nonlinear encoding** are said to be stored with a **gamma correction**, whereas **film** images are said to be stored in the **logarithmic color space** or nonlinear **color** space. Because images stored in a nonlinear color space appear too bright due to the shifting of the low to midrange colors, the images must be reconverted to their original color space, or a **monitor LUT** is required to view them properly. *See also images under **image encoding**.*

logarithmic format A **digital image** stored in a **logarithmic color space**.

logarithmic space See **logarithmic color space**.

logarithmic to linear An **image conversion** that applies a **color correction** to **image**s stored in a **nonlinear color space** to convert them into a **linear color space**. Opposite of **linear to logarithmic**. See also **nonlinear encoding**, **linear encoding**. *See images under **image encoding**.*

log file The **file** that keeps a **history** of all the activity on a **computer**.

log format Shorthand for **logarithmic format**. See **nonlinear format**.

logical operator 1. Mathematical **operator**s used in **programming** that are an extension of the standard **arithmetic operator**s, such as equal to (==), not equal to (!=), greater than (>), less than (<), greater than or equal to (>=), and less than or equal to (<=). 2. See **Boolean operator**s.

logged in A **user** who is actively interacting with the **computer** is said to be logged in. See **log in**.

log image Shorthand for **logarithmic image**. See **nonlinear format**.

log in To gain access to a **computer** by identifying oneself with a **user name** and **password**. Synonymous with **log on**. Also spelled **login**.

login 1. See **user name**. 2. See **log in**.

login account The **database** that contains information about each **user** and their **login name**, **user ID**, and **home directory**.

login ID See **user name**.

login name See **user name**.

login password The unique **password** required by each **user** when requesting access to a **computer**.

logo The **graphic** representation of a company name or television station. See **2D logo**, **3D logo**, **flying logo**.

log off Also spelled **logoff**. See **log out**.

logoff See **log out**.

logo ID Shorthand for **logo identification (logo ID)**.

logo identification (logo ID) See **station identification (ID)**.

log on Synonymous with **log in**. Also spelled **logon**.

logon ID See **user name**.

logon name See **user name**.

log out To end a session with a **computer**. Also spelled **logout**.

logout See **log out**.

log sheet See **camera report**.

log space Shorthand for **logarithmic color space**. See **nonlinear color space**.

log to lin Shorthand for **logarithmic to linear**.

log to linear Shorthand for **logarithmic to linear**.

long focal length Referring to a **focal length** in which the **lens** is a far distance from the **film**. The longer the focal length, the greater the magnification of the **image**. Opposite of **short focal length**. See also **foreshortening**.

longitudinal time code (LTC) The **analog** time code that is recorded onto one of the unused **audio** channels on a **videotape** or on a **track** that is specifically reserved for **time code**. LTC can only be **read** when the tape is moving. Also called **address track time code**. See also **vertical interval time code (VITC)**.

long lens A **lens** with a **focal length** that is longer than a **normal lens** and produces a **narrow angle of view**. Because **object**s lose their sense of **perspective** and **depth** as they get farther away from **camera**, a **scene** shot with a long lens can appear flat, with all the objects appearing to be at the same depth. A **telephoto lens** is an example of a long lens. Opposite of **short lens**. See also **wide-angle lens**.

long list See **bake-off**.

long pitch The distance between **perforation**s along one side of a strip of **positive film**, which is slightly longer than the distance between perforations on a strip of **negative film**. Also called **positive pitch**. Opposite of **short pitch**.

long precision See **double precision**.

long shot (LS) 1. A **wide shot** used to establish the area of **action** and to allow actors enough room to enter, exit, and move about within the **scene**. 2. Also can refer to a **shot** that uses a **long lens**.

lookat The **object** toward which the **digital camera** is oriented.

lookup See **lookup table**.

lookup table (LUT) An **array** of **value**s used by a **computer program** to convert **data** from an **input** value to a new **output** value. For example, a special type of LUT called a **color lookup table (CLUT)** can be used to map **indexed color**s to **pixel**s or to perform a **gamma correction**. In **programming**, a LUT can also be used as a way of implementing mathematical **function**s.

lookup table operation An **image process** that **color correct**s an **image** by directly manipulating the **curve** representing its **lookup table** via **control point**s on a **spline**.

loop 1. See **film loop**. 2. In **programming**, a chunk of **code** that repeats itself as long as the predefined **condition**s continue to be true. See also **while loop**, **for loop**. 3. For **sound**, see **Automatic Dialogue Replacement (ADR)**. 4. An **animation cycle** in which the last **frame** matches up to the first frame so there is no visible hitch or pause in the **motion** when it is repeated. Also called **looping**, **hookup**.

looping 1. See **Automatic Dialogue Replacement (ADR)**. 2. See **loop**— Definition #4.

loop tree A device that plays back a **film loop** for the purposes of repeated viewing during **dailies** and **dub** sessions. The alternative to repeated viewings in the absence of a loop tree is referred to as **rock and roll**.

loose Shorthand for **loose framing**.

loose framing A loosely framed **shot** in which the **subject** is **film**ed with a lot of open space around them. This technique is often used to give flexibility in creating a **postmove** and to alleviate the need for **2D tracking**. By **shooting** a **locked-off**, loosely framed **scene**, a wide range of **image transformation**s can be created in **compositing**.

lorez Slang abbreviation for **low resolution**.

lossless See **lossless compression**.

lossless compression Any **compression** algorithm in which no **data** is lost. All the original information can be perfectly restored back to its original

state with a **decompression** algorithm. Opposite of **lossy compression**. See also **lossless image compression**.

lossless image compression An **image** compression technique that does not decrease or degrade the quality of the original image. With lossless compression, an image can be **compress**ed to take up less **disk space** and can then later be **decompress**ed back to its original state without any information loss. Opposite of **lossy image compression**.

lossy See **lossy compression**.

lossy compression Any **compression** algorithm in which **data** is lost and can never be completely restored back to its original state with **decompression** algorithms. Opposite of **lossless compression**. See also **lossy image compression**.

lossy image compression An **image compression** technique that decreases or degrades the quality of the original image. With lossy compression, an image can be **compress**ed to take up less **disk space**, but when it is later **decompress**ed, it cannot be restored to its original state due to lost information resulting from the compression technique. Opposite of **lossless image compression**.

loupe See **film loupe**.

low-angle shot A **shot** in which the **camera** is angled upward toward the **subject**. Opposite of **high-angle shot**.

low-contrast film A **film stock** containing an **emulsion** that produces a wide range of intermediate steps of gray. Opposite of **high-contrast film**. See also **contrast range**.

low end A general term referring to **visual effects work** whose budget dictates the delivery of lower-quality, **low-resolution** imagery. The opposite of **high end**.

low hat A very low **camera mount** used to film **low-angle shot**s. Similar to a **high hat**, but it can get the **camera** even lower.

lower left quadrant See **quadrant three**.

lower right quadrant See **quadrant two**.

low-level code See **low-level source code**.

low-level language See **low-level programming language**.

low-level programming language Any **programming language** that is a close approximation to **machine language**, such as **assembly language**,

and whose **code** does not provide easily readable **syntax** for **Programmer**s to interact with. Opposite of **high-level programming language**.

low-level source code Any **source code** written in a **low-level programming language**. See also **high-level source code**.

low-pass filter A **spatial filter** used to decrease high-frequency detail or **sharpness** in an **image**. Opposite of **high-pass filter**.

low res Abbreviation for **low resolution**.

low resolution In general, low resolution is relative to the **high-resolution** version of the item being discussed: 1. A **computer display** with too low a number of **dots per inch (DPI)** to accurately present an **image**. 2. An **object** containing a low **level of detail (LOD)** and, as a result, a low amount of **geometry**. 3. Any **digital image** smaller than the final delivery **format**. Opposite of high resolution.

low-resolution data See **low-resolution geometry**.

low-resolution geometry A **3D object** that contains a low **level of detail (LOD)** and is, typically, a **stand-in object** for the **high-resolution geometry** that will be sent to the **renderer**. Because high-resolution **object**s contain so much more **data**, the **user** will use a low-resolution object when interacting with the **software** in order to get a faster response time from the **computer**. See also **geometry replacement**.

low-resolution image 1. An **image** that is smaller than the final delivery **format**. 2. An image that does not contain enough **bit depth** and/or **pixel resolution** to properly **display** the desired information.

low-resolution object See **low-resolution geometry**.

low shot Shorthand for **low-angle shot**.

low-speed camera Any **camera** capable of **filming** at a rate lower than the normal speed of **24 frames per second**. Low-speed cameras are used most often with **motion control photography (MOCO photography)**, **time lapse photography**, and **stop-motion animation**. See also **high-speed camera**.

low-speed film See **slow-speed film**.

LPI Abbreviation for **lines per inch (LPI)**.

LS Abbreviation for **long shot (LS)**.

L-System Abbreviation for **Lindenmayer System (L-System)**.

LTC See **longitudinal time code (LTC)**.

luma-key Abbreviation for **luminance key**.

luminance 1. Often used synonymously with **brightness**. In the **HSL color space**, luminance typically represents the weighted **average** of the **RGB channels**. 2. The brightness **component** in **video**.

luminance key A **matte extraction** technique that separates a **subject** from its **background (BG)** based on the **luminance** values in the **image**. The best results are obtained from a brightly lit subject on a dark **background (BG)** or a darkly lit subject on a brightly lit background. See also **chroma key**, **color difference key**. *See also Color Plate 13.*

luminescence The generation of **light** created by a chemical reaction at relatively low temperatures. See also **incandescence**.

lupe Another spelling for **loupe**. See **film loupe**.

LUT Abbreviation for **lookup table (LUT)**.

LUT operation Shorthand for **lookup table operation**.

lux A metric standard for measuring the intensity of **light** that illuminates a **surface**. 1 **foot candle** = 10.76 lux.

Lux See **Lux laser film recorder**.

Lux laser film recorder A **laser film recorder** from Digital Cinema Systems that uses both **gas laser**s and a **diode laser** to write **digital image**s back onto **film**. See also **Lightning II laser film recorder**, **ArriLaser film recorder**.

LZW compression See **Lempel-Ziv-Welch compression (LZW compression)**.

Mac Abbreviation for **Macintosh computer (Mac)**.

Mac-based See **Mac-based system**.

Mac-based system A general term describing a **computer** that runs under the **Macintosh operating system (Mac OS)**. See also **DOS-based system** and **Unix-based system**.

Macbeth chart An **industry standard** chart made up of square **color** and gray patches that is used for reference to determine the proper **calibration** for **film** and **video**. Also called a **color checker**. *See also Color Plate 7.*

mach bands Another name for **banding** named after the physicist Ernst Mach.

machine code Synonymous with **machine language**.

machine dependent See **platform dependent**.

machine independent See **platform independent**.

machine language The **language** that is **read** and understood by the **computer** and does not require any additional **conversion**. Machine language consists of **binary** instructions that the computer can directly **execute**. Also called **machine code, low-level programming language**.

machine readable **Data** that can be easily **read** by a **computer**.

machine room The climate-controlled room where **system**s such as **computer**s, **peripheral**s, and **video** equipment are stored.

Macintosh See **Macintosh computer (Mac)**.

Macintosh clone A **Macintosh**-like **personal computer (PC)** that is not manufactured by **Apple Computer, Inc.**

Macintosh computer (Mac) A range of single-user **personal computer**s (**PC**s) manufactured by **Apple Computer, Inc.** Its **graphical user interface (GUI)** uses **icon**s on the **screen** to represent various **function**s as opposed to typing in **command**s on the **keyboard**.

Macintosh operating system (Mac OS) The **operating system (OS)** used on the **Macintosh** family of **personal computers** (**PCs**).

Macintosh user interface The **graphical user interface (GUI)** used by the **Macintosh** family of **personal computers** (**PCs**) developed by **Apple Computer, Inc.**

Mac OS Abbreviation for **Macintosh operating system (Mac OS)**.

macro 1. In **computer graphics (CG)**, a combination of explicit **commands** or **functions** that are grouped together to perform a specific task. 2. In **film**, shorthand for **macro lens**.

macro lens A **camera lens** that is capable of **focus**ing from **infinity** to an **extreme close-up (ECU)** on the **subject**.

macro photography Close-up **photography** using special **lens**es, such as a **macro lens**.

mag 1. Abbreviation for **magazine**. 2. Abbreviation for **magnetic tape**. 3. Abbreviation for **magnetic film**. 4. **Sound track** stock. See **magnetic sound**.

magazine A removable lightproof chamber that holds **film** before and after **exposure**. Although each **camera** takes a different type of magazine, they are typically attached to the top of the camera and form two circular protrusions containing separate chambers. The area in the first chamber that holds the fresh, **unexposed raw stock** is called the **feed side**, and the area containing the **exposed film** is called the **take-up side**. The **Clapper/Loader** is responsible for inserting the film magazines into the camera.

magenta One of the **complementary colors** used in the **CMY/CMYK color model**s. Equal amounts of **red (R)** and **blue (B)** combined together or the subtraction of **green (G)** from **white** creates magenta. Adding magenta to an **image** is the equivalent of subtracting green.

magic eye method See **parallel viewing method**.

magic hour The short periods during dawn and dusk that allow enough **light** for **filming** and can **capture** beautiful **lighting** on **film**.

magic number A special number contained in a **file header** that identifies the **file** as a particular type of **data**.

magic wand A 3D **input device** used for pointing and interaction—a type of three-dimensional **mouse**.

magnetic disk A **storage device** covered with a magnetic coating, such as a **hard disk** or **floppy disk**, on which **data** can be stored. Data on magnetic disks is magnetically recorded and can be erased and rerecorded.

magnetic film **Film** coated with iron oxide rather than **light**-sensitive **emulsion** for recording **sound**.

magnetic motion capture A **motion capture (MOCAP)** technique that uses an electromagnetic field to simultaneously record the **position**al and **rotation**al data of the **subject**, as opposed to **optical motion capture**, which records only the positional data and then calculates the rotational **data** after the session. Magnetic motion **capture** offers **real-time playback** of the captured data, but in older systems, the subject is required to be tethered to the **system**, which decreases his freedom of movement. Some companies are now offering tetherless magnetic motion capture systems.

magnetic recording The recording of **sound** on **magnetic tape** or **film**. Sound waves are picked up by a **microphone** and then converted into electric impulses that are sent to a magnetic recording head.

magnetic sound Any **sound** recorded on and played back from **magnetic tape**, **film**, or a **magnetic sound stripe** attached to a **print**. See **optical sound**.

magnetic sound stripe The strip placed in the **sound area** of **film** for the **sound track**. Another strip is also placed on the opposite side of the film so the film will run evenly through the **camera** or **projector**. See **magnetic recording**, **optical sound**.

magnetic stripe See **magnetic sound stripe**.

magnetic tape A **storage device** used to record **audio** and **video signal**s or to store **computer data**. The **tape** itself is a thin plastic strip that has an iron oxide coating on one side. **Half-inch tape** and **digital audio tape**s (**DAT**s) are examples of magnetic tape. See also **sequential access**.

magnetic tape device See **magnetic tape drive**.

magnetic tape drive A **drive** that **read**s and **write**s **magnetic tape**.

mag stripe See **magnetic sound stripe**.

mag tape Shorthand for **magnetic tape**.

mail See **electronic mail (e-mail)**.

mail address See **electronic mail address (e-mail address)**.

mail alias See **electronic mail alias (e-mail alias)**.

mailbox A **file** belonging to each **user** on a **computer** in which received **electronic mail (e-mail)** messages are stored for the user to **read**. See **electronic mail address (e-mail address)**, **electronic mail server (e-mail server)**, **mailing list**.

mailer A **program** used to deliver **electronic mail (e-mail)**.

mail filter A **program** that can sort incoming **electronic mail (e-mail)** into different categories for the recipient based on information contained in the **header**.

mailing list See **electronic mail alias (e-mail alias)**.

mail server See **electronic mail server (e-mail server)**.

main bus See **bus**.

mainframe 1. The **central processing unit (CPU)** of a **computer**. 2. See **mainframe computer**.

mainframe computer A large **computer** that serves many other connected computers. Usually stored in an air-conditioned **machine room**. See also **workstation**, **minicomputer**, **personal computer (PC)**, **laptop computer**.

main memory See **memory**.

maintenance release A **software** release that contains **bug** fixes.

main storage See **main memory**.

main title credits See **main titles**.

main titles The name of the **film** and the list of **credits** that appear at the start of a film that typically include the **Director**, **Producer**, main actors, and various other key personnel involved in the creation of the film. Opposite of **end titles**. See also **subtitles**, **insert titles**.

Main Unit See **First Unit**.

major release A **software release** that contains major changes, as opposed to a **software revision** that contains only minor changes.

makefile A **shell script** that gives the **computer** instructions to **compile** a piece of **source code**.

makeup effects (makeup FX) Typically, a term used to describe some sort of active change to the makeup applied to an actor that goes beyond the basic cosmetic makeup applied to make the actor look good. Examples of makeup effects can include a wound or injury, bleeding, fake tears, and sweat. See **foam latex**, **silicone**.

makeup FX See **makeup effects (makeup FX)**.

male matte A **matte** that is the inverse of a "normal" matte, in which the area we want to maintain is **black**, and the area we want to remove is **white**. Also called an **inverted matte**. Opposite of **female matte**. Together, the male and female mattes are referred to as **complementary mattes**. *See also image under complementary mattes.*

Mandelbrot Set A commonly used **fractal** calculation named after the French mathematician Benoit Mandelbrot, who developed it. In the Mandelbrot system, dimensionality is not confined to whole numbers, such as **two-dimensional (2D)** or **three-dimensional (3D)**, but rather makes it possible to think of an **object** as 1.35 or 5.78 dimensional. See also **Koch island**, **Julia Set**, **Lindenmayer System (L-System)**.

man page See **manual page**.

manual data input The process of a **user** inputting **data** into a **computer** by hand.

manual page **Online documentation** available on most **computer platform**s for referencing the **syntax** and usage of various **program**s and **command**s. See also **usage statement**, **online documentation**, **readme file**.

manuscript See **script**—Definition #2.

map 1. The **2D image** used to **texture** a **3D object**. See **texture map**. 2. The process of applying **texture coordinates** to a **3D object**. See **texture mapping**. 3. A **lookup table (LUT)** of **pixel values** used to modify each pixel without using neighboring pixels. 4. To map each **pixel** of an **image** to a **display device**. See **bitmap display** 5. Short for **bitmap**.

mapping See **texture mapping**.

maquette A small scale **practical model** used as a reference to build a **3D model**. See **digitize**.

Marcie An **image** of a blond girl that is often used to meet **lab aim densities (LAD)** to adjust a **print**. This particular image was originally used in a **Kodak** demo to introduce their 5245 low speed, fine **grain** film. Even though the "real" **LAD girl** is a brunette, Marcie is often referred to as the LAD girl as well. *See also Color Plates 4–6.*

Marcie head See **Marcie**.

marker See **clapboard**.

marking menu A customized **menu** that allows the **user** to quickly access a variety of **tool**s and **command**s by **click**ing and **drag**ging with the **mouse**.

markup language A language that uses specific **syntax** to indicate the layout and styling of a **text language**. The **Hypertext Markup Language (HTML)**, used in **Web page document**s, is an example of a markup language.

marquee See **box select**.

marquee select See **box select**.

married print See **composite print**.

martini shot A term used to describe the last **shot** to be **film**ed for the day. The idea is that the next **shot** will be found in a martini glass!

mask 1. An **image** or **overlay** that is used to partially or completely prevent an **image process** from altering the area within the mask. Also referred to as **matte**. 2. An object placed in front of the **physical camera** to reshape or partially obscure the view. 3. The plates that are inserted into the **gate** of a **projector** to adjust the **aspect ratio** of the **project**ed image. 4. See **masking**.

masking A term used to describe the addition of **black** outside the original **capture**d **image**, referred to as **padding**, as a means of adjusting the **aspect ratio** of the final image. For example, for images captured with **Super 35mm film**, whose final **viewing format** will be presented with an aspect ratio of **2.35**, **1.85**, or **1.66**, it is common to include the black padding on the final **composite**s for delivery to client. This practice is referred to as a **hard mask** because it is permanently built in to the final images, as opposed to the masking of the images with physical plates inserted into the **gate** of a **projector** during **screening**. Hard masking is often used for **visual effects work** as a means of saving on **disk space**, **render** times, and the creation of unnecessary work that will not be seen in the theatre once masking is applied. See also **letterbox extraction area**, *images under film extraction*.

mass Mass is one of the **physical properties**, often used in **motion dynamics**, that is similar to but not quite the same as **weight**. While the weight of an **object** is affected by **gravity**, the **mass** of an object remains the same regardless of the amount of gravity present. See also **volume**.

mass storage A **storage device**, usually external, that can hold large amounts of **data**.

master 1. Any **device** that controls another device, called the **slave**. 2. See **master computer**. 3. See **master program**. 4. See **master videotape**.

5. Short for **master positive**. See **intermediate positive (IP)**. 6. See **master shot**.

master computer A **computer** that controls another computer, called the **slave computer**.

master copy The first copy. Synonymous with **first generation**.

master positive Synonymous with **intermediate positive (IP)**.

master program A **program** or **process** that controls another program, called the **slave program**.

master scene The **filming** of a continuous, chronological **take** of an entire event in one **location**. A master scene will often be filmed simultaneously with multiple **camera**s to allow for the **inter-cutting** of takes during **editing**. This technique is valuable when filming **uncontrolled action**. See also **triple-take**.

master shot A **shot** from a viewpoint in which the **subject**'s relationships are clear, and the events taking place can be easily portrayed and understood without the use of other shots to explain the action. Opposite of **establishing shot**.

master time code The **time-code generator** to which all other secondary **time code** generators are synchronized.

master videotape 1. The **videotape** containing the final **audio** and **image** mix. 2. The original videotaped footage.

Matador A **paint software** developed and sold by **Avid Technology, Inc.**

match clip A **clip** of **film** that has been **color correct**ed to represent the look and feel of the **scene**s that the **Director** wants to see. This clip is used to **color grade** the **scan**ned images for use in **compositing**.

match cutting Another name for **continuity cutting**.

matched cut A method of **editing**, called **continuity cutting**, in which smooth and continuous action flows from one **scene** to another. Examples include two **shot**s of the same **action** cut together to maintain continuous **motion** or two shots with different **subject**s sharing precisely registered graphic elements, such as **cutting** from the moon to the pupil of an eye.

matched dissolve A type of **dissolve** in which the two sets of **image**s used are similar in **motion** and content in order to get a smoother **transition**.

matched move 1. Referring to **element**s for the same **shot** that were **film**ed with **motion control (MOCO)** and, as a result, share the same **camera** move. 2. Referring to the **camera curve**s resulting from **3D tracking** of a **live action plate** as a means of adding **CG element**s that will be locked to that **plate**.

match frame edit An edit in which the source and record **tape**s begin exactly where they left off from the previous **edit**.

matchmove The process of extracting the **camera move** from a **live action plate** for use in creating **CG element**s that travel and lock with the **motion** on the **plate**. A matchmove is often created by hand by the **user**, often with the use of **survey data**, as opposed to **3D tracking** in which special **software** is used to help automate the process.

Matchmover An individual who creates a **camera move** in the **computer** that mimics the camera **motion** used when **shoot**ing the **live action plate**. See also **matchmove**, **3D tracker**.

material The visual **attribute**s of an **object**, such as its **color** and **texture**, that define how the object will look when hit with a **light source**.

material module The portion of a **3D software package** used to create and modify **material**s.

mathematical expression See **expression**.

mathematical function See **function**.

matrices Plural of **matrix**.

matrix A group of **value**s contained in a rectangular **array**. The array can be any size and contain any number of **dimension**s. Typical **matrices** used in **computer graphics (CG)** for calculating **transformation**s include a 3×3 **matrix** and 4×4 **matrix**.

matte 1. A **grayscale**, single **channel** image used to control the **opacity** of another **image**. The **pixel values** of the matte control the opacity of the **RGB channels** that are combined with it to achieve the desired **compositing operation**. Many types of mattes are used, such as an **articulate matte, complementary matte, difference matte, edge matte, garbage matte, hold-out matte, static matte, traveling matte**. See **alpha channel**, *image under **erode**, Color Plates 12, 19, 23–25*. 2. See **matte object**. 3. See **mask**.

Matte Artist See **Matte Painter**.

matte box A semienclosed **frame** mounted in front of the **camera lens** into which **filter**s and **mask**s can be placed.

matte channel Another name for **alpha channel**.

matte divide A **compositing operation** that divides the **RGB channels** of an **image** by its **alpha channel**. See **unpremultiply**.

matte extraction Any process used to create a **matte**, such as **rotoscope**, or pulling a **key**.

matte line An **artifact** of an improperly executed **composite** in which the **foreground (FG)** layer reveals a noticeable light or dark outline when placed **over** the **background (BG)** layer. Such a composite is said to feel "compy." See **premultiply**.

matte multiply A **compositing operation** that multiplies the **RGB channels** of an **image** by its **alpha channel**. See **premultiply**.

matte object A **3D object** that acts as a **hold out matte** to occlude other objects in a **scene** from being visible. Matte objects can be used either during **rendering** to produce the desired matting in the rendered **image** or can be rendered as a separate **alpha channel** for use during **compositing**.

Matte Painter An individual who creates **matte painting**s.

matte painting A hand-painted image, usually intended to act as the **background (BG)** layer to be combined with other **live action** or **full CG** elements in the **foreground (FG)**. Matte paintings can be created with a variety of techniques, including painting on glass for use in **rear projection (RP)** or **front projection (FP)** photography, with a **computer paint program** or with a combinaton of **3D geometry**, **texture mapping** and additional hand painting techniques. *See Color Plate 60.*

matte pass 1. In **multiple-pass photography**, a **pass** that can be used as a **matte** during **compositing**. 2. In **multiple-pass rendering**, a separate **render** of the **alpha channel** of one of the **object**s in the **scene** for use during compositing. See also **beauty pass**, **reflection pass**, **matte pass**, **light pass**.

matte reveal See **reveal matte**.

matte shot 1. For **multiple-pass photography**, see **matte pass**. 2. Often used to describe any **shot** with a **matte painting** as one of its **elements**. 3. Any photographic technique in which artwork, such as on glass, is combined with **live action**. 4. See **front projection**, **rear projection**.

max See **maximum operation**.

maximize See **open**—Definition #2.

maximum density See **D-max**.

max operation See **maximum operation**.

maximum operation A **compositing operation** that compares the **brightness** values of the **pixel**s in *Image A* with the corresponding pixels in *Image B* and keeps the higher value. Opposite of **minimum operation**. *See image below, and image under **layering operation**.*

Maya The **3D software package** developed by **Alias/Wavefront** that is the next-generation combination of **Alias** and **Wavefront** softwares.

Maya Embedded Language (MEL) The **scripting language** used by **Maya** software.

MB Abbreviation for **megabyte (MB)**.

MBPS Abbreviation for **megabytes per second (MBPS)**.

A Max B

M-byte Abbreviation for **megabyte (MB)**.

MCU Abbreviation for **medium close-up shot (MCU)**.

mean See **average**—Definition #1.

mechanical concepts system A type of **motion control rig (MOCO rig)** that is a modified version of a **Cartesian Robot system** and only allows for up-and-down **motion** along straight lines. Side to side motion can be either a straight **line** or an arc. See also **gantry system**, **boom/swing system**.

mechanical effects See **practical effects**.

mechanical mouse A **pointing device** that uses a semiencased ball housed in the underside of a **mouse** to move across a **mouse pad**. The **rotation**s of the ball are calculated by two **sensor**s at right angles to each other inside the mouse. The distance and direction of **motion** are then **transmit**ted from the sensors to the **computer** through a connecting wire, often referred to as the "mouse's tail." Also called a **roller-ball mouse**. See also **optical mouse**.

median See **average**—Definition #1.

Media 100 The trade name for a **digital editing** system.

Median filter A **blur filter** that replaces the **value** of each **pixel** in an **image** with the median value of its neighboring pixels. The median filter is good for removing single pixel noise **artifact**s while causing only a slight reduction in **image sharpness**.

medium close-up shot (MCU) A **shot** that **film**s an actor from approximately midway between the waist and shoulders to above the head.

medium shot (MS) A medium shot that falls in between a **long shot (LS)** and a **close-up (CU)**, used to **film** the actors from somewhere between above the knees and below to waist up to the top of their heads. While several actors might be present within the shot, the medium shot is still close enough to **capture** their facial expressions and gestures. The **two-shot** is a commonly used medium shot.

medium long shot (MLS) A **shot** between a **long shot (LS)** and a **medium shot (MS)**. Also called a **full shot**.

mega Prefix for one million. See **megabit**, **megabyte (MB)**.

megabit One million or, more specifically, 2^{20} or 1,048,576 **bit**s. See also **megabyte (MB)**, **kilobit**, **gigabit**.

megabyte (MB) One million or, more specifically, 2^20 or 1,048,576 **byte**s. Megabytes are a standard **unit** used to measure the **storage capacity** of **disk**s and **memory**. See also **kilobyte (KB)**, **gigabyte (GB)**, **megabit**, **terabyte (TB)**.

megabytes per second (MBPS) A measurement of **data transfer rate** based on one million **byte**s per second. Also referred to as **millions of bits per second**.

megahertz (MHZ) One million **cycles per second (CPS)**. The **unit**s used to measure the **transmission** speeds of **device**s, such as the speed of a **processor**. See also **hertz (HZ)**.

MEL Abbreviation for **Maya Embedded Language (MEL)**.

meltdown The **overload** of a **system**. See **network meltdown**.

memory The working space in a **computer** that can hold **data** in a **machine readable** format. Often used synonymously with **main memory** or **random access memory (RAM)**. Main memory is lost when the computer is turned off. See **memory cache**, **disk cache**.

memory address The precise location in **memory** where a piece of **data** is stored.

memory cache The portion of **memory** between the **main memory** and the **central processing unit (CPU)** that enables the **computer** to process **data** faster. Also called **internal cache**. See also **disk cache**.

memory capacity The amount of **memory**, usually expressed in **byte**s, available on a **computer**.

memory device See **storage device**.

memory intensive A **process** or **program** that requires a large amount of **memory** to calculate its processes. Also called a **memory hog**. See also **CPU intensive**.

memory hog See **memory intensive**.

memory usage The amount of **memory** used by a **program** or **process**.

Mental Ray A **renderer**, developed by Mental Images, that is commonly used as an alternative to **Softimage**'s native renderer.

menu A list of **option**s available for the **user** to choose that generally falls into the category of a **pull-down menu** or **pop-up menu**. The user **click**s and holds the **mouse button** on the desired menu's name and, without releasing the mouse **button**, moves the mouse **pointer** over the desired

menu option. When the desired item becomes **highlight**ed, the **mouse** button can be released. See also **marking menu, cascading menu**.

menu bar A set of horizontal **menu**s located at the top of a **window** that allow **user**s to **click** on and select various **function**s such as **file, edit, view, display**.

menu cell See **menu field**.

menu driven Any **software application** that allows the **user** to drive the **software** with a series of **menu option**s as opposed to using a **command line interface**.

menu field An area in a **window** or **node** that allows a **user** to enter precise **value**s, **command**s or **expression**s. Also called a **menu cell, cell, input field, field**.

menu item See **menu option**.

menu option A specific item chosen by a **user** among a series of choices offered within a particular **menu** in a **computer interface**. Also called **menu item**.

menu selection See **menu option**.

mesh A specific type of **surface** whose **point**s are ordered as a series of **rows and columns**. See **polygon mesh**.

metaball A special type of **sphere** whose **surface** becomes visible when its **density field** reaches a predefined **threshold** value. When the surfaces of a metaball exist due to the **density** value reaching the threshold value, it can be referred to as an **isosurface** because *iso* is Greek for "equal." The center of a metaball contains the strongest force field, whereas the perimeter is the weakest. When two metaballs are close to one another, their density fields add together, which is referred to as **fusion**. The density field and threshold of each metaball can typically be controlled by the **parameter**s of **weight, range**, or **influence** that control the way the metaballs fuse together. Also called **potential function modeling**. See also **negative density, density distribution**. *See image on following page.*

metaball element See **metaball**.

metaball field See **density field**.

metaball primitive Some **3D software package**s offer metaball **primitive**s, such as a cube or cylindrically shaped **metaball**.

metaball surface A **metaball** surface is created when the **density field** of one or more metaballs reaches the predefined **threshold** value and becomes visible.

The **density field** and **threshold** of each **metaball** determine the **fusion** that occurs between different metaballs.
IMAGE CREATED USING HOUDINI AND PROVIDED COURTESY OF SIDE EFFECTS SOFTWARE.

metaball systems The hierarchical structure used to organize a series of **metaball**s. A metaball **system** functions like a normal **hierarchy** in that multiples of metaballs can be **translate**d, **rotate**d, and **scale**d as a **group**. Additionally, metaball systems define the way in which different groups of metaballs **fuse** with one another. **Fusion group**s are used to define which metaballs systems are allowed to fuse with other systems.

Meta-Clay The **metaball** module used in **Softimage**.

meta element See **metaball**.

meta field See **density field**.

metamorphosis See **morph**.

meta primitive See **metaball primitive**.

meta surface See **metaball surface**.

meta system See **metaball system**.

MHZ See **megahertz (MHZ)**.

microchip See **computer chip**.

microcomputer A small **computer**, such as a **laptop** or **personal computer (PC)**, that is built with a **microprocessor** and designed to be used by one person at a time. See also **minicomputer**.

microelectronic A fancy name for a **computer chip**.

microphone A **device** capable of converting sound waves into electric **signal**s for recording.

microphone boom See **boom microphone**.

microprocessor An **integrated circuit** that holds the entire **central processing unit (CPU)** of a **computer** on a single **chip**. The first microprocessor created came from **Intel, Corp.** in 1971 and led to the development of **personal computer**s (**PC**s).

Microsoft, Corp. The largest supplier of **operating system**s (**OS**) and other **software** for **IBM PC** and compatible **computer**s. Products include **MS-DOS**, **Microsoft Windows**, **Windows NT**.

Microsoft Windows The proprietary **window system** and **user interface** developed by **Microsoft, Corp.** to run with **MS-DOS**.

middle click To depress, or **click**, the middle **button** on the **mouse**. See **left click**, **right click**.

MIDI Abbreviation for **Musical Instrument Digital Interface (MIDI)**.

midtones A term used to describe the middle range of **value**s in an **image**. See also **black point**, **white point**, **highlight**s, **shadow**s.

milky Another term to describe a **flat** or **flashed** image.

millions of bits per second See **megabytes per second (MBPS)**.

millions of instructions per second (MIPS) The **unit**s used to measure the speed at which a **processor** can **execute** instructions.

min See **minimum operation**.

miniature Any **physical model** of a **subject** built in a scale smaller than **full scale**.

miniature photography The **filming** of a **physical model** or **environment** that is built in a scale smaller than life size. See **model scale**, and *Color Plates 50–53, 60, 64–66.*

miniature scale See **model scale**.

miniature set A **set** or **model** that is built smaller than its actual size. See **full size set**.

miniature set piece A portion of a **set** or **model** that is built smaller than its actual size. Opposite of **full size set piece**.

miniature shot Any **shot** that uses a **miniature** as one of its **element**s.

Miniature Supervisor See **Model Supervisor**.

minicomputer A midsized **computer** in terms of both size and power. Minicomputers lie somewhere between **workstation**s and **mainframe computer**s. See also **microcomputer**.

Mini-DV A small digital **video** camcorder developed by Sony.

minimize See **close**.

minimum density See **D-min**.

min operation See **minimum operation**.

minimum operation A **compositing operation** that compares the **brightness** values of the **pixels** in *Image A* with the corresponding pixels in

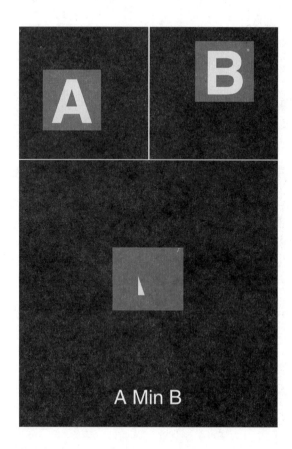

Image B and keeps the lower **value**. Opposite of **maximum operation**. *See image below and image under* **layering operation**.

minus 1. See **difference operation**. 2. A standard **arithmetic operator**.

minus operation See **difference operation**. *See image on following page and image under* **layering operation**.

MIP mapping From Latin *multi in partem* meaning "many parts," this is a **texture mapping** technique that calculates the **resolution** of the **texture maps** applied to a **surface** based on each **object**'s proximity to the **camera view**. The texture maps are successively **average**d down to produce **antialias**ed results by using several texture **pixel**s to contribute to the single pixel being **render**ed. See also **bilinear interpolation**.

MIPS Abbreviation for **millions of instructions per second (MIPS)**.

Mirage 1. An **effects** package developed by **Quantel** that is capable of manipulating **image**s in **3D space** for **real-time** effects. 2. A **facial capture** technique developed by Life F/X.

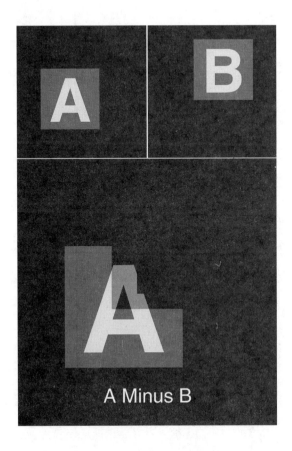

A Minus B

mirror 1. To **scale** an **image** or **3D object** by negative 1 along the **X-axis** or **Y-axis**. Also called **flip, flop, reflect**. 2. See **mirror site**. 3. To **copy** and store **data** on two or more **storage device**s.

mirror image See **mirror**—Definition #1.

mirror site To set up a **network** site that is a duplicate of another site as a means of reducing **traffic**.

Mitchell The trade name of a line of profession **film camera**s.

Mitchell blur See **Mitchell filter**.

Mitchell filter A good-quality **filtering algorithm** used to **resample** a **digital image**. A Mitchell filter is well suited for scaling an **image** to a larger **resolution**. See also **impulse filter, box filter, triangle filter, Sinc filter, Gaussian filter**.

mix 1. For **compositing**, see **mix operation**. 2. In **video editing**, combining two **clip**s, usually by **linear interpolation**.

Mixer See **Sound Mixer**.

mixing 1. For **compositing**, see **mix operation**. 2. For **sound**, see **sound mixing**.

mixing board An electronic console used to adjust the **equalization** for each **channel** within a **sound track**.

mix operation A **compositing operation** that combines two **image**s based on a **weight**ed **average** of their **pixel value**s. For example, a mix of 50 percent would reveal an evenly combined mix of *Image A* and *Image B*. *See image on following page and image under* **layering operation**.

MOCAP Abbreviation for **motion capture (MOCAP)**.

MOCO Abbreviation for **motion control (MOCO)**.

MOCO camera Abbreviation for **motion control camera (MOCO camera)**.

MOCO data Abbreviation for **motion control data (MOCO data)**.

MOCO offsets Abbreviation for **motion control offsets (MOCO offsets)**.

MOCO Operator Abbreviation for **Motion Control Operator (MOCO Operator)**.

MOCO passes Abbreviation for **motion control passes (MOCO passes)**.

MOCO photography Abbreviation for **motion control photography (MOCO photography)**.

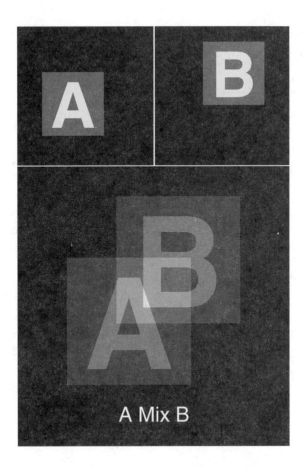

A Mix B

MOCO rig Abbreviation for **motion control rig (MOCO rig)**.

MOCO shot Abbreviation for **motion control shot (MOCO shot)**.

MOCO software Abbreviation for **motion control software (MOCO software)**.

mode The current operational state of a **computer** or **application**. See **module**. 3. See **maquette**.

model 1. In **computer graphics (CG)**, the **3D geometry** that used for **animation**, **lighting**, and **rendering**. 2. A **physical model** built in **miniature** or **full scale** for use in **plate photography**. 3. See **maquette**.

model constraint A method of constraining the range of **motion** allowed in a **model** by associating its **transformation**s to another model. See **constraint**, **position constraint**, **rotation constraint**, **direction constraint**.

model coordinates See **local coordinates**.

Modeler 1. The artist who **model**s the necessary **3D object**s for a **project**, such as **character**s, **set**s, and **prop**s. In some cases, the Modeler will begin by **digitizing** or **laser scanning** a **physical model**, such as a **maquette**, to get a good starting point toward the final model. 2. The specific **3D software package** used to create a **3D model**. 3. The artist who builds **physical model**s for use in **live action** and **stage photography**.

modeling In **computer graphics (CG)**, the process of creating **geometry** in **3D space**.

modeling package See **modeling software**.

modeling software A **software application** specifically designed to allow the **user** to create and modify **3D geometry**. Also called a **modeling package**. See also **lighting software**, **render software**, **tracking software**, **paint software**, **particle software**, **compositing software**.

modeling units The **unit**s of measure, such as millimeters, inches, or feet, that are used to create a practical or **CG model**. For **computer graphics (CG)**, the modeling units need to be determined at the start of a **project** so that all **user**s are working in the same **3D space**.

Model Maker An individual who makes **physical model**s for use in a **film**.

model module The portion of a **3D software package** used to create and modify **geometry**.

model mover Any **computer**-controlled **device** onto which a **physical model** is mounted as a means of moving it during a **shot**.

model scale The size of a physical or **CG model** expressed as a fraction relative to its actual size. For **miniature photography**, an appropriate **model** scale is important to achieve the illusion that the **action** occurred in **full scale** rather than with **miniature**s. For the **film**ing of falling **object**s whose **motion** is based on **gravity**, such as explosions, the camera **frame rate** is governed by the model scale. However, when object motion is based on time, speed, and distance traveled, **camera speed** should be increased by the inverse of the square root of the model scale. For example, for a model built at 1/16 full scale, the inverse of 1/16 is 16; the square root of 16 is 4; and therefore, the frame rate should be 4 times greater than its normal speed, which is 24 × 4 or 96 **frames per second (FPS)**. However, it is often desirable to film an object, such as a flipping car, at an even slower frame rate to ensure that the audience actually can see all the action. *See also Color Plates 50–53, 59, 64–66.*

model sheet For **cel animation**, the xeroxed copies of the approved **character model**s that are use to ensure consistency in drawing and **color** done by all the artists working on the **film**.

Model Shop The **facility** where **physical model**s are built.

Model Shop Crew All personnel involved in the creation of the **physical model**s used to create the **visual effects (VFX)** of a **project**.

Model Shop Supervisor See **Model Supervisor**.

model shot Any **shot** in a **film** that uses a **physical model** as one of its **element**s.

Model Supervisor 1. The individual responsible for the **3D model**s that are created for a **project**. The Model Supervisor manages a team of **Modeler**s and is responsible for delivering models that support the needs for **character animation**, **lighting**, and **texture**s. 2. The individual responsible for the creation of all the **physical model**s used on a **film**. The Model Supervisor manages the **Model Shop Crew**. Also referred to as **Model Shop Supervisor**, **Miniature Supervisor**.

modem Abbreviation for **modulator/demodulator (modem)**.

modulator/demodulator (modem) A **peripheral device** designed to **transmit** data across telephone lines. A modem converts the **digital data** from a **computer** into **analog data** to be sent across telephone lines, and then re-converts it back to digital **data** when it is sent back to the computer. Modems are used for sending and receiving **electronic mail (e-mail)** and for accessing the **Internet**.

module A self-contained **unit** of a **program** that is used within a larger **application**. Also called a **mode**.

moire pattern A wavelike **artifact** caused by repetitive patterns in an **image** or when the lines in a **video image** are nearly parallel to the **scan line**s on the **display device**.

monitor 1. A **display device**, such as a **computer** or a television, used to **display** information on **screen**. The **color temperature** on a **calibrate**d monitor should read at approximately **6500 Kelvin**. See **cathode ray tube (CRT)**, **liquid crystal display (LCD)**. 2. A **program** that observes and manages the activities of other programs **run**ning on a computer.

monitor calibration The process of creating a **color lookup table (CLUT)** that will **display** image **color**s on a **computer** or **video monitor** as closely as possible to the the way they will look in their final **viewing format**,

such as on **film** or **videotape**. **OptiCal** is a popular monitor **calibration** tool used in the industry. See also **lookup table (LUT)**.

monitor display To **display** an **image** on a **monitor**.

monitor lookup table (monitor LUT) See **color lookup table (CLUT)**.

monitor LUT Shorthand **for monitor lookup table (monitor LUT)**. See **color lookup table (CLUT)**.

monochromatic Meaning "of one **chrominance**" and referring to an **image** made up of a single **hue**. Variations within the image are based only on **luminance**. A **grayscale image**, and a **sepia tone**d image are both examples of monochromatic images. *See also Color Plate 15.*

monochromatic image See **monochromatic**.

monochrome See **monochromatic**.

monochrome operation An **image operator** that removes all the **color** from an **image**.

monofilament A synthetic, nonstranded version of string that is widely used in **makeup effects (makeup FX)** because it is very difficult to see on **camera**. For example, thin monofilament can be placed under the flesh portion of a makeup effect and then pulled during **filming** to create the illusion of the flesh being cut or ripped away.

montage An **editing** technique used to condense time or space by cutting a series of short **scenes** together with quick **cuts**, **dissolves**, and **wipes**. Used to portray a portion of the story that does not require great detail but must be included to maintain **continuity**.

monthlies A monthly **screening**, open to all employees, that occurs at many **visual effects (VFX)** facilities to showcase the **shots** that were **finalled** across the month. Because most **Digital Artists (DAs)** only go to the **dailies** for the **show** they are assigned to, monthlies offer an opportunity to see what all their fellow artists have been creating for other **projects**.

morph Generally, any technique in which a minimum of two **3D objects** or two **digital images** are blended together to create a new **interpolated** result. In most cases, this takes place over a period of time to create a series of **frames** that **animate** from Point A to Point B. However, the term *morph* is also used to describe any effect used to create **motion** within a single **image** or **object**, either by animating a **mesh** placed over the image or by animating the object with any variety of **deformation** tools,

such as a **lattice box**, **point group**s, or **motion dynamics**. See **2D morph**, **3D morph**.

morph targets The intermediate **keyshape**s used to **morph** a series of **image**s or **object**s together when using **2D morph**ing or **3D morph**ing techniques.

MOS Abbreviation from German slang *mit out sprechen*, which translates to "minus optical **sound**." Used to describe shots **film**ed without recording synchronized sound.

mosaic An **image process** that divides an **image** up into equal squares. Also called **pixellation**.

Mosaic The first **World Wide Web browser** created by the University of Illinois National Center for Supercomputing Applications. Mosaic was the first breakthrough that caused a push toward the **Internet** that we know today.

mother board The main **circuit board** in a **computer** that contains the **central processing unit (CPU)**, the **bus** and **expansion slot**s. Additional boards plugged into the mother board are called **daughter board**s.

motif A standard **graphical user interface (GUI)** for the **Unix operating system (Unix OS)**.

motion The process of changing **position** over time. See **animation**.

Motion Animator See **Animator**.

motion artifact A general term describing all forms of **image** artifacts due to **motion**, such as **strobing**, **wagon wheeling**, **aliasing**, **jitter**, and **chewing**.

motion base A **device** on which a **set** or **prop** can be placed and whose **motion** can be controlled by **motion control (MOCO)** for repeatable moves. Also called a **motion rig**, **motion platform**, **gimble**. *See Color Plates 59–60.*

motion blur The **blur**ring or smearing of an **image** caused by the distance an **object** moves relative to the amount of **camera motion**. 1. For **film**, the natural blurring of the **capture**d images that occurs when the **camera** shoots a moving object. Shots filmed with a slow **shutter speed** will produce more **motion** blur than shots filmed with a fast shutter speed. 2. For **computer graphics**, this effect needs to be added artificially, either by **3D motion blur** that is calculated during **rendering** or with a **2D motion blur** that is applied as a **post process** on the already rendered images. Moving objects rendered without motion blur can create **strobing**.

motion capture (MOCAP) An **animation** technique in which the precise **position** and movement of an actor is recorded so it can be applied to the **skeleton** of a **3D character**. The two basic types of motion capture techniques are **optical motion capture** and **magnetic motion capture**. See also **channel animation**.

motion control (MOCO) A **filming** technique in which the **motion** of the **camera** and/or **subject** being photographed is driven by a mechanism that can continuously repeat the move. MOCO is used most often for **stage photography** in which **multiple pass**es of an **object** must be filmed in order to provide the greatest control over **color** and integration during **compositing**. See **multiple-pass photography**, *Color Plates 58–59, 64–66*.

motion control camera (MOCO camera) A **camera** whose **motion** and settings are controlled by a **computer** for use in **motion control photography (MOCO photography)**.

motion control data (MOCO data) The **motion curve**s defining the **motion** performed with a **motion control rig (MOCO rig)**. This **data** can be imported into various **software package**s to help align the **CG element**s with the **element**s shot with **motion control (MOCO)**. It has also become more common to convert the **previs** data into **curve**s that can be read by the motion control rig. **Kuper software** is a popular **format** used for motion control. See **Kuper data**.

motion control offsets (MOCO offsets) In **motion control photography (MOCO photography)**, the distance between the **position** of the **motion control rig (MOCO rig)** on **frame** 1 of the **motion control (MOCO)** move and the position at which the **rig** is in its "zeroed out" or home default setup position. This distance must be measured in order to properly set up and position the **CG camera** relative to rig. See also **nodal offset**s.

Motion Control Operator (MOCO Operator) The individual that creates and modifies the repeatable **motion curve**s for the **camera** and **object**s during **motion control photography (MOCO photography)**.

motion control passes (MOCO passes) The individual **plate**s **capture**d with **motion control (MOCO)**, of the same **subject**, using different **lighting** or **exposure**s. See **multiple-pass photography**.

motion control photography (MOCO photography) Referring the **filming** of **plate elements** using **motion control (MOCO)** technology. See also *Color Plates 58–60, 64–66*.

motion control rig (MOCO rig) The rig that supports the **motion control camera (MOCO camera)**. Common types of MOCO rigs include the **boom/swing system**, **Cartesian robot system**, **gantry system**, and **mechanical concept systems**.

motion control shot (MOCO shot) Referring to any **shot** that uses an **element** shot with the use of **motion control (MOCO)**.

motion control software (MOCO software) The **software application** designed to allow the **user** to create and modify **motion control (MOCO)** moves. See **Kuper software**.

motion curve The **data** in the form of a series of **curve**s that represent each **channel** of **motion**, such as **translate**, **rotate**, and **scale**, for a particular **object** or **camera**.

motion cycle See **animation cycle**.

motion dailies See **animation dailies**.

motion dynamics The mathematically precise study of the **motion** of **object**s. The use of motion dynamics is of great help in **computer animation** when creating **physical effects** such as **gravity**, **wind**, and **collision**. Motion dynamics can be used with **particle**s, **rigid body object**s, or **soft body object**s. For example, while an object falling down a set of stairs can be very difficult to **animate** in a realistic way with **key frame**s, the physical laws of motion dynamics would be able to calculate a very precise and natural **simulation**. See **physical forces**, **physical properties**, **collision detection**, **collision avoidance**, **time steps**, and *Color Plates 43–45*.

motion dynamics simulation See **simulation**.

Motion Lead See **Animation Lead**.

motion parallax See **parallax**.

motion path 1. The **curve**s used to define the **motion** of an **object**. 2. The curve that an object is attached to and travels along in **path animation**. A separate **timing curve** can be referenced to adjust the speed of the object as it moves along the path.

motion picture Another term for **film**.

Motion Picture Association of America (MPAA) An organization representing many film **distributor**s.

motion platform See **gimble**.

motion preview The ability to **playback**, in **real time**, the **interpolate** motion that the **computer** has created between a series of **key frame**s. All **3D software package**s have this ability to view the calculated **motion**. Each time key frames are modified, added, or deleted, the **in-between** frames need to be recalculated once again for another motion preview. This process continues until the desired motion is achieved. Also called **playblast**, movie file.

motion rig See **gimble**.

motion setup See **character setup**.

Motion Setup Supervisor See **Character Setup Supervisor**.

Motion Setup TD Abbreviation for **Motion Setup Technical Director (Motion Setup TD)**. See **Character Setup Technical Director (Character Setup TD)**.

Motion Setup Technical Director (Motion Setup TD) See **Character Setup Technical Director (Character Setup TD)**.

motion simulation See **simulation**.

motion study The detailed analysis and testing of a **CG character** to determine the style and type of **motion** that will be used to best portray the character. See **walk cycle**, **animation cycle**, **run cycle**.

Motion TD Abbreviation for **Motion Technical Director (Motion TD)**. See **Character Setup Technical Director (Character Setup TD)**.

Motion Technical Director (Motion TD) See **Character Setup Technical Director (Character Setup TD)**.

motion test To **block** out the **motion** of the **object**s in a **scene**. See **previs**, **layout**.

motor cue The first **changeover cue** on a **release print** to alert the **Projectionist** to turn on the second **projector** in preparation for the **changeover**.

mount To make a **remote disk** resource accessible from your **workstation**.

mouse A hand-held **input device** that allows the **user** to **point**, **click**, and **drag** across a **computer screen**. The mouse is moved across a flat horizontal surface, such as a **mouse pad**, and generally has one or more **button**s with different **functions** recognizable by the particular **system** to which it is connected. The mouse gained its name because the wire that connects it to the **computer** or **keyboard** makes it look like a **mouse tail**. Also called a **puck**. See also **mechanical mouse**, **optical mouse**.

mouse button The individual **button**s that control the behavior of a **mouse**.

mouse click See **click**.

mouse cursor See **cursor**.

mouse command Any combination of **motion** and **button** pushing with a **mouse** that instructs a **computer** or **application** to take a particular action. See **keyboard command**, **accelerator**.

mouse mat See **mouse pad**.

mouse pad For an **optical mouse**, a rectangular, metallic surface that **read**s the movements of the **mouse**, and for a **mechanical mouse**, a soft, rectangular surface that makes the **track ball** roll smoothly. Many mouse pads contain some form of advertising across the surface. Also called a **mouse mat**.

mouse pointer See **mouse cursor**.

mouse tail A slang phrase used to refer to the wire that attaches the **mouse** to the **computer**.

movie 1. Synonym for **film**. 2. See **movie file**.

movie file A **sequence** of **moving image**s created to view on the **computer screen** or other **display device**. Also called a **flipbook**. See **QuickTime**.

moving images Any series of **image**s that portray **motion** when viewed in **real-time**. Opposite of a **static image**.

Moving Pictures Experts Group (MPEG) 1. MPEG uses a **lossy compression** technique specifically designed for the compression of a **sequence** of **image**s. MPEG uses a similar compression scheme as **JPEG** but also adds **frame**-to-frame **temporal** compression. 2. The organization that develops international standards for **compression** and **processing** for moving images and **audio**.

moving shot A **shot** in which the **camera** changes **position**, via a **pan**, **dolly**, **truck**, **crane**, and/or **boom**, during the **filming** of **action**. Opposite of a **lockoff shot**. See also **travelling shot**.

Moviola The trade name for a portable upright **film editing** machine. See also **flatbed editor**.

MBPS Abbreviation for **megabytes per second (MBPS)**.

MLS Abbreviation for **medium long shot (MLS)**.

MPAA Abbreviation for **Motion Picture Association of America (MPAA)**.

MPEG Abbreviation for **Moving Pictures Experts Group (MPEG)**.

MPEG compression A **lossy image compression** technique most commonly used for a series of **image**s.

MS Abbreviation for **medium shot (MS)**.

MS-DOS The **operating system (OS)** from **Microsoft, Corp.** that is designed to run on non-**IBM PC**s. See also **PC-DOS**.

multiburst A **test pattern** made up of **vertical** lines that get progressively narrower as they move from left to right, used to test the **horizontal resolution** of a **video signal**. The left side contains the lowest frequencies, and the right side contains the highest frequencies. See also *Color Plate 11*.

multimedia An overall term used to describe a wide range of methods used to **display** information with a combination of **sound** and **image**s.

mult. operation Shorthand for **multiply operation**.

multiplane 1. For **compositing**, any techniques used to simulate real-world **parallax** by moving **element**s intended to be farther away from the **camera** by smaller amounts than the elements intended to be closer. 2. Referring to the natural occurrence of parallax seen in **image**s **capture**d by a moving camera.

multiplatform See **platform independent**.

multiple-camera shot A **shot** that is filmed simultaneously with multiple **camera**s to allow for the **inter-cutting** of **action** during **editing**.

multiple exposure See **double exposure**.

multiple first run The first public showing of a **film** in multiple theatres in each major city. See also **first run**.

multiple image operator An **image operator** that takes two or more **sequence**s of **input image**s. See also **single-image operator**, **multiple source operator**.

multiple pass 1. For **motion control photography (MOCO photography)**, see **multiple-pass photography**. 2. For **computer graphics (CG)**, see **multiple-pass rendering**.

multiple-pass photography Any **film**ing in which two or more **exposure**s of the same **subject** are filmed. Each exposure, or **pass**, can be made on the same piece of film, known as a **double exposure**, or as a separate piece of

film for use in **compositing**. **Motion control (MOCO)** needs to be used if the **camera** is moving in order to ensure that the different passes will be properly aligned. Typical passes might include a **beauty pass**, **shadow pass**, **matte pass**, and **reflection pass**. See *Color Plates 50–53, 64–66*.

multiple-pass rendering A technique in which a **3D object** is **render**ed in a series of separate **layer**s in order to enable fast turnaround for changes and the greatest flexibility for adjustments during **compositing**. Typical passes might include **color**, **shadow**, **reflection**, **key light**, **fill light**, **backlight**. See also **multiple-pass photography**.

multiple run The distribution of a **feature film** to be exhibited at many theatres. See also **multiple first run**.

multiplexer A special device used to mix **video signal**s onto a single **video recorder**.

multiplexing A technique used to simultaneously send multiple **signal**s or information streams across a **communication line**.

multiple-point tracking Any type of **2D tracking** in which more than one **point** is used to extract the **camera move** based on the **motion** of those points over time. See **one-point track**, **two-point track**, **four-point track**, **stabilization**, **region of interest (ROI)**, **3D tracking**.

multiple source operator An **operator** or **node** that takes more than one **input file**. See **single-source operator**, **multiple-image operator**.

multiple track tape Any **audiotape** that can **record** more than one **channel**.

multiplicity The number of times a **point** is consecutively referenced in a **primitive**.

multiply 1. For **compositing**, see **multiply operation**. 2. A standard **arithmetic operator**.

multiply operation A **compositing operation** that multiplies each **pixel** in a single **image** by a constant **value**, or multiples the values of the pixels in *image A* with the corresponding pixels in *image B*. If working with **normalized value**s, any resulting **RGB values** greater than one are **clamp**ed to a value of one. However, many **compositing package**s offer the ability to specify a **clamping value** of greater than or less than one be specified. Opposite of **divide operation**. *See image on following page and image under **layering operation**.*

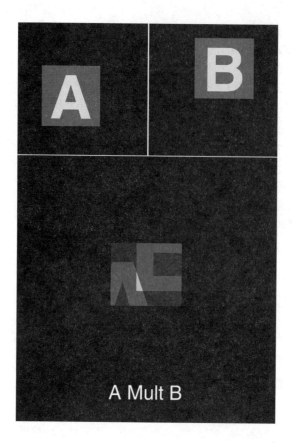

A Mult B

multiprocessing 1. Synonymous with **multitasking**. 2. The ability of a single **computer system** to utilize and support multiple **central process units** (**CPU**). Also referred to as **parallel processing**.

multiprocessor A **computer** with two or more **central processing units** (**CPUs**).

multitasking The ability of an **operating system (OS)** to **run** several **processes** simultaneously.

multithreading The ability of an **operating system (OS)** to simultaneously **execute** different parts of a **program**, called **threads**. The program must be designed in such a way that all the threads can **run** at the same time without interfering with one another.

multiuser An **operating system (OS)** that allows two or more **users** to simultaneously use the same **computer**. See also **single user**.

muscle system A type of **character setup** in which the actual **bone**s and muscles of the **character** are built underneath the **skin** as a means of simulating more realistic **motion**. Most muscle systems use a series of complex **function**s and **expression**s that will move the muscles and bones in a physically correct manner based on the **key frame**s and **pose**s that an **animator** creates. See also **facial system**.

Musical Instrument Digital Interface (MIDI) A method for storing and translating music from one electronic **device**, such as a synthesizer, to another, such as a **computer**.

music track The separate **sound track** channel onto which music is recorded. See also **effects track**, **dialogue track**.

Nagra The trade name for a professional **sound** recorder.

naming conventions The standardized names that are used to differentiate the various **element**s and **file**s that are stored on **disk** for a **project**. Like the **directory structure**, the naming conventions vary greatly in style between different facilities and often will vary across different **show**s within the same **facility**. Generally, a file contains a **root name** (a descriptive name of the element), a **frame number** (if it is one of a series), and a **filename extension** (to indicate the **file format** that it is stored in). For example, a **roto matte** for frame 20 of a **shot** called KG22 might be stored to disk as KG22_roto.0020.rgb.

narrow angle lens Another term for **telephoto lens**.

narrow angle of view Referring to the **angle of view** seen through a **telephoto lens**.

narrow angle shot A **shot** in which a **telephoto lens** is used to create a **narrow angle of view**.

narrow angle view See **narrow angle of view**.

narrated sound The **sound track** that tells the story and allows the **Editor** great flexibility in choosing the **cut**s to serve as visual representation to portray what is being narrated. See also **lip-sync-sound**.

National Television System Committee (NTSC) 1. The **video signal** standard used in the United States that carries 525 **scan line**s of information and uses a **playback rate** of **30 FPS** (29.97 FPS to be be exact) with a 4:3 **aspect ratio**. The **field dominance** of an NTSC image uses the first **field** to hold the even-numbered scan lines and the second field to hold the odd-numbered scan lines. NTSC is often humorously defined as "Never Twice the Same Color" due to its unreliable **color** reproduction. See also **Phase Alternate Line (PAL)**, **Sequential Color with Memory (SECAM)**, and **High Definition Television (HDTV)**. 2. The committee responsible for the NTSC video signal standard in North America.

native format The **file format** in which **data** or **image**s were originally **create**d or **capture**d.

native language See **machine language**.

natural number An **integer** that is greater than or equal to zero.

natural phenomena A general term referring to the creation of **effect**s seen in nature, such as smoke, water, fire, and clouds. For **computer graphics (CG)**, such effects can be created with **motion dynamics** or **particle system**s. *See also Color Plates 40, 43–45.*

nawk A pattern-scanning **interpretive language** that is an enhanced version of **awk**.

ND Abbreviation for neutral density. See **neutral density filter (ND filter)**.

ND filter Shorthand for **neutral density filter (ND filter)**.

near See **near clipping plane**.

near clipping plane The **value** used to define the **boundary** of a **clipping plane** closest to **camera** and in front of which no **object**s can be **render**ed. Also called **hither clipping plane**, **Z clipping plane**. Opposite of **far clipping plane**.

near/far axis Another name for **Z-axis**.

nearest-neighbor filter Another term for **impulse filter**.

neg See **negative**.

negate See **invert**.

negate operation See **invert operation**.

negative The **film** on which a **scene** is first **expose**d. The **light** and **color** values of the **negative image** are the inverse of the **value**s that existed in the actual scene during **shooting**. Sometimes used to describe **raw stock**. Also called **neg**, **camera original**, **original**, **original negative**, **original film**, **o-neg**.

negative assembly The process of stringing together all the **processed negative** for **printing**.

negative cut list The **computer generated** list used by the **Negative Cutter** to **conform** the **film**.

Negative Cutter The individual who **conform**s the **negative** of a **film** into its final version.

negative density 1. For **film**, see **density**. 2. For **metaball**s, a negative density applied to the **density field** can create **concave** surfaces by subtracting the density **value**s from one another, rather than adding them together, as is the case with **fusion**. The metaball with the larger density value becomes the positive density, and the metaball with the smaller density becomes the negative value.

negative film See **negative**.

negative film stock See **negative**.

negative gamma The **gamma** value of a **film negative**. It controls the **slope** of the straight line portion of the **negative**. This defaults to .6 per **Kodak standards**.

negative image 1. The image on a piece of **negative film. Positive print**s are made from these **negative** prints. 2. An **image** in which the **black and white** values are **invert**ed and the **color**s become the **complementary colors** of the original color. Opposite of **positive image**.

negative numbers See **edge numbers**.

negative pitch See **short pitch**.

negative print See **negative**.

Netscape Shorthand for **Netscape Navigator** or **Netscape Communicator**.

Netscape Communicator The latest version of **Netscape Navigator** offering more features and an improved **search engine**.

Netscape Navigator A widely-used commercial **Web browser** from Netscape Communications Corp. that allows **user**s to navigate around the **World Wide Web (WWW)**. The **Web** works on a **client-server** model, in which Netscape Navigator is the **client**, and the **Web server** that it talks to is the **server**. Netscape accepts **hyperlink** selections made by users and then sends the request for that information to the Web server. The Web server responds by putting the information on the **screen** for the user to view and **input** more selections.

Netscape page See **Web page**.

network 1. A network is composed of two or more **computer**s and their **peripheral device**s that can communicate with one another and share and transfer **data**. See **local area network (LAN)**, **wide area network (WAN)**. 2. Referring to a television network, such as ABC, CBS, NBC, or Fox.

network address A unique **address** used to identify the local **network**.

network administration See **system administration**.

Network Administrator See **System Administrator**.

network architecture Referring to the overall design of a **network**, including the **hardware**, **software** and **peripheral**s used.

network connection Any communication between **computer**s and **peripheral device**s across a **network**.

network crash See **crash**.

Network File System (NFS) **Network**ing **software** that provides for **remote** access to shared **computer**s and **file system**s. NFS also allows access to **data** stored on computers running under different **operating system**s (**OS**). The primary function of NFS is to **mount** or **export** directories to other computers so they can be accessed as if they were **local** to those computers. For example, if *Computer A* mounts the **file** system of *Computer B*, it will appear that *Computer B*'s files are stored on the **local disk**s of *Computer A*.

network layer A network layer determines the **routing** of **data** from sender to receiver. The most common network layer is the **Internet Protocol (IP)**. See also **packet**.

network meltdown An event that causes complete or near **overload** of a **network**, usually resulting from an illegal or misrouted **packet**, such as a **Chernobyl packet**. Networks are designed to handle a steady and moderate **load** rather than the irregular burst of usage patterns that can occur from particular **application**s. For example, when playing the game *Doom* on a **personal computer (PC)** in multiplayer mode, packets are used to inform other computers involved in the game that bullets have been fired. This causes problems with rapidly firing weapons, such as the chain gun, which can "blast" a network into a meltdown state. See also **broadcast storm**.

network server The main **computer** that stores **file**s for a **network**.

neural network (NN) An **artificial intelligence** model that attempts to simulate real-world responses and human neurological thought processes. Neural networks have the ability to "learn" from experience and are essentially comprised of a **network** of many simple units connected together by communications **channel**s carrying numerical **data**. Each unit operates only on their own **local** data and on the inputs they receive from the other units via the connections. Each time a pathway is used by a signal, the

chances are increased that the next signal, under the same conditions, will use the same path. In this way, a neural network is self-reinforcing, which is similar to the way our human brains work.

neutral density filter (ND) An **optical filter** used to reduce the **intensity** of **light** striking it without altering the **color** of the light. Neutral density filters are gray in color, and each increment of .3 is equal to one **stop** of light.

neutral print If an **18% gray card** is correctly photographed in terms of **lighting** and **exposure**, then the **density points**, read by the **densitomer** from the **print** of the gray card, will read 1.09, 1.06, 1.03 for **red (R)**, **green (G)**, and **blue (B)**, respectively. In simple terms, a neutral print just means that the gray card on the print looks the same as the actual gray card during photographing. When the gray card at the head of a print has taken on a color **hue**, it usually means that the **lab** is off due to chemicals, temperature, and/or exposure time. See also **lab aim densities (LAD)**.

neutral shot A **shot** in which the **subject** moves directly toward or away from the **camera**. See **head-on shot**, **tail-away shot**.

newsgroup A discussion group on the **Internet**.

Newtek, Inc. The company that developed the **3D software package**, **Lightwave**.

Newton Rings A **moire pattern** that sometimes appears on a **film print** in which the **negative** and **positive** were not properly aligned.

NFS Abbreviation for **network file system (NFS)**.

NG Abbreviation for **no good (NG)**.

NG takes See **no good (NG)**.

nibble A half a **byte**. Since a byte is composed of 8 **bits**, a nibble is equal to 4 bits. Sometimes spelled **nybble**.

night for night Night **sequence**s that are actually **shot** at night. See also **dusk for night**, **day for night**.

nitrate base A highly flammable **film base** used in the early days of filmmaking. It is comprised of **cellulose nitrate**, which is capable of self-igniting under certain conditions. It has since been replaced by **acetate base**.

nitrate-based See **nitrate-based film**.

nitrate-based film Any **film stock** containing a **nitrate base**. See also **acetate-based film**.

NN See **neural network (NN)**.

nodal offsets See **nodal point offset**.

nodal point 1. The point inside a **camera lens** where all entering **light rays** appear to converge. It is located at the **point** where the **focal point** of the **lens** meets the **film plane**. The nodal point is ideally the point about which the camera **rotate**s. When this is not the case, the **camera** is said to be **off nodal** and a **nodal point offset** needs to be calculated between the nodal point and the actual point of rotation in order to **encode** the camera rotations for later use in **post production** work. 2. The point inside a **projector lens** where all exiting **light** rays appear to originate.

nodal point offset The distance between the **nodal point** of a **camera** and the point around which the camera **rotate**s. If using an encoder to record the **motion** of a physical camera for later use in the creation of **CG elements**, the distance between the two **points** must be measured so they can be accounted for in the **setup** of the **CG camera**. See also **motion control offsets (MOCO offsets)**.

node 1. A block of **data** with a name attached to it. It can be a **parent**, **child**, or an independent **object**, **image**, or other item within a **hierarchy**. A node contains **attribute** information about a particular object or image that the **user** has **input**. Although every **software package** is different, nodes are generally rectangular in shape and often contain an **icon** for quick identification. See also **subnode**. 2. For a **network**, a node refers to any **processing** location, such as a **computer** or **peripheral device**. Every node has a unique **network address**.

node view A **view**, available in most **software package**s, that shows the **hierarchical structure** of the **node**s that make up a **scene**. Also called the **schematic view**.

no good (NG) 1. An unusable **take** of a **scene** caused by **errors**, such as a bad **camera move**, an out of **focus** actor, a flubbed line or a blown **set light**. 2. Referring to a **digital shot** that did not complete its **shoot** to the **film recorder** due to problems such as a **network crash**, not enough **film** on the **roll**, or the need to pull the **film roll** down early to get it **in the can** and make **lab cut-off**. 3. A film roll that comes back from the **lab** is termed NG for problems such as being **scratch**ed, too dark, blown out, or just simply being improperly **process**ed.

noise 1. See **noise function**. 2. In **video**, a general term used to describe any unwanted electrical **signal**s, such as snow, **fringing**, or **ghosting**.

noise function Random **procedural** functions used to break up and generate randomness across the **surface** of a **3D object** or across an **image**. When used on images, a noise function can be similar in quality to **film grain**.

nonconvex See **concave**.

noncurl backing A **transparent** gelatin used to coat the **film** on the opposite side of the **emulsion** layer in order to prevent curling of the film as it is wet and dried during **processing**.

nondigital Referring to any practical technique or process that is created without the use of a **computer**. For **film** effects, this can include a **matte painting** created on glass or canvas, a **maquette**, a **miniature** or effects created with **optical compositing** techniques.

nondrop frame A type of **SMPTE time code** that counts **30 frames per second (30 FPS)**, which means it does not exactly match to **NTSC**, which runs at 29.97 FPS. See **drop frame**.

non-GUI Abbreviation for **non-graphical user interface (non-GUI)**.

non-graphical user interface (non-GUI) Any **program** that only accepts **command line** interaction from the **user**, as opposed to a **graphical user interface (GUI)**, which allows for more **user-friendly** interactivity.

nonintegral number Any number, such as a fraction, that is not a **whole number**.

noninterlaced See **deinterlaced**.

nonlinear 1. Unevenly spaced or not directly proportional increments. 2. Not in a straight **line**. 3. In an equation, containing a **variable** with an exponent other than one. Opposite of **linear**.

nonlinear color encoding See **nonlinear encoding**.

nonlinear color remapping See **nonlinear encoding**.

nonlinear color space Any **color space** that is not **linear**. For **visual effects work**, the **logarithmic color space** is the most commonly used nonlinear color space for working with and storing **image**s.

nonlinear color space encoding See **nonlinear encoding**.

nonlinear conversion See **nonlinear encoding**.

nonlinear editing An **editing** method that uses **digital** processes to allow the **Editor** to work out of **sequence**. Nonlinear editing allows **random**

access to **image**s and a **cut-and-paste** style of arranging the **footage**. See also **linear editing**.

nonlinear encoding A method of **image encoding** that, unlike **linear encoding**, converts the **color**s from the **input image** to the **output image** by consolidating steps in the high **range**s in order to preserve more steps in the low to middle ranges. This produces a **curve** similar to a **gamma correction curve**. Also called **nonlinear mapping**. See also **nonlinear color space**, *images under image encoding*.

nonlinear format Any **data** that is not stored in a **linear format**. See **logarithmic format**.

nonlinear interpolation **Interpolation** of information with any **curve** other than a straight **line**.

nonlinear mapping See **nonlinear encoding**.

nonlinear space See **nonlinear color space**.

nonlinear video **Image**s that can be viewed and **edit**ed in any order. **CD-ROM**s and **laser disc**s are examples of nonlinear **video** because, unlike **linear video**, **user**s can instantly jump to images anywhere on the **disk** in any order, which is referred to as **random access**.

nonlinear video editing See **nonlinear editing**.

nonplanar object See **nonplanar surface**.

nonplanar polygon A **polygon** whose **vertices** don't all lie along the same **plane**.

nonplanar surface A **surface** whose **vertices** don't all lie along the same **plane**. Opposite of **planar surface**.

nonproportional scale To **scale** an **object** or **image** by different amounts along each **axis**. Opposite of **proportional scale**. Also called **nonuniform scale**.

nonsquare pixel A **pixel** whose **width** is not equal to its **height**. For example, the height of a pixel in a **video image** is only 90 percent of its width. Also called a **rectangular pixel**. Opposite of **square pixel**. See also **pixel aspect ratio**.

nonuniform parameterization Nonuniform parameterization occurs when the **delta**, or difference, between successive **knot**s on a **curve** do not need to be expressed in equal increments of one. This type of **parameterization** exists on **NURBS curve**s and is a feature that gives them superior

flexibility and control over many other **curve type**s. A nonuniform parameterized **surface**, whose **control point**s are spaced unequally, can apply a **texture map** based on the relative size of each **surface segment** and as a result prevents unwanted stretching in the **texture**s. See **uniform parameterization**.

nonuniform scale See **nonproportional scale**.

nonuniform rational B-spline (NURBS) NURBS are a special type of **approximating spline** that are a combination of the best features found in other **spline**s. Like an **interpolating spline**, NURBS pass directly through their first and last **control point**s and, like approximating splines, do not pass through the interior control points. Additionally, NURBS contain a set of **edit point**s, also referred to as **knot**s, that lie directly along the **curve** that allow for an additional level of curve modification on top of the control points. See also **NURBS components**.

nonunion shop A **facility** that is not under any agreement with a union and can hire any employees they choose. Opposite of a **union shop**.

nonvariable shutter See **fixed shutter**.

nonvolatile memory **Memory** that does not lose the **data** it has stored when the **computer** is **shut down**. Examples of nonvolatile memory include **read only memory (ROM)** and **programmable read only memory (PROM)**. Opposite of **volatile memory**.

nonvolatile storage See **nonvolatile memory**.

noodling See **tweaking**.

normal See **surface normal**.

normal distribution A theoretical **distribution** of a given set of **data** that is generally represented by a **bell-shaped curve**. Also called **Gaussian distribution**.

normal interpolating shading See **Phong shading**.

normalize To convert **value**s to a range between 0 and 1.

normalized black A 100% black **pixel** that has been converted to (0, 0, 0) from its original **bit depth** value. Also referred to as **pure black**. See also **normalized white**, **normalized value**.

normalized value Since there are a wide variety of **bit depth**s with which different **image**s can be stored, it is common practice to **normalize** all the **color value**s to a range between 0 and 1. Under this scenario, a **pure**

white pixel in a **24-bit image** would be converted from its **RGB values** of (255, 255, 255) to (1, 1, 1); a 50% gray **pixel** would be converted from (128, 128, 128) to (.5, .5, .5); and a **pure black** pixel remains at (0, 0, 0).

normalized white A 100% white **pixel** that has been converted to (1, 1, 1) from its original **bit depth** value. Also referred to as **pure white**. See also **normalized black**, **normalized value**s.

normal lens A **camera lens** that has a **focal length** that is not a **telephoto** or **wide-angle lens** and is a close approximation of "normal" vision. A normal lens has a shorter focal length and a wider **field of view (FOV)** than a telephoto lens, and a longer focal length and narrower field of view than a wide-angle lens. See also **zoom lens**, **auxiliary lens**, **anamorphic lens**.

normal perturbation See **bump mapping**.

normal vector See **normal**.

north Compass terminology used to refer to the top portion, or the positive portion of the **Y-axis**, of a **frame** or **image**.

north/south axis Another name for the **Y-axis**.

Norton Utilities A **program** designed for **data recovery**.

NOT Abbreviation for **NOT operator**. See **difference operation**.

NOT operator One of the **Boolean operator**s. See **difference operation**.

notebook A light **personal computer (PC)**, generally thinner than a **laptop**.

Nothing Real, Inc. The company that developed a **compositing software** called **Shake**.

notifier See **confirmation box**.

NT Abbreviation for new technology. See **Windows NT**.

NT file system The **file system** used by **Windows NT**.

NT operating system (NT OS) See **Windows NT**.

NT OS Abbreviation for **NT operating system (NT OS)**. See **Windows NT**.

NT platform Any **computer** using the **NT operating system (NT OS)**. See also **Unix platform**.

NTSC Abbreviation for **National Television System Committee (NTSC)**.

NTSC format See **National Television System Committee (NTSC)**.

NTSC image format A **digital image** stored in **NTSC format** contains a **width** of 720 **pixel**s across and 486 **scan line**s high. See also **PAL image format**, **SECAM image format**.

NTSC video See **National Television System Committee (NTSC)**.

NURBS Abbreviation for **nonuniform rational B-spline (NURBS)**.

NURBS components The **parameter**s and **element**s that define a **NURBS object**, such as **CV**s, **edit point**s, **hull**s, and **normal**s.

NURBS curve See **nonuniform rational B-spline (NURBS)**.

NURBS object See **NURBS surface**.

NURBS surface **Surface**s that are defined using the same mathematics that make up **NURBS curve**s except that they are defined in two dimensions— **U** and **V**.

null Zero or nothing. See **null node**.

null node Any **node** that is used to create an additional level of control within a **hierarchy**. A null node typically has no **geometry** connected to it, but it does have a **local coordinate system**. Also called **null object**, **dummy node**, **dummy object**.

null object See **null node**.

number crunching Slang term for **processing**.

numbering block See **coding machine**.

nybble See **nibble**.

Plate 1. A standard **color wheel**.
IMAGE CREATED USING **SHAKE** AND PROVIDED
COURTESY OF **NOTHING REAL, INC.**

Plate 2. A **four-corner gradient**.

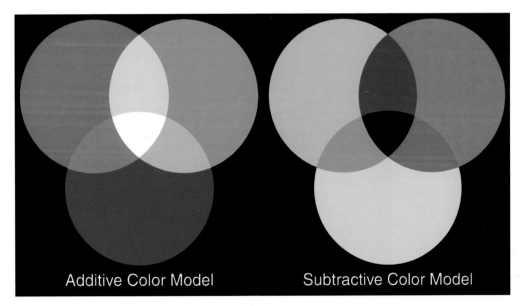

Additive Color Model

Subtractive Color Model

Plate 3.

Plate 4. The official **LAD girl** image created by **Kodak** to reach **lab aim densities (LAD)**.

Plate 5. This **image**, fondly referred to as "**Marcie**," which is presumably the name of the featured woman, is also used to reach **lab aim densities (LAD)**, although it was originally used in a **Kodak** demo to introduce their 5245 **film stock**.

Plate 6. Another **image**, often referred to as "**Girl Head**," that was also featured in a **Kodak** demo but now doubles as a **LAD girl** during the **printing** process at the **lab**.
PLATES 4–6 IMAGES PROVIDED COURTESY OF EASTMAN KODAK COMPANY.

Plate 7. The **Macbeth chart**. IMAGE PROVIDED COURTESY OF PACIFIC DATA IMAGES AND PRINTED WITH THE PERMISSION OF GRETAG MACBETH.

Plate 8. 100% color bars.

Plate 9. 75% color bars.

Plate 10. SMPTE color bars.

Plate 11. Multiburst.

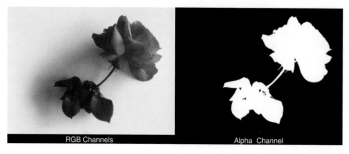

Plate 12. An **RGB image** and its corresponding **alpha channel**.

Plate 13. A **luminance key** pulled from the **RGB image** of the rose

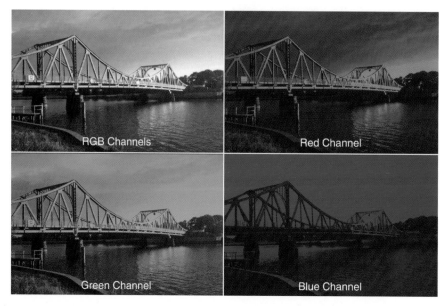

Plate 14. Every **digital image** can be represented by its **red, green,** and **blue channel**s.

Plate 15. An RGB image and its representation as a **grayscale image**.

Plate 16. A **histogram** represents the distribution and **frequency** of **pixel** characteristics in an **image**. PLATES 15, 16 BRIDGE IMAGES PHOTOGRAPHED COURTESY OF ALAN SONNEMAN.

Plate 17. The **background** frame.

Plate 18. The foreground **bluescreen element**.

Plate 19. The extracted **matte pass**.

Plate 20. The final **composite**.

IMAGES 17–20 CREATED USING **PRIMATTE** SOFTWARE COURTESY OF PHOTRON USA.

Plate 21. Background plate.

Plate 22. CG rendered blimps.

Plate 23. Alpha channel of the blimps.

Z COMPOSITING IMAGES 21–23 CREATED USING SHAKE AND COURTESY OF NOTHING REAL, INC.

Plate 24. Z channel of the blimps.

Plate 25. Hand-painted **Z depth matte** of the buildings.

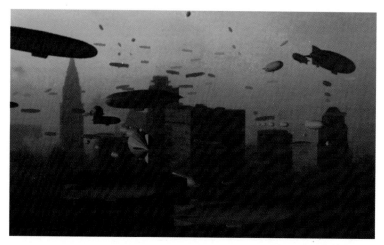

Plate 26. The final **composite** using **Z depth compositing**.
Z COMPOSITING IMAGES 24–26 CREATED USING **SHAKE** AND COURTESY OF **NOTHING REAL, INC.**

Plate 27. A **lens flare** shot with a **spherical** lens.

Plate 28. A **lens flare** projected with an **anamorphic lens**.

Plate 29. A **CG lens flare**.

Plates 30 & 31. The left and middle **images** can be used for the **parallel viewing method**, whereas the middle and right images can be used for the **cross-eyed viewing method**. IMAGES PHOTOGRAPHED COURTESY OF FRANKLIN LONDIN.

Plate 32. Hand-drawn splashes.

Plate 33. The **wireframe model** of the sea of water.

Plate 34. The **UV coordinate space** of the **model** used to place **textures** on the **surface**.

Plate 35. Rough lighting of the **scene**.

Plate 36. The final **composite** composed of both **2D** hand-drawn and **3D** CG **element**s.

Plate 37. The **2D layout** of the **scene**.

Plate 38. The **skeletal structure**s showing the **animation** of the **crowd simulation**.

Plate 39. The final **render**ed **CG** crowd **element**.

Plate 40. The **particle system** dust **layer**.

Plate 41. The final **composite** cropped with a **1.66 extraction** for **projection**.

Plate 42. Layout.

Plate 43. Motion simulation of the water and crowd of ants.

Plate 44. Rough lighting.

Plate 45. Final **composite**.

Plate 46. Layout.

Plate 47. Animation.

Plate 48. Rough lighting.

Plate 49. Final **composite**.

Plate 50. A spark **pass** shot on **stage**.

Plates 51–53. The following **frame**s from the final **composite** from the motion picture Apollo 13 depict the first stage of the *Saturn 5* being jettisoned out into space. The first stage, the ring, and the spark **pass** were **shot** as separate elements on **stage** using **motion control (MOCO)** and composited against a NASA-supplied still photograph that was **digital**ly enhanced. The final composite was cropped with a **1.85 extraction** area for **projection**.

Plate 52.

Plate 53.

Plate 54. A **greenscreen plate** shot on **stage** with a **stunt double**.

Plate 55. The final **composite** featuring a **full CG** environment and composited **stunt double** within a **2.35 center extraction**. Fun fact: The bus featured in the upper left-hand corner contains the letters "LE10," which was the actual name of the **visual effects shot**.

Plate 56. The final **composite** showing the **CG** robotic arms and their **reflections** interacting with the **practical** glove model. The final **image** was **cropped** with a **2.35 center extraction** for **projection** purposes. *THE FIFTH ELEMENT* 1997 COPYRIGHT © GAUMONT. ALL RIGHTS RESERVED. COURTESY OF COLUMBIA PICTURES. IMAGE CREATED BY DIGITAL DOMAIN.

Plate 57. The final **composite**, cropped with a **2.35 center extraction**, featuring a **close-up** view of the **CG** robotic arms building a human from the DNA information gathered from the glove.

Plate 58. The **pass**es of the reconstruction chamber were **shot** with **motion control (MOCO)** on **location** at Pinewood Studios in London, England. A **dolly track** was used for the motion control moves, and a **tracking cube**, placed next to the glove, was used as an aid in **3D tracking** during **post production**.

Plate 59. A **full-size set piece** mounted on a **motion base** to create the illusion of a ship that could fly through the sky.

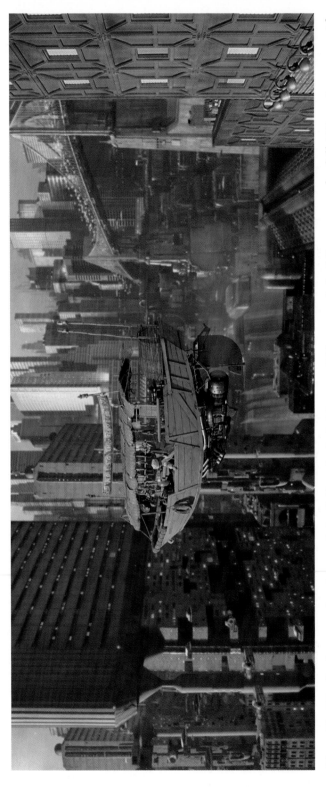

Plate 60. The final **composite** that used the **full-scale** thai ship, two different scale building **sets**, and a **full CG** environment with a **matte painting** of the far city.

THE FIFTH ELEMENT 1997 COPYRIGHT © GAUMONT. ALL RIGHTS RESERVED. COURTESY OF COLUMBIA PICTURES. IMAGE CREATED BY DIGITAL DOMAIN.

Plate 61. An **image** from the final **composite** of a **full CG** shot as Godzilla approaches the Brooklyn Bridge. *GODZILLA*® AND THE GODZILLA CHARACTER AND DESIGN ARE TRADEMARKS OF TOHO CO., LTD. THE GODZILLA CHARACTER AND DESIGN ARE COPYRIGHTED WORKS OF TOHO CO., LTD. ALL ARE USED WITH PERMISSION. COURTESY TOHO CO., LTD AND TRISTAR PICTURES. IMAGE CREATED BY CENTROPOLIS EFFECTS.

Plates 62. A later **frame,** from the same **composite** seen in Plate 61, after Godzilla has trampled across the bridge. *GODZILLA*® AND THE GODZILLA CHARACTER AND DESIGN ARE TRADEMARKS OF TOHO CO., LTD. THE GODZILLA CHARACTER AND DESIGN ARE COPYRIGHTED WORKS OF TOHO CO., LTD. ALL ARE USED WITH PERMISSION. COURTESY TOHO CO., LTD AND TRISTAR PICTURES. IMAGE CREATED BY CENTROPOLIS EFFECTS.

Plates 63. An image designed to show the various **layers** that make up a **CG image**, including the **wireframe, grayscale image** and the final **rendering**.

Plate 64. A **motion control pass** of a **miniature** ship **model**.

Plate 65. An alternate **miniature** ship section **shot** with **motion control (MOCO)** to replace the right portion of the above miniature ship **pass**.

Plate 66. Another **motion control pass** featuring the ripped interior portion of the ship.

Plate 67. One of many **CG** crowd **layers**

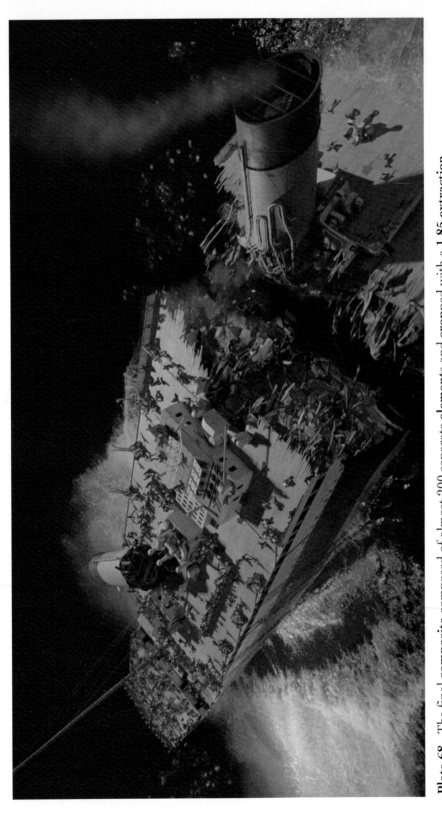

Plate 68. The final **composite** composed of almost 200 separate **elements** and **cropped** with a **1.85 extraction.** *Titanic* Copyright © 1997 Twentieth Century Fox Film Corporation and Paramount Pictures Corporation. All rights reserved. Image created by Digital Domain.

OBJ Abbreviation for **object**.

object 1. A common **ASCII file format**, known as "obj," used to represent **geometry** and **object attributes**. 2. A group of **surface**s treated as a single piece of geometry for purposes of **motion**, **shading**, and duplication. 3. A global term referring to all the physical **element**s that make up a **3D scene**, such as geometry, **light**s, and **camera**s. 4. Referring to the **subject** that is being photographed. 5. For **object-oriented programming language**, an item containing a set of instructions to be performed on it.

object attributes The **attribute**s that describe a particular **object**, such as its **topology**, **color**, **specularity**, **reflectivity**, **transparency**, and **texture**, to name just a few.

object-based graphics See **vector graphics**.

object center Synonymous with **object origin**.

object code Synonymous with **machine code**.

object coordinates See **local coordinates**.

object coordinate system See **local coordinate system**.

object deformation Any **deformation** technique used to reshape a **model**, such as with a **lattice box**, **point group**, **spline deformation**, **shape morph**.

object description The **geometry** that defines an **object**.

object instancing See **instancing**.

objective angle See **objective camera angle**.

objective camera angle A **shot** in which the **camera** films the **action** from an impersonal sideline **point of view (POV)**. Sometimes referred to as an **audience** point of view because the **scene** is viewed as if through the eyes of an unseen observer. See also **subjective camera angle**.

objective close-up Shorthand for **objective close-up shot**.

objective close-up shot A **close-up (CU)** of an actor filmed from an **objective camera angle**. Generally, the **camera** should be positioned at eye level with the actor being photographed.

objective shot A **shot** filmed with an **objective camera angle**.

object-oriented See **object-oriented programming language**.

object-orientated graphics See **vector graphics**.

object-oriented programming See **object-oriented programming language**.

object-oriented programming language A **programming language** in which the **Programmer** can define the **data** type of each **data structure** as well as the types of **operation**s and **function**s that can be applied to those data structures. With this method, each data structure is treated as an **object**, and each object is grouped into a **hierarchy** of classes, with each class inheriting the characteristics of the class above it. This type of **programming** allows for the creation of new **object type**s that can inherit many of their features from other existing object types.

object origin The **point** around which an **object** is centered and that serves as the point of reference when **transform**ing the object in relation to the **point of origin**.

object resolution The number of **steps** used to define the **level of detail (LOD)** of the **curve**s and **surface**s in an **object** for viewing and **render**ing. See **low-resolution object**, **high-resolution object**.

object rotation The **orientation** of an **object** around its center in **3D space** along the **XYZ axes**.

object scale The size of an **object**. By default, most **3D package**s will automatically set the **scale** of an object to 1.0 at the time of creation. Unless otherwise specified, an object will be scaled around its center, and the **value**s related to scaling are called **factors**. See **nonuniform scaling**, **uniform scaling**, and **volumetric scaling**. See also **model scale**, **modeling units**.

object space See **local coordinate system**.

object translation To move an **object** to a new location in **3D space**. The **point**s that make up the object are defined by their location along the **XYZ axes**, so when an object is **translate**d, its **coordinate**s are changed. See also **Cartesian coordinates**.

object type Referring to the **format** used to create and store **geometry**, such as **DXF** or **OBJ**. See **object**.

obstacle See **collision object**.

occlusion To **hide** an **object** or portion of an object from sight by the placement of other objects in a **scene**. See **Z-buffer**, **Z depth compositing**, **matte object**.

octal See **base 8**.

octal numbering system See **base 8**.

octrees A method of subdividing a **volume** in **3D space**. The volume is originally represented as a single rectangular **bounding box**, and if more **detail** is needed, the box is split in half along its **X**, **Y**, and **Z axis**, which results in eight smaller boxes. This process continues until each sub-box contains the desired **level of detail (LOD)**. Octrees are often used to boost efficiency. For example, if a particular **algorithm** needs to compare a set of **particle**s with its neighboring particles, it can compare each particle to every other particle in the **scene**. However, if the particles are instead sorted into octree partitions, then each particle need only be compared to every other particle within that particular octree partition. This technique can save a tremendous amount of calculation time. Octrees are the **3D** equivalent of **quadtrees**. See also **binary space partition trees (BSP)**.

odd field The half of a **video frame** that is made up of the odd-numbered **scan line**s. Opposite of **even field**. See **field**.

odd line See **odd field**.

odd scan lines See **odd field**.

off camera Another term for **off screen**.

offline 1. A **computer** that is not accessible to a **user**, **host**, or a **network**. Opposite of **online**. 2. Abbreviation for **offline editing**.

offline compositing Another term for **batch compositing**. Opposite of **online compositing**.

offline editing A preliminary **edit**, done on relatively low-cost **editing** systems, to create an **edit decision list (EDL)** for use during the **online editing** portion of the **project**.

offline editing system A type of **video editing** system, used in **offline editing**, that works at a lower **resolution** than **online editing system**s and

offers minimal control for **image** manipulations, such as **color correction**s and **transition**s. The **edit decision list (EDL)** is usually created during of-fline editing for later use during the **online editing** session.

Offline Editor The individual who creates prepares an **edit decision list (EDL)** and **rough cut**.

offload See **upload**.

off nodal A term used to describe a **camera** that does not **rotate** around the **nodal point** of the camera. When using an **encoder** to record the **motion** of a **physical camera** for later use in **computer graphics (CG)**, the distance be-tween the two **point**s, known as the **nodal point offset**s, must be calculated.

off screen Meaning that the **subject** cannot be seen by the camera. Also called **off camera**. Opposite of **on screen**.

off screen buffer Another name for **back buffer**. See also **double buffering**.

offsets 1. The RGB **color channel** controls within a **color grading** tool used to convert the **scan**ned **film** images from **log to linear** space. These set-tings mimic the effects of the **printing lights** at the **lab**. Ninety **points** of offset values are equal to one **stop** of **light**. 2. **Value**s that are applied to a set of **data** to offset the **attribute**s of that data. For example, when the par-ticular feature being used to **track** a series of **image**s exits the **frame**, a new **point** must be chosen for tracking. Because the new point is in a dif-ferent location from the previous point, the data from the new point must be offset by an amount that aligns it with the data from the previous point to create one fluid tracking **curve**. Offsets are also used when dealing with **motion capture data (MOCAP data)**, when the person whose **motion** was **capture**d has different bodily proportions than the **Digital Character** to which his motion is being applied. When **filming** out a **shot**, it is often desirable to offset the **RGB channels** of the images as a way of modifying the **color**. The uses of offsets are endless in **computer graphics (CG)**! 3. See **nodal point offset**s.

off the screen For **3D film**s, an **object** is said to be located off the **screen** if it is positioned in front of the **screen plane** in **depth**. See also **breaking the screen, behind the screen**.

off the shelf Referring to **software** or **hardware** that can be purchased from the company that created it. Opposite of **proprietary software** or hard-ware. See **3rd-party software**.

omnidirectional Equally in all directions. See **point light**.

omnidirectional light See **point light**.

Omnimax An extreme **widescreen** film **format** that uses the same system as **IMAX** but is designed to be **project**ed onto a dome-shaped **screen**.

on camera See **on screen**.

one-D See **1D**.

one-dimensional See **1D**.

one-dimensional array Another name for **vector**.

one-eight-five format See **1:85 format**.

on eight's A **shot** that uses one **frame** for every eight frames of **film** or **video**. See also **on one's**, **on two's**, **on four's**.

o-neg Abbreviation for **original negative**. See **negative**.

one hundred Base-T See **100Base-T**.

one hundred megabits per second See **100 megabits per second**.

one hundred percent color bars See **100% color bars**.

one-K See **1K**.

one-K resolution See **1K resolution**.

one light Refers to the standard **printing lights** used by the **film lab** on a given day when creating a **print**. Theoretically, this will produce a balanced neutral gray. In some cases, the lab will establish printing lights for a day exterior, day interior, night exterior, and night interior for a **Cinematographer** at the start of a **film** based on testing the film from the first few days of **shooting**. Sometimes also referred to as **rush print**, **rush**, **workprint**. See **lab aim densities (LAD)**.

one light print See **one-light**.

one line A schedule of the date and location when each **scene** and **shot** will be photographed. The one-line is a condensed version of the **shooting schedule**.

one-point track A type of **2D tracking**, in which only one **point** is selected from a **sequence** of **image**s to extract the **camera move** based on the **motion** of that point over time. The only **curve**s that can be calculated by using a single **tracking** point are **X** and **Y translation**. For more accurate information, it is common to use **multiple-point tracking**. See **two-point track**, **four-point track**, **stabilization**, **region of interest (ROI)**.

one's See **on one's**.

one-shot A **shot** in which only one actor is framed within the **camera** view. See also **two shot**.

one-sided geometry See **single-sided geometry**.

one-six-six format See **1:66 format**.

one thousand Base-T See **1000Base-T**.

on four's A **shot** that uses one **frame** for every four frames of **film** or **video**. See also **on one's**, **on two's**, **on eight's**.

online 1. A **computer** that is accessible to a **user**, **host**, or **network**. Opposite of **offline**. 2. Abbreviation for **online editing**.

online compositing Referring to a **compositing software** that is highly interactive and gives the **user** fast feedback to the applied **compositing operations**. Opposite of **offline compositing** or **batch compositing**. See also **graphical user interface (GUI)**.

online docs Shorthand for **online documentation**.

online documentation Any **software documentation** that can be accessed by the **user** on a **computer** rather than existing in print form in a manual. See also **manual page**, **readme file**, **usage statement**.

online editing The final assembly of the **master videotape**. An **edit decision list (EDL)** is often created during an **offline editing** session to increase the speed of the final **edit**.

online editing system A type of **video editing** system, used in **online editing**, that offers high quality **image** manipulation and is used to generate the **final cut** of the **master videotape** using the **edit decision list (EDL)** prepared during the **offline editing** session as reference.

Online Editor The individual who refers to the **edit decision list (EDL)** created during the **offline editing** session to create the final **cut**. See also **Offline Editor**.

online help See **online documentation**.

online system Any **software package** that allows you to work in an **interactive mode** in which **user-defined** functions can immediately produce the updated result. See also **batch system**.

on location See **location shoot**.

on nodal A **camera** that **rotate**s about the **nodal point** of the camera is said to be "on nodal." By default, all **CG camera**s are on nodal. See **off nodal**, **nodal point offset**s.

on one's 1. For **digital work**, a **render**, **playback**, or **record**ing of every frame of a **scene**. Final **shot**s are always delivered on one's, but in order to increase the number of iterations that can be viewed while a shot is still in **production**, it is quite common to judge the work **on two's**, **on four's**, and even **on eight's**. 2. For **cel animation**, an **animation** that uses a separate drawing for each **frame** of **film**. This creates the highest-quality of animation, although shots created on two's are quite common for budgetary reasons.

on screen Meaning that the **subject** can be seen by the **camera**. Opposite of **off screen**. Also called **on camera**.

on the fly A term used to describe the temporary creation of **data** in **memory** as it is needed by the **renderer** or by another **application**, as opposed to first writing the **data** to **disk**.

on two's A **shot** that uses one **frame** for every two frames of **film** or **video**. See also **on one's**, **on four's**, **on eight's**.

opacity Referring to the amount of **light** that can **transmit** through an **object**. For **film** this is measured in terms of its **density**, while for **computer graphics (CG)** it is measured by the degree of **transparency** contained in the **alpha channel** of an **image**. Transparency and opacity are the complement of one another. For example, an image containing 60% opacity is 40% transparent.

opaque To be impenetrable by **light**. The **density** of **film** is measured by how much light can **transmit** through it and is referred to as its **opacity**. An **image** whose **alpha channel** contains no **transparency** is said to be completely opaque and will fully obscure any **object**s it is placed in front of.

opaque matte An opaque matte is made up of 100% **white** in its interior and contains **grayscale** values only along its **edge**s where its **opacity** falls off to **transparency**.

open 1. See **open curve**. 2. To **double-click** on a **window** that is **iconified**. An open window can be worked within. Also called **maximize**. Opposite of **close**. 3. To **read** the contents of a **file**. 4. To launch an **application** or **software package**. 5. An **image** that has been **color grad**ed so that there is room to brighten or darken the image without immediately **clipping** the **white**s or **crush**ing the **black**s. See also **headroom**, **close**.

open architecture Any **system** or **software** designed to allow for expansion of the existing **configuration**. See **scalability**.

open curve A **curve** whose starting and ending **point**s are not at the same location, such as a semicircle. Opposite of **closed curve**.

OpenGL Abbreviation for **Open Graphics Library (Open GL)**.

Open Graphics Library (Open GL) An **application program interface (API)**, developed by **Silicon Graphics, Inc.**, for the creation of interactive **2D** and **3D application**s.

Open Inventor The **object-oriented** toolkit for **3D** applications developed by **Silicon Graphics, Inc.**

opening up the lens Turning the adjustment ring on the **lens** to a lower **f-stop** number to create a larger aperature opening and as a result allow more **light** to strike the **film**. Opposite of **closing down the lens**.

open object An **object** containing **surface**s that can be viewed on both sides, such as a glass. See also **double-sided geometry**.

open polygon A **polygon** whose start and end **point**s are not at the same location. Opposite of **closed polygon**. *See also image under closed polygon.*

open source A method of **software** licensing and **distribution** that encourages **user**s to use and improve the software by allowing anyone to **copy** and modify the **source code**. Also referred to as **free software**.

open surface See **open object**.

open system Any implementation in which incompatible **operating system**s **(OS)**, **software application**s, and **hardware platform**s are tied together to create a compatible computing **environment**.

open window A **window** on the **computer screen** that is not **iconified** and can be worked within. Opposite of **closed window**.

operation A specific **command** or **function** that is applied to an **object** or **image**.

Operator 1. See **Camera Operator**. 2. A general term referring to any artist interacting on a **computer** with a particular piece of **software**.

operator A mathematical **expression** or **function**.

operator error Any **error** made by the **user** rather than by a fault in the **hardware**, **software**, or **program**.

operating system (OS) The main controlling **program** of a **computer** that communicates with its **hardware** and manages the interface to **peripheral device**s, allocates **memory**, schedules tasks, and presents a default **user interface** when no other **application program** is **run**ning. The main part of the operating system is the **kernel**. Without the OS, all **software** programs would be useless.

OptiCal The trade name of a **monitor calibration** tool, developed by The Color Partnership, that can be used on multiple **platform**s, such as **SGI**, **Macintosh**, and **Windows**.

optical audio head The head that scans the **optical sound track** on a piece of **film** and plays the **audio** out to the audio system in the theatre. See **Digital Theatre Systems (DTS)**, **Dolby**, **Sony Dynamic Digital Sound (SDDS)**, and **THX**.

optical composite See **optical compositing**.

optical compositing Similar to **digital compositing**, optical compositing is the process of combining multiple layers of imagery together to create an integrated resulting **image**. Optical compositing, however, is achieved by layering two or more **strip**s of **film** together onto a third piece of **raw stock** with the use of an **optical printer**.

optical disk A plastic coated **disk** that uses a **laser beam** to **read** and record **data**. **Laser disc**s, **compact disc**s (**CD**s), and **CD-ROM**s are examples of optical disks.

optical double exposure To **expose** at least two different **image**s onto one **negative** to create a **mix**ed result of the images. See also **digital double exposure**.

optical effects Generally referring to **special effects (SFX)** created with an **optical printer** using **film** that has already been **expose**d. Such effects can include **optical composite**s, and **transition**s such as **cross dissolve**s, **fade**s, and **wipe**s. Also referred to as **optical**s.

optical filter A piece of translucent glass or **gel** that is placed in front of a **light** or **lens** to modify the **color** or **density** of the **scene**.

optical flow analysis A **procedural** method used to determine the **motion** of **object**s in a **sequence** of **image**s. Generally, the **pixel**s in each image are **track**ed from **frame** to frame to produce a **red (R)** and **blue (B)** image representing the **X** and **Y** motion **vector**s for each pixel.

optical memory **Memory** stored on an **optical disk**, such as a **laser disc** or **CD-ROM** that **read**s and **write**s its **data** with a **laser beam**.

optical motion capture A **motion capture (MOCAP)** technique that uses two or more **camera**s to record the **position**al data of reflective **marker**s placed on the **subject** and then later calculates the **rotation**al information, as opposed to **magnetic motion capture**, which records the positional and rotational **data** at the same time. Optical motion **capture** offers good freedom of movement but does not currently offer **real-time playback** of the captured data. However, many companies are in the process of developing real-time playback capabilities for the future **release**s of their **software**.

optical mouse Any type of **mouse** that uses **infrared** or visible **light** to calculate changes in its **position**. Unlike a **roller-ball mouse**, an optical mouse contains no moving parts, but it does require a reflective **mouse pad** to move across.

optical printer A **device** designed to rephotograph **film** and allow for a wide range of **optical compositing** techniques. The printer is composed of a **camera** and a **projector** facing one another and a **light** placed behind the film in the projector that sends an image onto the **lens**, which in turn **focus**es that image onto **raw stock**.

opticals See **optical effects**.

optical scanner An **input device** that converts **flat artwork** into **digital image**s. An optical scanner works by analyzing the **light** reflected from the input **image** and then creating an electronic **signal** that is proportional to the **intensity** of that light and **color**.

optical sound A system used to reproduce the **sound** in **film** by converting the photographed patterns of **light** into the original sound when passing through the **projector**. The original sound is **capture**d by a microphone and then converted into electric impulses that vary the **intensity** and area of the light patterns photographed on the film. See **magnetic sound**.

optical sound track A **composite print** in which the **soundtrack** is recorded on the portion of the **film** dedicated to **audio**. As the **projector** displays an **image** on the **screen**, an **optical audio head** scans and plays the **sound** track over the audio system. Also called the **optical track**.

optical track See **optical sound track**.

optics The area of physics that deals with **light** and vision. For a **camera lens**, the optics refer to the various glass components that make up the lens. See **lens assembly**.

optimization 1. The analysis of **application**s, such as a **program**, **shader**, or **compositing script** to make it **run** as efficiently as possible. 2. Periodic **operation**s that can be run on a **computer** to keep it in its optimum state.

option 1. See parameter. 2. See **menu option**.

option box Another term for **check box**.

option button See **check box**.

option menu See **menu**.

option window See **menu**.

OR Shorthand for the **OR Operator**.

orange screen A fluorescent orange **backing** that is placed behind the **subject** and lit by **black light** for **black light photography**. See also **redscreen (RS)**, **greenscreen (GS)**, **bluescreen (BS)**.

orbit To keep the **camera interest** fixed while moving the **camera location** around the **scene**. This is similar to locking your gaze on a fixed location while walking around it. For **computer graphics (CG)**, also referred to as **tumble**.

orientation The angle of a given **surface** relative to the **viewer**.

orientation constraint See **rotation constraint**.

orientation limits See **rotation constraint**.

origin The **point** in **space** where two or more **axes** intersect. For most **3D package**s, this will default to (0, 0, 0).

original Shorthand for **original negative**. See **negative**.

original camera negative See **negative**.

original film See **negative**.

original negative See **negative**.

OR operator One of the **Boolean operator**s. See **union operation**.

ortho Abbreviation for **orthographic**.

orthogonal See **orthographic**.

orthogonal projection See **orthographic projection**.

orthographic In **computer graphics (CG)**, the simulation of infinite distance by **display**ing all lines **parallel** to the **viewer**. The distance of an **ob-**

ject from the viewer does not change the apparent size of the object. Opposite of **perspective**. See **orthographic camera**, **orthographic window**, **orthographic projection**, *image under* **perspective view**.

orthographic camera See **orthographic view**.

orthographic map A **texture map** designed to be applied to an **object** with **orthographic projection**.

orthographic mapping See **orthographic projection mapping**.

orthographic projection 1. The application of a **texture map** on a **3D surface** from an **orthographic view**. 2. See **orthographic mapping**.

orthographic projection mapping A **projection mapping** technique in which a **texture map** is **project**ed along one of the three **axes—X**, **Y**, or **Z**. While this is a very common **mapping** technique, it is only successful when the **surface** being mapped is relatively flat; otherwise undesirable stretching of the texture across the surface can occur. Also called **planar mapping**, **orthographic projection**, **orthographic mapping**. See also **cylindrical mapping**, **spherical mapping**, **camera mapping**, **flat projection**.

orthographic view A **3D view** in which the lines of the **object** being viewed do not converge. Because **perspective** is absent, an object appears to be the same size regardless of its distance from **camera**. This orthographic view is most often used for **modeling** and most **software package**s will default to three orthographic views representing the **front view**, **side view**, and **top view** of the **3D environment**. Also called **parallel projection view**, **orthographic camera**, **orthographic window**. Opposite of **perspective view**. See **viewing windows**, *images under viewing windows and perspective view.*

orthographic window See **orthographic window**.

OS Abbreviation for **operating system (OS)**.

Oscar See **Academy Award**.

oscilloscope A **device** that draws a graph displaying varying electrical **signal**s. For example, **vectorscope**s use oscilloscopes to view the **chrominance** portion of a **video** signal. The word *oscilloscope* derives from "oscillate," since oscilloscopes are used to represent oscillating signals.

OTS Abbreviation for **over the shoulder (OTS)**.

OTS-CU Abbreviation for **over the shoulder close-up (OTS-CU)**.

out See **outside operation**.

outfile Abbreviation for **output file**.

out of focus Referring to an **image** that appears **soft** and not clearly defined during viewing. Opposite of **in focus**.

out of phase 1. For **3D film**s, when the two **projector**s are out of **sync** with each other. 2. See **out of sync**.

out of sync Referring to two **image**s or an image and a **sound track** that are not placed in the same **temporal** relationship on a **release print**, **videotape**, or **movie file**. Opposite of **in sync**.

out of the box A term used to describe any **software** or **hardware** that is so **user friendly** that it can be used right "out of the box" with minimal training or **documentation**. See also **turnkey system, off the shelf, 3rd-party software**.

out operation See **outside operation**.

out point The ending point of an **edit**. Opposite of **in point**.

output The information produced by a **computer** based on specific **input**.

output address The **location** where the **output data** will be written to **disk**. See **input address**.

output connector The connecting line that feeds the **output** from one **node** into the input of another node. Opposite of **input connector**.

output data The **data** that results from a **program** or **software application**.

output device A **peripheral device** capable of communicating **digital data** to the world outside the **computer**. For example, output devices are used to **display** an **image**, **print** a **file**, or convert **digital image**s into **film image**s on a **film recorder**. See **input device**.

output directory The **directory** to which **data** is written to. Opposite of **input directory**.

output disk The **disk** to which **data** is written. See **source disk**.

output drive The **drive** to which **data** is written. See **source drive**.

output file The resulting **file** created by a **program** or **software application**. Opposite of **input file**.

output image The **image** resulting from a **program** or **software application**. Opposite of **input image**.

output node A **node** whose results are driven by the **parameter**s contained in the **input node**s.

output pixel values The resulting **pixel values** created by a **compositing operation** that **source**s and modifies the original **input pixel values**.

output resolution The **resolution** of the image created from an **image process** or **render**. See **input resolution**.

outside operation A **compositing operation** that retains only the portion of the **foreground image** that exists outside the **alpha channel** of the **background image**. Opposite of **inside operation**. *See also image below and image under* **layering operation**.

outtake A **take** of a **scene** that is not selected for the final **edit**. It has become more common to use outtakes during the **credits**.

over See **over operation**.

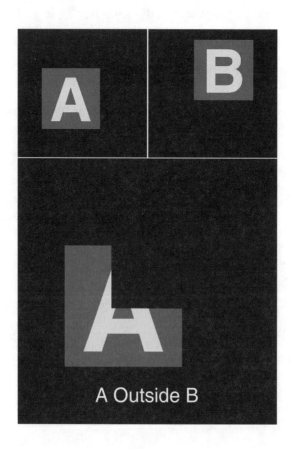

A Outside B

overcrank Running a **camera** at a **frame rate** higher than the normal speed of **24 frames per second (24 FPS)**. Increasing the number of frames per second shot during **filming** causes the action to appear to be in **slow motion** when **project**ed at 24 frames per second. This technique, also called **high-speed photography**, is often used when **shooting** explosions and stunts to ensure that the audience is able to catch all the action or as an aesthetic device to alter the mood of the **scene**. Opposite of **undercrank**.

overcoat A thin gelatin layer applied on top of the **film emulsion** to protect it from abrasions, such as **cinch marks**, during **exposure** and **processing**.

overdevelop See **overdevelopment**.

overdevelopment A **film** that has been **develop**ed for too long a period of time or in a solution that is above the standard temperature. The resulting **print** is washed out and lacking in detail. In some cases, overdevelop-

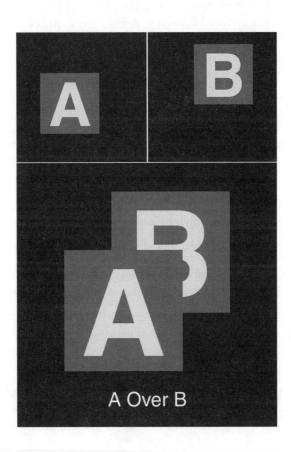

A Over B

ment is done intentionally to compensate for **underexposure**. Also called **pushing**, **forced development**, **forced processing**. Opposite of **under-development**.

overexpose See **overexposure**.

overexposure The **exposure** of **film** to too much **light** caused either by excessive light or from opening the **aperture** in the **camera** or **printer** for too long a period of time. The resulting **print** is dark with low detail in the **shadow**s. Opposite of **underexposure**. See also **overdevelopment**.

overlay 1. In **video**, the ability to **superimpose** information, such as **computer graphics (CG)** or **super**s, over a **video signal**. 2. For **compositing**, see **over operation**.

overload To place an excessive burden on a **system**. An overload can lead to a **crash**, **lockup**, or **meltdown**.

over operation A **compositing operation** that places the **foreground image** over the **background image** wherever the **alpha channel** of the foreground **image** exists. Opposite of **under operation**. *See also image on previous page and image under* **layering operation**.

oversampling A method of **sampling** data at a higher **resolution** as a means of reducing **error**s and inaccuracies during **processing**.

overscan The adjustment on a **video monitor** that decreases the viewable **height** and **width** of the **image area** so that the **edge**s of the **raster** cannot be seen. Opposite of **underscan**.

overshooting A term used to describe a **curve** calculated with **spline interpolation**s that overshoots the maximum intended results based on the specified **key frame**s or **control point**s. This overshooting occurs as a result of the requirement built into a **spline curve** to always remain smooth and continuous. Although the requirement of smooth continuity is a great advantage of **spline**s, these unwanted side effects must be corrected by adjusting or adding key frames and, in the case of a **Bézier spline**, by adjusting the **tangent vector**s.

over the shoulder (OTS) A **two-shot** in which the **camera** films the action of a actor as seen over the shoulder of another actor in the **foreground (FG)**. See **over the shoulder close-up (OTS-CU)**.

over the shoulder close-up (OTS-CU) A **close-up (CU)** of one actor as seen over the shoulder of another actor in the **foreground (FG)**. Generally,

over the shoulder close-ups should be shot in pairs with similar **camera** positions to maintain a uniform appearance.

oversize set A **set** that is built larger than **full scale** so that the actors appear to be smaller. See **model scale**.

overwrite To **write** over **data** on a **computer** or other **storage device**.

owner The **user** who created a particular **file** or **directory**.

Oxberry film scanner High-resolution **film scanner**s, manufactured by Oxberry, that offer multiple **resolution, pin registered**, **step scanning** for various **film format**s. The Oxberry shuttle-style movements, for which Oxberry has been known since the 1950s, is a method in which two metal plates lift the **film** on and off the **registration pins** to allow the **pulldown claw** to pull the film into its next **position**.

oxide The magnetic coating used on **audiotape**s and **videotape**s that store **sound** and **image** information.

PA Abbreviation for **Production Assistant (PA)**.

packet A **block** of **data** that is **transmit**ted between **computer**s across a **network**. See **ethernet, Chernobyl packet**.

pad See **padding**.

padded numbers **Frame number**s for a series of **image**s that are carried out to a predetermined number of places. For example, name.1.cin would become name.0001.cin if it was **pad**ded out to four places. Also referred to as **leading zeros**.

padding 1. Referring to the use of **padded numbers** in a series of **digital image**s. 2. Referring to the addition of **black** along the top and bottom edges of an **image** to adjust the original **aspect ratio** for **display** purposes. See **masking**. 3. See **handles**.

page 1. In **virtual memory**, the **block** of **memory** that has a **virtual address**. 2. See **Web page**.

Page Description Language (PDL) A language, such as Adobe Systems **PostScript** language, that allows for a standardized appearance of a printed **document** regardless of the **platform** on which it was created.

page turn A special effect, created with a **digital video effects (DVE)** device, to simulate the turning of a page between two distinct **image**s.

paintbox 1. The trade name of a **paint system** manufactured and sold by **Quantel** that is used to create **2D graphics**. 2. A global term describing a variety of paint systems generally used for **video resolution** work.

paint effects Referring to the wide array of **painting** techniques available on most **paint package**s, such as **airbrush**, **mask**, **marquee**, **clone**.

painting 1. See **matte painting**. 2. Any manipulation of an **image** done with **paint software**.

paint macros Any **macro** that performs a repeatable task within a **paint software**.

paint package See **paint software**.

paint program See **paint software**.

paint software A **computer program** that allows the **user** to "paint" on the **computer screen** using a **mouse** or **stylus**. Most **paint package**s offer a variety of drawing and painting tools and a full **palette** of **color**s. **Photoshop** is a widely used paint package for **visual effects work**.

paint system Another term for **paint software**.

paint tools A general category that includes common features found in most **paint software**, such as a variety of paintbrushes, **blur algorithm**s, **sharpen filter**s, basic **compositing operation**s, **warp**, **emboss**, **distort**, **corner pinning**.

paint work A global term referring to any work that involves the use of a **paint software**, such as **matte painting**, **dust busting**, and **rig removal**.

PAL Abbreviation for **phase alternate line (PAL)**.

palette See **color palette**.

PAL format See **phase alternate line (PAL)**.

PAL image format A **digital image** stored in **PAL format** contains a **width** of 720 **pixel**s across and 576 **scan line**s high. See also **NTSC image format**, **SECAM image format**.

PAL video See **phase alternate line (PAL)**.

pan 1. **Rotation** of the **camera** around the **horizontal axis**. Also called **yaw**, **camera pan**. Opposite of **tilt**. *See also image on following page and image under **camera move***. 2. In some cases, the term pan is used on **set** to refer to camera rotation that includes both right and left **motion**, as well as up-and-down motion. (This use of the term *pan* confuses me every time!) 3. Another name for **translate**.

pan and scan A technique used to conform **image**s stored in an **aspect ratio** different from the aspect ratio in which they will be **display**ed. With pan and scan, strips of the images are actually chopped off on both sides of the **picture** when displayed and handled on a **shot**-by-shot basis, depending on the original **shot composition**. See also **letterbox**.

pan and tile A technique in which a series of **image**s, **capture**d from a **physical camera**, are seamed together to create a large virtual world for the **digital camera** to move about within. For best results, the **taking camera**

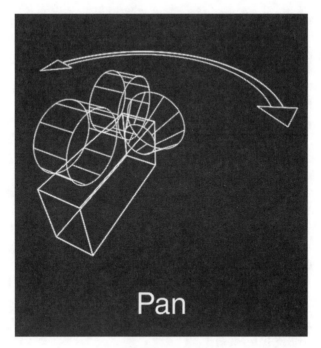

Camera pan.

should remain in a stationary **position** and use only its **pan and tilt head** to capture the various views of the **environment**. The use of **motion control (MOCO)** is ideal for capturing tiles as it can ensure that each tile is offset by the same amount from one another. This can make the job of stitching the tiles together in the **computer** much easier and yield better results.

pan and tilt head Any type of **head** that mounts to a **camera** and allows for the **pan**ning and **tilt**ing of the camera.

Panavision 1. A company that manufactures a line of professional **camera** equipment for **film**. 2. A specific **anamorphic** widescreen format developed by Panavision that produces an **image aspect ratio** of **2:35:1**. Also referred to as **Cinemascope**.

panic 1. An action taken by the **computer** or a **program** when a serious problem arises. A panic can fall into a number of responses, such as a **lock-up**, **crash**, or automatic **reboot**. 2. What you do when you realize you can't meet the **deadline**.

panorama A broad view of a **scene**, usually of a natural landscape.

pan shot A **scene** in which the **camera** rotates about the **Y-axis** during the **filming** of the **action**. However, it should be noted that for **live action photography**, a pan shot can also refer to any shot that **rotate**s about the camera center, including both pan and **tilt**.

Pantone See **Pantone Matching System (PMS)**.

Pantone Matching System (PMS) A **color** identification standard used in print work that contains over 3,000 different colors. Many **computer graphics program**s allow the **user** to select colors based on their **PMS number**.

PAR Abbreviation for **personal animation recorder (PAR)**.

parallax The amount of perceived **motion** in an **object** based on its distance from the **camera**. Objects in the distance will appear to have less motion than objects that are closer to camera. This effect is based on the total distance an object moves relative to the **field of view (FOV)** that it moves across. See also **multiplane**.

parallel Two or more straight **line**s or **plane**s that have the same **orientation** but do not **intersect**.

parallel computer A **computer** with two or more **central processing unit**s **(CPU**s) that can **run** multiple **process**es at the same time. See **serial computer**.

parallel interface See **parallel port**.

parallel method See **parallel viewing method**.

parallel pair The pair of **stereo image**s used for the **parallel viewing method**. See also **cross-eyed pair**.

parallel port A **port** on a **computer** that can **transmit** multiple **bit**s of **data** at the same time, as opposed to a **serial port** that can only send data one bit at a time. Also called a **parallel interface**.

parallel processing Synonymous with **multiprocessing**.

parallel processor A **computer** that contains more than one **central processing unit (CPU)** for use in **parallel processing**.

parallel projection See **orthographic projection**.

parallel projection view A **3D camera** in which the lines of the **object** being viewed do not **converge**. Because **perspective** is absent, an object appears to be the same size regardless of its distance from the **camera**. Also

referred to as an **orthographic view**, **orthographic camera**. See also **perspective view**.

parallelogram A four-sided **plane** whose opposite sides are **parallel**.

parallel viewing method A **free-viewing method** of viewing **stereo images** without the use of **3D glasses**. In the parallel viewing method, the normal tendency for the eyes to **converge** on a point of **focus** must be relaxed. Instead, the lines of sight of your eyes must move outward toward a "**parallel**" position and meet in the distance and focus at a point well beyond the **image plane**. Your eyes will, in essence, be seeing in "parallel." When you parallel view, the muscles that control the focusing **lens** inside your eyes relax and lengthen. Unlike the **cross-eyed viewing method**, the left **image** is on the left side and the right image is on the right side. Also called the **divergence method**, **magic eye method**, **parallel method**. *See also Color Plates 30–31, image under free viewing method.*

parameter An independent **value** passed to a **program**, **function**, **subroutine**, or **procedure**. Also called an **argument**.

parameter list See **argument list**.

parameter space The 2D **coordinate system** applied to the **points** of a **surface** in order to apply a **texture map**. See **UV coordinates**, *Color Plate 34.*

parametric singularity See **gimbal lock**.

parametric surface A type of **primitive surface** defined by the **interpolation** of **control points**. See **mesh**, **patch**, **NURBS**. See also **bicubic patch**.

parameterization Parameterization is the way in which the distance and direction between successive **points** on a **curve** is expressed. For example, **Bézier**, **B-spline**, **Cardinal**, and **linear** curves all use **uniform parameterization** whereas **NURBS** use **nonuniform parameterization**.

parameterized curve A **curve**, such as a **spline**, on which the location of its **points** can be defined in terms of their distance and direction along the curve relative to the **position** of the first point. See **parameterization**.

parameterized mapping A **texture mapping** technique in which a **texture map** is stretched onto a **3D surface**. Parameterized mapping works by mapping each **pixel** to a corresponding area of the 3D surface. In order to achieve this, the 3D surface is divided up into the same number of rectangular areas as there are pixels in the texture map. This **surface** division is accomplished by stepping along the surface in two opposite directions—the **U** and **V direction**s—just as the **2D image** can be stepped along in the **X** and

Y directions. The **color** corresponding to the rectangular **image** area located at XY (0,0) can then be mapped to the rectangular surface area located at UV (0,0). This process is continued until the entire image has been stepped through and the corresponding color are applied to the surface. This technique can create noticeable **image distortion** when the shape of the 3D surface differs greatly from the 2D image. **Nonuniform parameterization** of a **NURBS surface** is one way of addressing the problem of stretched textures. See also **uniform parameterization**.

parameterized texture mapping See **parameterized mapping**.

parent 1. An **object** or **node** that controls the **attributes** and **transformation**s of one or more **children** by **group**ing them together within a **hierarchy**. A parent is placed before its children in the hierarchy, and a parent can be a **child** of another parent. **Character animation** commonly uses parenting to control the way the different **limb**s of a **character** interact with one another. For example, if a leg is parented to the hip, when the hip moves, the leg inherits the hip transformations and moves with it. Another example is the Sun, which is the parent to all the planets in our solar system. 2. To make an object part of a **hierarchy**. Opposite of **unparent**. 3. See **parent process**.

parent directory A **directory** that contains one or more directories inside it.

parenting See **parent**.

parent process A **process** on a **Unix-based system** that creates one or more **child process**es.

parent program The **program** that is first loaded into **memory** when the **computer** is powered on and that **load**s all other programs, called **child program**s.

parse The process of searching for specific patterns of **character**s in order to modify **text file**s with a **text editor**, such as **vi, ed, jot, awk, sed, perl, TCL**. Also called **search and replace, pattern searching, pattern matching**.

parser See **text editor**.

particle Particles are **object**s, containing no **volume** or **surface**, that are used to simulate **natural phenomena**, such as dust or snow. Each particle contains unique **attributes**, such as **direction, velocity, age, life span, color**, and **opacity**. Once the **path** of a particle has been defined, any object can be **instance**d to it. See **particle animation, motion dynamics, zero-dimensional**, *image under **particle system***.

particle age The age of a **particle** relative to the **time** it was born. *See also image under **particle system**.*

particle animation Any **animation** created based on a **particle system**. *See also Color Plates 40, 43.*

particle attributes The **value**s that are assigned to the **particle**s within a **particle system**, such as their **color** and **transparency**, **particle life**, **particle age**, **initial velocity**, **particle emission rate**.

particle emitter The **source object** used to create the **particle**s within a **particle system**. See **initial velocity**.

particle emission rate The rate at which **particle**s are born per second. See **particle system**.

particle life The amount of **time** that a **particle** is allowed to be "alive" and active within a **particle system**. See also **initial velocity**, **particle age**.

particle object A collection of **particle**s ranging from zero to many.

particle package See **particle software**.

particle software A **software application** specifically designed to allow the **user** to create and modify **particle system**s. **Dynamation** is an example of a particle **software package**. See also **modeling software**, **animation software**, **lighting software**, **compositing software**, **paint software**, **render software**, **tracking software**.

particle speed The rate at which **particle**s in a **particle system** travel through **space**, based in part on the **particle emission rate**.

particle system A **3D animation** technique used to control the behavior of large numbers of **object**s through the use of an explicit **user-defined** set of rules and **dynamic simulation**s. This technique is commonly used to create smoke, fire, **flocking**, and any other type of **natural phenomena** effects. A wide range of **parameter**s are used to control how **particle**s move, such as **particle emission rate**, **particle speed**, **particle life**, **particle age**, **initial velocity**, **particle trail**, **turbulence**, and **particle attributes**. *See also image on following page and Color Plates 40, 43.*

particle trail The trail life of a **particle** is related to **motion blur**. The longer the life of a trail, the longer the trail of motion blur left behind.

partition A division within a **disk** or other **storage device**.

Pascal An **object-oriented programming language** designed for simplicity and for teaching **programming**.

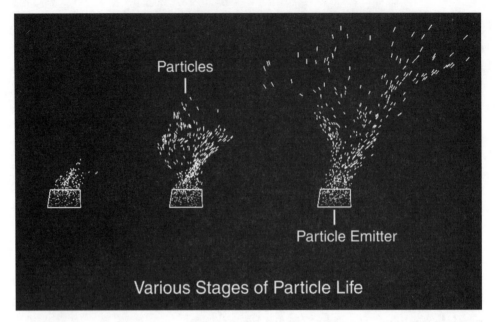

The **life** of a **particle** is controlled by factors such its **age, life span, emission rate, initial velocity, turbulence,** and gravitational pull.

pass 1. In **multiple-pass photography**, using **motion control (MOCO)**, one of several **element**s shot under different **lighting** conditions, such as the **beauty pass, shadow pass, matte pass, reflection pass**. 2. For **multiple-pass rendering**, one of several **CG element**s that are **rendered** under different lighting or **shading** conditions. 3. A single pass of a piece of **film** through the **camera** during which an **exposure** is made.

passive bodies See **passive rigid bodies**.

passive rigid bodies **Rigid body objects** that act as **collision object**s for **active rigid bodies** in **motion dynamics**.

password A unique **string** of **ASCII character**s chosen by each **user** for identification purposes when they **log in** to a **computer**. A password is used in conjunction with a **user name**.

paste To insert **text** or **image**s onto a page that have been previously copied into a temporary **paste buffer**, called a **clipboard**. See also **copy, cut, cut and paste**.

paste buffer See **clipboard**.

patch 1. Shorthand for **bicubic patch**. 2. A temporary fix to a **program**. 3. To connect equipment with wires or **cable**s.

patch bay A panel containing a series of **input** and **output** connectors in which **video** and **audio** cables can be plugged into to direct the **signal**s to the desired **tape** or audio **channel**s.

patch deformation A **deformation** technique in which a **patch**, placed through the center of an **object**, is used to deform that object based on the **shape** of that patch. See also **spline deformation**, **path deformation**.

path 1. For **path animation**, the **curve** along which an **object** or **camera** is **animate**d. 2. Shorthand for **path of extrusion**. 3. Shorthand for the **path-name** of a file. 4. The route between any two **computer**s or **peripheral device**s. 5. The route between the **node**s in a **hierarchy**.

path animation Path animation is a technique in which an **object** is assigned to move along a **path** that has been drawn as a **curve** in **3D space**. By modifying the **shape** of the curve or **motion path**, the **motion** of the object can be adjusted. When the **camera** is associated to a motion path, it is referred to as **camera path animation**. *See image below.*

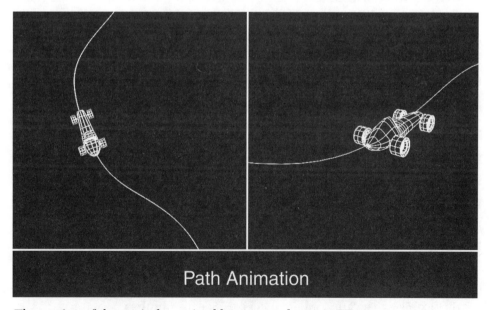

Path Animation

The **motion** of the car is determined by a **curve** drawn in **3D space**.
IMAGE CREATED USING HOUDINI AND COURTESY OF SIDE EFFECTS SOFTWARE.

path deformation A **deformation** technique in which the **path** to which an **object** is attached is **animate**d as a means of deforming the object as it travels along that **path**. Very similar in concept to **spline deformation**. See also **patch deformation**.

path of extrusion The **curve** used to **sweep** a **generating curve** along to create a **swept surface**. *See also image under sweep.*

pathname The name and location of a particular **file** or **directory** stored on **disk**. Pathnames use the slash character to denote the top or **root** of the **file system** and to separate directory names. For instance, the pathname of a **home account** might be "/usr/people/artist_name."

pattern matching See **parse**.

pattern searching See **parse**.

PC Abbreviation for **personal computer (PC)**.

PC clone A **personal computer** that is compatible with the **IBM PC**. Also referred to as **IBM compatible**, **IBM clone**.

PC compatible See **PC clone**.

PC-DOS The **operating system (OS)** from **Microsoft, Corp.** supplied with **IBM personal computer**s (**IBM PC**s). **Microsoft** also developed **MS-DOS** to run on non-IBM personal computers (PCs).

PC software Any **software package** that can **run** on a **personal computer (PC)**.

PDF Abbreviation for the Adobe **portable document format (PDF)**.

PDL Abbreviation for **Page Description Language (PDL)**.

pedestal See **blanking level**.

pen See **stylus**.

Pentium A high performance **microprocessor** developed by **Intel, Corp.**

Pentium II The **microprocessor** that followed the **Pentium** and offered design and speed improvements.

Pentium III The **microprocessor** that followed the **Pentium II** and offered improvements in **graphics**.

penumbra The area in which the **light source** is partially obscured by another **object**. The area of partial eclipse. See also **umbra**.

Perception Video Recorder (PVR) A **digital disk recorder (DDR)** for **PC**s and **DEC Alpha**s.

per diem A specific amount of money paid each day to **Crew Member**s while **shooting** on **location**. The money is meant to cover any costs of meals, laundry, lodging, and so forth.

perf Abbreviation for **perforation**.

perforation The evenly spaced holes that run along the edge of **film** that are used to guide the film reliably through the **camera**. Some **film format**s are referred to by the number of **perf**s that are contained along the edge of each **frame**, such as **4-perf** and **8-perf**. Also called **sprocket hole**s. See also **pitch**.

perforation pitch See **pitch**.

performance animation **Character animation** that is based on **data** originating from **motion capture (MOCAP)** or **puppet** devices.

performance capture See **motion capture (MOCAP)**.

peripheral See **peripheral device**.

peripheral device A general term used to describe **device**s attached to a **computer**, other than the **central processing unit (CPU)** or **memory**, such as a **mouse, keyboard, CD-ROM drive, modem, printer, scanner**, or **storage device**.

perl Abbreviation for **practical extraction and report language (perl)**.

Perlin fractal noise A commonly used **noise function**, created by Ken Perlin in the 1980s, used to create **procedural texture**s on **3D surface**s. In 1997, Perlin received a Technical Achievement Award from the **Academy of Motion Picture Arts and Sciences (AMPAS)** for his work.

permission Referring to the **permission mask** settings for a particular **file** or **directory**. The **owner**s of the files and directories can change the permissions at any time.

permission mask A **file** control system that uses three numbers to control the **read**, **write**, and **execute** permissions on files and directories based on the **owner**, **group**, and other **user**s. Also called **umask**.

perpendicular Referring to two **object**s that are at right angles relative to one another.

persistence of vision A phenomenon of the human eye that causes it to continue to perceive an **image** for a fraction of a second after it disappears. When a **sequence** of still images is successively displayed, our eyes retain a brief afterimage of each **frame** that fills the small gap of time between the

display of the previous and next frame on the **display device**. As a result, the adjacent frames appear to flow seamlessly together in one fluid **motion**. Without persistence of vision, we couldn't see **film** or **video** as continuous motion. See also **apparent motion**.

personal animation recorder (PAR) See **digital disk recorder (DDR)**.

Personal Assistant (PA) See **Production Assistant (PA)**.

personal computer (PC) Personal computers usually refer to **computer**s that conform to the standards defined by **IBM PC**s, which are based on **Intel microprocessors** and typically run with **DOS** or **Windows**.

perspective The appearance of **object**s in terms of their distance, **position**, and atmospheric influences relative to the position of the **camera**. Perspective is changed by moving the camera relative to the **subject** in the **frame**, whereas increasing or decreasing the **focal length** or a **zoom** will change the size of the subject but maintain a constant perspective. An object will appear to change size at a constant rate when changing the focal length or zoom **parameter**s, whereas objects far from the camera will change size at a much slower rate than those closer to camera. See also **linear perspective**, **aerial perspective**, *image under* **perspective view**.

perspective camera See **perspective view**.

perspective compensation Any **image processing** techniques that use **2D transform**ations to adjust a **3D** discrepancy. For example, if any **live action plate**s are **shot** with an inappropriate **perspective** relative to other **element**s shot for the **scene**, various **image warp**ing techniques, such as **corner pinning**, can be used to alleviate the problem.

perspective projection See **perspective camera**.

perspective view A **3D view** in which the **distortion** of an **object** in **3D space** is simulated as in the real world. The lines of the object **converge** to a vanishing point and objects closer to **camera** appear larger than those further away. Also called **perspective camera**, **perspective window**. Opposite of **orthographic view**. *See also image on following page and image under* **viewing windows**.

perspective window See **perspective view**.

perturbed geometry See **displaced geometry**.

perturbed normals **Surface normal**s that have been artificially tilted to simulate **bump mapping** are referred to as perturbed normals.

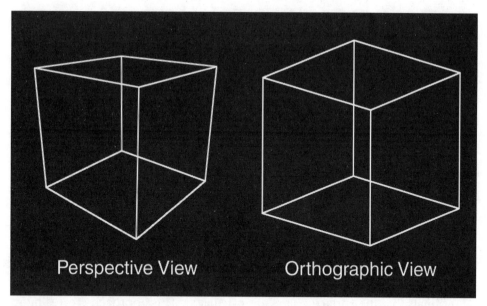

Perspective View Orthographic View

The view of the same **cube** through a **perspective view** and an **orthographic view**.

perturbing 1. The process of artificially tilting the **surface normal**s of a **3D object** in order to simulate a bumpy **surface** when **rendering** with **bump mapping**. 2. The process of actually displacing the **height** of a **3D** object when **displacement mapping** is used.

PGA Abbreviation for **Producer's Guild of America (PGA)**.

phantom control points Some **software package**s will automatically add **control point**s to **curve type**s that do not have true **end point interpolation**. Such points are sometimes referred to as phantom control points.

phantom object For **computer graphics (CG)**, an **object** that can be seen only in the **reflection**s and **shadow**s of another object. A phantom object is not **render**ed directly into the **scene**. See also **template object**.

phase Basic waves, such as **analog signal**s, that consist of repeating peaks and valleys. See also **amplitude**, **frequency**.

Phase Alternate Line (PAL) The **video signal** standard, developed in Germany and used in the United Kingdom and Western Europe, that carries 625 **scan line**s of information and uses a **playback rate** of **25 frames per second (25 FPS)** with a 4:3 **aspect ratio**. The **field dominance** of a **PAL** image uses the first **field** to hold the odd-numbered scan lines and the sec-

ond field to hold the even-numbered scan lines. See also **National Television System Committee (NTSC)**, **Sequential Color with Memory (SECAM)**, and **High Definition Television (HDTV)**.

phi phenomenon Synonym for **apparent motion**.

Phong interpolation The technique that creates a **surface normal** for each **point** on a **polygon** by **interpolation** across its **vertices**.

Phong lighting model See **Phong shading model**.

Phong shading See **Phong shading model**.

Phong shading model A **shading model**, developed by Bui-Tuong Phong, used to make **surface**s made up of connected **polygon**s appear to be smooth. Like the **Gouraud shading model**, Phong shading uses **averaged normal**s at each **vertex**, but rather than interpolating the **color**s between these **vertices**, it first calculates **interpolate**d **surface normal**s between the vertices of each polygon. It is from these newly interpolated surface normals that the surface colors are calculated. This approach creates more accurate calculations of the surface than Gouraud shading. See also **Blinn shading model**, **Lambert shading model**, **Cook/Torrence shading model**, *image below and under shading model.*

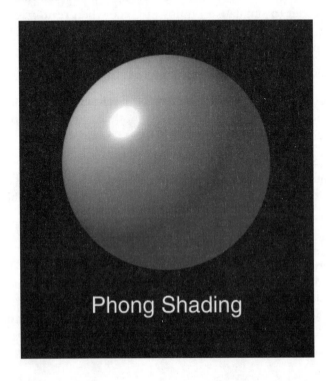

Phong Shading

phosphors The material used to coat a **cathode ray tube (CRT)**. Phosphors have a special property that causes them to **emit** light when struck by an **electron beam**.

photography The process of capturing **images** with **light rays** hitting a **surface**.

photogrammetry A method in which **texture**d **3D geometry** is created based on the analysis of multiple **2D image**s taken from different view points. See also **stereo reconstruction, Image Based Modeling and Rendering (IMBR)**.

photo lab Shorthand for **photo laboratory**. See **film lab**.

photo laboratory See **film lab**.

photorealism A global term used to describe **CG image**s that cannot be distinguished from **object**s seen in the real world.

Photo Realistic RenderMan (PRMAN) See **RenderMan**.

Photoshop The trade name of a widely used **paint software** from **Adobe Systems, Inc.**

physical camera Any **camera** not created in a **computer**. The physical camera is a piece of equipment used to photograph a **scene** and is composed of a **camera body**, **film magazine**, **lens**, **shutter**, and **viewfinder**. Opposite of a **virtual camera**.

physical effects 1. See **practical effects**. 2. For **motion dynamics**, referring to **natural phenomena** effects, such as **wind** and **gravity**.

physical forces The forces that act on an **object** in **motion dynamics**, such as **gravity**, **wind force**, and **fan force**s, that contribute to the calculation of realistic **motion**. See also **physical properties**.

physical memory The **memory**, normally **random access memory (RAM)**, that is installed in a **computer**. See **virtual memory**.

physical model Any **model**s or **miniature**s that are not created on a **computer**. Also called a **practical model**. See also **maquette**.

physical properties 1. For **motion dynamics**, the characteristics that make up an **object**, such as **mass**, **elasticity**, **volume**, and **friction** that must be calculated in order to **simulate** realistic and natural **motion**. See also **physical forces**. 2. For **computer graphics (CG)** in general, see **attribute**.

physical simulation See **simulation**.

physiquing A term sometimes used synonymously with **character setup** and **skinning**.

pica A unit of measurement used in **printing** applications.

pick box A **user-defined** rectangular shape drawn with the **mouse** from a defined point to its diagonally opposite corner. All **element**s or **object**s contained within this box will be affected by **operation**s or **function**s applied to this area.

pickups See **additional photography**.

pickup shot See **additional photography**.

PICT A **Macintosh**-based standard **file format** used for exchanging **image**s information.

picture See **image**.

picture aperture The rectangular opening in which each **frame** of **film** is placed during **exposure**, **printing**, or **projecting**.

picture element The term from which the word **pixel**, *pic*ture *el*ement, was derived.

picture gate See **film gate**.

picture map See **texture map**.

picture show See **motion picture**.

picture tube See **cathode ray tube (CRT)**.

PID Abbreviation for **process identifier (PID)**.

pin cushion distortion 1. A type of **lens distortion** in which straight lines are bent inward toward the center of an **image**. See also **barrel distortion**. 2. An **image process** available in some **compositing package**s that distorts the corners of an image in and out to mimic **lens** distortion in a **live action plate**. *See images on following page.*

pinhole camera A **camera** containing a small hole, rather than a **lens**, that is used to control the amount of **light** allowed to pass through. Similar to a lens but without the **lens distortion**. A **CG camera** is an example of a pinhole camera.

pin registered A **camera** or **projector** using **registration pins** or a **print** made on an **optical printer** that uses registration pins is said to be pin registered. See **electronic pin register**.

pin registration The process of inserting the **registration pins** into the **perforation**s of each **frame** of **film** as a means of positioning and holding the film **steady** within the **camera** or **projector**. Film that is not **pin regis-**

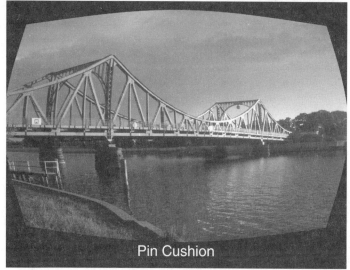

The result of **pincushion distortion** applied to a **source image**.

tered will shake and bounce when viewed and will have to be **stabilize**d during **compositing**.

pipeline See **digital pipeline**.

pirate To make an illegal copy of **software**.

Pirate See **software pirate**.

pirated software **Software** that has been illegally copied for personal or commercial use.

pitch 1. Another name for **tilt**. 2. The distance between the leading edge of one **perforation** to the leading edge of the next perforation on a piece of **film**. **Motion picture** film perforations are often referred to as having either a **long pitch** or **short pitch**. When the film is being **print**ed, the **negative** and **unexposed** print stock are both placed together on a curved printing **sprocket** for **exposure**. Because the print film is on the outside, it is given a slightly longer pitch than the negative on the inside, to accommodate for the slight difference in diameter between the placement of the two films relative to the printing sprocket. Also called **film pitch**, **perforation pitch**. 3. A property of **sound** that is determined by the frequency of sound waves. 4. A meeting with a group of people to present a particular scope of work, such as a **treatment**, **script**, or **storyboard**s, to try to generate interest in the work.

pivot See **pivot point**.

pivot point The stationary **point** in **3D** or **2D space** that an **object** or **image** is **rotate**d and **scale**d around. For most **software package**s, this defaults to the **point of origin** for each object or image. *See image on following page.*

pixel A pixel, from the words *"pic*ture *el*ement," is the smallest individual unit, defined as an **array of dots**, used to describe a **digital image**. The larger the number of these pixels, the greater the **resolution** of the image. Each pixel, which is always the same **color** throughout, is composed of the three **component**s of **red (R)**, **green (G)**, and **blue (B)**. By using a combination of these three **primary colors**, a digital image can be represented. When **display**ed on a **monitor**, each pixel is seen as a square dot. See also **pixel depth**, **pixel aspect ratio**.

pixel analyzer A tool available in most **compositing** and **paint package**s that allows the **user** to **point** the **mouse** over an area of **pixel**s in order to get the average **color value**s from that portion of the **image**. See also **color picker**.

pixel aspect ratio The ratio of **width** to **height** of a **pixel** on a **display device**. While most **image format**s use **square pixel**s, some **format**s, such as **video**, use **rectangular pixel**s that are 90 percent as tall as they are wide. So, for a pixel with a width equal to 1.0, the height would be equal to 0.9.

pixel color The **RGB values** that define the **color** of a **pixel**.

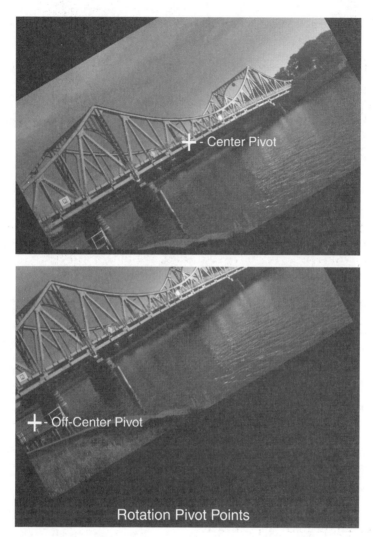

The **pivot point** of an **image** controls the way it will **rotate**.

pixel component The individual **RGB channels** that define the **color** of a **pixel**.

pixel degradation Referring to any loss of quality or **artifact**s that are introduced as a result of various **image processing** tools applied to an **image**.

pixel depth The number of **color**s that a **pixel** can **display** as measured in **bit**s. Pixel depth is determined by calculating 2 to the power of the number

of **bits per pixel**. For example, **8 bit**s per pixel will allow for 256 colors (2 to the 8th power = 256) for each pixel.

pixel fking** Slang for **tweaking**.

pixel graphics See **raster graphics**.

pixelize See **pixellation**—Definition #2.

pixellation 1. The visible pattern of the individual **pixel**s, similar to a mosaic effect, that results from **image**s being **display**ed with insufficient **resolution**. *See also image under **image processing***. 2. An image process available on some **compositing package**s that **filter**s an image into square blocks to create a **mosaic** look by averaging together all the **pixel values** within that block.

pixel manipulation To modify the **pixel**s defining an **image** with any variety of **image processing** tools.

pixel map A **3D array** of **bit**s used to represent the **2D array** of **pixel**s that make up a **color** image. Often abbreviated to **pixmap**. See **bitmap**.

pixels per inch (PPI) PPI is used to define the number of **pixel**s that a **scanner** can **capture** per inch.

pixel values The **color** of the **RGB components** that make up each **pixel** in a **digital image**.

pixilation A **stop-motion** technique in which **full-scale** props or actors are photographed one **frame** at a time to achieve unusual **motion** effects. After each frame is **expose**d, the **subject** moves into a new still position for the next frame of **exposure**.

pixmap Abbreviation for **pixel map**.

plain old telephone service (POTS) Basic **analog** telephone service that uses an extremely low **bandwidth**.

plain text Text in its original form, as opposed to **text** that has been run through an **encryption** process. Opposite of **cyphertext**.

planar 1. Synonym for **two dimensional (2D)**. 2. A geometric **object** that lies along a **plane**.

planar mapping See **orthographic mapping**.

planar object See **planar surface**.

planar projection mapping See **orthographic projection mapping**.

PLATE 381

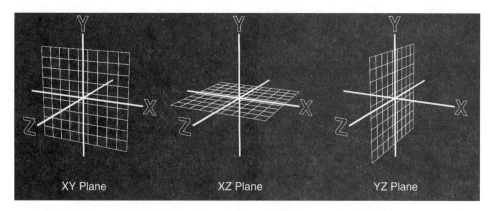

The three **plane**s of a **coordinate system**.

planar surface A **curve** or **surface** that contains no **depth** and lies along only one **plane**. **Polygon**s are examples of planar **object**s. Opposite of **nonplanar surface**.

plane 1. A flat **surface** that is **perpendicular** to one of the three **axes**, **X**, **Y**, or **Z**. The planes that are perpendicular in a **Cartesian Coordinate System** are the **XY plane**, **XZ plane**, and the **YZ plane**. A plane is a **two-dimensional (2D)** surface that contains information for only two **dimension**s, most often **height** and **width** but not **depth**. Three **point**s in space always define a plane, and that is why **triangle**s are commonly used to define **polygonal model**s. *See image above.* 2. See **film plane**.

plane normal The **vector** that is **perpendicular** to a **plane** and is used to calculate the **reflection** of **light** for a **surface**.

plan file The ".plan" **file** is displayed when a **user** is **finger**ed. It is stored in the user's **home directory** and generally **display**s information about one's location and future plans.

plant generator A **program** that creates plant life, such as trees and flowers, based on **parameter**s defining the plant type, species, age, and varying degrees of randomness. An **L-System** is an example of a plant generator.

plan view Generally, referring to the **top view** of a **3D scene** or **model**.

plate The **select**s from **live action** and **stage photography** that are **scan**ned for use in a **digital composite**. These **frame**s are often used as the primary guide for **lighting**, **color**, and **matte painting** reference.

Plate Coordinator A member of the **Visual Effects Crew** who takes **camera reports** for all **plate photography** that will involve **visual effects work**.

plate elements See **plate**.

plate photography See **live action photography**.

Plate Producer An individual who supervises the scheduling and **budget**ing of all the **plate**s that are **film**ed to serve as **element**s for **shot**s involving **visual effects work**. This job is often done by the **Line Producer**.

plate prep A general term used to describe work done on a **live action plate** before it goes to a **Compositor** as a means of speeding up the work required for the final **composite**. Such work includes, **dust busting**, **rig removal**, **articulate matte**s, **garbage matte**s, **image stabilization**, **color grading**.

plate restoration A global term used to describe any work done to remove unwanted **artifact**s, such as **dust** and scratches, from an **image**. See **dust busting**, **cinch marks**.

plate tracking The process of extracting **camera motion** for use in **computer graphics (CG)** from a **live action plate**. See **2D tracking**, **3D tracking**.

platform See **computer platform**.

platform dependent **Software** and **program**s that can **run** on only one type of **computer platform**. Also referred to as **machine dependent**. Opposite of **platform independent**.

platform independent The ability to run **software** and **program**s on different **computer platform**s. Also referred to as **machine independent**. Opposite of **platform dependent**.

playback 1. See playback speed. 2. The actual **display** of **image**s in **real time** or another **user-defined** speed. 3. The review of the previous **film**ed **take**s on the **video tap** by the **Director** and the **Crew** to determine what adjustments, if any, should be made for the next takes.

playback rate Synonymous with **playback speed**.

playback speed The rate, measured by the number of **frames per second (FPS)**, at which a **sequence** of **image**s is **display**ed.

playbar The **slider bar**, used in most **software package**s, that will indicate the **current frame** being **display**ed in the **view**. When playing back a **se-**

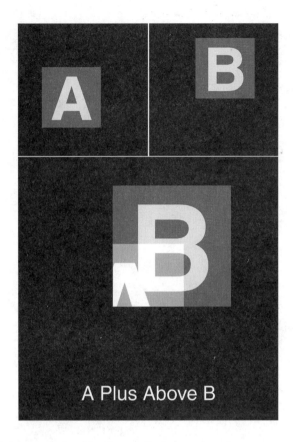

A Plus Above B

quence of **frames**, the playbar will slide in **real time** across the range of frames as they are played back.

playblast See **motion preview**.

plug and play A slang term used to describe an **effect** that has been so thoroughly developed and defined that an artist only needs to adjust a few **parameter**s to get the desired results. This is the optimistic goal of every **visual effects (VFX)** show but not always the reality.

plug in A **subprogram** that can be linked into the main **program** of an **application** to perform tasks that the main program cannot.

plus above See **plus above operation**.

plus above operation A **compositing operation** that adds the **foreground image** to the background image, but only inside the area covered by the **alpha channel** of the **background image**. See also **plus below operation**, **above operation**. *See image above and image under **layering operation**.*

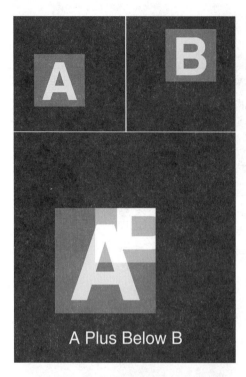

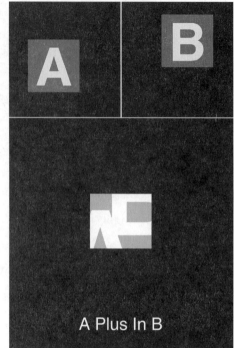

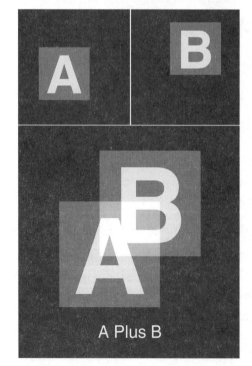

A Plus Below B

A Plus In B

A Plus B

A Plus Out B

plus below See **plus below operation**.

plus below operation A **compositing operation** that adds the **foreground image** to the **background image** but only inside the area covered by the **alpha channel** of the foreground image. See also **plus above operation**, **above operation**. *See image on previous page and image under **layering operation***.

plus in See **plus in operation**.

plus in operation A **compositing operation** that adds together the **pixel**s of two **image**s only where the **alpha channel**s of the two images overlap. Opposite of **plus out operation**. *See image on previous page and image under **layering operation***.

plus operation A **compositing operation** that adds together the **pixel**s of two **image**s. Also called an **addition operation**. *See image on previous page and image under **layering operation***.

plus out See **plus out operation**.

plus out operation A **compositing operation** that adds together the **pixel**s of two **image**s only where the **alpha channel**s of the two images do not overlap. Opposite of **plus in operation**. *See image on previous page and image under **layering operation***.

PMS Abbreviation for **Pantone Matching System (PMS)**.

PMS number The identifying number that corresponds to a specific **color** in the **Pantone Matching System (PMS)**.

point 1. An XYZ location in **3D space** based on a **Cartesian coordinate system**. Points are used to define an **object** and can carry information about **color**, **point normal**s, **texture coordinates**, and **weight**. Points contain no **height**, **width**, or **depth** information and are said to be **zero dimensional**. See also **vertex**. 2. To move a **pointing device**, such as a **mouse**, so that the corresponding on-screen **pointer** is positioned over the desired **button**, **icon**, **menu**, or **window**. See **click** and **drag**. 3. A particular feature chosen from a **sequence** of **image**s to use in extracting **camera information** with **2D tracking** tools. See also **one-point track**, **two-point track**, **four-point track**. 4. A decimal point.

point cloud **Data** composed of **point**s representing the **global coordinates** of a **surface**. Point cloud data can come from a wide range of sources, including a **cyberscan**, **survey data**, and **Lidar**. Each point described within a point cloud represents the measured **position** of a specific **sample**d point on a surface.

point cluster A series of **point**s or **vertices** that are **group**ed together so they can be **transform**ed and manipulated using various **modeling, animation**, and **deformation** techniques. A point cluster is similar in nature to a **hierarchy** since each cluster contains its own **pivot point** or **local origin** that can be used to modify the points contained in the cluster as a single **unit**. However, each point contained in the cluster can also be moved independently of the cluster. By positioning the points within the point cluster to create **keyshape**s, the **computer** can calculate the **interpolation**s across the various shapes to create a **point cluster animation**. Also called a **point group, cluster, group**. See also **lattice box**.

point cluster animation Any **animation** of an **object** based on the manipulation of the **point**s contained in a **point cluster**. Also called **point group animation, cluster animation**. See also **lattice box animation**.

point cluster deformation The process of **deform**ing an **object** based on the **transformation** of the **point**s contained in a **point cluster**.

point color The **RGB values** assigned to an individual **point**.

point constraint Similar to a **translation constraint**, a point constraint is often used to describe an **object** that is positionally constrained between two or more objects. Like **up vector constraint**s, point constraints are often used with **Digital Character**s that have been **motion capture**d.

point coordinate The location in **3D space** of a particular **point**.

pointer 1. See **laser pointer**. 2. See **cursor**. 3. In **programming**, an instruction or an **address** to jump to another section of the **data** structure. 4. See **hypertext link**.

point group See **point cluster**.

point group animation See **point cluster animation**.

point group deformation See **point cluster deformation**.

pointing device An **input device**, such as a **mouse, joystick**, or **stylus**, that allows a **user** to **click, point**, and **drag** across a **computer screen** to interact with the **graphical user interface (GUI)**.

point light A **light source** in which all **light rays** originate from one point and illuminate equally in all directions. The **intensity** of the rays will remain constant regardless of their distance from the point source unless a **falloff** value is explicitly stated. A light bulb is a good example of a point light. Also called an **omnidirectional light**. See also **spotlight**.

Point Normals

point light source See **point light**.

point list The **ASCII file** containing information about about all the **point**s contained in a **polygonal object** and the way the points connect to other points to form the **surface**. See also **vertices**.

point normal The **vector** that represents each **point** on a **surface**. See also **surface normals**. *See image above.*

point of origin The center point in **2D** or **3D space**. See **pivot point**.

point of presence (POP) The site closest to the **user** to which they can connect to the **Internet** or other **remote system**.

point of view (POV) 1. The relative position from which a **subject** is observed and viewed. See also **camera angle**. 2. See **point of view camera angle**.

point of view camera angle A **shot** in which the **camera** films the **scene** from a particular actor's viewpoint. The **point of view (POV)** shot is as close as an **objective shot** can be to a **subjective shot** and still be objective. The **cam-**

era is positioned at the side of the actor and as close to the **action axis** as possible.

point of view close-up A **close-up (CU)** in which the actor is **film**ed from the **point of view (POV)** of the **off-screen** actor. The **camera** should be positioned at the eye level of the opposing actor whose viewpoint is being depicted.

point of view shot (POV shot) A **shot** filmed with a **point of view camera angle**.

points The numerical **value**s that are used for **printing lights**.

point to point protocol (PPP) A method for establishing communication between **computer**s using a **TCP/IP** protocol across telephone lines.

point weighting See **weighting**.

polar axis The **vector** that can be drawn between a **point** in space and its **origin**. See **polar coordinates**.

polar coordinates A mathematical system in which the location of a **point** in space can be calculated by its distance from the **origin** and by the angle of a **vector**, known as the **polar axis**, between that point and its origin. Polar coordinates are calculated during **set surveying** and then later converted into **XYZ coordinates**. See also **Cartesian Coordinates**.

polarized glasses **3D glasses** that use **polarizing filter**s to differentiate between the **image**s sent to the **right and left eyes** in **stereo film**s. See also **flicker glasses**, **anaglyph glasses**.

polarizers See **polarizing filter**.

polarizing filter 1. For **filming**, a **filter** used to reduce the glare and **reflection**s from reflective **surface**s. 2. For **stereo film**s, the specially designed filters used in **3D glasses** as a means for differentiating between the left and right eyes. **Light** passing through the filters is **transform**ed into a series of straight **line**s or ovals. By placing the filters in front of the left and right eyes at opposite **rotation**s to each other, the **left eye** will only see the **image**s displayed by the left **projector** and the **right eye** will only see the images from the right projector. See also **linear polarizer**, **circular polarizer**.

pole vector A type of **vector** used to point **joint**s, such as elbows and knees, in a certain direction in an **IK skeleton**. A pole vector is designed to work specifically with a **pole vector constraint**.

pole vector constraint A specific type of **constraint** that causes the end of a **pole vector** to move to and follow the **position** of an **object** or the av-

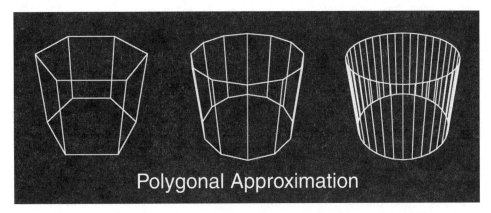

Polygonal Approximation

The more **polygon**s used for **polygonal approximation**, the greater the illusion of a truly **curved surface**.

erage position of several objects. Pole vector constraints are used to constrain a pole vector so the **joint chain** does not unexpectedly flip when other vectors approach or intersect it.

poly Abbreviation for **polygon**.

polygon A **planar surface** defined by one or more sides composed of straight **lines**. See **concave polygon**, **convex polygon**, **vertices**.

polygonal Referring to an **object** defined by **polygon**s.

polygonal approximation The technique used in **polygonal modeling** to approximate the curvature of a **surface** by using large numbers of very small **polygon**s. Polygonal approximation can never create a truly curved surface, regardless of the number of polygons used, because it will still be a **faceted surface** made up of flat polygons. See also **linear approximation**. *See image above.*

polygonal model Any **object** defined by **polygon**s. See also **polygon mesh**.

polygonal modeling The creation of **3D object**s with **planar surface**s, called **polygon**s. See **spline-based modeling**.

polygonal object See **polygonal model**.

polygonal subdivision The process of using **polygonal approximation** to convert **curved surface**s into a **polygonal model** prior to **rendering**. Also called **rendering subdivision**.

polygonal surface See **polygonal model**.

polygon-based modeling See **polygonal modeling**.

polygon components The **parameter**s and components that define a **polygonal object**, such as **vertices**, **face**s, and **normal**s.

polygon count The total number of **polygon**s used to define a **polygonal model**. Models with a high polygon count greatly reduce the ability of a **computer** to allow the **user** to modify the **object** with **real-time interaction**.

polygon detail Referring to the type of **topology** used to describe a **polygonal model**, such as **rows and columns**, **triangles**, **quadrilaterals**, **alternating triangles**. Polygon detail can also refer to the **level of detail (LOD)** used to represent the **model**. *See image below.*

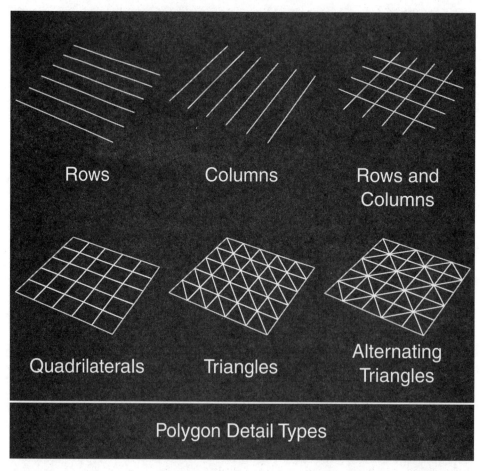

Rows Columns Rows and Columns

Quadrilaterals Triangles Alternating Triangles

Polygon Detail Types

Some various types of connected **topology** that can be used to describe a **polygonal model**.

polygon expansion A technique that increases the **polygon count** of a **polygonal model** while still retaining its original **shape**. Opposite of **polygon reduction**. See also **polygon rounding**.

polygon file The **Unix file** that contains the description of **point**s, **face**s, and **vertices** about a particular **object**.

polygonize To convert a **surface** made from something other than **polygon**s into a **polygonal model**.

polygon mesh A **surface** described by a collection of **polygon**s whose **points** are arranged as an **array** of points that can be connected together with straight **line segment**s in a variety of ways, such as **rows and columns**, **quad**s, **triangle**s or **line**s (**open polygons**). The amount of **smoothness** across the surface of an **object** is dependent entirely on the number of defined polygons.

polygon reduction A technique that reduces the **polygon count** of a **polygonal model** while attempting to retain its original **shape**. This is achieved by specifying a maximum polygon count allowed or by setting the minimum angle allowed to be maintained between **adjacent polygons** in the new **model**. With the latter approach, two polygons sharing similar angles would be reduce to one polygon. Also called **polygon thinning**. Opposite of **polygon expansion**. See also **dihedral angle** and *image on following page*.

polygon resolution See **polygon count**.

polygon rounding A **polygon expansion** technique that attempts to smooth the areas of a **polygonal object** that contain sharp angles by inserting additional **polygon**s.

polygons per second A **unit** used to measure the speed of a **3D software package** by the number of **polygon**s it can draw per second to the **screen**.

polygon thinning See **polygon reduction**.

polyhedra Plural of **polyhedron**.

polyhedron A **3D** object comprised of **polygon**s.

polyline An **object** defined by a series of connected straight **line**s. See also **spline**.

polynomial A mathematical equation containing a sequence of terms raised to a power.

polynomial of the third degree See **cubic**.

polynomial equation See **polynomial**.

Polygon Reduction

Polygon reduction is used to decrease the total number of **polygon**s used to represent an **object** while trying to maintain its original **shape**.
IMAGE CREATED USING HOUDINI AND PROVIDED COURTESY OF SIDE EFFECTS SOFTWARE.

pop 1. To bring a **window** or **process** into the **foreground**. Opposite of **push**. 2. A **reference tone**, lasting for one **frame**, used to mark a specific location on a **sound track**. When the tone is at the **head** of the reel, it's called a **head pop**, and when used at the **tail** of the reel, it's called a **tail pop**. Also called **sync-pop**.

POP 1. Abbreviation for **post office protocol (POP)**. 2. Abbreviation for **point of presence (POP)**.

pop-up menu The **menu** of **option**s that appears, anywhere within a **window**, when the **mouse button** is **click**ed. An option is selected by **dragg**ing the **mouse cursor** to the desired **menu item** and then releasing the **button**. See **pulldown menu**.

pop-up window A **window** that "pops up" on the **screen** when selected from a **pop-up menu** by the **user**.

port 1. The physical point where **peripheral device**s are connected to a **computer**. See **serial port**, **parallel port**. 2. In **programming**, to convert **software** from one **computer platform** to another.

portability The ability for **data**, **software**, or **program**s to be used on different **operating system**s (**OS**). See **data portability**.

portable See **portability**.

portable software Any **software** that was designed with **portability**.

portable document format (PDF) A **file format** created by **Adobe Systems, Inc.** for representing documents regardless of the original **software**, **hardware**, and **operating system (OS)** used to create them. A PDF file is **platform independent**. See **Acrobat**.

pose To **position** a **3D character** with its **skeletal chain**.

position 1. The location in **XYZ coordinates** of an **image** or **object**. 2. Another name for **translate**. 3. Referring to the **camera position**. See **camera angle**.

positional limits See **translation constraint**.

position constraints See **translation constraint**.

positive A **print** created from a **negative**, in which all the **color** and **lighting** values correspond to the **scene** as it was originally photographed. However, when using **reversal film**, the **original** film is made into a positive.

positive image 1. The image on a strip of **positive film**. **Negative print**s are made from these positive prints. 2. An **image** in which the **black and white** and **color** values correspond to the values **capture**d from the original **scene**. See also **negative image**.

positive film See **positive**.

positive pitch The distance between **perforation**s along one side of a **strip** of **positive film**, which is slightly longer than the distance between perforations on a strip of **negative film**. Also called **long pitch**. Opposite of **short pitch**.

positive print See **positive**.

post See **post production**.

postage stamp A very small **image** used as an **icon** for visual identification of the content of a **file**.

posterization 1. An **image artifact** similar to **banding**. 2. An **image process** used to intentionally reduce an **image** to a smaller number of **color**s.

post house A **facility** where the **post production** for a **film** takes place.

postmaster The individual responsible for the maintenance of the **electronic mail (e-mail)** on a **system**. This task is often addressed by the **System Administrator**. See also **Webmaster**.

postmortem A meeting that takes place with the **Digital Effects Crew** after a **project** has been delivered to discuss the areas of the **pipeline** that were either successful or are in need of improvement for future projects.

post move Referring to any **move** added to a **plate** via **image transformation**s performed in **compositing**, as opposed to **shooting** the **scene** with the desired **camera move**. Also called a **2D move**.

post office protocol (POP) A **protocol** used by **mail server**s on the **Internet** to **download** messages. See also **electronic mail (e-mail)**, **point of presence (POP)**.

post process Any type of **image processing** that is performed on a **sequence** of **image**s after they have been **render**ed. For example, in order to save on computing time, **3D motion blur** might be turned off during the **rendering** of an **object** with the intent of adding **2D motion blur** as a separate calculation.

post production Referring to work done after **principal photography** has been completed, such as the creation of digital **visual effects (VFX)**, **miniature photography**, and **editing**.

Post Production Coordinator An individual who works for and assists the **Post Production Supervisor**.

post production facility Any facility that creates **visual effects (VFX)** for a **film** or commercial during the **post production** phase. Usually referred to as the **facility**.

Post Production Supervisor The individual responsible for overseeing the **post production** of a **project**. This person reports to the **Producer** in charge of the **film** and supervises the tasks needed to complete the film on time and on budget.

PostScript A **Page Description Language (PDL)** used by many **laser printer**s and **graphics** systems to describe the appearance of text and **image**s on printed pages or **display device**s. Developed by **Adobe Systems, Inc.**

potential function modeling See **metaball**s.

POTS Abbreviation for **plain old telephone service (POTS)**.

POV Abbreviation for **point of view (POV)**.

power cycle To turn a **system**'s power off and on in rapid succession, usually to solve a problem such as a **lockup**. A power cycle is a type of **reboot** that is not generally recommended for delicate **hardware**. Also called a **reset**.

power down See **power off**.

power off To turn off or **shut down** a **computer**. Opposite of **power on**.

power hit A sudden change in electric power supply to a **computer** that can cause a **crash**. See **uninterruptible power supply (UPS)**.

power on To turn on or **boot up** a **computer**. Opposite of **power off**.

power surge See **power hit**.

power up See **power on**.

PPI Abbreviation for **pixels per inch (PPI)**.

PPP Abbreviation for **point to point protocol (PPP)**.

practical Referring to any techniques used in a **film** that don't require the use of **computer graphics (CG)**.

practical effects Any **special effects (SFX)** that are accomplished in front of the **camera**, such as **pyrotechnics** and **animatronic**s, that may or may not require additional **post production** work.

practical extraction and report language (perl) A general-purpose **scripting language** that was written by Larry Wall in 1987. Perl is a powerful **text editor** that is **portable** across different **platform**s.

practical model See **physical model**.

preblacked tape See **blacked tape**.

precision When used to describe **floating point number**s, precision refers to the number of digits used to express the fractional quantities of a number to the right of the decimal point. The greater the precision, the more exact the representation of the fractional quantities. Also called **float precision**. See also **single precision**, **double precision**.

precomp Shorthand for **preliminary composite (precomp)**.

precomposite Shorthand for **preliminary composite (precomp)**.

preferences A **file** that stores the **user-defined** preferences for a particular **application**, such as **window** placement, font styles, or any number of **parameter**s that might be available in the **program**.

preliminary composite (precomp) An intermediate set of **image process-**
es performed on a **sequence** of **image**s that are written to **disk** and later
used as a **source element** in the **composite**.

preliminary production (prepro) Referring to any planning, testing, and
design work done before the start of **principal photography**. This phase
includes **set construction**, **CG development**, **script editing**, **production
design**, **location scout**ing, and casting. See **film production**.

Premiere 1. The first public **screening** of a **feature film**. Sometimes re-
ferred to as the "**world premiere**" to make it feel like more of a monu-
mental occasion! See also **first run**. 2. A **digital video** software for **editing**
developed by **Adobe**.

premium run See **first run**.

premult Abbreviation for **premultiplied**. See **premultiplied image**.

premultiplied Referring to a **premultiplied image**.

premultiplied image An **image** whose **red (R)**, **green (G)**, and **blue (B)**
channels have already been multiplied by a **matte**. If the image was **com-
puter generated**, it will, in most cases, calculate its own **alpha channel**
during **rendering** and, as a result, produce an already premultiplied **ele-
ment**. Many **compositing software**s will assume that an element is al-
ready premultiplied by its own alpha channel, whereas others require that
the **RGB image** and its **matte** are brought in as separate elements to be
combined together before any **layering operation**s are performed. An im-
age whose RGB channels are combined without premultiplying them by
their alpha channel can result in bright **halo**s around the composited image,
and conversely, an image whose RGB channels have been accidentally pre-
multiplied twice can create dark halos in the resulting **composite**.
Whenever a **color correction** is applied to the RGB channels of an image,
an **unpremultiply** operation must first be performed in order to avoid
these undesirable halos that can result in an image whose RGB to alpha
channel relationship is no longer legal. When color correcting an image, the
proper method is to first unpremultiply it (if it has already been premulti-
plied), color correct as desired, and then remultiply again.

premultiply To multiply an **image** by its own **alpha channel**. Opposite of
unpremultiply. See **premultiplied image**.

prep See **preliminary production (prepro)**.

prepro Abbreviation for **preliminary production (prepro)**.

preproduction See **preliminary production (prepro)**.

preroll 1. The few seconds of **camera** running time before it reaches **speed** and the **captured image**s can be used in the **shot**. 2. For **particle systems**, the range of **frame**s precalculated so the particles are already at a certain **age** when frame one of the shot begins. 3. For **editing**, the few frames of automatic rewind that occurs on the edit system to ensure the machines have reached the proper speed to produce a stable **edit**.

pressure plate The metal plate that puts pressure on **film** and keeps it flat as it passes through the **film gate**.

pressure sensitive pen See **digitizing pen**.

preview 1. Synonymous with **trailer**. 2. An early screening of a **film** generally just before its proper **release**. This is usually used by the **Filmmaker**s to gauge the audience reaction in time to make changes that might result in a better reception of the film. Also referred to as an **advance screening**. 3. A quick **rendering** and **playback** of a **motion test**. See **motion preview**. 4. For **editing**, the viewing of all the actions listed in the **edit decision list (EDL)** without actually recording the result.

previs Abbreviation for **previsualization (previs)**.

Previs Artist A **Digital Artist** that creates **previsualization** for a **film**.

previsualization (previs) An invaluable **preproduction** tool that uses the **computer** to accurately plan for **visual effects work**. If the previs is correctly planned, it can aid in foreseeing costly problems that might otherwise not be discovered until the middle of **production**. It is becoming more common, however, to use previs as a tool to visualize an entire movie, as opposed to using it only for the **effects shot**s. Like the **layout** step done in **full CG feature**s, previs will typically use **low resolution, stand-in object**s as a means of speeding up **user interactivity**. The primary focus of previs is **camera motion**, although in many cases some basic **animation** must be done on the **characters** and **objects** in the **scene** as a means of timing out the camera motion that will support the real **motion** that will be added later. See also *Color Plate 42, 43, 46.*

primary colors 1. The **additive primary colors** of **red (R)**, **green (G)**, and **blue (B)**. When additive primary **color**s are mixed in equal amounts, **white light** is the result. All colors of light can be made of from varying combinations of these primary colors. 2. The **subtractive primary colors** of **cyan**, **magenta**, and **yellow**, each of which can be created by subtracting one of the additive primary colors from white light. *See Color Plate 3.*

primary focal plane Another term for **focus plane**.

primary focus setting Another term for **focus setting**.

primary hues The **colors red (R)**, **green (G)**, and **blue (B)** can be intermixed to create almost any **hue** and are referred to as the primary hues. See also **secondary hues**, **chroma**, **value**.

primary mouse button The leftmost **button** on a **mouse**.

primary storage See **random access memory (RAM)**.

Primatte A **chroma key**ing software used for **matte extraction**.

prime lens A **camera lens** with a fixed **focal length**, as opposed to a **zoom lens**, which has a variable focal length. Prime lenses often come as a set of different focal lengths and tend to be sharper and faster than zoom lenses. Also referred to as a **fixed lens**, **fixed focal length lens**.

primer cord Explosive fuselike material used in **pyrotechnics** to blow up things without creating smoke or flames.

primitive See **geometric primitive**.

primitive object See **geometric primitive**.

primitive solid A **solid model** defined by **primitive surface**s.

primitive surface See **geometric primitive**.

principal photography The main photography of a **film** in which all principal **scene**s involving actors and **stunts** are filmed by the **First Unit** and sometimes a **Second Unit**. See also **post production**.

print 1. A **positive** reel of **film** created either from a **negative** or on the original **reversal film**. The **image**s on the print correspond to the **lighting** and **color** of the actual **scene**. See **interpositive (IP)**, **internegative (IN)**. 2. In some cases, the term *print* is also used to describe any **duplicate**, either positive or negative, made from another print. 3. The actual act of creating a positive print from a negative or on reversal film. 4. The notation on a **camera report** that indicates that a particular **take** should be **develop**ed. See **printed takes**.

printed takes The **take**s of **picture** and **sound** selected by the **Director** for **printing** and kept track of by the **Script Supervisor**. Also referred to as **circled takes**. See also **camera report**.

printer A **peripheral device** attached to a **computer** that is able to produce printed information originating from the computer onto paper. The speed of

a printer is measured in terms of **lines per minute** that it can print. See also **dot matrix printer, scanner.**

printer aperture The **printer** opening that defines the amount of **light** that **expose**s the **film**. See also **aperture.**

printer buffer See **printer queue.**

printer points The **numerical values**, called **points,** used to adjust the **printing lights** that typically run on a scale from 1 to 50. In most cases, 8 points is equal to one **stop** of **light**, but the results can be different from **lab** to lab. Also called **light change points, timing points.**

printer resolution The amount of detail a **printer** can reproduce, measured in **dots per inch (DPI).**

printing 1. To create a paper copy from a **computer file**. 2. See **film printing**.

printing lights The **light**s in the **film printer** used to **expose** the **image**s of a **processed film** onto **raw stock** so that **positive**s can be made from **negative**s and negatives can be made from positives. When **timing** a **print**, the lights are adjusted in order to alter its **color** quality and to achieve the proper **density**. The light values are typically expressed as a series of three numbers running on a scale from 1 to 50 in which 8 points, called **printer points**, represent one **stop**. The three numbers represent the amount of **red (R)**, **green (G)**, and **blue (B)** (in some cases, **yellow**, **cyan**, and **magenta**) used to time the **shot**. Printing lights are usually expressed as 32-36-34 for red, green, and blue, respectively. The lower the number, the higher amount of that color in the print. Also called **timing lights**. See also **trims**.

print jobs The items requested to be sent to the **printer**. See **printer queue**.

print manager **Software** that monitors and controls requests to the **printer**.

printer queue The list of **print jobs** waiting to be sent to a particular **printer**.

print stock The **raw stock** used to **print** a copy of another roll of **film**.

print to aims To **print** a **roll** of **film** to hit specific pre-defined densities, called **lab aim densities (LAD)**.

priority A method of indicating the relative importance of a particular **process**.

Prisms A **3D software package**, developed by **Side Effects Software**, that has for the most part been replaced by **Houdini**.

PRman Abbreviation for **PhotoRealistic RenderMan**. See **RenderMan (RMAN)**.

proc Abbreviation for **processor**. See **central processing unit (CPU)**.

procedural Procedures that are generated by a **function** or mathematical expression to create **models**, **animation**, **textures**, or **shaders**.

procedural animation **Animation** that is created **procedurally**. Because many **3D software packages** offer a standardized **language** in which the **scene file**s are created and written to **disk**, custom **scripts** can be written to create **animation**. By modifying these scripts, **motion** changes to the **objects** in the **scene** will occur automatically, as opposed to placing **key frame**s by hand. For example, when using **L-Systems**, the growth of the trees can be controlled procedurally by modifying the **L-grammar** use to describe the growth of the plants over time. When this process is used to create **models**, it is called **procedural modeling**.

procedural effects Referring to any **effects** that are created **procedurally** with **computer graphics (CG)**.

procedural map See **procedural texture**.

procedural mapping A **surface mapping** technique that uses virtual **images**, created using **procedural** techniques, to apply **texture** to a **surface**. Unlike the **surface mapping** methods used with **projection mapping** and **parameterized mapping**, in which a texture is "placed" on a surface, procedural mapping works by creating a "**volume**" of texture in which an **object** can be "immersed." The texture that the object picks up is dependent on where the object "floats" within the volume. Since the texture pattern sits within a 3D volume, the pattern on the surface can be manipulated either by moving the volume or the object, as well as adjusting any number of **attribute**s that are associated with texture itself. Procedural mapping can be used to create many types of mapping, such as **bump mapping**, **displacement mapping**, **color mapping**, and **environment mapping**. Also referred to as **3D texture mapping**, **solid texture mapping**, and **volume texture mapping**.

procedural model An **object** created using **procedural modeling** techniques.

procedural modeling Many **3D software packages** use a standardized **language** with which **scene file**s are created and written to **disk**. By editing this scene file or by writing custom **scripts** in that language with a **text editor**, a **user** can write custom **programs** to generate **models**. Changes to this script will ripple through the model and automatically create all the desired changes. When this process is used to create motion, it is called **procedural animation**.

procedural paint A **paint software** capable of applying **paint effects** to a **sequence** of **image**s rather than just a single **frame** via the use of **macro**s. With procedural paint, even the **attribute**s of the paintbrush itself can be **animate**d over time.

procedural shader See **procedural mapping**.

procedural texture An **image** that is created by a collection of **procedure**s within a **software package**. Unlike most **texture mapping** techniques, no **2D image** is created and written out to be mapped to the **surface**. Also called **3D map**, **3D texture**, **volume map**, **volume texture**, **solid map**, **solid texture**.

procedural texture map See **procedural map**.

procedural texture mapping See **procedural mapping**.

procedure A set of instructions used to perform a specific task that is part of a larger **computer program**. Also called **function, subroutine, routine**.

process 1. To calculate **data** or **execute** a **program** on a **computer**. Also called a **computer process**. 2. For **film**, see **processing**. 3. One **thread** of a program that can execute independently of the other parts.

process color The four **color**s of **cyan**, **magenta**, **yellow**, and **black** used in the **CMYK color model** for color printing.

processed film See **processed negative**.

processed negative **Negative** that has been **develop**ed. Opposite of **unprocessed negative**. See also **raw stock, negative assembly**.

process identifier (PID) The number assigned by the **Unix kernel** as a means of identifying a **process**.

processing 1. The time used by the **computer** to calculate the series of **command**s or **macro**s it has been given, such as **rendering** and **compiling**. Also called **cooking, number crunching**. 2. See **film processing**. 3. See **image processing**.

processing unit Another name for **central processing unit (CPU)**.

processor Another name for **central processing unit (CPU)**.

Producer The person in charge of the overall **budget** and administrative aspects of a **production** from its initial planning through all the various stages of production, advertising, and **distribution**. Some Producers also

get very involved in the creative aspects of the **film** and can have a lot of influence on the final film quality. Often, the person fitting this role is also called the **Executive Producer (EP)**. However, the term *producer* is sometimes used loosely to describe the roles of the **Line Producer**, **Associate Producer**, **Visual Effects Producer (VFX Producer)**, **Coproducer**, and **Digital Effects Producer (DFX Producer)**.

Producer's Guild of America (PGA) An organization dedicated to the support and advancement of all aspects of producing in **motion picture**s and television.

production A global term referring to all phases that go into the creation of a **film** or **commercial**. To actively be making the film. See **film production**.

production artwork Any drawing or painting used in any part of the making a **film**. Production art can be used as design inspiration or as an actual **element** in the film. Examples of production artwork include **storyboard**s, **concept art**, **matte painting**s, **character design**, and **computer graphics**. See also **visual development**.

Production Assistant (PA) An individual responsible for a wide range of various jobs, such as delivering and picking up packages, answering phones, and assisting the **Production Team** in every possible way! Also referred to as **Gofer**, **Personal Assistant**, **Runner**.

production company A general term describing the company that is associated with making a **movie**.

Production Coordinator An individual who assists the **Production Team** with a wide range of tasks, such as coordinating schedules, meetings, screenings, **film** and **tape** delivery and pickup, etc.

Production Designer The person responsible for the overall visual quality of the world in which the actors appear in the **film**. This includes the design of the **set**s and decoration and adaption of practical **location**s. The job requires a strong knowledge of architecture, design, **photography**, and **lighting**. See also **Art Director**.

production experience A person who has worked on a variety of **film**s and **commercials** is said to have production experience. See also **production sense**.

Production Head See **Head of Production**.

production house A **facility** at which **post production** work is created.

Production Illustrator See **Storyboard Artist**.

Production Manager (PM) 1. For a **film shoot**, shorthand for **Unit Production Manager (UPM)**. 2. For **digital effects work**, the person responsible for the supervision and coordination of the **budget**ing and scheduling of the **shot**s and the management of the entire **Digital Crew**. This title is often used synonymously with **Digital Effects Producer (DFX Producer)** and **Digital Production Manager (DPM)**.

production pipeline See **digital pipeline**.

production report A daily report outlining the actual progress of the **production** as compared with the **production schedule**. See also **lined script**, **camera report**s.

production schedule A detailed plan of the timing of activities surrounding the making of a **film**. See also **shooting schedule**.

production sense The experience-based ability to choose the best course of action for the creation of a **visual effects shot**.

production side A term used to describe a member of the **Production Team** who has been hired directly by the movie **studio** or **Director** who is making the **movie**. Opposite of **facility side**.

Production Visual Effects Producer The **Visual Effects Producer (VFX Producer)** who is hired directly by the **studio** or **Director** of the **film** and whose responsibility is to **budget** the scope of the **visual effects work** that will be done at one or various facilities. See **Facility Visual Effects Producer**.

Production Visual Effects Supervisor The **Visual Effects Supervisor (VFX Sup)** who is hired directly by the **studio** or **Director** that is funding the **movie** and who is responsible for all the **visual effects work** required on the **film**. The Production VFX Sup, in conjunction with the **Director** and the **Production Visual Effects Producer**, will determine how many and which facilities will be **award**ed the work. See **Facility Visual Effects Supervisor**.

production still Any **picture**s taken before, during, and after **production** with a still camera for use in publicity. Also called a **publicity still**. See also **action still**.

Production Team 1. The team hired by the **studio** to create the **Director**'s vision of the **film**. It includes the **Producer**, **Director of Photography (DP)**,

Production Designer, **Visual Effects Supervisor (VFX Sup)**, **Special effects Supervisor (SFX Sup)**, **Costume Designer**, **Stunt Coordinator** and **Assistant Director (AD)**, to name just a few. This group determines the best way to achieve the needs of the film. See **production side**. 2. The team responsible for the **visual effects work** that has been awarded to their **facility** by the above production team. It includes the Visual Effects Supervisor, Visual Effects Producer, **Digital Effects Supervisor (DFX Sup)**, **Digital Effects Producer (DFX Producer)**, **Animation Director**, **Art Director**, **Animation Supervisor**, **CG supervisor (CG Sup)**, and **Compositing Supervisor**. See **facility side**.

profile A **dot file** used in **Unix-based system**s that serves as a control **file** that is automatically **read** from the **home directory** of each **user** at the time of **login** and is used to customize the behavior of the **program** and to avoid **hard-coded** data.

profile close-up shot A **close-up (CU)** in which the actors are **film**ed in profile.

profile shot A **shot** in which the profile of the actor is **film**ed. Profile shots can often feel very flat and cut out.

program 1. See **computer program**. 2. To write the **source code** that will later be **compile**d into an **executable program**.

programmable read-only memory (PROM) PROM is a type of **memory** that can be **program**med only once.

Programmer See **Computer Programmer**.

programming The process of writing **code** for a **program**.

programming language Any standardized set of grammatical rules and vocabulary used to instruct a **computer** to perform specific **function**s. Each programming language has a specific set of **keyword**s and **syntax** that are meaningful to the computer. The two basic types of programming languages are **machine language**, which is easy for a computer to understand, and **high-level programming language**, which is easy for a **Programmer** to understand. See **Assembly Language**, **awk**, **Basic**, **C**, **C++**, **Fortran**, **Java**, **LISP**, **Pascal**, **perl**, **sed**, **TCL**—to name just a few!

progressive scan A method of **display**ing an **image** without **interlacing**.

progressive shots A series of **shot**s in which the **camera** moves closer to the **subject** over time. Opposite of **regressive shots**.

project 1. Referring to the entire scope of work required for the creation of a **film**. 2. The current scope of **visual effects work** attached to a particular

film or commercial. Also referred to as **show, job**. 3. To cast **3D** information onto a **2D plane**. Each **point** in the **3D database** is **map**ped to a corresponding point on the **plane**. See **projection map**. 4. To **display** an **image** on a **display device**, such as a **monitor** or **projector**. 5. Work done on a **computer** is often referred to as the project or the job.

project deadline See **deadline**.

projection 1. See **projection mapping**. 2. To **project** a series of **image**s. 3. See **rear projection (RP)**. 4. See **front projection (FP)**.

Projectionist The individual who operates the **projector**.

projection map The **texture map** used in **projection mapping**.

projection mapping An **image** that is **project**ed directly onto an **object** in **3D space** and does not require the creation of **texture coordinate**s to be applied. Wherever the **texture map** hits the **surface**, the **3D object** inherits the **color**s in that section of the image. The most common types of projection mapping are **orthographic projection mapping, cylindrical mapping, spherical mapping**, and **camera mapping**.

projection screen The white or silver surface on which **image**s are **project**ed for viewing. Also called the **silver screen**.

projection speed The **playback rate** for **image**s that are **project**ed.

project name Typically, the name of the **feature film** or commercial that is being worked on. However, in many cases, a temporary name is used if the final working title has not yet been determined, or in other cases, a "secret" code name is used as a means of trying to maintain some secrecy about the **project**. Of course, the latter technique never actually succeeds in keeping the project a secret, but we still use secret names anyway! Also referred to as **job name**.

projector The **display device** that rapidly **display**s and enlarges successive **image**s on a **film reel** onto a **screen** to create the illusion of **motion**.

projector aperture The **projector** opening that defines the area of the **frame** to be projected on **screen**.

projector light The rotating disk in the **projector** used to avoid **flicker** on the **screen** while each **film** frame is pulled into position for **projection**.

projector shutter The rotating disk in the **projector** used to prevent **light** from entering the projector while each **film** frame is pulled into position for **projection**.

PROM Abbreviation for **programmable read-only memory (PROM)**.

prompt The **character**s in a **window** that indicate the **shell** is ready to accept **command**s from the **user**. Prompts will often contain the **user name** and the **current working directory**.

prop An **object** on a physical **set** or in a **3D environment** that is used as part of the set dressing or for a **character** to interact with.

properties See **attribute**s.

Property Master The individual responsible for acquiring any **prop**s needed for a **production**.

proportional scale To **scale** an **object** or **image** by an equal amount along all three **axes**. Opposite of **nonproportional scale**. Also called **uniform scale**.

proprietary See **proprietary software**.

proprietary software **Software** that has been written by the **Software Developer**s at a specific **facility** and is not available for use by the general public. Opposite of **3rd-party software**.

prosthetic Form-changing makeup appliances that are applied, blended, fitted, and colored to the skin of an actor as a means of altering their features. Prosthetics are typically made from **foam latex**, **gelatine**, plastic, or rubber.

prosthetic appliance See **prosthetic**.

protection interpositive See **protection master**.

protection IP See **protection master**.

protection master An **intermediate positive (IP)** that is used to create a **dupe negative** if the **original negative** gets damaged. Also called a **protection interpositive**, **protection IP**.

protection shot Another name for **cover shot**.

protocol The rules that govern the **format** and **transmission** of **data** across a **network** between the **client** and **server**. See **point to point protocol (PPP)**, **transmission control protocol (TCP)**, **Internet protocol (IP)**.

proxy A **low-resolution image** or **3D object** used as a **stand in** for the **high resolution** original for purposes of increasing **user interactivity** with the **computer**. See **proxy image**, **proxy scale**.

proxy image A **low-resolution image** that is used as a **stand in** for the original **high-resolution image**. The idea is to increase speed and interactivity while working on a **composite**. See **proxy scale**.

proxy resolution See **proxy scale**.

proxy scale The **scale** value used for the **element**s in a **composite**. For example, while working on a composite, the **user** might choose to work with the **high-resolution image**s at a smaller scale, such as one-third or one-half, to increase **user interactivity**. Or in some cases, each **input image** might reference both the **low-resolution** and high-resolution versions of the same **image**, and the actual image used depends on whether the proxy scale is set to low or high. Most **compositing package**s will automatically **scale up** or **scale down** all the **curve**s and **function**s relative to the proxy scale set for each element.

pseudocode A series of statements that outline what a **program** will do once the actual **code** is written. Pseudocode is used for the preliminary design of a program.

public domain Belonging to the public. See **public domain software**.

public domain software **Software** that can be used or copied by anyone free of charge. Public domain software has no copyright protection and the **Programmer** decides to donate his software for the good of the public. **LINUX** is an example of public domain software.

Publicist The person responsible for the overall publicity and advertisement of a **film**, **studio**, or **facility**. The Publicist prepares press releases, arranges interviews and press conferences, secures and releases **publicity still**s, and, in general, seeks the greatest overall exposure for the company or **film** that he or she represents.

Publicity Department The group of people responsible for promoting a **film**.

Publicity Director The title often used to describe the head **Publicist** of a **studio** or **facility**.

publicity still See **production still**.

puck Synonymous with **mouse**.

pull a key See **matte extraction**.

pull a matte See **matte extraction**.

pull-back shot A **shot** using a **dolly** or **zoom** effect to start on a **close-up** (CU) of the **subject** and **pull out** to widen out and reveal more area around the subject. Opposite of **push in shot**.

pulldown 1. Shorthand for **3:2 pulldown**. 2. A term used to describe the process of "pulling" the **film** through a **camera** or **projector** with a **pulldown claw**.

pulldown claw The portion of the **camera movement** that advances the **film** through the **film gate**. They are actually composed of small hooks or pins that attach onto the **perforation**s.

pulldown menu The **menu** of **option**s that appears along the **menu bar** when the **mouse button** is **click**ed. An option is selected by **drag**ging the **mouse cursor** to the desired menu item and then releasing the **button**. See also **pop-up menu**, **cascading menu**.

pull-down window See **pulldown menu**.

pull focus See **follow focus**.

pulling A term used to describe the intentional **underdevelopment** of **film**. See also **pushing**.

pull out To move the **camera** further away from the subject.

pullup Shorthand for **3:2 pullup**.

puppet A replica of an animal, human, or other creature that is designed to move and be **animate**d by the manipulations of **Puppeteer**s. Puppets can be controlled by a wide range of **device**s, such as a string, **rod**, **cable**, **Waldo**, or by hand.

Puppeteer An individual who **animate**s a **puppet**.

pure black See **black**.

pure white See **white**.

push To put a **window** or **process** into the **background (BG)**. Opposite of **pop**.

push button A common type of **button** in **software package**s that performs an action when **click**ed. See also **button**, **radio button**.

pushing A term used to describe the intentional **overdevelopment** of **film**. See also **pulling**.

push in To move the **camera** closer to the **subject**.

push in shot A **shot** using a **dolly** or **zoom** effect to start on a **wide shot** of the **subject** and push in to end on a **close-up** of the **subject**. Opposite of **pull-back shot**.

PVR Abbreviation for **Perception Video Recorder (PVR)**. See also **PDR**.

pyramid of vision The equivalent of the human **cone of vision** for **computer graphics (CG)**. In order to conform to the shape of the **computer screen**, the pyramid of vision is represented with a rectangular shape rather than a cone shape. The shape of the pyramid of vision is determined by the **field of view (FOV)**. **Object**s inside the pyramid of vision are visible and will be **render**ed, whereas objects outside the pyramid are not visible and will not be rendered.

pyrotechnics Referring to the use of fire, smoke, or explosives to achieve **special effects (SFX)** for a **film**. See **squib**.

Pyrotechnician The individual who sets up and executes the **pyrotechnics** for **feature film**s.

Python An **object-oriented programming language**.

quad 1. Abbreviation for **quadrant**. 2. Abbreviation for **quadrilateral**. 3. Two **bit**s or a quarter of a **byte**.

quadrant Any one of the four areas in which a **plane** is divided along the reference **axis** in a **Cartesian Coordinate System**. The quadrants are designated, counting clockwise from the area in which both **coordinate**s are **positive**, as **quadrant one**, (**upper right quadrant**), **quadrant two**

The four **quadrant**s of a **coordinate system**.

411

(lower right quadrant), **quadrant three (lower left quadrant)**, and **quadrant four (upper left quadrant)**. *See image on previous page.*

quadrant four The **quadrant** in a **Cartesian Coordinate System** located in the upper left portion of the **XYZ axes**. Also called **upper left quadrant**, **fourth quadrant**.

quadrant one The **quadrant** in a **Cartesian Coordinate System** located in the upper right portion of the **XYZ axes**. Also called **first quadrant**, **upper right quadrant**.

quadrant three The **quadrant** in a **Cartesian Coordinate System** located in the lower left portion of the **XYZ axes**. Also called **lower left quadrant**, **third quadrant**.

quadrant two The **quadrant** in a **Cartesian Coordinate System** located in the lower right portion of the **XYZ axes**. Also called **lower right quadrant**, **second quadrant**.

quadratic 1. Relating to or resembling a square. 2. Referring to a power of two.

quadratic equation An equation in which the highest power that a **value** is raised to is a **square**.

quadratic NURBS A **NURBS curve** that requires a minimum of four **control point**s. See also **cubic NURBS**, **linear NURBS**.

quadratic spline Any **spline** mathematically defined by **variable**s raised to a **square** or second power.

quadratic surface A type of **geometric primitive** that can be defined by **quadratic equation**s, such as a **sphere**, **cone**, **torus**. All quadric surfaces can be created by a **surface of revolution**.

quadrilateral A **polygon** comprised of four **edge**s. Quadrilaterals are one method used to connect the **point**s that make up a **polygon mesh**, in which each polygon is made up of four sides. Such a **surface**, will need to be **subdivide**d into **triangle**s at the time of **rendering**. See also **alternating triangles**, **rows and columns**, **polygon detail**.

quadtrees A method of subdividing a **2D** volume, such as an **image**, in **2D space**. The image is originally represented as a single rectangular **bounding box**, and if more detail is needed, the box is split in half along each of its **X**- and **Y-axes**, which results in four smaller boxes. This process continues until each sub-box contains the desired **level of detail (LOD)**. Quadtrees are the 2D equivalent of **octrees**.

Quantel 1. The developer of a wide range of **digital effects (DFX)** packages, including **Paintbox**, **Mirage**, **Harry**, **Harriet**, **Hal**, and **Domino**. 2. An **image format** that represents **RGB channels** only and does not have well-defined standards for **alpha** or **Z depth channels**. Its **bit depth** uses **8 bits per channel**, and typical **filename extension**s include .yuv, .qnt, .qtl and .pal.

quantization The process of assigning **digital** values to **sample**s taken from an **analog signal**. Quantization is one of the steps involved in **analog to digital conversion**s and is required to store a **digital image**. If this conversion is done with enough **precision**, the digital **copy** should be indistinguishable from the original **analog** copy. However, if there is not enough **data** allocated to store the sampled data, **quantization artifact**s, or **banding**, can result.

quantization artifact The fancy name for **banding**.

quantizing See **banding**. See **quantization**.

quarter apple An **apple box** that is one-quarter as thick as a regular apple box. See also **half apple**.

quarter inch tape See **1/4-inch tape**.

quaternion A quaternion is a combination of a **vector** and a **scalar** number used to represent a **rotation**. Visually, a quaternion could be represented as a vector attached to a **point** in **space**. As the point rotates about its **origin**, the vector can move directly into its new **position**, as opposed to actually rotating about three **axes** to reach that same location. Quaternions are often used in **animation package**s to represent rotations as a means of avoiding the **gimbal lock** than can result from traditional **XYZ** rotations.

query The request of information from a **database**.

queue An organization of **job**s used for lining up requests for resources, such as a **central processing unit (CPU)** or a **printer**. See **job queue**, **printer queue**, **render queue**.

quick shade A term used to describe the **rendering** of a **3D scene** with no special **material**s, **shader**s, **texture map**s, or **lighting** applied. Although the rendered images can be any **constant color**, a shade of gray is most commonly used. When the latter is the case, the quick shaded scene is also referred to as a **grayscale**. This type of rendering is used most often for **motion preview**s.

QuickTime A popular format for storing **sound** and **image**s developed by **Apple Computer, Inc. Movie file**s stored in quicktime format, generally, carry .mov as their **file extension** name.

quit To exit an **application**.

R Abbreviation for **red (R)**.

rack The **frame** that carries **film** through the **process**ing machine.

rack focus The change of **focus** from one **subject** to another subject during filming. Also called **shift focus**. See also **follow focus**.

rad Abbreviation for **radian**.

radial blur A **compositing operation** that can **blur** an **image** around a specific **point** radially.

radial grad Abbreviation for **radial gradation**.

radial gradation A type of **gradient** that **interpolate**s **color**s from the center of an **image** out to its **edge**s in the shape of a **circle**. Also called a **gradient**, **ramp**, **radial ramp**. See also **horizontal gradation**, **vertical gradation**, **four-corner gradation**. *See image on following page.*

radial ramp See **radial gradation**.

radian 1. The arc of a **circle** that is equal to its **radius**. 2. One radian equals 57.29578 degrees. Radians are sometimes used rather than degrees to express **rotation**s.

radio button A type of **button**, usually round, in **software package**s in which only one of the available options can be **active** at a time. Like all **button**s, an option is activated with a **mouse click**.

radio control (R/C) A wireless method used to control **animatronic**s.

radiosity A **rendering** technique that calculates the **diffuse reflection**s of the **surface**s in a **scene**. Radiosity can be described as the rate at which **light** energy travels away from a surface. Where **ray tracing** calculates only the **specular reflection** relative to the current **view**, radiosity calculates the **diffuse component** for the entire scene independent of the **viewing angle**.

A **radial gradation**.

radius The length of a straight **line** from the center of a **circle** or **sphere** to the **edge** of its **surface**, or **circumference**.

RAID Abbreviation for **redundant arrays of independent disks (RAID)**.

RAID Array See **redundant arrays of independent disks (RAID)**.

RAM Abbreviation for **random access memory (RAM)**.

RAM cache Abbreviation for **random access memory cache (RAM cache)**.

RAM disk Abbreviation for **random access memory disk (RAM disk)**.

RAM drive Abbreviation for **random access memory drive (RAM drive)**.

ramp See **gradient**.

ramped color Two or more **interpolate**d **color**s that are created with a **gradient**.

random access A method of storing and retrieving **data** whereby all data can be immediately accessed. For example, any **image**s on a **CD-ROM** or **laser**

disc can be immediately accessed. Opposite of **sequential access**. Also called **direct access**. See also **nonlinear video**.

random access memory (RAM) RAM is the portion of **memory** in a **computer** that can be accessed in any order and is used by **program**s to perform necessary tasks. Each time a program is accessed, it gets **load**ed from the **hard disk** into RAM because reading **data** from RAM is much faster than reading from **disk**. Generally, running programs from RAM allows them to function without any lag time. The more RAM on a computer, the more data that can be loaded from the hard disk. RAM is, sometimes, humorously referred to as "rarely adequate memory" to describe a computer with insufficient memory to handle the requested tasks. See also **physical memory**, **volatile memory**, **virtual memory**, **nonvolatile memory**, **dynamic random access memory (DRAM)**, **static random access memory (SRAM)**, and **extended data-out random access memory (EDO RAM)**.

random access memory cache (RAM cache) Fast **memory** that makes the **computer** perform faster by temporarily storing frequently used or recently accessed **data**.

random access memory disk (RAM disk) A virtual **disk drive** that uses part of the **random access memory (RAM)** in a **computer** to temporarily store **data** for retrieval. While a RAM disk offers very fast information access, all stored data is lost when the computer is turned off. See also **hard disk**.

random access memory drive (RAM drive) See **random access memory disk (RAM disk)**.

randomize To make random in arrangement, such as applying a **noise function** to the **surface** of a **3D object** or **image** or by varying the **motion** within a **particle system** to make it feel less regular.

random memory See **random access memory (RAM)**.

random number A number generated by an **algorithm** that calculates an even **distribution** over a range of **value**s.

random number generator Any **program** that creates **random number**s and can reproduce the same **output** from the same **input**, called the **seed**.

random seed See **seed**.

range 1. For **metaball**s, see **weight**—Definition #3. 2. See **frame range**. 3. See **dynamic range**. 4. See **contrast range**.

rangefinder A **device** included in many **camera**s to serve as an aid in **focus**ing.

range of motion The **limits** to the **position**s that a **CG character** can be **pose**d in before it becomes unacceptably distorted. These limits are set by the **Character Setup** Team.

Rank The trade name for a **Telecine** machine. Actual name is Rank-Cinetel Flying Spot Scanner.

raster 1. Synonymous with **bitmap**. 2. Synonymous with **bitmap display**.

raster burn 1. The **image** burn-in effect that a **monitor** can get without the use of a **screen saver**. 2. Eyestrain resulting from staring at a **computer screen** for too long.

raster coordinate system See **screen space**.

raster display See **bitmap display**.

raster graphics See **bitmapped graphics**.

raster image See **bitmap**.

rasterize To convert an **image** into a **bitmap** for **display**.

raster operation Any set of **operation**s that deal with **raster graphics**.

raster space See **screen space**.

Ras_Track A **3D tracking software** created by Hammerhead Productions.

ratio The relationship between two **value**s as expressed by the result of one divided by the other.

raw curve See **raw data**.

raw data **Data** on which no **process**ing or **interpolation** has occurred. Original data created by **motion capture (MOCAP)** and **channel animation** are all examples of raw data.

raw footage **Film** or **video** recordings that have not been **edit**ed.

raw stock **Film negative** that has not been **expose**d to **light** either in a **camera** or **printer**. Also called **unexposed film** stock.

ray bounce The **parameter** that controls the number of times a **light ray** is told to bounce off of **surface**s in the **scene** during **ray tracing**. The larger the number of bounces, the more accurate the render. However, with each additional ray bounce, the **render** time can increase dramatically. Also called **ray tracing depth**, **ray depth**.

ray casting 1. Synonymous with **ray tracing**. 2. The process of ray casting is used in **scan line rendering** to determine the **color** that each **pixel** should be. From the **camera view**, a ray is cast through to the first pixel of the first scan line. The ray continues until it either hits the **surface** of an **object** in the **3D scene** or exits beyond the **viewing frustrum**. If the ray hits an object, the **renderer** calculates the color of that object at the point it has been hit and assigns this **value** to the pixel through which the ray had been cast. A new ray is then cast for the next pixel, and this process continues with the same steps until the **image** is complete.

ray depth See **ray bounce**.

ray tracing A **rendering** technique that calculates the movement of **light beam**s as they bounce off of **object**s or pass through **transparent** objects in the **scene**. Ray tracing can be used to simulate realistic **reflection**s, **shadow**s, and **refraction**s but at the cost of long calculation times. See also **cast shadows**, **shadow depth map**, **radiosity**.

ray tracing depth See **ray bounce**.

R/C Abbreviation for **radio control (R/C)**.

reaction shot In general, a reaction **shot** is a silent and **close-up (CU)** of an actor reacting to what another actor is saying or doing in surrounding shots.

reactive animation A term used to describe when the **motion** of one **object** is based on the **animation** of another.

read 1. To view the contents of a **file** stored on **disk**. See **write**. 2. To **load data** onto a disk from a **storage device**.

read mask The portion of the **permissions** on a **file** that determines who can **read** its contents. See also **write mask** and **execute mask**.

read only A **file** whose **permissions** only allow its contents to be viewed. No **user**s can **write** to or **execute** that file. See also **write only**, **execute only**.

read only memory (ROM) This is a small portion of **computer memory** that is reserved for permanently stored **data**. The data can be quickly accessed but cannot be modified in any way. ROM is an example of **non-volatile memory**, whereas **random access memory (RAM)** is an example of volatile memory. See also **programmable read-only memory (PROM)**.

read-write-execute mask See **permission mask**.

read-write memory The most common type of **computer memory** that is used by **program**s to perform necessary tasks. Unlike **read-only mem-**

ory (ROM), information accessed with read-write memory can be **read**, modified and written out as needed. See also **random access memory (RAM)**.

readme See **readme file**.

readme file A traditionally included **text file** found in the top level **directory** of a **software distribution** or with the **source code** of a **program** that contains information about where to find **documentation** and notes. Many **user**s also use readme files to keep notes about changes they've made to their **scene file**s or **shell script**s.

real-time 1. See **real-time playback**. 2. A **computer process** that appears to calculate its results instantaneously. 3. Referring to the **film**ing of an event in the time it would naturally occur, as opposed to **high-speed photography**, **slow speed photography**, or **time lapse photography**.

real-time interaction The ability to modify an **object** or **image** without any perceptible delay in the response time of the **computer**.

real-time motion control A **motion control (MOCO)** system that can **capture** and play back **camera** moves in **real-time**.

real-time playback The ability to **playback** and **display** a **sequence** of **image**s at the same speed as they will be seen in their final **viewing format**.

rear projection (RP) An **in-camera compositing** technique in which **live action** is photographed in front of an **image** or **sequence** of images **project**ed onto a **rear projection screen** to produce a single combined image on the **exposed film**. While **front projection (FP)** projects the **background (BG)** from in front of the **screen**, rear projection projects the background from behind the screen. Also referred to as **back projection**.

rear projection photography See **rear projection (RP)**.

rear projection screen A large translucent **screen** used to **project** an **image** or **sequence** of images onto during **rear projection photography**.

rear screen projection See **rear projection (RP)**.

reboot To halt and **restart** the **system** in a controlled manner. See **soft boot**.

receiving computer The **computer** receiving **data** from the **source computer**. See **routing**.

record 1. One of the **red (R)**, **green (G)**, or **blue (B)** layers in a piece of **film**. 2. One of the red, green, or blue **channel**s in a **digital image**. 3. The

process of capturing **audio** or **film image**s. 4. A group of **field**s that make up one complete entry in a **database**.

recording studio A specially designed area for recording **sound track**s over a microphone in an acoustically engineered soundproof room. See also **sound stage**.

rectangle A **quadrilateral** whose alternate **edge**s are **parallel** to each other.

rectangular pixel See **nonsquare pixel**.

recover To bring back a **file** that was accidentally **delete**d.

recursion The process of defining something in terms of itself. Such a **recursive** process can go on forever because it is self-referencing. See **fractal**, **Koch island**, **Lindenmayer System (L-System)**.

recursive See **recursion**.

recursive subdivision The technique of using **fractal** mathematics to create **3D object**s. By taking a rectangle defined by four **point**s, subdividing it into four smaller rectangles with randomly displaced corners, and then subdividing and displacing each of the resulting rectangles over and over again, you can create a **fractal surface**. See also **recursion**. *See images under fractal,* **Koch island**, *and* **Lindenmayer System (L-System)**.

red (R) 1. One of the three **primary colors**. 2. For **digital**, see **red channel**. 3. For **film**, see **red record**.

red backing See **redscreen**, **backing color**.

red channel The **channel** that contains all the **red (R)** information represented in an **image**. Also called **red component**, **red record**. See also **blue channel**, **green channel**, *Color Plate 14*.

red component See **red channel**.

red contamination Shorthand for **redscreen contamination**.

red key Abbreviation for **redscreen key**. See also **chroma key**, **color difference key**.

redo A common **menu option** that repeats the last action **input** by the **user**. Opposite of **undo**.

red record 1. In **digital**, synonymous with the **red channel**. 2. In **film**, the red **color**-sensitive **layer** in a piece of film.

redscreen A primary **red backing** that is placed behind the **subject** to be photographed so that a **matte** can be extracted. Ideally, the redscreen is uniformly lit and contains no **color contamination** in order to **expose** only the **red (R)** layer of the **film**. Same concept as **greenscreen (GS)**, **bluescreen (BS)**. See also **redscreen key**, **orange screen**.

redscreen contamination 1. A **red backing** that is contaminated with **blue (B)** or **green (G)**. See **color contamination**. 2. Another term for **redscreen spill**. See also **color spill**.

redscreen element See **redscreen plate**.

redscreen key A **matte extraction** technique that separates a **subject** from its **background (BG)** based on a red **backing color** behind the subject that has been photographed. Also called a **color difference key**, the best results are obtained from a **redscreen** that contains strong **chroma** or purity of **color**. Same concept as **greenscreen key**, **bluescreen key**.

redscreen photography The process of **filming** a **subject** in front of a **redscreen** for use in **matte extraction** during **compositing**. Same concept as **bluescreen photography**, **greenscreen photography**. See also **blacklight photography**.

redscreen plate Any **element** photographed that uses **red (R)** for its **backing color**. See **bluescreen plate**, **greenscreen plate**.

redscreen shot Any **shot** that uses **redscreen photography**.

redscreen spill Referring to the red **color** that falls onto a **subject** during **redscreen photography** as a result of the red **light** reflecting off of the **red backing** behind it. Same as **bluescreen spill**, **greenscreen spill**. See **color spill**.

red signal The **red component** of a **video signal**.

red spill Shorthand for **redscreen spill**.

redraw A common **software option** that will redraw the **view**s in all open **window**s.

reduction printing An **optical printing** technique in which a smaller **copy** of the original **film gauge** is created.

redundant arrays of independent disks (RAID) A RAID array is two or more **disk**s grouped together that appear as a single **device** to the **host** system to provide increased disk performance and **data** availability. A RAID array also stores the information contained on all the other disks in such a way

that if one disk in the array goes bad, its data can still be recreated. While RAID technology does not prevent disk failures, it does provide insurance against data loss.

reel An individual **video** or **film reel**.

reel change See **change-over**.

reel change mark See **change-over cue**.

reference black See **black burst**.

reference clip Either a single **frame** or series of frames clipped out of a **film roll** for use in **color** and **lighting** reference. The **Color Grader** uses these clips to create the **lookup table**s **(LUT)** used to **grade** the **scanned image**.

reference frame 1. See **reference clip**. 2. A **digital frame** from the final **composite** of a **shot** that is used as **color** and **lighting** reference for a series of shots in a **sequence**. Ensuring **color continuity** throughout sequences is among the many responsibilities of the **Compositing Supervisor** and **Color Grader**. 3. See **lighting reference**.

reference page See **man page**.

reference tone The set of **sound tone**s that conform to **industry standard**s for recording **sound**. They are used to align any recorded **audio** to the proper **frequency** and **volume**. In **video**, these tones are often accompanied with **color bars** that are used to adjust **color** values to the proper settings, and when combined like this, they are referred to as **bars and tone**. Also called **alignment tone**, **tone**. See also **POP**.

reflect 1. See **mirror**. 2. To throw or bend back **light** from a **surface**.

reflectance The **ratio** of **light** reflected from a **surface** to the **incident light** striking it.

reflected color The **color**s that can be seen due to the **reflected light** that is reflecting off a **subject**. The **CMYK color model** used in printwork is designed to represent these reflected colors. See also **transmitted color**.

reflected light The amount of **light** reflected off the **subject**, as opposed to the light falling on the subject, which is known as the **incident light**. Reflected light is usually measured with a **reflected light meter**. See **indirect lighting**.

reflected light meter The **device** used to measure the amount of light reflecting off the **subject** in a **scene**. Also called a **spot meter** because it

takes a reading off a specific "spot" on the subject, as opposed to an **incident light meter** that measures all the **light** that falls on the subject.

reflection The return of **light** or **sound** from a **surface**.

reflection map See **environment map**.

reflection mapping See **environment mapping**.

reflection mask A reflection mask is used to indicate which **3D object**s in a **scene** will contain the **reflection**s of other **object**s. See also **light mask**, **shadow mask**.

reflection pass 1. In **multiple-pass photography**, a **pass** featuring the **reflectivity** of an **object** in its **environment** for use during **compositing**. 2. In **multiple-pass rendering**, a separate **render** of the **reflective surface**s of an **object** in a **scene** for use during compositing. See also **beauty pass**, **shadow pass**, **matte pass**.

reflective modeling See **symmetrical modeling**.

reflective surface A **surface** that is capable of **reflect**ing the **environment** that surrounds it.

reflectivity The degree that a **surface** can reflect its surrounding **environment**. In **computer graphics (CG)**, this is a **parameter** used to control the **specular highlight**s as well as a parameter used in **ray tracing** to define the degree of influence that **environment map**s will have on a particular surface.

reformat To re**initialize** a **disk** so that all the **data** is **delete**d from the disk.

refraction The way **light** bends when it passes from one **surface** to another. **Ray tracing** is a common technique used to simulate refraction in **computer graphics (CG)**. The amount of **refractivity** contained in a surface is dependent on its **refractive index**.

refractive index A **parameter** used in **ray tracing** to calculate the way **light ray**s will bend across **surface**s that contain **transparency**. Typically, a refractive index of 1 will create no **refraction** across a surface, while **value**s either higher or lower than 1 causes **light** to bend one way or another, which, in turn, creates distortions when looking through the surfaces. Also called **index of refraction**.

refractivity The amount of **refraction** across a **surface**.

refresh rate The maximum number of **frames per second (FPS)** that a **monitor** can display **image**s, as expressed in **hertz (HZ)**. An **electron**

beam starts in the upper left corner of the **screen** and **scan**s each line horizontally across the screen until it reaches the bottom of the screen. A slow refresh rate will cause the **display**ed images to **flicker**. Also called the **vertical refresh rate**. See also **horizontal refresh rate**.

region of interest (ROI) A **user-defined** rectangular region used to confine calculations to the area of an **image** that falls within that region. See also **domain of definition (DOD)**.

registration 1. The accurate placement of **film** in the **film gate** as it runs through the **camera**. 2. In **video**, the process of causing the **RGB components** to exactly coincide so that no **color fringing** is visible. 3. The precise alignment in position of a series of **image**s using a variety of techniques, such as **motion control (MOCO)**, **stabilization**, **2D tracking**, **3D tracking**, and **corner pinning**.

registration chart A chart composed of a series of crossed lines that is used to check for **camera stabilization**.

registration pins The metal pins that position and hold the **film** in preparation for **exposure** in a **camera** or **projector**. See also **pin registration**.

registered print A **print** that has been created using **pin registration**.

regressive shots A series of **shot**s in which the **camera** moves farther away from the **subject** over time. Opposite of **progressive shots**.

regular patterns **Procedural**ly generated patterns, such as **grid**s, wood grain, and marble. See **procedural texture**.

reinstall To **install** software again.

relational database A process of **data** storage, consisting of **rows and columns**, in which associations exist between various data items based on shared and common **attribute**s.

relational modeling Another term for **procedural modeling**.

relative address A location in **computer** memory or a **peripheral device** that is referenced to another **address**. Opposite of **absolute address**. See also **base address**.

relative coordinates See **relative location**.

relative location The location of an **object** relative to the previous location of that object expressed in **coordinates** within a **coordinate system**. Opposite of **absolute location**. Also referred to as **relative coordinates**. See also **relative value**, **relative transformation**.

relative path The location of a **file** relative to the **current working directory (CWD)**. Any **application**s referencing files based on their relative **path**s from the current working directory will not be able to find them if the current working directory is changed. See also **absolute path**.

relative pathname See **relative path**.

relative rotation The **rotation** of an **object** relative to its current location within the **coordinate system**. Opposite of **absolute rotation**. See also **relative scale**, **relative translation**, **relative transformation**.

relative scale The **scale** of an **object** relative to its current location within the **coordinate system**. Opposite of **absolute rotation**. See also **relative scale**, **relative translation**, **relative transformation**.

relative translation The **translation** of an **object** relative to its current location within the **coordinate system**. Opposite of **absolute scale**. See also **relative scale**, **relative rotation**, **relative transformation**.

relative transformation A **transformation matrix** that **position**s an **object** to a **relative location** based on its current location within the **coordinate system** in terms of **translation**, **rotation**, **scale** or any other nonlinear **transformation**s that have been applied. For example, if a **relative translation** is entered for an object, it will be **translate**d by the specified amount on each **axis** relative to the objects current **orientation** in space. So, if an object was located at (-2,1,3), the relative translation value to move it to a positive 2 **location** in **X** would be 4 (-2 + 4 = 2). See also **absolute transformation**, **absolute value**.

relative value See **relative transformation**.

relative vector Any **vector** whose **end point**s are defined in **relative coordinates**. See **absolute vector**.

release 1. See **software release**. 2. A term describing the phase during which a **film** is put into movie theatres for public viewing. The release of a **feature film** is generally preceded by a series of **trailer**s and an advertising campaign. Often, the release will begin with a **premiere**, followed by a **first-run** showing at a **first-run theatre** and then a general release to most markets. Films are often later **rerelease**d.

release date The date on which a **film** first opens.

release print The final **composite print**s of a **film** that are sent out for general theatre **distribution**. Release prints are made from **intermediate negative**s (**IN**).

release schedule The plan for the exhibition of a **film** in various theatres. See **first-run theatre**.

remap 1. To **map** a set of **value**s from one **source** to another, such as the **color** values in an **image** or the values along a particular **curve**. 2. To reapply the **texture coordinate**s to a **surface**.

remote Referring to **hardware**, **software**, **peripheral device**s, or **data** that reside on **remote computer**s and can be accessed from other **computer**s only across a **network**. Opposite of **local**.

remote copy To copy **file**s from one **computer** to another across a **network**.

remote computer A **workstation** that can be accessed across a **network** and is not physically connected to your **local workstation**.

remote control camera Any **camera** that can be operated from a distance to allow for photographing **scene**s in hard to reach areas. Sometimes referred to as a **snorkel camera**.

remote data Any **data** that resides on a **computer** on the **network** other than the **user**'s **local computer**. See **local data**.

remote disk A **disk** that can be accessed across a **network** and is not physically connected to your **local computer**. Also called **remote drive**. See **local disk**.

remote drive See **remote disk**.

remote login A **program** that provides a **command line interface** to a **remote computer** over a **network**.

remote printer A **printer** that can be accessed across a **network** and is not physically connected to your **local workstation**.

remote resource Any **peripheral device** that is not directly connected to a **local computer**. See **local resource**.

remote software Any **software** that resides on a **computer** on the **network** rather than the **user**'s **local computer**. See **local software**.

remote storage **Disk space** that does not reside on a **local computer**. See **local storage**.

remote system Any **computer**, other than the **local computer**, that is on the **network** and with which the local computer can interact. See **local system**.

remote workstation See **remote computer**.

removable disk A **storage device** that is not permanently attached to the **hard drive**, such as **Zip drive**s and **Jaz drive**s.

removable drive See **removable disk**.

render See **rendering**.

render engine A **computer** whose sole purpose is for **rendering**.

renderer See **rendering software**.

render farm The group of **computer**s that are solely dedicated to the **rendering** of **CG element**s.

render hog 1. Slang term for a **Digital Artist (DA)** who uses too many **central processing unit**s (**CPU**s) for their **render**s. See also **CPU hog**. 2. A render that requires a large number of CPUs to calculate an **image**. See also **CPU intensive**.

rendering The process of creating a **2D image** based on **3D** information, such as the **camera, object**s, **light**s, **surface attribute**s, and **animation curve**s contained in a **3D database**. The **field of view (FOV)** created by the **position** of the camera in the **scene** relative to the **location** of the various objects determines what portion of the scene will actually be rendered. Any **geometry** falling within the camera's field of view is mathematically **project**ed onto a **plane**, just as a real camera projects the **image** within its field of view onto **film**. The rendering process must also calculate which objects are obscured by other objects closer to camera. Once the **renderer** has determined which **surface**s will be rendered and where on the plane they will be projected, the last step is to calculate the actual **color** of each **pixel** that is being created in the resulting 2D image. See also **wireframe rendering, hidden line rendering, surface rendering, Z-buffer**.

rendering algorithm The procedures used by a particular **renderer** to calculate a **2D image** from a **3D scene**. See **scan line rendering**.

rendering package See **rendering software**.

rendering software A **software application** specifically designed to allow the **user** to **render** a **scene** created in **3D space**. Also called a **renderer**. **RenderMan (RMAN)** and **Mental Ray** are popular render **software package**s. See also **modeling software, lighting software, tracking software, animation software, particle software**.

rendering subdivision See **polygonal subdivision**.

render intensive A general term describing any **process**es that take a long time for the **computer** to calculate an **image**. See also **memory intensive**, **CPU intensive**.

render job A request to the **render queue** for a particular **scene** to be **process**ed on the **render farm**.

RenderMan (RMAN) The trade name for a **rendering software** developed by Pixar. Also called **Photo Realistic RenderMan (PRMAN)**. See also **RenderMan Interface Bytestream (RIB)**, **Blue Moon Rendering Tools (BMRT)**.

RenderMan Interface Bytestream (RIB) The **scene description** language developed by **RenderMan (RMAN)**. A rib file can be stored in **ASCII** or **binary** format and is the **file** containing all the information that makes up a **3D scene** and is used by the **renderer** to calculate the **image**s.

render model See **shading model**.

render queue The list of **render job**s waiting to be **process**ed on the **render farm**.

Render Watcher The individuals whose job it is to monitor and manage the **render job**s submitted to the **render farm**. The render watcher needs to check for **error message**s, stopped **render**s, bad **frame**s, and so forth. Also called **Wrangler**, **Render Wrangler**.

Render Wrangler See **Render Watcher**.

reorder Another name for **channel swapping**.

repetitious shots A sequence of **shot**s that are composed of a series of similar angles, such as a group of **close-up**s **(CU)** or **long shot**s **(LS)**. Opposite of **contrasting shots**.

Repetitive Strain Injury (RSI) A common injury found among computer **user**s that is caused by repetitive **motion**s such as typing, bad posture, and a poorly designed work space. Symptoms include numbness, pain and fatigue in the fingers, wrists, arms, neck, and back. Chairs with good back support, desks set at the proper height, and **wrist support**s are some ways of avoiding injury. See also **Carpal Tunnel Syndrome (CTS)**.

repo Shorthand for **reposition**. See **translate**.

reposition See **translate**.

rerelease A general **release** of a **film** for **screening** after its initial release. Films are generally rereleased if they were very popular or won a number of awards.

res Shorthand for **resolution**.

resample An **image process** that changes the **resolution** of an **image**. Re**sampling** to a higher resolution adds new **pixel** information through **interpolation** techniques, whereas resampling to a lower resolution discards pixel information.

reset 1. See **power cycle**. 2. To put a **software application** back to its original **default settings**.

reshoot See **additional photography**.

resize An **image operation** that modifies an **image** to a different **resolution**.

resolution 1. The amount of **data** used to represent an **object**. See **object resolution**. 2. The number of **pixel**s used to define an **image**. See **image resolution**. 3. The number of **rows and columns** used in a **display device**. 4. The number of **dots per inch (DPI)** that a **printer** can output. 5. Referring to the final **viewing format**.

resolution independence A feature available in most **compositing package**s that allows the **user** to work with a variety of different **image resolution**s.

restart See **soft boot**.

restore To copy **file**s residing on another **disk** or from **tape** onto the **hard disk**. Opposite of **archive**. Also called **unarchive**.

rest pose See **rest position**.

rest position The position that a **digital model** is originally created in and is used to build the **skeleton chain** within. The rest position is also used as a reference for the **software application** to ensure that **texture**s and **material**s will "stick" to the **model** during **animation** and **deformation**s. See also **sticky surface**.

retained model The **object** that is used to make **instance**s of itself. See **instanced object, instancing**.

reticle 1. The **image** etched into the **ground glass** of a **viewfinder** on a **physical camera**. 2. For **computer graphics (CG)**, the **overlay** used to indicate the portion of the **digital image** that will be seen during **projection**.

reticulation A defect in which the **film emulsion** layer becomes coarse and cracked due to improper **processing**. Typically, this is caused by a process solution that is too hot or alkaline, which creates swelling of the emulsion that may not dry to a smooth **layer**.

retrieval 1. To restore **digital data** from an **archive**. Opposite of **back up**. 2. To locate and access **data** that is stored on a **computer disk** for **display** and/or **processing**.

reveal 1. See **reveal matte**. 2. Any **image operation** in which some percentage of the **background image** is allowed to be seen in the **foreground image**.

reveal matte A **matte** that is **animated** to progressively reveal an **image**. Also called a **matte reveal, wipe matte**.

reversal film A special **film stock** that, after being **exposed** in a **camera**, is formed into a **positive image** on the **base** of the **original** film from the **camera**, which eliminates the need to create a **positive print** from the **negative**.

reversal print A **positive print** made on **reversal film**.

reversal processing A **processing** technique that creates a **positive image** on an original **reversal film** by reexposing the remaining **silver halide crystals** that are used to form a positive image.

reversal stock See **reversal film**.

reverse angle shot A **scene** filmed from the reverse direction of a previous **shot**.

reverse filmout A **filmout** process where the inverse of the **color corrections** applied to the **images** during **grading** are applied to the final **composite** when converting it back into a **nonlinear color space**, such as the **Cineon file format**, for filmout. The theory is based on the premise that if the **background plate** has been **color graded** to match the **match clip** and/or **workprint**, and all the **foreground elements** were properly color corrected during compositing to match to that background plate, then the inverse grading **value**s will apply to the final **composite**. Such a scenario makes the need to **wedge** a shot obsolete. Also called a **reverse out**.

reverse out See **reverse filmout**.

reverse shot Shorthand for **reverse angle shot**.

revision See **software revision**.

revolutions per minute (RPM) The speed at which a **disk drive** rotates is measured by the number of 360 degree revolutions it completes in a minute.

revolutions per second (RPS) The number of 360 degrees of revolution that an **object** takes each second. See **temporal aliasing**, **wagonwheeling**.

revolve See **surface of revolution**.

rewinds A crank and two high shafts placed on the **editing bench** to hold and rewind **reel**s of **film**.

RGB 1. Abbreviation for the three **additive primaries** of **red (R)**, **green (G)**, and **blue (B)**. See **RGB channels**, **RGB records**. 2. The red, green, and blue guns used in a **CRT monitor**. See **cathode ray tube (CRT)**.

RGBA Abbreviation for **red (R)**, **green (G)**, **blue (B)**, and **alpha**.

RGBA channels The **red (R)**, **green (G)**, **blue (B)**, and **alpha** values contained in an **RGBA image**.

RGBA image A **four-channel image** that contains the four **channel**s of **red (R)**, **green (G)**, **blue (B)**, and **alpha**, as opposed to an **RGB image**, which does not include the **alpha channel**.

RGBA values See **RGBA channels**.

RGB channels The **red (R)**, **green (G)**, and **blue (B)** values contained in an **RGB image**. *See also Color Plate 14.*

RGB color model The **color model** in which the three components of **red (R)**, **green (G)**, and **blue (B)** can be combined to create all other **hue**s in the **spectrum**. The **RGB** color model is an **additive color model**. *See Color Plate 3.*

RGB color system See **RGB color model**.

RGB components See **RGB channels**.

RGB correct A **image operation** that modifies the **color** of an **image** by modifying its **RGB channels**. See also **hue correct**.

RGB image A **three-channel image** that contains the three **channel**s of **red (R)**, **green (G)**, and **blue (B)**, as opposed to an **RGBA image** which also includes the **alpha channel**.

RGB monitor A **display device** that separates **red (R)**, **green (G)**, and **blue (B)** signals to **display** different **color**s on the **screen**. An RGB monitor can be an **analog** or **digital** display. See **CRT monitor**.

RGB records The **red (R)**, **green (G)**, and **blue (B)** layers contained in a piece of **film** or **video**.

RGB values See **RGB channels**.

RIB Abbreviation for **RenderMan Interface Bytestream (RIB)**.

ride See **film ride**.

ride film A location-based **film** that features **camera motion** synchronized to a moving **set** or **sequence** of **image**s. See also **stereo film**.

rig 1. To set up the various equipment, such as **cameras**, **light**s, and scaffolds, that are required for the **shoot**. 2. A **harness** that is attached to an Actor or **Stuntman** to protect him during the **filming** of **stunt**s. 3. Another term used for **character setup**. 4. See **motion control rig (MOCO rig)**.

Rigger 1. For **computer graphics (CG)**, see **Character Setup Technical Director (Character Setup TD)**. 2. The individual that sets up the various equipment and stunt **rig**s required for a **shoot**.

rigging 1. See **character setup**. 2. See **rig**—Definition #2.

right and left eyes Referring to the two **stereo image**s intended for their respective eye on a **stereo viewing system**. *See Color Plates 30, 31.*

right click To depress, or **click**, the rightmost **button** on the **mouse**. See **left click**, **middle click**.

right eye Referring to the **image**s **capture**d or **display**ed for the right eye on a **stereo viewing system**. Opposite of **left eye**.

right-handed coordinate system A standard **coordinate system**, used in **computer graphics (CG)**, in which the **X-axis** runs from **east** (positive) to **west** (negative), the **Y-axis** runs from **north** (positive) to **south** (negative), and the **Z-axis** runs toward (positive) and away (negative) relative to **screen space**. According to the **right hand rule**, if the thumb of the right hand points in the direction of the positive X-axis and the index finger points in the direction of the positive Y-axis, then the middle finger points in the direction of the positive Z-axis. The only difference between the right-handed coordinate system and a **left-handed coordinate system** is that the positive/negative val-

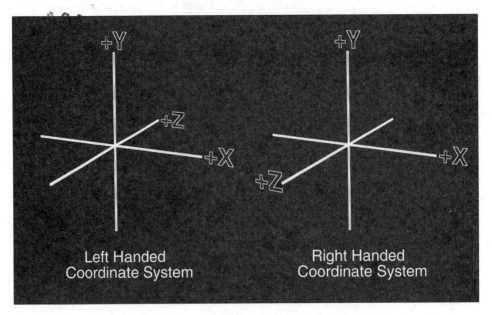

Two variations of **coordinate system handedness**.

ues along the Z-axis are reversed. See also **right-handed rotation**. *See image above.*

right-handed rotation To **rotate** an **object** around an **axis** so that if the thumb of your right hand was pointed toward the positive direction of the **axis of rotation**, the remaining four fingers of your hand would curl in the positive direction of the **rotation**. Positive right-handed rotations occur in the opposite directions in **left-handed rotation**s.

right hand rule A way of remembering the direction of the **XYZ axes** in a **right-handed coordinate system**. Hold up your right hand so that your palm is facing you. Extend your thumb to the right, your index finger pointed up and your middle finger pointing toward you. With your hand in this position, your thumb is pointed toward positive X, your index finger toward positive Y, and your middle finger toward positive Z. The opposite direction of your fingers represents negative X, Y, and Z, respectively. See also **left hand rule**, **right-handed rotation**.

rigid bodies See **rigid body objects**.

rigid body animation See **rigid body dynamics**.

rigid body dynamics The **animation** of **rigid body object**s uses **dynamics** to cause the **object**s to behave in a physically natural manner. However, unlike **soft body dynamics**, the interacting objects do not **deform** or change **shape**. For example, the **physical simulation** of a bowling ball crashing into bowling pins will cause the pins to collide and interact but not deform.

rigid body objects **Object**s that do not **deform** during an **animation**. Opposite of **soft body objects**. See **rigid body dynamics**, **active rigid bodies**, **passive rigid bodies**.

rigid body simulation Synonymous with **rigid body dynamics**.

rigid disk See **hard disk**.

rig removal The process of **painting** out any unwanted harness **rig**s or **rod**s that were attached to the **subject** in the **scene**. Also called **rod removal**. See also **wire removal**.

rim light See **back light**.

ringing An **image artifact** caused by sharp **transition**s between dark and light areas, usually due to excessive **sharpening**.

ripple The automatic update of an **edit decision list (EDL)** to reflect changes, as in "ripple through the list."

RLA A standard **image format** that uses a **bit depth** of either **8 bit**s or **16 bits per channel** and can represent **RGBA** and **Z-depth** channel information. RLA uses a **lossless compression** scheme, and its typical **filename extension** is .rla.

RLE Abbreviation for **run length encoding (RLE)**.

RMAN Abbreviation for **RenderMan (RMAN)**.

robotics See **animatronics**.

rock and roll Slang term for the **playback** of **film** in the absence of a **loop tree**. In order to repeatedly view a particular **shot** on a **film roll**, the **Projectionist** can stop and reverse the film back to the **head** of the shot and play forward again without loss of **synchronization**. This is generally done numerous times during **dailies** in order to enable the **Director** and/or **Effects Supervisor**s to determine what steps need to be taken to bring the shot to completion.

rod A slim pole, made from wood, plastic, or metal, that is used to control the **motion** of **puppet**s and **animatronics**. Often, the use of such a rod will require **rod removal** during **post production**.

Camera roll.

rod removal See **rig removal**.

ROI Abbreviation for **region of interest (ROI)**.

roll 1. **Rotation** of the **camera** around the **Z-axis**. Also called **dutch, camera roll**. See also **tilt, pan, dolly, zoom**. *See image above and image under camera move.* 2. Shorthand for **film roll**. 3. Shorthand for **roll camera**.

roll camera To begin **shooting** the **scene**.

roller-ball mouse See **mechanical mouse**.

roll number The unique number assigned to each **roll** of **film** when it is placed on the **camera**.

ROM Abbreviation for **read only memory (ROM)**.

root 1. The first **node** or **object** in a **hierarchy** to which the entire hierarchy is attached. Also called the **anchor, start joint, root node, root joint**. See also **effector**, *image under bone*. 2. The **directory** at the top of the **hier-**

archy in a **file system**. 3. The **user name** used by the **System Administrator**.

root account The **login account** used by the **System Administrator**. The root account allows full access to the entire **file system**. Also called **super-user**.

root directory See **root**—Definition #2.

root joint See **root**—Definition #1.

root name Typically, the first portion of a **filename** that is used as a description of the contents of the **file**. See **naming conventions**.

root node See **root**—Definition #1.

root privileges To be allowed access to the **root account**.

rotate 1. A **compositing operation** that orients an **image** around a specified center. 2. A **3D operation** that adjusts the **orientation** of an **object** in **3D space** along the **XYZ axes**. See **rotation pivot point**.

rotation The **orientation** of an **image** or **object** along a specific **axis**.

rotational limits See **rotation constraint**.

rotation channels The **value**s representing the **rotation**s along the **XYZ axes** of an **object** or **image**.

rotation constraint The **constraint**s that restrict the **rotation**s of one **object** to the rotations of another. The **constrained object** will always rotate by the same amount as the object to which it is constrained. Also called **orientation constraint**s. See also **translation constraint, direction constraint**.

rotation pivot point The **point** around which a **rotation** occurs for an **object** or **image**. See also **scale pivot point**, *image under **pivot point***.

rotation order See **rotation priorities**.

rotation priorities The order in which the **rotation**s along each of the **XYZ axes** will occur. See also **transformation priorities**.

rotation transformation The series of numbers used to express the amount to **rotate** an **image** or **object** along each **axis** within the current **coordinate system**. See **transformation matrix**.

roto Abbreviation for **rotoscope**.

Roto Artist Shorthand for **Rotoscope Artist**.

roto matte Shorthand for **rotoscope matte**.

rotoscope 1. A term used to describe the creation of **articulate matte**s for each **frame** in a **sequence** of **image**s for use in **digital compositing** or **optical compositing**. 2. For **cel animation**, rotoscope is the process of photographing a sequence of images and using them as reference on top of which the hand-drawn animation is traced. 3. For **3D animation**, rotoscope is similar to its use in cel animation, except that the series of reference images are used as a guide over which to **pose** a **3D model** to the corresponding **position** of the **character** in the image.

Rotoscope Artist An individual who creates **articulate matte**s.

rotoscope matte See **articulate matte**.

rough animation 1. For **computer graphics (CG)**, the early **motion test**s done during **layout**, **previs**, and **scene blocking**. *See also Color Plates 42, 43, 46.* 2. For **cel animation**, the first-generation sketches done by the **Animator**s to **block** out the **motion** of the scene. See **cleanup**.

rough comp Abbreviation for **rough composite**. Synonymous with **temporary composite**.

rough composite Synonymous with **temporary composite**.

rough cut The roughly **edit**ed version of the **cut**. Often done in the **offline editing** portion.

rough lighting An early look at the placement of the **light**s in a CG **environment** or for a particular **element**. At this stage in lighting, the basic orientation of the lights are determined and once approved, the final lighting can be developed. *See also Color Plates 35, 44, 48.*

roughness 1. The scattering of **light** across a **surface** as it **reflect**s off of it. 2. For **motion dynamics**, see **friction**.

rounds Synonymous with **walkthroughs**.

route The defined **path** of **data** from the **source address** to the **destination address**.

router A **device** that handles **data** transfer between **computer**s in a **network**. Also called a **gateway**.

routine See **procedure**.

routing The process of assigning a **route** for the **data** from a **source computer** to the **receiving computer**.

row The equally spaced **horizontal** lines that make up a **surface**. Opposite of **column**. See **rows and columns**.

rows and columns 1. A technique used to organize a **model** into a **mesh** made up of evenly spaced **horizontal** rows and **vertical** columns of **vertice**s. See also **polygon mesh, polygon detail, triangles, quadrilateral**s, **alternating triangles**, *image under polygon detail*. 2. A method used to organize **array**s of **data**, such as in a **transformation matrix** or a **convolution filter**.

RP Abbreviation for **rear projection (RP)**.

RPM Abbreviation for **revolutions per minute (RPM)**.

RPS Abbreviation for **revolutions per second (RPS)**.

RSI Abbreviation for **Repetitive Strain Injury (RSI)**.

RTFM A slang abbreviation for "Read the *ucking manual!" Used when a **digital artist (DA)** asks a question instead of taking the time to look the answer up in the manual.

rubber stamp See **tiling**.

run To **execute** a **program**.

run cycle A **motion cycle** in which the **digital character** runs in a **loop**. See **walk cycle**.

Runner See **Production Assistant (PA)**.

run length encoding (RLE) A **lossless compression** technique that consolidates groups of identical **pixel**s into a single representation. The **color value** of a pixel is stored together with the value representing subsequent pixels containing the same **color** as the initial pixel. A new pair of **value**s occurs when a new pixel is a different color than the pixel before it. Run length encoding can be very efficient for storing **CG image**s in which large areas of solid colors are used, but it is very inefficient for **live action element**s due to the high levels of **noise** and **grain** that create different color values for almost every pixel in the image. See also **Lempel-Ziv-Welch compression (LZW compression)**.

run time 1. The period of time during which a **process** is being **execute**d by the **computer**. 2. The total amount of time it takes a process to execute.

rushes The term for **dailies** used in Great Britain.

rush print See **one light**.

rush workprint See **one light**.

SA Abbreviation for **source address (SA)**.

safe action The region in which all action seen within the **camera** will actually appear in the final **display**. Most **software package**s offer a safe action box that surrounds approximately 90 percent of the viewable **frame**. For **live action photography**, markings are etched into the **viewfinder** indicating the **safe area**. Also called **safe action area**, **TV safe**, **television safe**. See also **safe title**. *See image below.*

safe action area See **safe action**.

safe area See **safe action**.

Safe action areas for **image** and **titles** for television.

safe title The region in which all **text** should be kept within if the final viewing **display** will be on a television screen. Most **software packages** offer a safe title box, that surrounds approximately 80 percent of the full **video frame** that the **user** can display over the **view**. Also called **title safe**. See also **safe action**, *and image on previous page.*

safe title area See **safe title**.

safety base See **acetate base**.

safety film Synonymous with **acetate film**.

SAG Abbreviation for **Screen Actors Guild (SAG)**.

sample A measurement of an **attribute** at a specific point in **time**. See **sampling**.

sampling 1. To **read** information at specific intervals. For example, when performing an **analog-to-digital conversion**, the **signal** is **read** at regular time intervals. 2. To read a **color value** from a single or **group** of **pixel**s. See also **pixel analyzer**.

sampling frequency See **sampling rate**.

sampling rate The **frequency** at which **sampling** occurs.

sandbag A sand-filled canvas bag used as support for **light**s and **prop**s on **set**.

saturated Referring to **color**s containing high **chroma**. Opposite of **desaturated**.

saturation Saturation, or **chroma**, refers to the **intensity** or purity of a **color**. Colors with a strong chroma or full of saturation are the most brilliant and vivid colors we can create. The chroma of a color is relative to the amount of **black** or **white** that it contains. However, black, white, and shades of gray contain no chrominance and contain only **luminance**. All colors have both chrominance and luminance. A **desaturated** blue will appear dull, whereas a very **saturated** blue will be brilliant.

save To **write** a **file** to a **disk** or other **storage device**. Opposite of **delete**.

save as To **write** a **file** to a **disk** with a different **filename** than previously used to store the file.

SC Abbreviation for **scene (SC)**.

scalar A single **value**, as opposed to the multiple values stored in a **vector**, **matrix**, or **array**. A scalar contains magnitude but no direction.

scalar multiplication The multiplication of a single number, or **scalar**, by another.

scalar product See **dot product**.

scalability The ability of a **program, application,** or **operating system (OS)** to work well when changed in size or **configuration**. For example, a scalable **network** is one that can begin with just a few **node**s but can easily expand to thousands of nodes without loss of performance. Scalability is an important feature when investing in a **system** to ensure that it can handle the projected growth. It is also important that a **compositing package** offers scalability so that the **user** can work out the **composite** at a **proxy resolution** and have the **software** automatically convert all the **value**s and **curve**s to their proper **scale** to support the **high-resolution image**s used for the final **output**.

scale 1. A **geometric transformation** that changes the size of an **object** along the **XYZ axes**. See **object scale, proportional scale, nonproportional scale**. 2. An **image process** that adjusts the size of an **image** by an **X** and **Y** multiplier. See **resize**. 3. See **model scale**.

scaled animation See **time warp**.

scale down To decrease the size of a **2D image** or **3D object**. Opposite of **scale up**.

scale pivot point The **point** around which size changes occur for an **object** or **image**. See also **rotation pivot point**.

scale transformation The series of numbers used to express the amount to **scale** an **image** or **object** along each **axis** within the current **coordinate system**. See **transformation matrix**.

scale up To increase the size of a **2D image** or **3D object**. Opposite of **scale down**.

scan 1. To convert an **image** into an electrical **signal** by moving an **electronic beam** across the image from left to right and top to bottom. See **blanking interval**. 2. The process of transferring **film, video,** or **print** material into **digital image**s. See also **film scanner, Telecine**.

scan in To use an **input device** to convert **film image**s, **video image**s, or **flat artwork** into **digital image**s. Opposite of **scan out**.

scan line A single **horizontal** row of **pixel**s that make up a **raster image**. During **scanning** or **display** to a **viewing device**, an **electron beam** or **laser beam** scans across the **frame** one scan line at a time to form the **image**.

scan line rendering A **rendering algorithm** that produces an **image** one vertical **scan line** at a time by calculating the intersection of each **polygon** with the **screen window**, rather than on an **object**-by-object basis as is done with **ray tracing**. The **color** of each **pixel** is determined by the calculated properties of **light** striking the polygons that are **project**ed onto the pixels. An advantage of scan line rendering is that different sets of scan lines belonging to the same image can be simultaneously **render**ed on different **computer**s to speed up the calculation time in creating the whole image. Scan line rendering is faster than ray tracing since the lighting computation is only performed once, but **shadow**s and **reflection**s have to be cheated or created in separate **pass**es. See **ray casting**.

scanned images 1. **Select**s that have been **scan**ned from **film**, such as **live action** and **stage photography** plates, for use in **compositing**. 2. **Flat artwork** that has been scanned onto the **computer** using a scanning device, such as a **flatbed scanner**.

scan out To use an **output device** to convert **digital image**s to **film image**s, **video image**s, or **flat artwork**. Opposite of **scan in**.

scanned plates Another term for **scanned images**.

scanner 1. An **input device** used to **digitize** film or **print** material into **digital image**s. See also **flatbed scanner**, **film scanner**, **laser scanner**. 2. A **program** that searches through stored **data** for specific data.

scan out To use an **output device** to convert **digital image**s to **film images**, **video image**s, or **flat artwork**. Opposite of **scan in**.

scan rate The speed at which an **image** is **scan**ned.

Scanrec Abbreviation for the **Scan/Record Department**.

Scan/Record Department The department responsible for the **scanning** and **record**ing of **film** to and from **digital image**s.

scattering The way **light** is dispersed across a **surface** or as it travels through the **atmosphere**. See also **roughness**.

scene (SC) 1. Describing the **location** or setting where the action takes place. 2. A continuous view of an action or series of events from a single **camera** without interruption. Also referred to as a **shot**. 3. A continuous series of **image**s representing the length of the shot. 4. The complete setup of **object**s, **light**s, and **camera**s in a **3D package**.

scene balance Referring to the psychological **weight** of an **image** based on the placement of **element**s in the **scene** and where the eye is drawn to as

a result. Also referred to as **image balance**, **shot balance**. See also **image composition**.

scene blocking The rehearsal of the **camera motion**, actor movement, and arrangement of **prop**s within a **scene**. Also called **blocking a scene**.

scene composition See **image composition**.

scene description For **computer graphics (CG)**, the **object**s, **attribute**s and **motion curve**s that make up the **scene file** that is used to calculate **image**s by the **renderer**.

scene file A **text file**, written out by many **software package**s, that is a complete verbal description of everything that comprises the **scene**, such as the **camera**, **object**s, **light**s, **surface attribute**s, and any **motion curve**s applied to those **element**s. The **renderer** refers to the scene file when calculating **image**s.

scene footage See **animation footage**.

scene hierarchy The **object**s, **light**s, **camera**s, and any other **attribute**s that make up a **3D scene**. See **hierarchy**.

scene number The unique number assigned to each **scene** based on its location in the **script**. Sometimes referred to as a **sequence number**.

scenic The constructed **set**, **cyclorama**, or **matte painting** that serves as the **background (BG)** for a **scene**.

Scenic Artist An individual who designs and creates the artwork positioned behind a **set**. See also **Matte Painter**.

schematic view A way of viewing a **hierarchy**, or **tree**, in a **3D software package** as a series of connected **node**s.

scoop A floodlight shaped like an ice cream scoop that gives off a wide angle of **light**.

scope 1. Abbreviation for any **anamorphic** processes, such as **Cinemascope**, **Techniscope**, **Superscope**. 2. Shorthand for a **video scope**. See **waveform monitor**. 3. The current range of modifiable **parameter**s in a **software application**.

score The musical portion of a film's **sound track**.

scout Abbreviation for **location scout**.

Scout Abbreviation for **Location Scout**.

scratch 1. See **cinch marks**. 2. See **scratch track**.

scratch track A term used to describe a temporary audio placeholder such as "scratch music" or "scratch dialogue." The scratch **track** is also used during a **looping** session as reference for the actors.

screen 1. The **surface** on which **data** or **image**s are **display**ed on a **display device**, such as a **computer screen**, **monitor**, or **projection screen**. 2. For **compositing**, see **screen operation**.

Screen Actors Guild (SAG) The organization that has jurisdiction over works that can be recorded with **picture** or **sound** and negotiates the salaries and working conditions for individuals appearing on **screen**.

screen capture See **screen grab**.

screen coordinates The **coordinate**s that define the **2D display** of a **3D scene** based on its **screen coordinate system**.

screen coordinate system The **coordinate system** that defines the final **2D** display of a **3D scene**. Also called **raster coordinate system**, **device coordinate system**.

screen direction The direction in which a person or **object** moves or looks during the **filming** of a series of **shots** as seen through the **camera**. See **directional continuity**.

Screen Extras Guild (SEG) The union that represents and negotiates the salaries and working conditions for film **Extra**s.

screen footage The amount of **scene footage** that is actually **cut** into the **movie** and is shown on **screen**. Screen footage is always the same as or less than **scene footage** because the **length** of each **scene** or **shot** is generally **pad**ded with extra **frame**s in order to give the **Director** and the **Editor** some room to play with the **cut length** in the **final edit**. See also **film footage**, **handles**.

screen grab To **copy** all or a portion of the **image** on the **computer screen** and **save** it to **disk** as an **image file**. Also called **screen capture**, **frame grab**, **frame capture**, **capture**, **snapshot**.

screen grabber The **application** used to **capture** an **image** from the **computer screen**. See **screen grab**.

screening The viewing of **film**.

screening room The room in which **film** and **video** is **project**ed and **screened** in a **facility**. It is the equivalent to a theatre except that it is not open to the public!

screen left The left side of the **screen** or **image** from the viewpoint of the **viewer**. See **screen right**.

screen operation A **compositing operation** that takes two **input image**s, **invert**s them, multiplies them together, and then inverts the result. It mimics the effect of exposing two **film negative**s together. *See also image below and image under* **layering operation**.

screen plane 1. In **3D film**s, the **plane** of the real **screen** in the theatre. All **3D object**s are referenced in relation to their distance from the screen plane. 2. See **screen window**.

screenplay A **script** written to be produced as a **film** for release in movie theatres, as opposed to a **teleplay**, which is produced as a television movie.

screen resolution The total number of **pixel**s that a **display device** can represent in the **horizontal** and **vertical** direction.

A Screen B

screen right The right side of the **screen** or **image** from the viewpoint of the **viewer**. Opposite of **screen left**.

screen saver A **program** that automatically **display**s either a black **image** or a series of moving images to protect the **monitor** from getting **raster burn** when the **computer** is not in use.

screen shot An **image** that was **capture**d from a **computer screen**.

screen space See **screen coordinate system**.

screen window The **image plane** that represents the area of a **scene** to be **render**ed. Also called **screen plane**.

Screenwriter A writer who creates a new **screenplay** or adapts an existing body of work into a **script** for **production** as a **film**.

scrim A special material placed in front of a **light** to decrease its **intensity**. See also **neutral density filter (ND filter)**.

script 1. A **program** written in a **scripting language** such as **C Shell (CSH)** and **Bourne Shell (SH)**. 2. The written story of a **movie**. See **screenplay**, **shooting script**, **lined script**.

scripting language A global term for a set of **command**s, called a **script**, that must be deciphered by an **interpreter** and operates with other **program**s to **execute** a range of **function**s. Examples of commonly used scripting languages are **C Shell (CSH)** , **Bourne Shell (SH)**, **TCL**.

script notes The detailed notes that the **Script Supervisor** takes for each **scene**, including **scene number**, **camera roll**, **lens**, **circled takes**, and details about the **shot** such as the dialogue and action that took place.

Script Supervisor The individual responsible for recording **script notes** for each **take**, and for **continuity** between surrounding **scene**s. The Script Supervisor is also responsible for ensuring that the **circled takes** selected by the **Director** throughout the day are sent to the **lab** for **processing** and review in **dailies**.

Scriptwriter See **Screenwriter**.

scroll 1. To move through a document in either an up-and-down or left-to-right direction. See **scroll bar**. 2. A **compositing operation** that functions like a **reposition** except that the **image** is wrapped around the **frame** so that it reemerges on the opposite side from where it left the **edge** of frame. *See image on following page.*

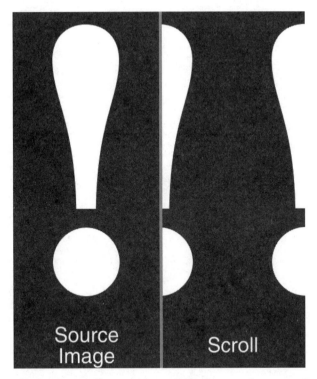

A **scroll**ed image will wrap around the **frame** when **translat**ed.

scrollable window Any **window** that cannot fully **display** its contents on the **screen** but can be **scroll**ed up-and-down or left-to-right to reveal the entire contents.

scroll arrow The arrow on the **scroll bar** that allows a **user** to **scroll** through a document.

scroll bar The bar at the bottom side of a **window** that allows a **user** to **view** all the information in a document when it is too large to **display** all the information in the **current window**. This is typically done by **click**ing on a **scroll arrow** on either end of the scroll bar, which then allows the user to **scroll** through the document. See also **thumb**, **gutter**.

scrub See **jog**.

SCSI Abbreviation for **Small Computer Systems Interface (SCSI)**.

sculpt object An **object** that is used to **deform** another object by using a **deformer** to reshape the **surface**s with which it comes into contact. See **deformation**.

scuzzy See **Small Computer Systems Interface (SCSI)**.

SDI Abbreviation for **serial digital interface (SDI)**.

SDK Abbreviation for **software developer's kit (SDK)**.

SDDS Abbreviation for **Sony Dynamic Digital Sound (SDDS)**.

SDSL Abbreviation for **symmetric digital subscriber line (SDSL)**.

search and replace See **parse**.

search engine A **program** used by the **Internet** to allow **user**s to search for information.

SECAM Abbreviation, in English, for **Sequential Color with Memory (SECAM)**.

SECAM image format A **digital image** stored in **SECAM** format is 720 **pixel**s wide and 625 **scan line**s high.

SECAM video See **Sequential Color with Memory (SECAM)**.

Second AC Abbreviation for **Second Assistant Cameraman (2nd AC)**.

Second AD Abbreviation for **Second Assistant Director (2nd AD)**.

Second AE Abbreviation for **Second Assistant Editor (2nd AE)**.

Second Assistant Cameraman (2nd AC) The member of the **Film Crew** responsible for marking the **slate**, clapping the **clapsticks**, loading and unloading **magazine**s, and filling in **camera report**s. The Assistant Cameraman reports to the **First Assistant Cameraman (1st AC)**. Also referred to as the **Clapper** or **Clapper/Loader**.

secondary hues Secondary hues refer to the **color**s **orange** (a mixture of **yellow** and **red (R)**), **green (G)** (a mixture of **blue (B)** and yellow); and **magenta** (a mixture of blue and red). See also **primary hues**, **hue**, **chroma**, **value**.

Second Assistant Director (2nd AD) The individual hired on larger **projects** to assist the **Assistant Director** with his tasks.

Second Assistant Editor (2nd AE) The individual who works for and assists the **Assistant Editor**.

second generation The second **copy** made from the **first-generation** copy of a series of **film** or **video image**s. Subsequent copies made from this second-generation copy are called **third-generation** copies. See also **generation**, **generation loss**, **intermediate positive (IP)**, **intermediate negative (IN)**.

second quadrant See **quadrant one**.

Second Unit A small **Film Crew** that is backup to the **First Unit** and that shoots **establishing shot**s, and shots involving **stunt**s or large numbers of **Extra**s during **principal photography**. This Crew is led by a **Second Unit Director**.

Second Unit Director The **Director** of the **Second Unit**.

sector A pielike division of a **disk**. **Disk storage** is organized in pie-shaped sectors and concentric rings, called **track**s. A combination of two or more sectors on a track creates a **cluster**, or a **block**, that is the smallest **unit** used to store **digital** information.

sed Abbreviation for **stream editor (sed)**.

seed An **integer** that is fed into a **program**, **algorithm**, or **matrix** to produce a **random number**. The same random seed will result in the same random numbers and therefore can provide for repeatable iterations. The sets of random numbers generated by a particular seed value are often used to produce **effect**s, such as **noise**, that will be consistent from **render** to render. Also called a **random seed**. See **random number generator**.

SEG Abbreviation for **Screen Extras Guild (SEG)**.

segment 1. The **curve** or **line** that connects between two **point**s or **key frame**s. 2. A range of **memory**.

select 1. To **click** on or draw a **bounding box** around **object**s, **node**s, or **text** to make them **active**. Active selections become **highlight**ed and can be modified by the **user** with any number of **editing** functions available within the particular **software application** being used. Also referred to as **choose**. Opposite of **unselect**. See also **cut**, **paste**, **copy**, **clone**. 2. See **selected take**.

select all To **select** all the items in a **window** by drawing a **bounding box** around them.

selected Another name for **current**.

selected take The **take** of a **scene** chosen by the **Director** to be used in the final cut of the **film**. For **visual effects work**, the select is the range of **frame**s that are **scan**ned and brought **online** for **digital** manipulation.

selection The **highlight**ed **object**s or **node**s that will be affected by **user commands**.

selective focus Selecting a **lens** opening that creates a shallow **depth of field (DOF)**. Selective focus is typically used to isolate the **subject** from the **background (BG)** by making most of the other **object**s in the **scene** blurry.

selective light See **exclusive light**.

self-similar See **self-similarity**.

self-similarity A characteristic found in **fractal**s in which each pattern looks like the whole regardless of how close you **zoom in** or **zoom out** to view it. See also **Koch island**, **Lindenmayer System (L-System)**.

self-shadowing Any **object** or **particle system** that casts **shadow**s upon itself.

semiconductor laser See **diode laser**.

sensitometer A device used to evaluate a **film**'s sensitivity to **light** with a **sensitometric strip**. See also **sensitometry**.

sensitometric strip A strip of **film** that is **expose**d in a series of steps to a **sensitometer** to measure the characteristics of the **film emulsion** and to ensure proper **processing**. See also **sensitometry**.

sensitometry The study of the effects of **light** on **film emulsion** under a series of various conditions and intensities. Using a **sensitometer**, **film** is **expose**d in progressive degrees of **exposure**s to assess the characteristics and qualities of a specific film to allow for optimum photography and **processing**. See also **sensitometric strip**.

sensor A term used to describe the **input device**s used in **motion capture (MOCAP)**.

senso strip See **sensitometric strip**.

sepia tone A shade of brown with a little **red (R)** mixed in.

sepia tone filter A **camera filter** used to mimic the brownish tones associated with old photographs as a means of creating the **on screen** feeling of a previous era.

sequence 1. A series of related **shot**s and **scene**s that create a single and coherent story point or action. A sequence can take place in either a single setting or in several settings. Action in a sequence should match across several shots so that the events it is depicting occur in a continuous manner. 2. A series of **image**s meant to be **display**ed sequentially.

sequence code 1. For **live action** projects, the two-letter code representing the name of a **sequence**. For example, the two letters used to represent the launch sequence in *Apollo 13* were "**LS**." **Shot**s within that sequence were then named LS01, LS02, LS03, and so on. 2. For **feature animation** projects, the unique number assigned to represent each sequence in the **film**, such as sequence 0100, 0200, 0300, and so on.

Sequence Lead See **Sequence Supervisor**.

sequence number The sequence number can be used synonymously with the **scene number**, but in some cases, it is also a unique number assigned to a sequence requiring **visual effects work** at a **post production facility**.

Sequence Supervisor On larger **project**s, a number of Sequence Supervisors will be assigned to oversee individual **sequence**s of the **digital effects work**. They will supervise a group of artists assigned to their series of **shot**s and will be responsible for aesthetic and technical continuity across the sequence. Depending on the **show hierarchy**, the Sequence Supervisors might report to the **Computer Graphics Supervisor (CG Sup)**, **Compositing Supervisor**, and/or the **Digital Effects Supervisor (DFX Sup)**.

sequential access A method of storing and retrieving **data** in sequential order. For example, while **CD-ROM**s and **laser disk**s use **random access**, accessing specific **image**s from a **tape** source requires forwarding or rewinding the tape to the desired location. See also **linear video**.

Sequential Color with Memory (SECAM) SECAM is really an abbreviation for "Sequence Couleurs a Memoire," but we use the English translation "Sequential Color with Memory." SECAM is the **video signal** standard, used in France, the Middle East, and most Eastern European nations, that carries 626 **scan line**s of information and uses a **playback rate** of **25 frames per second (25 FPS)**. See also **National Television System Committee (NTSC)**, **Phase Alternate Line (PAL)**, and **High Definition Television (HDTV)**.

sequential processing See **serial processing**.

serial One at a time.

serial computer A **computer** with only one **processor**. A serial computer can run only one task at a time, as opposed to a **parallel computer** that can **run** multiple **process**es at the same time.

serial device See **peripheral device**.

serial digital interface (SDI) A **device** used to connect two **digital** devices, such as a **D1** machines and a **digital disk recorder (DDR)**, for **lossless** multigenerational **copy**ing.

serial interface See **serial port**.

serial line A **transmission** line that connects two **serial port**s together.

serial mouse Any **mouse** that plugs into a **serial port**.

serial number The unique number used to identify each **hardware device** or **software** copy.

serial port A **port** on a **computer** that **transmit**s data one **bit** at a time, as opposed to a **parallel port** that can send multiple bits simultaneously. Also called a **serial interface**.

serial printer A **printer** connected to the **serial port** of a **computer**.

serial processing To use only a single **processor** to perform a task. Also called **sequential processing**. See also **multiprocessing**.

serial transmission To **transmit** one **bit** at a time over a **serial line**.

server A **computer** that is accessible to many **user**s across a **network** and provides **file**s and information to **client** programs. See also **file server**, **daemon**, **client server**.

servo The **device** that controls an **animatronic**. The servo receives an electronic position signal from an **input device** and then sends that information to the device controlling the animatronic.

set 1. An environment used for **filming**. A set typically refers to an artificially constructed environment, as opposed to a **location**. A portion of a set is called a **set piece**. 2. See **3D environment**. 3. To **input** or **save** a particular **value** in a **software application**, as in "to set a **key frame**."

Set Designer 1. An individual responsible for designing the **set**s and environments in which a **film** will be **shot** based on the vision of the **Production Designer** and **Director**. 2. For **computer graphics (CG)**, an artist who creates a **3D environment**.

Set Dresser An individual responsible for physically decorating a **set**.

set lights The configuration of **light**s that are set up on **location** or in a **studio** to create the mood and **lighting** of the particular **scene** being **shot**.

set piece A partial section of a complete **set**.

set surveying The process of gathering the measurements, represented as **XYZ coordinate**s, from a **set**, **location**, or **physical model** for use in the **3D tracking** of **live action plate**s. See also **Total Station**, **Lidar**.

setup 1. The choice and preparation of the **camera position**, **lens**, and **staging** of a **shot**. 2. See **template**. 3. See **character setup**. 4. See **development**.

setup level See **black level**.

seventy-five percent color bars See **75% color bars**.

seventy-millimeter film See **70mm film**.

SFX Abbreviation for **special effects (SFX)**.

SGI Abbreviation for **Silicon Graphics, Inc. (SGI).**

SH Abbreviation for **Bourne Shell (SH)**.

shade 1. The **darkness** or **brightness** of a particular **hue**. 2. The area in a **scene** that is obscured from the **light source**.

shaded rendering See **surface rendering**.

shader The **surface attribute**s that are calculated by the **renderer** to determine the appearance of the **object**s in a **scene**, such as their **color**, **specularity**, and **displacement**. Shaders come in many different types, including **surface shader**s, **volume shader**s, **displacement shader**s, and **light shader**s.

shading The effect of **light** across a **surface** based on the **position** of the **object** relative to the **light source**. The shading of a surface is also dependent on the **shading model** that has been assigned to the object, such as **flat shading**, **Blinn shading**, **Gouraud shading**, **Phong shading**, and **Cook/Torrence shading**.

shading algorithm See **shading model**.

shading language A **programming language** designed to write **shader**s.

shading model The specific **algorithm** used to calculate the **color** of an **object** based on the **position** of a **light** in **3D space**. The shading model used will affect the way in which the light causes the **surface** to react. Examples of shading models include **Gouraud shading**, **Phong shading**, **Blinn shading**, **Lambert shading**, **Cook/Torrence shading**, **smooth shading**. Also referred to as a **lighting model**, **shading algorithm**. *See image on following page.*

shading normal See **surface normal**.

shading rate The **attribute** that defines the number of calculations made for each **pixel** during **rendering**.

shadow 1. The darkened area falling across the **surface** of an **object** due to an occlusion between the **light source** and the object the **light** is hit-

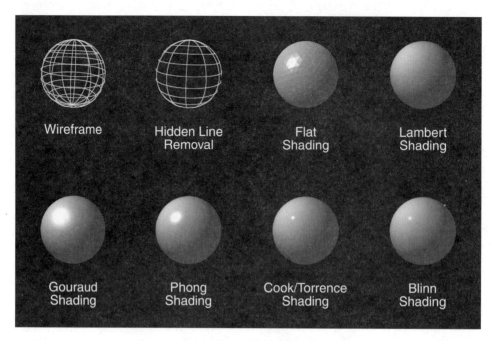

Some commonly used **shading models**.

ting. A shadow can be described as the absence of a particular light source. See also **highlight**s, **midtone**s. 2. The darkest part of an **image**.

shadow casting See **cast shadow**s.

shadow depth map See **shadow map**.

shadow map An **image** used by a shadow casting **light source** to determine when one **object** casts a **shadow** on another. The image used for this calculation is essentially a **Z depth map** in which objects farther away from the **light** source are brighter and objects closer to the light source are **render**ed darker. This shadow **depth** image can then be used in **Z depth compositing** to simulate the effects of the **falloff** of light across the objects in the **scene**. The shadow map approach is faster than **ray tracing** but is also less accurate.

shadow mask 1. A shadow mask is used in **3D lighting** to indicate which **object**s will cast **shadow**s from a specific **light source**. See also **light mask**, **reflection mask**. 2. The thin metal plate with many holes that is placed behind the glass of a **CRT monitor** as a way of keeping the **electron beam**s aligned with their targets.

shadow pass 1. In **multiple-pass photography**, the **pass** that can be used as a **matte** to create a **cast shadow** from one of the **object**s in the **scene** during **compositing**. 2. In **multiple-pass rendering**, a separate **render** of the **alpha channel** representing a cast shadow from one of the objects in the **scene** for use in compositing. See also **beauty pass, reflection pass, matte pass, light pass**.

Shake A **compositing software** developed by **Nothing Real, Inc.**

shallow depth of field See **shallow focus**.

shallow focus A **shot** that uses a large **camera aperture** to achieve a small **depth of field (DOF)** in which the **subject** is **film**ed in **focus** and the **foreground (FG)** and **background (BG)** a little out of focus as a means of isolating the **center of interest** in the **scene**. Opposite of **deep focus**.

shape The spatial aspects of an **object** that make up its physical form as defined by its contours.

shape animation A **deformation** technique in which a series of predefined **model**s, called **keyshape**s, are blended and **interpolate**d across to create a new resulting **animation**. Typically, the keyshapes need to be created from compatible **geometry**. Also called **shape morph, shape deformation, shape interpolation, shape change**. *See image under shape morph.*

shape change See **shape morph**.

shape deformation See **shape morph**.

shape interpolation See **shape morph**, *image under shape morph*.

shape morph A **deformation** technique used to create new **interpolate**d **object**s from two **source** objects. When these objects are used for **shape animation**, they are referred to as **keyshape**s. *See image on following page.*

shape node A **node** that contains the **attribute**s regarding the **shape** of an **object**, excluding **translate, rotate**, and **scale**.

shared card For **credits**, a **credit card** containing more than one name as opposed to a **single card** that contains only a single name.

shared memory **Memory** in a **parallel computer** that can be accessed by more than one **central processing unit (CPU)**.

shared normal A **surface normal** that can display **smooth shading** on a **polygonal object** by sharing the same normal across a group of **adjacent polygons**. Also called **averaged normal**s. See also **shading model**.

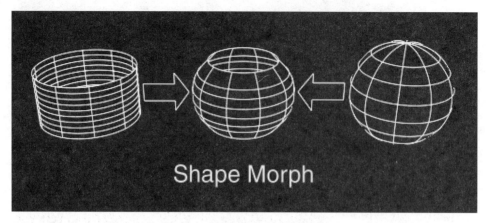

New **objects** can be created by interpolating between two source objects.
IMAGE CREATED USING HOUDINI AND COURTESY OF SIDE EFFECTS SOFTWARE.

shared resource Any **peripheral device** that is shared by more than one **computer**, such as a **printer**, **modem**, or **disk**.

shareware **Software** that has been copyrighted but can be **download**ed by a **user** for a limited time for free. After the limited period of time has elapsed, the user is asked to voluntarily send a small fee to the writers of the software. Some shareware software will offer additional features, **documentation**, and **technical support** to users who have paid this fee. See also **freeware**.

shareware software See **shareware**.

sharp Referring to an **image** or **subject** that is in **focus**.

sharpen See **sharpen filter**.

sharpen algorithm The mathematical **functions** that define the way an **image** is **sharpen**ed. Contrast is increased along **edges** and areas of **transition** that is perceived as increased sharpness by the eye. Many sharpen algorithms use **convolution filter**s. Opposite of **blur algorithm**. See **sharpen filter**.

sharpen filter An **image process** that uses many varieties of **sharpen algorithm**s to sharpen an **image**. Sharpening doesn't actually restore image information but rather the perception of it. Too much sharpening can cause undesirable **image artifact**s, such as **ringing** and more pronounced **grain** in the image. Opposite of **blur filter**. See also **unsharp mask**.

sharpening An **image process** that emphasizes the **edge**s and contours in a **digital image**. Used to create a perceived increase in **focus** and clarity of detail.

sharpen operation See **sharpen filter**.

sharpness Referring to the **focus** or clarity of an **image**.

shear The **deformation** of an **object** or **image** in which parallel **line**s remain **parallel** but are shifted in a specific direction that is parallel to themselves. See also **skew**.

shell A **command interpreter** used by the **user** to pass **command**s to an **operating system (OS)**. Commonly used **Unix Shell**s include **C Shell (CSH)**, **Bourne Shell (SH)**, and **Korn Shell (KSH)**. See also **shell script**.

shell script A **program** written to be interpreted by the **shell** of an **operating system (OS)**. Common shell scripts used in **Unix** are **C Shell (CSH)** and **Bourne Shell (SH)**.

shell variable A **parameter** accessed by a **shell script**. See also **command line argument**, **environment variable**.

shell window A **window** in which the **user** can interact with the **operating system (OS)** via a **command interpreter**.

shift focus See **rack focus**.

shininess See **specularity**.

shoot 1. The "shoot" is the actual **filming** of the **scene**s in a **film**. In some cases, the shoot is used to describe only the **principal photography** portion of the **show**, whereas the **stage photography** is referred to as the **stage shoot**. 2. The process of sending **digital image**s to a **film recorder** or **Digital Disk Recorder (DDR)**.

shoot around To continue to **shoot** a series of **scene**s in the absence of the major performers. The idea is to shoot out of sequential order by shooting first all the scenes that involve the performers and then allowing the **Crew** to go back and shoot all the remaining **surrounding shots** that don't require the actors' presence on **set**.

shooting 1. The process of photographing a **scene** with **film** or **videotape**. 2. A general term used to describe the period of **film production** when all the film is shot, including **principal photography** and **stage photography**.

shooting order The order in which the **scene**s of a **film** are **shot**.

shooting plan Another name for **shooting script**.

shooting schedule A detailed **production** schedule outlining when and where each **scene** of a **film** will be **shot**, and the **set**s equipment and actors required for the **shoot**. A **one-line** is an abbreviated version of the full shooting script.

shooting script The **script** from which a movie is actually made. A shooting script typically is composed of **camera position**s, **storyboard**s, and any other notes that will aid in the **filming** and **editing** of the entire **production**. See also **lined script**.

short end The **unexposed film** remaining in the **film magazine** after **shooting** because it was too short to use to **film** another complete **shot**.

short focal length Referring to a **focal length** in which the **lens** is a short distance from the **film**. The shorter the focal length, the less the magnification of the **image**. Opposite of **long focal length**.

short lens A **camera lens** that produces a **wide angle of view**. Opposite of **long lens**. A **wide-angle lens** is an example of a short lens.

short pitch The distance between **perforation**s along one side of a strip of **negative film**, which is slightly shorter than the distance between perforations of a **strip** of **positive film**. Also called **negative pitch**. Opposite of **long pitch**.

shot 1. A continuous view of an action or series of events from a single **camera** without interruption. Also referred to as a **scene**, **take**, or **cut**. 2. A continuous and unbroken **sequence** of **image**s. 3. The past tense of a **shoot**, as in a **scene** that was *shot* yesterday.

shot balance See **scene balance**.

shot breakdown A detailed description of the approach to be taken for each **shot** and the **element**s needed to create it. For example, a typical **visual effects shot** might require a **live action plate**, **greenscreen photography**, **motion control (MOCO)**, **3D tracking**, **roto matte**s, **matte painting**, **character animation**, **particle animation** effects, **lighting**, and **compositing**. See **breakdown**.

shot composition The arrangement of the key **element**s within the **frame**. See **image composition**.

shot continuity Referring to the smooth **transition** of actions and events from **shot** to shot without revealing the fact that each shot may have been photographed and/or **process**ed at different times. See **continuity**.

shot description The few words or phrases used in a **camera report**, **script notes**, **shooting script**, or **shot breakdown** to describe the action and classification of a particular **shot**. It will usually include the **shot type**, such as a **dolly shot**, **close-up (CU)**, **greenscreen shot**, the location and time of day, and a short description of the action and/or dialogue.

shotgun microphone A directional **microphone** that can be handheld or mounted on a **boom**.

shot length The number of **frame**s in a **shot** including **handles**. See also **cut length**.

shot name The unique name given to each **shot** created with **visual effects (VFX)** or for **feature animation** film. For **visual effects work**, a two-letter **sequence code** followed by a number is the common practice, but for **full CG** and **cel animation** work, the shot name is typically defined only with numbers.

shot on location Referring to any **live action plate**s that are **film**ed at a **physical location** other than on a **stage** or **set**.

shot on stage Referring to all **plate**s that are photographed on a **stage**.

shot type Referring to the wide variety of descriptions used to describe a particular category that a **shot** might fall into, such as a **two shot**, **aerial shot**, **motion control shot (MOCO shot)**, **CG shot**, **greenscreen shot**, **subjective shot**.

shoulder The highest part of a **characteristic curve** representing the **density** of a **negative** relative to the amount of **light** striking it during **exposure**. Opposite of **toe**.

show 1. An **interface** option used to "turn on," or **display**, certain items on the **computer screen**. Opposite of **hide**. 2. Referring to the particular **project** that is currently being produced.

show hierarchy The formal reporting structure laid out for each **visual effects (VFX)** show in terms of who reports to whom. For example, the **Digital Effects Supervisor (DFX Sup)**, **Art Director**, and **Animation Supervisor** would report to the **Visual Effects Supervisor (VFX Sup)**, while the **CG Supervisor** and **Compositing Supervisor** report to the Digital Effects Supervisor.

show name See **project name**.

Showscan A popular **widescreen** format that **shoot**s and **project**s **70mm film** at 60 **frames per second (FPS)**, rather than the normal 24. The re-

sulting **image** has nearly imperceptible **grain** and **flicker** and contains the illusion of increased **depth** without the use of special **3D glasses**.

shrinkwrap 1. A **modeling** technique in which one **surface** is **project**ed onto the surfaces of another **object** or **group** of objects. Typically, shrinkwrapping is used to convert a **polygonal model** to a **parametric surface**. 2. A **Mac** program that makes a **copy** of a **compact disc (CD)**, **floppy**, **drive**, or any other type of **file** and stores it as an **image** on the **desktop** that can be sent over the **Internet**.

shuffle 1. See **channel swapping**. 2. To modify the order in which **window**s are stacked on the **screen**.

shut down To safely **power off** a **computer** following normal procedures. See **power on**.

shutter The mechanical device in a **camera** or **projector** that controls the time during which **light** reaches the **film**. Most camera shutters contain a mirror that **reflect**s some of the light into the **eyepiece** to allow the **Cameraman** to view the **scene** during **filming**. As the shutter **rotate**s, it alternately blocks the light from striking the film, allowing it to go to the eyepiece; then it blocks the light going to the eyepiece and allows it to strike the film. This results in a slight **flicker**ing of the scene in the eyepiece during filming.

shutter angle 1. The angular measurement of the size of the opening of a rotating **shutter** that determines how long each **frame** of **film** will be **expose**d to **light**. A large shutter angle results in increased **motion blur** on the moving **subject**s. A shutter angle of 180 degrees is typically the standard shutter used for most professional **photography**. See also **shutter speed**. 2. For **computer graphics (CG)**, the setting that controls the amount of motion blur calculated during **rendering**.

shutter glasses See **flicker glasses**.

shutter rate See **shutter speed**.

shutter speed The length of time that the **camera shutter** is open during the **exposure** of each **frame**. A slow shutter speed allows more **light** to enter the **camera** and results in more **motion blur**. See also **shutter angle**, **aperture**, **depth of field (DOF)**.

shuttle See **jog**.

siblings See **children**.

Side Effects Software The company that developed **Prisms** and **Houdini** software.

side light **Lighting** that strikes the **subject** from the side relative to their **position** to the **camera**. See also **front light**, **back light**.

side lighting See **side light**.

side view An **orthographic view** of the side of a **scene**. See also **front view**, **top view**, *image under viewing windows*.

sig file See **signature file**.

SIGGRAPH A special-interest group within the **Association for Computing Machinery (ACM)**. The yearly SIGGRAPH convention is the most highly recognized and attended festival of professional **computer graphics (CG)**. And the parties aren't too bad either!

sight line Another term for **eye line**.

signal 1. An electronic impulse whose variations represent coded information. 2. A message sent between two **process**es or from the **kernel** to a process on a **Unix-based system**. Each signal carries a unique **process identifier (PID)** number and can communicate unexpected external events.

signature See **signature file**.

signature file A **text file** that contains a message that is automatically attached to the end of every **electronic mail (e-mail)** message that a **user** sends. A signature can include anything the user desires from basic contact information to favorite quotes and **ASCII art**.

signature quote Any quote that is used in the **signature file** of a **user**.

sign off Synonymous with **log out**.

sign on Synonymous with **log in**.

sig quote See **signature quote**

silicone The silica-based chemical that is commonly used to create molds and synthetic flesh for **makeup effects (makeup FX)**. See also **foam latex**.

Silicon Graphics, Inc. (SGI) 1. The manufacturer of high-end graphics **hardware** and **software**. 2. SGI is a standard **image format** that uses a **bit depth** of either **8 bits** or **16 bits per channel** and supports **RGBA** channel information but no **Z depth channel**. SGI uses a **lossless compression** scheme and its typical **filename extension** is .sgi or .rgb.

Silicon Valley The area around San Jose, California, where many **computer-**related businesses reside.

silver halide crystals The individual particles on **film** that **capture** the **image** when it is **expose**d to **light**. See **film grain**, **film emulsion**.

silver screen See **projection screen**.

simulation The creation of a **system** or **animation** based on the mathematical **model**s used in **motion dynamics**. In most **3D package**s after the **computer** has calculated a **motion** simulation, it will **playback** a **motion preview** of the resulting animation. The **user** can then modify a wide range of **physical properties** and **physical forces** that attribute to the resulting simulation until the desired behavior is reached.

simple mail transfer protocol (SMTP) A standard **protocol** used to transfer **electronic mail (e-mail)**.

Sinc blur See **Sinc filter**.

Sinc filter A **filtering algorithm** used to **resample** a **digital image**. Sinc filters are good at keeping small detail without causing too much **aliasing**. See also **box filter**, **Gaussian filter**, **impulse filter**, **triangle filter**, **Mitchell filter**.

single buffering **Images displayed** with single **buffer**ing often have a visible **flicker** that occurs because the image update is made directly to the **screen**. **Double buffering** reduces this **artifact** with the use of a second **background (BG)** buffer.

single card For **credits**, a **credit card** containing only one name as opposed to a **shared card** that holds more than one name.

single density disk A **disk** that has half as much **storage space** per **unit** than a **double density disk**. See also **high density disk**.

single image operator An **image operator** that takes only one **sequence** of **input image**s. See **multiple-image operator**.

single-perf Synonym for **Super 16mm film**.

single platform See **platform dependent**.

single precision See **single precision number**.

single precision number A **floating point number** that uses less **precision**, or fewer numbers to the right of the decimal point, than a **double precision number**. A single precision number does not necessarily contain half as many digits as the double precision number but rather half as many **bit**s. For example, if a single precision number requires 32 bits to represent, it will take 64 bits to represent it in double precision.

single shot A **shot** in which the **camera** films only one **subject** in the **frame**.

single-sided 1. See **single-sided geometry**. 2. See **single-sided disk**.

single-sided disk A **floppy disk** that can be written to on both sides.

single-sided geometry **Object**s made up of **surface**s with either **backface**s or **frontface**s. Also called **one-sided geometry**. See also **double-sided geometry**.

single-source operator An **operator** or **node** that takes only one **input file**. See **multiple source operator**, **single image operator**.

single user An **operating system (OS)** that is aware of only one **user** at a time on the **computer** and, as a result, does not distinguish or enforce ownership among **file**s or **system** settings. See **multiuser**.

site 1. See **Web site**. 2. See **facility**.

site license A **software license** that allows a **facility** to use a **3rd-party software** package on multiple **computer**s.

sitename 1. See **hostname**. 2. See **Web site**.

six pack Slang for **cubic environment map**.

sixteen bit See **16 bits per channel**.

sixteen-bit color 1. See **16 bits per channel**. 2. See **16-bit display**.

sixteen-bit computer See **16-bit computer**.

sixteen-bit display See **16-bit display**.

sixteen-bit image See **16-bit image**.

sixteen bits per channel See **16 bits per channel**.

sixteen bits per color channel See **16 bits per color channel**.

sixteen bits per component See **16 bits per component**.

sixteen millimeter See **16mm film**.

sixteen millimeter film See **16mm film**.

sixty-five millimeter See **65mm film**.

sixty-five hundred Kelvin See **6500 Kelvin**.

sixty-five-millimeter film See **65mm film**.

sixty-four-bit image See **64-bit image**.

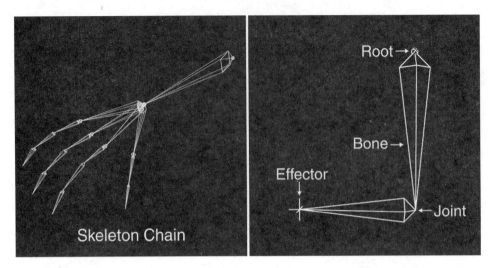

The **skeleton chain** of a hand and its components.
IMAGE CREATED USING HOUDINI AND COURTESY OF SIDE EFFECTS SOFTWARE.

skating See **slippage**.

skeleton See **skeleton chain**.

skeleton chain The **hierarchical structure** made up of a series of **bone**s that are constructed end to end between the **root** and **end effector**s to define the way a **3D character** can move. It is this skeleton chain that an **Animator** uses to **pose** a **character** by positioning the individual bones and effectors with **translation**s and **rotation**s to create **key frames**. Also called a **kinematic chain, chain, skeleton, skeleton joint chain, skeleton hierarchy, skeletal structure**. See also **inverse kinematics (IK), forward kinematics (FK), muscle system, facial system**, *Color Plate 38, and image above.*

skeleton deformation A term used to describe the way an **envelope** is deformed by the **skeleton chain** to which it is attached.

skeleton hierarchy See **skeleton chain**.

skeleton joint chain See **skeleton chain**.

skeletal structure See **skeleton chain**.

skew A **geometric transformation** that gives an angular slant to one side of an **object** or **image**. See also **shear**.

skin 1. The **surface** that is bound to the **skeleton chain** in **3D animation**. Also called an **envelope**. See **skinning**, *image under **lofting** and image on following page.* 2. The **surface** that connects a series of **contour curve**s together.

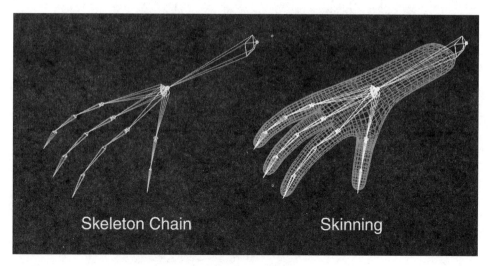

A **skeleton chain** and its attached **skin**.
IMAGE CREATED USING HOUDINI AND COURTESY OF SIDE EFFECTS SOFTWARE.

skinning 1. The binding of the **surface** of a **character** to a **skeleton** so that the character will **deform** with the **rotation** of the **joint**s. Sometimes referred to as **physiquing, enveloping**. *See image above.* 2. The technique used to create a surface by connecting together a series of **contour curve**s or **cross section**s. 3. See **blended surface**. 4. To specify how the **CV**s on one **patch** inherit **transformation**s from another **object**'s transformations within a **hierarchy**.

skip bleach See **bleach bypass**.

skip frame Another term for **skip print**.

skip print A method to increase the speed of a series of **image**s by omitting every other, every fourth, etc., **frame** in a **sequence**. The opposite of **double printing**. Also known as **skip frame**.

slap comp Shorthand for **slap composite**. See **temporary composite**.

slap composite See **temporary composite**.

slate A **frame** of information that is typically placed at the **head** of a **shot** for the purposes of providing information about the **scene**. For example, a slate for **live action photography** will usually include the **film, Director, Director of Photography (DP), scene number, take number**, and the **frames per second (FPS)** used if at a speed other than **24 FPS**. For **digital work**, the type of information used includes the **project name, shot name, Visual Effects Supervisor (VFX)**, the **version number**, the

Digital Artist (DA) who submitted the work and a brief description about the **image**s following the slate. When a slate is recorded at the beginning of a shot, it is referred to as a **head slate**. A **tail slate** is recorded at the end of the shot and is usually filmed upside down to distinguish it from a head slate. See also **clapboard**.

slave 1. Referring to any **device** that is controlled by another device, called the **master**. 2. See **slave computer**. 3. See **slave program**.

slave computer A **computer** that is controlled by another computer, called the **master computer**.

slave program A **program** or **process** that is controlled by another program, called the **master program**.

slide A **positive** photographic transparency that is mounted for **projection**.

slider See **slider bar**.

slider bar Similar to a **scroll bar**, a slider bar is used to change a numeric **value** by holding down the **mouse button** and **drag**ging the **thumb** along the bar. Use of a slider bar is the interactive equivalent to typing a specific number into the **edit field** on a **keyboard**.

slide scanner A **scanner** designed to **digitize** images originally **capture**d on **negative** or transparency **film**. See also **flatbed scanner**, **film scanner**.

slippage A term used to describe **foreground element**s that slide against the **background plate** in a **composite**, often due to inaccurate **2D** or **3D** **tracking** curves. Also called **skating**.

slip the sync To modify the timing between two or more **element**s or an **image** and its **sound track** by "slipping" their relative starting points.

slo-mo Shorthand for **slow motion**.

slop comp Shorthand for **slop composite**. See **temporary composite**.

slop composite Another term for **temporary composite**.

slope The rate of **vertical** change to **horizontal** change over **distance** represented in a **curve**. A gradual slope describes a slowly changing **value**, whereas a steep slope represents a rapid change in values. A slope of zero creates a flat **line** and represents no change.

slot See **expansion slot**.

slow film See **slow-speed film**.

slow in See **ease in**.

slow in/slow out See **ease in/ease out**.

slow lens A slow lens is one that does not allow for a very large opening of the **lens aperture**, and as a result, **transmits** less **light** than a **fast lens**. See **lens speed**.

slow motion Any technique used to slow down the **motion** of moving people or **objects** in a **scene**. See also **high-speed photography**, **overcranking**. Opposite of **fast motion**.

slow out See **ease out**.

slow speed See **slow-speed photography**.

slow-speed film A **film stock** with a low **ASA rating** that is less sensitive to **light** than a **high-speed film**. In general, slow-speed films are **sharper** and less **grainy** than high-speed films. Also called **slow film**, **low-speed film**.

slow-speed film stock See **slow-speed film**.

slow-speed photography Any technique used to **film** a **scene** at a **frame rate** slower than **24 frames per second (24 FPS)** so that the action will appear to be in **fast motion** when projected at 24 FPS. For example, a scene shot at 12 FPS and **project**ed at 24 FPS will appear to move at twice its original speed as each **frame** is **display**ed for only half the length of its original **exposure**. Also referred to as **undercranking**. Opposite of **high-speed photography**.

Small Computer Systems Interface (SCSI) SCSI, pronounced "scuzzy," is an input/output **bus** designed for attaching **peripheral device**s to a **computer**.

smear An **image operation** that can smudge an **image** in different directions.

Smoke A **2D software package** developed and sold by **Discreet Logic**. See also **Inferno**, **Flame**, **Flint**.

smooth shading See **smooth shading model**.

smooth shading algorithm A **shading algorithm** that renders **polygonal surface**s so that they appear smooth. See **Gouraud shading**, **Phong shading**.

smooth shading model A type of **shading** that makes a **surface** made up of flat, connected **polygons** appear to be smooth by using **shared normal**s to **interpolate** the **color** across the interior of each polygon. Opposite of **flat shading**. Also called **Gouraud shading**. See also **Phong shading model**, **Blinn shading model**. *See image on following page, and image under* ***shading model***.

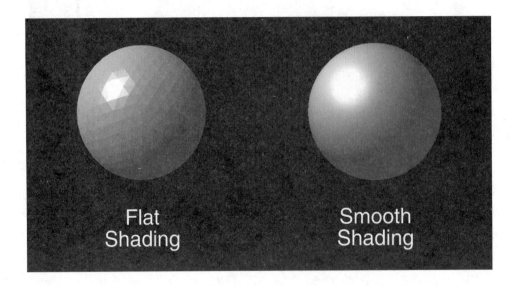

Flat
Shading

Smooth
Shading

SMTP Abbreviation for **simple mail transfer protocol (SMTP)**.

SMPTE Abbreviation for **Society of Motion Picture and Television Engineers (SMPTE)**.

SMPTE color bars A common **SMPTE** standard for **color bars** used to determine **video signal** quality. See also **75% color bars**, **100% color bars**. *See also Color Plates 8–10.*

SMPTE time code See **time code**.

SMPTE universal leader See **universal leader**.

snapshot Synonymous with **screen grab**.

snap to curve A **modeling** feature in which a **curve** is used to control the **position** of another **object**. See **snapping**.

snap to grid A **modeling** feature in which a **grid** is used to control the **position** of another **object**. See **snapping**.

snap object The **object** used for another object to **snap to**. See **snapping**.

snap to plane A **modeling** feature in which a **plane** is used to control the **position** of another **object**. See **snapping**.

snap to point A **modeling** feature in which a **point** is used to control the **position** of another **object**. See **snapping**.

snap to See **snapping**.

snapping The ability in a **software package** to control the **position** of an **object** by attaching it to a **curve**, **grid**, **point**, or **view plane**. As the **user** inputs a new point or **transform**s an object, it will "**snap to**" the position of the object defined as the **snap object**.

sneak preview See **preview**.

snoot A **cone**-shaped version of **barn doors** used to adjust the **focus** of the **light beam**.

snorkel camera A term used to describe any **remote control camera** that can be operated to **shoot** hard to reach areas.

snorkel lens Snorkel lenses protrude from the **camera** from long tubes for use in very close **shooting** situations where the camera cannot fit into the area being photographed.

Sobel filter An **edge detection** process often used for **edge blending** in a **composite**.

Society of Motion Picture and Television Engineers (SMPTE) An international organization that sets standards for **film**, television, and **video** production. SMPTE also developed **time code** for **audio** and video.

socking A type of **blended surface** used to create a smooth connection between two or more **surface**s. The biggest difference between a blended surface and the socking technique is that socking does not create a new surface but rather maintains **tangency** between the **edge**s of the two **source** surfaces.

soft 1. For **film**, having low contrast. 2. See **soft lighting**. 3. For **digital**, a **key** that contains a very soft and blurry **edge** when **composite**d. 4. In general, referring to an **image** that is lacking **sharpness** or is out of **focus**. Often the result of a **low-resolution image** or too much **blur** applied. 5. Shorthand for **Softimage**.

soft bodies See **soft body objects**.

soft body animation Synonymous with **soft body dynamics**.

soft body dynamics The **animation** of **soft body objects** using **motion dynamics** to cause the **object**s to behave in a physically natural manner. However, unlike **rigid body dynamics**, the interacting objects can **deform** or change **shape** when they interact. For example, the **physical simulation** of curtains reacting to the wind coming through an open window will cause the curtains to deform.

soft body objects **Object**s that deform during a **motion dynamics** simulation. Opposite of **rigid body objects**. See **soft body dynamics**.

soft body simulation Synonymous with **soft body dynamics**.

soft boot To **restart** a **computer** without turning off the power. Also called a **warm boot**. Opposite of **hard boot**.

softclip The amount of rolloff around the **white point**. A **value** of 0 results in a **linear** break, whereas higher values offer an increased ease out along the curve. See **Kodak standards**.

soft copy The **machine readable** version of a document that is stored on a **computer**, as opposed to the **hard copy** that is a paper printout.

soft crop Referring to an **image crop** that uses a soft or **blur**red **edge**.

soft-edged matte A **matte** with a soft or **blur**red **edge**. Opposite of **hard-edged matte**.

soft focus 1. A term used to describe a **shot** that appears to be **out of focus**. 2. Referring to the use of a **diffusion filter** designed to create soft outlines.

Softimage A **3D software package** owned by **Avid Technologies, Inc.**

soft lighting **Lighting** that creates minimal differences between the **highlight**s and **shadow**s and creates low **contrast**. Opposite of **hard lighting**.

soft start See **soft boot**.

software **Program**s and **procedure**s that are **execute**d by a **computer**, as opposed to the physical **hardware** on which they **run**. Software can be split into two main categories, **system software** and **application programs**. System software refers to any software that is required to support the execution of **application** programs, whereas application programs provide the **user** with tools to accomplish a particular task.

software application A self-contained **program** designed with a **user interface** and a specific task in mind. A **3D software package**, a **paint package**, and a word processor are all examples of a software application. Also called an **application**.

Software Developer A **Programmer** who writes **code** for **software application**s.

software developer's kit (SDK) A **programming** interface that accompanies most **software package**s. It is intended for use by advanced **user**s and **Programmer**s as a means of writing additional **plug in**s and **standalone**

programs to accompany the **software**. Also referred to as **toolkit, developer's kit**. See also **Application Program Interface (API)**.

software docs Shorthand for **software documentation**.

software documentation The documentation that accompanies any **software package** and comes as a printed manual or as **online documentation**. See also **readme file**, **man page**s, **usage statement**.

software failure A **software package** that **crash**es during use due to an **error** in the **program**.

Software Head See **Head of Software**.

software license The licensing that allows an individual or a **facility** to use a particular **3rd-party software** package. See also **site license**.

software package Any **software application**s that are developed for the **user** to interact with. See **3rd-party software**, **proprietary software**.

Software Pirate Any individual who makes illegal copies of **software** for personal or commercial use.

Software Programmer See **Software Developer**.

software release A **version** of **software** that is made available to the public. See **alpha release**, **beta release**.

software revision A **software release** that contains only minor changes from the previous **version**.

software support The **Programmer**s that provide **technical support** for the **software** that they write.

software theft The illegal **copy**ing of **software** by **Software Pirate**s.

software tools A global term referring to any **program**s and **software application**s that allow the **user** to interact with the **computer**.

Softwindows **Software** that emulates **Windows** application on **personal computer**s (**PC**s) and **Unix-based computer**s.

solarization An **image process** in which the range of **brightness** of an **image** is inverted in order to mimic the effect of extreme **overexposure** or **overdevelopment**.

solid See **solid model**.

solid map See **procedural map**.

solid mapping See **procedural mapping**.

solid model A **surface** created using **solid modeling** techniques that is a solid **volume** that can be defined by its **density** and **weight**. Opposite of **surface model**.

solid modeling In solid modeling, an **object** is defined by the **attribute**s that make up its **volume**, such as **density** and **weight**. For example, if you cut in half a **model** of a **sphere** that was created with solid modeling techniques, you get two solid hemispheres rather than the two hollow half spheres you would get from using **surface modeling** techniques to create that same sphere.

solid state laser See **diode laser**.

solid texture See **procedural map**.

solid texture map See **procedural map**.

solid texture mapping See **procedural mapping**.

Solitaire film recorder The trade name for a **CRT film recorder** from Management Graphics Inc.

Sony Dynamic Digital Sound (SDDS) A **digital** sound **format** containing a simultaneously running **analog** track that can play up to 8 **channel**s of **sound**.

sound See **sound track**.

sound area The area on a piece of **film** where the **sound track** is placed.

sound board See **audio card**.

sound card See **audio card**.

Sound Crew The individuals responsible for recording the **sound track** for a **film**.

Sound Designer The individual primarily responsible for the design and creation of the **sound track** for a **film**.

Sound Editor See **Sound Mixer**.

sound effects Any sounds added during **post production** by the **Sound Crew**.

Sound Man An individual responsible for recording the sound during the **filming** of a **scene**.

sound mix The process of rerecording multiple **sound track**s to produce one sound track. See also **automatic dialog replacement (ADR)**.

Sound Mixer The individual responsible for combining all the **sound track**s into the final **composite track** for a **film**. Also called a **Mixer**, **Sound Editor**.

sound speed Referring to the "normal" **frame rate** of **film** at **24 frames per second (24 FPS)**.

sound stage A large area where **set**s can be constructed and also allows for great control over the **sound** and **lighting** of a **production**. The studio is soundproof and acoustically engineered to achieve the best results when recording dialogue. Also called a **sound studio**. See also **recording studio**.

sound stripe See **sound track**.

sound studio See **sound stage**.

sound tone See **reference tone**.

sound track 1. The narrow strip along one **edge** of a film **frame** that carries the sound recording. Also called **audio track**, **sound stripe**, **stripe**. See **35mm film**. 2. A global term referring to the audio portion of a **film** or **videotape**. 3. Referring to the **music track** portion of the film that is sold on tapes and **compact disc**s (**CD**s).

source To reference a specific **file** or **peripheral device**.

source address The **location** of the **data** being **route**d to a **destination address**. See **routing**.

source code The set of **ASCII** instructions that must be **translate**d by a **compiler**, **assembler**, or **interpreter** into **machine code** before the **computer** can **execute** it. Also called **source language**, **source program**. See **computer program**.

source computer 1. The **computer** sending **data** to the **receiving computer**. See **routing**. 2. The computer on which a **program** is **compile**d.

source data The original **data** being referenced by a **program** or a **user**. See **output data**.

source directory The **directory** from which **data** is **read**. See **output directory**.

source disk The **disk** from which **data** is **read**. See **output disk**.

source drive See **source disk**.

source element See **input image**.

source file See **input file**.

source image See **input image**.

source language See **source code**.

source node The **node** that is connected into the **input** of another **node**. Also called **input node**.

source object The **object** used to create a **user-defined** number of **instanced object**s or as the **generator** to create a new resulting object.

source program See **source code**.

source tape The **tape** from which input **data** originates.

south Compass terminology used to refer to the top portion, or the negative portion of the **Y-axis**, of a **frame** or **image**.

space continuity Space continuity refers to the portrayal of action as it moves from one location to another across a **motion picture** that is easily comprehended by the audience. See also **time continuity**.

spaghetti code **Source code** that was written in a disorganized and confusing manner.

spam Junk mail sent through **electronic mail (e-mail)**.

spatial aliasing An **image artifact** caused by a limited **spatial resolution**.

spatial convolution See **convolution filter**.

spatial filter An **image process** that **sample**s an **image** by modifying a small group of **pixels** surrounding the original **input** pixel. One of the most common spatial **filter**s used is the **convolution filter**.

spatial partitioning See **spatial subdivision**.

spatial resolution See **image resolution**.

spatial subdivision A method for breaking down a large area into smaller units for easier calculation. See **voxel**, **octrees**, **quadtrees**, **Binary Space Partition Trees (BSP trees)**.

specs Abbreviation for **specifications**.

special effects (SFX) A global term encompassing both **visual effects (VFX)** and **practical effects**.

special makeup effects See **makeup effects (makeup FX)**.

Special Effects Supervisor (SFX Sup) The individual responsible for the creation and execution of **special effects (SFX)** for a **film**.

special visual effects A term used to describe **special effects (SFX)** that are primarily created after the completion of **principal photography**, such as **digital effects**, **miniature photography**, and **stage photography**. See also **visual effects (VFX)**.

specifications The detailed plans for the **network**, **hardware**, and **software** configuration for a **facility**.

specs Abbreviation for **specifications**.

spectrum 1. The rainbow of **color**s that result from shining a **white light** through a **prism**. A spectrum contains one **shade** of all possible colors. 2. See **gamut**.

specular The **highlight** caused by a **light** hitting an **object** that causes the perception of a shiny **surface**. The shinier the surface, the more pronounced the **specular highlight**s across that surface. The amount of **specularity** seen in a surface depends on the **viewing angle** and **angle of incidence** between the surface and the light that is hitting it. The **color** of the specular reflection is typically the color of the **light source** in the **scene**. For **computer graphics (CG)**, specularity is very important because it suggests the curvature of the object in **3D space**. Also referred to as **hot spot**. See also **diffuse**, **ambient**.

specular coefficient See **specular value**.

specular color See **specular reflection**.

specular component The amount of **specularity** found on a **surface**. The smaller and sharper the specular component, the shinier the surface appears. See **specular**.

specular highlight See **specular**.

specularity The **parameter**s that control how shiny a **surface** is. See also **specular**, **ambient**, **diffuse**.

specular light The **reflection** of a **light source** that can be seen on a **reflective surface**.

specular light source See **specular light**.

specular reflection See **specular light**.

specular value See **specular component**.

speech recognition The ability for a **computer** to recognize spoken words and convert them into **command**s that can be interpreted by the computer.

speed 1. See **particle speed**. 2. The announcement called out by the **Cameraman** to indicate to the **Director** that the **camera** is operating at the desired speed. Called just before **"action!"** 3. The rate the **film** travels through the camera during **filming**. Called **camera speed**. 4. See **film speed**. 5. The largest opening, or smallest **f-stop** number on a **lens**. Called **lens speed**.

speed ramp 1. For a **physical camera**, to be able to adjust the **frame rate** of a **shot** during **filming**. 2. For **computer graphics**, another term for **time warp**.

sphere A **quadratic surface** in which every **point** is equidistant from a given point within its center. The **parameter**s required to define a sphere as a **geometric primitive** are its **origin** and **radius**. *See also image under geometric primitive.*

sphere pass See **lighting spheres**.

spherical aberration See **spherical distortion**.

spherical distortion A fault found in a **spherical lens**, due to its spherical **shape**, that allows **light rays** to pass through its extremities and **focus** closer to the lens than the light rays that pass through its center. This can result in **image**s with square shapes appearing rounded and with decreased **sharpness**. This fault can be addressed by joining two or more spherical lenses with different **refraction** capacities to correct for one another.

spherical environment map See **spherical map**.

spherical environment mapping See **spherical mapping**.

spherical lens A **lens** that does not alter the **width**-to-**height** relationship of the **image**s through the **camera** or **projector**. Opposite of **anamorphic lens**.

spherical lens flare Any **lens flare** that is **filmed** using a **spherical lens**. See also **anamorphic lens flare**, **CG lens flare**, *Color Plate 27–29*.

spherical map Referring to a **texture map** that is **map**ped inside or around a virtual **sphere** for use as a **projection map** or **environment map**. See **sphereical mapping**.

spherical mapping 1. A **texture mapping** method in which a **2D image** is bent around an imaginary **sphere** before any **projection mapping** of the **3D object** occurs. Spherical **mapping** is most successful when the **surface** being mapped requires mapping from all directions. Also called **spherical projection**, **spherical projection mapping**. See also **orthographic mapping**, **cylindrical mapping**, **camera mapping**. 2. An **environment mapping** tech-

nique that uses one **image** mapped to the interior of a virtual sphere to cast reflections onto the **object**s it surrounds in the **scene**. See also **cubic mapping**.

spherical projection See **spherical mapping**.

spherical projection mapping See **spherical mapping**.

spherical reflection map See **spherical map**.

spherical texture map See **spherical map**.

spherical texture mapping See **spherical mapping**.

spill See **color spill**.

spill matte A **matte** that has to be created, either as an **articulate matte** or **garbage matte**, to compensate for areas in **bluescreen (BS)** or **green-screen photography** in which the **subject** contains **color spill**.

spill suppression See **color suppression**.

splice Shorthand for **film splice**.

spline A **curve** formed by the **position** of a series of **control point**s. The **shape** of a spline can easily and quickly be manipulated by modifying the individual control points that regulate their own portion of the spline. Different types of splines include **Bézier**, **B-spline**, **Cardinal**, **Hermite**, and **NURBS**. See also **hull**, **interpolating spline**, **approximating spline**, **spline interpolation**.

spline approximation See **spline interpolation**.

spline-based Any **object** created with **spline**s, as opposed to **polygon**s.

spline-based modeling The creation of **3D object**s with mathematically derived **curve**s, called **spline**s. See **polygon-based modeling**.

spline curve See **spline**.

spline deformation A **deformation** technique in which a **curve** drawn through the center of an **object** is used to deform that object based on the **shape** of the curve. By animating the curve, you can **animate** deformations across any objects associated to that curve. Also called **curve deformation**. See also **patch deformation**, **path deformation**.

spline deformation animation See **spline deformation**.

spline interpolation The calculation of a **curve** based on the **position** of its **key frame**s or **control point**s. Unlike **linear interpolation**, spline interpolation creates a true, smoothly defined curve. Different spline interpolation

techniques result in different types of **spline**s, such as **Bézier**, **B-spline**, **Cardinal**, and **NURBS**. See also **interpolating spline**, **approximating spline**.

split-bar A split-bar is used when a **window** is divided into two or more sections as a means of adjusting the size of the individual **window pane**s.

split focus The technique of setting the **focus** to a point between the **foreground (FG)** subject and the **background (BG)** objects in a **scene** so that they are both in focus.

splits A term used to describe a day of **filming** that takes place partly during the day and partly at night as opposed to entirely one or the other.

split screen 1. A **compositing** technique in which two separately filmed **element**s are combined together into a single **composite** by using a simple **matte** with little or no articulation. 2. To **display** two different **file**s or two different portions of the same file at the same time on a **computer screen**.

spool 1. The metal or plastic device used to wind **film** on. See also **core**. 2. Abbreviation for *s*imultaneous *p*eripheral *o*peration *o*n-*l*ine. The ability of a **computer** to **process** a **peripheral** operation, such as a **printer** request, while simultaneously performing another task.

spotlight A **light source** in which all **light rays** illuminate in the **shape** of a cone. The **falloff**, **spread**, and **dropoff** of a spotlight is adjustable.

spot meter See **reflective light meter**.

spread The **parameter** that controls the width of the **cone** of **light** produced by a **spotlight**. The spread is measured as the angle between the opposite sides of the cone. **Object**s that lie outside this cone do not receive any light. See also **dropoff**, **falloff**.

spreadsheet A representation of **data** in which each **field** may contain a particular **value**.

sprite 1. **Low-resolution**, **raster image**s used in video games for fast **refresh rates**. 2. A **texture mapping** technique in which complex **model**s are mapped onto **2D plane**s to reduce the high **render** times needed to load a large number of **character**s or detailed **object**s into a **scene**.

sprite animation An **animation** technique that uses **2D** moving **image**s, called **sprite**s.

sprocket The toothed wheels that move the **film** through the **gate** by locking into the **perforation**s.

sprocket hole Another term for **perforation**.

square 1. A **plane** defined by four equal sides. See **geometric primitive**. 2. The resulting number when a number is multiplied by itself.

square pixel A **pixel** whose **width** is equal to its **height**. Opposite of **rectangular pixel**. See also **pixel aspect ratio**.

squash See **squash and stretch**.

squash and stretch An **animation** technique in which an **object** is scaled down in one **axis** and scaled up in another as a means of simulating the conservation of **volume** during the **animate**d **deformation**. For example, a bouncing ball might **scale down** in the **Y-axis** and **scale up** in the **X-axis** in order to simulate the effects of impact when the ball strikes the floor.

squeeze ratio The **ratio** that an **anamorphic lens** compresses or "squeezes" an **image** along the **X-axis** during **photography**. A common squeeze ratio for **anamorphic** formats is 2:1.

squeezed image An **image** that has been **compress**ed along the **X-axis**. See **anamorphic**.

squib Small explosive charges used to create **bullet hits** and puncture wounds in **pyrotechnics**. When worn by an actor, a squib typically includes a small container of blood that explodes when detonated.

squishy box Another name for **lattice box**.

squishy box animation Another name for **lattice box animation**.

SRAM Abbreviation for **static random access memory (SRAM)**.

stable See **steady**.

stabilize See **stabilization**.

stabilization 1. See **image stabilization**. 2. See **camera stabilization**.

stacked transformations **Geometric transformation**s that are calculated in the reverse order from which they are declared.

stage A large indoor area where **set**s and **lighting** can be set up for **filming**. See **stage photography**.

Stage Crew A global term used to describe all the individuals involved in a **stage shoot** and who do not appear in the **film** itself.

stage dailies A **dailies** dedicated to reviewing the latest round of **stage photography** work that has come back from the **lab**. Stage dailies are generally re-

viewed first thing in the morning so the **Director** and **Director of Photography (DP)** can determine if anything needs to be reshot before they move onto the next **setup**. See **film dailies**.

stage element Any **plate**s that were **shot** on a **stage**. See **live action element**s.

stage photography A global term referring to any **element**s that were **shot** on a **stage** as opposed to being shot **on location**. See **live action photography**, *Color Plates 50–54, 58, 59*.

stage shoot The portion of the **film** that is **shot** on a **stage**. See **live action shoot**.

stage shot Any **shot** that contains **element**s filmed on a **stage**. Opposite of **location shot**.

staging The choice of **camera position** and **lens** relative to the **action** being filmed in the **scene**. Also called **setup**.

staircasing Another term for **aliasing**.

stairstepping Another term for **aliasing**.

standalone computer See **standalone workstation**.

standard 35mm See **Academy aperture**, **35mm film**.

standalone program A **program** or **tool** that performs a specific **task** and is not integrated in with a larger **software package**.

standalone system See **standalone workstation**.

standalone workstation A **workstation** that is not connected to a **network**.

standee A movie theatre display, usually a cardboard cutout or mounted poster, featuring **image**s from a **film** to advertise its upcoming **release**.

stand in 1. For **filming**, see **lighting reference**. 2. For **computer graphics (CG)**, see **stand-in object**.

Stand In An individual with similar physical characteristics as the actor, such as height, weight, and coloring, who stands on the **set** in place of the actor while the **camera** and **light**s are established for the **scene**. See also **Stunt Double, Body Double**.

stand-in object The **low-resolution object** that is used as a substitute for the **high-resolution object** to increase **user interactivity** with the **computer**.

star filter A **filter** placed in front of the **lens** to create **highlight**s from any **light**s appearing in the camera **viewfinder**. Star filters create points of light

like "stars" that streak outward from the center of the **light source**. This effect is usually produced by etching a series of lines onto a clear filter.

start joint See **root joint**.

startup See **boot**.

startup disk See **boot disk**.

startup drive See **boot drive**.

static camera shot Another name for **locked-off camera shot**.

static friction In **motion dynamics**, the static friction of an **object** is the physical property that prevents the object from sliding down an inclined **surface**. An object with high static friction will not slide at all, whereas an object with very low static friction will slide down inclinations. See also **kinetic friction**, **physical properties**.

static grain When a single **frame** is photographed for use in a **locked-off shot**, the **film grain** is not moving during the **shot** and is very noticeable to the audience. **Grain averaging** is used to address this problem.

static image An **image** that contains no **motion**. Opposite of **moving images**.

static matte A **matte** that does not move or change **shape** during the **shot**. Opposite of **articulate matte**. Also called a **fixed matte**.

state-of-the-art A term used to describe the use of the most advanced technology in terms of **hardware**, **software**, or the creation of **visual effects (VFX)**.

static random access memory (SRAM) A type of **random access memory (RAM)** that is faster than **dynamic random access memory (DRAM)** but slower than regular random access memory (RAM). See also **extended data-out random access memory (EDO RAM)**.

static shot See **locked-off camera shot**.

station See **workstation**.

station ID Shorthand for **station identification (station ID)**.

station identification (station ID) The **logo** and accompanying **animation package** used by television stations to create **viewer** recognition for their channel. Also called **logo identification (logo ID)**.

status A density The **density point**s read off of a **print** with a **densitometer**. See also **status M density**.

status M density The **density point**s read off of a **negative** with a **densitometer**. See also **status A density**.

Steadicam A special **camera** that is attached to the **Cameraman** with a mechanical harness designed to decrease any unsteadiness in the operator's motion.

Steadicam Operator The **Cameraman** who operates a **Steadicam**.

steadiness Referring to the precise alignment of photographic **element**s relative to the **perforation**s. See **unsteadiness**.

steady A term used to describe a series of **image**s that are stable relative to one another when viewed on a **display device**. See **unsteady**.

steady camera A **physical camera** that was stable during **filming** and was able to **capture** steady **image**s. Opposite of **unsteady camera**. See **steady test**.

steady gate See **electronic pin register (EPR)**.

steady test A test used to determine if the **image**s filmed by a particular **camera** are steady and contain no unwanted **jitter** or **bounce** from **frame** to frame. This test is accomplished by superimposing a **field chart** photographed by a camera that is known to be steady over the images **capture**d by the camera that is being tested. If the two sets of images are locked together, then the camera is said to be "steady."

steps 1. The **parameter** that controls the smoothness of a **curve** or **surface**. The higher the step value, the smoother the curve or surface and the higher the **resolution**. 2. The number of levels of **color** in an **image** based on its **bit depth**. 3. The increments used in the **capture**, **playback**, or **rendering** of **image**s, such as **one's**, **two's**, **four's**, **eight's**. Also called **increment**.

step printer A printing technique that keeps each **frame** of the **negative** or **raw stock** stationary during **exposure**.

step scanning A type of **film scanning** in which the **film** is stopped during **exposure** as opposed to other scanners belonging to the **Telecine** class of devices where the film is continuously moving and not usually **pin registered**. See **Cineon Genesis Film Scanner**, **Oxberry film scanner**, **Imagica film scanner**.

stereo Shorthand for **stereoscopic**.

stereo film Shorthand for **stereoscopic film**.

stereo image Shorthand for **stereoscopic image**.

stereo pair Shorthand for **stereoscopic pair**.

stereo photography Shorthand for **stereoscopic photography**.

stereo reconstruction Shorthand for **stereoscopic reconstruction**. See **photogrammetry**.

stereoscopic Referring to a dual view or true **3D view**.

stereoscopic film A **film** in which two pieces of film, each representing the left or right eye, are viewed simultaneously on a **stereo viewing device**. With the use of **3D glasses**, each eye sees only the **image**s specifically designated to be received by that eye.

stereoscopic image An **image** that contains two slightly different offset images that are placed side by side and are designed for the **viewer**'s right and left eye as a means of simulating a sense of **depth**. A stereo image can be viewed with a **stereo viewing system** or by using a **free viewing method**. Also called a **stereoscopic pair**. *See also Color Plates 30–31, image under free viewing method.*

stereoscopic pair The pair of side-by-side **image**s that comprise a **stereoscopic image**.

stereoscopic photography A photographing technique that records two **image**s slightly offset along the **horizontal axis** from one another as a means of creating **stereoscopic image**s for **stereo film**s.

stereoscopic reconstruction See **photogrammetry**.

stereoscopic viewing system Any **display device** that allows the **right and left eyes** to receive slightly different offset **image**s. Our brain fuses these two different **2D image**s together to create one image that contains **depth** information. See **stereo film**, **3D glasses**.

stereo viewing system Shorthand for **stereoscopic viewing system**.

sticks 1. Slang for **tripod**. 2. Slang for **clapsticks**.

sticky surface A phrase used to describe a **surface** whose **transformation**s of the **texture coordinates** and **surface coordinates** are linked together so the texture "sticks" to the surface wherever it moves through **3D space**.

still See **still frame**.

still frame A single **frame**.

Still Photographer The individual who photographs the various events that take place during **filming**.

still store Any **device** used to store individual **frame**s in either **analog** or **digital** form for later use. Also called a **frame store**.

stochastic Referring to a random **variable** or **process**.

stochastic patterns **Procedural**ly generated irregular patterns.

stochastic sampling A random **sampling** of **data** used for **anti-aliasing** and **motion blur**.

stock Shorthand for **film stock**.

stock footage Specific events **shot** on **film** that can be purchased for use in a film or commercial.

stock shot Any **shot** that uses **stock footage**.

stomp on To accidentally **overwrite** a **file**.

stop A stop is a measurement of the amount of **exposure** to **light** on a **camera lens**. The **F-stop**s or **T-stop**s are calibrated so that each successive stop will double the amount of exposure. To increase the **brightness** by one stop is to double the brightness, whereas to reduce the brightness by one stop is to decrease the brightness by half.

stop action See **stop-motion animation**.

stop-action animation See **stop-motion animation**.

stop down To adjust the **lens aperture** to a smaller opening.

stop-frame animation See **stop-motion animation**.

stop-frame photography See **stop-motion animation**.

stop-motion See **stop-motion animation**.

stop-motion animation A **traditional animation** technique in which a series of **physical model**s in a **scene** are manually **position**ed and photographed for each **frame** of **animation**. When played back at a normal speed, this technique results in continuously animated **object**s. Unlike **go motion**, stop-motion techniques are not capable of producing **motion blur**. See also **digital input device**, **clay animation**.

stop-motion photography See **stop-motion animation**.

stop-motion puppet A **character** that is built to be manually posed for **stop-motion animation**.

storage capacity The amount of **data** that a **storage device** can hold, often expressed in **kilobyte**s (**KB**s), **megabyte**s (**MB**s), and **gigabyte**s (**GB**s). See **high-density disk**, **double-density disk**, **single-density disk**.

storage device A **device** that stores and preserves **data** for later retrieval, such as **disk**s and **tape**. Also called a **memory device**.

storage space 1. See **storage capacity**. 2. The area where **data** is stored on a **computer**.

Story Artist See **Storyboard Artist**.

storyboard A series of drawings outlining the key moments of a **sequence** or **scene** that indicate **camera angle** and movement, actor performance, and **composition**. Early rough storyboard sketches are often called **thumbnail**s.

Storyboard Artist An individual who draws the **storyboard**s for a **project**.

storyboard panel A single drawing within a **storyboard** that indicates the **camera angle** and movement, actor performance, and **composition** for a particular action.

Story Head See **Head of Story**.

Story Lead See **Head of Story**.

story panel Shorthand for **storyboard panel**.

story reel An **edit** of the **film** or a **sequence** that is **cut** together with **storyboard**s and a rough **sound track** to get a sense of timing and overall flow of the story. See also **animatic**.

Story Team The group of **Storyboard Artist**s who work with the **Head of Story** and the **Director** of the **film** to create a series of **storyboard**s that depict the action, dialogue, mood, and type of **camera angle**s to be used when **shooting** or **animating** the film.

stow See **close**.

straight cut An **edit** in which the **audio** and **video** are **cut** at the same place. Contrast with **L-cut**.

stream editor (sed) A powerful **text editor** used for pattern searching and modification. See also **awk**, **parse**.

stretch See **squash and stretch**.

stretched animation See **time warp**.

string A set of consecutive **ASCII characters** interpreted by the **computer** as a single **argument**.

strip The portion of a wide **roll** of manufactured **film** that is cut into its final **film format** width.

stripe 1. See **sound track**. 2. To record **time code** and **control track** on a **videotape**.

striped tape See **blacked tape**.

striping See **blacking**.

stroboscopic motion Synonym for **apparent motion**.

strobing 1. The jerky **motion** of a **subject** due to a lack of or insufficient amount of **motion blur**. This effect becomes even more noticeable when **CG elements** are **composite**d over a **live-action plate**. 2. The visual patterns that can be seen as a result of the original **frame rate** of the **captured image**s being different from the frame rate at which it is **display**ed. 3. See also **wagon wheeling**. 4. An **artifact** of **aliasing**.

studio 1. The organization that develops, **greenlight**s, and controls the **budget** of a **film**. 2. See **visual effects facility**. 3. The location where a **set** is built for **shooting** a **film** or commercial.

studio lights The **light**s used to light a **set** for a **scene** that will be **shot** on a **stage**.

stunt Any difficult or dangerous action, such as falls and crashes, that must be performed for the **camera**. While some actors perform their own stunts, it is more common to hire a **Stuntman** for the task.

Stunt Coordinator The person hired to coordinate the **stunt**s and stunt personnel required for a **film**.

Stunt Double An individual who is substituted for the actor in order to perform a dangerous action or **stunt**. As well as having the athletic abilities to perform falls and crashes, the stunt man must have some resemblance to the original actor if their face will be seen on **camera**. Also called **Stunt Person**, **Stuntman**, *Color Plate 54*.

Stuntman See **Stunt Double**.

Stunt Person See **Stunt Double**.

stutter The effect of temporarily frozen **image**s seen when playing back **digital image**s on an **editing** system due to too much information being retrieved from the **hard disk**s at one time.

stylus An electronic **pointing device**, resembling a pen, that is moved by hand over the **graphical user interface (GUI)** to **select** or activate the desired item. Also called a **light pen**, **light stylus**, **pen**, **electronic stylus**.

subcarrier A portion of a **video signal** that carries a specific **signal**, such as **color**.

subdirectory The directories that **branch** off from the **root directory** in a **hierarchical file system**.

subdivide See **subdivision**.

subdivision 1. The number of divisions making up a **grid**. 2. The process of breaking **geometry** down into smaller components. See also **spatial subdivision**. 3. See **polygonal subdivision**.

subdivision surfaces Subdivision **surface**s are a special type of **3D geometry** that uses a **polygon mesh** to control and represent more complex **B-spline** surfaces, which can contain both smooth and sharp **topology**. They also allow for localized control of detail refinement by allowing small areas of the **geometry** to be successively divided into higher **resolution** sections without affecting the surrounding surfaces.

sub-d surfaces See **subdivision surfaces**.

subject The person or **object** that is being **film**ed.

subject angle The angle of the **subject** that is being **film**ed relative to the **camera position**.

subject distance The distance of the **subject** that is being **film**ed from the **film plane**. Also called the **camera distance**.

subject size The amount of **screen space** the **subject** takes up relative to the overall framing of the **camera view**.

subjective angle Shorthand for **subjective camera angle**.

subjective camera angle A **shot** in which the **camera** films the action from a personal viewpoint by acting as the unseen viewer's eyes. The camera becomes the collective eye of the audience. See also **objective camera angle**, **point-of-view (POV)**.

subjective shot A **shot** filmed with a **subjective camera angle**.

subnode Any **node** placed below another node in a **hierarchy**. Also called a **child**.

subpixel A unit of measurement derived from breaking a single **pixel** into multiple subunits.

subpixel accuracy The ability to **track** features in an **image** at a greater **precision** than whole **pixel**s. See **subpixel**.

subpixel resolution Any **image process** that can measure **spatial resolution** with a **resolution** of less than one **pixel**.

subprogram See **procedure**.

subroutine See **procedure**.

subtitles **Titles** that are placed at the bottom of the **screen**, usually to translate foreign dialogue. See also **main titles**, **end titles**, **insert titles**.

subtract 1. See **difference operation**. 2. A standard **arithmetic operator**.

subtraction See **difference operation**.

subtraction operation See **difference operation**.

subtractive color model A **color model**, known as **CMY**, in which some portion of **cyan**, **magenta**, and **yellow** are subtracted from **white light** to achieve other **color**s. Opposite of **additive color model**. See also **CMYK color model**, *Color Plate 3*.

subtractive colors See **subtractive primary colors**.

subtractive primaries See **subtractive primary colors**.

subtractive primary colors The **CMY color model**, represented by **cyan**, **magenta**, and **yellow**. Each of the subtractive primary **color**s can be created by subtracting one of the **additive primary colors red (R)**, **green (G)**, and **blue (B)**, from **white light**. The absence of red creates cyan, the absence of green makes magenta, and the absence of blue makes yellow. When mixed in equal amounts, the three subtractive primary colors of **light** create **black**.

subtract operation See **difference operation**.

super 1. Shorthand for **superimpose**. 2. A term used to describe the actual **text** that is superimposed over an **image**.

Super 8 See **Super 8mm film**.

Super 16 See **Super 16mm film**.

Super 8mm film A narrow **gauge** film that contains one **perforation** along each side and runs 72 **frames per foot**. Super 8 **capture**s a 50 percent larger **image** area than standard **8mm film**. This format is largely used for experimental **filmmaking**. See also **Super 16mm film**, **35mm film**, **65mm film**, **70mm film**.

Super 16mm film A **16mm film** that uses an **image area** that extends beyond the **sound track** and results in a **frame** that is approximately 40 percent larger than regular 16mm. Super 16 is a single-**perforation** film that extends the **image** area out to where the second row of **sprocket**s would normally be. Also called **single-perf**. See also **Super 8mm film**, **35mm film**, **65mm film**, **70mm film**.

Super 1.85 **Super 35mm film** that uses a **1.85:1** extraction when **project**ed. *See also images under* ***film extraction***.

Super 2.35 **Super 35mm film** that uses a **2.35:1** extraction when **project**ed. *See also images under* ***film extraction***.

Super 35 See **Super 35mm film**.

Super 35mm film The Super 35 format is a 35mm **film** that uses the **full aperture** of the **negative** to **capture** its **image**s. Super 35 can be used for a number of different **format**s that use the full aperture framing, but it is most commonly used for films that intend to be **project**ed with a 2.35:1 **aspect ratio**. Also referred to as **Super Techniscope**, **Super 1.85**, **Super 2.35**. See also **35mm film**, **Cinemascope**, **common topline**, *images under* ***film extraction***, ***Vista Vision***.

super black A **brightness** value that is lower than the normal representation of **black** for a particular **image** or **device**. See also **super white**.

supercomputer A **mainframe computer** that is the fastest and most powerful **computer** available at a given time.

super film A general term used to describe a modification to an existing **film format**, such as **Super 8**, **Super 16**, **Super 35**. Super films were created with the intent of maximizing the useable **image area** of a particular **film** as a means of improving the **image** quality without spending more for **film stock**.

superimpose The placement of one **image** over another.

supersampling A technique used to reduce **aliasing** by obtaining **subpixel** values for each **pixel** in an **image** and then **averaging** those **value**s to obtain a new pixel value.

Superscope An early **anamorphic** format that uses the full width of the **35mm film** area and is **crop**ped top and bottom for a 2:1 **aspect ratio** during **projection**. See also **Cinemascope**, **Techniscope**.

superuser Any **user** with **root privilege**.

Super thirty-five format See **Super 35 format**.

Super VHS (SVHS) A **video format** that has higher **resolution** than normal **VHS**. SVHS must be played on a **videocassette recorder (VCR)** that supports that **format**. The Super VHS format keeps **luminance** and **chrominance** as separate **components**. See **component video**.

Super Video (S-Video) A technology used to transmit **video signals** over a **cable** by dividing the video information into two separate signals representing **chrominance**, or **color**, and **luminance**, or **brightness**. The resulting **images displayed** on a television **monitor**, referred to as **component video**, produces much **sharper** images than **composite video**, in which information is **transmit**ted as a single **signal** over cable.

supervisory program See **executive program**.

Super Techniscope Another name for **Super 35**.

super white A **brightness** value that is higher than the normal representation of **white** for a particular **image** or **device**. See also **super black**.

supply reel See **feed reel**.

support See **technical support**.

suppress See **color suppression**.

suppression See **color suppression**.

surf To use a **Web browser**, or "surf the waves," of the **World Wide Web (WWW)**.

surface Referring to the series of **polygon**s, **patche**s, **curve**s, **vertice**s, and **point**s that define an **object** in **3D space**.

surface attribute The **parameter**s that define the visual appearance of an **object**.

surface coordinates The **XYZ coordinates** that describe an **object** in **3D space**.

surface divisions The number and direction of **control point**s used to define a **bicubic patch** based on the number and direction of control points in the original generating **spline**s. See also **U curve**, **V curve**, **steps**.

surface model An **object** defined by the **surface**s that enclose and make up the **shape** of the object. Opposite of **solid model**. See **surface modeling**.

surface mapping A **texture mapping** technique in which a **2D image**, the **texture**, is applied to a **surface**. Two common ways to apply a texture to a surface are with **projection mapping** and **parameterized mapping**.

surface modeling In surface modeling, the **skin** or **surface**s that enclose a **model** are what define the **shape** of that **object**. For example, if you cut in half a **model** of a **sphere** that was created with surface modeling techniques, you would get two hollow half spheres. However, a sphere created with a **solid modeling** approach, would give you two solid hemispheres.

surface normal Surface normals are used to calculate the **shading** of a **surface**. A surface normal is a **vector** that is **perpendicular** to a surface at a specific **point** on the surface. Surfaces that are oriented directly toward the **light**s in the **scene** and, as a result, whose surface normals are pointed directly toward the light, will be **render**ed the brightest, whereas surface normals pointed away from the light will be the darkest. While few normals are required when using **flat shading**, many normals are required to describe a **curved surface** with **smooth shading** because each point along the surface is oriented in a slightly different direction. Because it is easier for a **renderer** to calculate a single **normal** for each **flat surface** than it is to determine the many normals required for a curved surface, many renderers create **polygonal approximation**s of the **object**s at the time of **rendering**. Also called a **shading normal**. See also **shared normal**, **triangulation**, **point normal**. *See image on following page.*

surface of revolution A **surface** that is created by repeating and connecting a **curve** around an **axis of rotation**. If the **generating curve** touches any **point** along the **axis** of **rotation**, the resulting surface will be **closed** at that point. In most cases, the axis of revolution must be perpendicular with one of the three **axes**, **X**, **Y**, or **Z** within the **coordinate system**. Also called **revolve**, **lathed surface**. See also **extrude**, **lofting**, **sweep**. *See image on following page.*

surface operations The series of steps used to create and modify **geometry**.

surface rendering The **rendering** of an **object** based on information about its **surface attribute**s to define its **edge**s. See also **hidden line rendering**, **wireframe rendering**, **lighting model**.

surface resolution An **object**'s **level of detail (LOD)**.

surface shader A **shader** that calculates the **color** of a **surface** relative to its **position** to the **light**s in a **scene**. See also **displacement shader**, **volume shader**, **light shader**.

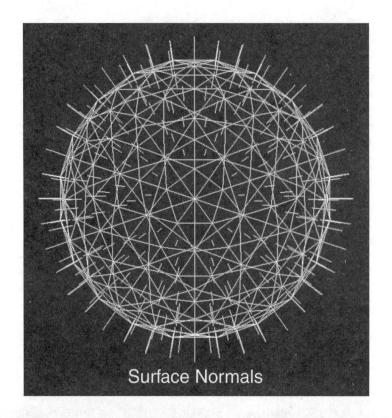

Surface Normals

Generating
Curve

Copy

Skin

Surface of Revolution

The **surface of revolution** technique used to create a bottle.

surface shading See **shading**.

surface texture mapping See **surface mapping**.

surfacing A term used to describe the process of assigning **material**s, **texture**s, and writing **shader**s for an **object**.

surrounding shots The **shot**s that come immediately before and after the particular shot that is being discussed.

surround sound A sound system that creates the illusion of multidirectional sound through the placement of speakers and **signal** processing.

survey To gather **3D data** about a **location**, **set**, or **physical model** for use in **3D tracking**. See **Total Station**, **Lidar**.

survey data The 3D **point cloud** that is gathered from a **location**, **set**, or **physical model** for use in **3D tracking**.

survey kit A global term describing any equipment used in **set surveying**, such as a **survey station** and **tracking marker**s.

survey station See **Total Station**.

SVHS Abbreviation for Super Video Home System. See **Super VHS (SVHS)**.

S-Video Abbreviation for **Super Video (S-Video)**.

swap 1. See **channel swapping**. 2. See **swap space**.

swap fields A **compositing operation** that can switch to either even- or odd-numbered lines in an **image**.

swap file See **virtual memory**.

swap space The portion of the **disk** that is set aside for **virtual memory** required by a **process** that has run short of **available memory**.

sweatbox A **production** step in **feature animation** in which the **Director**s, **Producer**s, and various **show** supervisors gather in **Editorial** to review the most recent work and discuss any outstanding tasks or **continuity** issues that need to be addressed.

sweep A variation of the **surface of revolution** technique to create an **object**, in which a **surface** is created by pushing a **generating curve** back in space along a second **curve**, called the **path of extrusion**. Many **software package**s also allow for additional **transformation**s to be applied to the generating curve as it moves along the path of extrusion. A corkscrew or a gardening hose is a good example of an object that can be

A **path of extrusion** and a **generating curve** can be used to create a **swept surface**.

created with this technique. *See also image above and image under **surface of revolution**.*

sweep angle The angle in degrees that a **curve** is repeated and connected around its **axis of rotation** to create a **surface of revolution**.

sweetening Shorthand for **audio sweetening**.

swept surface Referring to a **surface** created from a **sweep** technique. See also **surface of revolution**.

switch matte See **alpha copy**.

swish pan A **shot** in which the **camera** rapidly **pan**s across the **frame**, which creates extreme **motion blur** of the action. Often used as an **image transition**. Also called a **whip pan**.

switcher A **video** device that is capable of taking multiple **input**s and combining them into an **output image**.

symmetrical model A **model** that was created symmetrically. Opposite of **asymmetrical model**. See **symmetrical modeling**.

symmetrical modeling A **modeling** technique in which the **Modeler** works on one-half of the **object** and then symmetrically duplicates, or **mirror**s, it around a **3D axis**. For example, a modeler might create the right arm of a **character** and then mirror it to create the left arm. Also called **reflective modeling**. Opposite of **asymmetrical modeling**.

symmetric digital subscriber line (SDSL) A high-speed **modem** capable of **transmit**ting **data** at 1.5 **MBPS**.

sync Abbreviation for **synchronization**.

sync generator See **genlock**.

sync-point Any visual or **sound** information placed on the **film** to aid in finding the proper lineup between **picture** and sound, such as a **slate**, **bloop light**, or **sync-pop**.

sync-pop The sound used to find the **sync-point** between **image** and **sound**. Also called **pop**.

sync-sound The **synchronization** of the **audio track** to the **image**s.

synchronization 1. For **video**, the precise alignment of two **signal**s, usually **picture** and **sound**. 2. For **film**, the placement of two **image**s or an image and a **sound track** relative to one another on the **release print** so they can be **project**ed together. See also **in sync**, **out of sync**.

synopsis A summary of the major plot points and character descriptions of a **script** that is generally only about 1 to 2 pages in length. See also **treatment**.

syntax The set of rules and grammatical structure governing a particular **programming language**, **scripting language**, **command line interface program** or **software application**.

Synthespian The trademark name coined by Kleiser-Walczak Construction Company to describe **Digital Character**s. Jeff Kleiser and Diane Walczak created their first Synthespian, Nestor Sextone, in 1988. The word *Synthespian* is a blend of synthetic and thespian.

sysadmin Abbreviation for **system administration**.

system See **computer system**.

system administration The process of managing the **system**, which includes the management and monitoring of the **network** configuration, **disk space**, **hardware** and **software** installation, and allocation of **user accounts**.

System Administrator The individual who performs the **system administration** for a **computer system**.

system call The mechanism used by **application programs** to request services from the **operating system (OS)**.

system configuration See **configuration**.

system crash See **crash**.

system disk The physical **disk** containing the **operating system (OS)** and other **software** that makes a **workstation** operate.

system management Activities aimed at minimizing the use of excessive or redundant resources used to maintain **system** performance, such as **network** management, diagnosis, and repair. See also **system administration**.

system memory The amount of **memory** that the **operating system (OS)** of a **computer** uses.

system password See **dialup password**.

Systems Programmer A generic job title describing an individual who specializes in areas such as writing **low-level source code** that can communicate directly with the **operating system (OS)**.

system software Any **software** required to support the **execution** of **application programs** but is not specific to a particular **application**. The system software generally includes the **operating system (OS)**, **command line interpreter**, **window system**, and **desktop**.

T1 See **T1 line**.

T1 line A dedicated **communication line** used for the **digital transmission** of **data**. T1 lines are commonly used by facilities that need to send and receive large volumes of data very quickly.

T3 See **T3 line**.

T3 line A dedicated **communication line** that transfers **data** 30 times faster than a **T1 line**.

TA Abbreviation for **Technical Assistant (TA)**.

tab 1. The individual **menu option**s found within a **tabbed page**. By clicking on a specific tab, the **user** brings up a new **window** of related options. 2. A predefined number of spaces inserted in between the **character**s of a **text file**. Some **text editor**s, such as **awk**, can do **pattern searching** based on tabs.

tabbed page A way of organizing and grouping **button**s and **edit field**s in a **menu** in a compact way. Tabbed pages allow the **user** to quickly switch back and forth between related **option**s within a menu by **click**ing on the **tab**s.

table lookup To search for **data** in a table.

tablet An **input device** that allows the **user** to drive the **computer** with a **stylus** rather than a **mouse**. Most **paint program**s require a tablet. See also **digitizing tablet**.

table-top photography **Close-up (CU)** photography of very small-scale **set**s or **miniature**s that are laid out on a table during the **filming** of a **scene**.

Tagged Image File Format (TIFF) TIFF is a standard **image format** that uses a **bit depth** of **8 bits per channel** and and supports **RGBA channels** but no **Z-channel** information. TIFF uses a **lossless compression** scheme, and the typical **filename extension**s used are .tif and .tiff.

tags The series of **alphanumeric** rules and **parameter**s that define an **HTML** document for use on the **World Wide Web (WWW)**.

tail 1. The end of a **videotape** or **roll** of **film**. 2. The end of a **shot** or **scene**. 3. See **tail slate**.

tail-away shot A **shot** in which an **actor** moves directly away from the **camera**. The opposite of a **head-on shot**. Also referred to as a **neutral shot** because such a move is nondirectional.

tail pop The **sound tone** at the **tail** of a **reel** used to mark a specific location on a **sound track**. See also **head pop**.

tail slate A **slate** that is recorded at the end of a **shot**, as opposed to a **head slate**, which is recorded at the start of a shot. A tail slate is typically **film**ed upside down to distinguish it from a normal head slate. Also called an **end slate**.

take 1. The **filming** of a **scene** from start to finish, or from the **Director**'s call of "**action**" to "**cut**" is a "take" of that particular scene. A **slate** is marked and **film**ed at the **head** of each take in order for the **Script Supervisor** to take notes on the material filmed during the day. A particular scene might be repeated many times in order to get the best take on the desired action. For example, if scene 10 were photographed 2 times, the resulting takes would be called scene 10, take 1 and scene 10, take 2. Each **iteration** of a **digital effects shot** is tracked by a corresponding take or **version number**.

take number The unique number assigned to each **take** filmed by the **camera**.

take-up reel The **film reel** that receives the **film** that has already passed through the **projector**. Opposite of **feed reel**.

take-up side The side of the **magazine** that holds the **exposed film**. Opposite of **feed side**.

taking camera 1. The **camera** that is **filming** a **scene**. 2. The camera used during **scanning**.

taking lens The **lens** used for the actual **take** of a **shot**.

tangency The state of being **tangent**.

tangent To make contact at a single **point**, along a **line**, or between two or more **patch**es without intersecting. A tangent **object** will **render** without any undesirable **artifact**s. See also **tangent vector**.

tangent handle See **tangent vector**.

tangent plane A **plane** that touches a part of a **point** or **line**.

tangent vector The small **vector**s that run **tangent** to a **curve** and only touch the **point**s at one end. The tangent vectors, also referred to as **handles**, allow for **interactive** manipulation to adjust the **slope** of the curve based on their length and direction. Generally, two tangent vectors that share a **control point** will operate as one unit when they are **rotate**d or lengthened in order to maintain a smooth curve. However, if an intentional kink, or **break**, is desired in the smoothness of the curve, then a **cusp** needs to be created between that pair of tangent vectors so they can be separately manipulated. Typically, a tangent of zero results in a flat curve, whereas a value of one creates a steeper slope.

tape A **data** storage medium. See **magnetic tape**.

tape archive (tar) A **Unix** command used to **archive** and **restore** files.

tape backup To back up **data** on **magnetic tape**. See **archive**.

tape cartridge The plastic case that holds a loop of **magnetic tape**.

tape device See **tape drive**.

tape drive A **peripheral device** that can **read** and **write** stored **data** from a **computer** onto **tape**. See **magnetic tape drive**.

tape format The specific type of **tape** used for the storage of **data**, such as **beta** or **VHS**.

tape log A list of the contents on a **tape**.

tape mark See **cue mark**.

taper A **deformation** technique that gradually decreases the thickness or width of an **object** at one end. Tapering can be accomplished with various techniques such as a **lattice box**, **point group**, or **motion dynamics**. See also **bend**, **twist**.

tar See **tape archive (tar)**.

TARGA 1. A standard **image format** that uses a **bit depth** of **8 bits per channel** and can represents **RGBA channels** but contains no **Z-channel** information. TARGA uses a **lossless compression** scheme, and its typical **filename extension**s include .tga, .vst, .tpic. 2. The trade name for a line of **graphics board**s from True Vision.

TB Abbreviation for **terabyte (TB)**.

TBC Abbreviation for **Time Base Corrector (TBC)**.

T-byte Abbreviation for **terabyte (TB)**.

TCL Abbreviation for **Tool Command Language (TCL)**. Pronounced **tickle**.

TCP Abbreviation for **transmission control protocol (TCP)**.

TCP/IP Abbreviation for **transmission control protocol over internet protocol (TCP/IP)**.

TCSH A **Unix Shell**, written by Christos Zoulas, based on **C Shell (CSH)**.

TD 1. Abbreviation for **Technical Director (TD)**. 2. Abbreviation for the **modem** status of "**transmit**ting **data**."

teapot See **Utah teapot**.

teaser See **trailer**.

Technical Animator Synonymous with **Character Setup Technical Director (Character Setup TD)**.

Technical Assistant (TA) An individual who is responsible for handling the **backup**s and **retrieval**s of **digital data** on and off the **network**.

Technical Director (TD) An individual responsible for ensuring that the technical aspects of a **digital shot** are addressed. The job of the TD is to act as the "glue" for a **shot** by ensuring that the various **digital element**s created, such as **models**, **motion curve**s, **shader**s, **texture**s, **effects**, and **lighting** can be properly **render**ed to create the desired **element**. However, it should be noted that the title of Technical Director is one of the most confusing titles in that every **facility** seems to have a different definition of what the job entails.

technical support A global term referring to individuals who provide support for any technical issues that arise within a **facility** or from a **vendor** who has supplied **3rd-party software** to the company. When the technical support originates from a vendor, it is also referred to as **customer support**.

Technical Writer The individual who writes **documentation** for **software** and **hardware** products. When a **facility** creates and uses a lot of **proprietary software**, it is common to have a Technical Writer on staff.

Techniscope A system designed to produce 35mm **anamorphic** prints from **35mm** negatives containing an **image area** that is approximately half the height of regular 35mm **image**s by using a special two-**perforation** pull-down **camera**. During **printing**, the **negative** image area is blown up to normal height and then squeezed to provide a **projected aspect ratio** of **2.35:1**. See also **Cinemascope**, **Superscope**.

technobabble The bulk of what this book is about! A term used to describe the heavy use of technical jargon.

Technology Head See **Head of Technology**.

tech support See **technical support**.

Telecine A **device**, used to transfer **film** to **video** that is capable of converting film **image**s **capture**d at one **frame rate** into one of the international frame rates used for **video** in **real-time**. Usually, the **original negative** is **scan**ned and then the **digital** values are inverted to create an image whose **color** and **lighting** values correspond to the **scene** as it was originally photographed. Telecine images tend not to be as **steady**, **sharp**, or precise in **color** as images **capture**d with the **step scanning** technique. See also **2:3 pulldown**.

telecommunications The **transmission** of information across a **communication line**, such as a **modem** or fax.

telecommunications line See **communication line**.

telemetric device Any **device** that automatically measures the **transmission** of **data** from **remote** sources, such as radio or wire, to receivers for recording and analysis. A **Waldo** is an example of a telemetric device.

telephoto distortion The diminishment of **depth** that can result from a **telephoto lens**. **Object**s at various distances feel unnaturally large and objects moving toward or away from the **camera** appear to move extremely slow. See also **wide-angle distortion**.

telephoto lens A special **camera lens** with a longer than normal **focal length** that creates a **narrow angle of view**. A telephoto lens tends to reduce **perspective** and reduce the **depth of field (DOF)**. Also called a **long lens**. Opposite of **short lens**. See also **foreshortening**, **normal lens**, **anamorphic lens**, **zoom lens**, **auxiliary lens**.

telephoto shot A **shot** in which the **camera** uses a **telephoto lens**.

teleplay A **script** written to be produced as a **movie** for television. See **screenplay**.

teleprompter An electronic **device** mounted on the **camera** containing the dialogue of the actors. See also **cue card**s.

television safe See **safe action**.

television standard A term to describe the **format** used for displaying **image**s on a TV screen, such as **NTSC**, **PAL**, **SECAM**, and more recently, **HDTV**.

temp comp Shorthand for **temporary composite**.

temp file Shorthand for **temporary file**.

temp filmout Shorthand for **temporary filmout**.

temp music Shorthand for **temporary music**.

template 1. Any **file**s, such as **source code**, **shell script**s, or a **default scene**, and so forth, that are copied and used over and over again by **user**s as a starting point for their work. Also referred to as **boilerplate**, **default settings**. 2. See **template object**.

template object In a **3D package**, an **object** that can be seen but cannot be **select**ed or modified. See also **phantom object**.

temporal Referring to something that changes over **time**.

temporal aliasing An **image artifact**, usually a **strobing** effect, caused by an insufficient number of **image**s or **sample**s per second. Temporal aliasing can be reduced by adding **motion blur** to help the eye create a smooth **transition** between the **frame**s containing moving **object**s. See also **wagon wheeling**.

temporal artifacts A general term used to describe any visually noticeable problems in a **sequence** of moving **image**s over time. Such **artifact**s might include **strobing**, **flicker**, **crawling**, **chatter**, or **color fringing**.

temporal resolution The amount of **data** used to capture a **sequence** of **image**s. Generally, the **frames per second (FPS)** required to **capture** the sequence is used. For example, **NTSC video** is captured at **30 FPS**, **PAL video** at **25 FPS**, **Showscan** at **60 FPS**, and most **feature film**s at 24 FPS.

temporary composite (temp comp) A quick and dirty **composite** used to test that all the **element**s in a **shot** are working together as expected. These temporary composites often become the **temporary filmout**s that are cut into the **movie** as a means for the **Director** to get an early glimpse of the entire **cut** of his movie. Also used to verify if any **plate element**s need to be reshot or test the lineup of a **CG element** against its **background (BG)**. Synonymous with **rough composite**, **slop composite**. Sometimes referred to as a **preliminary composite (precomp)**.

temporary file (temp file) Any **file**s that are temporarily written to **disk** during **process**ing and can be **delete**d as soon as the process has completed its calculations.

temporary filmout (temp filmout) Any **shot** that is sent to **film** as a temporary placeholder in order for the **Director** and **studio** to view the current

state of the film. **Temp filmout**s are often use **video resolution** images and can be missing many of the **element**s that will go into the **final** shot.

temporary music (temp music) The music used by the **Editor** and **Director** during the early **cut**s of the **film** as a placeholder while the final **score** is being written and incorporated.

ten Base-2 See **10Base-2**.

ten Base-t See **10Base-T**.

ten bit See **10 bits per channel**.

ten-bit color See **10 bits per channel**.

ten-bit image See **Cineon file format**.

ten bits per channel See **10 bits per channel**.

tension The accuracy with which a **spline** or **patch** follows its **control point**s.

tera Prefix for one trillion. See **terabit**, **terabyte (TB)**.

terabit One trillion or, specifically, 2^40 or 1,099,511,627,776 **bit**s. See also **terabyte (TB)**, **kilobit**, **gigabit**, **megabit**.

terabyte (TB) One trillion or, specifically, 2^40 or 1,099,511,627,776 **byte**s. See also **terabit**, **gigabyte (GB)**, **megabyte (MB)**, **kilobyte (KB)**.

terminal A **display** and **keyboard** that allow the **user** to **input** and receive **data** from the **computer**.

terminate To stop a **program** or **process** from **run**ning.

tessellation See **polygonal subdivision**.

test comp See **test composite**.

test composite A **composite** done to test out a particular **element** in an **image**. While **temporary composite**s are generally done at **low resolution**, a test composite will often use the **high-resolution** element that is being tested to get an accurate assessment of how well the element will work in the **shot**. For example, when shooting a **bluescreen (BS)** or **greenscreen (GS)** element, it is common to test the first elements shot in a composite to ensure that the **exposure** will allow for a good **key**.

test pattern Any **image** or chart designed with specific patterns to be used as reference during **calibration** of a **monitor**, **projector**, **camera**, **scanner**, or **recorder**. See **color bars**. *See Color Plates 8–11 and images under* ***convergence chart***, ***grayscale chart***.

test strip See **sensitometric strip**.

text based Referring to a **file** made up of **ASCII characters**.

text editor Any language designed to create and modify **text file**s. Unlike a **word processor**, a text editor does not inbed special control codes to control formatting. Commonly used text editors include **vi**, **ed**, **jot**, **awk**, **sed**, **perl**. Also called a **parser**.

text file A **file** containing only **ASCII characters** and no invisible **control character**s.

text input **Menu cell**s that accept **text** or numerical **value**s from either **keyboard input** or mathematical **operation**s.

textport Any **window** in which the **user** can type **command**s.

text string A **command** or **expression** typed in by the **user** that can be understood by the **computer** or **software application**.

texture 1. The **surface attribute**s that affect the **color** or appearance of a **surface**. 2. See **texture map**.

texture coordinates See **UV coordinates**.

texture map **2D image**s that are applied to a **3D object** to define the **texture** of a **surface**. Texture maps can be used for **color mapping**, **bump mapping**, **displacement mapping**, **transparency mapping**, **environment mapping**, and **projection mapping**. See also **texture mapping**.

Texture Mapper An individual who specializes in applying **texture map**s to **3D geometry**.

texture mapping The process in which a **2D image**, referred to as a **texture map**, is applied to a **3D object**. Some common methods for texture mapping include **surface mapping**, **procedural mapping**, and **solid mapping**. Also called **image mapping**.

Texture Painter An individual who specializes in painting **texture map**s for **3D geometry**.

texture space See **UV coordinate space**.

texture string A **variable** containing only **ASCII** or **alphanumeric** information.

TGA See **TARGA**.

T-grain The trade name for a type of **film grain** from **Kodak** that uses uniquely shaped grains that are approximately one-tenth as tall as they are

wide. This results in grains that align better than conventional **silver halide crystals** and can absorb and **transmit** light more effectively to produce clearer and sharper **image**s with a finer grain.

that's a wrap Term used to indicate that a **scene** or **project** has been completed. Similar to **in the can**. See also **martini shot**.

thin negative A **negative** that is **underexpose**d and/or **underdevelop**ed. A thin negative contains less **density** than a **normal negative**.

thinnet Synonym for **10Base-2**.

thinning See **culling**.

third answer print See **answer print**.

third dimension See **Z-axis**.

third generation The third **copy** made from the **second-generation** copy of a series of **film** or **video image**s. Subsequent copies made from this third-generation copy are called fourth-generation copies. See also **generation, generation loss, intermediate positive, intermediate negative**.

third quadrant See **quadrant three**.

third party See **3rd-party software**.

third-party package See **3rd-party package**.

third-party software See **3rd-party software**.

thirty-five millimeter See **35mm film**.

thirty-five millimeter film See **35mm film**.

thirty frames per second See **30 frames per second (30 FPS)**.

thirty-six-bit image See **36-bit image**.

thirty-two-bit color See **32-bit color**.

thirty-two-bit image See **32-bit image**.

thirty-two hundred Kelvin See **3200 Kelvin**.

thread 1. A part of a **program** that can **execute** independently of other parts. **Operating system**s **(OS)** that support **multithreading** allow **Programmer**s to design programs with threaded parts that can **run** concurrently without interfering with each other. 2. The process of feeding **film** to the **projector** or machine used to **process** the film is referred to as "threading."

three by three matrix See **3 × 3 matrix**.

three channel image See **RGB image**.

three-D Abbreviation for **three-dimensional**. See **3D**.

three-D animation See **3D animation**.

three-D Animator See **3D Animator**.

three-D Artist See **3D Artist**.

three-D camera See **digital camera**—Definition #1.

three-D character See **digital character**.

three-D computer graphics See **3D computer graphics**.

three-D database See **3D database**.

three-D digitize See **3D digitize**.

three-D digitizing pen See **3D digitizing pen**.

three-D database See **3D scene**.

three-D element See **CG element**.

three-D environment See **3D environment**.

three-D Equalizer See **3D Equalizer**.

three-D film See **3D film**.

three-D glasses See **3D glasses**.

three-D graphics See **3D computer graphics**.

three-dimensional (3D) See **3D**.

three-D image See **3D image**.

three-D laser scanner See **3D laser scanner**.

three-D layout See **3D layout**.

three-D lighting See **3D lighting**.

three-D logo See **3D logo**.

three-D map See **procedural texture**.

three-D mapping See **3D mapping**.

three-D model See **3D model**.

Three-D Modeler See **3D Modeler**.

three-D morph See **3D morph**.

three-D morph target See **3D morph target**.

three-D motion blur See **3D motion blur**.

three-D move See **3D move**.

three-D object See **3D object**.

three-D operation See **3D operation**.

three-D package See **3D software package**.

three-D paint See **3D paint**.

three-D photography See **stereoscopic photography**.

three-D pipeline See **3D pipeline**.

three-D scanner See **laser scanner**—Definition #2.

three-D scene See **3D scene**.

three-D screen See **3D screen**.

three-D software See **3D software**.

three-D software package See **3D software package**.

three-D space See **3D space**.

Three-D Studio Max See **3D Studio Max**.

three-D surface See **3D surface**.

three-D texture See **procedural map**.

three-D texture map See **procedural map**.

three-D texture mapping See **procedural mapping**.

three-D tracking See **3D tracking**.

three-D tracking software See **3D tracking software**.

three-D transform See **3D transform**.

three-D view See **3D view**.

three-D viewing system Abbreviation for **3D viewing system**. See **stereo viewing system**.

three-K See **3K resolution**.

three-perf See **3-perf**.

three-quarter camera angle A **camera angle** used to create the strongest dimensional effect by photographing the **subject** to reveal the most sides and **depth**. Often used for **close-up**s (**CU**s).

three-quarter-inch tape A three-quarter inch **magnetic tape** format used for **video**.

three-quarter tape See **three-quarter inch tape**.

three shot As the name implies, a **shot** with three actors included in the **camera** view.

three:two pulldown See **2:3 pulldown**.

three:two pullup See **2:3 pullup**.

threshold 1. The point that separates the conditions that will produce a given effect from conditions of a higher or lower degree that will not produce the effect. For example, a **clamping value** specified in **compositing** is a threshold used to control the **white** levels that will or will not be included in the resulting **image**. 2. For **metaball**s, the **value** at which the **density field** reaches a predefined level of visibility and its **surface** is said to "exist." It is also the point at which different metaballs will merge with one another to form a **blended surface**. See also **fusion**.

thumb The rectangular bar on a **scroll bar** that allows the **user** to **drag** the bar to change the **window** view or the slider's **value**.

thumbnail 1. Very early and rough **storyboard** sketches. 2. See **postage stamp**.

THX The trade name of a **sound** system developed by Lucasfilm for commercial and home theatres. See also **Dolby**, **Digital Theatre Systems (DTS)**, **Sony Dynamic Digital Sound (SDDS)**.

tickle Pronunciation for TCL. See **Tool Command Language (TCL)**.

TIFF Abbreviation for **tagged image file format (TIFF)**.

tight close-up A **shot** that **film**s an actor from just below the lips to just above the eyes. Also called a **choker close-up**.

tight shot Referring to the size of the **camera view** relative to its **subject**. See also **tight close-up**.

tilde Pronounced "tilda." The sign on the **keyboard** used to indicate the **home account** of a **user**. For example, if the **login ID** of a particular user

is "deve," then all the **file**s contained in his **home directory** can be accessed by the **path** ~deve.

tile 1. Another term for **node**. 2. See **tiling**. 3. When **rendering** an **image**, some **renderer**s analyze the **scene** one section or tile at a time. It first evaluates if the tile can be rendered, and if it determines that it can, it then combines all the **data** in the scene into a single rendered tile. As it moves through the image, tile by tile, if the renderer encounters a section that contains more information than it can handle at one time, it will break down the tile into smaller tiles and renders. 4. See **pan and tile**.

tile X To repeat an **image** along the **X-axis**. Opposite of **tile Y**. *See image on following page.*

tile XY To repeat an **image** along both the **X-** and **Y-axis**. *See image on following page.*

tile Y To repeat an **image** along the **Y-axis**. Opposite of **tile X**. *See image on following page.*

tiling To **procedural**ly repeat an **image** multiple times. Also called a **rubber stamp**. *See image on following page.*

tilt **Rotation** of the **camera** around the **X-axis**. Also called **pitch**. Opposite of **pan**. Also referred to as **camera tilt**. *See also tilt image on following page and image under camera move.*

tilt angle The amount of **camera** rotation along the **X-axis** or **horizontal plane**.

tilt shot A **scene** in which the **camera tilt**s during the **filming** of the **action**.

time The length of a **scene** in terms of the **time unit**s used, such as **feet** or **frame**s. See **frames per second (FPS)**, **footage**.

Time Base Corrector (TBC) A **video** device that corrects timing, **color** errors, and **image** stability when **editing** from multiple **videotape** sources.

time code The **frame** numbering system devised by **SMPTE** that assigns a unique number to each frame of **video** in the format of hours:minutes:seconds:frames—02:37:28:02. Also referred to as **SMPTE time code**. See also **vertical interval time code (VITC)**.

time code generator An electronic **video** device that reads **keycode numbers** and converts them into **time code** that can be **display**ed as a **window burn-in**.

time compress See **time warp**.

Tiling can be used to **procedural**ly repeat an **image** in any direction.

Camera tilt.

time continuity Time continuity refers to the portrayal of time across a **motion picture** that is easily comprehended by the audience. See also **space continuity**.

timed print A **print** that has been **color time**d.

time expand See **time warp**.

time lapse camera A special camera, used for **time lapse photography**, that is capable of shooting one **frame** of **film** at a time at predetermined regular intervals.

time lapse photography The **filming** of a **scene** of long duration, one **frame** at a time, at relatively long time intervals between each **frame exposure**. The result is a greatly sped up **action** of the longer real-time event. This process is commonly used for events in nature such as clouds and the rising and setting of the sun.

timeline A **graphical representation**, available in many **software packages**, that provides a clear view of all the **element**s and **animation** in a **scene** and how they relate to one another in **time**. The timeline contains information for each element in terms of its starting point and its duration. Also called a **dope sheet**, **exposure sheet**.

timemark Another word for **key frame**.

Timer See **Color Timer**.

time slice See **Timetrack**.

time slider A type of **slider bar** that is used to change the **current frame** in a **software application**.

time steps In **motion dynamics**, time is broken up into a fixed number of **steps** when calculating the **simulation**, such as tenths of a second. The smaller the time steps, the more accurate and realistic the resulting simulation will be and the higher the calculation time.

time stretch See **time warp**.

Timetrack Timetrack is the patented process, invented in 1994 by Dayton Taylor, that allows for complete separation in time between a **physical camera** and the **motion** of the **subject**s in the **scene**. Also referred to as the **virtual camera movement process** or the **freeze frame effect**, Timetrack uses an **array** of still cameras positioned at slightly different **viewing angle**s that all photograph a **frame** of the scene at the same time. When the **image**s are **scan**ned into a computer, one smooth **sequence** of a

frozen moment can be viewed. Also referred to as **frozen time**, **dead time**, **time slice**. See also **FLO-MO**.

time units The **unit**s used to define **time** in a **software package**, such as seconds or **frame**s.

time warp Any technique in which the timing of a **sequence** of **image**s or an **animation** is modified to create a new sequence that is either longer or shorter than the original length of the sequence. When the length of the sequence is decreased, it is called **time compress**, whereas an increase to the sequence length is called a **time stretch** or **time expand**. Also called **speed ramp**.

timing 1. See **color timing**. 2. A term used to describe the way an **object** or event evolves over time.

timing curve A **curve** used to control the rate of speed of an **object** as it travels along the **motion path** to which it is attached. See also **path animation**.

timing lights See **printing lights**.

timing points See **printer points**.

tint To add a portion of **white** to a **color**.

title bar The top **border** of a **window** that contains a title or comment.

title card A single **frame** of printed material, such as **credits**. See also **shared card**, **single card**.

title music Music played with the **titles** at the start and end of a **film**.

titles Text **project**ed on the **screen** with or without **image**s behind them. Titles can be **credits**, time, or location identifiers, such as "Los Angeles, 2002," or translated lines of dialogue. See also **main titles**, **end titles**, **insert titles**, **subtitles**.

title safe See **safe title**.

toe The lowest part of a **characteristic curve** representing the **density** of a **negative** relative to the amount of **light** striking it during **exposure**. Opposite of **shoulder**.

toggle A **button** or mode that turns a particular **operation** on or off. Each **click** or **selection** of the **function** causes the action to be switched from its previous state.

toggle off To turn off or make **inactive** a particular **selection** in an **option box**.

toggle on To turn on or make **active** a particular **selection** in an **option box**.

tone 1. The continuous frequency **audio signal** used for reference in **sound** recording. See **reference tone**. 2. The quality and characteristics of a particular sound. 3. The mood and atmosphere of a **film**.

toolbar The vertical or horizontal bar used in some **application**s that contains **icon**s representing various **command**s.

toolbox The box containing **icon**s representing various **option**s in a particular **application**.

toolkit See **software developer's toolkit (SDK)**.

tools See **software tools**.

tool command language (TCL) A computer language and a library of **application program**s created by Dr. John Ousterhout from the University of California, Berkeley. TCL is a **programming language** primarily used for issuing **command**s to **interactive** programs such as **text editor**s, **shell**s, and **debugger**s. With its simple **syntax** and **programming** capabilities, TCL **user**s can write command **procedure**s to easily run more complex and powerful commands.

top-down design A method for developing a **computer program**, in which the highest-level actions are defined first and then broken into individual elements that can be defined in finer detail.

topology The topology of a **surface** is defined by its structure rather than its **shape**. If the **vertices** of a **mesh** are modified by the **user** to lie in a new **location** in space, the **shape** has been altered but the topology of the surface remains intact. However, if a **vertex** or **polygon** is deleted from the mesh, then the topology has changed, and the shape will, most likely, also have changed as a result. Often used synonymously with **geometry**.

top view An **orthographic view** of the top of a **scene**. See also **front view**, **side view**, *image under **viewing window***.

torus A **quadratic surface** created by **sweep**ing a **circle** around an **axis of rotation** that it does not intersect. The **parameter**s required to define a torus as a **geometric primitive** are its **origin** and the **radius** of both the **cross section** and the entire torus from its center to its edge. *See also image under geometric primitive.*

Total Station A total station is the most commonly used **survey station** used by land surveyors and for **set surveying** for **visual effects work**. It gets its

name because it contains all the devices necessary to "totally" determine the location of a point in **3D space**. By calculating the **horizontal angle**, the **vertical angle**, and the distance to the **point** relative to the total station, **polar coordinates** can be calculated. These polar coordinates can then be mathematically converted into the **XYZ coordinates** that are used in most **3D tracking software**s. See also **Zeiss**, **Lidar**.

touchpad A stationary **pointing device** most commonly used on **laptop computer**s. The touchpad provides a small, flat surface over which the **user** can slide his or her finger to mimic the same types of movements used with a **mouse** or **stylus**. Also called a **trackpad**.

touchscreen A **computer screen** that responds to **menu driven** selections that a **user** inputs by touching the **screen** with his finger or a **stylus**.

track 1. A **camera move** in which the **camera interest** and **camera position** move as a unit so that the **view** slides either horizontally or vertically. Also called **camera track**. See also **tracking shot**. 2. To extract camera move from a **plate**. See **tracking**. 3. The concentric rings on a **disk** used to record **data** onto. See **sectors**, **cluster**, **block**. 4. A single channel on a **soundtrack**.

trackball A **mechanical mouse** consisting of a semi-encased ball that contains **sensors** to detect **rotation** across two **axes**. The **user** rolls the ball with his thumb or palm of his hand to move the **cursor** to the desired location. As the ball is rolled, the sensors get stimulated and in turn cause the cursor to move across the **computer screen**.

tracking 1. The process of extracting a **camera** move from a series of **images** based on particular features in the images whose **motion** can be calculated over time. See **2D tracking**, **3D tracking**, **stabilization**. 2. See **tracking shot**.

tracking cube A specially designed cube that is used as an aid in **3D tracking**. By placing the tracking cube in a **scene** that is built to the same dimensions in **3D space**, the corners of the **cube** can be used as **tracking marker**s to calculate the **camera motion** with a **3D tracking software** or with **matchmove** techniques. *See also Color Plate 58.*

tracking curve The **data** resulting from any type of **tracking** technique.

tracking marker Marks placed into a **scene** before it is photographed to serve as positional reference for **plate tracking**. When using these markers to extract a **camera move** from the **plate** via **3D tracking** techniques, it is generally necessary to **survey** the location of these **point**s on **set** to get their **global coordinates**. With **2D tracking**, however, it is enough to sim-

ply ensure that these markers are contained within the **image** area photographed. Also called **tracking point**, **witness point**, **witness mark**.

tracking package See **tracking software**.

tracking point See **tracking marker**.

tracking shot 1. A **shot** in which the **camera** mounted on a **dolly** or a moving vehicle tracks along with the moving actors. Also called a **follow shot**. 2. Referring to a type of shot that requires the use of **2D tracking** and/or **3D tracking** techniques during **post production** to extract a **camera move** for use in locking other **element**s to the **plate**.

tracking software A **software application** specifically designed to allow the **user** to extract **motion curve**s from a **plate** with either **2D tracking** or **3D tracking** techniques. See also **modeling software**, **animation software**, **lighting software**, **compositing software**, **paint software**, **particle software**, **render software**.

trackpad See **touchpad**.

trades Newspapers and magazines that report the daily or weekly entertainment industry news, such as *The Hollywood Reporter* and *Daily Variety*.

traditional animation Referring to any **animation** techniques, such as **cel animation** or **stop motion animation**, that are not created with a **computer**.

traffic The amount of **data** that is **transmit**ted across a **network** at one time.

trailer A short **film**, usually two or three minutes long, that is used to advertise a **feature film** before its **release**. Generally, the trailer is shown in the theatre where the feature will appear and will include brief excerpts of the film that are used to entice the audience to come see it when it is released. Today, trailers are shown before the feature film. However, they were originally shown after the feature film and got their name because they "trailed" after the main screening. Also called a **preview**, **advance screening**, **teaser**. See also **cross-plug**.

trail life See **particle trail**.

transfer The process of transferring **image**s and **data** from one medium or location to another, such as to **film**, **tape**, another **disk** location or across a **T1 line** or **FTP site**.

transform The **rotation**, **scaling**, and **translation** of an **object** or **image**. See **transformation matrix**.

transformation 1. To **reposition** an **object** within a **coordinate system** based on a **transformation matrix** representing the desired **rotation**, **translation**, and **scale** values. 2. Any effect, such as a **warp** or **morph**, that results in one object changing into another.

transformation attributes The mathematical **value**s used for the **translation**, **rotation**, and **scale** of an **object** or **element**.

transformation concatenation The **compression** of all the **transformation**s called in an **application** into a single **translation**, **rotation**, and **scale** value. See **transformation matrix**.

transformation matrix 1. A **4×4 matrix** that defines the **translation**, **rotation**, and **scale** for a given **object** within the current **coordinate system**. **Transformation**s can be applied either globally or **local**ly to a **scene**. See also **absolute transformation**, **relative transformation**, **identity matrix**. 2. A **3×3 matrix** used to define the translation, rotation, and scale for an object or **image** in **2D space**.

transform node A **node** that contains the **attribute**s of positional information for an **object**, such as **translate**, **rotate**, and **scale**. See **transformation attributes**.

transformation operation An **image operator** that uses **transformation**s, such as **pan**, **rotate**, and **scale** to alter the size and **position** of the **image**.

transformation order See **transformation priorities**.

transformation priorities The order in which the **transformation**s will occur on an **object**. See also **rotation priorities**.

transition 1. Any technique that is used to move from one **scene** to another, such as a **fade**, **matched cut**, **dissolve**, **montage**, **wipe**, or **morph**, to name just a few. 2. The areas in an **image** where the **color** changes abruptly and creates the illusion of an **edge**.

transition effect 1. See **transition**. 2. See **morph**.

translate 1. To move an **object** or **image** from one **location** to another along the **XYZ axes**. Also called **position**, **reposition**. See also **object translation**, **image translation**, **Cartesian Coordinates**, *image under scroll*. 2. The process of converting **source code** into **machine code** with a **compiler**, **assembler**, or **interpreter** before the **computer** can **execute** it. 3. See **image conversion**.

translation See **translate**.

translational limits See **translation constraint**.

translation channels The **value**s representing the **position** of the **XYZ co-ordinates** for an **object** or **image**.

translation constraint The **constraint**s that restrict the **translation**s of one **object** to the translations of another. Translation constraints are very useful when animating with **inverse kinematics (IK)** as a means of preventing the feet of the **character** from sliding across or going through the floor. By constraining the **effector**s attached to the character's feet, the translation of the feet will remain stationary and will not be affected by the translations throughout the rest of the body. Also called **position constraint**. See also **rotation constraint**, **direction constraint**.

translation transformation The series of numbers used to express the amount to **translate** an **image** or **object** along each **axis** within the current **coordinate system**. See **transformation matrix**.

translight screen A large, translucent **screen** of a photograph or **matte painting** that is positioned behind the **set** and lit from behind as a means of avoiding additional set construction. Also spelled as **translite screen**. See also **cyclorama (CYC)**.

translite screen See **translight screen**.

translucent A **surface** that is partially **transparent** and modifies the quality of **light** that passes through it.

transmission See **transmit**.

transmission control protocol (TCP) A commonly used **protocol** for transporting **data** across **network**s. See also **transmission control protocol over internet protocol (TCP/IP)**.

transmission control protocol over internet protocol (TCP/IP) The **protocol** used to transport **data** across the **Internet**.

transmit 1. To pass **light** through a transparent **object**. 2. To send **data** over a **communication line**.

transmitted color See **transmitted light**.

transmitted light The **color** of **light** transmitted through a medium, such as **film**. See also **reflected light**, **incident light**.

transmitted ray See **transmitted light**.

transparency 1. Referring to a **surface** or material that is not **opaque** and can allow **light** to pass through it. 2. Referring to an **image** or **object** that is not **opaque** and as a result allows **light** to pass through and does not com-

pletely occlude objects behind it. See **occlusion**. 3. Referring to a **matte** that contains **grayscale** values will result in a **foreground image** that reveals a portion of the **background image** it is **composite**d on top of. Opposite of **opacity**. 4. A **parameter** used to control how **opaque** or **transparent** the **surface** of an object is. 5. A translucent image, such as a **slide**.

transparency mapping A **texture mapping** technique in which the **pixel value**s of the **texture map** are interpreted as the amount of **transparency** to apply to the corresponding **point**s on a **3D surface**. Transparency mapping can use either a **color image** or **grayscale image** since the mapping information is based only on the **brightness** of the pixels. See also **color mapping, bump mapping, displacement mapping, environment mapping**.

transparency texture mapping See **transparency mapping**.

transparent See **transparency**.

transport 1. The various mechanisms used to pull the **film** through a **camera**, **projector**, or **printer**. 2. The mechanism used to pull **magnetic tape** past the various **head**s in a tape recorder.

trap door See **back door**.

trash can The **icon**, typically represented by a small **image** of a trash can, that is used for deleting **file**s.

travelling matte Another name for **articulate matte**.

travelling shot A **shot** in which the **camera** moves through space via a variety of methods, such as a **crane shot, tracking shot, dolly shot**. A **pan, dutch**, or **tilt** are not considered traveling shots because the camera remains stationary during **filming**.

treatment A short version of a **script** consisting of a summary of the major story points and a description of the lead **character**s. While a full script is generally about 100-120 pages long, a treatment is usually about 10 pages. See also **synopsis**.

tree Synonymous with **hierarchy**.

triangle A **convex polygon** with three **edge**s. Triangles are often used as a way to connect the **point**s that make up a **polygon mesh** to make it a **surface** that can be **render**ed. See also **rows and columns, quadrilateral, alternating triangles, polygon detail**.

triangle blur See **triangle filter**.

triangle filter A relatively quick **filtering algorithm** used to **resample** an im-age. A triangle filter uses a slightly larger **sampling** area than a **box filter**. See also **impulse filter, Gaussian filter, Mitchell filter, Sinc filter**.

triangular plane A **plane** defined by three **edge**s. Triangular planes are commonly used for **polygonal modeling** and **rendering**.

triangulated Referring to any **object** that has been **subdivide**d with **trian-gle**s. See **triangulation**.

triangulation A process that **subdivide**s **curved surface**s into triangular **polygon**s, usually for **rendering** purposes. Because it is easier to calcu-late the **surface normal**s of an **object** for **flat surface**s, many **renderers** will triangulate the objects before rendering to speed up calculations. If a **triangulated** surface is rendered with **flat shading**, the facets will be vis-ible, but if it is rendered with **smooth shading**, the surface will look smoothly curved.

trilinear filtering See **trilinear interpolation**.

trilinear interpolation An **interpolation** technique used in **ray casting** to calculate the **value**s of the **sample**d **data**. See also **bilinear interpolation, MIP mapping**.

trim See **trimming**.

trim curve A **curve** that is the result of a **trim**.

trimming A **modeling** technique in which one or more **patch**es can be cut into two new resulting patches based on a **curve of intersection**. The ob-ject used to do the actual trimming can be either a **curve** or another **object**. Unlike a **Boolean operation**, a **trim operation** only cuts a **surface** and does not add new **geometry** to **close** the resulting surface.

trim operation See **trimming**.

trim patch Any **patch** that is the result of **trimming**.

trims 1. The range of **value**s used for the **printing lights**. Typically, this range runs from 1 to 50, but in some cases, the range is made smaller or larger. 2. The pieces of **film** that are cut from various **shot**s during **editing**. These trims must be kept track of in case they are needed to be incorpo-rated back into the film.

trim surface Any **surface** that is the result of **trimming**.

triple-take A method of maintaining **shot continuity** by **filming** overlapping action at the beginning and end of each **shot**. Also called **cutting in the**

camera, the action at the end of the first shot is repeated at the beginning of the second shot, and the action at the end of the second shot is repeated at the beginning of the third shot. This technique can only be utilized with **controlled action**. See also **master scene**.

tripod head The support on top of the **tripod** that permits the **camera** to be mounted and move freely for **pan** and **tilt** moves.

tripod The three-legged support used to mount the **camera**. The legs of a tripod are adjustable in height and can compensate for **shooting** a level shot on uneven ground. Also referred to as **legs, sticks**.

tropism The external factors, such as gravity or wind, that cause a plant to bend and sway. See also **tropism vector**.

tropism vector The **vector** used in an **L-System** to simulate the real world effects of **tropism** on plants.

truck Another name for **dolly**.

truck in Another name for **dolly in**.

truck out Another name for **dolly out**.

truck shot A **scene** in which the **camera dolly**s during the **filming** of the **action**.

true color A term sometimes used to describe **24-bit color**. Also referred to as **direct color**.

truncated cone A **quadratic surface** defined by a 360-degree **sweep** of a **line segment**, whose **end point**s are **parallel** to the **axis of rotation**. The **parameter**s required to define a truncated cone as a **geometric primitive** are its **origin**, **height**, and the **radius** of its base and top. *See also image under geometric primitive.*

trunk Synonymous with **parent**.

T-stop A number similar to an **F-stop** but much more precise. The T-stop indicates the exact amount of **light** that is **transmit**ted through the **lens** on a **physical camera**. While an F-stop indicates the size of the **iris** opening, it does not account for the loss of light due to absorption. Standard T-stop numbers include 1, 1.4, 2, 2.8, 4, 5.6, 8, 11, 16, 22, 32.

tumble 1. A common feature in **3D software package**s in which the **user** can simultaneously **rotate** the **camera view** in the **XYZ axes** with just one **mouse button**. 2. See **orbit**.

Tungsten balanced film A chemically balanced **color film** stock that reproduces accurate **color**s when **expose**d to **Tungsten light**. See also **daylight balanced film**.

Tungsten light source The **light source**s used when **shooting** with **Tungsten balanced film** that don't require any additional adjustments for **filter**s to the **camera** to correct for the **color temperature**. The approximate color temperature of Tungsten **light**s is **3200 Kelvin**, which is similar to the amount of light from regular room lamps. See also **daylight light source**.

Tungsten print A **print** balanced to **3200 Kelvin** so it can be **project**ed from a **projector** using **Tungsten light**.

turbulence 1. For **particle system**s, a **parameter** used to **randomize** the **motion** of each **particle**. 2. An **image process** that passes continuous fields of noise across the **pixel**s in an **image**. *See image under image processing.*

turnaround 1. A **project** is "in turnaround" when it has been dropped by one **studio** and is in search of another studio to pick it up. 2. The period of time between taking down one **set** and assembling another on a **stage**. 3. See **turntable**.

turnkey system A **computer system** that has been specially customized and includes all the **hardware** and **software** required for a particular **application**. The term originates from the idea that the **user** can simply turn a key and the **computer** is ready to go.

turntable An **animation** or **model** that is **render**ed as though it were placed on a rotating turntable. This is done as a way of judging the work from 360 degrees of view. Also called a **turnaround**.

TV safe See **safe action**.

tweaking A slang term used to describe the obsessive process of adjusting and fine-tuning a **shot** in **post production** to make it look as good as possible. Also called **noodling, tweaking, pixel f**king, fettle, twiddle**.

twelve bit See **12 bits per channel**.

twelve-bit color See **12 bits per channel**.

twelve bits per channel See **12 bits per channel**.

twelve bits per component See **12 bits per channel**.

twelve-field chart See **12-field chart**.

twenty-five frames per second See **25 FPS**.

twenty-four-bit 1. See **24-bit display**. 2. See **24-bit image**.

twenty-four-bit color See **24-bit display**.

twenty-four-bit display See **24-bit display**.

twenty-four-bit image See **24-bit image**.

twenty-four frames per second See **24 FPS**.

twiddle See **tweaking**.

twist A **deformation** technique used to **taper** a **surface** around its **local origin** or specified **pivot point** using any combination of **lattice box**es, **point group**s and **dynamic**s. See also **bend**.

twisted pair cable A type of **cable** made up of copper wire that is commonly used for **ethernet** connections. The two copper wires are twisted around each other in order to avoid **crosstalk**. See also **coaxial cable**s.

twisted pair ethernet An **ethernet** standard for **local area network**s **(LAN)** that **transmit**s information between **computer**s across **twisted pair cable**s. See **10Base-T**, **100Base-T**, **1000Base-T**.

two-and-a-half D See **2.5D**.

two-D Abbreviation for **two-dimensional**. See **2D**.

two-D animation See **2D animation**.

Two-D Animator See **2D Animator**.

two-D array See **2D array**.

Two-D Artist See **2D Artist**.

two-D digitize See **2D digitize**.

two-D face See **2D face**.

two-D geometry See **2D model**.

two-D graphics See **2D graphics**.

two-D image See **2D image**.

two-dimensional (2D) See **2D**.

two-D layout See **2D layout**.

two-D logo See **2D logo**.

two-D map See **2D texture**.

two-D model See **2D model**.

two-D morph See **2D morph**.

two-D motion blur See **2D motion blur**.

two-D move See **2D move**.

two-D object See **2D object**.

two-D package See **2D software**.

two-D paint See **2D paint**.

two-D pipeline See **2D pipeline**.

two-D plane See **2D plane**.

two-D software See **2D software**.

two-D software package See **2D software package**.

two-D space See **2D space**.

two-D surface See **2D surface**.

two-D texture See **2D texture**.

two-D tracking See **2D tracking**.

two-D tracking software See **2D tracking software**.

two-D transform See **2D transform**.

two-D work See **2D work**.

two-K See **2K resolution**.

two perf See **2-perf**.

two-point track A type of **2D tracking** in which two **point**s are selected from a **sequence** of **image**s to extract the **camera move** based on the **motion** of those points over time. With two points, the information extracted is **X translation**, **Y translation**, **rotation**al changes occurring between the two points and changes in **scale** based on the change in distance between the points. See also **four-point track**, **stabilization**, **region of interest (ROI)**, **3D tracking**.

two's See **on two's**.

two shot A **shot** in which two actors are framed within the **camera** view.

two-three five See **2.35 format**.

two-three-five format See **2:35 format**.

two-three pulldown See **2:3 pulldown**.

two-three pullup See **2:3 pullup**.

typeface A style of letters and numbers that make up a **font**, such as Helvetica Bold or Times Roman.

U See **U direction**.

U axis Opposite of **V axis**. See **U direction**.

U curve Generally, the first **curve** used to generate a **bicubic patch**. The number and direction of **control point**s contained in the U curve determine the number and direction of control points used along the **U direction** of the resulting **patch**. Opposite of **V curve**.

U direction By convention, the U direction is defined by the direction of the first **curve**, or **U curve**, used to generate a **bicubic patch**. The direction of the second **generating curve**, or **V curve**, is referred to as the **V direction**. See **UV coordinate**.

U divisions The number of **surface divisions**, as determined by the **U curve**, along the **U direction** of a **bicubic patch**. See **V divisions**.

UID Abbreviation for **user identifier (UID)**.

Ultimatte The trade name for a **matte extraction** tool based on the **color difference method** for pulling a **key**. See also **Primatte**, **Keylight**.

ultrasonic cleaner A **device** used to clean **film** using high-frequency sound waves to remove dirt.

ultraviolet (UV) A bluish-violet, short **wavelength** source of **light** beyond the **visible spectrum** that is invisible to humans but can still have an effect on a **film emulsion**. All film emulsions are sensitive to ultraviolet light in varying degrees. When used for **visual effects (VFX)** to light **element**s on **stage**, it is referred to as **black light**, and all the harmful radiation is filtered out. See also **infrared**.

umask See **permission mask**.

U-matic The trade name for a 3/4-inch **videotape** format developed by Sony.

umbra The area on a **surface** in which the **light source** is completely obscured by another **object**. The area of total eclipse. See also **penumbra**.

unarchive See **restore**.

unclosed curve See **closed curve**.

unclosed object See **closed object**.

unclosed polygon See **closed polygon**.

unclosed surface See **closed surface**.

uncontrolled action The **filming** of an event that cannot be staged or directed for the **camera**. Such **sequence**s need to be **capture**d in one **take**, and the **Cameraman** has no control over the **action** or staging. Opposite of **controlled action**.

uncompress See **decompress**.

under See **under operation**.

undercrank Running a **camera** at a speed lower than the normal speed of **24 frames per second (24 FPS)**. Decreasing the number of **frame**s per second **shot** during **filming** causes the **action** to appear to speed up when **project**ed at 24 frames per second. This technique, also called **slow-speed photography**, is often used when **shooting** action scenes that cannot be choreographed in **real-time**. Opposite of **overcrank**.

underdevelop See **underdevelopment**.

underdevelopment A **film** that has been **develop**ed for too short a period of time or in a solution that is below the standard temperature. The resulting **print** is dark and lacking in detail in the **shadow** areas. In some cases, underdevelopment is done intentionally to compensate for **overexposure**. Also called **pulling**. Opposite of **overdevelopment**.

underexposed See **underexposure**.

unexposed film **Raw stock** that has not yet been **expose**d. See **exposed film**.

unexposed raw stock See **raw stock**.

underexposure The **exposure** of **film** with insufficient **light** or from opening the **aperture** in the **camera** or **printer** for too short a period of time. The resulting **print** is dark with low detail in the **shadow**s. Opposite of **overexposure**. See also **underdevelopment**.

under operation A **compositing operation** that places the **background image** under the **foreground image** based on the **alpha channel** of the foreground **image**. Opposite of **over operation**. *See also image under **layering operation**, and image on following page.*

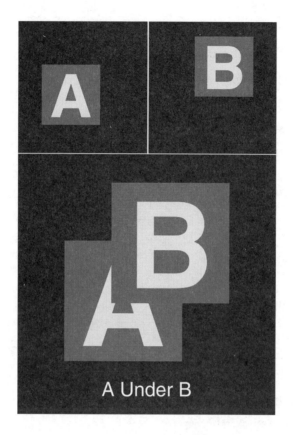

A Under B

underscan The adjustment on a **video monitor** that increases the viewable **height** and **width** of the **image area** so that the **edges** of the **display** can be seen.

undeveloped 1. **Exposed film** that has not yet been **process**ed. 2. **Film** that is being processed but has yet to reach the **development** stage.

undistort To **twist** or **warp** back to the original **shape** of an **object** or **image**. Because most **renderers** cannot account for the natural **lens distortion** found in **live action plates**, various **image processing** techniques are used to remove this natural distortion from the **plates** before **3D tracking** is done. The **CG element**s are then rendered with the non-distorted camera **curve**s that were extracted from the undistorted plate. During the **compositing** step, the inverse of these undistortion **value**s are then applied to the **CG element**s so they can appear to contain the same amount of lens distortion existing in the original plate. Opposite of **distort**.

undo A common **menu option** to remove the last action input by the **user**. Opposite of **redo**.

unexposed Shorthand for **unexposed film stock**. See **raw stock**.

unexposed film **Raw stock** that has not yet been **expose**d. See **exposed film**.

unexposed film stock See **raw stock**.

unexposed print stock See **raw stock**.

unexposed raw stock See **raw stock**.

unexposed stock See **raw stock**.

uniform parameterization Uniform parameterization occurs when the **delta**, or difference, between successive **knot**s on a **curve** is expressed in equal increments of 1, regardless of the actual distance between the knots. This type of **parameterization** exists in **Bézier**, **B-spline**, **Cardinal**, and **linear** curves. A **surface** defined by uniform parameterization but whose **control point**s are unequally spaced can cause unwanted stretching of applied **texture**s across the surface as each **surface segment** is assigned an equal-sized chunk of the **texture map**. See also **nonuniform parameterization**.

uniform resource locator (URL) The addressing system used on the **World Wide Web (WWW)** that contains information about the method of access, the **server** to be accessed, and the **path** of the **file**s to be accessed. Using a **Web browser**, a **user** can jump to a particular **Web site** or from site to site using these **address**es.

uniform scale See **proportional scale**.

uninstall To remove **software** or **hardware** that has already been **install**ed on the **computer**.

uninterruptible power supply (UPS) A power supply used to maintain power to the **computer**s in the event of a power outage for a long enough period of time to enable **data** to be saved and to properly **shut down** the computers. Many UPS systems offer automatic **back up** and shut down procedures in the event of a power failure while the **System Administrator**s are away from the **network**.

union See **union operation**.

union operation 1. For **compositing**, synonymous with a **plus operation**. 2. A **Boolean operation** that creates a new **object** based on the addition of two **source object**s. Also called **addition operation**, **OR operation**. See also **difference operation**, **intersection operation**, **exclusive operation**, *image under Boolean operation, and image on following page.*

Boolean union operation.

union shop A **facility** that has signed an agreement with a union to hire only members of that union. Nonunion workers can still get a job there but will have to join the union in order to do so. Opposite of **nonunion shop**.

unit 1. The unit of measurement used to define the world in **3D space** in terms of **linear units**, **angular units**, and **time units**. 2. See **group**.

Unit An individual **Film Crew** for a specific **project**. Large **film**s often have a smaller **Second Unit** Crew for **location shooting**, whereas the **First Unit** crew focuses on shooting the actors in the main action.

Unit Manager See **Unit Production Manager (UPM)**.

Unit Photographer See **Still Photographer**.

Unit Production Manager (UPM) The person who works for the **Producer** of the **film** and is responsible for coordinating and supervising the administrative and technical details involved in **budget**ing and scheduling the **shoot**. The Unit Production Manager is responsible for all preparation for the shoot, such as transportation, housing, food, equipment, and managing the **Film Crew**. Also called **Unit Manager**, **Production Manager (PM)**.

Unit Publicist See **Publicist**.

unit vector A **vector** with a length of 1.

universal leader The standardized length of **film** attached by the **lab** at the **head** and **tail** of **release print**s that meets the standards specified by the

Society of Motion Picture and Television Engineers (SMPTE). The **leader** contains **cue mark**s and other information for use as a guide to alert the **Projectionist** for approaching **change over**s and to allow the **projector** to gain full speed before the first **image** reaches the **film gate**. Sometimes referred to as **SMPTE universal leader**. See also **Academy leader**.

universal serial bus (USB) An interface between **computer**s and **peripheral device**s that supports a **data** transmission speed of 12 **megabytes per second (MBPS)**.

Unix See **Unix operating system (Unix OS)**.

Unix-based See **Unix-based system**.

Unix-based system A general term describing a **computer** that runs under the **Unix operating system (Unix OS)**. See also **DOS-based system** and **Mac-based system**.

Unix kernel See **kernel**.

Unix OS Abbreviation for **Unix operating system (Unix OS)**.

Unix operating system (Unix OS) The **operating system (OS)** under which many **software package**s run. **Unix** is a trademark of **AT&T/Bell Laboratories** and is a **multiuser** and **multitasking** system. Unix is written in the **C programming language**, which was also developed by AT&T. Unix is also one of the oldest operating systems used today and is available for almost every **computer platform** in various forms. It has survived the test of time primarily because of its **scalability** and **open architecture**.

Unix platform Any **computer** using the **Unix operating system (Unix OS)**. See **NT platform**.

Unix shell A **command interpreter** used by the **Unix operating system (Unix OS)**, such as **C Shell (CSH)**, **Bourne Shell (SH)**, and **Korn Shell (KSH)**. See also **DOS Shell**.

Unix system Any **system** operating under the **Unix operating system (Unix OS)**.

Unix to Unix copy (UUCP) A **protocol** that enables **files** from one **Unix-based** computer to be copied to another via a telephone line or **network**.

unload 1. To remove a **disk** or **tape** from a **drive**. 2. Synonymous with **uninstall**. 3. To remove **data** from a **storage device**.

unmount To make a **remote disk** temporarily inaccessible from a **workstation**. Opposite of **mount**.

unparent To remove an **object** from a **hierarchy**. Opposite of **parent**.

unpremult Shorthand for **unpremultiplied**. See **unpremultiplied image**.

unpremultiplied See **unpremultiplied image**.

unpremultiplied image An **image** whose **red (R)**, **green (G)**, and **blue (B)** **channel**s have not been multiplied by an alpha channel. When an artist needs to **color correct** a **premultiplied image**, it is necessary to unpremultiply it in order to avoid undesirable dark or light halos around the **ele-ment**s when used in a **layering operation**. Unpremultiplication is simply a tool that redivides the **RGB channels** of an image by its own **alpha channel** while still maintaining high-quality **anti-alias**ed **edge**s.

unpremultiply To redivide the **RGB channels** of an **image** by its own **al-pha channel**. Opposite of **premultiply**. See **unpremultiplied image**.

unprocessed film See **unprocessed negative**.

unprocessed negative **Film negative** that has not been **develop**ed. Opposite of **processed negative**. See also **raw stock**.

unselect A **user** can "unchoose" an **object** or **node** by selecting another object or node or by reselecting it if the **toggle** option is on. Some **software package**s will also allow an item to be unselected simply by **click**ing in an empty portion of the **view**. An unselected item is no longer **highlight**ed. Opposite of **select**. Also called **deselect**.

unsharp mask An **image process** used to **sharpen** an **image** by subtracting a slightly **blur**red image from the original unblurred image. The result is a **sharpening** of the contours. See also **sharpen operation**.

unsqueezed See **anamorphic format**.

unsqueezed print A **print** in which the **distort**ed **image** of an **anamorphic negative** has not been corrected for normal **projection**.

unstable See **unsteady**.

unsteadiness See **unsteady**.

unsteady A term used to describe a series of **image**s that are are not **steady** relative to one another when viewed on a **display device**. Such images will need to be **stabilize**d during **post production**.

unsteady camera A **physical camera** that was not stable during **filming** and produced **images** that need to be **stabilize**d during **post production**. Opposite of **steady camera**. See **steady test**.

unzip To **uncompress** files. Opposite of **zip**.

upgrade 1. **Hardware** or **software** that is added to the **system** to presumably increase performance. 2. A new **version** of **software**.

upload To transfer **data** from a **computer** to another **storage device**. Also called **offload**. Opposite of **download**.

UPM Abbreviation for **Unit Production Manager (UPM)**.

upper left quadrant See **quadrant four**.

upper right quadrant See **quadrant one**.

UPS Abbreviation for **uninterruptible power supply (UPS)**.

up vector A **vector** whose **orientation** is pointed up relative to the **construction plane**.

up vector constraint A type of **constraint** that is often combined with a **directional constraint** to establish a **plane** of **rotation** for a given **object**, such as an elbow or knee **orientation** on a humanlike **digital character**. Typically, up vector constraints are used when dealing with a **character** that has been **motion capture**d (**MOCAP**).

upward compatible See **forward compatible**.

URL Abbreviation for **uniform resource locator (URL)**.

usage See **usage statement**.

usage statement The **online documentation** that is printed on the **computer screen** when a **user** types in the name of a **program**, **shell script**, or any **software application** that requires the user to **input** a series of **argument**s for the program to **run**. In most cases, the **Programmer** of the particular **application** will supply a brief description of what the program is designed to do followed by a list of all the various **flag**s required to make it run.

USB Abbreviation for **universal serial bus (USB)**.

user The person interacting with the **computer**, **network**, or **application**.

user account See **login account**.

user area The **memory** that is designated for **user data**.

user bits The portions of **vertical interval time code (VITC)** and **longitudinal time code (LTC)** that are reserved for recoding **user-defined** information, such as **keycode numbers**, **footage counter**, **time code**.

user commands The explicit instructions or actions that a **user** gives to the **computer** to **execute**.

user data Any **data** created and used by **user**s on a **computer**.

user defined Any **parameter**s or preferences that are specified by the **user**.

user friendly A term used to describe a **computer interface** that supplies a **graphical user interface (GUI)** that is easy for the **user** to interact with. However, use of this term when referring to an **application** is really a matter of individual opinion.

user group A group of **user**s who work with a specific type of **computer** or **software** and use one another as a resource for information.

user ID Short for **user identifier (UID)**.

user identifier (UID) A unique number that identifies a particular **user** to a **system**. Once a user has logged in to a system, the **operating system (OS)** uses their UID rather than their **user name** to control user access and to identify ownership of **file**s and **process**es.

user input Any **data** or **command**s entered into a **computer** by a **user**.

user interface The portion of the **computer program** that deals with **user interactivity** and **input**. A user interface consists of various **graphics** on the **screen** that allow the user to interact with the programs. Also called **computer interface**, **interface**. A user interface that consists of a graphical **front end** of available tools is called a **graphical user interface (GUI)**.

user interactivity Referring to the ability of a **user** to communicate with a **computer**.

user login See **user name**.

user login ID See **user name**.

user name The unique name for each **user** working on a single **computer** or across a **network**. In order to **log in** to a computer, a user must specify his user name and a unique **password**. User names are also used in **e-mail address**es. Also called **user login ID**, **user login**. See also **user identifier (UID)**.

username See **user name**.

user password See **password**

user parameters Synonymous with **user preferences**.

user preferences **User-defined** options, within an **application**, used to configure **user interface** items, such as the **windows**, **layouts**, **fonts**. Also called **user parameters**.

usr The area on a **Unix system** designated for **user data**.

Utah teapot A **3D model** of a teapot that is commonly used in tutorials of **3D packages**. It got its name because of its original use at the University of Utah in the 1970s during the early years of **computer graphics (CG)** research and development.

utility A small helper **program**. See **application**.

UUCP Abbreviation for **Unix to Unix copy (UUCP)**.

UV 1. See **UV coordinates**. 2. Abbreviation for **ultraviolet (UV)**.

UV coordinates The **2D** directional **coordinates** assigned to each **point** on a **surface** that define the placement of **texture maps**. Also called **texture coordinates**. See also **parameter space**, **U direction**, **V direction**, *Color Plate 34.*

UV coordinate space The **coordinate space** on a **surface** that is defined by **U** in one direction and **V** in another. These **coordinates** can be used to place **textures** on a surface. Also called **texture space**. See also *Color Plate 34.*

UV map A **texture** that has been applied to a **surface** based on its **UV coordinates**.

UV pass See **black light pass**.

UV texture See **UV map**.

V See **V direction**.

V axis Opposite of **U axis**. See **V direction**.

V curve Generally, the second **curve** used to generate a **bicubic patch**. The number and direction of **control point**s contained in the V curve determine the number and direction of control points used along the **V direction** of the resulting **patch**. Opposite of **U curve**.

V direction By convention, the V direction is defined by the direction of the second **curve**, or **V curve**, used to generate a **bicubic patch**. The direction of the first **generating curve**, or **U curve**, is referred to as the **U direction**. See **UV coordinates**.

V divisions The number of **surface divisions**, as determined by the **V curve**, along the **V direction** of a **bicubic patch**. See **U divisions**.

value 1. Synonymous with **brightness**. In the **HSV color space**, value represents the maximum value of the **RGB channels**. 2. Another name for **attribute**.

vaporware A slang term for a **software** or **hardware** application that does not yet exist but has been promised for delivery. In many cases, such **application**s may never materialize.

variable Any **value** that can be changed over **time** and distance within a given **application**.

variable bit depth A term used to describe a **software package** that is capable of reading and writing **digital image**s with different **bit depth**s. This is a very important feature in **compositing**.

variable focal length lens See **zoom lens**.

variable shutter A **camera shutter** that can control the **exposure time** of each **frame** which, in turn, controls the amount of resulting **motion blur**. Opposite of **fixed shutter**. See also **shutter angle**.

vaseline filter A term used to describe the smearing of petroleum jelly onto a piece of glass for use as a **diffusion filter**. See **soft focus**.

VCR Abbreviation for **videocassette recorder (VCR)**.

vector A **line** in space representing both length and direction. A **surface normal** is an example of a vector. Sometimes called a **one-dimensional array**. See also **scalar**, **array**.

vector display Any **display device** that uses **vector graphics**.

vector graphics A **computer** drawing **program** that **display**s separate **shape**s as a series of **line**s on the **screen**. Unlike **raster graphics**, an advantage of vector graphics is that it is possible to modify any **element** making up the **image** at anytime as each **object** is stored as an independent entity. Sometimes called **object-based graphics**, **object-oriented graphics**.

vector primitive Another name for **line segment**.

vectorscope A **device** used to set up and view the **chrominance** portion of a **video signal**. Radial distance from the center of the **display** represents **saturation** (chrominance **amplitude**), and the counterclockwise or clockwise angular distance represents the **hue** (chrominance **phase**). See also **waveform monitor**.

veiling **Image** contamination from unwanted **light** reflecting off the **camera lens**.

velocity The measurement of distance traveled for a particular action over a period of time. For example, for **particle animation**, velocity is a common **variable** used to control the speed at which the **particle**s travel within a given time sample. The **initial velocity** is used to define the starting speed that a particle leaves its **particle emitter**.

vendor 1. See **facility** 2. Any company that supplies and sells **hardware**, **peripheral device**s, **3rd-party software**.

version 1. A unique number attached to a particular **software release**. 2. A unique number used to define each iteration of a **CG element** or **scene file**.

version number See **version**.

vertex Any **point** in **3D space** that is used to define two or more **edge**s of an **object**. The plural of vertex is **vertices**.

vertical 1. Referring to the **height** of an **image**. 2. Referring to the **Y-axis**.

vertical angle The angle from a particular **point of view (POV)** to the **object** that is oriented along the **vertical axis**. For example, in **set surveying**, the **vertical** angle needs to be calculated from the position of the **Total Station** to the **point** that is being surveyed. See also **horizontal angle**.

vertical axis Another name for the **Y-axis**.

vertical blanking See **vertical blanking interval**.

vertical blanking interval The period of time between an **electron beam**'s completion of **scanning** one **field** of **video** and the beginning of the next field. The action taken by the beam in the **monitor** during this period is called the **vertical retrace**. See also **horizontal blanking**.

vertical field of view The number of **degree**s representing the **vertical** area that can be viewed through the **camera lens**. Opposite of **horizontal field of view**.

vertical grad Abbreviation for **vertical gradation**.

vertical gradation A type of **gradient** that **interpolates colors** from the top to bottom **edge**s of the **frame**. Also called a **gradient, ramp, vertical ramp**. See also **horizontal gradation, four-corner gradation, radial gradation**, *and see image below.*

A **vertical gradation.**

vertical interval See **vertical blanking interval**.

vertical interval time code (VITC) **Time code** that is recorded during the **blanking interval** of the **video signal** above the active **image area**. VITC is a version of time code that is stored in each video **field** and allows for precise **frame** identification during stopped or **slow motion** viewing of the **image**s. See also **longitudinal time code (LTC)**.

vertical plane A **plane** that is **parallel** with the **vertical axis**. Opposite of **horizontal plane**.

vertical ramp See **vertical gradation**.

vertical refresh rate The rate at which **field**s on a **CRT monitor** are redrawn. See also **horizontal refresh rate**, **refresh rate**.

vertical resolution The number of **pixel**s making up the **height** of an **image**. Also called **Y resolution**.

vertical retrace The action taken by the **scan**ning beam in the **monitor** when it reaches the bottom of one **field** and returns to the top of the **frame** to begin the next. The period of time it takes to perform the vertical retrace is called the **vertical blanking interval**.

vertical sync The synchronized pulses used to identify the end of one **video field** and the start of the next.

vertices The series of **point**s in **3D space** used to define the **line**s and resulting **plane**s that define the **shape** of an **object**. Vertices can be thought of as the index to the list of points that make up the **polygon**s that form the complete **surface**. See also **vertex**.

VFX Abbreviation for **visual effects (VFX)**.

VFX DP See **Visual Effects Director of Photography (VFX DP)**.

VFX Producer See **Visual Effects Producer (VFX Producer)**.

VFX Sup See **Visual Effects Supervisor (VFX Sup)**.

VFX Supervisor See **Visual Effects Supervisor (VFX Sup)**.

VHS Abbreviation for **video home system (VHS)**.

VHS deck Any machine that can play or record to **VHS** tapes.

vi Abbreviation for **visual interface (vi)**.

video Referring to the recording, manipulation, and **display** of **image**s in a **resolution** that can be viewed on a standard television.

video adaptor See **graphics board**.

video artifact An unwanted effect that occurs when the **display device** reproduces an **image** with **aliasing**, **pixellation**, or **banding**.

video assist A system that incorporates a **video camera** on a **film camera**. The **image** striking the **shutter** mirror is split between the **viewfinder** and the video camera. Also called a **video tap**.

video board See **graphics board**.

video camera A **camera** that uses an electronic sensor to capture **image**s as opposed to using photographic **film** used in **film camera**s.

video card See **graphics board**.

videocassette recorder (VCR) A **half-inch tape** or **three-quarter inch tape** player and recorder that is, usually, connected to a television or **monitor** to view or record to tapes. Also referred to as a **videotape recorder (VTR)**.

video clip **Sequence**s of **image**s organized into segments for use in **nonlinear editing**.

video conferencing The ability to transmit **image** and **sound** from one location to another. Video conferencing has become more common in **visual effects work** as a means to show the **Director** and **Visual Effects Supervisor (VFX Sup)** the work being done at a **facility** while they are away on **location**.

video dailies A **dailies** dedicated to reviewing the latest round of **video resolution** work. Video dailies can be reviewed in a wide variety of **format**s, such as from **digital disk recorder (DDR)**, **tape**, or **movie file**s. See also **film dailies**.

video editing The process of **cutting** and rearranging portions of **video-tape**d **image**s from the photographed **scene**s. See **film editing**.

Video Editor The individual who **edit**s a **videotape** from the photographed **footage**. The job involves careful **shot** selection, arrangement, and timing to maintain **continuity** and portray the screen story in its best light. See **Film Editor**, **film editing**.

video format See **fullscreen**.

video frame A complete **image** made up of two **field**s.

Videographer An individual who photographs **video**.

video home system (VHS) The trade name for one of the most widely used 1/2-inch **magnetic tape** formats developed by JVC. Also referred to as **half-inch tape**.

video image **Image**s that are recorded, modified, and **display**ed with a **resolution** that can be presented on a **television**.

video level The **amplitude** of the **video signal**.

video master See **master videotape**.

video monitor A **display device**, such as a television or **computer** monitor, that can display **video resolution** images.

video noise The measure of how pure a **video signal** is in terms of **luminance**. **Videotape** with a strong luminance **signal** produces a **sharp**er and clearer image.

video port The **computer** socket where the **monitor** cord plugs in.

video release A term describing the phase during which a **film** is made available to the public on **videotape**, either by renting or purchasing. See **release**.

video resolution See **video image**.

video resolution image See **video image**.

video scope See **waveform monitor**.

video signal The **signal** that carries the **value**s of a **video image**. The two most common types of video signals are **composite video** and **component video**. See **analog signal**.

video tap The **video camera** attached to the **film camera** during **filming**. See **video assist**.

videotape **Magnetic tape** used to record audio and **image**s that can be played back on a videotape player such as a **videocassette recorder (VCR)**. See also **video home system (VHS)**, **beta**, **three-quarter-inch tape**.

videotape recorder (VTR) See **videocassette recorder (VCR)**.

video waveform Video waveforms carry **video** information during the active video and **blanking** portion of the **signal**.

vidres Abbreviation for **video resolution**.

view 1. For **3D software**, see **viewing window**. 2. For **2D software**, the **region of interest (ROI)** or **domain of definition (DOD)** that surrounds the current **image**. 3. See **viewfinder**.

viewer The person or **device** receiving the **image**s shown on a particular **display device**.

viewfinder The area of the **camera** that enables the **Cameraman** to view the **scene** as it will be **capture**d during **shooting**. The **image** coming through the **lens** is reflected onto a mirror in the **shutter** and is formed on the **ground glass** in the viewfinder.

viewing angle The viewing angle of a **shot** is described by the **camera position** and **lens** relative to the **position** of the **subject** being photographed. See also **subject angle**, **camera angle**.

viewing device See **display device**.

viewing direction The **direction** the **viewer** or **camera** is pointed within a **scene**.

viewing format 1. The **display device** on which **image**s are viewed. 2. The final **resolution** and **display** medium, such as on **film** or **videotape**, on which the images will be viewed. *See also images under film extraction, Vista Vision, anamorphic.*

viewing frustrum The truncated **pyramid of vision** that is created based on the **value**s used for the **near** and **far clipping plane**s in a **3D scene**. Any **object**s that lie within the viewing frustrum will be **render**ed, whereas those that lie outside of it will not. Also called the **frustrum of vision**.

viewing location The location of the **viewer** or **camera** relative to the **scene**. Also called the **viewpoint**.

viewing surface The physical location on a **viewing device** where an **image** is formed, such as on **film**, the **monitor screen**, or the retina of the eye.

viewing transformation The **transformation** that converts **point**s contained in **world space** into **camera space**.

viewing window For **3D software**, the viewing windows are generally represented as either the **perspective view** or **orthographic view** and is the equivalent of what the **Cameraman** sees through a **camera lens** on **set**. Most commonly, 3D software packages default to a perspective view and three orthographic views for the **top view**, **front view**, and **side view** of the **scene**. Many **software package**s also offer the ability to view the scene from the viewpoint of any one of the **light source**s, which can be be very helpful in determining **light** placement. Also referred to as **view**, **window view**. *See image on following page.*

viewpoint See **viewing location**.

The basic **viewing windows**, found in most **3D software package**s; the **perspective view, top view, front view** and **side view** of a **3D object**.
IMAGE CREATED USING HOUDINI AND COURTESY OF SIDE EFFECTS SOFTWARE.

viewport The virtual **window** area, defined by rectangular **screen coordinates**, in which an **image** or view of **3D space** can be **display**ed within a particular **software package**.

vignetting A **falloff** in the **brightness** at the **edge**s of an **image**, slide or **print** due to a **lens artifact**.

virgin stock **Magnetic tape** or **sound track** on which nothing has yet been recorded.

virtual actor See **digital character**.

virtual address A location in **memory** that uses **virtual memory**.

virtual camera See **digital camera**—Definition #1.

virtual camera movement process See **Timetrack**.

virtual celebrities See **digital character**.

virtual memory **Computer memory** that is used as an extension to a **computer**'s **main memory**. When a **file** is too large for the available memory, part of the **data** is stored on **disk** and is divided into **segment**s, called **page**s. Each page is then associated with an **address** in **physical memory** or **random access memory (RAM)**, and when this address is referenced, the page is **swap**ped into memory and then sent back to disk when the next page is referenced.

virtual reality (VR) A **simulation** created by a **computer** of a hypothetical 3D world in which special **device**s, such as goggles and **data glove**s, allow the **user** to interact with the simulation.

virtual reality simulation See **virtual reality**.

virtual reality modeling language (VRML) VRML is a **programming language** used to create the illusion of **3D object**s for **virtual reality (VR)** environments. The **computer display** shows what appears to be a **three-dimensional (3D)** object from a particular **viewpoint** and then creates the illusion of **motion** by adjusting the viewpoint for each **frame**. **Voyager** is an an example of a VRML.

virtual storage See **virtual memory**.

virus See **computer virus**.

visible line determination See **hidden line removal**.

visible spectrum The range of **color**s between the **ultraviolet (UV)** and **infrared** portions that are visible to the human eye. See also **black light**.

visible surface determination See **hidden surface removal**.

visibility threshold See **threshold**.

Vista Vision (VV) A **film format** that runs standard **35mm film** stock through the **film gate** in a **horizontal** direction rather than the more common **vertical** direction. Because of this, the **width** of the Vista Vision frame is twice that of a standard 35mm **frame** and uses eight film **perforation**s per frame. It is also referred to as **eight-perf**. The **aspect ratio** of the **capture**d Vista Vision frame is 1.5, and the typical working **image resolution** is 3072 × 2048. The actual size of the **image area** captured on film is 1.485″ × .991″. *See image on following page.*

Vista Vision Framing
1.5:1 Aspect Ratio
1.485" x .991"

The **Vista Vision** film format uses 8 **perforation**s and runs horizontally through the **film gate**.

visual development The period of a **film** during which **production artwork** is created. The visual development phase of a film typically includes **storyboard**s, paintings, and illustrations that are used to define the style, look, and feel of the **film** and its characters. It has also become more common to use **computer graphics (CG)** as an exploratory means of defining the style of a film.

visual effects (VFX) A global term describing **effects** that cannot be created with standard **filming** techniques. Examples include **digital effects (DFX)**, **miniature photography**, **greenscreen/bluescreen** photography, and **optical compositing**.

Visual Effects Crew All personnel involved in the various aspects of creating **visual effects (VFX)** for a **project**, such as the **Digital Effects Crew**, **Art Department** and **Model Makers**.

Visual Effects Director of Photography (VFX DP) The Visual Effects Director of Photography is responsible for photographing any **element**s required for the **visual effects work** that were not **shot** by the **Director of Photography (DP)** during **principal photography**. This can include **motion control photography (MOCO photography)**, **stage shoot**s, and reference elements shot on **location**.

Visual Effects DP See **Visual Effects Director of Photography (VFX DP)**.

visual effects facility Any company that creates or offers services for **visual effects work**. Also called a **visual effects house**, **visual effects studio**. See **facility**.

visual effects house See **visual effects facility**.

Visual Effects Producer (VFX Producer) The person responsible for the **budget**, scheduling, and administrative portion of the creation of the **visual effects work** for a **project**. The Visual Effects Producer works closely with the **Visual Effects Supervisor (VFX Sup)** to translate the **script** into **shot breakdown**s and costs. Based on the size of the **show**, this individual will often have a **Digital Effects Producer (DFX Producer)** and/or **Digital Production Manager (DPM)** working for them.

visual effects shot Any **shot** in a **film** that required additional work to what was shot on **camera**. See **visual effects work**.

visual effects studio See **visual effects facility**.

Visual Effects Supervisor (VFX Sup) The individual responsible for the aesthetic, technical, and creative portion of the **visual effects work** for a **project**. The VFX Supervisor works closely with the **Director** to ensure the **effects** created properly represent the Director's vision. The VFX Sup is also responsible for determining the best techniques to be used for each **shot** in the areas of **digital effects (DFX)**, **miniatures**, and **bluescreen (BS)** or **greenscreen (GS)** photography.

visual effects work A global term used to describe any work created for a **film** that was not shot completely **in camera** with traditional **live action** techniques. Visual effects work includes **digital effects (DFX)** and **stage** and **miniature photography**.

visual interface (VI) A widely used **text editor** that is based on the underlying editor called **EX**. See also **EMACS**, **jot**.

visual timecode See **burn-in timecode**.

VITC See **vertical interval time code (VITC)**.

vizdev Abbreviation for **visual development**.

VO Abbreviation for **voice-over (VO)**.

voice-over (VO) A term used to describe dialogue that will be heard on the **sound track**, but the speaker will not be seen **on camera**. The abbreviation VO is used often in **script**s.

volatile memory **Memory** that loses the **data** it is storing when the **computer** is **shut down**. **Random access memory (RAM)** is an example of volatile memory; **read-only memory (ROM)** is an example of **nonvolatile memory**.

volatile storage See **volatile memory**.

volume 1. The total amount of space occupied by a **3D object** as opposed to a **surface** that only defines the boundaries of a volume. See also **solid modeling**, **volume picture element (voxel)**. 2. For **motion dynamics**, the volume of an **object** is based on a combination of its size and the **density** of the **material** from which it is made. See also **mass**, **weight**, **friction** 3. A **unit** of storage, such as a **disk** or **magnetic tape**. 4. The **sound** level. 5. See **volume shader**.

volume element See **volume picture element (voxel)**.

volume light In **computer graphics (CG)**, a **light source** that is restricted to a clearly defined **volume** such as a **sphere**, **cube**, **cone**, or **cylinder**. Any **object**s that lie outside this volume will not receive any **light**. See also **ambient light**, **area light**, **directional light**, **spotlight**.

volume map See **procedural map**.

volume mapping See **procedural mapping**.

volume picture element (voxel) A voxel is a **unit** of information used to define the **volume** of a **3D object**. A voxel defines each **point** representing an object in **3D space** in terms of its **XYZ coordinates**, **color**, and **density**. With this information, a **renderer** can create a **2D image** from the **3D** information in the **scene**, such as clouds or scanned human tissue. Each voxel is assigned an **opacity** value and a color that can allow the underlying structure of the volume to be viewed.

volume pixel See **volume picture element (voxel)**.

volume rendering The **rendering** of complete **volume**s, as opposed to only rendering **surfaces**. See also **solid modeling**, **volume pixel element (voxel)**.

volume shader A **shader** that calculates the **light** that is **reflect**ed and absorbed while passing through a **volume**. Volume shaders are generally used to simulate the **effects** of **natural phenomena**, such as smoke, water, dust, and so forth. See also **surface shader**, **displacement shader**, **light shader**.

volume texture See **procedural map**.

volume texture map See **procedural map**.

volume texture mapping See **procedural mapping**.

volumetric Pertaining to the measurement of **volume**.

volumetric light See **volume light**.

volumetric scaling To **scale** an **object** or **image** along any **axis** while maintaining the **volume** of its **bounding box** by allowing its proportions to change.

voxel Abbreviation for **volume picture element (voxel)**.

voxel rendering A type of **renderer** that uses **volume** cubes to calculate **voxel**s.

Voyager A **virtual reality modeling language** viewer for **Macintosh**.

VR Abbreviation for **virtual reality (VR)**.

VRML Abbreviation for **virtual reality modeling language (VRML)**.

VTR Abbreviation for **videotape recorder (VTR)**. See **videocassette recorder (VCR)**.

VV Abbreviation for **Vista Vision (VV)**.

Wacom tablet A range of **input device**s, developed by Wacom Technology, for use on the **Macintosh (Mac)**, **personal computer**s (**PCs**), and **SGI** platforms. Wacom tablets are typically used to **digitize 2D** artwork and with **paint package**s.

wagon wheeling An **image artifact** caused when a rolling wheel appears to be moving faster or slower relative to the **scene**. This **temporal aliasing** results from the fact that the **revolutions per second (RPM)** are close to but not quite the same as the **frame rate** of the **display**ed **image**s. For example, if the wheel has 12 spokes with 30 degrees of angle between them, and the wheel rotates 29 degrees per **frame** (1/24 of a second for **film**), the wheel will appear to be backing up by 1 degree per frame, or 24 degrees per second. Conversely, if the wheel rotates by 31 degrees per frame, it will appear to be advancing by 1 degree per frame.

Waldo An **input device** controlled by a human **limb** to capture **animation** into a **computer**. The term originated from an invention in Robert Heinlein's science fiction book *Waldo* in 1942. Waldo is also the trademark name of an input device designed by The Creature Shop that is engineered to comfortably fit to a **Puppeteer**'s body and allow a wide range of physical motion. **Data** is **capture**d by measuring the angle and movement of the wearer's **joint**s and limbs. A Waldo is considered a **telemetric device** because the **motion** data is measured and then sent via remote control.

walk cycle A **motion cycle** in which the **digital character** is walking in a loop. See **run cycle**.

walkies Slang for **walkthroughs**.

walkthroughs 1. Walkthroughs are a time when the **Director** and/or various **Supervisor**s of a **project** literally walk from **workstation** to workstation to review the work of individual artists. Unlike **dailies**, walkthroughs offer a chance for the artists to discuss their work with their supervisors on a more personal level. 2. A rehearsal in which the actors go through the

physical **motion**s of the **scene** without speaking their lines of dialogue and without the **camera** running.

walkthrus See **walkthroughs**.

WAN Abbreviation for **wide-area network (WAN)**.

warm A **color** or **image** that is biased toward **red** or **yellow**. Opposite of **cool**.

warm boot For **computer**s, synonymous with **soft boot**.

warm colors See **warm**.

warm start See **warm boot**.

Warnock algorithm See **Warnock recursive subdivision algorithm**.

Warnock recursive subdivision algorithm An **algorithm** that uses **recursive subdivision** to break a **surface** into smaller areas to aid in calculations for **hidden surface removal**.

warp To bend or **distort** an **object** or **image** away from its natural **shape**. See **image warp**, **deformation**.

warping engine The **code** that defines the **geometric transformation**s within a particular **compositing package**.

washed out Another term for **flat** or **flashed**.

water tank A large vessel used to hold water, generally located inside a **studio** or outside on the studio lot, that is used for **scene**s taking place on or under the water.

WAV Abbreviation for **windows audio volume (WAV)**.

wave generator See **wave machine**.

wavelet A **compression** algorithm that **sample**s a **video image** based on **frequency** and duration as a way to **encode** its information.

wave machine A **device** run by a motor and placed at the side of a **water tank** that creates waves by rhythmically being dipped into the water. This device is commonly used when **filming model**s and **miniature**s in water tanks. Also called **wave generator**.

waveform A **graphical representation** of wavelike patterns showing such characteristics as **frequency** and **amplitude**.

waveform monitor A **device** primarily used to measure **luminance** and the **blanking interval** of a **video signal**. Also called a **scope**. See also **vectorscope**.

Wavefront A **3D software package** that has for the most part been replaced by **Maya**. See **Alias/Wavefront**.

Wavefront Composer See **Composer**.

wavelength The distance between one **point** on a wave and the same point on the next cycle in a **waveform**.

wax transfer printer A **printer** in which **color**ed wax paper is heated and transferred for full-color reproduction.

weave See **film weave**.

Web See **World Wide Web (WWW)**.

Web address See **Internet address**.

Web browser A **program**, such as **Netscape Navigator**, used to view **HTML documents** on the **World Wide Web (WWW)**.

Web doc See **Web documentation**.

Web documentation (Web doc) See **Web page**.

Web jumper See **Web browser**.

Webmaster The individual responsible for developing, designing, and managing a **Web site**.

Web page A document written in **HTML** format and stored on a **server** to be **display**ed by a **Web browser** on the **World Wide Web (WWW)**. Web pages are often used as a method of **project** management and organization for **visual effects (VFX)** shows in which an artist can look up information about assigned **shot**s. Typical information might include the **shot length**, shot **element**s, and the type of shot, such as a **greenscreen shot**, **miniature shot**, or a **full CG shot**.

Web page document See **Web page**.

Web server The **server** that stores **World Wide Web (WWW)** documents and makes them available from **Web browser**s.

Web site A group of interconnected **Web page**s, generally located on the same **server**, that are prepared and maintained to represent a particular person or organization. The name of a Web site is an **ASCII** string, such as yahoo.com, where "yahoo" is the local name and "com" is the **domain name**. Most **visual effects (VFX)** facilities have internal Web sites that are used to post **software documentation** and information about the various **project**s that are being worked on. Typically, each project will have its own

Web site with information about artist assignments and details about each **shot**. See also **home page**.

wedge 1. A term used to describe the creation of a series of **frame**s that differ only in the **parameter**s that are being tested. For example, an **exposure wedge** contains incremental steps of **brightness**; a **color wedge** might contain steps in **red (R)** or **saturation**. 2. The name for the resulting range of **image**s produced from the above wedging process described in Definition #1. To view a wedge, as opposed to the creation of it. 3. A method of isolating a portion of a **3D volume** that allows you to see the interior of the **object** in **3D**.

wedging The process of creating a **wedge**. Also called **bracketing**.

weight 1. For **curve**s in **computer graphics (CG)**, weight controls the relative influence of each **control point** on a **curve segment** within its proximity. For example, the control points that make up a **NURBS curve** is defined by four parameters: **X**, **Y**, and **Z** values and weight. The greater the weight of the control points, the closer the **surface** or curve will be positioned toward it. 2. For **motion dynamics**, weight is a **physical property** used in conjunction with **gravity** to calculate physical **simulation**s. Contrast with **mass**. See also **volume**, **friction**. 3. For **metaball**s, a **parameter** that influences the **fusion** between two overlapping metaballs. Also referred to as **range** and **influence**. 4. For a **skeleton structure**, weight refers to the amount of **deformation** influence each **bone** has on its surrounding **skin**.

weighting 1. The process of assigning a **weight** to each **control point** on a **curve** or **surface**. 2. The process of defining the amount of influence a **bone** or **skeletal structure** has on a particular **point** on a **skin** or other external boundary.

west Compass terminology used to refer to the negative portion of the **X-axis**, of a **frame** or **image**.

wet-gate printing A method of **printing** in which the **original negative** is placed in a liquid at the moment of **exposure** in order to reduce the visibility of surface scratches. Also called a **liquid gate**.

WGA Abbreviation for **Writer's Guild of America (WGA)**.

while loop A **conditional statement** used in **programming** that defines the conditions under which certain events can occur: "While something is true, then do this." See also **for loop**, **if/then/else loop**.

whip pan See **swish pan**.

white 1. As a **color**, to produce or **reflect** the maximum lightness and be devoid of **hue**. 2. For **digital**, white is typically thought of as the **normalized value**s in an **image** whose **RGB channels** are equal to (1, 1, 1), which is also referred to as a **normalized white**. Images that do not contain normalized values will represent their **RGB** values based on the number of **bits per channel** in which the image is stored. For example, in an image containing **8 bits per channel** that has not been normalized to values in a range between 0 and 1, the value of white would be equal to (255, 255, 255). Also referred to as **pure white**. 3. For **display device**s, white is only as light as the **display** can represent. 4. For the **additive color model**, white is the culmination of all colors in equal parts.

white balance The **calibration** of a **camera** for accurate **color** display based on different **lighting** conditions, such as indoor or outdoor lighting. A **white card** is often used in this process.

white card The white board that is held in front of a **camera** when it is being **white balance**d.

white light Any **light source** that is absent of **color** and is used to **illuminate** a **scene** in its natural colors.

whiteness Referring to the amount of **white** mixed with **hue** in the **HWB color space**. See also **blackness**.

white paper A document discussing a particular piece of technology.

white point 1. For **film**, the measurement of **density** in the most **transparent** portion of the **frame**. 2. For **digital**, the numerical **value** corresponding to the brightest area that will be **display**ed in its final **viewing format**. For example, white in an **image** might be considered as any value above 0.9. By treating the **pixel**s in this range as if they were the limit of the **brightness** range, a bit of extra room is created at the top end of the image. When this image is sent to a **display device**, any pixel containing a value above or equal to the specified white point value will appear to be pure **white**. See also **black point, look-up table (LUT)**.

whole number Any number that is **positive, negative**, or zero with no fractional part. Also called an **integer**. See also **nonintegral number**.

whole pixel filter A special **filter** that performs no **filtering** or **anti-aliasing** operations on an **image** but is used instead to calculate math expressions on a per-**pixel** basis.

wide angle distortion The **lens distortion** that can occur when using a **wide**-**angle lens** in which the **object**s close to **camera** seem abnormally

large while the objects far from camera feel abnormally small. Objects close to camera may also appear **warp**ed or stretched out, which is referred to as **barrel distortion**.

wide-angle lens A special **camera lens** that has a shorter **focal length** and a wider **field of view (FOV)** than a **normal lens**. Wide angular lenses tend to increase the angular effects of a **scene** and create more **lens distortion**, referred to as **wide angle distortion**. The **depth of field (DOF)** is also greatly increased. Also called a **short lens**. Opposite of a **telephoto lens**. See also **fisheye lens**, **long lens**.

wide angle of view Referring to the **angle of view** seen through a **wide-angle lens**.

wide-angle shot Any **shot** in which a **wide-angle lens** is used to create a **wide angle of view**.

wide-angle view See **wide angle of view**.

wide-area network (WAN) A **network** that connects **computer**s to each other over a long distance with the use of telephone lines and satellite communications. See also **local area network (LAN)**.

widescreen 1. A general term used to describe any **film** displayed at an **aspect ratio** greater than **1.33:1**. Commonly used aspect ratios include **1.66:1**, **1.85:1**, and **2.35:1**. 2. For widescreen television, the **display** of **image**s with an aspect ratio of **16:9**. See **HDTV**.

wide shot (WS) 1. A **shot** used to establish a wide view of action and to allow actors enough room to enter, exit, and move about within the **scene**. 2. Also can refer to a **shot** that uses a **wide lens**.

widget Any one of the items that make up a **graphical user interface (GUI)** application on a **window system**, such as a **button**, **check box**, **scroll bar**, or **icon**.

width How wide an **object** or **image** is along the **X-axis**. See **height**.

wildcard For **computers**, a special **character**, such as the asterisk (*) for **Unix**, that is used to specify all the **file**s in a **directory**. When used in combination with other characters, it can be used to specify all files sharing common letters in their names.

wind See **wind force**.

wind force A **physical force** used in **motion dynamics** to **simulate** the effect of wind on the **object**s. Unlike a **fan force**, a wind force will affect the

objects in the entire **scene** equally regardless of their distance from the wind source. See also **gravity**.

window An area of the **computer screen** used to **display** and modify information. A window can be nothing more than a **textport**, or it can contain many **interface element**s. Multiple windows of various sizes and shapes can be **open**ed and **stow**ed at the **user**'s discretion. See **dialog box**, **check box**, **split-bar**, **window pane**, **viewing window**.

window border The border that surrounds the **edge**s of a **window**. See **borderless window**.

window burn-in See **burn-in timecode**.

window code See **burn-in timecode**.

window coordinates The **coordinate system** of a **window**.

window manager The part of a **window system** that controls the arrangement and appearance of the various **window**s on a **computer screen**.

window pane Any **window** on a **computer screen** is that is split into two or more areas by a **split-bar**. Each individual section is called a window pane.

window preferences **User-defined** parameters to specify **window** settings, such as its size and background **color**, within a **software application** or **operating system (OS)**.

Windows 1. See **window system**. 2. A trademark name for a variety of **GUI**-based window systems. Examples include **Macintosh**, **X Windows**, **Windows NT**.

windows audio volume (WAV) A standard **audio file** format used with **Microsoft Windows**. WAV files can represent a wide range of varying **bit depth**s and **sampling** frequencies. Typically, WAV files carry .wav as their **filename extension**.

Windows New Technology See **Windows NT**.

Windows 2000 The latest version of **Windows NT**.

Windows NT A widely used 32-bit **operating system (OS)** developed by **Microsoft, Corp.** Windows **NT** has built-in **network**ing and can be used on a wide variety of **platform**s, such as **personal computer**s (**PC**s) and **DEC Alpha**s. Windows NT is essentially Microsoft's answer to **Unix** and is a **multiuser**, **multitasking**, and **multithreading** operating system.

window system A **program** that allows the **screen** of a **workstation** to be divided into **user** defined rectangular areas that control the **input** and **out**-

put of different **application**s. This gives the **user** the ability to interact with several **process**es at once. A **window** is made **current** by selecting it with a **pointing device**. See also **window manager**.

window view　See **viewing window**.

wipe　Shorthand for **wipe transition**.

wipe matte　Another name for **reveal matte**.

wipe off　An **image** that disappears through a **wipe transition** is a "wipe off."

wipe on　An **image** that is revealed through a **wipe transition** is a "wipe on."

wipe reveal　Another name for **reveal matte**.

wipe transition　An **image transition** used to replace one **image** with another by revealing the new image through a **matte** that sweeps across the **screen** (referred to as a wipe). An **A/B roll** is required if the wipe is done **nondigital**ly as an **optical effect**.

witness mark　Another name for **tracking marker**.

witness point　Another name for **tracking marker**.

wireframe　A common way to display a **3D object** in which the **edge**s and contour **line**s of an **object** are drawn as a series of lines. The object resembles a model made up of wire. See also **hidden line**, *Color Plate 33, 63, and images under **shading model** and **hidden line rendering***.

wireframe animation　An **animation** that is calculated and played back using **wireframe model**s.

wireframe model　See **wireframe**.

wireframe rendering　A **rendering** of an **object** as though it were composed only of a series of **line**s to define its **edge**s. See also **hidden line rendering**, **surface rendering**, **wireframe**, *and image under **shading model***.

wireframe shading　See **wireframe rendering**.

wire removal　The process of removing any visible practical wires used in **plate photography** from the **scan**ned **select**. This can be done by hand, with a **paint program**, with various **compositing** tricks, or with special software **application**s. See also **rig removal**.

word　A **unit** of **memory** typically composed of two **byte**s or 16 **bit**s.

word processor　An **application** that provides the **user** with **tool**s to create and modify formatted **text**. See also **text editor**.

workaround A temporary fix or bypass solution to a problem in a **system** or **software**. Also referred to as a **kluge, cheat**.

workflow The scheduling and organization of a **project** within a **network** as well as between one department or artist and another.

working memory Temporary **memory** used by the **computer** during calculations.

working resolution The size of the **image** created from a **render** or **composite**. See **image resolution**.

working title The name used for the title of a **film** while it is being made. See **project name**.

workprint A **positive print** made from the **original negative (o-neg)** for use by the **Editor** to **cut** the **film**. The workprint is generally made with a single **printing light** called a **one light**, which is a **print** without final **color timing**. The original negative is conformed to the final cut of the workprint. The workprint is also used for viewing **dailies** and as a reference for **color grading** used in **visual effects work** in conjunction with a **match clip**.

workstation A **desktop computer** using a **keyboard, computer screen**, and a variety of **peripheral device**s that generally offers the **user** higher performance than a **personal computer (PC)** or **laptop computer**. A workstation can be a **standalone** or connected to a **network**.

workstation visits See **walkthroughs**.

world coordinates The **coordinate**s that define a **scene** based on its **world coordinate system**. Also called **global coordinates**.

world coordinate system The **coordinate system** that defines the placement and **orientation** of all the **object**s in a **3D scene**. The **origin** is almost always located at (0, 0, 0). Also called **world space, global space, global coordinate system**.

world origin The **point of origin** within a **world coordinate system**. For most **software package**s, this defaults to (0, 0, 0).

world premiere The dramatic way to refer to the **premiere** of a **feature film**!

world space See **world coordinate system**.

World Wide Web (WWW) A **network**ed collection of **Web sites** offering text, **graphics**, and sound on the **Internet** that adhere to **HTML** standards. **Hypertext link**s connect together the many sites available on

the Web, and **user**s can travel from one **Web site** to another by using a **Web browser**.

World Wide Web browser See **Web browser**.

Wrangler 1. Short for **Data Wrangler**. See **Job Technical Director (Job TD)**. 2. Short for **Render Wrangler**. See **Render Watcher**. 3. The individual responsible for "wrangling" the animals that appear in a film.

wrap The completion of **shooting**, either for the day or for the entire **project**.

wrapper A **program** that is combined with another piece of **code** to determine the way in which that code will be **execute**d. Wrappers are commonly used to create compatibility between code written in different **programming language**s.

wrist rest See **wrist support**.

wrist support A long, rectangular pad that is placed in front of the **keyboard** so the **user**s' wrists have a place to rest while typing. Wrist supports are used to prevent **Repetitive Strain Injury (RSI)**. See also **Carpal Tunnel Syndrome (CTS)**.

write To save **file**s onto **disk**. Opposite of **read**.

write mask The portion of the **permission**s on a **file** that determines who can modify and **write** to that file. See also **read** and **execute**.

write only A **file** whose **permission**s allow it to be written to only. No **user**s can **read** or **execute** that file. See also **read only**, **execute only**.

Writer's Guild of America (WGA) The professional union that negotiates the writing and working conditions for writers in **film**, television, cable, and new media industries.

WS Abbreviation for **wide shot (WS)**.

WWW Abbreviation for **World Wide Web (WWW)**.

X 1. Referring to the **X channel** or **X-axis**. 2. Abbreviation for a **frame**, where 48x means 48 frames. 3. See **X frame** 4. Shorthand for the **X window system**. 5. The letter *X* is also used to imply magnification, as in a 10X magnification, which is ten times the normal magnification.

X-axis Generally referring to the **horizontal axis** for both **2D** and **3D work**. Sometimes also called the **east/west axis**.

X channel Generally refers to the numerical **value**s representing the **translation**, **rotation**, and **scale** of an **object**, **image**, or **camera** along the **X-axis**.

X crop The number of **pixel**s in **width** that define the portion of an **image** to **crop** in the **X-axis**.

X direction The direction of the **X-axis**. In a **Y-up** world, this would be along the **horizontal axis**.

xform Abbreviation for **transform**.

X frame An additional single **frame** of reference shot on **film** to aid in syncing **picture** and **sound**. This frame is often represented with a **bloop light** or an actual frame with an *X* on it.

X mirror Synonymous with **flip**. See also **flop**, **mirror**.

Xmodem A **file transfer protocol (FTP)** for sending and receiving **data** using a **dialup connection**. Xmodems are slower and less efficient than both their successors, **Ymodem**s and **Zmodem**s.

XOR 1. See **XOR operation**. 2. See **XOR operator**.

XOR operation A **compositing operation** that retains both **source images** only where their **alpha channel**s don't overlap. *See also image under **layering operation**, and image on following page.*

XOR operator One of the **Boolean operator**s. See **exclusive operation**.

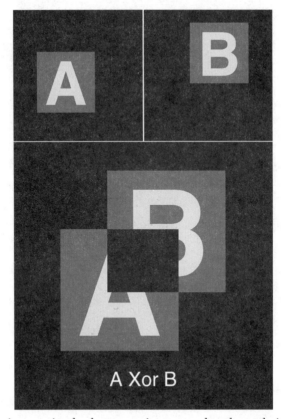

A Xor B

An **XOR operation** retains both **source images** only where their **alpha** channels don't overlap.

X res Abbreviation for **X resolution**. See **horizontal resolution**.

X rotation To orient an **object** or **image** along the **X-axis**. Also referred to as **tilt**. See also **Y rotation**, **Z rotation**.

X resolution See **horizontal resolution**.

X scale To **scale** an **object** or **image** along the **X-axis**. See also **Y scale**, **Z scale**.

X shear To **shear** an **object** or **image** along the **X-axis**. See also **Y shear**, **Z shear**.

X sheet See **exposure sheet**.

X size See **horizontal resolution**.

XY Plane

The **XY plane** is created by the **perpendicular** intersection of the **X** and **Y axes**.

X translation To **translate** an **object** or **image** along the **X-axis**. See also **Y translation**, **Z translation**.

X Windows See **X Window system**.

X Window system A **window system**, developed by MIT, that is **device-independent**. X is commonly used on **Unix** systems.

XY Shorthand for the **XY plane**.

XY plane The **2D plane** that is created by the **perpendicular** intersection of the **X-axis** and **Y-axis** in a **Cartesian Coordinate System**. See also **XZ plane**, **YZ plane**. *See image under **plane**, and image above.*

XY view To **orient** the **camera** perpendicular to the **XY plane** or to be **parallel** with the **XY** plane.

XYZ axes The three **axes** that define the orientation of the **XYZ coordinate system**. *See also image under **plane**.*

XYZ coordinates The **position** of a **point** along the **XYZ axes** in the **XYZ coordinate system**.

XYZ coordinate system A **3D coordinate system** in which the **origin** is located in the center at 0, 0, 0 and all **point**s are defined by their **position** along the **X-axis**, **Y-axis**, and **Z-axis**. The XYZ coordinate system can be oriented as either **Y-up** or **Z-up**.

XZ Shorthand for the **XZ plane**.

XZ plane The **2D plane** that is created by the **perpendicular** intersection of the **X-axis** and **Z-axis** in a **Cartesian Coordinate System**. See also **XY plane**, **YZ plane**, *image under **plane**, and image above.*

XZ view To **orient** the **camera** perpendicular to the **XZ plane** or to be **parallel** with the **XZ** plane.

Y 1. The **Y channel** or **Y-axis**. 2. The abbreviation used to represent the **luminance** value in an **image** or in **component video**. 3. Abbreviation for **yellow** in the **CMY** and **CMYK color models**.

YACC Abbreviation for "Yet another Compiler Compiler." A **compiler** available on most **Unix** systems.

yaw Another name for **pan**.

Y-axis Generally referring to the **vertical axis** for both **2D** and **3D work**. Sometimes also called the **north/south axis**.

Y channel Generally refers to the numerical **value**s representing the **translation**, **rotation**, and **scale** of an **object**, **image**, or **camera** along the **Y-axis**.

Y crop The number of **pixel**s in **height** that define the portion of an **image** to **crop** in the **Y-axis**.

Y/C video Synonymous with **S-Video**. See **Super Video**.

Y depth image See **Y depth matte**.

Y depth map See **Y depth matte**.

Y depth matte A **grayscale image** that represents the **height** from a **ground plane** where each **object** in a **3D scene** resides. The **pixel values** of the **image** can be used in **compositing** to control the amount of **blur** or **atmosphere** that affects objects as they increase in distance from the ground plane. See **Z depth compositing**.

Y direction The direction of the **Y-axis**. In a **Y-up** world, this would be along the **vertical axis**.

yellow One of the **complementary colors** used in the **CMY/CMYK color model**s. Equal amounts of **green (G)** and **red (R)** combined together or the subtraction of **blue (B)** from **white** creates yellow. Adding yellow to an **image** is the equivalent of subtracting blue.

YIQ The **video signal** used to **encode** the components of Y (**luminance**), I (orange-cyan), and Q (green-magenta) together. **Black** and **white** televisions **display** only the Y **component** of the **signal**.

Y map See **Y depth matte**.

Y mirror Synonymous with **flop**. See also **flip**, **mirror**.

Ymodem A **file transfer protocol (FTP)** for sending and receiving **data** using a **dialup connection**. Ymodems are faster and more efficient than **Xmodem**s but slower than their successor, the **Zmodem**.

yon See **far clipping plane**.

yon clipping plane See **far clipping plane**.

Y res Abbreviation for **Y resolution**. See **vertical resolution**.

Y resolution (Yres) See **vertical resolution**.

Y rotation To orient an **image** or **object** along the **Y-axis**. Also referred to as **pan**. See also **X rotation**, **Z rotation**.

Y scale To **scale** an **image** or **object** along the **Y-axis**. See also **X scale**, **Z scale**.

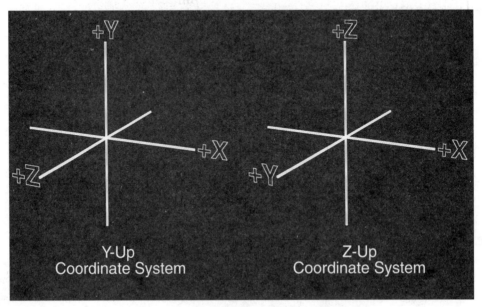

Two variations of **coordinate system orientation**.

Y shear To **shear** an **image** or **object** along the **Y-axis**. See also **X shear**, **Z shear**.

Ysize Abbreviation for **Y size**. See **vertical resolution**.

Y translation To **translate** an **image** or **object** along the **Y-axis**. See also **X translation**, **Z translation**.

Y-up Shorthand for **Y-up coordinate system**.

Y-up world Another name for **Y-up coordinate system**.

Y-up coordinate system In a **Y-up world**, the **X-axis** represents the **horizontal plane**, the **Y-axis** is the **vertical plane**, and the **Z-axis** defines the **depth** of the **scene**. Y-up is a common orientation for **Animator**s and game developers. See also **Z-up coordinate system**, *and image on previous page.*

YUV A **color space** in which **Y** represents the **luminance** and **U** and **V** represent the **chrominance** of an **image** or **video**.

YZ Shorthand for the **YZ plane**.

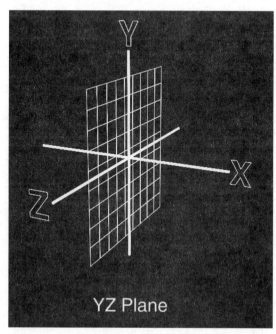

The **YZ plane** is created by the perpendicular intersection of the **X-** and **Z-axes**.

YZ plane The **2D plane** that is created by the **perpendicular** intersection of the **Y-axis** and **Z-axis** in a **Cartesian Coordinate System**. See also **XY plane**, **XZ plane**, *image under **plane**, and image on previous page.*

YZ view To **orient** the **camera** perpendicular to the **YZ plane** or to be **parallel** with the YZ plane.

Z Referring to the **Z channel** or **Z-axis**.

Zapit A **digital disk recorder (DDR)** capable of **real-time playback** of images.

Z-axis Generally referring to the **axis** that represents **depth** for **2D** and **3D work**. Sometimes also called the **near/far axis**, **depth axis**, **third dimension**.

Z-buffer The Z-buffer controls which **3D objects** are **displayed** in the **viewport** in front of other **objects** based on their distance from the **camera view**. The Z-buffer gathers and stores the **depth** information for all objects in a **scene** and then calculates and writes the proper "foreground" **pixels** to the display. Also called the **depth buffer**. See **occlusion**, **draw order**.

Z channel See **Z depth channel**.

Z clipping plane See **far clipping plane**, **near clipping plane**.

Z compositing See **Z depth compositing**.

Z depth 1. In **computer graphics (CG)**, the distance an **object** is from **camera** is referred to as its **Z depth**. This information is used during **rendering** to create **Z depth matte**s. 2. The depth of an object along the **Z-axis** in a **Y-up world**.

Z depth channel 1. A **Z depth matte** that is integrated in with the **RGBA channels** of an **image** as an additional **channel**, rather than being stored as a separate **file**. See **Z depth compositing** 2. Referring to the numerical **value**s of an **object** or **camera** along the **Z-axis**.

Z depth compositing A method of **compositing** that is used to determine the spatial relationships between **objects rendered** from a **3D scene**. During **rendering**, the **field of view (FOV)** created by the **position** of the **camera** relative to the position of all the objects in the **scene** is what determines the portion of the scene that will actually be **rendered**. Not only does the camera **project** onto a **plane** all the objects falling within its field

of view, it also calculates which objects are obscured by other objects closer to camera. In order to use this spatial information during compositing, the renderer can produce a special **grayscale image**, called a **Z depth matte**, in which each **pixel** represents a specific distance from some fixed reference point in the scene. Typically, the darker pixels correspond to the areas in the **image** that are closest to camera, whereas the brighter pixels represent areas further from camera. The Z depth matte is a single-**channel** image that can be stored as a separate **file** or integrated in with the **RGBA** information as an additional channel. When this is the case, it is referred to as the **Z depth channel** of the image. During compositing, not only does the use of this Z depth information automatically calculate the proper **foreground (FG)** and **background (BG)** relationships between the different objects in the scene, but it can also be used to simulate **depth of field (DOF)** and atmospheric effects based on each object's distance from camera. *See also Color Plates 21–26.*

Z depth image Another name for **Z depth matte**.

Z depth map Another name for **Z depth matte**.

Z depth matte A **grayscale image** in which the **pixel**s represent the distance from **camera** where each **object** in a **3D scene** resides, much the way an **alpha channel** stores information regarding the **opacity** for each pixel. These pixel **value**s can be used in **Z depth compositing** to automatically calculate the proper **foreground (FG)** and **background (BG)** spatial relationships between the different objects in the image and as a means of simulating **depth of field (DOF)** and atmospheric effects, such as **fog**, based on each object's distance from camera. However, it should be noted that many **renderer**s produce Z depth mattes without spatial or temporal **anti-aliasing**, which can result to edge **artifact**s during **compositing**. A Z depth matte that is integrated into the **color channel**s of the image as an additional channel is referred to as a **Z depth channel**. Also called **Z map**, **Z matte**, **Z depth image**, **Z image**. *See also Color Plates 21–26.*

Z direction The direction of the **Z-axis**. In a **Y-up** world, this would be along the **depth axis**.

Zeiss 1. The trade name of a brand of professional **camera lens**es. 2. The trade name of a **survey station** used to **survey** location **point**s or **tracking marker**s placed on a **set** to record their **global coordinates** for later use in **3D tracking**.

Z image Another name for **Z depth matte**.

Z map Another name for **Z depth matte**.

Z matte Another name for **Z depth matte**.

zero-dimensional An **object**, such as a **point** or **particle**, that contains no **height**, **width**, or **depth** information. See also **one-dimensional**, **2D**, **3D**.

zero-dimensional array See **scalar**.

zip 1. The original name of a commonly used **text editor** called **jot**. 2. To **compress** a **file**. Opposite of **unzip**.

zip compression One of several commonly used file **compression** utilities, widely used on **MS-DOS** and **Windows**-based **computer**s. Typically, the **filename extension** used to store zip compressed **file**s is .zip.

zip disk A type of **floppy disk** used to **backup** or transfer **data** from one **computer** to another that stores either 100MB or 250MB.

zip drive A portable or built-in **disk drive** from Iomega Corp. that **read**s and **write**s **zip disk**s.

zip file A **file** that has been **compress**ed and contains a .zip **filename extension**. In general, the file needs to be **decompress**ed to access its contents.

zip pan Another name for **swish pan**.

Zmail One of a wide variety of **electronic mail (e-mail)** programs for **DOS** and **Unix**.

Zmodem A **file transfer protocol (FTP)** for sending and receiving **data** using a **dialup connection**. Zmodems are faster and more efficient than **Xmodem**s and **Ymodem**s.

zoom 1. To magnify or push in on a portion of a **scene** by increasing the **focal length** of the **camera lens** on the **physical camera** or **virtual camera**. A zoom involves no movement of the **camera location** and creates no change in **perspective**. 2. A method of simulating the effects of a camera zoom on a **digital image** by pushing in or pulling back from the desired **image** area. A **zoom in** magnifies a portion of the image, whereas a zoom out **scale**s down the image. 3. A common **software application** that allows the **user** to temporarily magnify or push out a portion of the **screen**. See **push in**, **pull out**.

zoom in 1. To adjust the camera **zoom** so that the **angle of view** decreases and the **focal length** of the **lens** increases so that the **subject** becomes larger in frame. Zooming in tends to decreases **depth of field (DOF)** and

flattens the sense of **depth**. Opposite of **zoom out**. 2. To **push in** to an **image** or **object**. Opposite of zoom out.

zoom lens A **camera lens** that has a variable **focal length**, as opposed to a **prime lens** which has a fixed focal length. Zoom lenses contain an additional ring besides the normal **focus** and **iris** rings that allows the focal length to be adjusted. Also referred to as a **variable focal length lens**. See also **telephoto lens, anamorphic lens, normal lens, auxiliary lens**.

zoom out 1. To adjust the camera **zoom** so that the **angle of view** increases and the **focal length** of the **lens** decreases so that the **subject** becomes smaller in frame. Zooming out tends to increase **depth of field**. See also **zoom in**. 2. To **pull out** of an **image** or **object**. Opposite of zoom in.

zoom shot 1. For **film**, any **shot** in which the **camera** uses a **zoom lens** whose **focal length** changes over the duration of the shot. 2. For **digital**, any technique used to **push in** or **pull out** to a portion of a **scene**.

Z rotation (Zrot) To orient an **image** or **object** along the **Z-axis**. Also referred to as **roll**. See also **X rotation, Y rotation**.

Z scale (Zscal) To **scale** an **object** along the **Z-axis**. See also **X scale, Y scale**.

ZSH See **Z shell**.

Z shear To **shear** an **image** or **object** along the **Z-axis**. See also **X shear, Y shear**.

Z shell (ZSH) A **command interpreter** for **Unix**.

Z size See **Z resolution**.

Z translation (Ztran) To **translate** an **image** or **object** along the **Z-axis**. See also **X translation, Y translation**.

Z-up Shorthand for **Z-up coordinate system**.

Z-up world Another name for **Z-up coordinate system**.

Z-up coordinate system In a Z-up world, the **X-axis** is set along the **horizontal plane**, the **Z-axis** along the **vertical plane**, and the **Y-axis** represents the **depth** of the **scene**. This is the **orientation** most commonly used by architects and land surveyors, whose main concern is their plans relative to the **ground plane**. For example, when importing **survey data** for use in **3D-tracking**, it is common to swap the Y and Z columns of **data** to convert it from a **Z-up** world to the **Y-up** world in which **Animator**s prefer to work. See also **Y-up coordinate system**.

1/2-inch tape See **VHS tape**.

1/4-inch tape A standard width of **magnetic tape** used to record **sound**.

1D Abbreviation for **one-dimensional** (1D). An **object** that contains only one **dimension** of information. For example, a line that is drawn along the **horizontal axis** in **3D space** contains **width** but no **height** or **depth** information. See also **zero-dimensional**, **2D**, **3D**.

1K See **1K resolution**.

1K resolution A general term referring to any **digital image** containing an **X resolution** of approximately 1000 **pixel**s. The actual dimensions of the **X** and **Y resolution** of a 1K image depends on the required **aspect ratio** of the final images. A commonly used 1K resolution used in **visual effects (VFX)** is 1024 × 778 when working with **full aperture** framing. See also **2K**, **3K**, **4K**.

1-point track See **one-point track**.

1's See **on one's**.

1st AC Abbreviation for **First Assistant Cameraman (1st AC)**. See **Assistant Cameraman**.

1st AD See **Assistant Director (1st AD)**.

1st Assistant Cameraman See **Assistant Cameraman**.

1st Assistant Director (1st AD) See **Assistant Director (1st AD)**.

1st Assistant Editor (1st AE) See **Assistant Editor (1st AE)**.

1st generation See **first generation**.

1st Unit See **First Unit**.

10Base-2 An **ethernet** standard for **local area network**s **(LAN)** that **transmit**s information between **computer**s across **coaxial cable**s at 10 **megabits per second (MBPS)**. Also referred as **thinnet**. See **10Base-T**.

10Base-T An **ethernet** standard for **local area networks (LAN)** that **transmit**s information between **computer**s across **twisted pair cable**s at 10 **megabits per second (MBPS)**. Also referred to as **twisted pair ethernet**. The cable is thinner and more flexible than the **coaxial cable** that is used for the its counterpart, **10Base-2**.

100Base-T An **ethernet** standard for **local area networks (LAN)** that **transmit**s information between **computer**s across **twisted pair cable**s at 100 **megabits per second (MBPS)**. Also referred as **fast ethernet, twisted pair ethernet**.

1000Base-T An **ethernet** standard for **local area networks (LAN)** that **transmit**s information between **computer**s across **twisted pair cable**s at 1000 **megabits per second (MBPS)**. Also referred as **gigabit ethernet, twisted pair ethernet**.

10-bit See **10 bits per channel**.

10-bit color See **10 bits per channel**.

10-bit image Any **image** containing a total of 10 **bits** of **color** information per **pixel**. The most widely used 10-bit **image format** used in **visual effects work** is the **Cineon file format**.

10 bits per channel See **Cineon file format**.

10 bits per component See **10 bits per channel**.

100% color bars A common standard for **color bars** used to determine **video signal** quality. See also **75% color bars**, **SMPTE color bars**, *Color Plate 8.*

12-bit See **12 bits per channel**.

12-bit color See **12 bits per channel**.

12 bits per channel Typically, a **hardware**-based **image format** that can represent up to 12 **bits** of information per **channel**. Not really a specific **file format**. See **Inferno**.

12 bits per component See **12 bits per channel**.

12-field chart See **field chart**.

1.33 See **1.33 format**.

1.33 format The **aspect ratio** of **image**s displayed on most **monitor**s. **NTSC** and **PAL** are **display**ed with a **1.33:1** aspect ratio. Also referred to as **fullscreen, 4:3**. See also **16:9**.

1.33:1 See **1.33 format**.

15-bit color Any **display device** with 15-bit **color** can **display** 32,768 colors. **Digital video** requires a minimum of 15-bit color.

16:9 An **aspect ratio** typically used display **image**s for **high definition television (HDTV)**. See also **4:3**.

16-bit 1. See **16 bits per channel**. 2. See **16-bit display**.

16-bit color 1. See **16 bits per channel**. 2. See **16-bit display**.

16-bit computer Any **computer** whose **central processing unit (CPU)** can **process** 16 **bit**s of information at one time.

16-bit display Any **display device** with 16-**bit** color can **display** 65,536 **color**s.

16-bit image 1. An **image** that uses a total of 16 **bit**s of **data** to represent **color** information. 2. A term commonly used to describe an **image** containing **16 bits per channel**.

16 bits per channel An **image** with 16 **bit**s per channel can have 65,536 (2^{16}) different possible **color value**s for each **channel**. The combination of all three **component**s can represent about 281 trillion **color**s by computing 2^{48} or $65536 \times 65536 \times 65536$. While many **feature film**s have successfully delivered their **visual effects work** using images with **8 bits per channel**, it has become more commonplace to opt for the higher-color range found in a **48-bit image** with 16 bits per channel. See also **bit depth**.

16 bits per color channel Synonymous with **16 bits per channel**.

16 bits per component Another term for **16 bits per channel**.

16-millimeter film See **16mm film**.

16mm See **16mm film**.

16mm film A **film format** with a **gauge** of 16mm that carries only two **perforation**s along each **frame** and contains 40 frames per foot. Because the **captured image** area is significantly smaller than that of **35mm film**, this **film format** is rarely used for **visual effects work**. However, 16mm is still widely used for documentaries and television commercials.

1.66 See **1.66 format**.

1.66:1 See **1.66 format**.

1.66 extraction To use only the portion of an **image** representing a 1.66:1 **aspect ratio**. See **1.66 format**.

1.66 format Pronounced "one-six-six format," this is the most common **aspect ratio** used for movies in Europe. It can also be written as 1.66:1, which means that the **image** is 1.66 times as wide as it is high. As with the **1.85**, the **projector** is **mask**ed during **projection** to show only the image area that falls within this framing. See also **2.35**, **35mm film**. *See also images under film extraction*.

18% gray card See **gray card**.

1.85 See **1.85 format**.

1.85:1 See **1.85 format**.

1.85 extraction To use only the portion of an **image** representing a 1.85:1 **aspect ratio**. See **1.85 format**.

1.85 format Pronounced "one-eight-five format," this is the most common **aspect ratio** used for movies in the United States. It can also be written as 1.85:1, which means that the image is 1.85 times as wide as it is high. Generally, a **mask** is placed over the **projector** during **projection** to block the area of the **frame** that falls outside the 1.85 border. For **visual effects work**, it is not uncommon to **hard mask** the delivered **image**s with black in order to save on **disk space** and computing time. See also **1.66**, **2.35**, **35mm film**, *Color Plates 50–53, and image under film extraction*.

2-dimensional See **2D**.

2-dimensional array See **2D array**.

2'S See **on two's**.

2D Shorthand for **two-dimensional (2D)**. It means having only two dimensions, most often, **width** and **height**. The term 2D is generally used to describe **flat artwork**, **geometry**, or **image**s that contain **X** and **Y** coordinates or **pixel** information, but no **Z-depth** information. However, even in the absence of true Z information, 2D images can be created to have the illusion of **depth**. See also **1D** and **3D**.

2D animation Any **animation** created in **2D space** on a **computer** or hand-drawn **frame** by frame on **cel**s.

2D Animator An **Animator** who works in **2D space** on a **computer** or hand draws each **frame** for **cel animation**.

2D array Synonymous with **vector**. See also **matrix**.

2D Artist A global term referring to any artist whose tasks focus primarily on **2D work**, such as **matte painting**, **rig removal**, **dust busting**, **rotoscoping** and **compositing**, and **morphing**. See **3D Artist**.

2D digitize The process of **scanning** flat artwork into a **computer** and storing it as a **digital image**. See also **3D digitize**.

2D face A closed **curve** that is **planar**. See **face**.

2D geometry See **2D model**.

2D graphics Referring to **digital image**s that are created in **2D space**, rather than in **3D space**.

2D image See **digital image**.

2D layout The process of using detailed **2D** drawings to represent the main features of a **scene**, as opposed to a **3D layout** which uses the **computer** to create a **3D** representation of the scene. 2D layout is used, most commonly, for **cel animation**. See **layout**, *Color Plate 37.*

2D logo Generally, referring to numbers or letters that have been designed in **2D space**, as opposed to a **3D logo** that is generally **extrude**d and **bev-el**led in **3D space**.

2D map See **2D texture**.

2D model Any **object** created in **3D space** that contains only **2D** information, such as its **height** and **width**, but contains no **depth**. A **plane** is an example of a **2D** model. Also called **2D object**, **2D geometry**, **2D surface**. See also **3D model**.

2D morph An **image process** in which two distinct **image** sequences are **warp**ed in such a way that similar key features are lined up as closely as possible and selectively **cross dissolve**d from one **sequence** to the other. The first step is to identify the key features in *Image A* that correspond to the key features in *Image B* and then **warp** Image A over a period of time to end up looking as close as possible as Image B and warp Image B over time to end up looking as close as possible to Image A. Once the two sequences are created, the Image B sequence is reversed so that it starts with the distorted version of Image A, and a simple cross dissolve used between the two warped sequences over time produces the final 2D morph.

2D motion blur **Motion blur** that is added as a **post process** to **CG** elements or during **compositing** to **2D** or **3D element**s that have had an additional **2D move** applied. See also **3D motion blur**.

2D move A **transformation** that moves an **object** or image in **2D space** via an **X** or **Y translation** or a **Z rotation**. See **3D move**.

2D object See **2D model**.

2D package See **2D software package**.

2D paint Any **paint work** that is performed on a **digital image**, as opposed to **3D paint** which works directly on a **3D model**.

2D pipeline The 2D pipeline of a **project** involves all aspects of **2D work**, such as **color grading**, **matte painting**, **rotoscope**, **paint work**, and **compositing**, as well as the chosen **software package**s, **naming conventions**, and all other standards that are defined for those tasks.

2D plane See **plane**.

2D software A **software application** specifically designed to allow the **user** to create and modify **image**s using any combination of **image processing**, **paint tools**, and **compositing** techniques. Popular **2D software package**s used include **Flame** and **Shake** for **compositing**, **Photoshop** for **paint work**, and **Elastic Reality (ER)** for **morph**ing and **articulate matte**s. See also **paint software**, **2D tracking software**, **compositing software**.

2D software package Any **2D software** that is sold as **3rd-party software**.

2D space Any **coordinate system** in which **object**s and **image**s can be created, modified, and **display**ed as coordinates along the **X** and **Y** axes but not along the **Z axis**.

2D surface See **2D model**.

2D texture Any **digital image** that is used as a **texture map**. Also called a **2D map**.

2D tracking The process of deriving **motion curve**s from a **sequence** of **image**s by selecting a **region of interest (ROI)** in those images and calculating their movement over time. The **data** derived by a 2D track is dependent on the number of **point**s tracked. For example, a **one-point track** will yield only **X translation** and **Y translation** information, whereas a **two-point track** can additionally reproduce changes in **scale** and **rotation**al information that occurs between the two points. It is common practice to place **tracking marker**s on the **set** during **filming** to ensure high-**contrast** points are available to track. See also **3D tracking**, **four-point track**.

2D tracking software A **software application** specifically designed to allow the **user** to extract **motion curve**s in **2D space** from an **image**. The

Discreet Logic family of **compositing package**s offers very powerful **2D tracking** capabilities. See also **3D tracking software**.

2D transform The **transformation** of an **image** or **object** in **2D space**. See **3D transform**.

2D work All aspects of **digital effects work** that are performed on **digital image**s, such as **grading**, **matte painting**, **rotoscoping**, **dustbusting**, **rig removal**, **compositing**, and **morphing**. See **3D work**.

2K Abbreviation for **2K resolution**.

2K resolution A general term referring to any **digital image** containing an **X resolution** of approximately 2000 **pixel**s. The actual dimensions of the **X** and **Y resolution** of a 2K **image** depends on the required **aspect ratio** of the final images. A commonly used 2K resolution use in **visual effects (VFX)** is 2048 × 1556 when working with **full aperture** framing. See also **1K**, **3K**, **4K**.

2nd AC Abbreviation for **Second Assistant Cameraman (2nd AC)**.

2nd AD Abbreviation for **Second Assistant Director (2nd AD)**.

2nd AE Abbreviation for **Second Assistant Editor (2nd AE)**.

2nd Assistant Cameraman (2nd AC) See **Second Assistant Cameraman (2nd AC)**.

2nd Assistant Director (2nd AD) See **Second Assistant Director (2nd AD)**.

2nd Assistant Editor (2nd AE) See **Second Assistant Editor (2nd AE)**.

2nd generation See **second generation**.

2nd Unit See **Second Unit**.

2nd Unit Director See **Second Unit Director**.

2-perf Nickname for **16mm film** because it carries only two **perforation**s for each **frame**.

2-point track See **two-point track**.

2:3 pulldown One method for converting standard **film** frames running at **24 FPS** into **NTSC video** frames running at **30 FPS**. The process involves taking a film **frame** and converting it into two **field**s of **video** and then taking the next frame of film and converting into three fields of video. This alternation between two fields and three fields is done as a means of synchronizing the film timing to video timing. In this manner, film frame #1 is used to create the two fields of video frame #1, film frame #2 creates both fields for video frame

Film Frames	Video Fields	Video Frames
1	1A	1
	1B	
2	2A	2
	2B	
	2C	3
3	3A	
	3B	4
4	4A	
	4B	5
	4C	

The **2:3 pulldown** conversion.

#2 and the first field of video frame #3. Film frame #3 is then used to create the second field of video frame #3 and the first field of video frame #4, and finally, film frame #4 is used to create the second field of video frame #4 and both fields of video frame #5. Thus, it takes 4 film frames to create exactly 5 video frames, which results in 24 film frames equaling 30 video frames. In a case where the film is being shot intentionally for a video transfer, the frame rate of the film **camera** can be adjusted to **shoot** at 30 FPS as a means of avoiding any pulldown conversions. Pronounced as "two-three pulldown." Also called **3:2 pulldown, pulldown**. *See image above.*

2:3 pullup A method for converting between **NTSC** video running at **30 FPS** and standard **film** at **24 FPS**. The **video** frames must first be **deinterlace**d to produce film **frame**s. A **Telecine** device is used to calculate the appropriate **frame rate** conversions. Also called a **3:2 pullup, pullup**.

2.35 See **2.35 format**.

2.35:1 See **2.35 format**.

2.35 extraction To use only the portion of an **image** representing a 2.35:1 **aspect ratio**. See **2.35 format**.

2.35 format Pronounced "two-three-five format," 2.35 is a widely used **aspect ratio** for **film**. It can also be written as 2.35:1, which means that the **image** is 2.35 times as wide as it is high. **Cinemascope** and **Super 35** are most commonly used as the **acquisition format** to acquire this **widescreen** format. See also **1.85**, **1.66**, **35mm film**, **common topline**. *See also Color Plate 56–57, 60* and *image under **film extraction***.

2.40 format Pronounced "two-four-o format," referring to 2.40:1 **anamorphic**. In the early 1970s, the **aspect ratio** was slightly modified by **SMPTE** as a way to help hide **film splice**s. Even though the aspect ratio used is actually 2.40, it is generally still referred to as 2.35 anamorphic.

24-bit 1. See **24-bit display** 2. See **24-bit image**.

24-bit color See **24-bit display**.

24-bit display Any **display device** with 24-**bit** color can **display** 16.8 million **color**s.

24-bit image A 24-**bit** image contains **8 bits per channel** for the three **channel**s of **red (R)**, **green (G)**, and **blue (B)**. The only difference between a 24-bit image and a **32-bit image** is that the 32-bit image contains a fourth **alpha channel** and therefore holds an additional 8 bits of information to represent it. However, as the alpha channel does not contain **color** information, there are no color differences between the two **format**s.

24 FPS Abbreviation for **24 frames per second (24 FPS)**.

24 frames per second (24 FPS) The standard speed at which **film image**s are **capture**d and **project**ed. See also **30 frames per second (30 FPS)**, **25 frames per second (25 FPS)**.

2.5D Pronounced "**two-and-a-half D**," any **image processing** technique that attempts to trick the **viewer** into believing that the **2D image**s they are seeing are actually true **render**ings of **3D object**s. Some of the methods used include **corner pin**ning, **image warp**ing, **2D morph**ing, and **matte painting**. See also **photogrammetry**.

25 FPS Abbreviation for **25 frames per second (25 FPS)**.

25 frames per second (25 FPS) The speed at which **PAL video** is **capture**d and played back. When speaking in terms of **field**s, the equivalent to **25 FPS** is **50 fields per second**. See also **24 frames per second (24 FPS)**, **30 frames per second (30 FPS)**, **60 fields per second**.

3/4 tape See **three-quarter-inch tape**.

3D Abbreviation for **three-dimensional (3D)**. 1. Relating to the ability to view an **object** in **perspective** from any **viewing angle**. The term 3D is generally used to describe **geometry** containing **XYZ coordinates** that represent its **height**, **width**, and **depth**. 2. Often used to describe **stereo images**. See also **1D**.

3D animation Any **animation** created in **3D space** on a **computer**.

3D Animator An **Animator** who works in **3D space** on a **computer**.

3D Artist A global term referring to any artist whose tasks focus primarily on **3D work**, such as **modeling**, **surfacing**, **layout**, **animation**, **effects**, **lighting**, and **render**ing.

3D camera 1. Any **camera** used in a **computer** that can represent the three **axes** of XYZ. Also referred to as a **digital camera** or **CG camera**. 2. Any camera capable of taking **stereoscopic image**s.

3D character See **digital character**.

3D computer graphics Referring to the creation and **render**ing of three-dimensional **model**s in a **computer**.

3D database See **3D scene**.

3D digitize The process using a sensor moved by hand across the **surface** of a **physical model** to gather the **3D** data needed to represent the **object** in the **computer**. See also **2D digitize**, **laser scanning**, **faro arm**.

3D digitizing pen See **digitizing pen**.

3D element Any **image** that is **render**ed from a **3D scene**.

3D environment 1. Referring to the **3D space** that is viewed and **render**ed by the **digital camera**. 2. A complete virtual **set** created in 3D space in the **computer**.

3D Equalizer A **3D tracking** software developed and sold by Science.d.Visions in Germany.

3D film 1. A general term referring to a **film** created entirely with **computer graphics (CG)**, such as *Toy Story* or *Antz*. 2. See **stereo film**.

3D geometry See **3D model**.

3D glasses Specially designed glasses that are worn to view a **stereo film**. Some use **red (R)** and **blue (B)** filters to differentiate between the two eyes,

called **anaglyph glasses**. Others use **polarizing filters** and are called **polarized glasses**, and still others use an electronic **shutter** technology called **flicker glasses**.

3D graphics Shorthand for **3D computer graphics**.

3D image 1. Any **image** that was **render**ed from a **3D scene**. 2. See **stereo image**.

3D laser scanner See **laser scanner**—Definition #2.

3D layout The process of creating a representation of a **scene** in **3D space**. 3D layout is used primarily to create the **camera move** and **blocking** of the **character**s and **object**s in the scene before going to the **animation stage**. See also **2D layout**, **layout**, *Color Plates 42, 46.*

3D lighting The process of setting **light**s for an **object** or **scene** in **3D space**.

3D logo Generally, referring to numbers or letters that have been **extrude**d and **bevel**ed in **3D space** as opposed to a **2D logo** that is creation in only one **dimension**. See also **flying logo**.

3D map See **procedural texture**.

3D mapping See **procedural mapping**.

3D model Any **object** created in **3D space** that contains **3D** information based on its **height**, **width**, and **depth**. A cube is an example of a 3D model. Also called **3D object**, **3D geometry**, **3D surface**. See also **2D model**.

3D Modeler See **Modeler**.

3D morph The change in **shape**, or **deformation**, of a **3D object**. See **shape animation**.

3D morph target Unique **keyshape**s created for single or multiple **object**s to **interpolate** across for **shape animation**.

3D motion blur **Motion blur** that is calculated for a **scene** as it is **render**ed, as opposed to applying **2D motion blur** as a **post process**.

3D move Any **camera** or **object** motion performed in **3D space**.

3D object See **3D model**.

3D operation Referring to the manipulation of an **object** in **3D space**.

3D package See **3D software package**.

3D paint A **paint package** that allows an artist to paint **texture**s directly onto the **surface** of an **object** in **3D space**. As you paint, the **software** automatically creates predistorted **texture map**s to create accurate mapping.

3D photography See **stereoscopic photography**.

3D pipeline The 3D pipeline of a **project** involves all aspects of **3D work**, such as **modeling**, **previs**, **layout**, **animation**, **shading**, **lighting**, and **effects**. Basically, any task that is performed in **3D space** within a **3D package**. See also **2D pipeline**.

3D scanner See **laser scanner**—Definition #2.

3D scene The **motion curve**s, **object**s, **light**s, **material**s, and **texture**s that define the **attribute**s of a **scene** created in a **3D package**. Also called a **3D database**.

3D screen A specially designed **projection screen** used for **3D film**s. They are painted with a silver paint that helps to maintain the **polarity** of the light for the **viewer**.

3D software A **software application** specifically designed to allow the **user** to create and modify **geometry** in **3D space**. Popular **3D software package**s include **Maya**, **Houdini**, **Softimage**, **Lightwave**, and **3D Studio Max**. See also **2D software**.

3D software package Any **3D software** that is sold as **3rd-party software**.

3D space Any **coordinate system** in which **object**s can be created, modified, and **display**ed as **coordinate**s along the **XYZ axes**. See **2D space**, **Cartesian Coordinates**.

3D Studio Max A **3D software package** distributed by **Autodesk**.

3D surface See **3D model**.

3D texture See **procedural map**.

3D texture map See **procedural map**.

3D texture mapping See **procedural mapping**.

3D tracking Unlike **2D tracking**, 3D tracking can recreate a full **3D camera** move from a **sequence** of **plate**s. The information extracted with 3D tracking includes the **camera lens**, **field of view (FOV)**, **XYZ translation**, and **rotation**. A number of **3rd-party package**s, such as **Ras_Track** and **3D Equalizer**, are widely used, although many facilities have written their own **proprietary software** to accomplish the tracking required for their **visual effects work**. While it is still common to acquire **survey data** to accom-

plish an accurate track, many packages have become efficient at recreating the camera information in the absence of survey data. See also **match move**, *Color Plate 58.*

3D tracking software A **software application** specifically designed to allow the **user** to extract **motion curve**s in **3D space** from an **image**. **Ras_Track** and **3D Equalizer** are widely used 3D tracking software packages. See also **2D tracking software**.

3D transform The **transformation** of an **image** or **object** in **3D space**. See **2D transform**.

3D work All aspects of **visual effects work** that is performed in **3D space**, such as **modeling**, **previs**, **layout**, **animation**, **effects**, and **lighting**. See also **2D work**.

3D view 1. A **perspective camera** view in a **3D software package**. 2. The ability of the brain to process visual information received by each eye into an **image** containing **depth**. See **depth perception**. 3. See **stereoscopic viewing device**.

3D viewing system See **stereo viewing system**.

3K Short for **3K resolution**.

3K resolution A general term referring to any **digital image** containing an **X resolution** of approximately 3000 **pixel**s. The actual dimensions of the **X** and **Y resolution** of a 3K image depends on the required **aspect ratio** of the final images. A commonly used 3K resolution use in **visual effects (VFX)** is 3072×2334 when working with **full aperture** framing. See also **1K**, **2K**, **4K**.

3rd generation See **third generation**.

3rd-party Shorthand for **3rd-party software**.

3rd-party package Another term for **3rd-party software**.

3rd-party software Any **software package** that is created, maintained, and sold by a company or business.

3×3 matrix A **transformation matrix** used to define **translation**s, **rotation**s, and **scale** in **2D space**, as opposed to a 4×4 **matrix** which is used to define the translations, rotations and scale of an **object** in **3D space**.

30 FPS Abbreviation for **30 frames per second (30 FPS)**.

30 frames per second (30 FPS) The speed at which **NTSC video** is played back. However, it should be noted that the "actual" **playback** speed of NTSC is 29.97. When speaking in terms of **field**s, the equivalent to 30 FPS is **60**

fields per second. See also **24 frames per second (24 FPS)**, **25 frames per second (25 FPS)**.

32-bit 1. See **32-bit display**. 2. See **32-bit image**. 3. See **32-bit computer**.

32-bit color See **32-bit display**.

32-bit computer Any **computer** whose **central processing unit (CPU)** can **process** 32 **bit**s of information at one time.

32-bit display A **display device** with **24-bit color** that can **display** 16.8 million **color**s. A 32-bit display does not add more colors, but it does allow for additional masking and **channel**ing capabilities.

32-bit image A 32-bit **image** contains **8 bits per channel** for the four **channel**s of **red (R)**, **green (G)**, **blue (B)**, and **alpha**. The only difference between a 32-**bit** image and a **24-bit image** is that the 24-bit image does not have an **alpha channel** and therefore can be represented with 8 fewer bits of information. However, as the alpha channel does not contain color information, there are no color differences between the two **format**s. See also **Cineon file format**.

3:2 pulldown See **2:3 pulldown**.

3:2 pullup See **2:3 pullup**, and *image under 2:3 pulldown*.

3200 Kelvin The approximate **color temperature** of a **Tungsten light source**. See also **daylight light source**.

35 mm See **35mm film**.

35 millimeter camera Any **camera** that uses **35mm film**.

35 millimeter film See **35mm film**.

35mm film 35mm is the most common **film format** used in professional moviemaking. Each **frame** contains a **gauge** of 35mm and four **perforation**s (thus, its nickname **4-perf**) and 16 **frames per foot**. The **sound stripe** runs along the left side of the **film** between the perforations and the **image**. There are many different formats that use 35mm film, such as **Super 35**, **Cinemascope**, and **Vista Vision**. See **full aperture**, **Academy aperture**. *See also image under Vista Vision*.

36-bit image An **image** with **12 bits per channel** is also referred to as a 36-**bit** image—12 × the three **channel**s **red (R)**, **green (G)**, and **blue (B)**. The combination of all three **component**s represent about 65 billion **color**s. See also **bit depth**, **Inferno**.

3-channel image Another name for an **RGB image**.

3-dimensional (3D) See **3D**.

3-perf A technique used to maximize the use of **raw film stock** in **1.85 formats** so that almost no film is wasted. Most **cameras** use a **4-perf** pulldown that creates a lot of unused **film** between the **captured images**, whereas a 3-perf **pulldown** positions the captured **images** closer together.

4:3 The **aspect ratio** used on most **monitors**. See **1.33 format**.

4-bit 1. See **4 bits per channel**. 2. See **4-bit display**.

4-bit color See **4-bit display**.

4-bit display Any **display device** with 4-**bit** color can **display** 16 **colors**. The use of 4-bit color produces a very low quality **image**.

4 bits per channel An **image** with 4 **bits** per channel can have 16 (2^4) different possible **color value**s for each **channel**. The combination of all three **component**s in a three-channel image can represent 4096 colors by computing 2^12 or (16 × 16 × 16). While this **bit depth**, also referred to as a **12-bit** image, is insufficient for **video** and **film** work due to the resulting **image quantization**, it has been successfully used for low-end video games.

4 bits per color channel Synonymous with **4 bits per channel**.

4 bits per component Another term for **4 bits per channel**.

4-channel image Another name for an **RGBA image**.

4-corner grad See **four-corner gradation**.

4-corner gradation See **four-corner gradation**.

4K See **4K resolution**.

4K resolution A general term referring to any **digital image** containing an **X resolution** of approximately 4000 **pixels**. The actual dimensions of the **X** and **Y resolution** of a 4K image depends on the required **aspect ratio** of the final **image**s. A commonly used 4K **resolution** use in **visual effects (VFX)** is 4096 × 3112 when working with **full aperture** framing. See also **1K resolution**, **2K resolution**, **3K resolution**.

4-perf Another name for the standard **35mm film** format based on the fact that each **frame** contains four **perforation**s along each **edge**. See also **8-perf**.

4-point track See **four-point track**.

4's See **on four's**.

4:1:1 These numbers represent the number of **YUV** samples stored within a 2×2 **pixel** block in a **digital image**. In this case, for every four pixels, only one of the four contains both **luminance** (**Y**) and **UV** (**chroma**), whereas the remaining three contain only luminance information. See **4:1:1 compression**.

4:1:1 compression This method of **image compression** samples **Y** (**luminance**) for every **pixel** but removes every other **UV** (**chroma**) pixel in both the **horizontal** and **vertical** direction. For most **JPEG** implementations, this method is the default **compression**. The **YUV** samples for each 2×2 **matrix** of pixels in the resulting compressed **image** would be represented like this:

YUV Y

Y Y

4:2:2 These numbers represent the number of **YUV** samples stored within a 2×2 **pixel** block in a **digital image**. In this case, for every four pixels, only two of the four contain both **luminance** (**Y**) and **UV** (**chroma**), whereas the remaining two contain only luminance information. **D1 video** and **Betacam SP** are examples of 4:2:2. See also **4:2:2 compression**.

4:2:2 compression This method of image **sampling** samples **Y** (**luminance**) for every **pixel** but removes every other **UV** (**chroma**) pixel in the **horizontal** direction. Because the sampling is greater in the **X** (horizontal) direction than in **Y** (**vertical**) direction, the resulting **image artifact**s are also different for both directions. While this is the sampling scheme used for **D1 video**, the artifacts are less obvious due to the fact that **video resolution** images use **nonsquare pixel**s and the sampling is higher in the horizontal direction. A benefit of using this sampling scheme as an option for **JPEG compression** is that it is commonly supported by **video hardware** and can therefore promote **decompression** of JPEG image sequences (motion JPEG) in **real-time**. The **YUV** samples for a 2×2 **matrix** of pixels in the resulting compressed image would be represented like this:

YUV Y

YUV Y

4:2:2 D1 See **D1**.

4:4:4 These numbers represent the number of **YUV** samples stored within a 2×2 **pixel** block in a **digital image**. In this case, for every four pixels, all

four pixels contain both **luminance (Y)** and **UV (chroma)**. See also **4:4:4 compression**.

4:4:4 compression This method of **image compression** samples **Y (luminance)** and **UV (chroma)** for every **pixel** in the **image**. This method of **compression** yields a higher image quality but also creates a much larger image **file** than either **4:1:1** or **4:2:2 compression**. The **YUV** samples for a 2 × 2 **matrix** of pixels in the resulting compressed image would be represented like this:

YUV YUV

YUV YUV

4 × 4 matrix A **transformation matrix** used to define **translations**, **rotations**, and **scale** in **3D space**, as opposed to a **3 × 3 matrix**, which is used to define the translations, rotations, and scale of an **object** in **2D space**.

48-bit image A 48-**bit** image contains **16 bits per channel** for the three **channel**s of **red (R)**, **green (G)**, and **blue (B)**. The only difference between a 48-bit image and a **64-bit image** is that the 64-bit image contains a fourth **alpha channel** and therefore holds an additional 16 bits of information to represent it. However, as the alpha channel does not contain **color** information, there are no color differences between the two **format**s.

5-perf Nickname for **65mm film**. See also **70mm film**.

50 fields per second The equivalent to **25 frames per second (25 FPS)** when speaking in terms of **field**s. See also **60 fields per second**.

5400 Kelvin The approximate measurement in **Kelvin** of "natural" daylight on a clear day. The sun has a surface of about 6000K, but by the time the skylight from the sun has been scattered and filtered through the earth's atmosphere, the light hitting the earth is at approximately 5400K. See also **3200 Kelvin**, **6500 Kelvin**.

60 fields per second The equivalent to **30 frames per second (30 FPS)** when speaking in terms of **field**s. See also **50 fields per second**.

64-bit See **64-bit image**.

64-bit image A 64-**bit** image contains **16 bits per channel** for the four **channel**s of **red (R)**, **green (G)**, **blue (B)**, and **alpha**. The only difference between a 64-bit **image** and a **48-bit image** is that the 48-bit image does not have an **alpha channel** and therefore can be represented with 16 fewer bits of information. However, as the alpha channel does not contain **color** information, there are no color differences between the two **format**s.

6500 Kelvin The approximate **color temperature** that **white** should read on a professionally adjusted broadcast **monitor**. See also **5400 Kelvin**, **3200 Kelvin**.

65mm See **65mm film**.

65 millimeter film See **65mm film**.

65mm film A popular **wide-screen** format that contains five **perforation**s (hence, the nickname **5-perf**) and uses a 1.85:1 **aspect ratio** with an area 4.5 times larger than the **image** captured on **35mm film**. The 65mm is usually **print**ed onto **70mm film** stock and, due to its **high resolution**, is sometimes used for **visual effects work**. See also **IMAX**, **8mm film**, **16mm film**.

70mm See **70mm film**.

70-millimeter film See **70mm film**.

70mm film The widest-**gauge** film format, containing twice the **width** of standard **35mm film** and a **project**ing **aspect ratio** of 2.2:1. 70mm film is actually 65mm wide, which saves 5mm of space on the **print** for the **sound track**s. Each frame is **5-perf**s and has 2.5 times the **image area** of an **anamorphic** frame and 3 times the area of **Academy aperture**. The typical working **image resolution** of images **capture**d on 70mm film is 4096 × 1840. The actual **image** area on the film is 1.912″ × .87″. See also **IMAX**. *See also image under anamorphic.*

75% color bars A common standard for **color bars** used to determine **video signal** quality. See also **100% color bars**, **SMPTE color bars**, *Color Plate 9.*

8 bit 1. See **8 bits per channel**. 2. See **8-bit image**. 3. See **8-bit display**.

8-bit color 1. See **8 bits per channel**. 2. See **8-bit image**. 3. See **8-bit display**.

8-bit computer Any **computer** whose **central processing unit (CPU)** can **process** 8 **bit**s of information at one time.

8-bit display Any **display device** with **8-bit color** can **display** 256 **color**s. **Image**s with a **bit depth** greater than 8-bit tend to be **dither**ed on such a device.

8-bit image 1. An 8-bit image contains only a total of 8 bits of color information per **pixel**. Because this limits the **display** to only 256 possible **color value**s, a workaround was created, known as **color index**ing, in which those 256 values are used to look up colors in an index containing many more colors. Because two different images probably won't use all 256 col-

ors, new colors can be added as needed. 2. A term commonly used to describe an **image** containing **8 bits per channel**.

8 bits per channel An **image** with 8 **bit**s per channel can have 256 (2^8) different possible **color value**s from 0 to 255 for each **channel**. The combination of all three **component**s in a **three-channel image** can represent 16,777,216 **color**s by computing 2^24 or (256 × 256 × 256). This **bit depth** can also be referred to as a **24-bit image**. See also **12 bits per channel**.

8 bits per color channel Synonymous with **8 bits per channel**.

8 bits per component Another term for **8 bits per channel**.

8-millimeter film See **8mm film**.

8mm film The narrowest **gauge** film available that runs 74 **frames per foot**. This **film format**, used most often for experimental **films**, has been largely replaced by **Super 8mm film**. See also **16mm film, 35mm film, 65mm film, 70mm film**.

8-perf A nickname for **Vista Vision**.

8's See **on eight's**.

References

Books

Anderson, Gail and Paul Anderson. 1986. *The UNIX C shell field guide.* Engelwood Cliffs, NJ: Prentice Hall.

Brinkmann, Ron. 1999. *The art and science of digital compositing.* San Diego, CA: Morgan Kaufmann Publishers.

Brown, Blaine. 1994. *The filmmaker's pocket reference.* Woburn, MA: Focal Press.

Digital fact book, The. 8th ed.1996. London: Quantel Limited.

Dobbs, Darris and Bill Fleming. 1999. *Animating facial features and expressions.* Hingham, MA: Charles River Media.

Dougherty, Dale. 1997. *Sed & awk.* Cambridge, MA: O'Reilly & Associates, Inc.

Elkins, David E. 1996. *The camera assistant's manual.* 2d ed. Woburn, MA: Butterworth-Heinemann.

Glassner, Andrew S. 1990. *Graphics gems.* San Diego, CA: Morgan Kaufmann Publishers.

Glassner, Andrew S. 1984. *Computer graphics user's guide.* Sarasota, FL: Howards W. Sams & Co., Inc.

Hollyn, Norman. 1998. *The film editing room handbook.* 3d ed. Los Angeles: Lone Eagle Publishing Company, LLC.

Inferno. 1996. New York: Discreet Logic, Inc.

Katz, Ephraim. 1998. *The film encyclopedia.* 3d ed. New York: HarperResource.

Katz, Steven D. 1991. *Film directing shot by shot: visualizing from concept to screen.* Woburn, MA: Focal Press.

Kelly, Doug. 1998. *Character animation in depth.* Scottsdale, AZ: The Coriolis Group, Inc.

Kernighan, Brain W. and Rob Pike. 1984. *The UNIX programming environment.* Upper Saddle River, NJ: Prentice Hall.

Konigsberg, Ira. 1998. *The complete film dictionary*. London: Penguin.

Lathrop, Olin. 1997. *The way computer graphics works*. New York: John Wiley & Sons, Inc.

Makliewicz, Kris and Jim Fletcher. 1992. *Cinematography: a guide for film makers and*

film teachers. 2d ed. New York: Simon & Schuster, Inc.

Mascelli, Joseph V. 1998. *The five C's of cinematography*. Los Angeles: Silman-James Press.

Masson, Terrence. 1999. *CG 101: a computer graphics industry reference*. Indianapolis, IN: New Riders Publishing.

McAlister, Michael J. 1993. *The language of visual effects*. Los Angeles: Lone Eagle Publishing Company, LLC.

McCord, James W. 1991. *C programmer's guide to graphics*. Carmel, IN: Sams Technical Publishing.

Menache, Alberto. 1999. *Understanding motion capture for computer animation and video games*. San Diego, CA: Morgan Kaufmann Publishers.

O'Rourke, Michael. 1998. *Principles of three-dimensional computer animation*. New York: W. W. Norton & Co.

Ousterhout, John K. 1994. *Tcl and the Tk toolkit*. Boston: Addison-Wesley Longman, Inc.

Przemyslaw, Prusinkiewicz and Aristid Lindenmayer. 1996. *The algorithmic beauty of Plants*. New York: Springer-Verlag.

Ryan, Rod, ed. 1993. *American cinematographer manual*. 7th ed. Hollywood, CA: The ASC Press.

Singleton, Ralph S. 1996. *Film budgeting, or, how much it will cost to shoot your movie?* Los Angeles: Lone Eagle Publishing Company, LLC.

Thomas, Rebecca and Jean Yates. 1985. *The user guide to the UNIX system*. 2d ed. New York: McGraw-Hill, Inc.

Thompson, Catherine, ed. 1993. *Hutchinson dictionary of mathematics*. Oxford, UK: Helicon Publishing Limited.

Throup, David. 1996. *Film in the digital age*. London: Quantel Limited.

Upstill, Steve. 1989. *The RenderMan companion*. Boston: Addison-Wesley Longman, Inc.

Watt, Alan and Mark Watt. 1992. *Advanced animation and rendering techniques: theory and practice,* Boston: Addison-Wesley Longman, Inc.

Wong, Wucius. 1997. *Principles of color design*. New York: John Wiley & Sons.

Online Documentation

Houdini 2.5.2 Docs

Maya 2.0 Docs

SGI Glossary

Shake 2.01 Docs

Softimage 3.5 Docs

Web Sites

Abstract Dimensions
http://www.psptips.com/

Academy of Motion Picture Arts and Sciences Home Page
http://www.oscars.org/academy/index.html

Accelerated Networks Glossary
http://www.acceleratednetworks.com/glossary/glossary.html

Accom Home Page
http://www.accom.com

A Glossary of Film Terms
http://homepage.newschool.edu/~schlemoj/film_courses/
glossary_of_film_terms/glossary.html

American Cinematographer
http://www.cinematographer.com

An Artist's Real-Time 3D Glossary
http://www.mondomedia.net/mlabs/glossary.html

AOL Webopaedia
http://aol.pcwebopedia.com/

Arri Group
http://www.arri.com/

Association for Computing Machinery
http://www.acm.org

Autodesk Home Page
http://www.autodesk.com

A Webwide World
http://www.mrl.nyu.edu/perlin/demox/Planet.html

Basic Internet Terms
http://www.geocities.com/FashionAvenue/4869/desc.html

BAVC Video Glossary
http://www.bavc.org/html/resources/glossary.html

Bay Photo Lab Glossary of Digital Imaging Terms
http://www.bayphoto.com/glossary/

CERN High Speed Interconnect
http://www1.cern.ch/HSI/

CNET: The Computer Network
http://coverage.cnet.com/Resources/Info/Glossary/

CNET Singapore
http://www.singapore.cnet.com/Briefs/Glossary/

Computer Currents High-Tech Dictionary
http://www.currents.net/resources/dictionary/index.html

Computer Effects Glossary
http://library.thinkquest.org/3496/nfglossary.html

DataHiding Glossary
http://www.trl.ibm.co.jp/projects/s7730/Hiding/

Design Glossary
http://www.grantasticdesigns.com/glossary.html

Digital Design Media Glossary
http://www.gsd.harvard.edu/~malcolm/DDM/DDMglossary.html

Dr. T's Internet Glossary
http://www.gnofn.org/~tlewis/glossary.htm

Duke University Medical Center
http://surgery.mc.duke.edu/avmedia/Media_PC/glossary.htm

EETimes.com
http://www.eet.com/mediakit99/edaterms.html

Elastic Reality Home Page
http://www.elasticreality.com

Film Glossary
http://www.3by3.com/ring/glossary.html

Free On-Line Dictionary of Computing
http://wombat.doc.ic.ac.uk/foldoc/index.htm

Glindex
http://www.cognivis.com/book/glossary.htm

Glossary of Internet Terms
http://www.matisse.net/files/glossary.html

Graphics Glossary
http://www.swan.ac.uk/compsci/ResearchGroups/CGVGroup/Docs/MWJ/GlMWJ.html

Haywood & Sullivan Glossary
http://www.hsdesign.com/scanning/glossary/glossary.html

Image-based Modeling and Rendering
http://www.ri.cmu.edu/projects/project_253.html

IMDb Film Glossary
http://us.imdb.com/Glossary/

IMI Introduction
http://www.uiah.fi/~spo/glos_model.html

Immersive Imaging Glossary
http://www.dsp.surroundpix.com/defish/glossary.html

InstantWeb Online Computing Dictionary
http://www.instantweb.com/d/dictionary/index.html

Internet Dictionary
http://www.oh-no.com/define.html

Jim Henson's Creature Shop Home Page
http://www.henson.com/creatureshop/index.html

Ken's Dictionary of Computer Standards
http://www.charm.net/~kmarsh/dict.html

Kodak Professional Imaging
http://www.kodak.com
http://www.kodak.cl

KSU Physics Education Group
http://www.phys.ksu.edu/perg/vqm/

Learn the Net
http://www.learnthenet.com/english/

Medialink Broadcast Terminology
http://www.medialink.com/glossary.htm

Mondo Media
http://www.mechadeus.com

Net Lingo Online Dictionary
http://www.netlingo.com

New Mexico Tech Computer Center
http://www.nmt.edu/tcc/help/g/

Nintendo 64 Glossary
http://www.nintendo.com/n64/n64terms.html

Nova Online
http://www.pbs.org/wgbh/nova/specialfx2/glossary.html

QuickTime API Documentation
http://devworld.apple.com/techpubs/quicktime/qtdevdocs/RM/QT3Glossary.htm

Online Dictionary
http://www.dictionary.com

PC Magazine Online
http://www.zdnet.com/pcmag/features/software/1519/3d-s4.htm

Pinnacle Systems Technical Support Glossary
http://www2.truevision.com/glossary.html

Pixar Animation Studios Home Page
http://www.pixar.com

POP Digital Film
http://www.popstudios.com/film/

Pulse Home Page
http://www.pulsewan.com

RUCS Newsletter
http://www.nbcs.rutgers.edu/newsletter/RN62/glossary.html

Shake Software
http://www.nothingreal.com

Side Effects Software Home Page
http://www.sidefx.com

Silicon Graphics
http://www.sgi.com

Silicon Graphics Glossary
http://sgline.epfl.ch:88/SGI_EndUser/glossary/

Softimage Eddie 3.5 Glossary
http://www.uni-duesseldorf.de/WWW/URZ/hardware/parallel/local/softimage/
user_guide/Eddie35-366.html

Tektronix
http://www.tek.com

The Adaptec Array Guide
http://www.adaptec.com/products/guide/arrayguide01.html

The Creature Shop
http://www.character-shop.com/glossary.html

The Jargon Lexicon
http://www.hack.gr/jargon/html/lexicon.html

The Sharpened.net Glossary
http://www.sharpened.net/glossary/terms/cookie.html

The URISA Glossary of Terms
http://www.urisa.org/glossary/gloss.html

The Visual Effects Resource Center
http://www.visualfx.com/glossary.htm

3D Photography
http://www.3dphoto.net/stereo/text/glossary/glossary.html

3D Vision
http://www.vision3e.com/3views.html

Timetrack Virtual Camera Movement
http://www.virtualcamera.com/welcome.html

U-Geek.com
http://ugeek.com

Virtual Reality in Medicine: A Survey of the State of the Art
http://www.informatik.umu.se/~jwworth/medpage.html

Vision 3D
http://www.vision3d.com/

Web Monkey Reference Glossary
http://hotwired.lycos.com/webmonkey/glossary/

Webopedia
http://webopedia.internet.com

Web Reference
http://www.webreference.com/glossary/

Whatis.com
http://whatis.com/

What is RSI
http://www.thehelpinghand.com/basic.htm

World Wide Words
http://www.clever.net/quinion/words/turnsofphrase/

Praise for Visual Effects in a Digital World

"A comprehensive guide to both visual effects terms and techniques, Karen Goulekas' "Visual Effects in a Digital World" renders a complete picture of how visual effects movies are made."

— *Sean Dever, 3D Manager, Cinesite*

"The guessing is over. Due to Goulekas' meticulous research, filmmakers from different generations and even different continents finally will be able to speak the same language."

— *Volker Engel, Visual Effects Supervisor*

"If Karen said it, it must be true!"

— *Mark Stetson, Visual Effects Supervisor*

"This book merges the worlds of film production, cinematography and special effects into one visually-oriented universe."

— *Chris Roda, Independent Producer/Director*

"If you are new to the industry, you should read this book from cover to cover, and if you are a 10- to 20-year veteran, this book has you covered."

— *Teddy Yang, CG Supervisor*

"Never again will I have to pretend that I know what a digital artist is saying. This book stays with me always.

— *Ron Gress, Visual Effects Art Director*

"If you only own two books about digital visual effects, this should be one of them.
— *Ron Brinkmann, Author, "The Art and Science of Digital Compositing."*

"Karen Goulekas, the voice of digital visual effects!"

— *Steven Blakey, Digital Animator*

"Comprehensive and insightful. A great production tool."

— *Steve Molen, Production Executive, DreamWorks.*

"All the terminology you wanted to know but never dared to ask."
— *Remo Balcells, CG Supervisor, Square Hawaii*

"A must-have reference not only for visual effects enthusiasts or professionals, but for any modern-day filmmaker."
— *Carey Villegas, Associate Visual Effects Supervisor, Sony Pictures ImageWorks*

"Karen has created a comprehensive reference for visual effects filmmaking in the new millenium. In a field where cutting-edge science intersects with cutting-edge art, she has provided a valuable resource for us all."
— *Scott Gordon, Digital Effects Supervisor*

"This is the only book that truly quantifies visual effects. Excellent bathroom reading material."
— *Bryan Grill, Compositing Supervisor, Digital Domain*

"In an industry that has grown and changed so rapidly, Karen's book is a welcome tool to help us all communicate better with a common language."
— *Ruth Scovill, President, COO, Cinesite*

"Karen's compiled glossary is as thorough and informative as she is herself. She's provided a fabulous resource to us all!"
— *Janet Healy, Head of Digital Production, DreamWorks*

"I laughed, I cried."
— *Tim Sarnoff, Executive Vice President/General Manager, Sony Pictures Imageworks*

"More information than you'll ever want to know."
— *Nancy St. John, Visual Effects Producer/Consultant*

"An absolute must have. Karen has pinpointed the terminology used and information needed to survive in today's "Digital Revolution." All filmmaker's, seasoned veterans or film school "newbies," need this book for today's techniques that will be tomorrow's vision."
— *Dan Lombardo, VFX Executive Producer, Manex Visual Effects*

"An essential guide for anyone involved in digital effects filmmaking. It is a great help for bridging the communication gap between the techies and the rest of us."
— *William Fay, Executive Producer*

"Karen has put together what will soon be referred to as the 'FX terminology bible.' Amazingly comprehensive and as books go, a whole lot of words and very, very heavy."
— *Steve Oedekerk, Director*

Related Titles from Morgan Kaufmann

Morgan Kaufmann

http://www.mkp.com

- **THE ART AND SCIENCE OF DIGITAL COMPOSITING**
 Ron Brinkmann
 1999 ISBN: 0-12-133960-2

- **3D MODELING AND SURFACING**
 Bill Fleming
 April 1999 ISBN: 0-12-260490-3

- **UNDERSTANDING MOTION CAPTURE FOR COMPUTER ANIMATION AND VIDEO GAMES**
 Alberto Menache
 October 1999 ISBN: 0-12-490630-3

- **MASTERING PIXELS 3D: A COMPREHENSIVE GUIDE**
 R. Shamms Mortier
 May 2000 ISBN: 0-12-508040-9